W9-AFD-737

Illuminating Video

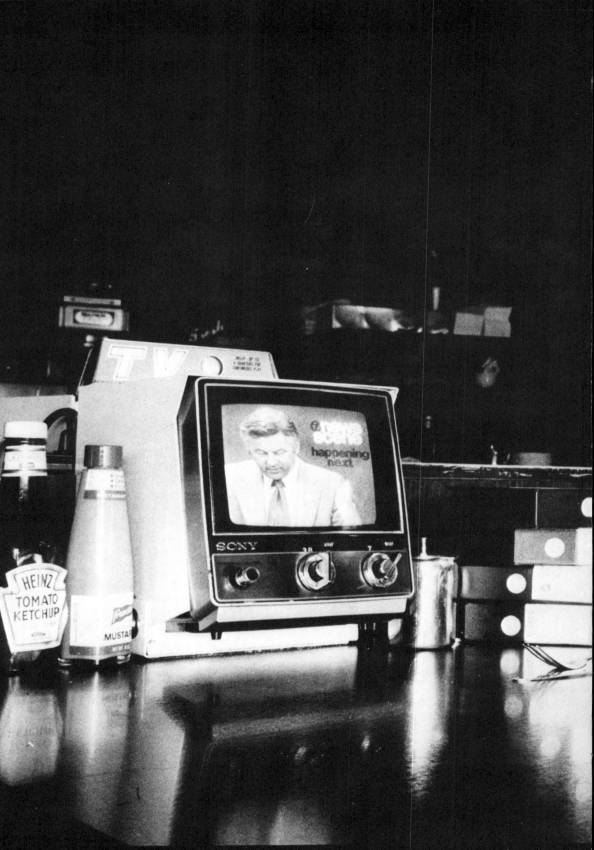

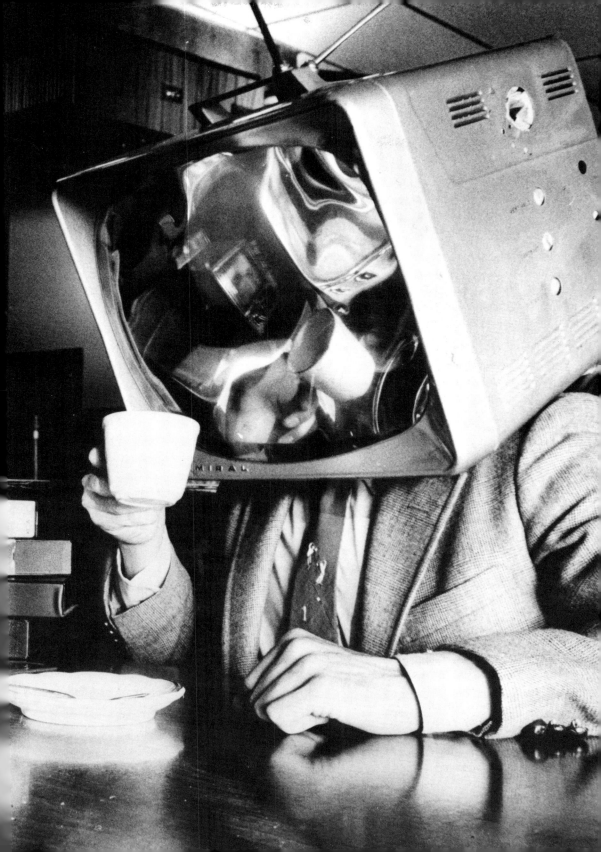

Vito Acconci
Judith Barry
Raymond Bellour
Dara Birnbaum
Deirdre Boyle
Peter d'Agostino
Juan Downey
Bruce Ferguson
Howard Fried
Coco Fusco
Martha Gever
Dan Graham
Dee Dee Halleck
John G. Hanhardt
Lynn Hershman
Gary Hill
Kathy Rae Huffman
Joan Jonas
Norman M. Klein
Tony Labat
Chip Lord
Mary Lucier
Rita Myers
Margaret Morse
Muntadas
Kathy O'Dell
Tony Oursler
Martha Rosler
Ann–Sargent Wooster
Marita Sturken
Christine Tamblyn
Francesc Torres
Maureen Turim
Steina Vasulka
Woody Vasulka
Bill Viola
Bruce and Norman
 Yonemoto

Illuminating Video

An Essential Guide to Video Art

**Edited by Doug Hall and
Sally Jo Fifer**

Preface by David Bolt

Foreword by David Ross

**Introduction by Doug Hall and
Sally Jo Fifer**

**Aperture in association with
the Bay Area Video Coalition**

Contents

Syntax and Genre

Telling Stories

(Boldface denotes artists' pages)

Acknowledgments

This project was funded by The Rockefeller Foundation, The National Endowment for the Media Arts National Services, The National Endowment for the Arts Visual Artists Forums, and the Zellerbach Family Fund. We would also like to thank David Bolt, Janet M. Sternberg, Marita Sturken, Margaret Morse, Jim and Judy Newman, Steve Dietz, Jane D. Marsching, Bob Riley, Luke Hones, Patricia Carney, Beverly Crawford, Diane Andrews Hall, Jules Backus, Kira Perov, Ardath Grant, Connie Fitzsimmons, John Rapko, Bonnie Lloyd, Petrified Films, Reginald D. Fifer, Kate Horsfield, Video Data Bank, Chicago, Electronic Arts Intermix, New York, Howard Boyer, and the Department of Film and Video at the Whitney Museum of American Art, New York.—D.H. & S.J.F.

Preface

D A V I D B O L T

The origins of *Illuminating Video* go back to the tenth anniversary of the Bay Area Video Coalition (BAVC). In 1986, Doug Hall and Sally Jo Fifer began discussing the idea of a publication that would highlight ten years of video production at BAVC. Their initial conception broadened into a more ambitious plan: to produce a book that was national in scope and which presented video as the complex and diverse field that it is.

Media arts centers such as BAVC have had an intimate relationship with the development of video art in this country. Indeed many of the artists represented in this book could not have realized their projects without the support of media arts centers, which have been crucial in the production of independent video, in the exhibition of tapes, and most importantly, the dissemination of a critical discourse about video art.

This has been an ambitious undertaking for BAVC, one that could not have been attempted without broad support from the media community and for which we are deeply appreciative. To the many artists, critics, and scholars who have contributed to the book, we thank you. We are also grateful for the assistance from The Rockefeller Foundation, the National Endowment for the Arts, and the Zellerbach Family Fund.

We appreciate that Aperture, highly regarded for its photographic publications, has broken with its own tradition by publishing a book on video. In the process they have made a great contribution to the field of video and to the contemporary art community.

Foreword

D A V I D A . R O S S

One of the curious ironies of video art's early years is that for a field of prac-
tice generated by new technologies and allied with a broad range of advanced
aesthetic positions it generated a rather limited critical discourse. To many
working with the reinvented medium, the lack of a critical establishment was
a pure delight. More than one artist noted that critical elbow room was a
prime reason for working in this relatively obscure form. But as the 1970s
progressed, it became clear that many significant issues raised by the continu-
ing production of undeniably important work both required and deserved a
more substantial and consequential discourse generated not solely by the dis-
tinct formal qualities of video and television but by the broader aesthetic and
ideological issues raised by artists working within this seminal postmodern
form. In recent years, a number of important video anthologies and readers
have emerged, but to date none has yet managed to fully embrace and reflect
this critical juncture in the development of the medium and its study.

This new collection of original critical writing, organized and edited by
artist Doug Hall and critic Sally Jo Fifer, marks an important milestone in the
progress of video both as an art form and a center for significant cultural de-
bate. Encouragingly, artists' video—within the past decade—has developed a
broad array of critical voices and has begun to reflect an engagement with fun-
damental questions in both the formation of its own particular critical vocabu-
lary and its emerging history and a set of deeper issues one must recognize as
central to the notion of postmodernism itself. Crucial issues ranging from the
representation of difference to ideological and epistemological relationships im-
bedded in the interactive reader/writer union made possible by new two-way
technologies merely hint at the frame of reference established by this volume of
critical writings. *Illuminating Video* underscores the heterogeneity of the video
discourse and for the first time demonstrates that video has, in fact, begun to
live up to its potential.

Video art has continually benefited from its inherently radical character.
On one hand, it has always been associated with the concepts of superindepen-
dent alternatives to the hegemony of commercial television. From its earliest
portapak productions, video has been the purposeful outsider, attempting not
merely a critical stance but models for a less alienated and alienating set of
uses for the technology that has reshaped our century. On the other hand, its
root within the art world linked it to the complex Fluxus sensibility and to
those other conceptualists who used blank irony, appropriation, and inversion

often to critique a commodified culture and its attendant forms of representation and reification. These oppositional practices, which tend to view the apparatus of television as anything but neutral, tended to explore the complex individual and social relationships within a culture undergoing extreme transformations. Accordingly, they were produced in a medium that challenged the standard commerce in works of art and the way that artists' ideas were located and historicized.

As video's critical writing emerged, it reflected this set of concerns. It remained somewhat apart from the bulk of hagiographic writing about the reemergence of painting that dominated art journals in the late 1970s and early 1980s, and (allied more closely to poststructuralist photography, film, and architectural criticism), it remained openly critical of the simplified politics of much of the first generation of video's literature.

The critic Rosalind Krauss in 1976 was the first to discuss the implications of video's essential psychological character and sexual nature, opening video criticism to the influence of contemporary Parisian theory. Her *October* essay, "Video: The Aesthetics of Narcissism," brought psychoanalytic theory to the discussion of video art and offered a rich model for its future direction. Similarly the 1979 *October* publication of Douglas Crimp's 1977 catalog essay for the exhibition *Pictures* brought to a relatively wide audience an exploration of our increasingly fetishized relationships with mass media imagery and the extent to which media conciousness defines and controls our sense of self. These works, like the Walter Benjamin-influenced 1970s writings of Douglas Davis (an early supporter of Paik, Beuys, and the Fluxus aesthetic), pressed video criticism to explore the primary relationship between the individual and an alienated society and the difficulty of reconciling individual and social behavior. In this anthology of video writing, the editors have incorporated new writing that combines this approach to video criticism to the broader field of contemporary critical writing, successfully opening this often closed universe to a broader critical debate. Without a doubt, *Illuminating Video* contains significant new American critical writing to advance our thinking about this subject well into the 1990s.

If there has been one area in which video writing has consistently made a significant contribution, it has been in the area of artists' writings. From the first video writings anthology *Video Art* to special issues of magazines like *Art-Rite* to *Video By Artists,* the Canadian series of international anthologies produced by Art Metropole, the artist's word has been the clearest and most powerful component of video's critical corpus.

Interestingly, there is no irony here, for it is in fact the emergence of the artist's voice—clear, insightful, powerful, and fully controlled by the artist— that forms the foundation of video as an art form. In this anthology, coedited

by an artist, once again artists' writings form the core of the volume. This is particulary important as, in my education as a curator and writer, it has always been the artist who has insisted upon expanding the range of the video discourse. It is precisely that insistence which makes this book so important and which reflects that level of intellectual ambition which is the promise of video's illuminating glow.

Introduction:

Complexities of an Art Form

DOUG HALL AND SALLY JO FIFER

Illuminating Video is a collection of new essays by forty-two artists, critics, curators, and scholars about a complex visual form, video art. While on the surface this book is solely about video, the essays are not intended to quarantine video from discourses that involve all the arts. The intent of this book is, in fact, to disseminate information about video as an art form in the United States, while situating it in the context of current debates on contemporary art and culture.

A distinct quality of *Illuminating Video* is the inclusion of writings by the artists themselves. These take two forms. Several follow the traditional essay, and as such are indistinguishable from the more scholarly writings in the book. What differentiates most of them is that they represent personal and often idiosyncratic points of view (the voice of the artist), and establish a valuable counterpoint to the more scholarly writings. This difference is even more noticeable in the second group of artists' pieces in which the artists deviate from the traditional essay by employing visual and textual structures that more directly convey their ideas. In all cases, the artists' contributions have been integrated into the various chapters along side the writings of critics and scholars and offer the reader valuable first-hand insight into the artists' thoughts and creative process.

The contributors to *Illuminating Video* express a diversity of opinion that is a representation of the field's heterogeneity. The different voices comment indirectly on one another, highlighting areas of disagreement while simultaneously avoiding any attempt at constructing a linear history. In order to bring these voices together, we have divided the book into the following five sections:

1. **Histories** looks at the various narratives that provide video with its myths of origination and, at the same time, presents arguments that point to the problems involved in constructing such a history.

2. **Furniture/Sculpture/Architecture** considers the object—the television set and the video monitor—through which television and video are transmitted, relating it to sites of domesticity, to urban and suburban architecture, and to the art institutions where video is exhibited.

3. **Audience/Reception: Access/Control** investigates video as a vehicle of oppression and (mis)representation, while providing several scenarios for the viewer's response to the spectacle of image control.

4. **Syntax and Genre** looks at the structure of video and, to a lesser extent, of television, in terms of its own grammar and potential for narrative.

5. **Telling Stories,** the final section, concentrates on the works of artists who use video to convey the abstract and metaphysical. Through video's unique capabilities for image manipulation, they construct analogies to such human experiences as the perception of light and the patterning of memory.

Histories

Video's pedigree is anything but pure.[1] Conceived from a promiscuous mix of disciplines in the great optimism of post-World War II culture, its stock of early practitioners includes a jumble of musicians, poets, documentarians, sculptors, painters, dancers, and technology freaks. Its lineage can be traced to the discourses of art, science, linguistics, technology, mass media, and politics. Cutting across such diverse fields, early video displays a broad range of concerns, often linked by nothing more than the tools themselves. Nonetheless, the challenge of video's history has been taken on by the art world, though it might well have been claimed by social history or, for that matter, the history of science and technology. Art historians, however, face two obstacles to constructing a credible history of video: video's multiple origins and its explicitly anti-Establishment beginnings. These obstacles to historicization, either directly or by implication, are the focus of the essays in this section.

When art historians consider video's origins, they encounter the first obstacle: a wild plurality of styles for sorting and analysis. History is a process of selection. Art history, however, selects within the already isolated sphere of aesthetics. Traditionally, art historians have ignored social and political factors because they have been considered beyond their carefully delineated parameters. Video, as a product and process that represents many differently derived practices by numerous artists and social groups, resists this closed system.

Furthermore, video defies the art historical practice of ordering the field into a depoliticized hierarchy of stylistic categories. Over time, this hierarchy, when based on historical inclusion and exclusion, implicitly endows cultural value to certain works. Works of art perceived as valuable enough to be positioned in a historical niche then risk becoming neutralized as they are isolated from their social and political context and assigned new meaning in the historical process.

As with all the arts, the process of creating an art historical narrative for video is complex. It includes not only historians but also the art institutions—the museums in which cultural value is assigned to artworks and the universities where the historical process is made academic. A third part of this equation of legitimization is the interested public, which reaffirms the institutional

selection process. This public, complicit with art history, forms the art market and helps to generate the menu of "important" art from which the institutions, mediated by curators, critics, and scholars, select the works that are made available to the market in the first place. Since this closed system of historicization traditionally has been based on formal aesthetic criteria, it has been taxed by works of art that gain their meaning from the very thing which formalist art criticism strives to deny—the unruly social and political tangle that exists beyond the walls of art history. This, then, is the second obstacle for creating a coherent art history for video: anti-Establishment in its disregard for commodity values, video defies a depoliticized hierarchy, since it is socially engaged.

The problems in constructing video's historical narrative are further exacerbated by the impermanence of the materials from which video is made. Videotape rapidly disintegrates. As Marita Sturken points out, there is a problem when the historical record becomes a substitute for the work itself. Only a few tapes can be afforded the privilege of being revived and archived by the institutions. Countless tapes will be lost once they are omitted from institutional selection. The institutions' agenda for connoisseurship, therefore, must be differentiated from their agenda for historical preservation. Sometimes connoisseurship and preservation work in sync, so that tapes selected for archiving represent a broad history of early video. Many times, however, they do not. If the actual videotape no longer exists, the historical record remains frozen in time, making later evaluations of that work impossible. As a result, work lost in its own time has no chance of emerging for revaluation in a later one. As Sturken points out, this may be one of the reasons that video is so conscious of its history.

For many artists, video's impermanence represents a denial of art as precious object. It also provides a medium for challenging art institutions because it is reproducible and because it deviates from art institutional agendas dedicated to the protection and display of unique artifacts. As Martha Rosler notes, video is not only reproducible, it also affords the viewer access to a two-way machine confusing the relationship between the maker and the consumer of art. Rosler takes this argument one step further. Tracing the nineteenth-century responses to technology, using photography as the primary example, Rosler examines the utopian assumptions that surround technology. Has video met the expectations held by early users about the impact of technology on society? Has technology changed the players ultimately in control of the production and the consumption of cultural activity?

Though the extent of the impact is questionable, the democratization of photography and video, their rapid and inexpensive reproducibility, idealized by early users, nonetheless challenges institutional power and privilege attached to public image making. Sturken notes that institutions can thwart

resistance to their power and privilege by incorporating video into their collections. They justify the acquisition of video by promoting its formalist qualities that, as previously described, displace its political messages.

Video's funding by and inclusion in the art world depend on establishing its uniqueness and aligning itself with art and away from TV. Sturken warns, however, that there is a danger in the conventional criticism that emphasizes video's formalist qualities. The plurality of intentions behind early work is ignored while works that conform to formalist interpretations are celebrated. More important, works that meet an institutional agenda for connoisseurship are preserved and become the focus of analysis in art history while other works are marginalized.

Three contributors examine the tension between video artists and institutions and, by extension, the problem of writing the history of video from an art historical vantage point. John G. Hanhardt tells us that early video artists wished to expose art as an "elitist and nonpublic discourse." Hanhardt constructs a historical context for the utopian objectives embedded in the practices of art making. On the other hand, Deirdre Boyle finds utopian roots in early video fertilized by the social movements of the 1960s and 1970s. Boyle describes portable video as a tool that political activists used to challenge authority in their attempt to gain access to mass media. It was also, as Kathy Huffman argues, an experimental tool for public television centers, which hoped to be alternatives to network TV. Though the artistic outcomes of these strategies were remarkably diverse, the videomakers shared radical intentions to subvert the power of institutions and their hegemony.

As more and more tapes disappear, their surfaces oxidizing with time, it is tempting to retreat from video's multiple histories and anti-Establishment beginnings to construct a narrative suitable for the needs of art history. By recording video's multiple histories and listening to artists, however, we will be more likely to stumble upon historical truths. In the process, another kind of knowledge about video art is gained: one that is responsible to its various lives, appreciative of its contradictions, and critical of the historical process that records video into public memory.

Furniture/Sculpture/Architecture

In this section, the television set (upon which we watch broadcast and cable transmissions) and the video monitor (used for viewing videotapes and for closed-circuit situations) are treated as physical objects with complex relations to the broader social order. Part of the intent of this section is to describe some of these cultural (or institutional) connections so that one can better understand how video influences our physical, perceptual, and psychological relationship to the world. Vito Acconci, Kathy O'Dell, and Dan Graham consider

television and video in terms of the family and the home. Graham, Chip Lord, and Dara Birnbaum take television and video into the (potentially) more alienating enclosures of public architecture. Finally, Margaret Morse and Francesc Torres examine video in its most sculptural form, as installation within the art museum. In the course of negotiating these domains, we move from a notion of television as furniture to one in which video monitors and projections are incorporated by artists into large environments of sound and image.

To consider television as furniture is to confront ourselves sitting in our homes and watching television. Here we take for granted that spectacular events (assassinations, wars, hijackings, mass murders) as well as more benign ones (sporting events, soap operas, game shows) will come to us, through the appliance, while we sit, comfortable and detached, in the privacy of our living rooms. Much has been written about the role of television in our lives and the way it has distorted our sense of self and of the world. Theoretical discourses from spectatorship to textual analysis have been constructed to describe our relationship to television's (dis)continuous flow of information. Epithets such as "hyper-real" have been summoned to connote a world dominated by television, a world in which "real" experience is seen as simulated through mediated surrogates.

These thoughts, however, do not ordinarily occur to us when, sprawled on the Lazy Boy recliner, we bathe in the mesmerizing glow of the family TV. Consuming television in the familiar surroundings of the home does very little to encourage a critical dialogue with it. For this to happen, we must place TV outside of the normalcy of the domestic site. According to Acconci, it is this presence of the home, existing in television, that "stops us in our tracks" when we come upon a TV in nondomestic, public spaces. In other words, we always see home and family in television and especially when it's removed from its usual domestic environment. Before we can consider how video operates outside of the home, however, we need a better idea of what television means within the home. This is the concern of three of the authors in this section.

First, and most obviously, TV is a manufactured object—a piece of furniture. As Vito Acconci points out in his essay, a television is like the other furnishings in the home, except that for many of us, it is the most important one: the one we look at or stare into. And, we do not stare alone. We watch television at home as a collective experience, and many of the programs reinforce the family structure. As Dan Graham writes, "TV might be metaphorically visualized as a mirror in which the viewing family sees an idealized, ideologically distorted reflection of themselves represented in typical genres of TV: the situation comedy or the soap opera. Where TV represents typical American families, it symbolically represents an image of the American family to itself." Television is also the conduit through which the world at large enters the privacy of the home.

Doug Hall, *The Terrible Uncertainty of the Thing Described,* 1987.

Trouble in the home is the focus of Kathy O'Dell's essay. Reflecting on the early performance video of Acconci, Graham, and Joan Jonas, her emphasis is on the psychodynamics of the home, which television as a system supports and helps to construct. For O'Dell, the home is important as the site where one first constructs the self. In the hands of many performance artists from the early 1970s, video became a symbolic mirror in which the self was fragmented, frozen, and disconnected. O'Dell contends that video, in this sense, is a tool that helps continue the process of reflection that begins in the earliest symbolic stage of human psychic development. Using a psychoanalytic method derived from Jacques Lacan, she perceives in video the potential to continue this "mirror stage," since it provides the possibility of reflecting back new imaginings or identities. The newly integrated identity, she argues, could be freed of gender and hierarchies derived from the patriarchy of the home, the original site of identity construction. It is, according to her, through video's metaphors of fragmentation and alienation that the original fictions of identity are exposed so that new ones can be constructed.

Outside of the home, there is another kind of architectural space—a public one that includes suburban malls, high-rise office buildings, airports, and

freeways. Several of the authors see parallels between these architectural expanses and the two-dimensional topographies of television. At first, this seems an unlikely analogy. Seeing the connection between architecture and television, however, can help one understand how artists use video to examine our physical and mental relationships to built and mediated space.

The postmodern architectural environment includes buildings of every imaginable style and design. From Greek revival to neorococo, the styles are often imposed one on top of the other, without consideration for the meaning of the individual parts. The result is an eclecticism in which buildings incorporate a pastiche of signs and referents whose exact meanings are nearly impossible to decode. This layering of information is similar to the collaging of images that takes place on television during an ordinary viewing day or even in the space of a few moments as we scan the channels with remote controllers.

Both television and architecture present us with walls of conflicting signs, with few clues on how to access their topographies nor suggestions about what to do once we get beyond the surface. We are involved in an experience of superficies in which attempts to probe deeper yield only to more surfaces as impenetrable as the first. In fact, any endeavor to deduce meaning from these topographies—to dig beneath their seductive veneers—can cause a feeling of psychological displacement and a sense that our mental and physical spaces have become intermingled and confused. The result could be described as a state of walking somnambulism. It is caused by our sense that there is nothing there—beyond the surface—that we are nowhere and that television is, in effect, a two-dimensional shopping mall in which there is nothing to buy.

In his essay, Dan Graham shows how the codes and signs that are architecturally inscribed into urban and suburban life arbitrarily "reflect and direct the social order." The intent of his site-specific video installations is didactic: to return to the viewer a sense of psychological and perceptual control, even as one experiences the conflicting messages of built and mediated space. Graham does this by constructing works in public and semipublic spaces (such as the Citicorp atrium in New York City), which draw attention to our complex relationship to architecture and to its two-dimensional equivalent, television. As Nigel Coates says, "We learn to compensate, by adopting the vocabulary we are faced with."[2] Television is a basic component within the vocabulary of contemporary experience. For many artists, video is the language of TV absorbed into the discourse of cultural critique. It is television turned against itself. Through the work of Graham and other artists, video is a weapon in the battle against the tyranny of images.

When removed from the context of television commodities and placed within the museum, video takes on the status of art. The relationship between video and the art museum, however, has been an uneasy one. The reasons for this are complex; yet one explanation is to be found in their differing attitudes

toward time. With single-channel videotapes, there is a linear narrativity that requires that the visitor view the work from beginning to end. This time-based aspect of video clashes with the viewing time that one expects in a museum, which is more leisurely.

All institutional spaces such as banks, supermarkets, movie theaters, and art museums have their own set of temporal rules. When we enter one of those spaces, our expectations of how events will unfold, the amount of time they will take, the order in which they will occur, and the degree of control we will have over them are based on our experiences of similar spaces. When time flows differently than what we expect, we can become impatient and resistant to the temporal imposition.

The phenomenological time of the art museum could be described as self-guided. A visitor expects to control the time spent looking at individual artworks. Static arts such as painting, sculpture, and photography work comfortably in this climate. Video, on the other hand, has its own temporal agenda. This is one of the things that strikes us when we come upon a television or a monitor in an art museum, especially if seating has been arranged in front of it: video announces the presence of another kind of time, one that demands more focused attention. It is, in a most important sense, a viewing experience that is in conflict with the temporality of the museum.

Video installation has prospered partially because of its ability to be more responsive to the temporal demands of both video and the viewer. Since video installation is the incorporation of television or video monitors into complex sculptural and architectural configurations, it is a form that appears to comply with many of the rules that govern sculpture. These works seem to invite the visitor to engage them for a period of time that is determined by the viewer and not dictated by the internal time of the work itself. Hence, installations have been more readily integrated into the museum context than have single-channel tapes.

However, as Margaret Morse points out in her essay, video installation is a form whose strategies of time and uses of space lead the viewer to a kines-thetic experience that is of an order different from either looking at traditional sculpture or watching television. With video installation, we move among the images, sharing their space, becoming performers in the work. According to Morse, the art form is no longer just the images on the monitor, as it would be in single-channel works, but more important, it is their relation to the body of the visitor, which she terms the "space in between."

Audience/Reception: Access/Control

Television is a source of cultural hegemony and hierarchy, a reigning discourse in the shaping of world politics and in the writing of history. Disconnected

from broadcast feeds, however, television sets become monitors, and video cameras and recorders become potential tools of resistance—providing program alternatives to mainstream media.

That artists would be among the first to oppose television as an instrument of power is not surprising. As the contributors in the "Histories" section describe, a utopian impulse to explore the democratic possibilities of mass media or at least to comment on its Orwellian tendencies pervaded much of early video art. Video was an inevitable vehicle for artists of the New Left. "Its relationship to television, technology, and information, and its reproducibility, made it seem like the appropriately radical tool, with which to achieve their goals," says Marita Sturken. In this section "Audience/Reception: Access/Control," the authors look at television as a system of representation and discuss video art's role in establishing strategies for questioning its representational hegemony.

One of the more prevalent critiques of television focuses on the way television represents and perpetuates dominant ideologies. Television tends to compress the world into simplified equations in which everything is designated as either similar (dominant) or different (other). In this order, universality is ascribed to the dominant's characteristics whereas qualities that belong to the other are marginalized and objectified. The other does not represent but rather is represented. Thus, a hierarchy is encoded into the iconography and the ideologies of every soap, sitcom, and advertisement. This simulation of hierarchical social relationships fixes identities, mythologies, or stereotypes that preserve the interests of the class, gender, sexual preference, or race of the dominant.

In addition to imposing hierarchies that mirror already present structures of power in society, television also acts as a filter to exclude realities—realities that, more often than not, belong to the other. Critiquing representation not only involves countering the myths and stereotypes of (mis)representation but also including that which has been rejected by the dominant.

In her essay, Coco Fusco argues that current attempts at inclusion and diversity are not necessarily a guarantee against stereotyping and mythmaking. Fusco examines how defining and exploring culture as other can create still more artificial representations of ethnic minorities. She describes the term "other" as an art historical formality that "calls forth ontological processes of definition." Race, she says, is neither a formal category, nor ontological condition; rather, race is relative to other categories such as gender and class.

Martha Gever argues that the economy of video production can invite the other, in this case women, to interrogate the role of representation and to create works that inject a feminist perspective into social politics and history. She adds that women video artists have helped define terms, based on the feminist critique, that have become historically sanctioned and inseparable from the dominant discourses. Further, feminist strategies of intervention have been

widely adopted by video artists to challenge all forms of representation, not only those related to gender. One of these strategies is appropriation, a tactic in which images are isolated and recontextualized to expose the dominant myths encoded into mass media. As Gever demonstrates, in the hands of feminists, appropriation is a means of resistance because it displaces the prevailing fictions of gender, particularly those expressed through TV.

According to Judith Barry, who invokes Edward Said's lecture on cultural resistance, appropriation can work in two directions. Artists engage the vocabulary of television, its image codes and special effects, in order to pursue their aesthetic goals and to deconstruct television's vernacular. Conversely, TV consumes artists' innovations in order to satisfy the audience's insatiable desire for new and seductive imagery. Barry describes this spiral of interdependence as parasitic.

Dee Dee Halleck contends that this parasitic relationship makes video artists vulnerable to censorship, a particularly dark shadow that she sees cast over high-cost video productions. She argues that artists who must make their projects appear attractive to funding institutions have become dependent on the industry's prohibitively expensive tools. According to Halleck, "censorship begins with the very choice of subject and style at the grant application phase." She suggests that the increased availability of consumer video in conjunction with decentralized media activity, such as public access, allows artists to overcome some of the issues of censorship. For Halleck, working outside the main communication conduits permits more experimentation and open expression of diverse ideas.

Consumer technologies make it possible for people to become media literate as they shoot and edit their own programs. As people learn about media practices, they become less passive and more capable of countering its demagoguery. Lynn Hershman makes a case for interactive technology based on this prescription. She describes her attempts to empower audiences by supplanting passivity with participation. Interactive systems require viewers to react. As viewers become active participants instead of passive consumers, they are more able to counter being dominated by the myths of media.

Ann-Sargent Wooster, however, questions the current romance with interactivity and its promise of democratizing media. She argues that interactive video discs lull the viewer into even greater passivity. Viewers are tricked into believing that they are creating a new work instead of merely choosing from a limited number of options determined by the artist. As a result, viewers experience a false sense of power and freedom while becoming more susceptible to manipulation. Unaware of the facade of choice, viewers have no impetus to look beyond the artist's select menu for alternatives. As Wooster points out, if there are no real options, choosing is meaningless.

Taken together, these essays suggest that video art leads a double existence. On the one hand, it operates as a marginal and critical form in relation to dominant media by revealing methods of audience manipulation. On the other, video makes use of the very strategies it criticizes in order to capture and hold the attention of a viewer. Video both illustrates power and is a means to its resistance.

Syntax and Genre

The dominant approach of art criticism has concentrated on the formal aspects of an artwork's distinct properties. "Critics of this approach point out that limiting discussions of video to its distinct properties restricts the discourse of the medium to the limitations of modernist art theory," explains Marita Sturken in her essay for this book. In the section "Syntax and Genre," the authors take on the task of considering video in terms of its own phenomenology in attempts to move this formalist discourse beyond the restrictive (and purely aesthetic) perceptions of modernism.

The claim that an art medium has inherent properties demands that each art form be seen as distinct from all others and to possess qualities that are unique to it alone. For example, Clement Greenberg identified the inherent properties in painting as flatness, support, surface, color, and scale. To define analogous properties in video is considerably more difficult, but we could suggest the following possibilities: a glowing surface that is composed of bits of information on a (relatively small) phosphorous screen; a source of light looked into; a light emanating from a machine called a television; instantaneous transmission; an instancy that instills in the viewer an illusion of immediacy; and a temporality that is both informed by and a reaction against TV's use of time.

These medium-specific properties could also be described as the language through which a work constructs its meaning as art. Hence, the inherent properties are seen as equivalent to lexical parts such as words; the system of rules that govern and control the constituent properties is the grammar; and the manipulation of the constituent parts according to the governing rules of grammar constitutes the syntax.

The modernist account demands that critical emphasis be placed on a work's formal properties because it is through them that it makes its claim as a (good) work of art. This need to categorize and isolate artistic practices from one another and from any social context allows for an establishment of criteria by which critical judgments can be made.[3]

One of video's distinct qualities may very well be its ability to defy the boundaries that have been so carefully constructed by modernism. "Omnivorously, or even cannibalistically," writes Christine Tamblyn, "the video me-

dium seems to be capable of accommodating any synthetic aesthetic strategy, production method, or format that artists have managed to devise." By limiting itself to this refined purist account, modernist discourse seems to insist that some ineffable truth will emerge miraculously out of its own properties to reveal such essences as "presentness" and "grace."[4]

There is, however, widespread suspicion among contemporary artists and critics that the mechanisms through which meaning attaches and detaches itself to the stuff of art are more complex—mechanisms that include a process in which the artwork's properties interact with the very social matrix that modernism denies. This suspicion informs the essays in this section. Taken as a whole, they argue that the concept of distinct properties has been liberated from the restrictive connotations of its modernist involvement. They use a strategy that describes proclivities rather than legislates rules for determining acceptable aesthetic behavior. This method of description presents video as possessing certain qualities and propensities (which may or may not be unique to it), inclining video to behave in particular ways. This strategy provides the reader with a more complex and useful understanding of how the grammar of an artwork might behave. It could lead us back and forth between the form itself and the social context from which meaning was gathered and to which it must, eventually, be returned.

This could also easily be the description of Maureen Turim's essay, "The Cultural Logic of Video," in which she proposes a methodology that integrates a discussion of video's properties into a broader cultural discourse. As with the other authors in this section, she presents video as heterogenous and frees it from the potential for pedagogy found in modernist (or, for that matter, post-modernist) theory. "A generation groomed on such theoretical mythologies is condemned perhaps to see the world in their terms," writes Turim.

The authors in this section do differ, however, in their definitions of what constitutes video's grammar and in their conception of how it becomes organized to form meaning. Turim is interested in examining the way in which video, through its apparatus, can alter our usual orientation to time and space. Our perception of this "temporal and spatial fluidity," she maintains, has the "potential to transform the very concept of history into one far more dynamic and more global than a linear series of events." Turim considers video's ability to handle time in a unique way as one of its essential properties. Her interest, though, is to employ the quality of the medium as a way to connect it to a larger social and political order.

For Norman M. Klein, history has been replaced by an audience memory partially constructed by television. He finds in the genres of television, such as sitcoms and game shows, a syntax with a specific vocabulary from which narratives are constructed. For him, the concern is not with the individual story lines of the various television programs (their literary narratives) but with a

metanarrative that he sees as derived from television's vocabulary of gestures, special effects, and editing rhythms. This larger narrativity is one that is constructed by the audience in the course of a day, a year, or even a lifetime. For Klein, history has become a mental theme park. He examines how the work of artists of such as Dara Birnbaum, Max Almy, Ilene Segalove, and Bruce and Norman Yonemoto appropriate the genres of television in order to expose their fictions and how these fictions are, in turn, involved in the process of creating audience memory.

Like Klein, Bruce Ferguson is interested in television genres. His focus, however, is on comedy and the career of Ernie Kovacs: how Kovacs managed to manipulate and expose the conventions of television production. As Ferguson points out, Kovacs not only created brilliant comedy, but just as important, his skits revealed the artifice of TV's codes and styles. By opening television's seams and interrupting its effortless flow, Kovacs provided his audience with some of the earliest, and most entertaining, strategies of opposition and resistance to television.

In the final essay for this section, Christine Tamblyn also considers genre, but from a feminist perspective. She focuses on the work of six women artists. As she points out, not all of them are directly involved in feminism, and yet they share a strategy. As Tamblyn states, the artists bring together the genres of portraiture and personal documentary, which they use as a basis for self-reflection while simultaneously presenting images of the world beyond them. In other words, they look out as a means to look in. Paradoxically, genres that are associated with the presentation of public experience become vehicles for revealing the private.

Although the essays in this section offer different perspectives, they are similar in that they share a methodology. Their approach is one in which both description and theoretical construction emerge from careful consideration of television's and video's distinctive properties.

Telling Stories

Surrounded by analysis and interpretation, we may become smothered by language, denied vision, oblivious to the rich possibilities of looking at video as an expression of both poetry and criticism. Referring to his writings, Sol Lewitt once warned: "These sentences comment on art, but are not art."[5] Here, in *Illuminating Video,* Gary Hill echoes Lewitt: "There is something of every description which can only be a trap. Maybe it all moves proportionately thereby canceling out change and the estrangement of judgment." While this collection of writings is a testament to the necessity of critique, it will fail if, in the process, it threatens to destroy that which it studies. "[Y]our mind can't help but mince and suddenly you're beside yourself." It is in this section, "Telling

Stories," that the authors' words seem to echo the structure and feeling of video itself.

In Raymond Bellour's essay, "Video Writing," we understand his metaphor of the "pen-camera" as being similar to Douglas Davis's "[t]he camera is a pencil," as referred to in Mary Lucier's essay for this section. Both yield to an idea that is elegant in its simplicity: that video (or, more precisely the active camera of the videomaker) is involved in making marks (writing or drawing) in a basic desire to inscribe meaning. Bellour writes, "I believe that the profound discomfort that comes across us when we are face to face with one of these new images stems from the way they force us to reform, together, and to project into a still unlikely future the two oldest gestures of expression linked in the hand of man: the lines of a drawing and of the letter."

For Mary Lucier, as with Bellour, the concept of video as a conduit to human consciousness and memory is expressed through the metaphor of the mark. In the video installation *Dawn Burn* (1975–76), she describes how the repeated recordings of the rising sun "engrave a signature of decay onto the technological apparatus." The residue of this activity is a calligraphy that takes us to the source of vision by establishing an analogy between the iris of the eye and the lens of the camera. Whether the scar is the sun's trail burned into the phosphorous of the television tube or is an image etched into the memory, the result is the same: both "represent a kind of knowledge."

The mark also represents the passage of time in which the burn is only a residue. It is not, after all, the look of these disfiguring scars to which we respond. We are moved, instead, by an allusion to the poignancy of decay, the movement of light toward dark, and the mortality of vision. An equivalence between the technical apparatus of video and the human act of perception is expressed through video's descriptions of light and its synchronic recording of time. This is the meaning of the words "Light and Death," the title of Mary Lucier's essay. It is a theme that carries through into Bill Viola's "Video Black—The Mortality of the Image."

Viola writes, "[A thought] is more like a cloud than a rock, although its effects can be just as long lasting as a block of stone, and its aging subject to the similar processes of destructive erosion and constructive edification. Duration is the medium which makes thought possible, therefore duration is to consciousness as light is to the eye."

By equating duration, consciousness, and death to the phenomenology of video, Lucier and Viola state a belief in video's ability to express meaning through its own qualities. Although stated in different ways by the various authors, this faith underlies "Telling Stories."

It is appropriate that Tony Oursler's essay, "Phototopic," be the final word in this book. Not only does it add a pleasantly sinister edge to the discussion but, more important, it brings us full circle by returning to the home.

Like Acconci's television, Oursler's Utility sits in the den and is a mind machine that disintegrates the connection between body and intelligence. Acconci's TV, "a rehearsal for a time when human beings no longer have bodies," and Oursler's Utility, an inducement to schizophrenia, are both intimately related to a notion of video as a form that directly affects the consciousness. The difference is that Oursler adds an element of dread by depicting the Utility as parasitic and the cause of deep psychological rupture.

Some final thoughts about *Illuminating Video*. This book can be used as a map or conceptual core sample of the field; its intended purpose is to construct a base from which we can address the issues that are raised by video. After all, a primary function of criticism is to provide a vocabulary so that we can challenge our assumptions as viewers and nonviewers, curators and funders, and, most important, to make our appreciations of the art informed ones. What *Illuminating Video* does not purport to be, however, is a definitive history of the field. Indeed, a subtheme of this book is that no single history can (or should) be written and that to understand video one must consider its several origins as well as its diverging agendas, both social and aesthetic. Multiplicity is one of video's strengths and the source of much of its power. It is also video's location on the margins of official aesthetic acceptability that allows it to maintain a residence within the conscience of the art world.

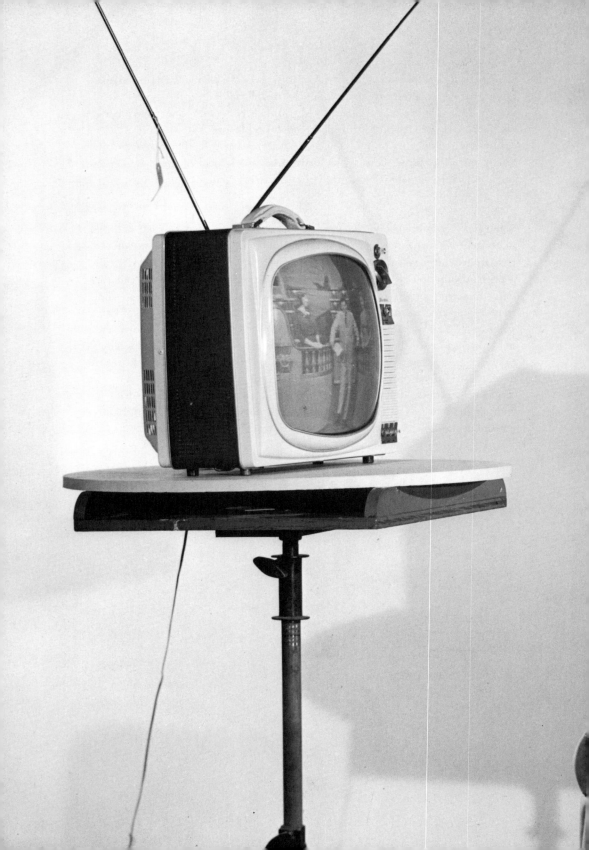

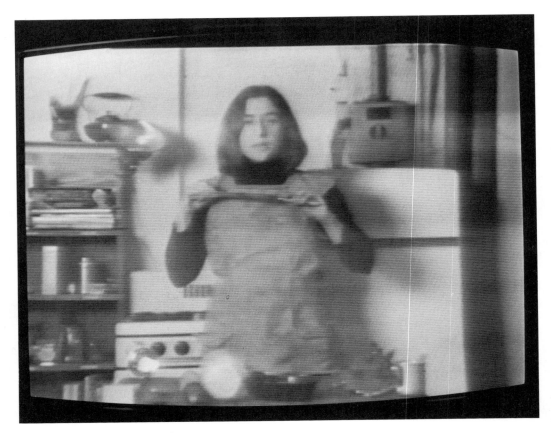

Martha Rosler, *Semiotics of the Kitchen*, 1975.

Video: Shedding The Utopian Moment

MARTHA ROSLER

What we have come to know as *video art* experienced a utopian moment in its early period of development, encouraged by the events of the 1960s. Attention to the conduct of social life, including a questioning of its ultimate aims, had inevitable effects on intellectual and artistic pursuits. Communications and systems theories of art making, based partly on the visionary theories of Marshall McLuhan and Buckminster Fuller, as well as on the structuralism of Claude Lévi-Strauss—to mention only a few representative figures—displaced the expressive models of art that had held sway in the West since the early postwar period. Artists looked to a new shaping and interventionist self-image (if not a shamanistic-magical one), seeking yet another route to power for art, in counterpoint—whether discordant or harmonious—to the shaping power of the mass media over Western culture.

Regardless of the intentions (which were heterogeneous) of artists who turned to television technologies, especially the portable equipment introduced into North America in the late 1960s, these artists' use of the media necessarily occurred in relation to the parent technology: broadcast television and the structures of celebrity it locked into place. Many of these early users saw themselves as carrying out an act of profound social criticism, criticism specifically directed at the domination of groups and individuals epitomized by broadcast television and perhaps all of mainstream Western industrial and technological culture. This act of criticism was carried out itself through a technological medium, one whose potential for interactive and multi-sided communication ironically appeared boundless. Artists were responding not only to the positioning of the mass audience but also to the particular silencing or muting of *artists* as producers of living culture in the face of the vast mass-media industries: the culture industry versus the consciousness industry.

As a reflection of this second, perhaps more immediate motivation, the early uses of portable video technology represented a critique of the institutions of art in Western culture, regarded as another structure of domination. Thus, video posed a challenge to the sites of art production in society, to the forms and "channels" of delivery, and to the passivity of reception built into them. Not only a systemic but also a utopian critique was implicit in video's early use, for the effort was not to enter the system but to transform every aspect of it and—legacy of the revolutionary avant-garde project—to redefine the system out of existence by merging art with social life and making audience and producer interchangeable.

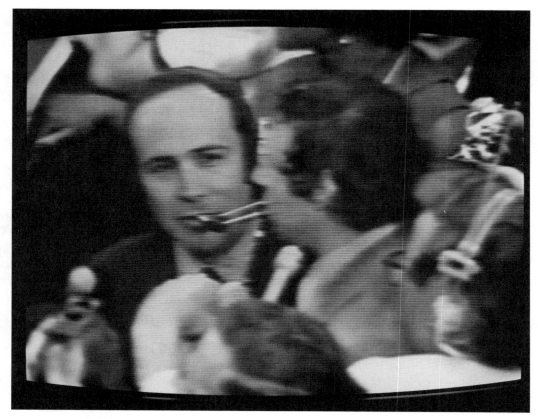

TVTV, *Four More Years*, 1972.

The attempt to use the premier vernacular and popular medium had several streams. The surrealist-inspired or -influenced effort meant to develop a new poetry from this everyday "language" of television, to insert aesthetic pleasure into a mass form and to provide the utopic glimpse afforded by "liberated" sensibilities. This was meant not merely as a hedonic-aesthetic respite from instrumental reality but as a liberatory maneuver. Another stream was more interested in information than in poetry, less interested in spiritual transcendence but equally or more interested in social transformation. Its political dimension was arguably more collective, less visionary, in its effort to open up a space in which the voices of the voiceless might be articulated.

That the first of these streams rested on the sensibility and positioning of the individual meant, of course, that the possibilities for the use of video as a theater of the self, as a narcissistic and *self*-referential medium, constantly presented themselves. And, indeed, the positioning of the individual and the world of the "private" over and against the "public" space of the mass is constantly in question in modern culture. Yet this emphasis on the experience and sensibilities of the individual, and therefore upon "expression" as emblematic

of personal freedom and this as an end in itself, provided an opening for the assimilation of video—as "video art"—into existing art-world structures.

A main effort of the institutionalized art-delivery structures (museums, galleries, and so on) has been to tame video, ignoring or excising the elements of implicit critique. As with earlier modern movements, video art has had to position itself in relation to "the machine"—to the apparatuses of technological society, in this case, electronic broadcasting. Yet the "museumization" of video has meant the consistent neglect by art-world writers and supporters of the relation between "video art" and broadcasting, in favor of a concentration on a distinctly modernist concern with the "essentials of the medium." This paper, in Part I, attempts to trace some basic threads of artists' reactions to nascent technological society and marketplace values in the nineteenth century, using photography as the main example. The discussion invokes the dialectic of science and technology, on one side, and myth and magic, on the other. In considering the strategies of early twentieth-century avant-gardes with respect to the now well-entrenched technological-consumerist society, it asks the question: movement toward liberation or toward accommodation? Part II considers historiography and the interests of the sponsoring institutions, with video history in mind. Part III considers the role of myth in relation to technology, with a look at the shaping effects of the postwar U.S. avant-garde and Marshall McLuhan on the formation and reception of "video art" practices.

Part I: Prehistory

Video is new, a practice that depends on technologies of reproduction late on the scene. Still, video art has been, is being, forced into patterns laid down in the last century. In that century, science and the machine—that is, technology—began to appear as a means to the education of the new classes as well as to the rationalization of industrial and agricultural production, which had given impetus to their development. Although the engineering wonders of the age were proudly displayed in great exhibitions and fairs for all to admire, the consensus on the shaping effects that these forces, and their attendant values, had on society was by no means clear. Commentators of both Left and Right looked on the centrality of the machine as meaning the decline of cultural values in the West. Industrialization, technology's master, seemed to many to rend the social fabric, destroying rural life and traditional values of social cohesiveness and hard work that had heretofore given life meaning.

Central to the growing hegemony of the newly ascendant middle classes, bearers of materialist values and beneficiaries of these new social dislocations, were the media of communication—not excluding those physical means, such as the railroads, which welded communities together with bands of steel—and incidentally added to the repertoire of perceptual effects. Although the new

mass press aided communication among classes and factions vying for social power, its overweening function was the continuous propagation of bourgeois ideology among members of the still-developing middle classes and, beyond them, to the rest of society. And it was this ideology that accorded science a central position. "Science," as sociologist Alvin Gouldner had noted, "became the prestigious and focally visible paradigm of the new mode of discourse."[1] One need hardly add that this focus on science and technology incorporated the implicit goals of conquest, mastery, and instrumentalism responsible for the degradation of work and the destruction of community.

The new technologies of reproduction, from the early nineteenth century on, were not segregated for the use or consumption of ruling elites but soon became embedded in cultural life. Perhaps the most public examples are the growth of the mass press, as previously noted, and the invention of photography, both before mid-century. The birth of the press in the previous century has been identified with the tremendous expansion of the public sphere, inhabited by the cultured, including the cultured bourgeois tradesman alongside the literate aristocrat. The growth of the mass press coincided with the pressure for broader democratic participation, to include the uncultured and unpropertied as well. The erosion of traditional authority, which had emanated from the aristocracy, helped bring the previous ruling ideologies into crisis.

Thus, conflict over cultural values and the machine stemmed from the aristocracy and from the newly proletarianized "masses" as well as from traditional craftspeople, tradespeople, and artists. Artists' revolts against the technologization and commodification of "culture" and its ghettoization as a private preserve of the ebullient middle classes took place in the context of the artists' own immersion in the same "free-market system" that characterized those classes. Thus, opposition to technological optimism was located in diverse social sectors, and for diverse reasons. Both cultural conservatives, such as John Ruskin, and political progressives, such as his former student William Morris, sought to find a synthesis of modern conditions and earlier social values. It might not be stretching a point too far to remark that the centrality of instrumental reason over intellectual (and spiritual) life is what motivated the search of these figures and others for countervailing values. The romantic movement, in both its backward-looking and forward-looking aspects, incorporates this perspective.

> *The world is too much with us; late and soon,*
> *Getting and spending, we lay waste our powers:*
> *Little we see in Nature that is ours . . .*
> —Wordsworth[2]

To some the political struggles of the day, the growth of turbulent metropo-

lises housing the ever-burgeoning working classes, and the attendant depletion of rural life were the worst aspects of nineteenth-century society. To others, like Morris, the worst aspect was the situation of those new classes, their immiseration of material and cultural life, and its deleterious effect on all of society, which he came to see as a matter of political power. Technological pessimism and an attempt to create a new "humanist" anti-technological culture marked the efforts of these latter critics.

The American history of responses to technology differs, if only at first. Initially mistrustful of technology, American thinkers by mid-century looked to technological innovation to improve the labor process and develop American industry, while safeguarding the moral development of women and children. The American transcendentalist poet and minister Ralph Waldo Emerson was initially one of the supreme optimists, but even he had turned pessimist by the 1860s.

Despite the doubts, stresses, and strains, there was, of course, no turning back. In cultural circles even those most suspicious of technological optimism and machine-age values incorporated a response to—and often some acceptance of—science and the technologies of mass reproduction in their work. The impressionist painters, for example, placed optical theories drawn from scientific and technical endeavors (such as the weaving of tapestries) at the center of their work, while keeping photography at bay by emphasizing color. They also turned away from the visible traces of industrialism on the landscape, in a nostalgic pastoralism. Photography itself quickly forced the other visual (and poetic!) practices to take account of it, but strove in its aesthetic practices to ape the traditional arts.

As Richard Rudisill has demonstrated, visual images, which were a mania with Americans even before the invention of daguerreotypy, went straight to the heart of the American culture as soon as the processes of reproduction became available.[3] Rudisill notes that Emerson had referred to himself as a great eyeball looking out during his moments of greatest *in*sight. As John Kasson observes, Emerson was "most concerned with the possibilities of the imagination in a democracy" and "devoted himself not so much to politics directly as to 'the politics of vision.' . . . For Emerson, political democracy was incomplete unless it led to full human freedom in a state of illuminated consciousness and perception. . . ."[4] The identification of the closely observed details of the external object world with the contents of interiority, landscape with inscape, and with the ethical and intellectual demands of democratic participation, provided a motif for American cultural metaphysics that we retain.

Just before photography appeared, the popularity of American art with Americans reached a zenith with the art clubs, in which ordinary people, through subscription or lottery, received American artworks, most of which were carefully described in the popular press. The decline of these clubs coin-

cided with the rise of the new photo technologies, which rested far closer to the heart of private life than did paintings and graphics. Artists took note.

It is worth noting that the person who introduced photography to America not only was a painter but also was the inventor of the telegraph, Samuel F. B. Morse, who received the photographic processes from Daguerre himself. While they chatted in Morse's Paris lodgings, Daguerre's diorama theater, based on the protofilmic illusions of backdrops, scrims, and variable lighting, burned to the ground. This is the stuff of myth. Despite their conjuncture in Morse's person, it took close to one hundred years to get the technologies of sound and image reproduction together.

The subsequent history of Western high culture, which eventually included American high culture as well, included efforts to adapt to, subsume, and resist the new technologies. Although artists had had a history of alliance with science since the Enlightenment (and despite their market positioning vis-à-vis the middle classes, as previously described), even such technologically invested artists as the impressionists, and even photographers, were likely to challenge the authority of scientists often by stressing magic, poetry, incommensurability.

The powers of imagination were at the center of artists' claim to a new authority of their own, based on command of interiority and sensation or perception, notwithstanding the fact that the formulation of those powers might be based on the methods and discoveries of the rival, science. Sectors of late-nineteenth-century art practice, then, pressed occultist, primitivist, sexist, and other irrationalist sources of knowledge and authority, spiritual insights often based not on sight per se but on interpretation and synesthesia, and a rejection of "feminine" Nature. The dialectic of these impulses is the familiar one of modern culture, as Nietzsche suggested.

John Fekete, in *The Critical Twilight,* has called symbolism, whose genesis occurred during this period, "aesthetics in crisis, protesting hysterically against commodity pressures."[5] Fekete refers to its attempt to shut out all of history and the social world as "the sheer despair of total frustration and impotence."[6] Wordsworth's lament about "getting and spending" is transformed into aesthetic inversion and mysticism. Fekete, notes, significantly, the transformation from the formalism of Rimbaud's insistence on "disordering of all these senses" to that of more modern versions of formalized aestheticism, which "make a fetish of language and [embrace] its principles of order," promoting "the unity characteristic of the contemporary ideologies of order."[7] Including social order.

The capitulation to modernity is associated with cubism, which identified rationalized sight with inhuman culture. We should note that rejecting realism, as cubism did, allowed painting to continue to compete with photography, partly by including in a visual art analogies to the rest of the sensorium, and partly by opposing simultaneity to the photographic presentation of the

moment. The sensorium and its relation to form remained at the center of art- ists' attention. Futurism's apologia for the least salutary shocks of modernity and urbanism featured a disjointed simultaneity that abolished time and space, history and tradition. Its perceptual effects were composed into a formal whole in which figure and ground were indistinguishable and ideological meaning suppressed. Although futurism handled modernity through abstraction and condensation, Picasso's cubism incorporated African and other "primitive" im- agery as a technique of transgression and interruption, signifying, one may speculate, incommensurability and mystery, a break in bourgeois rationality. Both cubism and futurism rejected photographic space.

So far I have cast photography in the role of rational and rationalizing handmaiden of bourgeois technological domination. There is another side to it. By the turn of the twentieth century, photography was well established as a rational and representational form, not only of private life and public spectacles of every type, but as implicated in official and unofficial technologies of social control: police photography, anthropometry, urban documentation, and time- and-motion study, for example. Photographs were commodities available to the millions by the millions. But, as previously noted, aesthetic practice in pho- tography was interested in the model provided by the other arts. European aes- thetic photography after the middle of the nineteenth century was associated both with the self-image of the intellectual and social elite (through the work of Julia Margaret Cameron) and with an appreciation of the premises of paint- erly Realism, though in coolly distanced from (P. H. Emerson).

The first important art-photographic practice in the United States, Alfred Stieglitz's photo-secession, was modeled after the European *fin-de-siècle* secession movements, with which Stieglitz had had some firsthand experience. Stieglitz melded symbolist notions with the aestheticized pictorial realism of his mentor Emerson. The sensory simultaneity of symbolist synesthesia appealed to this former engineering student, who also revealed his enthusiasm for the mechani- cal reproduction of sound offered by the wireless and the player piano.[8]

The photographic example provides an insight into the choices and si- lences of aestheticism with respect to technology. In addition to the use of a camera—a still-confusing mechanical intrusion—this new art photography de- pended for its influence on the latest technologies of mass reproduction. In Stieglitz's publication *Camera Work,* which helped create a nationwide, or worldwide, art-photography canon, current and historical photographs ap- peared as gravures and halftones, the products of processes only recently devel- oped for the mass press. Thus, an art apparently hostile and antithetical to mass culture, preserving craft values and arguing against "labor consciousness," in fact depended on its technologies: a seeming paradox worth keeping in mind. The camera and print technologies were perceived as neutral, tool-like machines to be subsumed under the superior understandings of an aesthetic

elite. The aesthetic sensibility was an alchemical crucible that effected a magical transformation.

Still, by 1916 Stieglitz had so thoroughly acceded to the photographic modernism of Paul Strand that he devoted the last two issues of the moribund *Camera Work*, specially resurrected for this purpose, to his work. After Strand, the camera apparatus and its "properties" prevailed, displacing the negative-to-print handiwork at the center of art-photographic practice. For Strand and others, the camera was an instrument of conscious seeing that allowed for a politicized "cut" into, say urban microcosms, peasant counterexamples, and the structures of nature. Photography was, for them, mediation *toward*, not away from, social meaning. For others, of course, photographic modernism meant a new abstract formalism or, through the rapid growth of product photography, a corporate symbolism of commodities.

Thus, photographic modernism accepted science and rationality but also allowed for an updated symbolism of the object in a commodified world, a transformation that advertising made into its credo. Whereas photographic pictorialism had suggested a predictable alliance of aestheticism and elitism as a noble bulwark against the monetary measure of the marketplace and sold proletarian labor, formalist modernism united the high arts with the mass culture of modern entertainment forms and commodity culture. Modernism, in Kantian fashion, favored the material artwork while remaining vague about the meaning it was supposed to produce. Formalist ideologies were furthered by such Bauhaus figures as László Moholy-Nagy, who propagated a scientific vocabulary of research and development, therapeutic pedagogy, and experimentation. In art and architecture, formalist modernism promised a healthier, more efficient and adaptive—and liberatory—way of life, for all classes. The possibly revolutionary intent, to pave the way for democratic participation, could quickly turn into accommodation to new—technocratic—elites.

It has been observed that postwar American modernism, despite its strict separation of the arts from each other as well as from the social world, and with its fetishization of materials, nevertheless institutionalized the avant-garde. To discover what this represents for our concerns, we must look at the aims of the classic twentieth-century avant-garde movements, dada and surrealism, which appeared in the 1920s and 1930s, when modern technological society was already firmly established. The use of, or transgression against, the media of communication and reproduction was on their agenda, for the avant-garde saw art institutions as integrated into oppressive society but as ideally positioned nonetheless to effect revolutionary social change; this was a reworking of the symbolist effort to disorder the senses, perhaps, but with new political intentions. The aim of dada and surrealism was to destroy art as an institution by merging it with everyday life, transforming it and rupturing the now well-established technological rationalism of mass society and its capacity

for manufacturing consent to wage enslavement and rationalized mass killing. Peter Bürger has described the activity of the avant-garde as the self-criticism of art as an institution, turning against both "the distribution apparatus on which the work of art depends, and the status of art in bourgeois society as defined by the concept of autonomy."[9] Thus, Duchamp's *Readymades,* which, through their validation of despised objects by the agency of the artist's signature, exposed the real operations of the art-distribution apparatus. Bürger writes:

. . . *the intention of the avant-gardists may be defined as the attempt to direct toward the practical the aesthetic experience (which rebels against the praxis of life) that Aestheticism developed. What most strongly conflicts with the means-end rationality of bourgeois society is to become life's organizing principle.*[10]

The disruptive efforts of expressionism, dada, and surrealism intended to transgress against not just the art world but conventional social reality and thereby become an instrument of liberation. As Bürger suggests, the avant-garde intended on the one hand to replace individualized production with a more collectivized and anonymous practice and on the other to get away from the individualized address and restricted reception of art. But, as Bürger concludes, the avant-garde movements failed. Instead of destroying the art world, the art world swelled to take them in, and their techniques of shock and transgression were absorbed as the production of refreshing new effects. *Anti-art* became *Art,* to use the terms set in opposition by Allan Kaprow in the early 1970s. Kaprow—himself a representative postwar U.S. avant-gardist, student of John Cage—had helped devise a temporarily unassimilable form, the "happening" a decade or so earlier. Kaprow wrote, in "The Education of the Un-Artist, Part I":

At this stage of consciousness, the sociology of culture emerges as an in-group "dumb show." Its sole audience is a roster of the creative and performing professions, watching itself, as if in a mirror, enact a struggle between self-appointed priests and a cadre of equally self-appointed commandos, jokers, gutter-snipers, and triple agents who seem to be attempting to destroy the priests' church. But everyone knows how it all ends: in church, of course . . .[11]

As Kaprow plainly realized, the projected destruction of art as a separate sphere was accomplished, if anywhere, in the marketplace, which meant a thwarting of avant-gardist desires. But nothing succeeds like failure, and in this case failure meant that the avant-garde became the academy of the postwar world. The postwar American scene presented a picture of ebullient hegemony over the Western art world. Stability and order seemed to have been successfully erected on an art of alienation and isolation. High culture appeared to have conquered the "negative" influences of both politics and mass culture by

rigorously excluding—or digesting and transforming—both through a now thoroughly familiar radical aestheticism. Art discourse made updated use of the dialectic of scientific experimentation on technique and magical transformation through aestheticism and primitivism, veering toward an avant-garde of technical expertise.

This hegemonic condition lasted about as long as "the American century" it seemed to accompany—that is, until the new decade of the 1960s. The rapid growth of television and the cybernetic technologies, which had gotten a big boost from the war and American militarization, hastened the crisis. Television had no difficulty building on the structure and format of radio, with pictures added. Radio had established itself in a manner like that of the mass press and photography in the previous century and had played a vital role in disseminating the new ideologies of consumerism, Americanism, and the State. Like photography, radio depended on action at a distance, but with the added fact of simultaneity. It appeared to be a gift, free as air. The only direct sales came through hardware—which took on the fanciful forms of furniture, sky-scraping architecture, cathedrals, and the hearth, the mantelpiece, and the piano, all in one, with echoes of the steamship. Bought time appeared as free time, and absence appeared as presence. Radio had the legitimacy of science (and nature) and the fascination of magic.

Television was able to incorporate into this all the accommodations of photography and film, though in degraded form. As with advertising, the all-important text was held together with images of the object world, plus the spectacle of the State and the chaos of the street, and voyeuristic intrusions into the private lives of the high and the low, the celebrity and the anonymous. Television was like an animated mass magazine and more. As commentators from Dwight Macdonald and Marshall McLuhan to Guy Debord and Jean Baudrillard have observed, the totalizing, ever-whirling and -spinning microcosm of television supplanted the more ambiguous experience of the real world.

Alvin Gouldner comments on the war between the *cultural apparatus* (using C. Wright Mill's term) and the *consciousness industry* (Enzensberger's term). Gouldner quotes Herbert Gans's essay of 1972 that "the most interesting phenomenon in America . . . is the political struggle between taste cultures over whose culture is to predominate in the mass media, and over whose culture will provide society with its symbols, values, and world view."[12]

This struggle, the reader will immediately recognize, is the continuation of that of the previous century, which appeared at that juncture as a conflict between the culture based on aristocratic values and that based on new, middle-class-centered, scientistic values. Abstract expressionism had followed the path of an impoverished bohemian avant-garde with strong aestheticist elements, but neither as dismissive of proletarian sympathies as the Stieglitz set

nor as comfortably situated. With relative speed, abstract expressionism found itself blessed with success—or cursed. Suddenly these artists, used to a marginal and secessionist existence, were producing extremely expensive commodities and bearing highly fetishized biographies. Jackson Pollock appeared on the cover of *Life* and was shown in poses bearing some similarity to James Dean, another rebel figure and belovéd prodigal son. Artists' enshrinement as mass-media celebrities inverted their meaning. The dominance of the distribution system over the artists who stocked it was proved again to those who cared to see. Others have also demonstrated the way in which this elite art, an art that suggested doubt and abstraction, freedom and impoverishment, an art that dismayed populists of the Right and the Left, become the ambassador of the American empire.[13]

Pop art followed a logical next step, a public and ritualized acceptance of the power of mass culture through an emphasis on passivity and a renunciation of patriarchy, high-culture aura, and autonomy. It was mass culture and the State, after all, that had made abstract expressionism a "success," made it a *product* bearing the stamp Made in the USA much like any other product. Warhol's pop was a multifaceted and intricate "confession" of powerlessness, accomplished through productions, entourages, modes of production, and poses, that mimicked, degraded, fetishized, and "misconstrued," in slave fashion, the slick, seamless productions of corporate mass culture, especially those of the technologies of reproduction. The slave's ironic take on the relation between art and technology was to retain the older, craft-oriented media of oil paint and silk screen, but to use them to copy or reorder the reified icons of the photographic mass media. The apotheosis of the avant-garde was its transmutation into the servant of mass culture. Aura had passed to the copy.

As Kaprow wrote about the social context and *art consciousness*, as he termed it, of the period:

. . . *it is hard not to assert as matters of fact: that the LM {Lunar Module} mooncraft is patently superior to all contemporary sculptural efforts; that the broadcast verbal exchange between Houston's Manned Spacecraft Center and Apollo 11 astronauts was better than contemporary poetry; that, with its sound distortions, beeps, static, and communication breaks, such exchanges also surpassed the electronic music of the concert halls; that certain remote-control video tapes of the lives of ghetto families recorded (with their permission) by anthropologists, are more fascinating than the celebrated slice-of-life underground films; that not a few of those brightly lit, plastic and stainless-steel gas stations of, say, Las Vegas, are the most extraordinary architecture to date; that the random, trancelike movements of shoppers in a supermarket are richer than anything done in the modern dance; that the lint under beds and the debris of industrial dumps are more engaging than the recent rash of exhibitions of scattered waste matter; that the vapor trails left by rocket tests—motionless, rainbow-colored, sky-filling scribbles—are un-*

equaled by artists exploring gaseous mediums; that the Southeast Asian theater of war in Viet Nam, or the trial of the "Chicago Eight," while indefensible, is better than any play; that . . . etc., etc., non-art is more art than ART-art.[14]

Apprehending the collapses of public and private spaces, Kaprow, too, representing the aesthetic consciousness, could only bow before the power of science, technology, the State, and the ephemera of modern urban-suburbanism, especially as orchestrated through television. The "antihegemonic" 1960s also brought a different relation to issues of power and freedom, more populist than avant-gardist, more political than aestheticist. Students rebelled against the construction of what Marcuse termed one-dimensional culture and its mass subject, while the politically excluded struggled against the conditions and groups enforcing their powerlessness. The iron hand of science and technology became a focus of agitation, particularly in relation to militarism and the threat of total war. The twin critique of technological and political domination helped beget a communitarian, utopic, populist, irrationalist, anti-urban, anti-industrial, anti-elitist, anti-intellectual, antimilitarist, communitarian counter-culture, centered on youth. Hedonic, progressive, rationalist, antisexist, anti-racist, anti-imperialist, and ecological strains also appeared. The severe stress on the reigning ideologies also put models of high culture in doubt, not least among its own younger practitioners.

Artists looked to science, social science, and cultural theory—anywhere but to dealers, critics, or aesthetics—for leads. New forms attacked head-on the commodity status of art. "Objecthood" was an issue not only because art objects were commodities but because they seemed insignificant and inert next to the electronic and mass-produced offerings of the mass media.

Part II: History

At last, video. This is well-worked territory. In fact, video's past is the ground not so much of history as of myth. We could all recite together like a litany the "facts" underlying the development of video art. Some look to the substantive use of a television set or sets in altered or damaged form in art settings in the late 1950s or early 1960s. Others prefer the sudden availability of the Sony Portapak in the mid-1960s, or the push supplied by Rockefeller capital to artists' use of this new scaled-down technology. But the consensus appears to be that there is a history of video to be written—and soon. I would like to consider the nature of such histories, and their possible significance for us.

Historical accounts are intent on establishing the legitimacy of a claim to public history. Such a history would follow a pattern of a quasi-interpretive account of a broad trend activated by significant occurrences, which, on the one side, are brought about by powerful figures and, on the other side, determine or affect what follows. Video's history is not to be a *social* history but an

art history, one related to, but separate from, that of the other forms of art. Video, in addition, wants to be a major, not a minor, art.

Why histories now? Is it just time, or are the guardians of video reading the graffiti on the gallery wall, which proclaim the death or demotion of photographic media? (Like those of color photos, video's keeping, archival, qualities seem dismal, and the two are liable to vanish together without a trace.) If video loses credibility, it might collapse as a curated field. Or perhaps the growth of home video and music television has made the construction of a codified chain of *art*-video causation and influence interesting and imperative.

Some fear that if histories are written by others, important issues and events will be left out. Others realize the importance of a history in keeping money flowing in. The naturalization of video in mass culture puts the pressure on to produce a history of art video, or video art, that belongs in the art world and that was authored by people with definable styles and intentions, all recognizable in relation to the principles of construction of the other modern art histories.

Sometimes this effort to follow a pattern appears silly. For example, one well-placed U.S. curator made the following remarks in the faraway days of 1974:

The idea of the video screen as a window is . . . opposite from the truth in the use of video by the best people. Video in the hands of Bruce Nauman, or in the hands of Richard Serra, is opaque as opposed to transparent. It's an extension of a conceptual idea in art. It enables the audience—again on a very subliminal and intuitive level—to return to painting, to look at painting again, in a renewed way.

. . . In the future, most of us who have been watching video with any amount of attentiveness are going to be able to recognize the hand of the artist in the use of the camera. It's possible to know a Van Gogh as not a fake . . . by a certain kind of brush-stroking; very soon we're going to know the difference between Diane Graham {sic?} and Bruce Nauman and Vito Acconci because of the way the camera is held or not held. Style in video, that kind of personal marking, is going to become an issue. And it's going to subsume information theory with old-fashioned esthetic concepts.[15]

Ouch! I suppose it is not Jane Livingston's fault that in 1974 video editing had not yet imposed itself as the style marker she thought would be the analogue of the "brush-stroking" maneuver. As absurd as her remarks (should) sound, she was right about the role of "old-fashioned esthetic concepts," for aestheticism has been busily at work trying to reclaim video from "information" ever since. It is the self-imposed mission of the art world to tie video into its boundaries and cut out more than passing reference to film, photography, and broadcast television, as the art world's competition, and to quash questions of reception, praxis, and meaning in favor of the ordinary questions of originality and "touch."

Historiography is not only an ordering and selecting process, it is also a process of simplification. Walter Hines Page, editor of the turn-of-the-century magazine *The World's Work*, liked to tell writers that "the creation of the world has been told in a single paragraph."[16] Video histories are not now produced by or for scholars but for potential funders, for the museum-going public, and for others professionally involved in the field, as well as to form the basis for collections and shows. The history of video becomes a pop history, a pantheon, a chronicle. Most important, the history becomes an *incorporative* rather than a transgressive one. And the names populating the slots for the early years are likely to be those of artists known for earlier work not in video or those of people who remained in the system, producing museumable work over a period of years or at the present. And, of course, they are likely to be New Yorkers, not Detroiters, or even Angelenos or San Franciscans, not to mention San Diegans. Some histories do recognize the contribution of Europeans—perhaps mostly those histories produced in Europe—or Canadians or even Japanese, always assuming they have entered the Western art world. Finally, the genres of production are likely to fit those of film and sculpture. Codification belies open-endedness and experimentation, creating reified forms where they were not, perhaps, intended. This even happens when the intent of the history is to preserve the record of open-endedness. And so forth.

Thus, museumization—which some might point to as the best hope of video at present for it to retain its relative autonomy from the marketplace—contains and minimizes the *social negativity* that was the matrix for the early uses of video.

Part III: Myth

At the head of virtually every video history is the name Nam June Paik. Martha Gever, in her definitive article on the subject upon the occasion of his unprecedented exhibition at New York's Whitney Museum of American Art, referred to Paik's "coronation."[17] I prefer the word "sanctification"; for Paik, it would appear, was born to absolve video of sin. The myths of Paik suggest that he had laid all the groundwork, touched every base, in freeing *video* from the domination of corporate TV, and *video* can now go on to other things. Paik also frees video history from boring complexity but allows for a less ordered present. By putting the prophet at the front, we need not squabble over doctrine now, nor anoint another towering figure, since the video-art industry still needs lots and lots of new and different production.

The myth of Paik begins with his sudden enlightenment in Germany—the site of technical superiority—through John Cage, the archetypal modernist avant-gardist, at a meeting in 1958. Martha Gever relates that Paik later wrote to Cage in 1972 "I think that my past 14 years is nothing but an ex-

tention of one memorable evening at Darmstadt '58." Paik came to America around 1960, affiliated, more or less, with the Fluxus movement. Fluxus was a typical avant-garde in its desire to deflate art institutions, its use of mixed media, urban detritus, and language; the pursuit of pretention-puncturing fun; its de-emphasis of authorship, preciousness, and domination. Paik participated in some events and, we are told, showed his first tape at a Fluxus event. Again showing the rest of us the way, this time to funding, Paik supposedly made this tape with some of the first portable equipment to reach U.S. shores, equipment he bought with a grant from the John D. Rockefeller the Third Fund. According to the myth, the tape was of the pope(!).

The elements of the myth thus include an Eastern visitor from a country ravaged by war (our war) who was inoculated by the leading U.S. avant-garde master while in technology heaven (Germany), who, once in the States repeatedly violated the central shrine, TV, and then goes to face the representative of God on earth, capturing his image to bring to the avant-garde, and who then went out from it to pull together the two ends of the American cultural spectrum by symbolically incorporating the consciousness industry into the methods and ideas of the cultural apparatus—always with foundation, government, museum, broadcast, and other institutional support.

And—oh yes!—he is a man. The hero stands up for masculine mastery and bows to patriarchy, if only in representation. The thread of his work includes the fetishization of a female body as an instrument that plays itself, and the complementary thread of homage to other famous male artist-magicians or seers (quintessentially, Cage).

The mythic figure Paik has done all the bad and disrespectful things to television that the art world's collective imaginary might wish to do. He has mutilated, defiled, and fetishized the TV set, reduplicated it, symbolically defecated on it by filling it with dirt, confronted its time boundedness and thoughtlessness by putting it in proximity with eternal Mind in the form of the Buddha, in proximity with natural time by growing plants in it, and in proximity with architecture and interior design by making it an element of furniture, and finally turned its signal into colorful and musical noise.

Paik's interference with TV's inviolability, its air of nonmateriality, overwhelmed its single-minded instrumentality with an antic "creativity." Paik imported TV into art-world culture, identifying it as an element of daily life susceptible to symbolic, anti-aesthetic aestheticism, what Allan Kaprow called "anti-art art."

Gever discusses the hypnotic effects of his museum installations—effects that formalize the TV signal and replicate viewer passivity, replacing messages of the State and the marketplace with aestheticized entertainment. In some installations the viewer is required to lie flat. He neither analyzed TV messages or effects, nor provided a counterdiscourse based on rational exchange, nor

made its technology available to others. He gave us an upscale symphony of the most pervasive cultural entity of everyday life, without giving us any conceptual or other means of coming to grips with it in anything other than a symbolically displaced form. Paik's playful poetry pins the person in place.

The *figure* of Paik in these mythic histories combines the now-familiar antinomies, magic and science, that help reinforce and perpetuate rather than effectively challenge the dominant social discourse. Why is this important? The historical avant-garde has shown a deep ambivalence toward the social power of science and technology. Surrealism and dada attempted to counter and destroy the institutionalization of art in machine society, to merge it with everyday life and transform both through liberation of the senses, unfreezing the power of dissent and revolt. Although this attempt certainly failed, subsequent avant-gardes, including those that begin to use or address television technology, had similar aims.

Herbert Marcuse spelled this out back in 1937 in his essay "The Affirmative Character of Culture."[18] Marcuse traces the use of culture by dominant elites to divert people's attention from collective struggles to change human life and toward individualized effort to cultivate the soul like a garden, with the reward being pie in the sky by and by—or, more contemporaneously, "personal growth." Succinctly put, Marcuse shows the idea of culture in the West to be the defusing of social activity and the enforcement of passive acceptance. In the Western tradition, form was identified as the means to actually affect an audience.

I would like to take a brief look at a sector of the U.S. avant-garde and the attempt to contain the damage perceived to have been wrought on the cultural apparatuses by the mass media. Consider the notable influence of John Cage and the Black Mountaineers, which has deeply marked all the arts. Cage and company taught a quietist attention to the vernacular of everyday life, an attention to perception and sensibility that was inclusive rather than exclusive but that made a radical closure when it came to divining the causes of what entered the perceptual field. This outlook bears some resemblance to American turn-of-the-century antimodernism, such as the U.S. version of the arts and crafts movement, which stressed the therapeutic and spiritual importance of aesthetic experience.[19]

Cage's mid-1950s version, like Minor White's in photography, was marked by Eastern-derived mysticism; in Cage's case the antirational, anticausative Zen Buddhism, which relied on sudden epiphany to provide instantaneous transcendence; transport from the stubbornly mundane to the Sublime. Such an experience could be prepared for through the creation of a sensory ground, to be met with a meditative receptiveness, but could not be translated into symbolic discourse. Cagean tactics relied on avant-garde shock, in always operating counter to received procedures or outside the bounds of a normative

closure. Like playing the strings of the piano rather than the keys or concentrating on the tuning before a concert—or making a TV set into a musical instrument. As Kaprow complained, this idea was so powerful that soon "non-art was more Art than Art-art." Meaning that this supposedly challenging counterartistic practice, this anti-aésthetic, this noninstitutionalizable form of "perceptual consciousness," was quickly and oppressively institutionalized, gobbled up by the ravenous institutions of official art (Art).

Many of the early users of video had similar strategies and similar outlooks. A number (Paik among them) have referred to the use of video as being against television. It was a counterpractice, making gestures and inroads against Big Brother. They decried the idea of making art—Douglas Davis called *video art* "that loathsome term." The scientistic modernist term *experimentation* was to be understood in the context of the 1960s as an angry and political response. For others, the currency of theories of information in the art world and in cultural criticism made the rethinking of the video apparatus as a means for the multiple transmission of useful, socially empowering information rather than the individualized reception of disempowering ideology or sub-ideology a vital necessity.

Enter McLuhan. McLuhan began with a decided bias in favor of traditional literacy—reading—but shifted his approval to television. With a peremptory aphoristic style McLuhan simplified history to a succession of Technological First Causes. Many artists liked this because it was simple, and because it was formal. They loved the phrase "The medium is the message" and loved McLuhan's identification of the artist as "the antenna of the race." McLuhan offered the counterculture the imaginary power of overcoming through understanding. Communitarians, both countercultural and leftist, were taken with another epithet, "the global village," and the valorization of preliterate culture. The idea of simultaneity and a return to an Eden of sensory immediacy gave hippies and critics of the alienated and repressed one-dimensionality of industrial society, a rosy psychedelic wet dream.

John Fekete notes that McLuhan opposed mythic and analogic structures of consciousness—made attractive also through the writings of Claude Lévi-Strauss—to logic and dialectic, a move that Fekete "says opens the door to the displacement of attention from immanent connections (whether social, political, economic or cultural) to transcendent unities formed outside human control."[20] Fekete then rightly quotes Roland Barthes on myth (here slightly abbreviated):

. . . myth is depoliticized speech. *One must naturally understand* political *in its deeper meaning, as describing the whole of human relations in their real, social structure, in their power of making the world; . . . Myth does not deny things, on the contrary, its function is to talk about them; simply, it purifies them, it makes them inno-*

cent, it gives them a natural and eternal justification, it gives them a clarity which is not that of an explanation but that of a statement of fact. . . . In passing from history to nature, myth acts economically: it abolishes the complexity of human acts, it gives them the simplicity of essence, it does away with all dialectics, with any going back beyond what is immediately visible, it organizes a world which is without contradictions because it is without depth, a world wide open and wallowing in the evident, it establishes a blissful clarity: things appear to mean something by themselves![21]

This is the modern artist's dream! McLuhan granted artists a shaman's role, with visionary, mythopoeic powers.

McLuhan wrote that art's function is "to make tangible and to subject to scrutiny the nameless psychic dimensions of new experience" and noted that, as much as science, art is "a laboratory means of investigation." He called art "an early warning system" and "radar feedback" meant not to enable us to change but rather to maintain an even course. Note the military talk. Art is to assist in our accommodation to the effects of a technology whose very appearance in world history creates it as a force above the humans who brought it into being.

McLuhan gave artists a mythic power in relation to form that fulfilled their impotent fantasies of conquering or neutralizing the mass media. By accepting rather than analyzing their power, by tracing their effects to physiology and biology rather than to social forces, artists could apply an old and familiar formula in new and exciting ways. The old formula involved the relation of the formalist avant-garde to the phenomena of everyday life and culture.

I do not intend to trace the actual effects of McLuhanism on video art, for I believe that artists, like other people, take what they need from the discourse around them and make of it what they can. Many progressive and anti-accommodationist producers were spurred by the catch phrases and rumors of McLuhanism to try new ways to work with media, especially outside the gallery. Clearly, though, McLuhanism, like other familiar theories, offered artists a chance to shine in the reflected glory of the prepotent media and cash in on their power over others through formalized mimetic aestheticization.

Conclusion

Some new histories of video have taken up this formalized approach and have portrayed artists in the act of objectifying their element, as though tinkering could provide a way out of the power relations structured into the apparatus. Reinforcing the formalist approach has brought them—inadvertently—to bow, as McLuhan had done, to the power of these media over everyday life. In sepa-

rating out something called video art from the other ways that people, including artists, are attempting to work with video technologies, they have tacitly accepted the idea that the transformations of art are formal, cognitive, and perceptual. At the very least, this promotes a mystified relation to the question of how the means of production are structured, organized, legitimated, and controlled, for the domestic market and the international one as well.

Video, it has been noted, is an art in which it is harder than usual to make money. Museums and granting agencies protect video from the marketplace, as I remarked earlier, but they exact a stiff price. Arts that are marginally salable have shrunken or absent critical apparatuses, and video is not an exception. Video reviewing has been sparse and lackluster in major publications. This leaves the theorizing to people with other vested interests. In the absence of such critical supports, museumization must involve the truncation of both practice and discourse to the pattern most familiar and most palatable to those notoriously conservative museum boards and funders—even when the institutions actually show work that goes beyond such a narrow compass.

To recapitulate, these histories seem to rely on *encompassable* (pseudo-) transgressions of the institutions of both television and the museum, formalist rearrangements of what are uncritically called the "capabilities" of the medium, as though these were God-given, a technocratic scientism that replaces considerations of human use and social reception with highly abstracted discussions of time, space, cybernetic circuitry, and physiology; that is, a vocabulary straight out of old-fashioned discredited formalist modernism.

Museumization has heightened the importance of installations that make video into sculpture, painting, or still life, because installations can live only in museums—which display a modern high-tech expansiveness in their acceptance of mountains of obedient and glamorous hardware. Curatorial frameworks also like to differentiate genres, so that video has been forced into those old familiar forms: documentary, personal, travelogue, abstract-formal, image-processed—and now those horrors, dance and landscape (and music) video. And, of these, only the brave curator will show documentary regularly. Even interactive systems, a regular transgressive form of the early 1970s, appear far less often now.

Perhaps the hardest consequence of museumization is the "professionalization" of the field, with its inevitable worship of what are called "production values." These are nothing more than a set of stylistic changes rung on the givens of commercial broadcast television, at best the objective correlatives of the electronic universe. Nothing could better suit the consciousness industry than to have artists playing about its edges embroidering its forms and quite literally developing new strategies for ads and graphics. The trouble is, "production values" mean the expenditure of huge amounts of money on produc-

tion and postproduction. And the costs of computerized video editing, quickly becoming the standard in video-art circles, surpass those of (personal) film editing in factors of ten.

Some of the most earnest producers of art videotapes imagine that condensation of the formal effects of this kindly technology will expose the manipulative intent of television. The history of the avant-gardes and their failure to make inroads into the power of either art institutions or the advancing technologies through these means suggests that these efforts cannot succeed.

Alvin Gouldner describes the relation between art and the media as follows:

Both the cultural apparatus and the consciousness industry parallel the schismatic character of the modern consciousness; its highly unstable mixture of cultural pessimism and technological optimism. The cultural apparatus is more likely to be the bearer of the "bad news" concerning—for example—ecological crisis, political corruption, class bias; while the consciousness industry becomes the purveyors of hope, the professional lookers-on-the-bright-side. The very political impotence and isolation of the cadres of the cultural apparatus grounds their pessimism in their own everyday life, while the technicians of the consciousness industry are surrounded by and have use of the most powerful, advanced, and expensive communications hardware, which is the everyday grounding of their own technological optimism.[22]

We may infer that American video artists' current craze for super high-tech production is a matter of envy. It would be a pity if the institutionalization of video art gave unwarranted impetus to artists' desires to conquer their pessimism by decking themselves out in these powerful and positivist technologies.[23]

On the other hand, as the examination of the Paik myth suggests, it would be equally mistaken to think that the best path of transgression is the destruction of the TV as a material object, the deflection of its signal, or other acts of the holy fool. The power of television relies on its ability to corner the market on messages, interesting messages, boring messages, instantly and endlessly repeating images. Surely we can offer an array of more socially invested, socially productive counterpractices, ones making a virtue of their person-centeredness, origination with persons—rather than from industries or institutions. These, of course, will have to live more outside museums than in them. But it would be foolish to yield the territory of the museum, the easiest place to reach other producers and to challenge the impotence imposed by art's central institutions. Obviously the issue at hand as always is who controls the means of communication in the modern world and what are to be the forms of discourse countenanced and created.

A Brief History of American Documentary Video

D E I R D R E B O Y L E

From the earliest days of free-form experimentation, documentary video has
tended toward a radical pluralism. This is evident in the diversity of titles by
which it has been known—*street video, community* or *grass-roots video, guerrilla
television, alternative TV,* and *video essay.*[1] These terms only hint at the various
stages and aspirations of documentary video in the United States.

The 1960s: Underground Video

In 1965 the Sony Corporation decided to launch its first major effort at mar-
keting consumer video equipment in the United States. The first "consumer"
to buy this still rather cumbersome equipment was Korean artist Nam June
Paik, who produced the first publicized video documentary while riding in a
taxi cab in New York City. The 1960s was an auspicious time for the debut of
portable video. The role of the artist as individualist and alienated hero was
being eclipsed by a resurgence of interest in the artist's social responsibility,
and as art became politically and socially engaged, the distinctions between art
and communication blurred.[2] At first there were few distinctions between
video artists and activists, and nearly everyone made documentary tapes. Les
Levine was one of the first artists to have access to half-inch video equipment
when it became available in 1965, and with it he made *Bum,* one of the first
street tapes. His interviews with the winos and derelicts on New York's skid
row were edited in the camera, one of two primitive means of editing before
electronic editing became possible. Rough, unstructured, and episodic, *Bum*
was characteristic of early video.

Street Tapes

Street tapes were not necessarily made on the street. With the arrival of the
first truly portable video rigs—the half-inch, reel-to-reel CV Portapak—in
1968, video freaks could hang out with skid-row winos, drug-tripping hip-
pies, sexually liberated commune dwellers, cross-country wanderers, and yippie
rebels, capturing spontaneous material literally on their doorsteps. During the
summer of 1968, Frank Gillette taped a five-hour documentary of street life on
St. Mark's Place in New York City, unofficial headquarters of the Eastern hip-
pie community.[3] Gillette was one of a number of artists, journalists, actors,

filmmakers, students, and assorted members of the Now generation who were drawn to video. Portable video served as a bonding agent for individuals in search of a new source of community and shared sense of purpose. They were "the progeny of the Baby Boom, a generation at home with technology—the Bomb and the cathode-ray tube, ready to make imaginative use of the communications media to convey their messages of change."[4] Aware of the centrality of media in modern life, of the way television shapes reality and consciousness, they tried to gain access to mass media. When frustrated, they created their own underground and alternative media, taking seriously A. J. Liebling's observation, "Freedom of the press is guaranteed only to those who own one."

Turning the limits of their technology into a virtue, underground videomakers invented a distinctive style unique to the medium. Some pioneers used surveillance cameras and became adept at "free-handing" a camera because there was no viewfinder.[5] Tripods—with their fixed viewpoints—were out; hand-held fluidity was in. Video's unique ability to capitalize on the moment with instant playback and real-time monitoring of events also suited the era's emphasis on "process, not product." Process art, earth art, conceptual art, and performance art all shared a deemphasis on the final work and an emphasis on how it came to be. The absence of electronic editing equipment—which discouraged shaping a tape into a finished "product"—further encouraged the development of a "process" video aesthetic.

The early video shooting styles were as much influenced by meditation techniques like t'ai chi and drug-induced epiphanies as they were by existing technology. Aspiring to the "minimal presence" of an "absorber" of information, videomakers like Paul Ryan believed in waiting for the scene to happen, trying not to shape it by directing events. The fact that videotape was relatively cheap and reusable made laissez-faire work as feasible as it was desirable.

Underground video groups appeared throughout the United States, but New York City served as the hub of the sixties video underground scene. Prominent early groups included the Videofreex, People's Video Theater, Global Village, and Raindance Corporation. The Videofreex was the movement's preeminent production group, acting as its technological and aesthetic innovator; People's Video Theater used live and taped feedback of embattled community groups as a catalyst for social change; Global Village initiated the first closed-circuit video theater to show underground work (followed by the Philo T. Farnesworth Obelisk Theater, a project of the Electric Eye in California); and Raindance served as the movement's research and development arm.

Since the chronicling of any movement tends to encourage its expansion, Raindance played a key role, producing underground video's chief information source and national networking tool, *Radical Software* (edited by Beryl Korot and Phyllis Gershuny). In addition, Raindance members contributed to a cul-

tural data bank of videotapes from which they collectively fashioned "Media Primers," collages of interviews, street tapes, and off-air television excerpts that explored the nature of television and portable video's potential as a medium for criticism and analysis.

Hundreds of hours of documentary tapes were shot by underground groups, tapes on New Left polemics and the drama of political confrontation as well as video erotica. Video offered an opportunity to challenge the boob tube's authority, to replace television's often negative images of youthful protest and rebellion with the counterculture's own values and televisual reality.

Observers outside the video scene found early tapes guilty of inconsistent technical quality. Critics faulted underground video for being frequently infantile, but they also praised it for carrying an immediacy rare in Establishment TV.[6] The underground's response to such criticism was to concede there was a loss in technical quality when compared to broadcast. Hollywood had also been fixated on glossy productions until the French "New Wave" filmmakers in the early 1960s created a demand for the grainy quality of *cinéma-vérité,* jump cuts, and hand-held camera shots. Like the *vérité* filmmakers ten years before them, video pioneers were inventing a new style, and they expected to dazzle the networks with their radical approach and insider's ability to get stories unavailable to commercial television. The networks did try underground video, briefly.

In the fall of 1969, CBS pumped thousands of dollars into the ill-fated "Now" project, a magazine show of 16mm and portable video documentary vignettes that promised to show America what the 1960s youth and culture rebellion was really about. Nearly everyone with a portapak in New York worked on the show, but CBS concentrated its resources and hopes on the Videofreex, who interviewed Abbie Hoffman at the Chicago 9 conspiracy trial, got Black Panther Fred Hampton on tape days before he was murdered, and captured scenes of alternative life and hot-tub enlightenment along the California coast. CBS executives eventually rejected the 90-minute show, titled "Subject to Change," euphemistically finding it "ahead of its time."[7] Arrogant and politically naive, the underground learned the hard way that television had no intention of relinquishing its power. They would have to look elsewhere for funding sources and broader distribution outlets for their work.

Multichannel Documentary

One reason the "Now" project proved antithetical to broadcast TV norms was that it was performed as a live, multichannel spectacle, mixing live music performance with colorized tape and film documentary segments. Video innovators sought to extend the limits of the small video screen to embrace a larger spectacle. Since playing back a single-channel, edited tape on a small video

monitor lacked the impact and spontaneity demanded of the happenings of the era, producers devised multichannel video installations as live theatrical events. This called for live mixing of a variety of inputs—including performance, video feedback of an audience, and edited video and film clips—displayed on ten or more monitors in specially designed video theaters.

Ira Schneider, Frank Gillette, Les Levine, Rudi Stern, Skip Sweeney, and Steina and Woody Vasulka were some of the early explorers of multichannel video. In the early 1970s, two major documentary installations were produced, and their innovation on the form proved sensational but short-lived.

Global Village's cofounder John Reilly became interested in the conflicts in Ireland in 1970. He invited Stefan Moore and a crew to shoot what turned out to be some highly explosive sequences in Belfast, pioneering the use of half-inch portable video in a combat zone. Moore's quest to edit one hundred hours of tape was still unrealized after three versions when Reilly suggested that he edit three channels instead of one for playback on ten monitors. Not only would Moore be able to escape the linear narrative form, but he could create an "event" to engage viewers more deeply in the dramatic, emotionally charged scenes on tape. The format allowed Reilly and Moore to juxtapose the hard-edged reality of the war-torn Irish with images and attitudes about the Irish at a New York City St. Patrick's Day parade.[8] Their live performance of *The Irish Tapes* was presented in 1973 and was greeted with controversy and acclaim.[9]

On the West Coast, *The Continuing Story of Carel and Ferd* by Arthur Ginsberg and Skip Sweeney of Video Free America was presented as a multi-channel show in 1972 and billed as an "underground video documentary soap opera—a closed-circuit, multiple-image, videotape novel about pornography, sexual identities, the institution of marriage, and the effect of living too close to an electronic medium."[10] This improbable chronicle of the marriage between a porn star and a bisexual junkie was performed using three cameras (one on the audience, one on the operators, one on the preview monitors) and three VTRs (one with the narrative line, one with highlighting comments, one with bold visuals). All six inputs were processed through a matrix switcher and juxtaposed in varying combinations on twelve monitors.

Arthur Ginsberg noted at the time in *Radical Software #4* that he and Skip Sweeney began taping the couple as "a piece of video erotica," but their project quickly metamorphosed into "a Warholesque study of a couple of freaky people, then a hip study of the institution of marriage, and finally . . . a number about media process and public life style."

Both *Carel and Ferd* and *The Irish Tapes* were later updated and edited into single-channel tapes for broadcast in 1975 by WNET-TV. By the mid-1970s video theaters were a thing of the past, multichannel installations were

John Gustafson/John Reilly, *Giving Birth, Four Portraits*, 1976.

the province of art, and public television was the chief venue for documentary video work.

The "Now" project marked a turning point. The underground had discovered its freewheeling rebellious days were over. The time had come for an information revolution. Influenced by visionaries like Marshall McLuhan and Buckminster Fuller, artist/activists began to plot their utopian program to change the structure of information in America. In the pages of *Radical Software* and in the alternative movement's 1971 manifesto, *Guerrilla Television*, written by Michael Shamberg and Raindance, they outlined their plan to decentralize television so that the medium could be made by as well as for the people. Adopting a sharply critical relationship to broadcast television, they determined to use video to create an alternative to the aesthetically bankrupt and commercially corrupt broadcast medium. As the underground began to search for other ways of reaching their audiences, cable TV and video cassettes seemed to offer an answer.

The 1970s: Alternative TV

The 1970s ushered in a new era of alternative video. The underground became an above-ground media phenomenon as magazine articles on the "alternate-media guerrillas" appeared in mainstream periodicals like *Newsweek* and *New York* magazine. When federal rules mandated local origination programming and public-access channels for most cable systems, cable seemed to promise a new, utopian era of democratic information, functioning as a decentralized alternative to the commercially driven broadcast medium.

The new AV format portapak appeared in 1970, conforming to a new international standard for half-inch videotape. For the first time, tapes made with one manufacturer's portable video equipment could be played back on competing manufacturers' equipment. Not only did this boost competition among video manufacturers and accelerate the development of portable video, it also facilitated the exchange of tapes, which would become even more widespread once the 3/4-inch U-matic cassette became available in 1972. The new AV format, with an eyepiece that allowed instant playback in the camera, proliferated across the country as more and more people began to explore the medium.

Government funding for video was inaugurated by the New York State Council on the Arts in 1970. With it, the "all-for-one" camaraderie of early video activity, which had begun to break down in the scramble for CBS dollars the year before, soon deteriorated into an all-out funding battle as video groups competed for their share of the pie.[11] Within a year, sharp divisions between "video artists" and "video activists" surfaced. In time alternative videomakers subdivided into two factions: community video advocates and guerrilla television producers.

Guerrilla Television

Although exponents of guerrilla television professed an interest in community video, they were generally far more interested in developing the video medium and getting tapes aired on television than in serving a localized constituency. Probably the best-known guerrilla television was produced by an ad hoc group of videomakers assembled in 1972 to cover the political conventions for cable television. Top Value Television (aka TVTV) produced hour-long, documentary tapes of the Democratic and Republican National Conventions and made video history, providing national viewers with an iconoclastic, alternative vision of the American political process and the media that cover it. TVTV relied upon the technical and artistic expertise of groups like the Videofreex, Raindance, and the San Francisco–based group Ant Farm, adding a distinctive way of producing and promoting the event for cable television.

In *Four More Years* (1972), TVTV's crew of nineteen threaded its way

Skip Blumberg interviews correspondent Douglas Kiker as Nancy Cain videotapes them with a half-inch, open reel, black and white portapak for TVTV's classic documentary, *Four More Years*, 1972.

through delegate caucuses, Young Republican rallies, cocktail parties, antiwar demonstrations, and the frenzy of the convention floor, capturing the hysteria of zealots while entertaining viewers with the foibles of politicians, press, and camp followers alike. With a style loosely modeled on New Journalism and dedicated to making facts as vivid and entertaining as fiction, TVTV used a sharp sense of irony to puncture many an inflated ego. As self-proclaimed guerrillas, they tackled the Establishment and caught it off guard with the portable, nonthreatening equipment that gave them entrée to people and places where network cameramen, burdened with heavy equipment and the seriousness of commercial TV, never thought of trying.

Like *cinéma-vérité* in the 1960s, guerrilla television's documentary style was opposed to the authoritarian voice-of-God narrator ordained by early sound-film documentaries and subsequently the model for most made-for-television documentaries. Practitioners eschewed narration, substituting unconventional interviewers and snappy graphics to provide context without seeming to condescend. They challenged the objectivity of television's documentary journalism, with its superficial on-the-one-hand, on-the-other-hand balancing of issues. Distinguishing themselves from network reporters who stood loftily above the crowd, video guerrillas proudly announced they were shooting from *within* the crowd, subjective and involved. [12]

TVTV's success with its first two documentaries for cable TV attracted the interest of public television, and TVTV was the first video group commissioned to produce work for national broadcast on public television. New technology—notably color portapaks, electronic editing equipment, and the stand-alone time base corrector—made it possible to broadcast half-inch video. And so guerrilla television revised its revolutionary aims into a reform movement to improve broadcast television by example. Without the radical politics of the 1960s to inspire them, guerrilla television's producers became increasingly concerned with the politics of broadcasting.

In 1974, shortly after TVTV introduced national audiences to guerrilla television, the first all-color portable video documentary was produced by Downtown Community Television Center (DCTV) and aired on PBS. DCTV was formed as a community video group serving New York City's Lower East Side. But unlike other community video organizations, DCTV did not confine itself solely to social issues on the local level. *Cuba: The People* (1974) offered a fast-paced tour of life in Cuba, indicative of a style of investigative video journalism that DCTV developed throughout the 1970s. More conventional than TVTV's guerrilla iconoclasm, DCTV modeled itself on television documentaries but introduced an advocacy viewpoint disarmingly interpreted by codirector Jon Alpert. For this tape, DCTV toured the mountains, countryside, and capital of Cuba, talking with people about life before and after the revolution. These interviews were linked by Alpert's narration. Unlike the detached statements of a stand-up reporter, Alpert's high-pitched voice registered irony, enthusiasm, and frequent surprise, pointing up improvements since the revolution without glossing over some deficits under socialism. Public television agreed to air the tape, but not without a wraparound with Harrison Salisbury to stave off possible criticism. The wraparound afforded an unexpected and amusing contrast between old-style TV journalism and DCTV's contribution to guerrilla television's direct, informal, advocacy style. [13]

One of the most talked about tapes of the period was produced by two filmmakers who decided to explore the potential of low-light video cameras to capture the nighttime reality of an urban police force. Alan and Susan Raymond's *The Police Tapes* (1976) was a disturbing video *vérité* view of ghetto crime as seen by the policemen of the 44th Precinct in the South Bronx, better known as Fort Apache. Structured around the nightly patrols, it focused on ten real-life dramas and the leadership of an above-average commanding officer frustrated by "commanding an army of occupation in the ghetto." Distilled from over forty hours of videotape, *The Police Tapes* was produced for public television and then reedited into an hour-long version for ABC. [14]

Because guerrilla television was given national exposure on public TV, its gutsy style influenced many documentary video producers around the country. Not only were many community video groups affected, but as television news

went from all-film crews to ENG (electronic news gathering) units, the style of TV's news began to reflect guerrilla television's influence. Once absorbed by television, the style and purpose of guerrilla television was transformed into something often at odds with its origins. For example, independent videomakers' preference for ordinary people rather than Establishment spokespersons began to show up in "mockumentary" entertainment shows like *Real People* and *That's Incredible!* By the end of the decade, many of the distinctions between guerrilla and network television had blurred as the networks absorbed the style and content of independent work as well as some of its practitioners. TVTV, after making an unsuccessful comedy pilot for NBC, disbanded in 1978, and several of its members found work in commercial television and film. By 1981, the Peabody Award–winning *The Police Tapes* had become the template for the popular TV drama series *Hill Street Blues,* and its producers were working for ABC; and by 1979, DCTV's Jon Alpert was an independent journalist producing investigative stories of NBC's *Today Show* and *The Nightly News.*

Community Video

Proponents of grassroots video saw the medium as a means to an end—community organizing. Their primary focus was to use portable video to effect social change, not to experiment with a new medium or dismantle the structure of broadcast television. Canada's Challenge for Change, a government-sponsored effort, pioneered the use of video as a catalyst for community change in the late 1960s and served as a model for many U.S. experiments.[15] Community video groups sprang up all across the United States, reflecting the regionalism of the 1970s. Some of the many groups active during this time include the Alternate Media Center (cofounded by George Stoney, former director of the Challenge for Change), People's Video Theater, and Downtown Community Television Center (New York), Portable Channel (Rochester, N.Y.), Urban Planning Aid (Boston), Marin Community Video (Calif.), Broadside TV (Johnson City, Tenn.), Headwaters TV (Whitesburg, Ky.), University Community Video (Minneapolis), LA Public Access, People's Video (Madison, Wis.), Washington (D.C.) Community Video Center, Videopolis (Chicago), and New Orleans Video Access Center, to name a few.

Community video advocates often differed about whether they should be producing tapes for broadcast or emphasizing process over product by exhibiting unedited tapes to citizens in their homes, community centers or other closed-circuit environments. Many activists were leery of being co-opted by their involvement with television, and their fears were well grounded, as the experiences of at least three early community groups testify. In Johnson City, Broadside TV produced community video for multisystem cable operators who were mandated by the Federal Communications Commission (FCC) to provide

Jon Alpert, independent video journalist, totes a broadcast Betacam rig as he interviews a Phillipine family for the *Today Show*.

local origination programming; in Minneapolis, University Community Video purchased a half hour of broadcast time weekly to air its half-hour documentary video series on local public television; and the New Orleans Video Access Center (NOVAC) relied on the public affairs interest of a local network affiliate to get its documentary productions broadcast. For various reasons each group's involvement with television—whether cable, public TV, or network TV— eventually jeopardized the organization's commitment to community-made media.

Broadside TV was founded by Ted Carpenter, a former VISTA volunteer and Ford Foundation Fellow, who had combed the backhills of Appalachia during the early 1970s, making short documentaries or "holler tapes" on regional issues. Carpenter held his camera in his lap and used a monitor rather than his camera viewfinder to frame a picture, allowing him to establish an intimate rapport with his speakers. He then shared these tapes with remote neighbors, inviting them to make their own tape. Half-inch video's portability, simple operation, and unthreatening nature made it easy for people to speak their piece before the camera. Carpenter's form of networking informa-

tion among Appalachian mountain people inaugurated an electronic era for oral tradition and established an important model for community documentary productions.[16]

In 1972 Carpenter went to Johnson City, Tennessee, where he started Broadside TV. Since Appalachia had been a prime cable market since the early 1950s, Carpenter realized that Broadside TV could provide all the "narrowcast" progamming—both local origination and public access—demanded by the FCC. From 1972 to 1974 Broadside TV was a uniquely self-supporting community video enterprise, supplying all the local programming for four multicable systems in the area, narrowcasting four to six hours of programming each week. Shows featured Appalachian studies, mountain and bluegrass music, regional news and public affairs programs, entertainment, and local sports. However, the demand to generate programming led Broadside away from the intimate neighbor-to-neighbor communication originally championed by Carpenter. Programming was produced for the community, not by it. Disaster struck once the federal mandate on local origination programming on cable was challenged in 1974, and Broadside lost its distribution outlet and economic support structure. Although Broadside continued to produce documentary tapes, its independence and vitality were seriously compromised as was its ability to extend access to community members. With efforts divided between producing and fund-raising from private and government sources, Broadside TV was finally forced to close up shop in 1978.[17]

In Minneapolis, a coalition of students and community video activists forged one of the most successful video access centers of the 1970s. Backed by liberal funding from student fees, University Community Video (UCV) rapidly developed into a thriving center for community-based documentary production. In 1974 UCV began producing a weekly documentary series for local public television, buying the time from KTCA to air its critically acclaimed series, *Changing Channels*.[18] Influenced by midwestern populism and a strong tradition of journalistic integrity, UCV's award-winning documentary programs married guerrilla television to broadcast journalism. *Changing Channels* was named the best local public affairs program on public television in 1977, but as UCV staffers became more and more interested in producing documentaries for television, the organization's original intention of making video accessible to community members took a backseat. The pull to produce tapes that met the ever higher broadcast production standards prompted a crisis of purpose for the group.[19] Although UCV decided to cancel *Changing Channels* to concentrate on community production in 1978, it metamorphosed in the 1980s into a media arts center and severed its ties to the university and local community. What had once been a bastion of community and regional documentary production in the 1970s, had, by the 1980s, evolved into a media

arts center for nationally recognized video artists. Other forces besides those of television were influencing once-thriving community video groups.

Realizing that New Orleans would not be wired for cable for years and the local public television affiliate was uninterested in airing community video productions, the New Orleans Video Access Center (NOVAC) turned to network television for distribution of its documentary tapes in the mid-1970s. NOVAC staffers began producing social documentaries on the problems facing the city's low-income black population for a local network affiliate and won awards for their work. With the pressure to produce technically sophisticated and conceptually complex documentary productions, NOVAC—like UCV—increasingly relied on staff producers rather than community members. NOVAC learned, as did many other community access groups of the time, that once the novelty of exploring video equipment wore off, many community members had little interest in becoming video producers. Although many residents expressed interest in using this new tool for social progress, few had the time to develop the skills required to become producers of documentaries for broadcast.[20] And so the pressure to produce for television, with its large audiences and increased possibility for influencing social change, unwittingly seduced many community access centers away from their original purpose of facilitating people-to-people video.

New Constituencies

Community video activists were not only dedicated to serving regional constituencies but also to serving the specialized interests of multicultural communities such as women, gays, blacks, Latinos, Asians, and Native Americans, among others.

Portable video's debut coincided with the burgeoning of the women's movement, and documentary video offered another avenue of expression for women who were redefining their history as well as their future. Since half-inch, black-and-white video was still a lightweight, low-status medium, women were free to move into the forefront as video producers, and their concerns represented a distinctive voice in early video work. Women began exchanging videoletters; they started their own video access centers and programmed their own cable channels; and they ran their own video festivals.

In 1972, Susan Milano organized the first Women's Video Festival in New York City, defining guerrilla activity in feminist terms. In 1973, the first feminist documentary aired on public television was produced by a San Francisco video group known as Optic Nerve. Sherrie Rabinowitz and Lynn Adler went behind the scenes for an unusual view of the Miss California Beauty Pageant. 50 *Wonderful Years in vérité* style subtly asked viewers to con-

sider the demeaning nature of the pageant's policies, not by ridiculing the enthusiastic contestants, but by probing the organizers to reveal how sexism is perpetuated in society. In 1975, Cara DeVito's intimate portrait of her grandmother, *Ama L'Uomo Tuo (Always Love Your Man),* presented a view of cross-generational communication between women. Made during a time of increasing interest in family roots and growing feminist awareness about the psychological and sexual abuse of women, the tape offered a complex view of one woman and the social structure that molded her.

As video technology became heavier, more established, and costlier, it became increasingly difficult for women to act in central production roles. Hierarchical structures, borrowed from film and television, were applied to videotape production; and as the medium gained new professional status, video increasingly became a man's domain. Some women receded into the background as editors, while others struggled to maintain a high profile as producers and camera operators.[21]

Black pioneers like Bill Stephens and Philip Mallory Jones mapped out different territories for early video work. Stephens began as an underground videomaker politically engaged by the tumultuous events of the late 1960s. In 1971 Stephens founded the Revolutionary People's Communication Network with Black Panther Eldridge Cleaver in Algiers. There he recorded the breakup between Cleaver and the U.S. Panther Party in one of the first half-inch videotapes to be aired on network TV on Cronkite's "Nightly News." Upon his return to the States, Stephens established the People's Communication Network as a community video access center in Harlem. He later produced a documentary on Idi Amin, which was excerpted by ABC, NBC, CBS, PBS, and the BBC.[22] During the 1970s Philip Mallory Jones established the Ithaca Video Festival, a major touring showcase for video art and documentary work, and he also began producing documentaries and lyrical video essays. Today, they are joined by a growing number of producers of color, many of whom—like Warrington Hudlin, St. Clair Bourne, and Michelle Parkerson—are former filmmakers who became involved with video while producing for public television.

The first Hispanic videotapes were made by the Young Lords in cooperation with People's Video Theater. Since then, Chicano, Puerto Rican, and Latin American-born producers have championed social issues and explored personal expression, developing a variety of styles reflective of their diverse heritages. For example, Californian Rick Tejada-Flores invented a lively, visually opulent style for *Low 'n Slow, The Art of Lowriding* (1983). Puerto Rican-born Edin Velez developed his lush, multileveled, nonlinear style while making documentaries in Central America. And Chilean artist Juan Downey also redefined the documentary in personal terms while exploring his roots in the Brazilian rainforests. Asian producers such as Loni Ding and Keiko Tsuno pio-

neered documentary video during the 1970s, joined in the 1980s by a growing community of concerned Asian videomakers, including Shu Lea Chang, Chris Choy, Sachiko Hamada, and Renee Tajima, to name a few.

Native Americans were actively engaged in producing community video throughout the 1970s, addressing local and national issues from tribal council meetings to American Indian Movement protests.[23] By the 1980s, American Indian producers had penetrated mainstream media with conventional documentaries about pressing social and political issues, such as disputed land rights and the tragedy of alcoholism and unemployment, as well as experimental documentaries like those by Hopi documentarist Victor Masayesva, Jr., who focuses on spiritual concerns and vanishing traditions.

Rise of Independent Documentary Producers

By the mid-1970s, teams and individuals had replaced the collectives, a result of changing funding patterns, the end of an era of collectivism, and a creative need felt by many individuals to branch out and develop their own styles and subjects. People who had learned their craft as members of video collectives or community groups began to produce independent documentaries for public and network TV, for example: Greg Pratt and Jim Mulligan of University Community Video; Louis Alvarez, Andy Kolker, and Stevenson Palfi of New Orleans Video Access Center; and Blaine Dunlap of Broadside TV.

One of the most prominent "new" independents was Skip Blumberg, who had developed the intimate style of video cameraman/interviewer as a veteran member of such collectives as the Videofreex, TVTV, Videopolis, and Image Union. In the mid-1970s, Blumberg began producing lively cultural documentaries on ski jumpers, whistling champs, jugglers, and musical saw players—work that he felt "warmed up the cool medium of television." Blumberg's artful cutting of his Emmy Award–winning tape, *Pick Up Your Feet: The Double Dutch Show* (1981), made his largely one-camera shooting seem like live-TV studio mixing, revealing an underground appreciation of stretching the limits of low-budget technology to their maximum effectiveness.[24] His inspiring portrait of black and Hispanic urban girls excelling in a sport of their own typified a new style of documentary suited for the 1980s, one that addressed social issues in an oblique but effective manner.

The 1980s: Documentary Pluralism

The 1980s arrived on a wave of conservativism that threatened to undermine the efforts of social activists and video innovators of earlier decades. As young videomakers opted to make lucrative music videos or neo-expressionist narratives hailed by the art world, the documentary seemed on the verge of becom-

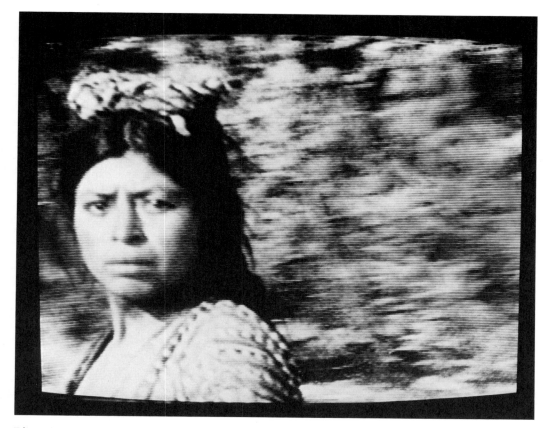

Edin Velez, *Meta Mayan II*. Arresting the gaze of a walking Indian woman of Guatemala, Edin Velez uses slow motion to underscore the relationship of the "other" to the outside observer. 1981.

ing an anachronism. But enterprising videomakers invented new strategies so that they could continue to address controversial subjects without driving away their increasingly conservative sources of funding and distribution. Challenged to discover new forms for their work and inspired by advances in video production and postproduction equipment, videomakers veered in two different directions, responding to the low- and high-tech options and funding available to them.

Producers like Dan Reeves, Skip Sweeney, Edin Velez, Victor Masayesva, Jr., and Juan Downey, to name a few, incorporated the aesthetic strategies of video art to produce personal essays and autobiographies that pushed the limits of the documentary genre. This overlapping of the narrower definitions of art and documentary not only served to bridge the chasm between the two, but it also reanimated the video documentary in otherwise inhospitable times.

Edin Velez was the first to call his nonlinear, poetic documentaries "video essays." In *Meta Mayan II* (1981), he exaggerated the natural rhythms of the mountain Indians of northern Guatemala to reveal the depths of an ancient

culture in conflict with a hostile world. A far cry from the realism typically employed in political documentaries, *Meta Mayan II* spoke powerfully but symbolically. By juxtaposing an American news broadcast about a Marxist peasant "uprising" with the slow-motion walk of an Indian woman down a country road, Velez used the woman's floating passage as an emblem of her people's plight: like her, they were suspended in time and space, vulnerable to external forces over which they had little control.

Dan Reeves's romantic autobiographical essay on his wartime experiences in Vietnam further stretched the boundaries of documentary video. His hallucinatory collage of audio and visual images snatched from the collective data bank of television and popular music culminated in a re-creation of an ambush on the Cua Viet River in Vietnam in 1969 that had haunted him ever since. Weaving together childhood dreams of military glory with adult nightmares of gruesome death, *Smothering Dreams* (1981) was a cathartic reenactment, a burning antiwar statement, and a devastating analysis of the mass media's role in inculcating violence and aggression from childhood onward.

Hopi videomaker Victor Masayesva, Jr. used the natural landscapes of Arizona to poetically evoke the history of his people. In *Itam Hakim Hopiit* (1984), the last male member of the Bow Clan recounted his own personal history as well as traditional versions of the Hopi Emergence story and an account of the Pueblo Revolt of 1680. By adapting the latest state-of-the-art video techniques to serve his age-old oral tradition and culture. Masayesva slipped effortlessly from realism to surrealism, colorizing images and speeding up actions, visually creating a mythic dimension that invited viewers to experience a different, Hopi sense of time, place, and meaning.

In contrast with the special effects and symbolic language of these experimental documentaries, a new interest in stripped-down minimalist portraits and straightforward storytelling was seen. Fred Simon's *Frank: A Vietnam Veteran* (1981) offered a relentlessly compelling account of what it is like to love killing only to live long enough to regret every bloody deed. Simon concentrated the black-and-white camera on Frank talking—a style that, in the hands of a lesser person, would produce nothing more than a banal "talking head"— but Simon's persistence in revealing the deeper messages conveyed in Frank's tormented eyes and strained face yielded a forceful, moving portrait.

Wendy Clarke's minimalist portraits, collected in her series *The Love Tapes* (1981), were equally spare and emotionally riveting. Traveling around the country, Clarke set up video booths where individuals of all ages, races, and walks of life could record their thoughts about love for three minutes, then play it back and decide whether to erase the tape or keep it. Clarke then compiled edited versions drawn from the statements of more than 800 people who offered alternately funny, pained, angry, philosophic, sensitive, and weird monologues on the complexity and endurance of love. The deceptive simplicity

of these powerful yet minimalist portraits were a stark reminder that much could be done with a low budget plus some sensitivity, political awareness, and social concern.

From Portapak to Betacam

Over the years documentary video evolved from the raw vitality of underground "street tapes" to the polished independent "minidoc" for prime-time TV news. Although it seems ironic that the very people who set themselves up in opposition to broadcast TV should now be making television, the irony existed from the start, with abortive efforts like the CBS "Now" project or the failure of the MayDay Video Collective in 1971 to get its tapes broadcast by NBC. Despite their utopian visions of creating an alternative to broadcast television, those video guerrillas determined to reach a mass audience had to abandon cable as an alternative and work within the broadcasting system, subject to numerous factors over which they had little or no control. And despite congressional mandates fostering independent productions on public television, the Corporation for Public Broadcasting and the Public Broadcasting System have generally denied independents regular access to a mass audience. A glimmer of hope is on the horizon for the 1990s in the form of new legislation establishing an independent production service. How this service will work and what role CPB and the independent community will have in setting guidelines will determine how varied in form and content such independent media will be.[25]

For those with the more modest aspiration of serving local audiences using public access cable channels, revised FCC rulings during the 1970s undermined the production of local origination and public access programming and turned the cable medium over to the marketplace. Community videomakers who persevere today must produce work on shoestring budgets for embattled public access and leased access channels. But recent efforts to network independent work via satellite interconnects are hopeful signs that independent ingenuity may prevail against otherwise insurmountable odds. Curiously, the development of "trash television" programs for network TV has spawned new interest by cable program services in documentaries with controversial subjects. Whether Home Box Office and Arts & Entertainment can offer a safe—and ethical—haven for independent documentarists remains to be seen, but the courtship dance has already begun.[26]

Just as the channels of distribution for documentary video work have diminished, so too has its funding by private as well as government agencies. In an age of conservatism, the fostering of nonfiction work by independent producers who historically have been linked to the Left clearly threatens the status quo. This reduction of funding is made all the more poignant by the ever-increasing cost of state-of-the-art broadcast videotape production and postproduc-

tion equipment. It is not surprising that producers of the 1980s have frequently chosen either to cast their fortunes with the lot of commercial television and hope for the best or produce a new brand of low-tech work for limited or closed-circuit distribution.

An example of the former is Jon Alpert, the only independent video producer to successfully straddle the worlds of network TV and radical community video. His investigative "minidocs" for NBC's "Today Show" have won both criticism and praise. As one of the few independent producers to cross over from public TV to network TV and maintain control over his stories, Alpert has brought the plight of midwestern farmers, urban squatters, and inner-city heroin addicts as well as embattled citizens around the globe into the breakfast nooks of mainstream America. Alpert is a muckraking reformer—not of broadcast television—but of contemporary society. Yet critics on the Right and on the Left insist he has not been above staging sequences and entrapping "the enemy" for dramatic effect despite NBC's staunch defense of his journalistic integrity.[27]

The Faustian bargain Alpert made in his decision to work within the networks demanded an inevitable compromise. Although his transformation into another hired gun for network TV may be overstated, it suggests the enormous problems that have continually faced documentary video producers who have tried to work within the transformative context of broadcast television.

This issue was raised early on in *Guerrilla Television* (1971):

Anyone who thinks that broadcast-TV is capable of reform just doesn't understand media. A standard of success that demands thirty to fifty million people can only trend toward homogenization. . . . Information survival demands a diversity of options, and they're just not possible within the broadcast technology or context.[28]

Mainstream media simply absorb alternative efforts, transforming them into standard fare. The alternative press discovered this fact the hard way, and alternative television producers have had to learn this lesson, too.

Guerrilla Video Revived

On June 12, 1982, a historic event boldly proclaimed the revival of guerrilla television and collective video action. A massive rally in support of the United Nations Conference on Disarmament was held in New York City, and as a part of that demonstration three hundred independent video producers collaborated to interview over three thousand individuals about their views on disarmament. In keeping with minimal video aesthetics developed by Wendy Clarke and others, each interview had a standard wide-angle, head-and-shoulder shot with no internal editing of any statement allowed. Eight hour-long compilations were made and shown—*not* on television—but closed circuit in

media vans during the rally in New York City and in other locations.[29] Taped when disarmament was the world's most discussed public policy issue, the *Disarmament Video Survey* revealed video at its grass-roots best, turning a frequently passive medium into an active one, a forum for an exchange of ideas and debate. Emerging from a tradition of collective, politically motivated video begun in the late 1960s, it suggested the best impulse of guerrilla television to decentralize TV and turn it back to the people was still alive.

Since 1981, a weekly cable program critical of American media has been produced for the public access channel in New York City by an energetic collective of independent videomakers. Drawing upon the traditions of radical video, Paper Tiger Television has invented its own funky home-grown studio aesthetic, demonstrating that energy, talent, modest resources, and public access cable are enough to make revolutionary television. Many of Paper Tiger's half-hour programs are live studio "events," faintly reminiscent of 1960s video "happenings." The show's hosts are articulate critics of mainstream American media who analyze newsstand publications for the most part, examining their corporate ownership, hidden agendas, and information biases.[30]

In 1986, Paper Tiger organized "Deep Dish TV," the first national public access series, distributed via satellite to participating cable systems and public television stations around the country. The successful syndication of this anthology of community-made programs on issues such as labor, housing, the farming crisis, and racism promises a new era for alternative documentary productions.

The return of guerrilla tactics and idealism has been sparked, in part, by the widespread availability of consumer video equipment and by a younger generation of videomakers caught up in the political and social issues of a newer age—from disarmament to war in Central America to the challenge of AIDS—yet tutored in the lessons of video's past. Forgoing broadcast television and mass audiences for closed-circuit distribution and public access exposure to targeted audiences, a new generation of committed video documentarists seems determined to avoid the traps that derailed video revolutionaries in the past.

Eclectic and pragmatic, these young video activists incorporate whatever works into their tapes: by mixing the slick sophistication of music video style with guerrillalike coverage of demonstrations, by juxtaposing the high-end quality of broadcast Betacam with the low-tech grit of home video camcorders, they have appropriated the full range of production tools and aesthetics and effectively rendered distinctions between low- and high-tech documentary video obsolete, further democratizing the medium and opening it up for creative and political possibilities. Thus, the gauntlet passes from one generation to the next. What new directions for documentary video the 1990s will hold remains to be seen. But for the past three decades, documentary video had been subject to change, even as it has changed our ideas about art, documentary, and television.

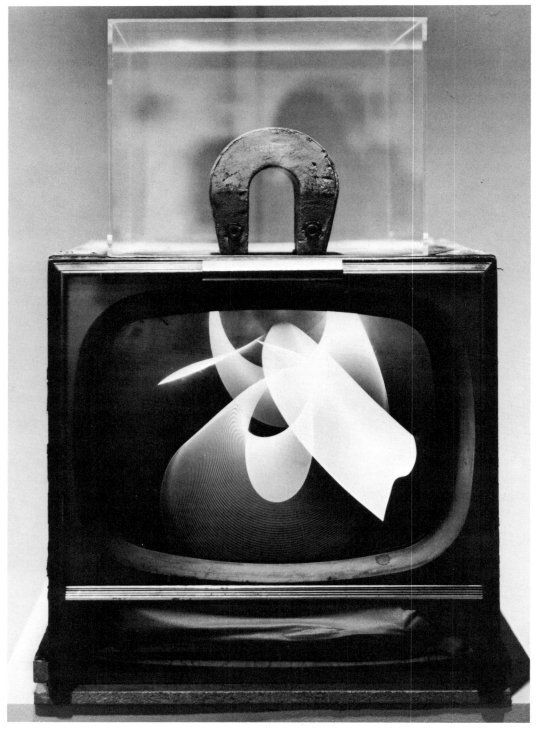

Nam June Paik, *Magnet TV,* 1965.

Dé-collage/Collage:

Notes Toward a Reexamination of the Origins of Video Art

JOHN G. HANHARDT

to create new meanings by breaking up the old . . .

Wolf Vostell

**I am tired of renewing the form of music . . . , I
must renew the ontological form of music.**

Nam June Paik

The thesis of this paper is that video, as a cultural discourse, has been formed by two issues: (1) its opposition to the dominant institution of commercial television; (2) the intertextual art practices of an international constellation of artists during the late 1950s and early 1960s. The materials and argument presented here are introductory and, I hope, serve to encourage research into the formal, aesthetic, and ideological agendas that were later to be embodied in video as a contemporary international art form.

The institutionalization of the electronic medium of television as a commercial/studio production led to uniform styles and codes for cultural/political programming in the United States and Europe. By the mid-1950s, the statistics of how many people owned televisions and the amount of time they spent in front of their sets were staggering. One did not usually watch broadcast television to see a new visual art form or an innovative means of expression. Whether explicitly in terms of advertising or implicitly in the way of life portrayed in popular melodramas or the content of news programming, television had become a marketing tool. It was not the communications medium it claimed to be but, rather, a one-way channel, broadcasting programs that sanctioned limited innovation and whose very means of production were invisible to the home consumer. Television, through its management by corporate monopolies or state-run systems, had become a seamless hegemonic institution.

The introduction of the portable videotape recorder and player in 1965 created the potential for alternative production by placing the tools of the medium in the hands of the individual artist. Yet the body of post-1965 video art was profoundly influenced by the work of a few artists who had appropriated the television as icon and apparatus in the years preceding 1965. These formative concepts are important in delineating the trajectory of the history of video art as a discourse through the 1960s to the present. I propose a reading of the work of Nam June Paik and Wolf Vostell that suggests that they provided powerful models and genealogies for the later practices and thinking of video artists.

In their examination of television, Paik and Vostell confronted a powerful state apparatus that, in both Europe and the United States, loomed large beyond the high-art aura of museums and art galleries. Television (and later video) was not coded by traditional art-world categories and, like film before it, offered a new means for reproducing and transforming the world around us through recorded images. Because television was seen as a mass medium, its possibilities as a flexible electronic and real-time medium were barely explored or recognized in the years before artists gained access to a portable video technology. The achievements of Paik and Vostell, both independently and collaboratively, were to strip television of its institutional meanings and expose it as a powerful co-optive force in capitalist society. In their writings and actions, Paik and Vostell were attracted to both ideological and epistemological issues. By fusing the social and aesthetic in single-channel and multimedia works within installation, performance, and television formats, they radically questioned the basis of art as an elitist and nonpublic discourse.

The incorporation of the television set into artworks began amid a constellation of art and nonart events in a period when the process of creation and the perception of art were changing. A number of movements, which were identified by the labels Gutai, assemblage, environments, happenings, musique concrète, lettrisme, nouveaux réalistes, concrete poetry, pop, fluxus, minimalism, objective dance, and avant-garde film, all shared an engagement with direct experience, the physical presence of materials, and by extension, the social and cultural worlds these artists inhabited. By rejecting the notion of the heroic, existential artist-self, which had been associated with abstract expressionism, these movements reevaluated the art object and its sources. It would be a mistake, however, to define this period as a marginal phase or experiment in some larger narrative of art history; rather, I would argue that this period was not peripheral but located a major effort to demolish both the boundaries between art forms and practices in addition to those higher battlements that sanctioned off art from the political and social.

The acknowledgment of the everyday was articulated in various parodistic and ironically critical agendas: the replication of popular culture and consumer goods (pop art); the performance of everyday gestures and movements (dance and performance art); the reduction of method to a fundamental material base (early minimalism); a skeptical reversal of high cultural standards and sanctions (Fluxus); the revision of language as a medium of visual and linguistic expression (lettrism); the reworking of the everyday visual environment (nouveaux réalistes); and the joining of different media and materials in public actions (happenings). These strategies reoriented artistic practice away from previous hierarchies and standardized categories toward an ironic, detached, and exploratory approach that acknowledged the quotidian ebb and flow of life. One of the inescapable facts of this daily life was the omnipresence of television.

dé-collage actions to change the environment ...

Wolf Vostell

**As collage technic replaced oil-paint, the cathode
ray tube will replace the canvas.**

Nam June Paik

It is the thesis of this paper that artists working with video in the early
1960s were engaged in a utopian impulse to refashion television into a dia-
logue of visual and auditory experiences that would allow them to reconstitute
themselves as an ever-renewing community of artists.

The focus of my attention is on Fluxus and the nouveaux réalistes, two
groups that incorporated the "real" into their work, an aesthetic technique that
the Fluxus artist Wolf Vostell called "dé-collage." I will further suggest that
décollage together with the earlier strategies of collage (Kurt Schwiters) and
readymades (Marcel Duchamp) provide a basis for understanding the strategies
of video art. The following, which were selected to identify issues and are not
definitive for either artist or period, are drawn from fluxus and the nouveaux
realistes to suggest that there was a real dialogue and blurring of categories be-
tween affiliations of artists. I will further propose that the techniques of collage
and dé-collage overlap media technologies and strategies as they share in a turn
to social and political issues through the manipulation of the material world.

Fluxus was a loose, anarchic association of artists formed around the mer-
curial figure of George Maciunas, its founder and leading advocate. Beginning
in the late 1950s and extending through the 1960s and 1970s, Fluxus as-
sumed a stance that can best be described as anti-high art. Its actions de-
bunked the institutions of the art world with a playfulness and humor pre-
viously associated with dada and the seminal ideas of Marcel Duchamp. John
Cage, who taught at the New School for Social Research in 1954, was a pri-
mary influence on Fluxus and a catalyst for the happenings that would occur
later in that decade. Cage's emphasis on the role of chance in artmaking and
perception had a profound impact on a group of artists including Allan Ka-
prow, Wolf Vostell, Nam June Paik, George Brecht, George Maciunas, Dick
Higgins, and Jackson MacLow. They postulated a conceptual basis for Fluxus
that resulted in events which highlighted the materiality of consumer culture.
As with other anti-art movements during this turbulent time, this gave a dis-
tinct social edge to Fluxus, whose efforts were directed to overturning the jar-
gon of art history and politics through subversive humor and irony.

The nouveaux réalistes, an affiliation that was identified by the French
critic Pierre Restany in 1960 and that was to break up by 1964, consisted of
Arman, Dufrêne, Raymond Hains, Yves Klein, Martial Raysse, Danile
Spoerri, Jean Tinguely, Jacques de la Villeglé. The group, which, although
based in Europe, was aligned with such American artists as Jasper Johns, Rob-

ert Rauschenberg, John Chamberlain, and Richard Stankiewicz, reexamined the aesthetic treatment of the object by pursuing the appropriation of the real to new limits. It is the torn posters of the "affichistes" (Hains, Villeglé, Dufrêne, and Mimmo Rotella) that I am particularly interested in, especially in relation to the dé-collage of Wolf Vostell and Fluxus. The spectator participates in the process as he or she deciphers and reexamines the consumer object within the text of the work. The poster as a container of commercial and political messages was a preelectronic form of public advertisement. The visual and linguistic economy of slogans and graphic announcements is torn apart by the artist to reveal an archeological layer of hidden messages, deconstructed to expose their material and ideological base.

As the Happening is the fusion of various arts, so cybernetics is the exploitation of boundary regions between and across various existing sciences.

Nam June Paik

marcel duchamps has declared readymade objects as art, & the futurists declared noises as art—it is an important characteristic of my efforts & those of my colleagues to declare as art the total event, comprising noise/object/movement/ color/& psychology—a merging of elements, so that life (man) can be art—

Wolf Vostell

Drawing upon the Fluxus aesthetic, Paik and Vostell removed television from its conventional setting by incorporating it into their performances and installations. In so doing, they challenged what Erving Goffman has called the "organization of experience" by inventing the "primary frameworks" of the social order.[1] By violating the social and cultural frames of reference we use to organize our everyday life, Paik and Vostell "broke frame" (Goffman). They employed humor—defined here as a subversive action from inside the frame that mocks or undermines conventions of behavior—to highlight the obvious. As Umberto Eco noted, humor "reminds us of the presence of law that we no longer have reason to obey. In so doing it undermines the law. It makes us feel the uneasiness of living under the law—any law."[2] The work of Paik and Vostell attempted to undermine the "law" of television by employing collage and dé-collage to make us uneasily aware of how television functions as a medium shaping our world views.

Nam June Paik was born in Korea and educated in Japan where he studied Western modernism in music. In the 1950s he moved to West Germany in order to pursue his interest in composition and performance. In his performances Paik used his body as a metaphor for and extension of the musical in-

strument. He created a number of "prepared" pianos—instruments decorated with noisemakers, clocks, and assorted household objects. He would chop, wreck, or otherwise violate the pianos, often obtaining extraordinary sounds.

Having attacked one of the most cherished symbols of Western culture and bourgeois life, the piano, Paik went after the television set, which was fast becoming a new icon. His approach to television was first delineated in his 1963 exhibition at the Galerie Parnass in Wuppertal, West Germany, where he filled a room with televisions that were randomly scattered about on their sides, on their backs, or upside down. The apparatus was scratched and disfigured, and its screen was either filled with abstract noise or patterns generated by magnets applied to the set, or was left blank; thus stripped of TV's traditional connotations and associations, it no longer fulfilled the function that television usually serves in the home. By utilizing the concept of "breaking the frame," Paik subverted not only what was seen on the screen, but also challenged the way in which television is understood as an object of daily life.

In 1964 Paik moved to New York, and the following year he presented a one-artist exhibition at the New School, "Nam June Paik: Electronic TV, Color TV Experiments, 3 Robots, 2 Zen Boxes and 1 Zen Can." In this installation, televisions were remade so that new images could be created, often by the viewers themselves. Among these pieces were *Demagnetizer (or Life Ring)* (1965), a circular electromagnet that created wave patterns on the television screen; and *Magnet TV* (1965), a television set with a large magnet placed on top that could be moved to manipulate the abstract image on the screen. In addition to these participatory pieces created with magnets, Paik in collaboration with Jud Yalkut created pieces such as *Videotape Study No. 3* (1967–69), which distorted the received image from broadcast television. By manipulating soundtrack as well as image, Paik and Yalkut gave a wry and satirical commentary on the politics and content of broadcast television. Paik employed the dé-collage techniques of deconstructing images and techniques through chance procedures in order to expose their hypocrisy. These works became a model for a viewer-controlled television, a concept Paik has pursued throughout his career.

Paik was always at the forefront in appropriating new video technology, such as the Sony Portapak in 1965, as well as in developing new tools for image-making as he did in creating the Paik-Abe video synthesizer with the Japanese engineer Shuya Abe. In *Global Groove* (1973), produced through the Television Laboratory at WNET in New York, Paik introduced a global model of artists' television, proclaiming a future "TV Guide as thick as the Manhattan telephone directory." In this work, Paik developed a collage technique by synthesizing images from a variety of sources (Japanese television, avant-garde filmmakers such as Robert Breer and Jonas Mekas, and other artists from John Cage to Korean folk dancers). Paik's video collage technique has been extended

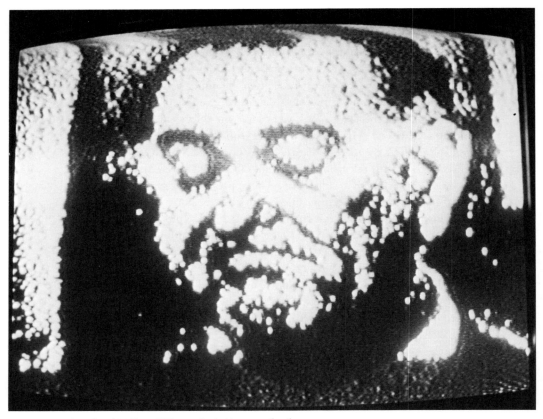

Nam June Paik and Jud Yalkut, *Videotape Study No. 3*, 1967–69.

to his global satellite projects such as *Good Morning Mr. Orwell* (1986), which invited the participation of performers and artists around the world to be part of his "Global Groove" extravaganza, an international mix of synthesized images that combined and recombined with each other in both real-time and postproduced modes.

By the mid-1950s, the German-born artist Wolf Vostell had begun to produce a remarkable series of multimedia projects, performances, and actions. His artist's publication, *Dé-colllage,* to which Paik contributed, documented Vostell's concept of dé-collage, a kind of happening event that often took place on a large scale and involved an engagement with the public space as a social environment. In the *Dé-colllage* publication, all manners of text and information were erased in a technique that revealed different elements by tearing off the surface to reveal new combinations. This was opposed to the collage technique of adding on and joining different materials in new combinations. In his dé-collage projects that incorporated television, Vostell articulated a powerful critique of the medium as ideology, seeking to undermine the political

assumptions of social discourse and the commodity definitions of high-art culture.

Vostell's performances explored the boundaries between the primary frames of organized experience; in his video works, the social and cultural meaning of television was transformed and, in the process, so was our relation to it. In his *TV Dé-collage* (1961), a wall display in a Parisian department store, Vostell proposed distorting the received broadcast image in order to subvert the ordinary frame of reference, a dé-collage technique that relied on random interference with the broadcast to cause a constantly changing erasure of the image. The ironic intention of Vostell's installation was to comment on programming within the very marketplace that television serves—the department store.

Two other projects were presented at the 1963 Yam Festival organized by Robert Watts, George Brecht, and Allan Kaprow at George Segal's farm in New Jersey and concurrently in an installation at the Smolin Gallery in New York City. A performance of *TV Dé-collage* in New Jersey began inside a shed where a television was covered with objects, such as barbed wire and a picture frame, which dé-collaged the set by reframing it and removing it from its customary context. In a mock ceremonial interment, Vostell, with Dick Higgins, Ayo, Al Hansen, and others, carried the television into a field where a hole was dug in the ground with shovel and jackhammer. The broadcast image was then altered and transformed, the set was removed and destroyed, and finally the television set itself was buried. In this public action of dé-collage, Vostell commented on the public institution of television as something to be confronted and transformed through art. The text prepared by Vostell for the event is a description of dé-collage TV.

TV-picture De-formation
 with
magnetic zones
 DO IT YOURSELF

 Wolf Vostell

How to de-educate the educational TV???

 Nam June Paik

TV Trouble (1963) at the Smolin Gallery consisted of a room filled with televisions resting on top of the furniture and file cabinets, or laid on their sides; TVs whose reception had been distorted or reduced to simple wave bands. As a commentary on both office space as information storage and on television as a form of information, the piece was a dé-collage of the space as well as of television itself. By deconstructing the ideology of television, Vostell effectively "broke the frame," taking art out of the art world in order to help us understand the real function of television within society.

Wolf Vostell, *Dé-collage Performance*, 1961. © Peter Moore.

The strategies employed by Nam June Paik and Wolf Vostell are closely aligned to those of Fluxus and the nouveaux réalistes. Paik is identified with Vostell in that they shared collaborations and interests as members of the international Fluxus movement. However, my point is not to delineate their differences or similarities or to ascertain who did what first, for Paik and Vostell are not alone in the early history of video as an art form. Nor should we see influences on the early history of video art only in terms of those artists who directly employed the medium. The roles that these movements played were important both art historically and culturally as examples of the reciprocal relationship that exists between evolving modes of depiction and perceiving.

These early pieces demonstrated the need for artists to question television's economic and ideological power (as exemplified in Vostell's work) and to create new tools and experiences out of video and television (as embodied in the extraordinary career of Paik). By questioning the notion of a high art removed from everyday experience, Fluxus and other constellations of artists attempted a dialogue between artist, artwork, and public. The dé-collaged posters of Villeglé, which were ripped and torn apart to reveal altered alignments, were more than a formal exercise: like Vostell's proposed dé-collaged wall of

televisions in the department store, the public wall of the posters combined statements of defacement and revelation. By alerting us to how we looked at television, Paik and Vostell proclaimed the possibility of changing this relationship from a passive to an active one.

The history of video as an aesthetic discourse is one of a language of collage, in which strategies of image processing and recombination evoke a new visual language from the multitextual resources of international culture. The spectacular history of the expanded forms of video installation can be seen as an extension of the techniques of collage into the temporal and spatial dimensions provided by video monitors placed in an intertextual dialogue with other materials. Thus the works of Mary Lucier, Rita Myers, Fabrizio Plessi, Buky Schwartz, and others continue and build on this process. The technique of décollage in video installation also extends performance and multimedia into a critique of the social and ideological by deconstructing existing constructions of communication technologies and industries. Here one is reminded of the work of Francesc Torres, Juan Downey, Paper Tiger Television, and Dieter Froese.

The directions and oppositions articulated in the early appropriation of television by artists and their contribution to image making continues today in the international and intercultural alignment of artists who are regaining a community of shared intention as they continue to explore the possibilities of this art of the future.

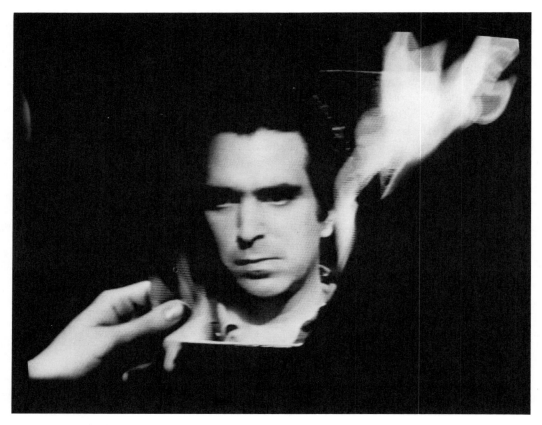

Peter Campus, *Three Transitions*, 1973.

Video Art:

What's TV Got To Do With It?

KATHY RAE HUFFMAN

American public television took an expansive leap into the creative realm of the artist in 1964, just one year after John F. Kennedy's death. The presidential assassination was the first television spectacle in history, and brought widespread attention to the overwhelming cultural influence of the broadcast medium by uniting the American public in shared emotion. From this point on, the "media event" became a cultural phenomenon of enormous power, frequently preempting regularly scheduled programming. Up until that time television, a postwar commercial venture of radio broadcasting networks, had been slow to bring in the vast profits anticipated by its developers in the 1930s and 1940s. In fact, television was not considered financially successful until the early 1960s, by which time the medium had become a staple of American entertainment and consciousness.

During this era, a time of political unrest in the nation but of rapid expansion in the noncommercial broadcast industry, a growing number of educational and cable television stations began to challenge commercial network autonomy.[1] Dedicated educational television broadcasters developed important political strategies to finance their activities; unlike the networks they did not have access to commercial resources. The Corporation for Public Broadcasting (CPB), was established by Congress in 1967 to provide federal funding for "a new and fundamental institution in American culture," and the Public Broadcasting Service (PBS) was formed in 1969.[2] The development of artists' access to television also begins at about the same time, simultaneous to availability of the first portable video equipment. In fact, technical developments helped to create an experimental impetus, a curiosity and creative approach to the production of programming among a few public TV broadcasters. Until the 1960s, most programs produced by television were still "live" and could be considered "experimental" by today's standards. The medium was new, rapid technical advances offered fresh challenges and capabilities daily, and most TV studio crew members learned their trade on the job. But because of broadcast television's emphasis as a major form of entertainment and its commercial mass media enterprise, it was not a medium considered an appropriate forum for "art."

Using the new technology to full advantage was Boston's public television station WGBH, which went on to play a decisive role in video art over the

next two decades. Fred Barzyk, a young producer who took a bold approach to programming and production, is credited with encouraging cameramen and technicians to experiment with the medium, and in doing so produced some of the most interesting and innovative programs seen on television.[3] On air from 1964 to 1966, the first "art" to enter weekly broadcasts was *Jazz Images.* This unique music program brought top jazz artists into the studio to play while the WGBH production crew improvised along with them, flipping switches to try something new. As WGBH staffer David Atwood recalled this experience, "There was a climate of experimentation . . . and nobody said stop . . . I never looked at myself as a director, I looked at myself as a real artist, helping in the process."[4]

Three years later, in 1967, Barzyk and his station associates produced another, more controversial television series, "What's Happening, Mr. Silver?", which was hosted by Tufts University professor David Silver. The program was an outrageous weekly broadcast that presented a random mix of live and prerecorded video images, bombarding the home audience with a visual representation of the shifting moral attitudes of the times. "We wanted to experiment with every possible aspect of the medium," Barzyk explained, "and intimate behavior in the form of nudity became one factor. We tried to create new problems in the broadcast system so that we could break down the system as it existed."[5] Barzyk's influence set the tempo for artists to work in the television model, a style that WGBH would continue to encourage and endorse in its programming.

Boston in the 1960s was an active center of experimental art forms. The Center for Advanced Visual Studies (CAVS) at the Massachusetts Institute of Technology (MIT) attracted an international group of artists who were attempting to combine their conceptual interests with the advanced technical research in computers, electronics, and robotics being conducted there.[6] When the first official artists-in-residence program was established at WGBH in 1967, with grants from the Rockefeller Foundation and the Ford Foundation, several CAVS artists participated. By 1969 they, and others, had produced a significant body of videotapes. Ron Hays, John Cage, Peter Campus, Otto Piene, Alan Kaprow, and William Wegman were among artists who became familiar names around the station. Fred Barzyk formatted the work of this first group of video artists as a half-hour television special, "The Medium Is the Medium." This first television anthology of videoart, and its broadcast, set the stage and became a model for future artists' experiments with television.

On the West Coast, San Francisco's public television station KQED became the focus of research and experimentation. The Bay Area was a haven for the sixties counterculture, and KQED achieved a reputation for liberal programming policy. In 1967, the station became the home of the Center for Experiments in Television, funded by the Rockefeller Foundation as a kind of re-

search and development arm for the TV industry where artists would find new ways to use the medium. The center operated under the direction of Brice Howard, the former executive producer of cultural programming at WNET, New York's public television station. Associated with radical San Francisco aesthetics, Howard was not interested in developing "product" for television and proclaimed that neither the Rockefeller Foundation nor KQED should expect to see any tangible results from the program.[7] Renamed the National Center for Experiments in Television (NCET) in 1969, when its funding was renewed by the newly formed National Endowment for the Arts (NEA) and CPB, this unusual artists-in-residence program brought visual artists, designers, painters, sculptors, musicians, and dancers together with technicians and engineers. The center encouraged broad innovation in technology and design, sponsoring artists such as Stephen Beck, who developed his Direct Video Synthesizer while a regular participant of KQED's experimental studio facility.

Rather than create straightforward television "programs," the artists at NCET emphasized abstract, synthesized, mystical-looking images that demonstrated state-of-the-art analog technology and bewildered many viewers. When broadcast on KQED, these creations were derided as "wallpaper" by critics. The term soon became generic, used not only in reference to all works relying on colorized feedback techniques, but to describe any work in which technology dominated content. KQED broadcast one of the innovative works produced at NCET, William Gwin's *Point Lobos State Reserve,* in 1973. Although the images were of actual scenes recorded on location, Gwin's broadcast looked startlingly different from other programs on TV. In an attempt to mediate this imagery, a voice-over soothingly offered advice to "see your television set as a painting that moves. . . ." A victim of the changing attitudes and ambitions and of its members, NCET closed in 1974. Although it disbanded, its participants continued to work in alternative media, and established a center for art education and an artists workshop at the University of California, Berkeley, headed up by NCET's William Rosenquist.[8]

The 1970s: The Myth Explodes and the Era of Conflict Begins

Throughout the 1970s, Boston continued to be an active center for artists working with television. Multi-media artist Nam June Paik, for one, frequently commuted between New York and Boston, building a sizeable reputation with his avant-garde Fluxus events.[9] An experimental musician, he incorporated electronic technology and television imagery into performance pieces. In 1970 he worked closely with WGBH producers and with artists at MIT's CAVS to build a futurist environment. Having become the official advisor to Howard Klein at the Rockefeller Foundation in 1973, Paik was instrumental in fostering the Foundation's commitment to the media arts for two decades.

Nam June Paik and producer Fred Barzyk at the WGBH Project for
New Television in Boston, 1970.

With Rockefeller funding, Paik began to collaborate with engineers at
WGBH, where he introduced his own real-time television mixing console,
which he built in collaboration with artist-engineer Shuye Abe. A one-man
unit, Paik's video synthesizer generated hours of shifting luminescent abstrac-
tions during its maiden telecast. Paik called it "an electronic watercolor set for
everybody to see."[10] The legendary broadcast was entitled *Video Commune—The
Beatles from Beginning to End,* and typified the kind of freedom and commit-
ment to experimentation that public television encouraged, thanks to generous
funding, during the 1970s. The celebrated work of Paik and others contrib-
uted to an illusion of freer access for video artists and greater support from
public television than was actually available. In reality, the surge in video art
was due to the intense motivation of a few individuals who worked from
within the system to expand it.

Boston audiences continued to see experimental broadcasts in 1972.
WGBH producers organized *The Very First On-The-Air Half-Inch Videotape Festi-
val Ever,* where artists were invited to provide their videotapes, made on reel-
to-reel porta-paks, for what became a marathon four-hour special broadcast.
The event helped convince funders and station management that the future for
video was strong. In the same year, the Music Image Workshop was created
by Ron Hays, who used the Paik-Abe Synthesizer to create abstract images
that were mixed with regular broadcasts of the the Boston Symphony Orches-

tra. In 1974, the WGBH New Television Workshop was officially founded. Under the direction of Fred Barzyk, it was the first such television-sponsored workshop to offer artists the use of its half-inch non-broadcast quality porta-paks, and to encourage them to take an interdisciplinary approach to video and television, exploring dance, drama, performance, music and visual art.[11] The Workshop's weekly videoart broadcast, *Artists Showcase,* was the longest continuous artists' television series when it ended in 1982, and brought widespread attention to WGBH. A high point for the Workshop was the 1974 landmark production *Video: The New Wave,*[12] the first national PBS broadcast of video art. Written and narrated by Brian O'Doherty (who was also the director of the NEA's media arts program), it served as a retrospective for achievements in the field.

In New York, video production and broadcast got a boost when the TV Laboratory was established at WNET public television in 1972. At that time access to any kind of editing equipment was very limited in the city. Headed by David Loxton, WNET's Lab was inspired by the work going on at WGBH, and shared ideas, funds and equipment with its Boston counterpart. As Fred Barzyk recalled, "We shared a lot of times, we even sent whatever cash we had to the Laboratory so that [David Loxton] could do things we weren't allowed to do, and vice versa. There were a lot of times when we collaborated on shows, probably the most disastrous one was something called *Collisions* (1976) with Lily Tomlin, Danny Ackroyd, Gilda Radner, and Professor Irwin Corey."[13]

Loxton established direct working relationships with recognized video artists who, up until that time had little access to sophisticated editing and other broadcast quality equipment. Once selected to be part of the TV Lab, the artists were given access to WNET's broadcast editing systems, which utilized the newest technology available to public television at the time. While many artists had some experience with three-quarter-inch editing, they were now allowed to work with state-of-the-art two-inch technology under the direction of station technicians and producers. Because of union regulations and other restrictions, artists were not permitted to operate the equipment directly. Bill Viola says, about WNET's TV Lab, "It was a place where I grew up in video. When you were accepted into the program, you made a quantum leap in terms of what was possible."[14] A TV Lab residency was prestigious and usually led at least to a local broadcast of the finished work.

Artists who were selected during the Lab's ten-year history formed a who's who of New York video artists of that decade. In the words of one of its producers, Carol Brandenberg, the Lab ". . . nurtured many of the most talented independent film and videomakers working. . . ."[15] Even though the roster included many documentary makers, it excluded artists airing minority viewpoints and others who didn't fit into the stylistic and conceptual frame-

work demanded by the producers. Brandenberg was instrumental in maintaining strong funding during the early years, but crucial New York State Council on the Arts (NYSCA) support dwindled in 1982. NYSCA artist peer panels were concerned about the high overhead required by WNET, the method of selecting participants, and the fact that WNET had not increased station support to the Lab. When the confrontation between the organizations hit an impasse, WNET issued an immediate notice to all former participants of the TV Lab to collect their master tapes, and then closed the project. Many of the original two-inch masters are now housed in the video archives of the Museum of Modern Art

The 1970s saw the greatest funding support for artists' residencies in public television and the most flexible years in public television's art programming history. Yet despite the remarkable output of new work during this time, relations among donors, artists, and station bureaucrats were not smooth. Although the NEA and NYSCA had established program funds for video production support, and along with the Corporation for Public Broadcasting and Rockefeller Foundation support, artists expected continued expansion of television access. Instead, conflicts arose between artists and arts television producers, and expectations that once soared became confused. Lured by the illusion of vast amounts of funding and technical support that public television had become known to provide, more artists sought entry into the workshop programs than could be accommodated. Program support diminished across the board by the late 1970s, and grants made to WGBH for artists' programs, for example, did not even provide enough operating support for a full-time director. Public television began to feel the pressure from tightening dollars. Complicating this situation further was the fact that in order to obtain private sector funds for more mainstream programs, public television was forced to compete with commercial television for larger audiences, financial supporters, and wealthy subscribers. Their strategy, by definition, excluded most programs that were controversial or difficult. Public TV became geared to the specialized, over-50-years-old and educated home audience, and rationalized demands from women's groups and minority artists who perceived themselves as being excluded from its programming.

Responding to the conservative "home grown" nature of public television's program policy, a special international closed conference of artists and television producers was hosted by the Rockefeller Foundation at Lake Como, Italy in May 1977. The conference, suggested by Italian television's Sergio Borelli, was inspired by several European conferences called CIRCOM. Out of this watershed meeting came the International Public Television screening conference, INPUT, established as an annual forum at which creative producers from around the world could discuss quality non-commercial television programming. INPUT provided the first opportunity for American public TV

producers to compare their productions with their European counterparts who were not embroiled in competition with commercial TV and its point of view. Although Europe was considered a vast market for American programs (and a source of station funding), public broadcasting stations rarely programmed foreign language productions (and were adverse to subtitles). The mission of INPUT was to bring public television producers together as visionaries and potential collaborators, and video artists and independent filmmakers were asked to participate in this process.[16] Hosted by a different country each year, INPUT continues to provide one of the few opportunities where artists, broadcasters, and independent producers can discuss program content.

As foundation and federal funds to public television for experimental works decreased during the 1970s, the financial support for artists grew. A new era in funding had started when the the NEA began supporting a small (but reported to be growing) number of not-for-profit media art centers. Anticipating the shift in funding, media art centers were created in desperation by artists who wanted access to equipment and did not qualify, or who would not accept the conditions imposed on artists by TV stations producers. These centers ultimately provided equipment and a showcase for artists that was more democratic than the selection process utilized by television stations. As needs arose, the new non-profit organizations gained access to digital state-of-the-art equipment—which was becoming available at more affordable rates—through commercial facilities. By contrast, the public television stations, which had invested heavily in equipment at the beginning of the 1970s, could not afford to keep up with technical developments that included advanced digital effects, computer animation and paint box graphics, and other specialized equipment that commercial video editing studios offered in the early 1980s.

As Rockefeller Foundation funding became diverted directly to artists, to research in the field of media arts, and to regional media art center facilities, artists' television projects received less fiscal support. The funders who established the initial experimental television art programs had hoped that individual stations would pursue funding sources within the PBS system to perpetuate, and expand, their seed money. Some media art centers, like the Bay Area Video Coalition in San Francisco and the Long Beach Museum's LBMA VIDEO, became technically sophisticated in the 1980s with grants from the Rockefeller Foundation and the NEA. In fact, many media art centers surpassed public television in offering artists both advanced equipment and unrestricted freedom. Access to products such as three-quarter-inch broadcast-quality portable color cameras, time-coded editing, and frame-accurate edit controllers, attracted artists drawn to the alternative environment, and who, with and without the support of funding agencies, created videotapes that expressed varied points of view and aesthetic approaches. Little of this work found its way to television; instead it was exhibited in alternative and artist-

run spaces as well as in a few museum exhibition programs. These venues, and not public television, remain the main vehicle for showing video art today. As John Reilly wisely surmised in 1979: "The field of media centers is organic and responds to changing needs and emerging talent. This structure is not the creation of a single bureaucracy in Washington, New York, or wherever. It is diverse and evolves as needs and talents emerge."[17]

The 1980s: Commercial and Creative Forces Seek Common Ground

In the mid-1980s, three public television program series were developed to broadcast video art across the country: *Alive From Off Center,* the nation's PBS-supported dance/performance/ video series, first aired in Summer 1985; *New Television,* which began as an acquisition program at WNET, New York in 1985, and was joined by WGBH as a co-producer in 1987; and The Learning Channel's independent national cable series, *The Independents,* also established in 1985. Several of *The Independents'* thirteen-week thematic program series, which negotiated PBS carriage in its fourth year, often mix documentary, film, and video art in the same one-hour program. Direct grants to each of the producing stations were made by the Rockefeller Foundation, The John D. and Catherine T. MacArthur Foundation, and by various NEA program funds and state art councils. Public television used the grants to pay program costs for acquisition and production of artists' work, and were mandated by federal and state agencies to encourage alternative and minority artist participation.

The most influential of the series, *Alive From Off Center,* began as a collaboration with Minneapolis's public television station KTCA and the Walker Art Center to produce an eight-week series of half-hour programs featuring contemporary dance, performance, and video art. With initial major support from the NEA's dance program and from the Rockefeller Foundation, *Alive's* ambitious plans called for the production of a series suitable for national broadcast. It was the first time funding agencies and producers combined efforts to target the national audience for contemporary performance (and to a lesser extent, video art), and they were determined to make the program what the program's first executive producer, Melinda Ward, often called "good television," rather than good art. The series, which promised the largest audience yet in the United States for artists, also hoped to make inroads into the yet untapped, younger (under fifty) audience for PBS. The first season's broadcast of *Alive From Off Center* elicited double-edged criticism. Although public television stations in most metropolitan cities carried *Alive,* programmers elsewhere were not impressed by a series designed for a young, upscale audience and found that the coded images in the arts programs didn't appeal to their mid-American taste. Meanwhile, art critics found the programs to be ". . . the sil-

liest mix of art and commerce, confusing, in the American way . . . an expensive look with no real substance that can't decide if they should entertain or ennoble and try to do both with the patented PBS schoolmarmish didacticism."[18]

Even with its innovative program history, WGBH's New Television Workshop, headed by Susan Dowling since 1979, found the 1980s a difficult time for fundraising, and foresaw a dismal future. In response to this, and after two years of planning, in 1983 WGBH and The Institute of Contemporary Art (ICA), Boston, formed a joint production project to reinvigorate the New Television Workshop and introduce television programming and production at The ICA. With initial funding for three years from the Massachusetts Council on the Arts and Humanities' special New Works Development Award, The Contemporary Art Television (CAT) Fund was established. The CAT Fund was designed to provide artists much-needed production funding support within the broad context of public television, and to find innovative methods to professionalize the international distribution of video works, especially to television, in order to eventually build a self-sustaining operation. Managed by this author in a newly conceived position as curator/producer, The CAT Fund was directed jointly by Susan Dowling and David Ross, director of The ICA since 1981. The co-venture was an effort to combine support structures from both the TV and museum worlds, with the blessing and full support from both institutions. Although controversial because it was perceived as a grant-giving agency, The CAT Fund co-produced and assisted in arranging broadcast for productions by an international group of artists. But, unlike the artists' television series which began during this period, The CAT Fund ultimately suffered from the lack of development support from its parent institutions, and a major funding source for the project did not materialize. Released from its broadcast partner, The Fund became an ICA program that could explore a variety of directions in video including broadcast, installation, performance, and single-channel works inappropriate for television. WGBH's New Television Workshop, in the meantime, began a successful collaboration with WNET to co-produce the artists series *New Television*.

In 1989 federal legislation established the creation of an Independent Programming Service separate from PBS and CPB with the stated purpose of guaranteeing new funding for independent producers working outside the established public television system. This bold plan promises that public television will contain more artists' work, alternative documentary formats, minority voices, and other non-traditional programming. Lawrence Sapadin, co-chair of the media community's National Coalition and executive director of the Association of Independent Video and Filmmakers, hailed the plan as "a victory for the American public, who will now be able to see on television the most diverse and innovative programming."[19] Given the history of video art on televi-

sion from the late 1960s to the present, it is clear that the Independent Programming Service will face major challenges as it strives to meet its goals. Even when this plan succeeds in creating more television that is nontraditional, the fact remains that the future of televised video art will be problematic. Spurred by its commercial need to garner the greatest possible audience, TV programming is still geared toward the greatest common denominator. Funders and program directors will continue to select programs that can not only deliver their "product" or reflect their "message" but also "deliver" an audience.

Television, the vast consumer of programming aimed at an ambiguous "mass audience," was conceived for consumption by the largest possible common denominator audience. TV remains the single most important reference point for determining uniformity in American culture. The question remains how, today, with TV a cultural constant and a social fact, can artists as individuals influence this unsympathetic system? Because art and television remain at philosophical odds with each other's perspectives, the value is often in the discourse rather than in the work. Ultimately then, the issue is less about the individual program on television and more about the complex discourse that arises when aesthetic aspirations come in head-on contact with consumer practices, blurring the boundaries between art and entertainment. Experimentation and art influenced public television during the 1960s. The challenge for video artists will be to expand the definition of their art and cultural assumptions in order to keep alive this rich discourse of parallel alternatives and individual voices.

Gary Hill, *Happenstance (part one of many parts)*, 1982–83.

And if the Right Hand did not know What the Left Hand is doing

Yes, this is it, perhaps only slightly different from when others passed through. Perhaps not, the difference only being my time and theirs. Nothing seems to have ever been moved. There is something of every description that can only be a trap. Maybe it all moves proportionately thereby canceling out change and the estrangement of judgement. No, an other order pervades. It's happening all at once; I'm just a disturbance wrapped up in myself trying to pass through the gate of a great halfway house.

Video Art: Theory and Practice (that bulge of nouns, perhaps more honest if bolted with quotes; as if certain words can't have closed mouths, part they must, from whence whatever language they still bear begins to seep). But that was only a working title for this book. And What is it now? No matter, for if we repeat any number of words over and over again they too will empty themselves in equally hideous fashion. "[Other] words to avoid because of their excessive theoretical freight: 'signifier,' 'symbol-

Yes, this must be it; that hall of mirrors where the upper extremities of erosion take place; where the upper echelon of controlled emotion is called upon to do its dance to reach the other side; **where opposite views line. . . .** the path chanting truths like parallel lines that are said to meet at the points of entry and exit, the two nodal hemispheres that play havoc in your skull. **Your mind can't help but mince.** and suddenly you're beside yourself entertaining a party of two only to fall back a few steps, a few words gone by, a few instructions on how to get from point A to point B. Points, known only by the needle that records everything.

It's happening right before my hands. The circumstances of standing still surround me. I'm paralyzed. A waiting awaits awaiting. My legs stand among logs impartial to my steppings. It behooves me to step gently betwixt the swollen details. **The foretelling of a dervish and its sub-.** sequentessential rendezvous with entropy. I only have so much time. The sun will rise and I won't know what to do with it. Its beak will torture me as will its slow movement, **the** movement it invented that I can only reiterate. So much remains. No doubt it can all be counted. Starting with any one, continuing on with any other one until it is all accounted for, a concensus is reached. That it can all be shelved **in all its quantized splendor, this** then is the turf.

A little island among many islands to be connected together in

ic,' 'text,' 'textual,' and then 'being,' and finally all words, and this would still not suffice…[1]

When first approached to write for this publication, I had morbid **thoughts of being part of a body** of knowledge; of having to fill my shape; in a strange way, of having to behave (on behalf of the facts) to come to terms within terms of a public at **large.** My thoughts doubled up. Went back. Came forth. Wrapped around. Sought traction in forward movement—there must be something to say. Put another way, I was offered a platform(ality) to create a voice on the subject. And so I accepted this invitation as that of a gift; of being one of the chosen ones. But did I have a choice? Not really; a "no" is somehow conspicuous—the refuse of erasure, its smear—and even if somehow it were to cancel the exchange (were it not a gift), a trace is left if only on my own psyche. I would have annihilated a **space to "have my say"**—*the final sin.* And so I bit, backed by that unspoken optimism that can only resonate from the horse's mouth (the artist speaks), I blurted "yes," at which **point my mouth filled with a last image** of blood. *(vide page 98)*

Once having seized up on the opportune moment, the preamble has all but run its course and thus, looking back, gets tripped up by that "forward movement" falling (pre)face down into a momentomb. So what is left but the **business *between* hands.** On the one, to dig (deeper); on the other, to bury (deeper)… And if the right hand did not know what the left hand is doing…

some form or fashion to make the whole picture. Yes, this is it. No one can tell me otherwise. On or off the beaten track (this is it). Time to kick up some mud, forget the finishing touches. The quieter and stiller I become the livelier everything else seems to get. The longer I wait the more the little deaths pile up. Bodily sustenance is no longer an excuse. **Too much time goes by to** take it by surprise. I must become a warrior of self-consciousness and move my body to move my mind to move the words to move my mouth to spin the spur of the moment.

Maybe this has always been it, a **bewildering object in my path collecting** more and more of whatever collecting tends to collect when nothing clicks when things just couple becoming twos instead of ones. **And then it stops. Stops dead in its tracks,** backlogs, rolls back on one of its many convoluted surfaces and sits there perfecting stillness. My gaze thickens before a black spherical object laden with dull silvery characters, symbols and **num-** bers that, now and then, jolts forth and back; each time to rotate a discrete distance. **The movement is** quick; animated like certain walking arachnids.

One eye can never be left to leave it. Perhaps the eye is kept by it, toyed with, left to wander (never too far off). Always drawn back, peripheries anew. And still (as it were) not an inkling of what's behind it, of what's up front, **of what's to come,** of what tense waits in passing.

These citings. This scene before me made up of just so many *just* views (nature's constituency) sits with indifference to the centripetal

It's difficult to palm the polemic off. Being commissioned, rather than thrown from my own space of participation—where for an instant I found myself in a quick word & image with automatic hands speaking in tongues "wroughting" out **an explanation**—brings to the fore a contradiction that for the sake of honesty I maintain. But is maintenance enough? Isn't it really just another way of explaining it to **death**—**one part** of the rigamarole to another?

(*"Neither reading nor writing, nor speaking—and yet* *it is by those paths we escape what has been said already."*)The mouth is a wound forever reopening. "Yes" (or "no"), splits the "tending" (forks the tongue), **between an act *within video*** and an otherwise acting *around & about* it. We are caught between seeing and **speaking**—discourse (Latin: "a running back and forth")—slowly accumulating mud in the treads, micro assumptions that begin to *make* sense, consolidate and solidify positions, claim territories for which there are no maps.

For example, what is political video? To which one might respond with another question, what is **sociopolitical art if art is not** sociopolitical to begin with? Or at the other **end** of the categorical spectrum, how do the ever-increasing technological possibilities bear upon the medium? To which we might fold the question

GARY HILL

vanishing point that mentality posits so falsely. **The brain, minding** business, incessantly constructs an **infinite series of makeshifts designed** to perpetuate the picture—the one like all others that holds it breath for a thousand words, each of which, **con-** versely, exhales point zero zero one pictures. And thus the insidious wraparound, based on the notion I have eyes in the back of my head, binds me to my double, implodes my being to a mere word as it **winds the world around my mouth. A** seamless scroll weaves my view back into place—back to back with itself—ah yes, the boomerang effect(ually) decapitates any and all hallucinations leaving (lo and behold) the naked eye stalking each and every word that comes to pass, **that breaks and enters** the dormitories of perception.

Imagining the brain closer than the eyes.

Can I finally be beyond that shadow of that doubt and lower my pointed finger lest it vegetate amongst the reverberations of my own reach? . . .and then **and then and then perhaps the stone** thrown happens to skip (walks on water), that is to say, meets its own reflection in a manner that propels its to its next reflexive moment and so on across the abyss and little by little, little divides: The prong of duality impales my being; I should become someone else and proceed accordingly.

I'm in a quandry. **A vague language** drapes everything but the walls—what walls? The very walls that never vary—my enclosure, so glorious from a distance, stands on the brink of nothing like a four-legged table. What is it? An island with a

back on itself and suggest that perhaps what's called for is *a loss of technology*—a recognition of fallibility, an openness to the possibility that the nature of the questions might only arise authentically within the cyber-netic milieu of video itself—the poetics as they occur. (Here I think of at least one unac-knowledged founder, Paul Ryan.)
Are "feedback," "electronic linguistics," "border culture", and "time/energy objects" particulars of video? Perhaps. But the question reverberates, where is this to be explored? "The effort of the critical mind to get a handle on processual/eventual poetries is itself belied by the nature of transformative poetics ("Metapoetics"), which contrives by various strategies to throw the reader/listener/viewer back on direct experience—back to the root of the composition itself, where the generalizing of intelligence is shunned, altered, or supplanted."[2]
So how do I proceed with these bulbous things, this seed, coinage, and ruminate this question of video? Or from a slightly different vantage point, *of video?* Do I point as to exemplify, retrospectively encapsulate—swallow it, pick a subject from the field, and entertain it? (Bateson, "information: any difference that makes a difference")

never-ending approach? A of différance? (a difference deferred
stopgap from when to where?.by the absence of the presence of
Something to huddle over with my
elbows like trestles without
tracks, the bases of which are
scattered with evidence of ence? Which one? Can I enter it from writing
unsolved crimes? The over-
allness of it soaks through,
runs through the holes in my
hands and continues to run
amok, overturning rocks that
should not be overturned,
breaking bread that should
not be broken. My shoulders
bracket my head.

 The writing's on the wall
and I can't stop reading it.

 If there were hints, however the psychic cushion of etymology. The
indistinct, a path, a sign, a sound
or perhaps something more
grandiose—a labyrinth.with someone else's eyes—the cathode ray tube
wherein I could wander for
results through blinding geome-
tries of light, vast openings
(earth-shattering vistas) that.nonsite of television? Is television the
would fill me with terror
followed by sadness like great.ears? Are there spirals in your eyes? A
passages of fiction.

 Perhaps it all comes down to
final hours, last utterances, and
mute gazes. Bodies take shape
with kept language. Flesh pre-
tends its part. Ointments avail
themselves. Night fills with
orphaned pixels. Mouths can't. .video?
quite fit around the words.
Vocal execution looms.

difference deferred by the… adinfini-
tum-tempertantrum—a delirium of
reduction). Does a pixel make a differ-
or least discover the barrier of passage? If the
latter, does it follow to climb out? Is there
ground here; am I on to something now,
on my way perhaps getting in your way?
 Shall I move so you can see?
 And what about this seeing, looking at
this *video* word (from Latin *videre,* "to see")?
We've seen this reiteration before, the utopian
embrace of *our* word being at one with the
cornerstone of art of existence (seeing is
believing)—the danger of nestling into
eyes should be pulled from their roots and
replanted somewhere else—*acts of seeing*
dislodged from its body, its entire frame of
reference. Am I moving towards (to
words) to ward off the site? Is video the
obscenery of reality? Is there a ringing in your
mother, father, or cat in your mouth? Are
these questions sequential? Essential?
crystallized? fractalized? (virtual ques-
tions)—a matter of short cuts cutting cor-
ners creating more sides, piles, accumula-
tions, surface scrap? Can meaning become
impacted—like teeth, like words, like
Have I forgotten video? Have I forgot-
ten how to see?

"YES"

Yes. What is happening when I say this word, this one of a kind utterance which can't double back on itself, partake of the realms of negation and remorse (Latin: *"to bite back"*). What is the shape of "yes"? (again the problem is where to begin). Back when the back of the tongue enlarges, slightly stiffens like a pestered sea anemone and then, in an almost violent fashion, contact with its enclosure (its house—that ensures its wetness, its readiness) is prevented at the last possible moment, as if the sound of resonation were to have caught the beast off guard abruptly halting its welling up and thus holding it at bay. (Would it be helpful if I were to write groups of letters that phonetically signify this sound/shape? I think not. As this would entail the coming of a logical progression—a regression into "points," an infinite description resigned to representation. Furthermore, this nodal awakening which constitutes the beginning of the sound is significantly smaller than the available phonetic inscriptions and must be felt out by the reader from within their own uttered "yes.")

The word is birthed as the sound opens from its not quite pinched beginnings into an amorphic slightly ovaled form at which time the tongue relaxes or rather pauses as if to flirt with its resting place, the bite—where it parks; is kept (wet). The word's body as it were (admittedly, I've quantized a few hundred points here if only to escape a verbal cocoon), whose source hovers somewhere in medical terminology above the Adam's apple, like a bee about a flower, is the "vocalization"—the duration of the utterance. And yet it is part of the sound which is perhaps most undifferentiated from the "vocalization" of other words. In other words the word's *other* parts are its articulations—the overwhelmingly complex openings and closings—wherein thought is cut, healed, and cut again. And yet this body of sound is perhaps that which is central to the pleasure and mystery of speaking.

Not quite fully settled in its closed mouthed position, as quickly as it laxed, the tongue once more is called upon. What at first seems like a languid rising toward the roof of its abode is a studied meditation of recoiling, coinciding with a not quite closure of the teeth (almost clenched) which is the final irony of this emission "yes". The word is closed down upon as if the mouth decided (after the fact) to grasp the words tail—a moment of keep's sake before releasing the offering.

"NO"

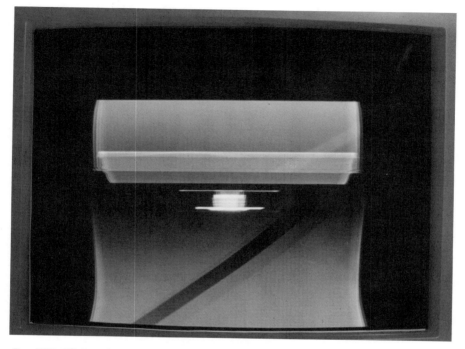

Gary Hill, *Offering*, photograph in the moment a TV is turned off.

Nancy Cain of TVTV taping for *Four More Years*, 1972.

Paradox in the Evolution of an Art Form:
Great Expectations and the Making of a History

MARITA STURKEN

> People are always shouting they want to create a
> better future. It's not true. The future is an apa-
> thetic void of no interest to anyone. The past is
> full of life, eager to irritate us, provoke and insult
> us, tempt us to destroy or repaint it. The only rea-
> son people want to be masters of the future is to
> change the past. They are fighting for access to
> the laboratories where photographs are retouched
> and biographies and histories are written.
>
> **Milan Kundera,** *The Book of Laughter and
> Forgetting*

The making of history is an elaborate and highly regimented process—a com-
plex structuring of a particular narrative that sets out to tell a single, well-con-
tained story, replete with a delineated beginning, middle, and end, neatly
sealed with closure, and governed by cause and effect. Histories do not simply
evolve, they are *constructed* through certain agendas. As narratives, they adhere
to a specific set of cultural codes governing the nature of shared reality and the
communicability of experience.

History is, in fact, not a process of accumulation but of selection, a ver-
sion of events that can be defined through its exclusion of many stories. (Most
commonly written out of history are women and people of color.) History is
amorphous; it is redefined and reshaped according to the ideologies of any
given period of retrospection. It represents to us not simply the telling of
events, but the interpretation of those events—interpretation by individuals
and institutions. Today, this interpretation is a process that begins with the
media as the primary initial interpreter of political and social events.

Those stories that are for whatever reasons excluded from the metanarra-
tive of history, however, are not destroyed. While they may be silenced, they
often work in subversive ways against the totalizing effect of history. Michel
Foucault was instrumental in defining these localized or subjugated knowl-
edges. Foucault defined subjugated knowledges as "historical contents that
have been buried and disguised in a functionalist coherence of formal system-
atisation," as well as knowledges "that have been disqualified as inadequate to
their task or insufficiently elaborated: naive knowledges, located low down on
the hierarchy, beneath the required level of cognition or scientificity."[1]

This paper is concerned with a very specific history, in an attempt to
open up a space for the histories, or subjugated knowledges, that this history

has worked to exclude. The historical narrative of video art, which has been constructed in a brief twenty years, is thick with myth and follows the conventional narrative codes of history making. It does, however, represent an important historical rupture. As a historical model, the development of video art can provide us with a microcosm of the social dynamic of the late twentieth century precisely because of video's problematic relationship with history and the paradoxes of our culture that are embodied in perceptions of the medium. This problematic of history is irrevocably tied to the relationship of art and technology in contemporary Western culture, and ultimately to the phenomenology of the video (and television) medium. I am interested here in examining the reasons for this problematic relationship and the paradoxes of the video medium, in examining video history as it has been constructed. This paper is an attempt to analyze this dynamic; it is not an attempt to replace the history with another.

The Need for a History

Video has been plagued by the notion of its own history. Attempts to define the medium have shadowed its growth from the very beginning. Bill Viola recalled: "In 1974, people were already talking about history, and had been for a few years. . . . 'Video may be the only art form ever to have a history before it had a history.' Video was being invented, and simultaneously so were its myths and culture heroes."[2]

Not only was video being "invented," it was being staked out and claimed. Many of the artists involved with the video medium were interested not only in using the camera to interpret certain events but in the new medium itself as their subject matter. Many of the art institutions that dealt with video upon its inception were keenly aware of the importance of situating specific figures and events within a larger context. The intense self-consciousness that pervaded this medium can be seen in many ways as a postmodern self-consciousness, one that came out of the perception of video as marginalized—on the fringes of the art world, straddling the fence between art and information, defining itself against and in spite of the overwhelming presence of television. This self-consciousness fed the early desire to shape video history as it evolved—to label the "first" of all developments and to establish central heroes in the construction of a growing mythology.[3]

Indeed, this preoccupation with history seems extraordinarily paradoxical in a medium whose very technology is geared to the present and associated with the future. There are two primary reasons for this compulsion to shape and define video's history: the first is technological, the second institutional.

The advent of accessible and portable video technology in the mid-1960s began an era in which the consumer video market would expand and develop with extraordinary rapidity, to the point that within twenty years VCRs and

portable cameras have become commonplace in our society. This changing technology has been fueled not only by the consumer market but also by advances in industrial equipment resulting from broadcast news's increased reliance on electronic news gathering and the integration of video editing systems with computer technologies. This technology has advanced with a speed that is unprecedented in the history of the imaging arts.

Technological change is not, of course, a neutral event. The accelerated development of electronic imaging and television technology in the last two decades has been the direct result of a specific ideology. The increased mobility of television cameras and the massive push for a consumer market (the replacement of the Kodak Instamatic with the home video camera) were directly related to the desire to capture reality in "real time." Television is coded as the immediate—the live image transmitted to many locations at once. It has never been conceived, either culturally or industrially, as an archival medium. As a consequence, video is materially a rapidly deteriorating medium. Videotapes made in 1973 (a mere sixteen years ago), with their blurred, grainy images and muffled sound, seem like distant aesthetic antecedents to contemporary work. These tapes (those that are not already irretrievable because of image deterioration or because their equipment format is now obsolete) appear to be strange and elusive artifacts of another era; in other words, they seem much older, and much more evocative of a past, than, for instance, 16mm films from that time.[4] These early tapes also represent a time when preservation was simply not seen as a relevant issue and when image quality, as it is commonly defined today, carried less significance than the drama of capturing an event on camera.

In a medium heavily dependent on technology, these technical changes ultimately become aesthetic changes. Artists can only express something visually according to the limits of a given medium's technology.[5] With every new technique or effect, such as slow motion or frame-accurate editing, attempts have been made to use those effects for specific aesthetic results. The aesthetic changes in video, irrevocably tied to changes in its technology, consequently evolved at an equally accelerated pace. For instance, within a short period of time, digital imaging and frame-accurate rapid editing have replaced real time as the most prevalent aesthetic styles. Whereas in 1975 it was still standard fare to produce a tape in real time, by 1982 it had become (when rarely used) a formal statement.

We are thus confronted with a new, accelerated time frame for perceiving an art form and its development, a time frame that has had a direct effect on video's apparent "need" for a history. In a mere twenty years, the technical and aesthetic changes in video evoke the equivalent of decades of development in such diverse media as photography and painting, thus provoking the perception that it must be quickly historicized. The need for history increased when information begins to erode and become irretrievable. As the *electronic*

history of video fades, its *written* history gains importance. When the tapes are no longer decipherable, there will still be interpretive texts. Video's preoccupation with history, its underlying fear for survival as a medium within the master narrative of art history, is manifested in the construction of history as word.

The other primary reason for video's concern with its own history is not technological but institutional; however, it also carries with it a fear about survival. A history is often created as an act of preservation within specific social structures. That is, to formulate a history is to establish the legitimacy and autonomy of a particular field. The role museums and art organizations have played in institutionalizing video (a medium that, one must add, artists originally perceived as antithetical to the art establishment) has significantly shaped the field. This "museumization" has succeeded in both nurturing and isolating work produced in video, a factor that can be seen as the direct result of nonprofit funding structures in the United States.[6]

In order to receive funding, museums and art organizations segregated the medium of video into departments separate from other media. This segregation has meant that most exhibitions of video have been presented in a solitary context, rarely in the context of film, painting, or other media. The prevalent nonacceptance of this new medium in the art world has caused video curators and critics to reemphasize video's properties constantly and to defend its inclusion in their exhibitions and in the museum context in general. Within the modernist conventions that have governed these institutions, a medium that deserves curatorial attention is defined by its properties and most importantly through its development or history. Thus, the establishment of criteria for the history of video has been a means for video departments to defend not only their existence but their funding. Museums such as the Museum of Modern Art, the Whitney Museum of American Art, and the Long Beach Museum of Art have taken on the role of defining video history. In 1983 and 1984, each presented a major history show that was selective in its presentation and produced a particular historical narrative.[7] These institutions are shaping video history with little acknowledgment of the influence of other art forms, communications theory, and sociopolitical factors that were instrumental in the development of the work.[8] Furthermore, it is paradoxical that institutions are the primary historical interpreters of a medium that initially developed outside of and in opposition to the established art world and still considers itself not to have gained full acceptance in that world.

The Myths of Video History

That history is a myth-making process perhaps does not need to be reiterated yet again; however, the role that narrativity plays in this myth-making is crucial. Hayden White has written,

*It is sometimes said that the aim of the historian is to explain the past by "finding,"
"identifying," or "uncovering" the "stories" that lie buried in chronicles; and that the
difference between "history" and "fiction" resides in the fact that the historian "finds"
his stories, whereas the fiction writer "invents" his. This conception of the historian's
task, however, obscures the extent to which "invention" also plays a part in the histori-
an's operations. . . . The historian arranges the events in the chronicle into a hierarchy
of significance by assigning events different functions as story elements in such a way as
to disclose the formal coherence of a whole set of events considered as a comprehensible
process with a discernible beginning, middle, and end.*[9]

The history of video has been turned into narrative according to a particular
"hierarchy of significance," and it differs from many conventional histories only
in that it has been so actively written by many of its participants even as they
are participating in it. The telling of this history has constantly emphasized
the role of video as a subjugated knowledge within art history. This emphasis
on its marginalization has ignored the fact that video itself has a history that
has eclipsed other possible histories of the medium.[10]

The story as it has been told is usually quite simple—in the late 1960s,
the advent of the portable video camera sparked an energetic movement as art-
ists and activists picked up cameras and pursued an electronic revolution. It is
said that Nam June Paik was the *first*—while driving home with a new porta-
pak, he shot tape of the pope's visit to New York, which he showed that
night at Cafe à Go Go. Soon, many artists and activists began making anti-
television, gritty tapes about the counterculture and the antiwar movement, as
well as tapes that examined video's capabilities and electronic properties: inti-
macy, instant replay, and real-time. The mythic history is charted through
various events—the "TV as a Creative Medium" exhibition at the Howard
Wise Gallery in New York in 1969, the artist-produced tape *The Medium is the
Medium* (1969) at WGBH in Boston, the initiation of media funding by the
New York State Council on the Arts in 1970, the Circuits conference at the
Museum of Modern Art in 1974, and so forth. It then moves effortlessly on to
the late 1970s, with technical advances allowing for the frame-accurate edit-
ing, digital effects, and artists producing "works for television" using increas-
ingly sophisticated equipment.

There are many problems with this version of video history. It is institu-
tionally based and technologically determinist and highlights the accomplish-
ments of one individual in what was (and is) an extremely diverse field. It is
art-historical to the extent of negating video's use as a social tool. In her semi-
nal paper on the myths of video, "Video: Shedding the Utopian Moment,"
Martha Rosler states, "The elements of the myth thus include an Eastern visi-
tor from a country ravaged by war (our war) inoculated by the leading U.S.
avant-garde master [John Cage] while in technology heaven (Germany), who
once in the States repeatedly violated the central shrine, TV, and then goes to

face the representative of God on earth, capturing his image to bring to the avant-garde. . . ."[11]

Video's inception is seen through the rosy light of nostalgia. According to myth, it was an era when freedom of the spirit abounded, when artists and activists discovered a new medium and took to the streets with it, assured that their "guerrilla" tactics would ultimately change television. From the perspective of the 1980s and the 1990s, the 1960s as an era of commitment and optimism has become an increasingly important cultural symbol, as evidenced in the repackaging of 1960s icons into television commercials and the fervored re-embracement of the Kennedy myth. With the rise of conservative influence in this country as well as the increased commercialization of the art world, it should be no surprise that the 1960s, with their mix of practice and theory, politics and actions, are looked on as a "utopian moment" by both artists and activists in the United States today.

While the technological and institutional factors I have discussed offer reasons for video's preoccupation with history, they do not wholly explain the distorted aspects of that history as it was handed down. Certainly it is not unusual for a history to be constructed around the accomplishments of "great men," and Paik has always been very shrewd not only about his own role in video history but also about how history is made—by institutions with power. An emerging field's need for a central hero in the construction of its narrative is obviously a contributing factor, as was the anti-establishment, anti-individualist ideology of the video collectives, which eschewed the "hierarchy of significance" being constructed by the art institutions' defining and highlighting of the "video artists." That video had not yet become (and still is just barely) a topic of exploration within academia was also a contributing factor. However, beyond these factors lies a more fundamental reason, one that contributes to video's overall problem with history. This is a medium whose development embodies many dichotomies of Western culture, whose position at the axis of art, electronic technology, and telecommunications offers a problematic subject for historical interpretation that has no direct antecedents.

The Political Ideology That Gave Birth to the Myth

The era in which video evolved was an intensely active and idealistic one, now seen as the primary moment of radical social upheaval in the United States and Europe in the latter half of this century. That video's emergence coincided with this pivotal moment of idealism about cultural change and social pluralism contributed to its initial burst of energy and diversity. The motives of those who began working in video in the late 1960s and early 1970s were multifarious, although not initially incompatible. For many, video represented a tool with which to "revolt" against the establishment of commercial televi-

sion. For others, it was an art medium with which to wage "war" on the establishment of the commercial art world. For example, artist Frank Gillette has said, "Video was the solution because it had no tradition. It was the precise opposite of painting. It had no formal burdens at all. In fact, it had a kind of perverse aura around it, because of its crude application up to that point, its crass commercial utilization in the mass media."[12]

Video art was introduced at a time when the art world was undergoing upheaval, as artists questioned the traditional art object through nonmarketable art forms such as performance, conceptual art, earthworks, and body art. It was also, appropriately, a time when the power of the media had been overwhelmingly reaffirmed, just after the on-camera assassination of this country's first "media president" and in the middle of its first "living-room war." These social and political events were delivered to an eager audience via the medium of television, whose role as the primary interpreter of events had only recently been established.

While rigid boundaries are now drawn between socially concerned videotapes and video art by the institutions that fund and exhibit this work, few categorizations were used when artists and activists first began making tapes. The standard subcategories that are commonly used to describe video today— such as documentary, media-concerned, image-processing, and narrative— while glaringly inadequate now, had no relevant meaning in the late 1960s and early 1970s. Distinctions between art and information were not initially made by these artists; to them, everything was simply "tape" (and many eschewed the title "artist" as one that connoted elitism). Steina Vasulka has noted, "We all knew we were interested in different things, like video synthesis and electronic video, which was definitely different from community access-type video, but we didn't see ourselves in opposite camps. We were all struggling together and we were all using the same tools."[13]

This overlapping of aesthetic intent and communications/social critique was the direct result of the political ideology of the time. In the late 1960s it seemed possible to infiltrate and change the hierarchical system of telecommunications in Western society. At a time when artists and activists were reading Marshall McLuhan and thinking in the technologically idealistic terms of "the medium is the message" and the electronic community of the "global village," video was seen as a stepping-stone to the new communications revolution. Activists believed that the television revolution could be sparked simply by putting inexpensive, portable equipment into the hands of the public, allowing them to use media to define themselves. The first video artists are now commonly referred to as *pioneers*, evoking images of rustic souls staking out new terrain in art and society. The term *guerrilla television*, with its implications of aggression and subversion, came to signify a specific kind of activist videotape, one that functioned as an ironic observation of the follies of the establishment

as well as a stylistic revolt against the conventions of television. Michael Shamberg, who coined the term from the phraseology of fellow Raindance member Paul Ryan, defined guerrilla television as "the applications of guerrilla techniques in the realm of process. Guerrilla Television is grassroots television. It works with people, not from above them. On a simple level, this is no more than 'do-it-yourself-TV.' But the context for that notion is that survival in an information environment demands information tools."[14] This blend of naive optimism with a sophisticated understanding of the fundamentals of communications and media manipulation was typical of the times.

Rosler has written,

Many of these early users saw themselves as carrying out an act of profound social criticism, criticism specifically directed at the domination of groups and individuals epitomized by broadcast television and perhaps all of mainstream Western industrial and technological culture. This act of criticism was carried out itself through a technological medium, one whose potential for interactive and multi-sided communication ironically appeared boundless.[15]

Great expectations accompanied video's emergence. Not only were the media towers going to topple and the individuals going to have their say, but the realms of art and society were to lose their boundaries—everyone would be a producer; everyone would control information flow. Video's arrival came to symbolize this potential redefinition of the system. It has inevitably disappointed those expectations.

The Paradoxes of the Medium

What emerged from this complex set of events was not a medium with a clear set of aesthetic properties and cleanly delineated theoretical concepts. Instead, one sees paradox, the paradox of video's apparent merging of (hence its negation of) certain cultural oppositions—art and technology, television and art, art and issues of social change, collectives and individual artists, the art establishment and anti-establishment strategies, profit and nonprofit worlds, and formalism and content. These paradoxes are at the root of video's problematic relationship to both history and modernism. At the base of each lies the traditional notion of the opposition of science and art in Western culture.

While the history-making process has simplified the diversity and conflicting intent apparent in the stories told about video's early years, the merging of the cultural oppositions of television vs. art, profit vs. nonprofit, and the establishment vs. anti-establishment was in evidence from the beginning:

- Most of the video collectives have been historicized as zany, anti-Establishment groups with mutually supportive and egalitarian structures. However,

Raindance, for instance, was conceived as a "think tank" (its name coined by Frank Gillette as a take-off on corporate R&D and the RAND Corporation) and began as a profit-making corporation. Furthermore, many of these groups were hierarchical and male-dominated as well.

- The collectives were also primarily historicized as anti-establishment. However, TVTV (Top Value Television), which was begun by ex-Raindance member Michael Shamberg and made its name with two behind-the-scenes vérité documentaries on the 1972 national political conventions, eventually lost its impact when confronting the potentially more seductive subject matter of the entertainment industry. (Several ex-TVTV members are now Hollywood producers.)[16]

- The definition of video as an art form has most commonly been noted as being realized with the exhibition "TV as a Creative Medium," yet many of the works in that show—such as Frank Gillette and Ira Schneider's *Wipe Cycle* (1969), a grid of monitors intended to subvert the viewer's standard relationship to television—dealt with both political and aesthetic concerns. In fact, while signaling the emergence of a new art form, "TV as a Creative Medium" acts in retrospect like an indicator of the diversity of concerns in early video—the legacy of machine art and kinetic sculpture, issues of mass media and information, as well as explorations of the aesthetics, technology, and time-based aspects of the medium.

- Although it is commonly noted that many artists began making tapes that were antithetical and antagonistic to television, the fact is that from the beginning there were artists trying to get on the airwaves. They attempted to do so through public television experimental workshops and projects like the infamous and ill-fated 1969 attempt in which the Videofreex and several other video collectives made a (never-aired) pilot about the counterculture for CBS called (somewhat prophetically) *Subject to Change*.

The writing of history necessarily homogenizes difference in an attempt to qualify and define a particular era or field. Indeed, these kinds of conflicts in video's development—conflicts that arise from its embodiment of aspects of our culture that we insist on reading as oppositions—have been simplified in retrospect in order to construct this historical narrative.

The burden of an art form that paradoxically combines both science and art as a technological medium is a culturally weighty one. Video is heir to the ideology sparked by kinetic sculpture and the art and technology movement of the 1960s (rooted in cubism, futurism, and the Bauhaus) in which the merging of art and the machine was seen as paramount. As the most recent addition to the camera arts, video shares (albeit not consciously) the legacy of pho-

tography as an infinitely reproducible art form. Yet video is an instantly reproducible medium with unprecedented powers of transmission, whose very essence is simultaneity. Not only does it retain those qualities of reproduction, it also signifies the electronic factor, which through television and computers has come to symbolize information in contemporary culture.

Video's paradox of art and technology is deeply rooted in cultural perceptions of the role of technology in Western culture. Early attitudes toward technology easily manifested themselves as either an antitelevision and antitechnology tendency—epitomized by the burning TV sets in Ant Farm's *Media Burn* (1975) and the gritty, antislick style of many early tapes—or an emphatic embracing of technology with the notion that the influence of artists could somehow alleviate its destructive potential. Nam June Paik, who has professed to "make technology ridiculous," was not alone in thinking that the role of artists in a technological medium was to create a new kind of technology through humanizing use. (Paik's stated method of humanizing the medium was to construct a "TV Bra" from two miniature television sets for his collaborator Charlotte Moorman to wear while playing a "TV Cello," a rather sexist gesture that tended to considerably reduce the notion of humanism.) The first issue of *Radical Software,* a video magazine published by Raindance in the early 1970s, suggested, "Our species will survive neither by totally rejecting nor unconditionally embracing technology—but by humanizing it; by allowing people access to the information tools they need to shape and reassert control over their lives."[17]

In 1970, when Gene Youngblood published his seminal book *Expanded Cinema,* the era of techno-speak and embrace of new technology was well under way. Youngblood was one of the first to write about video, and he situated it in the context of other media, such as film and performance/theater. His particular brand of technovocabulary and technological utopianism in the arts was very influential. He wrote, "It is now obvious that we are entering a completely new video environment and image-exchange life-style. The videosphere will alter the minds of men and the architecture of their dwellings."[18] In that same year, Nam June Paik and Shuya Abe built the Paik/Abe Synthesizer while artists-in-residence at WGBH in Boston; Stephen Beck built his Direct Video Synthesizer while at the National Center for Experiments in Television (NCET) at KQED in San Francisco; and Eric Siegel, experimenting on his own, built his Electronic Video Synthesizer. Later, Dan Sandin and Steina and Woody Vasulka would design their own devices as well. With variations, all of these machines were designed to allow unprecedented manipulation of the electronic signal and to put the technology directly in the hands of the artists. Hence, the artist would not only be the producer, but also the manufacturer, governing the initial design level at which aesthetic parameters are established. Technology was thus perceived as something that must not only be humanized

but made pluralistic and accessible, and electronic technology was seen, because of its phenomenology, to be inherently more accessible.[19]

The Role of the Institutions

The institutional and nonprofit worlds have converged in unique ways in the field of independent video. The very reproducibility of videotape as well as its time-based properties placed it squarely outside of the commercial art world market. Attempts to amend this were made initially, by galleries such as Castelli Gallery in New York and Art/Tapes/22 in Italy, in producing tapes in "limited editions" for special worth, but they failed. The notion of an art form intrinsically set outside of the traditional art market dovetailed easily with the anti-art-market movements of the 1960s. Here, many thought, was a medium that simply could not be co-opted by the commercial art world.

Nevertheless, the outsider role played by video as a foundation-supported art form is equally complicated. Ironically, while the majority of early video activity took place outside of established social organizations and museums, the institutionalization of the medium (however ambivalent) took hold quickly. Several funding institutions, such as the Rockefeller Foundation and the New York State Council on the Arts (NYSCA) began doling out large sums of money to artists and media organizations by 1970, a mere two years after most artists began to use the equipment. (That they were so eager to embrace electronic media can be seen, in part, as indicative of the powerful way in which independent video symbolized the communications revolution at the time.) Public television artist-in-residence workshops were in evidence by the early 1970s, and most of the major museums in the country—the Museum of Modern Art (MoMA) and the Whitney Museum of American Art in New York, the Institute of Contemporary Art in Philadelphia; the Everson Museum in Syracuse, New York; the Walker Art Center in Minneapolis, the Los Angeles County Museum of Art, the Long Beach Museum of Art, and the San Francisco Museum of Modern Art—had all had major exhibitions of video or exhibitions that included a significant amount of video by 1976. Four of those museums—MoMA, the Whitney, the Everson, and Long Beach—had also established video departments or programs by that time.

The influx of a significant amount of funding from both NYSCA and the Rockefeller Foundation (funding that, it should be noted, has not increased proportionally to the growth in the field) radically changed the video community. There was a lot of "new" money to be fought over in the beginning, which inevitably had a fracturing effect on the nascent video community. In a medium that by its very nature could not fit into the support system of the art world, the role of funding institutions is an immensely influential one. The Rockefeller Foundation, for instance, played a central role in shaping the kind

of work that was produced throughout the 1970s. The foundation's director for arts, Howard Klein, saw the funding of video art primarily as a kind of television research and development—he was interested in effecting broad social change (on the level of the Rockefeller's "green revolution") and saw television as the means to accomplish this. Klein, for whom Nam June Paik was a highly influential adviser, was instrumental in establishing experimental television workshops at public television stations where artists could have access to equipment and in helping to establish and maintain sophisticated postproduction facilities throughout the country.[20]

The Rockefeller Foundation's decision to explore artists' television and to fund postproduction centers, and the fact that NYSCA can, by law, only fund organizations and not individuals were major factors in shaping the video community as it evolved. From the beginning, public television and art institutions became the primary arbiters of taste, deciding what was worth producing and worth watching. Throughout the 1970s, this kind of funding structure not only served to influence what kind of tapes were made, it also served to establish the increased demand for production values. One of video's early attractions as a medium was its low cost, which fit perfectly with the idea of everyone being (and being able to afford to be) a producer. The role of funders and museums has also served to emphasize production values, and many artists, unhappy with life on the fringes of these institutions, wanted access to commercial techniques. The prohibitive cost of making videotapes with current production values has in turn served to strengthen the influence of funders and exhibiting institutions.

That the Rockefeller Foundation chose to concentrate its funding on public television, in an attempt to change television as an institution and hence have widespread cultural impact, can be seen in retrospect as a fatal mistake. Public television did not fulfill its promise of diverse programming and opportunities; neither did cable. The increased desire among many artists for production values and access to broadcast, which was fostered in part by funders such as the Rockefeller Foundation, can perhaps be seen as inevitable. However, it is part of the video myth to assume that all artists became hungry for production values. There are many video artists and activists who have chosen not to follow this route.

The role played by institutions has also been a central factor in the dichotomy of art and social issues in video. Many of video's funding institutions, such as the New York State Council on the Arts, began to veer away from financing community-based, information-oriented works to funding "video art" by the mid-1970s. This was responsible in part for causing the split in what had been diverse yet somewhat coexistent intents among videomakers, in widening the schism that had existed between the two worlds. Irrevocable distinc-

tions were soon made at the institutional level between those who saw video as a social tool and those who saw it as a new art form.

This kind of division increased as the political intensity of the 1960s wound down. That video would, despite its fringe status, be institutionalized and absorbed by the art world was perhaps inevitable. After all, most of the anti-art market movements such as conceptualism and performance art were eventually co-opted by the art world and lost their anti-art establishment status. However, the role that the collectives and socially concerned videomakers played in video's inception and development as a medium is significant; their fate in video history is telling.

The Collectives

An examination of the role played by the collectives in the development of video's difficult history reveals the opposition of art and social issues as a primary dichotomy that was initially made problematic in independent video. The marginal way in which the collectives are treated in video history is indicative of the way in which socially concerned work was simply written out of the art-historical agenda for video set forth in its museumization (and ultimately historicized quite separately).[21]

These collectives—which included the Videofreex, Raindance, Global Village, and People's Video Theater in New York, and Ant Farm, Video Free America, and Optic Nerve on the West Coast, among others—were not formed in isolation. Collectivism was a life-style of the times; the prevalent ideology was one of sharing—living environments, work, information. Video collectives also formed in order to pool equipment resources and coalesced as more formal nonprofit entities in order to be eligible for funding.

Of all of the activity generated in video in the late 1960s and early 1970s, that of the collectives was the most spontaneous and intense. Throughout the country, they produced an abundance of "street tapes" that epitomized the drama and excitement of capturing images and people on the street, characterized by a tangible immediacy and fascination with the simple act of recording. These tapes were arbitrary, often chaotic and unviewable, sometimes keenly observant and revealing. An examination of two collectives reveals the diversity of their intent.

The Videofreex concentrated on documenting the counterculture, and providing an alternative history through the television medium. They taped anti-war protests, the Black Panthers, communes, the trial of the Chicago 7, and other aspects of the anti-establishment movement. This was not a selective documentation of events, it was an amassing of information based on the valorization of the notion of real-time tape as more "real"—because of its lack of

intrusive editing and its immediacy—than other imaging means. After the debacle of their attempt to work with CBS, the Videofreex moved to upstate New York and became involved in grass-roots television and the dissemination of information at a local level. Shedding their naïveté about usurping the power of the media on a national level, they chose to exercise their ideas at a community level.

Raindance, on the other hand, was a highly cerebral group that leaned toward theoretical concerns. Its members were interested in cybernetics, ecology, and issues of media, and the tapes produced by Raindance explore the points of intersection of television, art, and social change. The power of Raindance's work was not in accumulation, like that of the Videofreex, but in editing and juxtaposition. After amassing tapes from the street, interviews in their loft, and excerpts from television, Raindance members combined those elements into "Media Primers" which form ironic commentaries on the fluctuating state of society and the complex power relationships evident in daily life. In their juxtaposition of the mass media with alternative media, these tapes reaffirmed their subversive tactics.

Those video collectives of the 1960s and 1970s that did not evolve into more established nonprofit organizations fell victim to changing times, personality clashes, and the institutionalization of the medium, and they disbanded by the mid-1970s. Many of the videotapes created by them are lost or technically irretrievable, and issues of ownership (raised by institutions such as museums and distributors) replaced what had been a more casual notion of sharing tape. While the members of these collectives were artists (and many still are practicing artists), their concerns with amassing alternative information, addressing issues of media and technology, and their pluralist approach to documenting history were antithetical to the way in which discussions of video evolved in the art world. The belief structure of art in Western culture espouses the primacy of the individual creator and the notion of a masterpiece as a means to establish the financial worth of a work of art; it does not bend easily toward the concept of collectivity.

While the collectives have often been written out of the museum-formulated history of video, they are replete with their own particular mythology, one irrevocably tied to the notion of the 1960s as an egalitarian and visionary society. I offer them as an example here not to indicate their special omission in video history, but to note one aspect of a vast array of political work being done in video that does not factor in the art-historical narrative of the medium. In addition, the work of the collectives is extremely important precisely because it represents an alternative television document of a pivotal moment in history. Without this work, we have only the mainstream media's view of a movement that was conceived precisely in opposition to that monolithic viewpoint. One of the most important influences of electronic technology on our

culture is the potential for many *moving-image* histories to be created and preserved.

The Problem of Inherent Properties

The issue of video's inherent properties has reached new levels of debate within recent years, a debate that centers on the key issues of video's relationship to modernism and its potential for an electronic language. Discussion of video's inherent properties has been the predominant method of tracing the medium's history since its beginnings.[22] That discussions of this medium should be so overshadowed by this kind of technologically determinist way of thinking reveals fundamental flaws in the way in which our culture perceives the act of artistic creation with technological tools. It points to a tendency to believe that machines dictate aesthetic development and a deep-set cultural belief that people do not really control machines but are always on some level controlled by them. Can it be, as Woody Vasulka says, "a dialogue with the machine" between the artist and the tool? The cultural inability to perceive technology as having creative potential is a fundamental aspect of video's problematic theoretical base.

The problem of how to discuss the properties of video is fundamentally tied to video's relationship to modernism, a relationship complicated by video's emergence in modernism's final stages. Attempts to locate video within the modernist discourse began early. In 1974, critic David Antin wrote that video had acquired two discourses:

One, a kind of enthusiastic welcoming prose peppered with fragments of communication theory and McLuhanesque media talk; the other, a rather nervous attempt to locate the "unique properties of the medium." Discourse 1 could be called "cyberscat" and Discourse 2, because it engages the issues that pass for "formalism" in the art world, could be called "the formalist rap."[23]

In modernist discourse, a medium is distinguished by its unique properties; its formal principles define it as a medium and differentiate it from other media. Critics of this approach point out that limiting discussion of video to its distinct properties restricts the discourse of the medium to the limitations of modernist art theory. Martha Gever has written,

Even without a guiding set of principles that might constitute a theoretical premise, video made by artists tries to gain a foothold in contemporary culture at large, resting all the while on the traditions of fine art. In accordance with modernist art tenets, theoretical constructs pertaining to video cannot be directly translated from either film or visual arts like painting. {In modernist discourse} each medium exhibits distinctive properties, and those specific to video must be defined in order to validate that medi-

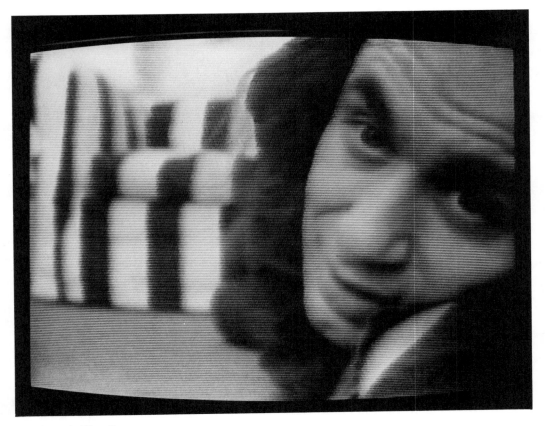

Vito Acconci, *Theme Song,* 1973.

um's aesthetic credentials and participation in existing cultural institutions and to distinguish video from its crass relative, commercial television.[24]

While it is undeniable that many of the first videotapes made by artists were concerned in a reflexive way with the specific properties of video—what distinguished it from film, painting, sculpture, and performance—this aspect of many early videotapes was closely allied with other concerns at the time—minimal sculpture, conceptual art, and body art/performance—in a reduction of the work of art to the bare essentials of the tools and questioning of the art process. Video history may have isolated the reflexive aspects of early videotapes to emphasize video's properties, but these tendencies in video formed part of a larger aesthetic discourse in many art media.

Artists like Vito Acconci, Joan Jonas, Bruce Nauman, Nancy Holt, Keith Sonnier, John Baldessari, Richard Serra, Lynda Benglis, Eleanor Antin, and others added video to their repertory of media not with intentions of changing television and directly effecting social change, but with an interest in changing the standard artist/viewer relationship and the rigid criteria of the commercial

art world. They were interested in seeing the system, in this case that of the art world, irrevocably undermined and redefined. Like the proponents of guerrilla television, these artists were interested in significant change. In both contexts, the newness of the video medium, its relationship to television, technology, and information, and its reproducibility, made it seem like the appropriately radical tool with which to achieve their goals. That video seemed like the medium with which to explore these ideas was a political as well as an aesthetic decision—its materiality and relationship to television inevitably made it a political tool in the art world.

Yet, it should also be noted that an early preoccupation with video's inherent properties was part of the self-consciousness of the new medium. Many of the artists who first began working with video explored their new tool by essentially teaching themselves, methodically creating rules to be deliberately broken. For instance, Bill Viola tried to get at the essence of video by reducing his choices with a camera, working for a long time without recording, and then making pieces of predetermined length. Peter Campus, James Byrne, and several other artists methodically examined video's instant replay, scale, the relationship to the viewer, camera movement, and color—in effect, its phenomenology. (Some of the artists working in the collectives examined these properties in their work as well.) Steina and Woody Vasulka produced many tapes throughout the 1970s that can be seen as meticulously documenting formal imaging effects in order to isolate and derive meaning from specific imaging techniques. Thus, there are some video artists who, as they have continued to work in the medium, have produced bodies of work that, seen in their entirety, provide microcosms of the developing capabilities of the medium as it is irrevocably allied to technological advances. One can follow the capacity of video to transform and manipulate time in the evolution of Viola's work, and its image-processing capabilities in the Vasulkas' work; indeed, it is quite tempting to do so. However, done without the larger context, this is simply an isolated and reductive reading.

An examination of two so-called properties of video, intimacy and real time, makes this point clearer. While as a tool for expression video would seem to have many distancing factors, such as the actual television set, it is often pointed out that the size of the screen and the instant image provide an intimacy not shared by paintings or the cinematic apparatus. The tendency of artists to set the camera up and perform in the space before it and to use the monitor as a mirror caused art critic Rosalind Krauss to label video as inherently narcissistic. She noted, "Self-encapsulation—the body or psyche as its own surrounding—is everywhere to be found in the corpus of video art."[25] However, to say that one medium is categorically more intimate than another or that intimacy is inherent to a medium is to privilege the notion of technology dictating aesthetics. One can question whether artists used the camera this

way simply because of its technological properties. The "intimacy" evidenced in early works by artists such as Vito Acconci can also be read in the context of the strategies being used at the time to change the viewer/artist relationship, to undermine notions of personal and private, and to redefine the role of art in society.

Many early videotapes were lengthy ongoing projects of extended footage, such as *The Continuing Story of Carel and Ferd* (1970–75) and Paul Ryan's twelve-hour *Video Wake for My Father* (1976), which bore no relation to the restrictions of television time (that now govern, however indirectly, contemporary works). Other projects were referred to as "tapes," implying that they were a continuous process (a monitoring process) as opposed to a finished work. Because there existed very little editing equipment until the early 1970s, the notion of real time can be seen as one which grew out of circumstance. Yet these explorations of real time can be related to concerns in independent filmmaking (particularly the structural films of Michael Snow and Hollis Frampton) and the notion, propagated by Allan Kaprow, among others, and rooted in dada and the historical avant-garde, that art and life, especially in performance and "happenings," could be interchangeable and indistinguishable. For many, real time was a defiant reaction to the fragmented, incomplete view of events offered by television. Thus, the real-time quality of many of these videotapes was a technological property that was exploited for aesthetic intent.

It is precisely at this distinction between aesthetics and properties that this issue can be centered. The assumption that the aesthetics of video is a direct result of its properties leads us into technologically determinist terrain yet again. Technologies such as television do not simply appear at specific point of history, they arise out of specific desires and ideologies. However, this distinction does not negate the fact that video has a specific phenomenology, which effects our experience of the medium. It is crucial that this phenomenology be seen in the larger context of the medium's development.

Most recently, the debate of video's properties has raised the issue of the potential to construct an electronic language. As artists deconstruct particular digital effects and attempt to explore their metaphoric and narrative meaning, they take steps toward the construction of a syntax. Hence, properties take on meaning as codes. What does it mean to use slow motion? What kind of meaning do certain digital effects impart—the potential of turning a moving image into a two-dimensional sheet that can be manipulated on the screen or the seemingly limitless possibilities of combining images within the frame? Certain artists have almost systematically attempted to use effects to impart specific meaning: Woody Vasulka has used digital effects for specific narrative meaning; Bill Viola, Barbara Buckner, and Dan Reeves have used certain effects, for instance, to evoke spiritual states—keying an image through a mov-

ing landscape to evoke transcendence, using ghostlike and shadowing digital effects to portray the transience of human nature. Yet, attempts to define an electronic language have not taken into consideration the extent to which language in this context (one has only to look at cinematic language to confirm this) functions merely as a kind of convention, a shorthand way for the viewer to read the form as it defines the content. It remains to be seen whether or not the construction of a syntax in electronic imaging can be anything more than one of convention.

The confusion over the role of video's properties is irrevocably tied, as Gever noted, to video's relationship to modernist art discourse. Video's difficult alliance with the tenets of modernism is attributable to the ways in which its qualities and presence as a medium questions those tenets. Defining video in terms of its individual properties is meant to act like a ticket of admission to modernist art theory; but ironically, the art world has at best ignored and at worse dismissed video art precisely *because* of its time-based and electronic properties and its relationship to television. Artist Rita Myers has stated,

That video emerged during the final stages of the modernist enterprise is crucial. While it did attempt to locate its "inherent properties" like a good modernist medium, these properties were inextricably linked to subject matter, a natural consequence of the camera but also a radical shift away from the other modernist media, painting, sculpture, etc. You can't really reduce a medium to its constituent elements when one of those elements virtually gives you the world back. Video challenged the modernist creed with content and it continues to challenge the traditional museum/gallery world with moving parts and time, among other things.[26]

The kind of modernist formalism that has reigned in the art world through the power and doctrine of institutions like the Museum of Modern Art has been challenged not only by the deliberate pluralism of postmodernism but also by the camera arts: photography, film, and video. Video's role in the transition from modernism to postmodernism remains to be explored, but the development of its own theoretical base must not be solely derived from these discourses.

Questions of Theory

The struggle for a comprehensive theory of video in the United States has resulted so far in a surprisingly limited discourse, mired in myth supported by selective historical accounts and weighted by the issue of the medium's properties as defined by modernism. This frustratingly narrow discourse has stalemated in its nonacknowledgment of several key issues: the diversity of intent of videomakers and the unresolved relationship of art and technology in our culture. This is a medium in which the ongoing developments in electronic

technology, and their relationship to the power of technology in our culture—
as it is manifested in the transmission of images on television, the storage of
information in computers, and the mass media—cannot be ignored.

But we are ambivalent about technology in Western culture. On one
hand we see it as a panacea for global problems, on the other hand we feel we
have little control over it. Popular culture is rife with images of technology
overpowering those who attempt to use it—people are beset by appliances on
TV commercials and computers overpower humans in science-fiction movies. It
should be no surprise, therefore, that there is a cultural difficulty in discussing
a medium in which artists engage in a dialogue with electronic technology and
that the dominant approach in analyzing the development of this medium has
been to chart technological change and the capabilities of machines rather than
people. Technology itself has been a difficult subject for video artists as it pres-
ents them with a dilemma—how can one critique applications of technology
while formally appearing to embrace it by using a technological medium?

The problematic relationship of technology and art in Western culture
and our ambivalent perception of technology are fundamental reasons for the
immature state of video theory and video's difficult relationship to history.
That this discourse has remained until now within the realm of modernist art
discourse has also been a fundamental deterrent to a comprehensive theoretical
discourse taking shape. The cultural paradoxes presented and represented by
video simply cannot be contained solely within an art theory paradigm but
must be considered within a larger cultural context. The development of this
particular medium at this particular time was no accident. Its problematic re-
lationship to history can provide us with insight into the role of memory and
the difficulty of history-making in postmodern culture.

In the late twentieth century, we perceive historical fact as that which is
recorded by a camera. It has been noted by such theorists as Roland Barthes
that the photograph is always coded as the past, the what-has-been. Cinema,
on the other hand, while it represents a kind of movement into the present,
has increasingly come to evoke history. A grainy black-and-white or faded
color film, for instance, is immediately read as representing history and mem-
ory, and the Vietnam War and the assassination of President Kennedy are
events that are culturally perceived as filmic images. However, the television
image (and video is implicated within this definition) has a different set of cul-
tural readings. Television is defined as transmission—the image transmitted at
the same time to innumerable TV sets—and this simultaneity is a major factor
in cultural perceptions of it. The television image is the copy with no origi-
nal—it is many images everywhere at the same time. It is coded not only as
"live" (there are many conventions in television that make it appear live when
it is actually prerecorded) but also as continuous and immediate.

This concept of the immediacy of television (and of electronic culture in general) has broad implications in our cultural perceptions of the medium. Because of this aspect of television's phenomenology, it is simply not seen as representing the past in the way that photography and film do. Obviously, few contemporary events have been recorded on tape (the Iran-Contra hearings and the *Challenger* disaster stand out as the most obvious),[27] and as this changes, the cultural perception of television as an historical medium will change. However, the ideology that resulted in the invention of television and video technology, as well as many aspects of computer technology, is one based significantly on the notion of immediacy. In an information culture, the speed of information is paramount—information is more valuable if it is more immediate. Television technology simply did not evolve out of a desire for the preservation of history. Many early videomakers were responding to precisely this aspect of immediacy, with the attitude that tape was ephemeral and instant, the "now." (The paradox of this is, of course, that this ephemerality resulted in tapes that appear to age faster than other works do, thus helping to fuel the desire for a history.) Thus, the very nature of television technology, in its materiality, acts as a negation of history, and this negation forces us to redefine and reconceptualize the notion of what constitutes the past.

That video was formed with an *a priori* need for history reveals, in many ways, the precarious position of Western culture, and video's role as a technological medium offers a challenge to contemporary discourse. Our future, like the preservation of our past, is irrevocably dependent on electronic technology. In the 1980s, that technology took on new cultural meaning, not of space progress and prowess but of careless space disaster, not of harnessing new energies but of uncontrolled nuclear contamination. In this nuclear age, our vision of the future is more often tinged with anxiety than with optimism; at a period of time when the state of the world seems especially precarious, the need to establish the past reveals an attempt to reclaim the future.

David Cronenberg, *Videodrome*, 1983.

Television, Furniture, and Sculpture:
The Room with the American View

V I T O A C C O N C I

Television space is fishbowl space. There's a world going on in there: that ex-clamation might be made by a child-person looking, from out of the large world he/she is in, into the small world behind either the aquarium glass or the TV screen. In the case of TV, the world is *on* something, on-screen, not (as in the case of the aquarium) *in* something, in the bowl; but, unlike mov-ies, the TV screen isn't all, there's something behind it, something underneath it all—the TV tube lies behind the screen. We know that the screen is only the facade of the box; even now that the screen can be drastically reduced in size—as in the two-inch "watchman"—there still has to be room for the TV tube. The TV box still has to have depth, which remains the largest dimen-sion of the box. The TV screen might be thought of as the window into the box—except that we probably can't, in 1990s be innocent enough to believe we're really looking through a window, really peering inside the box. Rather, the screen might be seen as some kind of distorting, inside-out mirror, which the power inside the box holds up to the world at large. Inside the box, the world—or the power-to-be-a-world—is condensed: it's the size of a conven-tional package, a gift, it's power made handleable. The viewer might be led to believe, then, that the world is in his or her hands.

The close-up literalizes television. The close-up face is the same size as the TV screen; the face on-screen, then, is a fact, just as the TV set is a fact in the living room. Whereas on a movie screen a close-up face is at least fifteen times the size of an actual face (so that the face on film is a landscape, like John Wayne's face, a face to walk around on—the face is distant, out-of-reach, like a landscape outside a train window, untouchable, like Greta Garbo's face; or the face is a monument or a monster—it comes up from the ground or the grave, it comes from another time), on a TV screen a close-up face is approxi-mately the same size as an actual face: "his"/"her" face and "my" face are face-to-face—we're in the same world—this is here and now. The viewer and the face on-screen are comfortable with each other; the news from that face, then, is assumed, taken as fact. But then second thoughts might come up: if this is a face, where's the body? The face on-screen is a detached head: a head-with-out-a-body-without-organs. This is pure mind, without a body to ground it; this is a head that floats, and can't (won't) come down to earth. The news from that face is news from nowhere. (The world is nowhere: if the world were placed, then we might be able to handle it, control it.)

Watching television is like staring into a fireplace, or looking at a light bulb. The viewer is "heated," information has been passed. "I'm not myself," the viewer might justifiably say. Well, who are you then? You are what you see. There's no time to think; information has already been implanted in the brain. The viewer has television inside the self, like a cancer (the disease that has become the dominant disease of the time, the time in which television has become the dominant medium); the person is "replaced," "displaced" (as in the film *The Invasion of the Body Snatchers*). Television is a rehearsal for the time when human beings no longer need to have bodies. The way a movie projector shoots images onto a movie screen, the television set "shoots" images into the viewer: the viewer functions as the screen. With television, a person finally is enabled to become a "model person"—but what the person is a model of is nonself. The person functions as a "screen," a simulation, of self. Television confirms the diagnosis that the boundaries between inside and outside are blurred: the diagnosis that "self" is an out-dated concept. (Saying the word *myself* has been reassuring: it announces possession, claims something to grab onto; writing the word *I*, in English, is similar to writing the numeral *I/1*—it gives the illusion of placement in a hierarchy of importance.)

Television broadcasts the same program, all over a particular country, at the same time. One world is transported into different worlds: each different world (different household) is kept in place (in step, in line, in time) by the importation of the same ("universal") world. When a TV set, in a particular household, is turned off, that world is lying in wait, the world-within-the-TV-set ready to erupt, to flash on "in the middle of things" (the plot has already been going on without us). "It" is always there, though we might not be yet, we might not be watching. But people in some other house are already watching: "it" has plenty of time, plenty of viewers already—and, anyway, we'll probably come around to watch sooner or later. This wave of sameness, about to enter everywhere, could be seen either as "frightening" (as a loss of individuality: all those supposedly particular "I's" about to be entered by "it") or as "reassuring" (as a unification of people in community, or as something to fall back on: regularity in the midst of psychological and sociological variables). One way television, in its early days, was made to appear "reassuring" by means of its housing: the introduction of the TV console—the TV appeared in the home as furniture, like any other furniture. The nonphysicality of television was made physical; the air was grounded and brought down to earth. This was something we could "feel at home with." The sameness imported into the home did not have to be seen as anonymity; rather, it could be seen as the sameness of furniture, the sameness of clothing and fashion—a sign of comfort and equality.

Looked at from the viewpoint of art, furniture is analogous to sculpture. Just as furniture fits into a room and takes up floor space inside a house, sculp-

Television Programs Sent on Light Beams

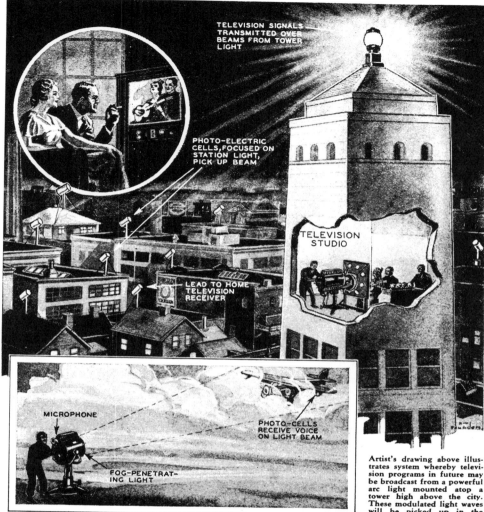

TELEVISION SIGNALS TRANSMITTED OVER BEAMS FROM TOWER LIGHT

PHOTO-ELECTRIC CELLS, FOCUSED ON STATION LIGHT, PICK UP BEAM

TELEVISION STUDIO

LEAD TO HOME TELEVISION RECEIVER

MICROPHONE

PHOTO-CELLS RECEIVE VOICE ON LIGHT BEAM

FOG-PENETRATING LIGHT

Artist's drawing above illustrates system whereby television programs in future may be broadcast from a powerful arc light mounted atop a tower high above the city. These modulated light waves will be picked up in the homes by individual photo electric cells, or "electric eyes," instead of the present type of wire antenna.

Airport supervisor directs plane landing over voice-modulated beam of light. Photo-cells on plane pick up beam, which is transformed back into voice speaking directions.

TELEVISION transmitted on a light beam, opening the way to a new era in the art of broadcasting, has been successfully demonstrated at Schenectady, N. Y. by Dr. E. F. W. Alexanderson, noted radio engineer.

In the laboratory tests, instead of the electric impulses being fed into the radio transmitter as heretofore, they were modulated into high frequencies on a light beam from a high-intensity arc. This beam was projected the length of the laboratory into a photo-electric tube, which transformed the light waves back into electric impulses. These latter impulses reproduced the original image by means of an ordinary television receiver.

Light-transmitted television points the way to the development of a new method of communicating with planes whereby a fog penetrating light, modulated into voice waves, is projected to photo-electric cells on the wings of a plane, so that landing directions may be transmitted through fog for prevention of smash-ups.

"Television Programs Sent on Light Beams," illustration from *Wasn't the Future Wonderful*.

ture fits into and takes up space in an art-exhibition area. Take this "thing": it isn't as big as a room, so it's only furniture; it isn't as big as architecture, so it's only sculpture. In its early days, the TV set took, inside the house, the position of specialized furniture: the position of sculpture. It was like other furniture, but there were differences: it couldn't be sat in, like a chair; it couldn't be sat at, like a table; part of the console could, as a by-product, function like a cabinet, for storage, but not the TV part itself. Compared to other furniture, the television set couldn't be used, it could only be looked at; it had the uselessness that one associates with art. A person could walk around the TV set, the way a person could walk around a sculpture; but, in order to see what was being transmitted, the person would have to look at it frontally (the way a sculpture is looked at in photographs: photographs being the most convenient way a sculpture becomes known, since a sculpture is harder to move than a painting—the world of art distribution, the world of art books, is predicated on frontality and therefore on painting). But recently there's been a change in the shape of television: the mode of television is no longer the un-movable console but the portable. What was analogous to sculpture is now, at first glance, more analogous to painting: the TV set can be moved from corner to bed to kitchen counter, the way a painting can be moved from wall to wall. But the analogy doesn't hold: the TV set is too "thick," too deep, to be a painting (though soon-to-be-possible, probably, and maybe already existent in privileged cases, is the dream of the paper-thin TV). At the moment, anyway, the conventional TV set is neither painting nor sculpture: television evades the world of art—television is too much science to be art.

The connotation of television is: science and technology. In the 1950s, this spelled terror to the American home: science belonged to the Russians, the Russians had put the first person into space, outer space was the Russians' territory (cf. science-fiction movies of that time—like *Invasion of the Body Snatchers* and *The Thing*—which equated the unknown with the "Red Menace," the Communist spy). In an atmosphere like that, bringing science into the home in the shape of a bare TV, space would have been like inviting to dinner a composite of Dr. Frankenstein and Kim Philby. So science had to be domes-ticated: turned into furniture, it was nothing to be afraid of, it was something to relax with. But then things changed; by 1969, the first person to step on the moon was an American, the American flag was implanted on the moon. Science wasn't frightening anymore, the heavens were brought down to (an American) earth, the future was now. More recently, therefore, there hasn't been the need to camouflage the science look of television inside the hand-crafted-looking console; the handcrafted look could be seen as the Old World, the European world, dragging the American back, whereas the American now was allowed to be a cowboy again—and the cowboy traveled spare and lean, with tenuous connections to "home," the cowboy was the "Swinging Single."

The new spareness and leanness could be exemplified in the sleekness of the television set; the new TV set has been allowed, encouraged, to announce its hi-tech background. Television, now, is science-fiction dropped into the middle of your home: television (as well as stereo equipment, etc.) is science turned into a pet. The viewer/consumer can have part of what NASA has, what Bell Telephone Labs have: science becomes democratized.

Assume that there are two kinds of power: economic power and sexual power. What new TV equipment does, now, is camouflage economic power: it gives the buyer the illusion that economic power is in his/her hands—after all, the buyer can prove it, the buyer can hold the state-of-the-art in a box (as if looking at himself/herself in a photograph, like other people, in other photographs, holding the state-of-the-art in a box). And holding it, and looking at it later in the privacy of his/her home, and making that home a showplace where equipment can be shown off to friends—all this is a way of draining sexual power. Because television is the absence of the body; television signifies the body-become-electronics, the body-without-sex. This sexlessness, then, is placed in the home, in exactly those spots where the body runs rampant: the woman watches the TV set in the kitchen, as she prepares food—the couple watches the TV set at the foot of their bed, right before sexual intercourse. The sexlessness of the television set functions as a sign, a reminder; it induces a nostalgia not so much for the past as for a fiction of the future: "If only we didn't need to eat," "If only we didn't desire to fuck . . ."

Since television represents an absence, a difference, it has to be seen as at least slightly out-of-place in the home. It has to look more "hi-tech" than anything else in the home. Science, though democratized, still flaunts its future (science, talking democracy, announces capitalism): the current TV set is being outdated at the very moment it's looked at—the fact that it's so advanced says only that "you ain't seen nothin' yet." The viewer, the buyer, owns only a piece of the future: the viewer, the buyer, has only a model, only a toy version, of technological development. Science maintains itself as ungraspable, while at the same time promising itself as "dreams money can buy." The toy version of science announces that matter is governable, with money; its secret message is: once matter is governed, then sex will be governed along with it. Having money, then, might be the opposite of the possibility of "buying sex"; having money might be a matter of "buying out" sex, getting rid of sex, the way the businessperson gets rid of the opposition. Toy science allows a person in the role of television viewer to practice other roles: practice for a role in the world of the rich, practice for a role in the world of nobody.

The TV consumer practices the role of the TV producer. The means is the field of home-made video. Theoretically, cable TV is public-access TV—anyone can have a program on cable television. The connotation of home-made video, put on cable television, is: this is television from one home to an-

other—television like a cookbook, like a recipe handed down from grand-mother. The proof of this is: you can see the seams show—this is television with its pants down. Home-made television presents itself as evidence and prophecy: this is both the past and the future of television. On the one hand, this is television on-the-cheap, before corporations and advertising slicked it up (but this past is a simulated past: TV came into existence only by means of the money provided by corporations and advertising). On the other hand, this is television by the people and for the people (but this future is an abstract future, without real-time political determinants).

Art video might be placed as a subcategory of home-made video. Or it might be placed on a sliding scale somewhere between home-made video on the one side and regular broadcast television on the other side. Wherever it is located, theoretically, art video is grounded, practically, in America. The fact is: getting hold of video equipment at all, not to mention getting hold of more sophisticated video equipment, is easier for artists living in the United States. Making the choice to do video, then, is the privilege of someone who participates in a power culture. Video art might be considered as American art's last-ditch attempt to retain hegemony (a hegemony that, furthermore, could be retained by employing the style of an American tradition: a push toward more and more airiness, a push for purity, like chasing after Moby Dick), before Europe fought back with neo-expressionism. Neo-expressionism was, for one thing, a last desperate attempt to retain the body in an electronic world where the body was in the process of disappearing—in this sense, neo-expressionism is like jogging, or aerobic dancing. But jogging and aerobic dancing are also badges, proofs, of income and class: the signs of a rising young professional upper-middle class. So neo-expressionism, just as it brought back the body to a world at large that was becoming bodyless, brought back "body," substantiveness, to art at the time it was talked about as being object-less, Neo-expressionism courted collectors by giving them something they could, at the same time, put their minds to and put their hands on: neo-expressionism confirmed the body consciousness of a wealthy class and, at the same time, gave collectors something to do again, something to collect. The desperate American attempt at hegemony, then, advertising video art as the product, was still-born: it concentrated too much on production and not enough on accumulation—since video art was inherently multiple, it couldn't attract the collector, who needed to acquire something unique. The video artist, born in a situation of power, had no power of his/her own, that could go outside the self. Like a spoiled child, then, the video artist had the luxury of playing at power: the video artist could take on all the roles in a solitary world. On the one hand, video art could claim the advantage of the context of regular broadcast television (since this is the tool of big business, video art must have power and influence); on the other hand, at the same time, video

art could claim the advantage of home-made video (since the video artist is not part of the commercial television system, the video artist must be the people's artist).

The sensibility drawn to regular broadcast television is willing to give up the name "artist" and slide off into the category of "TV producer." This type of sensibility shows self-sufficiency: it doesn't need the name "art" to justify one's own existence—art is seen as, on the one hand, a bag of tricks (skills, crafts) and, on the other hand, an attitude, a piloting device, that can be applied to any number of roles ("there's no art, we just try to do things the best way we can"). This type of sensibility is comfortable with the notions of "summary" and "condensation" and doesn't feel the need for "experience" (this sensibility would, probably, prefer driving to walking, choose the airplane over the railroad). In a world before video (or, more precisely, further back than that: in a world before mass media), this type of sensibility would have turned, probably—for lack of anything else—to painting: this type of sensibility feels comfortable with walls, and with standing in front of a wall—it feels no need for a floor to walk around on. At the same time, this sensibility feels uncomfortable with walls confined to one kind of place, like the walls of a museum; between the time of the dominance of painting and the time of the dominance of television, this sensibility would be drawn to posters on the sides of buildings—or to (miniature) walls that can be turned, like comic books.

The alternative sensibility—that of the video artist who turns toward home-made video—might leave the arena (of distribution) altogether, and withdraw into the gallery/museum. Video, there, is shown as an exhibit (like a wild animal exhibit): video is brought into the museum and displayed as an artifact of the twentieth century—the way period furniture, for example, is displayed elsewhere in the museum. The sensibility drawn to the gallery/museum is unsure of itself: it needs the terms *art* and *artist* to fall back on. This sensibility has to "gather in" rather than "spread out"; anything, from any field, can be used for art doing, but whatever is used has to be imported into the category of art (rather than allowing the category of art to dissipate itself into other fields). This type of sensibility, in a time before video (before mass media), would have turned, probably, toward sculpture: this sensibility needs a space to be in, needs something tangible to grab on to. This sculpture sensibility might begin by having a tendency to go outside, where it could have the space of town and country to work in—but, once outside, that sensibility is in danger of sliding into the category of "architecture." To stop that slide, and keep for itself the name "art," this sensibility has to resort to an architecture that already exists. This sensibility needs an enclosure into which something can be fit, like squeezing a figure into an alcove. Inside the gallery/museum, the video monitor is placed on a pedestal or base. The video situation is transformed into a theater situation: inside a room, the TV monitor is set up

Vito Acconci, *TV Lives/VD Must Die,* 1978.

in front of rows of seats—the lights are out (video shoots back into the past, into the world of movies). This situation might cause the sculpture sensibility to have nagging doubts: it has kept the name "artist" only to lose the name "sculptor"—"sculpture" slips into "performance art." To preserve the term *sculpture,* this type of sensibility might have to resort to the paradox of "video installation."

Video installation is the conjunction of opposites (or, to put it another way: video installation is like having your cake and eating it, too). On the one hand, "installation" places an artwork in a specific site, for a specific time (a specific duration and also, possibly, a specific historic time). On the other hand, "video" (with its consequences followed through: video broadcast on television) is placeless: at least, its place can't be determined—there's no way of knowing the particular look of all those millions of homes that receive the TV broadcast. Video installation, then, places placelessness; video installation is an attempt to stop time. The urge toward video installation might be nostalgic; it takes airplane travel, where all you can see is sky, and imposes onto it the landscape incidents of a railroad journey. Video installation returns the TV set to the domain of furniture; the TV set, in the gallery/museum, is surrounded by the sculptural apparatus of the installation, the way the TV set, in the home, is surrounded by the furnishings of the room. The difference is: in the home, the TV set is assumed as a home companion, almost unnoticed, a household pet that can be handled and kicked around; the viewer doesn't have to keep his/her eyes focused on the TV screen, the TV set remains on while

the viewer (the home body) comes and goes, the viewer goes to get something in the kitchen and brings it back to the TV set. Once a TV set, however, is placed in a sculpture installation, the TV set tends to dominate; the TV set acts as a target—the rest of the installation functions as a display device, a support structure for the light on the screen (the viewer stares into the television set, as if staring into a fireplace). The rest of the installation is in danger of fading away; the rest of the installation is the past that upholds the future (as embodied in the TV set), but the future wins. Video installation starts out by dealing with a whole system, a whole space; but the field, the ground, disappears in favor of the "point," the TV set. The situation seems similar to wanting what you can't have; now that the TV set is camouflaged by the apparatus of an installation, an extra effort is made to find it, to "get the point." The reason for this might be that the conventional location for a television set is in the home; when it is come upon elsewhere, whether inside a gallery/museum or outside, in a store window or a supermarket, the viewer is stopped in his/her tracks: the situation is like that of a visitor from another planet happening upon a TV set—only in this case it is the "other planet (the home, the living-room) that comes upon the viewer, out of the privacy of his/her home and in public. The viewer, seeing the TV set, is brought back home—and here, abstractly, "home" reads the way it could never be allowed to read when surrounded by the customs of living-room furniture: "home" means "resting-place," "the final resting place," the land of the numb/the still/the dead.

If the electronics of TV makes it comparable to science fiction, then the sculpture part of a video installation brings the science fiction down to earth: there's a mix of genres—the genre of science-fiction is brought together with the genre of the *film noir,* the gangster flick. The way a viewer moves around a sculpture, the detective moves over the streetscape looking for clues, finding the body (and, after that, trying to find the agent that caused the body to be considered no longer a "person" but only a "body"). The detective story might drift off into another genre, that of the horror movie—the body becomes the body that couldn't, wouldn't, die. If television posits the body-that-disappears-into-thin-air, then sculpture counters that by positing the body-that-can't-die. Sculpture, while refusing the urge for the supernatural that painting reveals, betrays the urge for something even more unnatural: the urge for permanence, the urge to be the undead. Sculpture, placed under the cover of its father/mother architecture, yearns, finally, to be experienced; it can't always depend on being photographed and documented, because then it would lose its category—sculpture drifts off into painting or photography. This doesn't mean that the only way each person knows sculpture is by experiencing it; of course a person can know it through photographs—but that knowledge is sufficient only because it includes the knowledge that, somewhere, the sculpture is already being experienced by somebody else. (It's not enough to know that

somebody *already has* experienced it, in the past, now that the sculpture no longer exists: in that case, sculpture drifts off into the realm of archaeology.) Sculpture, in order to be experienced, has to be preserved; it has to exist the way a city exists, long enough to be taken for granted. The sculptor, then, whatever other intentions he/she might claim to have, is always engaged in an act of conservatism; though the means might be the apparent flaunting of traditions, the end is the most traditional, the most conservative, of all—making the being that refuses to die. The sculptor, then, who tries to thicken this plot, the sculptor who imports video into his/her object installation, might be a person who's afraid of being outdated, a person embarassed about clinging so hard to the past.

Performance, Video, and Trouble in the Home

KATHY O'DELL

A television producer recently said to me that he thought *The Honeymooners* was the first video art piece ever made. Initially, the comment struck me as glib. But every time I came back to the prescribed content of this essay—early seventies "performance-based video"[1] and its relations to sixties performance art—along came that silly comment, begging for attention. Images of Alice, Ralph, Trixie, and Norton flooded my mind: Ralph trying to protect his home from armed intruders by bombastically brandishing a water pistol; Norton teaching Ralph to dance so that Alice wouldn't be attracted to the young, single dance instructor who had just moved into the building; Ralph loudly admonishing Alice for never "standing behind him" on his harebrained schemes and Alice icily responding, "I'd love to, Ralph, but there's not much room back there."

While these memories were pleasurable, I was hardly convinced they constituted the ancestral roots of video art, and furthermore, my mission was not to enter into a genealogical hunt. Then something struck me about *The Honeymooners*—a certain sort of "trouble in the home," the sort that was of interest to me in the work I was exploring. The trouble in the Kramdens' home was that they rarely left it, and this was the paradoxical crux of the series—although they called themselves the "honeymooners," we never saw them on their honeymoon and whenever they tried to take a vacation (the equivalent of a second honeymoon), the car would break down, Ralph would get hooked into a shady real estate deal on a summer cabin, and so forth. Typical of fifties television agendas, we were meant to believe that the Kramdens were on an extended honeymoon in their marriage, stabilized in and by the home site, which doubled as a holiday site.[2] Atypical, however, was that this holiday was no picnic. With Ralph reverse-stereotyped as "female" hysteric and Alice as "male" rationalist, trouble was constantly brewing. Now, this reversed stereotyping, which could be so easily re-reversed, did not represent any great stride forward in the history of male-female social relations, but in the context of the 1950s, the fact that the notion of gender could be reconstructed at all was a small, significant step.

I am more interested, however, in the subtler psychohistorical implications of *The Honeymooners*. First, since the home was shown as the site of gender's *reconstruction*, it was suggested that the home is also the site of its *original* construction—a process shown to be problematic by the Kramdens' desire to reverse it. Second, since it was evident that this thing called television was mediating our own subjective positions in the home from which we watched

(that is to say, *The Honeymooners* never fooled us into thinking we were looking in on a picture of our own homes—for one thing, neither the Kramdens nor the Nortons had kids), we could understand that subjecthood overall is mediated, that it is constructed through the difference-forming tendencies of representation. And third, Ralph's weighty presence called visual attention to the locus of psychological work from which identifications are formed—the human body.

The body, the psychologized drama in which its representations are perceived, and the institutions (often homelike and/or holidaylike) which frame those representations are the issues discussed in this essay. Evoked in the 1950s by such television shows as *The Honeymooners,* these issues explode in the 1960s and 1970s in related media like performance and video. The body becomes the chief material of these art forms, brought up close to viewers, often pushing its way aggressively into their space. "There's not much room back there," as Alice said, but what space there is—behind and around the performing body—is far from neutral.

The institutions in which performance and video were presented in the early 1970s—ranging from galleries to schools, from proto-alternative spaces to alternative spaces—were heavily coded with psychological familiarities rotating around the construct of the family. Mikhail Bakhtin, in his theorizations upon Rabelais's writings on sixteenth-century carnival, has suggested that the modern parallel to the sixteenth-century opposition between the state (as power) and carnival (as mixed-up power) is the opposition between home and holiday.[3] For argument's sake, we shall consider the space of the gallery, with dealers functioning as maternal or paternal figures, to be comparable to the home venue; alternative spaces as comparable to the holiday space; and proto-alternative spaces and schools, in which the bulk of early seventies works took place, as a curious mix of the two. The performance-based videos of Vito Acconci, Dan Graham, Joan Jonas, and others touch on all the issues mentioned above, leading us to question the stability of the institutions in which the artists' work was situated and the institution toward which the viewers' attention was directed. Was there, after all, "trouble in the home"?

Perhaps no other piece from the early 1970s more thoroughly spells out the psychologized drama engendered by performance-based video than Acconci's *Claim* (1971). Blindfolded, seated in a basement at the end of a long flight of stairs, armed with metal pipes and a crowbar, threatening to swing at anyone who tried to come near, Acconci simultaneously invited and prohibited every visitor to the 93 Grand Street loft to descend into the world of the unconscious. As he spoke without ceasing, spoke repetitiously, spoke in excess ("I don't want anybody down here with me. . . . I'll keep anyone from com-

ing down the stairs. . . . I'll keep anyone from coming down here with me. . . ."), he emphatically enacted the move from what Jacques Lacan calls the "imaginary" to the "symbolic." In the latter, according to Lacan, language serves as a method of representation by which the subject claims identity after being forced to separate from an imagined identification with the mother (or equivalent figure). This separation—which, in Freudian terms is brought to conclusion in the oedipal scenario—is enforced by an intervention on the part of the father (or equivalent figure) whose phallic presence signifies territorial rights to the mother.[4] What interests me here has less to do with actual mothers or fathers (i.e., I am not about to conduct a biosexual reading of Acconci's, or any other artist's, work) than with the conceptualization of the body in processes of identification and what I see as a "missed chance" on the part of Acconci and the other early seventies artists we shall be discussing at recapturing a sense of unity, a sense of physical and emotional wholeness generally associated with the preoedipal.

"Identification" is a multilevel process and concerns both the viewing subject and the subject viewed. It is a popularly held notion that in performance art pieces, audience members identify with the artists through the art form's chief material—the body. This level corresponds to what Jean Laplanche, Freud's and Lacan's metacritic, has called an "identification that is both extremely early and probably also extremely sketchy . . . an identification with a form conceived of as a limit, or a sack: a sack of skin."[5] It is this sort of thought that sustains the belief that performance provides direct experience, as if by taking away such obvious forms of mediation as painting, sculpture, or theater scripts, the process of mediation itself is eradicated and pure experience can be forged by the knowledge of a shared possession—that fleshy sack of selfhood. However, just beyond this "extremely early" stage of psychical development and, similarly, this fundamental conception of performance pieces, identification is not so poetically simple. The next developmental level of identification, somewhat related to the "sketchy" one, occurs in what Lacan calls the "mirror stage," in which a child first discovers an image of the self.[6] Unlike a sketch, the reflected image seems finished and whole. But the identity-yielding image is, in actuality, split: "the very image which places the child divides its identity into two."[7] Thus, our perceptions of the human body—our own and others—are mediated from an early age.

Lacan defined the mirror stage as "a drama whose internal thrust is precipitated from insufficiency to anticipation—and which manufactures for the subject, caught up in the lure of spatial identification, the succession of phantasies that extends from a fragmented body-image to a form of its totality that I shall call orthopaedic—and, lastly, to the assumption of the armour of an alienating identity, which will mark with its rigid structure the subject's entire

mental development."[8] I suggest that the interpolation of video into performance in the early 1970s elucidates the fragmentation experienced during the mirror stage of psychical development—a fragmentation that, when focused upon, functions to betray the "orthopaedic" myth that identificatory processes totalize meanings of, or for, the subject.

To a certain extent—or, I should say, to a further extent—these concepts have already been examined by feminist film theorists and, more specifically in relation to video, by Rosalind Krauss, who so accurately concluded that "in th[e] image of self-regard is configured a narcissism . . . endemic to works of video."[9] Rather then step out and away from this moment of self-regard into the problematics of narcissism to which it sometimes leads, however, I would like to stay with that moment, observe how it operates for the viewing subject and subject viewed, and ultimately argue its contribution to long-range processes of identification. "Viewing subject" has more than one characterization here. Besides the person who looks into a reflecting apparatus such as a mirror, or a camera which feeds that person's image back to him or her for immediate or future use through the monitor (in *Claim,* Acconci occupies this position), there is the witness of the mirroring process. In the Lacanian configuration, this is the mother; in performance-based video, the audience. For all these individuals, however, the experience of viewing is the experience of fragmentation.[10]

Visitors to 93 Grand Street first viewed Acconci at the bottom of the stairs through a video monitor located outside the door at the top of the stairs. If they chose to open the door they would see the *present*ation to which the video *re*presentation referred. This split in experience disallowed the audience a sense of direct identification with the performer, a point that was driven home by the alienating effect of Acconci's constantly swinging metal pipe. For Acconci this effect served the purpose of "armouring," which was augmented by the wearing of the blindfold. The piece of black cloth tied tightly over the eyes not only demarcated the importance to identificatory processes of vision, which the subject ironically denies himself, but on a more mundane level, tested the ethics of the audience. Who, one might ask, would assault a "blind" man?

Of course, a few individuals did attempt to overtake Acconci. Occasionally the image of his body on the screen is infringed upon and then obliterated by a shadowy mass. The banging of the pipes on the wooden stairs grows in volume and regularity, a struggle can be detected, but Acconci never stops barking his possessive proclamations. Nobody succeeded in their attempts to take over his territory. Again, it was as if Acconci's "I" statements armored him, protected him from being overtaken, despite the fact that accession to the realm of the symbolic provides no more stability than does the mirror stage itself. As linguists like Benveniste have noted, the pronoun "I" works as

a shifter, only tentatively holding meaning for the person who utters it. This fact may account for the title of this piece, as Acconci lays *claim* to the territory of his unconscious—that territory that is "structured like a language"[11]—by continually repeating his proclamations, by not letting anyone else get a word in, by never dispossessing the "I."[12]

His three-hour domination of the field of language, the splitting of his image, and the wearing of the blindfold eradicated any possibility of Acconci's "directly" identifying with his audience. I suggest that Acconci's choice not to identify constituted a deliberately missed chance to recreate a sense of wholeness, a choice that implicitly stated the impossibility of such a recreation. In the progression from sack of skin, to exteriorized image, to an "I," the concept of the body as unified naturally with entities outside itself or, for that matter, within itself is revealed as just that—a concept, realizable only through illusion or myth.[13] Asserting this myth was the project of the 1960s, a project that was interrupted by Acconci, Graham, Jonas, and others through the use of video in performance.[14]

I shall expand on this comparison to the 1960s, but first, further examination of the mirror stage is needed or, rather, further discussion of artists' work that examined it for us, for it is the very regularity of artists' attention to its complicated aspects in the early 1970s that sparks the historian's question of a need for such attention and the place from which the need arose. As we shall see, this attention did more than point to a mere lack of it in previous artwork; it pointed to very particular problems in the institutions around which the work was done.

By using mirrors, video monitors, and cameras in his work, Dan Graham not only demonstrated the disparity between presentation and representation and the fragmentation processes they share, as we saw Acconci do in *Claim,* but expanded the volume of disparity and fragmentation. In *Opposing Mirrors and Video Monitors on Time Delay* (1974), two monitors were placed a few feet in front of, and facing, mirrors which were positioned on walls forty feet apart. Mounted on top of the monitors and pointed in the same direction as the monitors were two video cameras, each of which was paired with the monitor on the other side of the room, set on a five-second time delay. Visitors to the space found a variety of scenarios available: a view, on the monitor, of what had happened five seconds earlier, as reflected in the mirror on the other side of the room; a view, in the mirror nearest them, of themselves and the nearby video monitor; a faraway view, in the opposite mirror, of what had occurred five seconds earlier on their own side of the room appearing now on the opposite monitor. The installation, and the self-guided performances it encouraged, provided an array of disjunctive points of view made available by mirror, monitor, and camera.[15]

Dan Graham, *Present Continuous Past*, 1974.

The volume of this disjunctiveness was enhanced, by way of contrast, by the layout of the installation. That is, upon entering the precisely symmetrical arrangement, with two sections structurally mirroring each other, the visitor might have been led to think that the show was about sameness of views; whereas, by performing within the installation, the visitor quickly learned that mirroring proliferates difference. This conclusion is comparable to that reached in the psychical mirror stage—the conclusion that any seemingly identical identification is, as Lacan says, a fiction, or, as Graham has shown via time delay, an image under the illusion-making influence of memory.

Graham has stated that "you only get the future by your memories of the past . . . in a certain kind of way . . . which you're constructing in present time."[16] However, this act of construction—no matter how strong an action is suggested by the verb "construct," nor how self-consciously "constructed" Graham's video installations and performances were—does not help stabilize identification for either the viewing subject or subject viewed. Rather, the imbrication of past, present, and future in Graham's work signifies the very split occurring at Lacan's mirror, a split witnessed by both the subject positioned there and the witness, who stands off to the side.

Graham explores these ideas in *Past Future Split Attention* (1972) in which

two performers (friends), holding microphones, are videotaped as they simultaneously speak, one performer describing the past experiences of his friend, while that friend describes the projected future behavior of the other. Each performer operates, clumsily, as a speaking mirror, taking up the position of "other," articulating to the person before him who he was or who he will be. It is very difficult, as a viewer of the videotape, to concentrate on the performers' speeches. Words collide, overlap, and intermittently disappear into a mélange of utterances, demonstrating how much past, present, and future data bombard us in our experience of any given moment, rendering it almost impossible to isolate a particular experience of a particular person at a particular time. But among the more decipherable statements are those at the beginning of the monologues. Interestingly, each performer begins by making reference to the other's mother: "You'll see your mother this year more than once and you'll talk to her about . . ."; "You had . . . a fairly unstable family background. . . . You were down in Brighton tonight where you . . . met your mother. . . ."[17] The invocation of the mother, at this moment of participating in a reconstruction of the psychodynamics of mirroring, implicates her presence as witness of the original split at the mirror and, also, bespeaks the subject's nostalgia for previous anaclitic moments in which stability was procured through leaning upon, and feeling at one with, the maternal object.

This nostalgia is stirred up in the viewer of the videotape as well, in the sense that the viewer strives to hear everything being said, tries to put all the pieces together so as to "know" the individuals on screen, attempts to stabilize the constantly shifting and splitting identifications. The attempts are futile, though not pessimistic. On the contrary, by being reminded of the mirror stage and our fragmented subjectivity, we are also reminded of the way in which this moment of splitting paves the way for subsequent experience, in which this already fragmented subjectivity becomes sexually identified, engendered, constructed in language. By being led to recognize the *structural* nature of this process we are deposited on the threshold of possibility of restructuring identity. For artists like Graham or Acconci to remind us of these moments constitutes a useful reinforcement of the contributions of Lacan, whose theories suggested that by working within the structures in which gendered identifications have been formed—that is, within systems of fragmentation—we may be able to destabilize identifications ideologically determined by *biological* nature and structure new ones that would resist oppressive forms of stability.

The threshold of which I am speaking is not only figurative but also material in two senses. First, it relates to the historical position in which many individuals, especially women, found themselves in the 1970s as the first wave of 1960s women's liberation (schematically summarized here as focusing on equality through role reversal) subsided, revealing the need for deeper struc-

tural changes in the complicated, ideological workings of oppression. Since representation and the distribution of representations play key roles in the formation of ideologies, the fact that video became a useful tool for artists dealing with these feminist issues, however obliquely, is not surprising.[18] Second, it refers to the liminal spaces in which the video performances under discussion were actually presented and the need for institutional change prompted therein.

It should not be forgotten that video and performance had no homes of their own in the late 1960s and early 1970s.[19] Artists worked in whatever space was available including, for performance artists, the outdoors. The incorporation of video into performance, however, necessitated indoor space, and artists' lofts, schools, and galleries became potentially available.[20] However, these various spaces did not offer the *same* potential. Something would inevitably seem "off" whenever performance, performance-based videos, or performance-and-video pieces were presented within commercial gallery spaces. Joan Jonas, for example, presented *Vertical Roll* (to be discussed shortly) at the Leo Castelli Gallery in New York in 1973 but subsequently did not find such contexts, in general, ideal for the type of work she was doing at that time—partly because it had been the roughness of loft spaces that had inspired her work in the first place.[21] Although asked to do subsequent pieces at Castelli, Jonas declined. While this "off-ness" was indicative of the transgressive, avant-garde quality of these new forms, and while some dealers wished to be identified by this quality and therefore showcased the work, sometimes the "off-ness" was evident enough from the start, prompting them to arrange "adjunct spaces" in which artists could present performance and video work.[22] In 1970 John Gibson Gallery, for example, arranged for Dan Graham to conduct *TV Camera/Monitor Performance* (in which the artist rolled back and forth on a stage while holding a video camera aimed at a video monitor located behind the audience) at the Loeb Student Center at New York University.

Performance and video work was also presented, of course, in artists' lofts like 93 Grand Street, or artist-run organizations like 112 Greene Street Workshop where the power hierarchy of the art market could be sidestepped. In some cases, like that of 112 Greene, curatorial decisions were not even made because, as founder Jeffrey Lew said, "I never understood the difference between selection and elitism."[23] From our historical perspective these sites could be considered proto-alternative spaces inasmuch as it would be a few more years until the term *alternative space* would be adopted by individuals running such spaces, as well as by the government agencies that would fund them.[24] The term *alternative* is loaded, but its complexity is useful in that it constantly forces us to look back to the institutional constructs to which the spaces attempted to contrast themselves. Although it is outside the scope of this essay to assess the degree to which alternative spaces have provided a "true" alterna-

tive to artists, looking at the sites located on the threshold between the commercial and noncommercial worlds of the early 1970s will establish a theoretical base from which such an assessment may one day, perhaps, be made.[25]

The straddling of these two worlds was echoed internally, as already mentioned, by a straddling of the constructs of home and holiday. It's helpful now to turn to Bakhtin and, perhaps more helpful, to his critics. In the modern world, which for Bakhtin seems to date from the seventeenth century,[26] holiday time could effect the same leveling of rule-enforcing power as carnival, where people of all ranks mingled, freely trafficking in self-deprecating humor, grotesquely altering body images through costumes and masks—where, Bakhtin claimed, "all were considered equal." Carnival, according to Bakhtin, took the world ruled by the hierarchies of the state and turned it "inside out," causing a "continual shifting from top to bottom, from front to rear."[27] Establishing such a scenario—nonhierarchical, where caprice could blend with intention—was the aim of artists working in proto-alternative and adjunct spaces in the early 1970s. But the spaces' ability to lend themselves to this project would always be compromised by material links back to the order of the domestic site. Artists' lofts, or workshops located in loft spaces, are still functionally coded as home space. And schools, no matter how much they encourage "experimentation" (and always will in the name of academia's commitment to stimulating "scientific" progress), are controlled by patriarchal figures who clearly delineate the limits of such activity.

Creating even stronger links to home, however, were the very forms of art presented within these quasi-alternative spaces. It could be argued that performance work, with its chief materials being the human body and the psychodynamics attached to its reception, inevitably links us to the psychodynamics of the domestic site. But the introduction of video into performance work literally drove this point home, for inherent to the operation of video is, quite simply, a piece of domestic furniture—the television set. The mobilization of this apparatus into other venues, as Acconci has argued, has profound effects upon the viewer:

{T}he conventional location for a television-set is in the home; when it is come upon elsewhere, whether inside a gallery/museum or outside, in a store-window or a supermarket, the viewer is stopped in his/her tracks. . . . The viewer, seeing the TV set, is brought back home—and here, abstractly, "home" reads the way it could never be allowed to read when surrounded by the customs of living-room furniture: "home" means "resting-place", "the final resting place", the land of the numb/the still/the dead.[28]

Continuing with the psychoanalytic methodology I have been laying out in this essay, we might respond to Acconci's provocative quotation by asking: What is this sense of numbness and stasis other than the sense obtained in front of the mirror, in the home site, when the self is reflected as frozen frag-

ment? And what is the evocation of death other than the fear of disempowerment evinced by the developmental experience that follows the mirror stage—or, put more clinically, the threat of castration evoked in the oedipal scenario? If the assertions lodged in these rhetorical questions are accurate, then is it any surprise that the introduction of performance and video into galleries, with their hierarchies styled upon domestic, patriarchal models, might threaten the ideology of these hierarchies and send dealers scurrying after adjunct spaces?[29] After all, the traditional function of this ideology has been to link galleries just enough to the home site to assure sales to fill its interiors. What would happen if, suddenly, the *psychology* of this ideology were stirred up and it was revealed that there was trouble in the home—that is, that the gallery space was revealed to be not a home at all, but a simulacrum providing ersatz nurturing in the form of profit?

Of course, such support was only extended to the artist whose behavior was that of the "perfect child," which, in the postwar context of *neo*-avant-gardism, could entail a smidgen of financially viable, therefore tolerated, unruliness.[30] Nowhere in this domain of tolerance, however, was there room for failure; for this freedom, more holidaylike spaces were sought and, interestingly, were often found(ed) with the help of those in positions of power.[31]

This element of secondary support became integral to the development of the "official" alternative space. Help took the form of everything from financial backing to the loaning of influential names to advisory boards (to lend clout to spaces applying elsewhere for funds). But how are we to read these efforts? Were dealers being responsive to the needs and desires of artists seeking space for their unwieldy work, or does this support qualify as a sort of permission-giving that reflexively permitted those in positions of dominant power to bolster their identity as alleged guardians of the (neo) avant-garde while simultaneously reinstating command over their own spaces and the financial security that would obtain? Related here is Natalie Zemon Davis's analysis of the medieval phenomenon of the church's shifting saturnalian activities (sometimes involving choir boys' officiating burlesque masses, leading asses around the church, and so forth) to "Abbeys of Misrule." Even the term for these medieval "alternative spaces" suggests a certain degree of permission-giving on the part of the church, which was no doubt anxious to recapture its orderly command over the sacred world but was unwilling to let go completely of the secular world over which it no doubt wanted to rule as well.[32]

But do these systems of patronization necessarily nullify the ability of carnivalesque spaces to offer an alternative or to stimulate change in the institutions from which they differ? Umberto Eco would say yes. He concludes, "[C]omedy and carnival are not instances of real transgressions: on the contrary, they represent paramount examples of law reinforcement."[33] Indeed, we have all seen so-called alternative spaces evolve, virtually, into their original

opposites. However, the question of carnivalesque alternativeness and transformation is more complicated.[34] Perhaps we can avoid the pessimism of the foregoing conclusion by acknowledging two flaws in Bakhtin's theorization. One flaw is his implication that any system, no matter how marginal or temporary, can operate outside dominant power in the first place. Bakhtin's definitive criterion for the carnivalesque is that it constitute a "second life" suspended from the "established order" of the state. A second flaw is apparent. Bakhtin claims that any carnivalesque "escape from the usual official way of life" should yield transformative effects, but practices associated with "renewal" and "regeneration"—utopian terms lacing his text—are tightly circumscribed by the powers of nature.[35] In the practice of making the body grotesque, for example, bellies and/or genitals would be made to look as if they were bulging, hanging down weightily toward the ground, thus literally and figuratively enjoining the body to the natural regenerative forces of the earth. But any bridging we might expect in Bakhtin's thinking—from the conceptual transformation of the natural body to the actual transformation of the body politic—is just not there.[36]

Such a bridging is, of course, conceivable. A material, ongoing relationship existed between carnival and the state, as it does between the alternative space and the gallery system, or any other system that qualifies as homelike by virtue of its patriarchal, authoritative, hierarchical setup (including the government agencies, foundations, and corporations upon which alternative spaces came to depend for survival).[37] To understand the ramifications of this bridging we need to view the relationship between dominant and marginal institutions as symbiotic. Peter Stallybrass and Allon White have suggested that "the carnivalesque was marked out as an intensely powerful semiotic realm precisely because bourgeois culture constructed its self-identity by rejecting it."[38] This symbiotic identificatory process—marked by the linguistic concept of "I am this because I am not that"—constitutes what I would call a "purgative mirror stage" for systems of dominant power, paradoxically *re*flecting its opposite while *de*flecting to marginal systems that which has been negated and purged.

So, even though we may have glimpsed the impossibility of alternative spaces functioning as true holiday spaces, it is important to polemicize them consistently as such, for in projecting their alternativeness they embody that which galleries, for example, thought they had purged from their systems. Stallybrass and White described this twist as the " 'poetics' of transgression" which "reveals the disgust, fear and desire which inform the dramatic self-representation of the [bourgeois] culture through the 'scene of its low Other.' "[39] The ultimate ramification, then, of the symbiosis between the alternative space and the gallery system is that the mirroring process which establishes the latter's power simultaneously reveals its greatest points of vulnerability. The value in understanding this process is that it is through locating vulnerability that change can begin to be fostered. The precise point of vulnerability here is

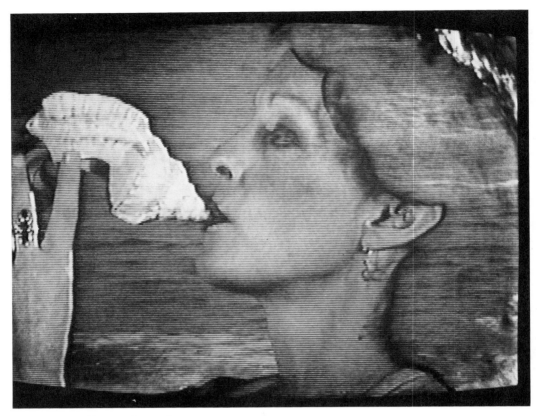

Joan Jonas, *Double Lunar Dogs*, 1984.

that site of otherness known as the body—not the ideologized natural body of which Bakhtin speaks, but the socialized and psychologized body, the body-in-fragment.

Joan Jonas plays with the ontology of the body-in-fragment in her performance-based videos. Looking at her work will help us draw contrasts to sixties performance work, which, in general, is aligned with Bakhtin's outlook on medieval carnival—that is, with utopian vision. Jonas's work is paradigmatic of the early 1970s, illustrating what Bakhtin would classify as the modern, bourgeois body—"private, egotistic . . . severed from the other spheres of life," "isolated."[40] In *Vertical Roll* (1972), we rarely see Jonas's complete body—just her face, her hand, her belly, her legs, all seeming to operate on their own. Or, they appear to move solely with the mechanical assistance of the video apparatus. The tape begins, for example, with Jonas's head—signifier of ego—dropping slowly from the top of the frame, but its smooth move downward is interrupted by the rolling motion of the vertical hold bar, which seems to conduct an act of reverse-gravity, intermittently tugging the head

back up toward the top of the frame. Counteracting this attempt, Jonas starts to tap the screen with a silver spoon, which makes rhythmic, but slightly out-of-synch, contact with the rolling bar. Any relation between her head and hand is ambiguous, however. As her face finally retreats off the top of the screen it is, again, as if the rolling bar, now in alliance with the tapping spoon, is responsible for pushing the head out of view. When we do see the whole body, our perception of its wholeness is disrupted by its orientation to the screen. Jonas's masked face and body, for example, are slowly eclipsed as she lifts her feet up toward the camera. As she peddles her feet toward us, they take up almost all available screen space. We are only allowed glimpses of her body, which now appears suspended from some mystical space above.

Indeed, the isolation of body parts on the screen, tne appearance of the body as suspended or "sever[ed] from the material and bodily roots of the world,"[41] the featuring of the face as the signifier of ego—all conspire to map the body as an individualized, privatized entity. This privatization is at para-doxical odds with the nature of video to yield any image to the public. And herein lies the beauty of Jonas's video, for through the activation of the video apparatus's built-in mechanisms to "de-synchronize" (as Douglas Crimp has put it),[42] to fragment vision and to destabilize the viewer (emphasized throughout by the constant movement of the vertical hold bar), Jonas defies television's popular capacity to unify viewers around a mythically definitive un-derstanding of the body. Instead, she unifies viewers around an understanding of the body as representation itself, as constantly traversed by the technical tropes of media and potentially proliferating in meaning.

In a sense, processes of representation are also at work in Bakhtin's con-ception of the medieval body, but they aim at the grandiose unification that the modern body rejects. The medieval body is made to appear "degraded" in order to represent "the lowering of all that is high, spiritual, ideal, abstract; it [degradation] is a transfer . . . to the sphere of earth and body in their indis-soluble unity." Thus conflated with nature, the body is immune to any charac-terization as a psychologized entity, in the sense of being defined *by* its repre-sentations, and is only allowed to serve as a vehicle *of* representation—for Bakhtin, as a representation of "the collective ancestral body of all the people."[43]

In part, Bakhtin's ideologizing of the body as unmitigatingly glued to nature is enhanced by carnival's use of the mask, which, predictably, bears dif-ferent meanings in medieval and modern times. In the former, the grimacing, caricatured mask "rejects conformity to oneself"; in the rejection, the individu-alized self is linked to "folk culture's organic whole." In contrast, in modern times, the mask "hides something, keeps a secret, deceives."[44] This is the use epitomized by Jonas, who in parts of *Vertical Roll* and its predecessor *Organic Honey's Visual Telepathy* (1972) wears a mask that because of its near-translu-

Joan Jonas, *Organic Honey's Visual Telepathy,* 1972.

cence can often be mistaken for her real face, until the uncanniness of the like-
ness reveals the obvious differences—the mask's lack of cheekbone delineations,
skin texture, and so forth. In the realization of this difference we are set at as
great a distance from the "real" Jonas as the closeness we thought we had—a
distance that is emphasized by the glare of studio light as it bounces off the
mask's slick plastic surface. But it is this function of distancing that takes
Jonas's use of the mask—purchased at a store selling erotica—beyond mere re-
jection of any carnivalesque enchantment with organicism. This distancing
ironicizes the implications of her pseudonym—"Organic Honey"—chosen at
the time the video was produced. For what she hides, as she hides behind this
mask, is the problematic tendency of the viewing subject to reduce gender to
"organic," "natural" meaning.

In her now-famous article on masquerade, Mary Ann Doane argued that
the "masquerade, in flaunting femininity, holds it at a distance. Womanliness
is a mask which can be worn or removed. The masquerade's resistance to patri-
archal positioning would therefore lie in its denial of the production of femi-

ninity as closeness, as presence-to-itself, as, precisely, imagistic."[45] By wearing the mask, Jonas sets femininity apart from the body and situates it appropriately in the arena of production. Her denial of closeness is everywhere in her work, particularly in the processes of production. *Vertical Roll*, for example, was originally produced in a performance context that confused the sixties traditions of bringing the physical body up close to the audience. Instead, the audience at Jonas's performance saw her from a considerable distance, performing before a video camera. The only "closeness" to the performer was that provided by the obvious representation of her on the monitor—a representation that she closely watched as she, herself, created it.

Jonas also uses mirrors in her work to deny closeness.[46] Early performances of *Vertical Roll* began with Jonas, standing nude before the audience, methodically scrutinizing her body with a small, round, hand mirror. As much as this action was overarchingly narcissistic (serving as an emblem of Jonas's closeness to herself) and exhibitionist (forcing closeness onto the audience, making them feel as if they were inside her own home), the hyperfragmenting of the image of the body reduced it to a series of ridiculous abstractions. In this simplistic illustration of the fundamental fragmentation of the mirror stage, Jonas presented a table of contents of her more complicated video work—its dealings with the body, its necessarily fragmented representation in processes of identification, and its reference to the domestic site in which those processes originate. It was through the apparatus of video, with its facility to promote all these contents, that Jonas was able to stage her "resistance to patriarchal positioning." For it is through video that we are repeatedly returned to and forced to confront "trouble in the home."

As I mentioned earlier, performance-without-video also has the power to connect us to the domestic site by way of the body and the psychodynamics of its reception. Performance of the 1960s sidestepped this connection, however, in the name of social protest. One site targeted for protest, according to art historian Maurice Berger, was the site of labor:

A number of sixties performances (such as those of Robert Morris, Carolee Schneemann and Lucio Pozzi) were about pleasure and art as a mechanism of desublimation, as a response to being a worker in industrial society. Perhaps these were naive or utopian gestures but the artists thought they could possibly skirt oppression or show how, in the end, that possibility itself was a myth.[47]

We might look at any of the task-oriented performances by Judson Dance Theater artists, like Trisha Brown or Yvonne Rainer, as examples here, but a more spectacular piece like Schneemann's *Meat Joy* (1964) would also qualify as a symbolic staging of protest. It is the site of *artistic* labor, in part, that was contested in *Meat Joy*—a piece that, not surprisingly, was carnivalesque in na-

ture. Male and female performers, clad in bikinis and underwear, interspersed acts of erotically writhing around each other on the floor with painting one another's body. The traditional act of painting is thus *degraded*, to use Bakhtin's term, removed from its lofty heights and transferred to the comic arena of the carnivalesque, where it is used to unify the performers and to symbolically extend this sense of unity to the audience, which was positioned close to the performance area. "Our proximity," recalls Schneemann, "heightened the sense of communality, transgressing the polarity between performer and audience."[48]

Art historian Kristine Stiles, in her work on DIAS (the Destruction in Art Symposium held in London in 1966), has theorized how this polarity is, at least in part, obliterated in performance. The body, she claimed, functions metonymically, like a bridge or conduit, to link audience and performer. In works like Herman Nitsch's *Orgies Mysteries Theatre* productions, one of which was conducted at DIAS, Stiles saw the artist as "mediat[ing] between the viewer and the meaning of the event. The alienation between subject and object was thereby reduced, although not resolved. In other words, the artist as being-in-the-world visualized the contingency and inter-dependence of subject identifying with subject."[49] In Nitsch's pieces all audience members are simultaneously performer-participants. They manipulate and interact with ritual elements such as milk, honey, and animal carcases in what could be viewed as a carnivalesque attempt at renewing the human body through its symbolic association with the animal world.

Whether or not sixties work really succeeded in its Bakhtinian, carnivalesque attempts is a question that would require yet another essay. What interests me more for now, as I close this essay, is the *nature* of the attempts, recognized by Stiles as effecting a reduction, though not resolution, of alienation, and by Berger as showing, perhaps, that the possibility of skirting oppression through performance is itself a myth. These recognitions, I believe, were precisely those of the early seventies artists who questioned the value of utopianism by exploring the very psychodynamics of alienation and myth. From our brief look at sixties performance and these two art historians' assessments of it, we can see how the work of that era strongly pronounced a desire for anaclitic totalization and used the body as the chief material for the project. While the body can, indeed, be mobilized in protest, without also looking at the psychodynamics stirred up by that protest and the hierarchized institutions in which they originate, the problems sought to be solved through reduction of alienation, or desublimation, are only treated *orthopaedically,* to recall Lacan's term.

As video became available as a medium, artists in the early 1970s were literally equipped to stand before the mirror of representation and confront physical identity as psychical, fragmentary, and metaphoric, thus passing up their chance at the aforementioned treatment. If, as Stiles concluded, "[b]y

presenting the living figure as form, subject matter, and content, destruction-in-art works condensed and displaced paradoxes of destruction and creation experienced only indirectly as historical events,"[50] then the events of the Vietnam War, so indirectly experienced by most of us as mediated history, cannot be discounted as one, among many, historico-logical motivations for artists of the early 1970s to seize on the medium of television as an expedient tool for investigating the "*re*presentation of the figure" and the psychologized structure of alienation and myth that had been witnessed nightly in the home.[51] The trouble that was piped into our homes had a direct relation to the trouble that was there already—the trouble with power, organized around patriarchal hierarchy, which had caused such a mistaken conflict in the first place. The time for physical protest over this specific conflict was passing by the time the work discussed in this essay was produced, and the time for analysis of the underlying structure of that which had been protested had begun.

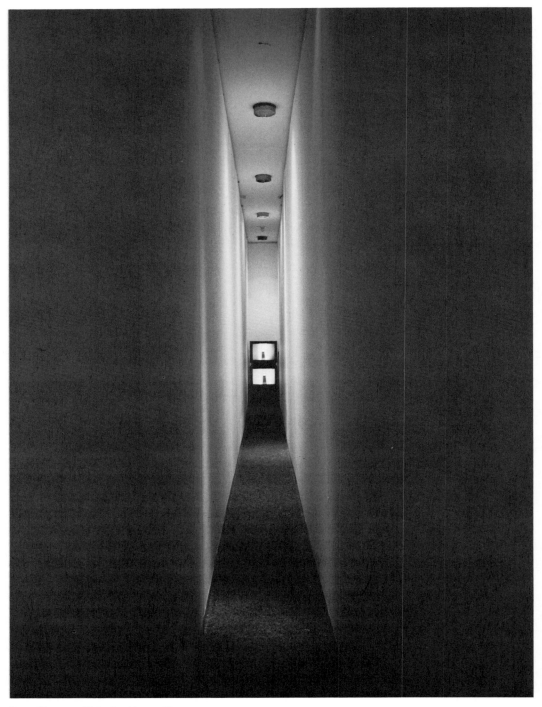

Bruce Nauman, *Video Corridor*, 1968–70.

Video Installation Art:
The Body, the Image, and the Space-in-Between

MARGARET MORSE

> But our argument indicates that [learning] is a ca-
> pacity which is innate in each man's mind, and
> that the organ by which he learns is like an eye
> which cannot be turned from darkness to light
> unless the whole body is turned.
>
> **Plato, "The Simile of the Cave"**

Introduction

The following hypotheses on video installation art are speculative answers to
fundamental questions that someone rather new to video installation as an art
form would ask. The answers posed here were based on recent research and in-
terviews with artists and were conceptualized with the tools of cinema and
television theory rather than with those of the discourse of art history. The ba-
sic questions—What is a video installation? What are its means of expression?
How do these differ from the media per se and from other arts? What kinds of
installations are there? What effects on a visitor does the art form promote?
What cultural function does or could this art form serve?—are questions I
would never have cared enough to ask had I never experienced a video installa-
tion. Such an experience, for instance of Bruce Nauman's *Video Corridor* (1968–
70)[1] can be stunning. To me it was as if I my body had come unglued from
my own image, as if the ground of my orientation in space were pulled out
from under me. Some installations jam habitual modes of sensorimotor experi-
ence, others operate at a more contemplative level, depending on the passage
of images or conceptual fields through various dimensions, rather than on the
passage of the body of a visitor through the installation. Yet, even then, the
visitor is enclosed within an envelope of images, textures, and sounds.

We lack the vocabulary for kinesthetic "insights," for learning at the
level of the body ego and its orientation in space. (Perhaps such learning prin-
ciples might be considered "Deweyian," a "figuring within" as opposed to the
"reading" of literature or the "imagining" of pictorial art.) These hypotheses
attempt to articulate this kind of experience, in the preliminaries to a poetics
of video installation art. Detailed description and interpretation of specific in-
stallations must reluctantly be left aside. The following sections address in
turn: (1) the conditions of existence of the art form; (2) its plane of expression
and different levels within that plane; (3) the disposition of bodies and images

in space; and (4) the temporal and experiential passage, reflections toward a metapsychology of video installation art.

The Conditions of Existence of a Noncommodity Art Form

The designation *video installation* is not an accurate guide to what is undoubtedly the most complex art form in contemporary culture. However, the term does suggest much about this art form's conditions of existence: *Installation* per se suggests that an artist must actually come and install the elements, including electronic components in the case of video, in a designated space. Such an activity presumes the support of an entity to clear and hallow the ground to be occupied, i.e., most likely a museum, but sometimes also a gallery, an alternative, or even perhaps a commercial or public space. Thus, installation is a topsy-turvy art that depends for its very existence on the museum or like institutions, whereas for commodity arts such as painting, the museum serves as the pinnacle of validation in a longer history of display.

Furthermore, the process of installing suggests a temporary occupation of space, a bracketed existence enclosed by a matching process of breaking down the composition into its elements again and vacating the site. Thus, installation implies a kind of art that is ephemeral and never to be utterly severed from the subject, time, and place of its enunciation.

In contrast, an object that can be completely freed from the act of its production, such as a painting, becomes displaceable and freely exchangeable, that is, commodifiable. In addition, this severance from the process of enunciation is what ordinarily allows a magical origin or aura to be supplied to objects of art. It is the tie to process, to the action of a subject in a here and now, whether loose or tight, which works against the installation as a commodity and also suggests why it is so hard to document. While an installation can be diagrammed, photographed, videotaped, or described in language, its crucial element is ultimately missing from any such two-dimensional construction, that is, "the space-in-between," or the actual construction of a passage for bodies or figures in space and time. Indeed, I would argue, the part that collapses whenever the installation isn't installed is the art.[2]

The frame of an installation is then only apparently the actual room in which it is placed. This room is rather the *ground* over which a conceptual, figural, embodied, and temporalized space that is the installation breaks. Then, the material objects placed in space and the images on the monitor(s) are meaningful within the whole pattern of orientations and constraints on the passage of either the body of the visitor or of conceptual figures through various modes of manifestation—pictorial, sculptural, kinesthetic, aural, and linguistic.

Note that the artist vacates the scene in installation per se.[3] This allows the visitor rather than the artist to perform the piece. Indeed, she or he is *in* the piece as its experiential subject, not by identification, but in body. Thus, the installation is not a proscenium art. (Hence the choice of "visitor" over spectator or viewer.) It is not hard to see the relation of installation to other anticommodity art forms that emerged in the 1960s, such as conceptual art, performance, body art, earth works, and expanded forms of sculpture.[4]

But how does this noncommodity art survive? Sometimes an installation is commissioned by a museum, such as the Whitney Museum for its biennial, or by the Carnegie Museum in Pittsburgh, or the Institute of Contemporary Art in Boston. In addition, like "single-channel" or narrative video, the form is generally dependent on corporate, civic, and charitable art subventions and the economic support of the artist in some other occupation. Provided an installation is site-independent and can be re-erected in various places, a museum-sponsored tour can also generate rentals for the artist/installer.[5]

Because of the nature of its economic support, some artists decry the growing "bureaucratization" of the art: that is, funding a piece requires not only formal requests to corporations, foundations, and commissions, but the generation of detailed plans, models, and prototypes: improvisation is reduced to a minimum. But, however detailed a video installation becomes in conception, there remains an element of uncertainty and risk at the level of the material execution and installation of its elements conceived by the artist, and an element of surprise in the actual bodily experience of the visitor. Indeed, I speculate that exploring the materialization of the conceptual through all the various modes available to our heavily mediated society is at the heart of the cultural function of video installation.

In that sense, the "video" in video installation stands for contemporary image-culture per se.[6] Then, each installation is an experiment in the redesign of the apparatus that represents our culture to itself: a new disposition of machines that project the imagination onto the world and that store, recirculate, and display images; and, a fresh orientation of the body in space and a reformulation of visual and kinesthetic experience.

While video installation as a form is not directly related to or dependent on the institution and apparatus of television, it is just as hard to imagine the art form as it is to imagine the contemporary world without television. Not only do we live surrounded by images, our built environment and even our natural world has largely passed through image-culture before rematerializing in three-dimensional space. Thus, though they completely overpower the art form in size and reach, television broadcasting, cable, and the videocassette as usually consumed are each but one kind of video installation that is reproduced over and over again in a field of open and otherwise unrealized possibilities.[7]

The materialization of other possible apparatuses allows us to imagine alternatives and thus provides the Archimedean points from which to criticize what we have come to take for granted.

The following section distinguishes video installation from proscenium arts such as theater and film, as well as from traditional painting and sculpture. Then, various modes and types of installation apparatuses are discussed, drawing on examples from various artists, emphasizing first spatial, then temporal dimensions.

One Among the New Arts of Presentation

Explaining why the video installation is not theatrical or filmic does much to clarify other aspects, from its metapsychology to its modes of expression, which distinguish it from the other more illusionistic arts:

In the proscenium arts—and one can begin them with Plato's "Simile of the Cave"—the spectator is carefully divided from the field to be contemplated. The machinery that creates the vision of another world is largely hidden, allowing the immobilized spectator to sink into an impression of its reality with horror or delight but without danger from the world on view. The proscenium of the theater, and in its most ideal expression, the fourth wall, as well as the screen of film divide the here and now of the spectator from the elsewhere and elsewhen beyond with varying degrees of absoluteness. The frame of a painting likewise allows a painting not to be taken literally (as well as to be transportable and salable), and to allow a not here and not now to occupy the present. The visitor to an installation, on the other hand, is surrounded by a spatial here and now, enclosed within a construction that is grounded in actual (not illusionistic) space. (The title of the group installation exhibition and catalog *The Situated Image*,[8] emphasizes that aspect.)

Video installation can be seen as part of a larger shift in art forms toward "liveness" that began in earnest in the 1960s, in a field that included happenings, performance, conceptual art, body art, earth works and the larger category of installation art. If there are two planes of language,[9] a *here* and *now* in which we can speak and be present to each other, and an *elsewhere* and *elsewhen*, inhabited by people and things that are absent from the act of enunciation, then these new arts explore expression on the plane of presentation and of subjects in a here and now.

Art on the plane of presentation can be contrasted to art as representation, an evocation of absences that been the focus of artistic exploration since the Renaissance. Representation invokes things apart from us, using language as a window on another world. In Western art, that world came to be represented as realistically as possible, using a variety of techniques such as perspective in painting and photography. Other techniques developed to suppress the

here and now in which we inevitably receive representations, for instance, separation from the realm of reception by means of the aforementioned proscenium, frame, or screen. In photography and the cinema, the separation became absolute temporal and physical separation. Cinema spectators immobilized in darkness were like the prisoners in Plato's Cave, but they are not held in place by chains but by machines of desire, enjoying the impression of mastery over an imaginary world. We ordinarily think of fiction effect and illusionism in terms of these arts of representation.

While the cinematic machine or apparatus includes the cinema in which viewers sit and the projection room (not to mention the box office and the candy counter), "movies" are what appears on the screen, just as photographs and paintings are what is in frame. Attention to this other plane, the here and now of production and reception beyond the frame, became a rich object of theoretical investigation and a critique of representation in philosophy and in cultural and film studies—as well as in art—in the 1960s.[10]

It is hard to imagine at first how much this new ontological status—presence, or here and nowness of art with the receiver of art—changes the rules of art making and receiving. In fact, from the beginning there were many who refused the work on the presentational plane the status of art. For one thing, then art and everyday life can share the same place of language. What then does distinguish art from life? What happens when "experience" must substitute for "transcendence"? What does it mean to "participate" in art? At first, these questions may not have seemed complicated: a faith in perceiving things as they "really" are and a habit of confusing the present tense with reality and of equating experience with personal change common to the 1960s, may have been useful in exposing the fictions of there and then and in exploring the apparatuses of the past. But the disconcerting discovery of fictions and manipulations that inhabit the here and now is on ongoing project of video installation.[11]

The impetus behind the artistic exploration of this plane of presentation and discovering its rules and limits perhaps began with Utopian desires to change society via changes in consciousness.[12] But the impetus was also apparently ontological—a new and virtually unknown postwar world had yet to be explored, a world mythically first discovered for art in Tony Smith's car ride along a newly constructed New Jersey Turnpike at night. What Smith saw in the dark horizon beyond the freeway has become in the intervening period a landscape of suburbs, malls, and television in which everything, including the natural environment, is either enveloped by the low-intensity fictions of consumer culture or abandoned to decay. A subject in this everyday world is surrounded by images and a built environment that are, at times, hard to tell apart. Three-dimensional objects are no longer a prior reality to be represented, but rather seem to be blowups of a two-dimensional world. Two and

three dimensions interchange freely with each other in a derealizing process so hard to grasp that we turn to catchwords like *postmodernism* in desperation.[13]

The arts of presentation and, particularly, video installation are the privileged art forms for setting this mediated/built environment into play for purposes of reflection. Indeed, the underlying premise of the installation appears to be that the audiovisual experience supplemented kinesthetically can be a kind of learning not with the mind alone, but with the body itself.

While the new arts of presentation have been conceptualized as "theatrical,"[14] it is important to note the massive difference between the two worlds of a traditional theater, in which the audience receives the events on stage as happening safe in an "elsewhere," and a theater in which events happen on the same plane of here and now as the audience inhabits. It is as if the audience in this new kind of theater were free to cross the proscenium and wander about on stage, contemplating the actor's makeup and props, able to change point of view, to hear actor's asides, seeing both the process of creating an imaginary world and—more dimly than before—the represented world itself. But the difference can be even more radical, for in performance art, as opposed to traditional theater, the body of the performer and his or her experience in a here and now can be presented directly and discursively to an audience, which thereby becomes a you, a partner inhabiting the same world, possessing the capacity to influence as well as respond to events.

Even sculptural objects could participate in this plane of presentations in a here and now: minimal sculpture in the 1960s, as Michael Fried perceptively noted at the time, offered a sculptural object, not as a monument or memorial of some world or time, but as an ersatz person that confronted the viewer *in his or her own space.* Indeed, the work consisted not just of an object, but implicated the physical space around the object and the play of light in it. The minimal object also required a subject capable of realizing the work, responding to the changing light and positions of a here and now, so that each time a work is perceived it is a different one.

Even the inevitably more narrative "single-channel" video art is part of this move toward exploring the presentational plane. While structuralist film was largely engaged in a modernist exploration of the unique properties of the medium, narrative video has long been engaged in exploring what it means to narrate stories, how stories are told, what cultural function narrative serves, and so on, so that the plane of presentation is represented over stories in a "messier," multileveled form.[15]

Instead of offering simplicity, the presentational arts are hybrid and complex. For instance, even though the plane of expression of presentational arts is essentially the present, it is possible to explore physically more than one tense—reference to the past and future can coexist with the present, provided

that all are figured and grounded in the experience of here and now. Two types of video installation art can be differentiated by tense:

1. Closed-circuit video plays with "presence." A "live" camera can relay the image and sound of visitors in charged positions in installation space to one or more monitors. Shifting back and forth between two and three dimensions, closed-circuit installation explores the fit between images and the built environment and the process of mediating identity and power.

2. The recorded-video art installation, can be compared to the spectator wandering about on a stage, in a bodily experience of conceptual propositions and imaginary worlds of memory and anticipation. A conceptual world is made manifest as literal objects and images set in physical relation to each other. That is, the technique for raising referent worlds to consciousness is not mimesis, but simulation. In general, the *mode* of enunciation in video installation in terms of speech act theory is *performative* or *declarative*.[16] That is, legitimated and contained by the boundaries of the art institution, a world is declared into existence. It need not match the world outside (i.e., be constative), nor does installation video command the visitor nor commit the artist nor merely express some state of mind.

One could further divide this field of installation work into the referent world(s) that symbols made literal evoke. Yet it seems seldom that these worlds are cleanly one thing or one tense—they are rather a copresence of multiple worlds, linked like stories (Mary Lucier's *Ohio at Giverny,* 1983), like sagas [Joan Jonas's, *Iceland Naples Express (Icelandic and Neopolitan Volcanic Sagas),* 1985–88], like dreams (Rita Myers's *The Allure of the Concentric,* 1985) and obsessions (Ken Feingold's *The Lost Soul,* 1988) as condensations of public and private space (Muntadas's, *The Board Room,* 1987), or even as if they were a simile (Dieter Froese's *Eavesdrop,* 1989) or syllogism (Francesc Torres, *Belchite– South Bronx,* 1987–1988). In this sense, multiple channels distributed over multiple monitors are but another way of setting co-present worlds in relation to each other. And from the beginning, installation video has been a mixed medium: closed circuit with recorded video, slides, and photography.

Thus, what ultimately distinguishes the one type of installation from the other is less tense or medium than whether or not the visitor spatially enters two as well as three dimensions or remains in "real" space. The ultimate question that differentiates among the arts of presentation appears to be, who is the subject of the experience? Performance, even where it has installationlike sets, differs from installation, nonetheless, because the artist occupies the position of the subject within the installation world. Interactive work differs in yet another way, for room is made for the visitor to play with the parameters of a posited world, thus taking on a virtual role of "artist/installer" if not the role of artist as declarer and inventer of that world.[17] In a larger sense, all installa-

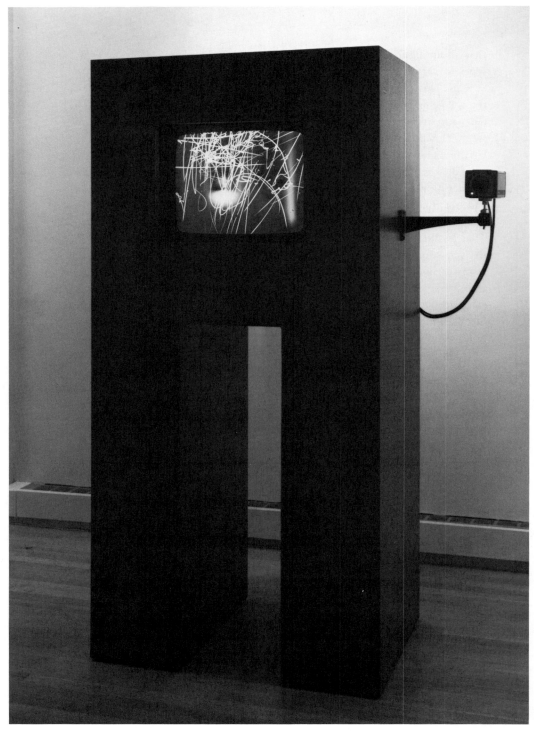

Mary Lucier, *Untitled Display System*, 1975/87.

tion art is interactive, since the visitor chooses a trajectory among all the possibilities. This trajectory is a variable narrative simultaneously embodied and constructed at the level of presentation.

The Play of Apparatuses: Passages in Two and Three Dimensions

Television as a kind of primordial video apparatus already encloses the viewer within a virtual space of the monitor in several ways: light from the screen (as emphasized in the title of another group video installation *The Luminous Image,*) bathes surrounding space in shifting tones and colors.[18] In addition, what is on the television screen typically begins by presenting itself as if it were a here and now actually shared by viewer and media presenters and personalities. That is, television has developed a mode of presentation that envelops the viewer and presenter in a virtual space of an imaginary conversation. This "fiction of discourse" or of presence is furthered by the habitual and distracted way in which we receive television.

If, however, the television apparatus were a video art installation and not a part of a habitual home environment, then awareness of the charged position in space in front of the television set (that is, the position of a virtual subject of address) would be part of the experience of the visitor. Furthermore, one would be aware of the television set itself as a object, with a shape and position in (living room) space. One could walk around the "news" and note the backside of the "window on the world"—the annexation of our own three-dimensional world by the two-dimensional image would be obvious not only to our conscious minds but a part of our sensorimotor experience.[19]

The development of video installation as an art form and the discovery of its parameters can begin, as in John Hanhardt's work on Wolf Vostell and Nam June Paik, with the use of the television set itself as sculptural object. To become aware of its sculptural aspects, this object had to be freed from its context, as in Paik's displacement of the monitor into clothing for the (female) body (Charlotte Moorman's *TV Bra for Living Sculpture,* 1969) or as in his reorientation of television sets into *TV Clock* (1968–81),[20] in a literalization of the temporal order of television programming. The displacement of TV sets into a natural setting in *TV Garden* (1974–78), on which *Global Groove* (1973), tape compiled from all over the world was played, demonstrated an image world as natural and international environment. That is, our image-surround no longer represents a world apart; it is our world. The computer processing of images, in which Paik played a pioneering role, is another indication that images were now themselves our raw material, the natural world upon which we exercise our influence as subjects.

Rather than pretending to timelessness,[21] these early TV sculptures were subjected to the processes of mortality, in a literal kind of deconstruction, sub-

mitting the object to destruction, decay, and disappearance as in the performance of physical burial in Wolf Vostell's *TV Dé-collage* (1961). The performance of Ant Farm's *Media Burn* (1975) comes to mind as well. Mary Lucier's closed-circuit installation, *Untitled Display System* (1975/87), displaying on a monitor the "live" image from a camera burned and scarred by light, is another example of the machine made mortal.[22] The contrary process (to the death drive), of building sets into greater and greater unities, is exemplified in Paik's work, with his robot family, and continuing to such symbolic forms as *Video Flag X* (1985, in the collection of the Chase Manhattan Bank), *Video Flag Z* (1986, collection of the Los Angeles County Museum of Art), *Flag Y* (1986, collection of the Detroit Institute of Art), and *Get-Away Car* (1988, collection of the American Museum of the Moving Image).

The physical arrangement of television monitors into sculptural objects continues to be significant in installation video, though when an artist wishes to suppress the immediate reference to the primordial American video installation—the home TV set—that TVs and even video monitors inevitably bring to mind, then how to mask or distract the visitor from these connotations becomes a problem. Then, various housings and sculptural enclosures for monitors are part of a strategy for allowing other apparatuses to emerge.

Developing the parameters of video installation beyond the monitor image/object itself, video sculpture can present an act of inverting what is inside to the outside: for example, in Shigeko Kubota's video sculpture *Three Mountains* (1976–79),[23] it is as if the TV image of mountains were emptied out, its contents taking geometrical shape in the pyramids surrounding the monitors. These pyramids are, then, no longer imitations of mountains, but processed, so to speak, through our image culture and offered to us again as image ghosts and mental apparations in three dimensions.

But the act of inversion is not limited to image culture per se: Ken Feingold sees his installations as exteriorizations of his own interior, mental life. Alternatively, as I interpret an installation by Mary Lucier, *Asylum, A Romance* (1986), the symbolic map of our culture with its dated and inadequate oppositions and boundaries is made manifest *and* undermined as obsolete.[24]

The interiority of such exteriorized images becomes most obvious, least anchored in materiality in video projections, such as Peter Campus's *Mem* (1975).[25] There is no monitor, only the visitor's body and perceptual system in relation to an image projection system, an interrelationship embodied in ghostly images, nothing but light. In contrast, this projection of interiority can be given massive form, equivalent to the very walls around the visitor in Bill Viola's *Room for St. John of the Cross* (1983).[26] The saint's imagination is projected as the visitor's overwhelming subjective view of a risky flight over mountain peaks. (Meanwhile an exterior surface of calm contemplation is pre-

sented within the interior of a hut with a still video image of a snow-capped mountain.)

There are also different degrees to which installation work occupies three-dimensional space, e.g., the video wall, the kinetic painting, the relief, the sculpture, and the installation. Insofar as spatial positions outside the two-dimensional field are charged with meaning that is an essential aspect of the work, all these levels partake of the poetics of installation. The spectator thus enters a charged space-in-between, taking on an itinerary, a role in a set in which images move through different ontological levels with each shift in dimension, in a kinesthetic art, a body art, an image art that is rather an embodied conceptual art.

Once multiple monitors and multiple channels of video were used, other parameters for comparison and contrast came into play. In Ira Schneider's *Manhattan is an Island* (1974), for example, an informational topographic map was created from video recordings taken at various height levels (a boat, a helicopter) and locations (downtown, midtown, uptown) of Manhattan.[27] In *Time Zones (A Reality Simulation)*, (1980), Schneider attempted the same on a world scale, displaying a circle of twenty-four (recorded, but ideally simultaneous satellite) images, one from each zone. These pieces are technologically complex, but conceptually simple elaborations of the notion of place.

In their collaboration on temporality, *Wipe Cycle* (1969),[28] Frank Gillette and Ira Schneider used nine color monitors around which pretaped material, live broadcast television, and live closed-circuit television images from the entrance to the gallery were subjected to time delay and switching. Here the possibility for an image track to migrate from monitor to monitor was exploited, as well as a series of contrasts between three different types of "liveness" and time delay. In his own work, however, the serial contrasts Frank Gillette makes are not restricted to the same conceptual realm. For example, in *Quidditas,* a three-part installation from 1974–75,[29] images and ambient sound were collected in Cape Cod, Vermont, and New Hampshire, in a display that compared three different rates of "nature time." (Here, rather than establish equivalent series, the camera could establish rhythms counter to that of natural process.)

Beryl Korot's *Dachau* (1974) was the first video installation to systematically explore the juxtaposition of the material on monitors, in a process that could be compared to serial music, or, as Korot noted, to weaving.[30] The spatial disposition of four monitors recreates a kind of broken proscenium space; it is the play at the temporal level that makes the piece, as intended, "impossible to put on television" (Korot) and that forces a viewer to watch the images differently. The ascetic, black-and-white video images show a rather banal tour of the contemporary concentration camp in Dachau, the Holocaust an absence

like horror left unspoken. The monitors use architectural features in the image to create vertical and horizontal patterns. The images from two channels alternate across the monitors: a/b/a/b. However, the pattern is not true—there is a slight delay that puts every repetition across the visual field a little off. The whole reflects a complex relation to recording and memory, to images and what they do and don't convey.

I have come to think of this possibility for repetition, contrast, and migration of images across a shape as a poetic dimension of video installation; that is, it is a practice that deemphasizes the content of images in favor of such properties as line, color, and vectors of motion, with content of their own to convey. The choreography of these properties is another kinesthetic dimension of transformation.[31]

The transformation from monitor to monitor, from two to three dimensions and back again, is most visible when these ontological levels do not match and the conceptual is transformed in its passage through various material manifestations. Curt Royston's installations (such as *Room with Blinds,* 1987, or *Flat World,* 1987) are like large paintings folded over, creating such mismatches at an optical level: two and three dimensions intersect—but the information one gets by examining the three-dimensional painting/relief/sculptural objects up close contradicts the (false) perspectival image one gets from a distance or by viewing a video monitor. (Note that Royston's video image can potentially include a visitor within the "painting.")

Dieter Froese's installation *Eavesdrop* (1989) is an example of a transformation at the conceptual level, in a piece on the socioeconomic relations of art as an institution from the point of view of artists. One part of the installation makes an idiom, "eavesdropping," literal by dropping a live-video camera from the eaves of the museum where the piece is to be installed. The subjective display of rapidly encroaching ground on a monitor gives the notion a new kinesthetic dimension (of risk, of terror, and, potentially, of failure).

Several of Muntadas's pieces illustrate another kind of mismatching: that is, the conceptual realm of the installation is not contained within a gallery space, but spills over into public space. *The Board Room* shown in Barcelona at La Virreina, 1988, is an example. Or, in another piece, *haute CULTURE Part I* (Montpellier, France, 1983) a seesaw with a monitor at each end, tilted one way in a mall and the other way in a museum, makes an implicit comparison between them. In *Part II* (Santa Monica Mall, 1984) the difference between the two social-institutional spaces is virtually moot—one seesaw with monitors tilts slowly this way and that. These pieces suggest that an installation need not coincide with its container or exist in contiguous space; what unites an installation is the conceptual space that breaks unevenly over a spatial realm charged with social meaning. Another Muntadas technique, the evacuation of all the image material from the installation *Exposicion* (1985), leaving only the

shell or spatial frame, is yet another exposure of the mismatch of realms ordinarily so liquid in our commercial image culture that the seams are virtually invisible to us. Thus, we learn that ideas and dreams are not utterly interchangeable with images nor are either exchangeable with bodies and objects.

Experience in One or Four Dimensions

If there is transcendence in the presentational arts, it must come not from elsewhere, nor in a controlled regression to a preconscious state via identification with the not-self as self. These arts address the wide-awake consciousness that we call experience. Such a realm is not immune from its own fictions and intensities, nor does it lack spirtuality; play, ritual, and revolution are part of this plane of presence. Experience implies that a change has taken place in the visitor, that he or she has learned something. This learning is not a kind of knowing better . . . but, nevertheless . . . , nor is it knowing unleashed from the habitual realm of a body that never learns, but rather endlessly repeats. Rather, it exploits the capacities of the body itself and its senses to grasp the world visually, aurally, and kinesthetically. If the first kind of transcendence in the arts is the kind denigrated in Plato's "Simile of the Cave," the second kind of transcendence, while not a peripatetic philosophy in motion through the groves of academe itself, could be compared with the trajectory of a prisoner in motion from the darkness to light. (If it is possible to do so, I would prefer not to adopt Plato's idealism or his hierarchy of values along with his simile.) An installation without this intertwining of corporeal and conceptual transcendence would be nothing more than an exhibition, a site for learning knowledge always already known, transmitted by the authorities who know it—governments, corporations, schools, and other institutions of all kinds.

To describe the things we can learn from installation art requires each experience itself and its interpretation. These things are left to the detailed treatment they deserve in other venues; but, the range of subjects treated in installation art is easy to summarize as vast—from the spatial and temporal notions of identity, to the exploration of image culture, reaching from the technological sublime to institution of art itself, to mourning the loss of the natural world and the desire for the renewal of a spiritual dimension in material reality.

"You Had to Be There . . .": The Limits of Video Installation

Beyond whatever failures there might be in specific installations that, for whatever reason, might offer visitors an experience of puzzlement or boredom rather than insight, there are limitations intrinsic to the art form. Perhaps the most intransigent problem is the relation of video installation to temporality, a sub-

ject left virtually unaddressed until now: As a spatial form, installation art might appear to have escaped the ghetto of time-based arts into the museum proper, leaving single-channel video art to fend for itself. Video installation, however, remains a form that unfolds in time—the time a visitor requires to complete a trajectory inspecting objects and monitors, the time a video track or a poetic juxtaposition of tracks requires to play out, or the time for a track to wander across a field of monitors, and, one might add, the time for reflection in the subject her- or himself, that is, for the experience of a transformation to occur.

Temporal unfolding is commonly organized within video installations in repeating cycles that allow a visitor to enter and leave at any point. (Some installations cycle a kind of narrative instead.) There is a contradiction between cyclic repetition in the art form and the transcendence of repetition through experience that is the desired result—yet at the level of each individual visitor this contradiction may be moot. A more practical problem with temporality has to do with the dominant mode of perceiving in museums and galleries. However long the cycle, at whatever rate the installation unfolds, this unfolding is incompatible with taking in visual objects all at once, in a matter of seconds. If, in response to this dominant mode, one were to reduce temporal unfolding to the barest minimum, what would happen then to the notion of experience or transcendence? This incommensurability of perceptual modes is, of course, related to the difference between the arts of presentation and the arts of representation, and the different planes of language that have come to cohabit in the museum.

In this light, the "museumization" of installation art can be evaluated in two diametrically opposed ways. In one way, installation art could be said to transform the nature of the museum itself, now a place fraught with problems related to the commodification of art and the penetration of corporations with economic agendas of their own into the command of the art world. Installation art in this setting reinvigorates all the spaces-in-between, so that the museum visitor becomes aware of the museum itself as a mega-installation, even to the point of self-critique: an installation full of spatial positions charged with power, full of fetish-objects transposable anywhere, a site that oils the fluid transpositions of concepts and commodity-objects between ontological realms.

On the other hand, installation art begins to partake in a long overdue recognition afforded to arts of presentation. In the process, installation art itself could become more commodifiable, a prestige art, and its practioners a relatively closed elite. I personally see that there are intrinsic limits to the commodifiability of installation art that brake what some would see as its corruption as well as its acceptance. More problematic is the accessibility of the art form itself to a general public. "You had to be there . . ." to know what an installation is. Even then, until recently a general lack of discourse on

the arts of presentation has led to incomprehension or misunderstanding about the premises or goals of this art form as well.

Most recently, particularly in Europe, video installation has achieved a new plateau of display and recognition. There is yet another kind of temporal unfolding involved in this art form; its relative rarity means that its potentialities are discovered at a very slow rate. Thus, much remains to be explored in the art of experience.

Video in Relation to Architecture

An architectural code both reflects and determines the social order of public/ private space and the psychological sense of self. This code has become increasingly modified and overlaid by the code of video/television. As cable television images displayed on wall-sized monitors connect and mediate among rooms, families, social classes, public/private domains, connecting architecturally (and socially) bounded regions, they take on an architectural (and social) function.

History of Television: The Postwar Suburban Family

Television became widespread in the early 1950s, after the relocation to suburbia of a large part of the working class, who now commuted to their jobs in the city by day and to their suburban homes at night. The once large and extended working-class family had changed into a small, nuclear unit, which had to be willing to pack up its belongings and move to another location rapidly as work conditions required greater mobility. The TV set, like the car and other modern appliances, was designed to be transportable. Products were built to allow the workers/consumers to plug in quickly to whatever location they might find themselves in. Television took the form of a centrally controlled transmission sent to the passive home viewer on a privately owned TV set for several reasons. The first is that television came into being as a commodity item that had to be cheap to reach a mass market and transportable enough to move with each family from residence to residence. Further, the passive, one-way nature of broadcast TV transmission provided noninvolving entertainment removed from the pressures of a more technically organized work life. The private areas of family and home had become retreats for workers on their "time off." Television programming allowed people in this private space to feel nonstressfully connected to the larger, public world, but free of its demands and sheltered in their home life. Viewed in face-to-face, intimate, family or familylike groups within a home or in a homelike architectural container (the friendly neighborhood bar), TV took on the family as its main subject.

TV as a Distorting Mirror of the Home and Family

TV might be metaphorically visualized as a mirror in which the viewing family sees an idealized, ideologically distorted reflection of itself represented in

typical genres of TV: the situation comedy or the soap opera. Where TV represents typical American families, it symbolically represents an image of the American family to itself. Other types of programs, while not overtly representing the American family, are organized as familylike structures. In the local ("happy news") newscast, for instance, a "team" of newsmen/women "represent" an idealized happy family at their leisure—somewhere between work and play (or tiredness) just after work is done and where they can "be themselves." They are a distorted reflection of many families at dinner-time or cocktail hour watching the news on TV.

Video as Television: *An American Family*

An American Family, produced in 1971 by Craig Gilbert for American Educational Television, was a twelve-part, weekly, one-hour video documentary that was shot and edited nine months prior to its airing. It dealt with the domestic life of the Loud family of Santa Barbara. They had been selected as fairly typical, experiencing all the tensions that seemed to be pulling the nuclear family apart. As a concept, the series perhaps owed something to Alan King's CBS-TV one-hour documentary, *A Married Couple,* to the camera style of Fred Wiseman, and to some of Warhol's theories and his intrusive but deadpan camera work. Craig Gilbert's premise was that the series would function like an anthropological field study, but instead of documenting an exotic culture, it would study the viewer's own culture at a time nearly concurrent with that of the program's viewing. As Gilbert put it: "If I film any one American family over a long period of time, I will expose the myth, the value systems, the ways of interacting that are American and apply in some way to all of us."[1] The Louds would seem to be "representative" of the families the viewer saw most nights on TV.

Horace Newcome, in *TV: The Most Popular Art,* noted: "The children are rock musicians, dancers, concerned with school, their friends, their pets. Their problems are with money, cars and part-time work. To the degree that they see themselves this way, and to the degree that they play for the ever-present cameras, they become part of television's fantasy world. As the eldest son puts it: 'Everybody wants to star in their own TV series, don't they?' "[2] (This is a paraphrase of a statement by his hero, Andy Warhol: "In the future everybody will be a star for fifteen minutes.") But as the series progresses we see more and more differences between the families of TV and the families of reality.

When the show first appeared, viewers had an adverse reaction. An idealization of the American family was placed in doubt: The Louds were thought not to be typically representative of the American family. The program or the Loud's life-style were termed "negative"; the editing was considered biased.

Initially, critics thought the show to be an attack on the "shallow, petty and materialistic" aspects of the American family or of only the affluent California family. They saw the Louds as "all too typical but not like us" *or* totally atypical and a deliberate misrepresentation of the normal American family. It was difficult at first to separate viewer subjectivity as projected onto the program from the actual video screened. As no voice-over narration or story line imposed on the images, it was difficult to establish a common "objective" frame of reference.

A viewer could not easily identify with another American family so close to itself without the use of the objectifying conventions of "TV reality." Identity is established more comfortably with an ideologically distanced/distorted image of a viewer/viewing family—in other words, an idealization. The images of the Louds were literally too close to a mirror image to establish an unproblematic identity or to empathize with.

Another objection to the series was that it was an invasion of privacy—a pandering to the viewer's voyeurism. This objection overlooked the existence of programs like *Candid Camera* or *The Newlywed Game.* It overlooks the inherent voyeurism in the TV viewing apparatus: viewers are placed in the positions of concealed "Peeping Toms" in their relation to the one-way image. Many normally operative conventions such as a story line and various editing rules tend to conceal this voyeurism.

Thus *An American Family* highlighted for viewers a self-consciousness of their own voyeurism. Typically video, (and film) smooth over, camouflage, and conceal their manipulation of viewers' psychological positions. The troublesome "closeness" of ourselves, as spectators, to the family, was dealt with, as the series progressed in time, by the birth of a cult of the family as stars. Their personalities were no longer "like" ours, but had an aura, which helped them sell various products for consumption (records, confessional articles, and books); they themselves became objectified as market commodities.

Video as Definer of Urban Codes/Deconstructer of Urban Codes

A 1976 work of mine referred to the (then) open possibilities of video as a present-time, architecturally deconstructive media. It involved the use of two channels as described in Feature 1. In staging the typical local "happy news" program, the space of the stage set is meant to represent fictionally both the interior psychological space experience of the viewer and the projection of the exterior living-room space in which typical viewers are presumed to be enclosed.

TV sells the notion of the idealized happy family. As simulated on the "happy news" program, it consists of the news anchor—the parent—his sons

Feature 1: Production/Distribution
(Piece for 2 Cable TV Channels) (1976)

The piece utilizes two cable channels in a local environment in addition to a normal commercial broadcast. Two cable programs are to be broadcast live and at a time simultaneous to a commercial program originating on a local station. Any locally produced commercial program can be used, for instance, a local evening news program.

Cable channel A broadcasts a live view originating from a single camera placed inside the control room of the studio producing the local commercial program. A wide-angle lens is used, and the camera, aimed through the glass panel at the stage, shows the entire stage set, surrounding cameras, camerapeople, director, assistants, and the other technicians and technical operations necessary to produce the program. Microphones placed in many locations within the stage set, behind the stage, and in the control booth are mixed together and accompany the visual image. They give a complete sense of all relationships occurring within the enclosed space of the commercial TV studio.

Cable channel B broadcasts a live view from a single camera from within a typical family house in the community. It shows viewers at home observing the local commercial broadcast on their TV set (the view shows both the television image as well as the viewers present). The camera view is fixed. Occupants of the household may or may not be present in the room watching the TV set at a given time. Sounds from all the rooms of the house, documenting all of the activities taking place there during the duration of the broadcast, are mixed together and accompany the camera view.

Anyone in the local community with cable television in addition to the commercial channels may, by switching from channel to channel, see channel A's view framing the local program in the context of its process within the frame of a typical family's household, or turn to the commercial channel and be themselves receiving the particular local program in their house.

and daughters, uncles and aunts. The father or mother is a condoning figurehead who rests at home while the more active sons and daughters pursue (literally follow the action of) developing local news stories by traveling to their sites of origin. Although the news may not be good, the overall feeling projected is one of reassurance; news stories (no matter how grisly) are presented

tongue in cheek, or may be subject to wry comments or even giggles by various members of the inner circle of the news "family."

A contrast is apparent between the "representation" of this on screen— into which members of the real families are transported—and the actual reality taking place (around—outside of—the space framed by the screen) in the real studio space and in the specific viewer's real home life. The TV news program is a distorting mirror of the reality of the family group watching it. Actual local news is found, not in its "reflection" on TV, but in the home of its viewer(s).

The time at which the "happy news" is scheduled corresponds to the time between work and relaxation in the family house before dinner; it is a transition point between the outside world and the "inner" world of private self-indulgence. As it is when the workers in the family come home from work, it serves as a transition period from the frame of public to that of domestic space. Like the cocktail "happy hour," it has the socially important function of ritualizing the passage from public sphere to private sphere.

TV news programs are often constructed in relation to immediacy; for the news stories that are its ostensive content are taking place simultaneously with the time/space of every viewer's lived world. However, in the actual construction of a typical daily news program, unmediated immediacy is non-existent; "action" news is planned in advance of the stories taking place so that camera, crew, and reporter can be "there when it happens." In fact, most news stories are just that, stories, stereotypes repeated in slightly different forms each day and not very different from other fictional TV programs. They are, in distinction from other shows, isolated fragments, episodes, the assembled parts of each one-hour or half-hour show constituting a somewhat predetermined complete story.

Public/Private Codes

Public versus *private* can be dependent upon architectural conventions. By social convention, a window mediates between private (inside) and public (outside) space. The interior seen defines or is defined by the publicly accepted notion of privacy. An architectural division, the house, separates the private person from the public person and sanctions certain kinds of behavior for each. Feature 2 shows how video projection outside the home might be developed. Feature 3 examines daily living rhythms of sound and sight. The *meaning* of privacy, beyond its mere distinguishability from publicness, is more complexly connected to other social rules. For example: a private home restricts access to members of one family; a bathroom within that house is private as it allows usage by only one person at a time

Feature 2: Video Projection Outside Home (1978)

In many houses, the limited view of the interior provided by the "picture window" simply gives outsiders a picture of accepted conventional normalcy. Other conventional ornaments placed in front of the house also express the homeowner's individual identity.

Here, a large video projection screen is placed on the front lawn, facing pedestrians on the sidewalk. It shows an image of whatever TV program is being watched by the family on their TV set within the house. When the set is off, the video projector is off; when the channels are being changed, this is seen on the enlarged public screen outside the house.

The illuminated television advertisements will simultaneously refer to artificial, illuminated signs, such as the moon.

Feature 3: Yesterday/Today (1975)

A video monitor in a public space displays a present-time view of the visual activities of a second, nearby room. This space is one having a characteristic presence in which the inhabitants' daily activities follow a defined routine with rhythmic periodicity related to a specific time of the day, where people discuss ongoing activities (informing an ongoing chronicle), and which imposes a definite modification in role, or of conciousness, upon someone entering it.

The visual scene on the monitor is accompanied by an audio playback of sounds, tape-recorded from the second room one day before, but at exactly the same time of the day. Two time continua, having a presumed same rate of forward flow, one sound and the other visual, can be observed separately or conjointly. The visual activities and the sounds may more or less phase rhythmically, overlap, or actually coincide. As the room is nearby, the spectator may directly enter its actual space if she or he desires. The installation may be repeated daily indefinitely.

(whereas a toilet in a public place is public as it allows multiple access, but is gender restrictive); the individual bedroom of a child or adult member of the family may be considered to be private at certain times. Moral sanctions are attached to violation of these codes. There are areas that reflect transitional social change. The taping of private conversations for public law enforcement is one area of unresolved claims between private (including interpretation of the

term, *private*) rights and public rights to effect justice or knowledge. The widespread use of video surveillance cameras involves similar moral/legal issues. The use of video would have social-psychological implications for the family structure: for instance, children being continuously observed through the use of a video camera by their parents, lose their right to be different in private, that is, to have separate public and private identities.

Video and Surveillance

Public corporate central city atrium spaces built into lobbies of corporate headquarters in mid-town New York and in other U.S. cities which were rehabilitated in the late 1960s and 1970s, are the new inner-city parks, plazas, and museum gardens. Ostensively these were attempts to humanize the areas adjacent to corporations' inner-city high-rise towers with social, park, and shopping and dining space, which had been lost as the central city had become dangerous and sterile in the 1960s. Garden plantings and solar illumination in these greenhouselike spaces demonstrated the image of the corporations' responsibility to the environment. The atriums owe their existence to a trade-off with the city, an exchange of public space for an allowance of more square footage the city permitted the developer to build.

As privately owned and maintained public sanctuaries, these spaces are kept under video and audio surveillance through the building's (generally) hidden electronic systems, as well as by uniformed guards.

Feature 4: Video View of Suburbia in an Urban Atrium (1979)

In the atrium of the Citicorp Building, an enclosed public space in the center of New York City, a continuously repeating sequence is seen on several video monitors. The casual viewer sees a house and its landscaped suburban setting. This sequence might suggest an advertisement for homes or videotapes of houses for sale done by real estate agents. Instead of viewers in their private home interiors seeing a view of public life in the city (while safely ensconced within their homes), a public viewer in the center of the city sees a television image of the exterior of a suburban house.

The atrium of the Citicorp Building is a patio-like seating area surrounded by various concessions selling coffee, desserts, and health salads. Real trees used with high-tech and breezeway suburban design—green-and-white metal openwork

chairs, green lettering on shop windows, the use of trees and earth all connote the suburban outdoors. Something of a vest-pocket urban park in a high-rise office building, Citicorp's atrium suggests suburban arcadia in the midst of the city. If the atrium's design represents an urban fantasy of the picturesque brought to the city center, the image on the monitors represents the actual suburban edge of the city.

The Citicorp Building's interior public atrium was intended to be the location for a series of video installations sponsored by video curator, Barbara London of the Museum of Modern Art. Although the show never materialized, my project was temporarily installed and recorded in August 1979 by Ernst Mitzka for German television in connection with the *Westkunst* exhibition.

The corporate atrium space became a way of competing with and paralleling the suburban shopping mall. As a large segment of the upper middle class moved back to the city from the suburbs, the atrium design was extended to include shopping and dining facilities, and it came to reflect suburban forms.

In the city, pure architectural forms are often modified or violated by applied verbal, pictographic advertising or corporate signs. The meaning in architecture relates as much to the signage (or the sequence of signs along a pedestrian or automotive street facade) as to the building as a self-contained form. Anne Rorimer, writing in the "Buildings and Signs" catalogue of my exhibition at the Renaissance Society at the University of Chicago and the Museum of Modern Art in Oxford, England, in 1981, related *Video View of Suburbia in an Urban Atrium* to another work, *Edge of the City:*

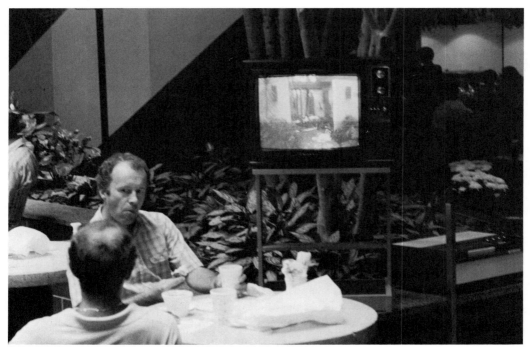

Dan Graham, *Video View of Suburbia in an Urban Atrium*, 1979.

DAN GRAHAM

The insertion of the monitors into the Citicorp context has double-edged significance, considering the fact that televised information is principally associated with viewing inside the home environment. Here, at the "core" of the city in a multi-purpose situation, the Citicorp frequenter comes up against an image of the exterior of a private home. Whereas Citicorp brings the natural elements of the suburb into the concept of its interior design fabrication, the video imports the view of an actual suburban home. The video image showing a real house rings truer in this case than does the artificial nature of the surroundings. The video as representation assumes an independent reality within the framework of the given environment.

Edge of the City, *related to the Citicorp piece, derives its meaning from its public setting—here the Philadelphia train station where Graham installed three television monitors directly under signs saying "Stairway to Suburban Trains" in the station concourse. Like the signs with which they align, the monitors, with the image of a car passing by a row of new suburban houses, visually announce the destination of the trains and of the viewers. The work, set within a public station, and not within a traditional art environment, signals the viewer to "make connections" between the dichotomies and contradictions of his present existence.*[3]

Signs in the Urban Environment / Video as a Sign

Video functions semiotically as an architectural and cultural sign of the urban environment.

Signs (Video) Atop Architecture

One sees a row of signs in sequence. Each sign stands out from the signs preceding and following it, having a prescribed, separate meaning in relation to the other signs that surround (and define) it in terms of its position. For a sign to convey meaning, it must conform to the general code shared by the surrounding signs and to distinguish itself from—establish its position relative to—other signs. Each sign depends ultimately for its meaning upon its position in relation to the others.

Venturi and Rauch's 1961–63 Guild Houses, inexpensive apartment-house block residences for older people sponsored by the Society of Quakers, appear at first glance to replicate the exterior facade of ordinary glazed brick postwar lower-income housing. More detailed inspection reveals applied ornamentation suggestive of the Renaissance and mannerist palazzo. There, an ornamental Greek and Roman mythological statuary was placed atop the roof, just over oversized entranceways. Similarly, above the Guild House, a large contemporary statuary was positioned on the roof above an oversized portal. This was an exaggeratedly large, gold-plated TV antenna. Its symbolism alluded to what Venturi saw as the major occupation of the residents inside; it

also related to the usual ornament atop postwar houses. This ornament ironically undermined the neutral, functional, unadorned "box" then favored by international-style modernist architecture, in favor of the "decorated shed" of main-street vernacular building in which a sign was added onto the functional box to give it semiotic meaning. There was an expressionist, ironic pathos (akin to poetry) in the symbolism of the building's main interior purpose for its users. Finally, the architect also wanted to acknowledge the real function of television in the cultural and family structure and as part of American domestic architecture and life. The TV aerial on the roof of the single-family house had begun to symbolize hearth and home as much as did the chimney.

In the 1970s, environmental concerns had produced a new cultural ethos. Conservation of natural resources would only be possible if individual members of the public were educated about local and global ecological environments. Venturi, Rauch, and Scott Brown's design for a science museum for a downtown location in Charlotte, South Carolina responded to this need for popular, site-specific ecological information. The plan used the outdoor building as sign. The museum's sidewalk display windows would have a "living exhibition" with a frieze "in the form of a moving electronic sign giving messages about ecological happenings in the world to passersby"[4] just above the window display. The museum's sides, entrance portal, and roof were all part of an enormously enlarged model—what, inside the usual museum, would have been a small-scale model geological strata of the surrounding South Carolina terrain. To the sides of the entrance, using the enlarged model of the strata as a simulated landscape, was what amounted to a small outdoor park. In one of the plans, a giant statue of a dinosaur, resembling "Dino the Dinosaur," the former symbol of the H. C. Sinclair Gas Company, was to be placed on the geological strata roof. The scale, height, and position of these signs—brought from what conventionally would be an interior museum display to the main street of a small-scale city—underlie the message of the ecology movement: Smaller scale, decentralized concentrations of populations, and the move toward an information, low-energy-consumption political economy was necessary. The scale and position of the museum as sign gave the ecological information on the electric sign a great prominence, which effectively competed with commercial advertising displays meant to be seen from an auto.

Video as Architectural Mirror and Window

Video in architecture functions semiotically as window and mirror simultaneously but subverts the effects and functions of both. Windows in architecture mediate separated spatial units and frame a conventional perspective of one unit's relation to the other; mirrors in architecture define self-reflectively spatial enclosure and ego enclosure.

Feature 5: Video Piece for Showcase Windows in a Shopping Arcade (1976)

This video piece takes place in two facing and parallel shop windows, located in a modern shopping arcade where people pass through the arcade between the two windows.

Each shop-window showcase contains a mirror on its back wall, opposite and parallel to the window. This mirror reflects what is inside the showcase and the view through the window. This view through the window includes the reflections on either side of both windows, the interior of the other window, and the spectators (shoppers) passing in the arcade between the two facades.

Both shop windows have monitors placed in the front of the showcase near the window. The monitor within the left showcase faces outward toward the window; whereas the monitor within the right showcase faces inward toward the mirror. The camera on top of the left monitor faces inward toward the mirror; whereas the camera on top of the right monitor faces outward toward the window.

The view from the camera in the left showcase is transmitted live to the monitor in the right window; but the view from the camera in the right showcase window is transmitted five seconds delayed to the monitor in the left window.

The showcase window either can be empty or contain normal product displays. It may be possible for spectators to enter into the showcase window if it is part of a store. These details depend upon the specific situation of the piece's placement.

A mirror's image optically responds to a human observer's movements, varying as a function of his or her position. As the observer approaches, the mirror opens up a wider and deeper view of the room environment and magnifies the image of the perceiver. By contrast, a video image on a monitor does not shift in perspective with a viewer's shift in position. The mirror's image connects subjectivity with the perceiver's time/space axis. Optically, mirrors are designed to be seen frontally. A video monitor's projected image of a spectator observing it, depends on that spectator's relation to the position of the camera, but not on his or her relation to the monitor. A view of the perceiver can be transmitted from the camera instantaneously or time-delayed over a distance to a monitor which may be near or far from the perceiver's (viewing) position in space or time. Unlike the flat visuality of Renaissance painting, in the video image geometrical surfaces are lost to ambiguously modeled contours and to a translucent depth. Mirrors in enclosures exteriorize all objects within the interior space, so that they appear on the mirror as frontal surface planes.

In rectilinear enclosures, mirrors create illusory perspective boxes. The symmetry of mirrors tends to conceal or cancel the passage of time, so that the overall architectural form appears to transcend time, while the interior area of the architecture, inhabited by human movements, process, and gradual change, is emptied of significance. As the image in the mirror is perceived as a static instant, place (time and space) becomes illusorily eternal. The world seen on video, by contrast, is in temporal flux and connected subjectively to (because it can be identified with) experienced duration.

Video Feedback Systems I

Through a videotape loop time-delay video feedback system, viewers can see their images replayed almost immediately on the monitor. Thus their self-images of their behavior are connected to their inner mental states of consciousness—to their intentions. This removes self-perception, as in the mirror image, from the viewing of a detached-state image of self. Instead, feedback creates both a process of continuous learning and also the subjective sense of an endlessly extendible present time in flux, an interior time connected to an unfixed future goal and continuous reexperienced immediate past. Early video artists, such as Paul Ryan, compared the video feedback process to the topological moebius strip:

A moebius strip is a model for the power video-tape gives to take in our own outside . . . (and) avoid . . . Servo-mechanistic closure. One can learn to accept the extension out there on tape as part of self. There is the possibility of taking the extending back in and reprocessing over and again on one's personal time wrap.[5]

Soft Furniture Design and Video Feedback

Soft, topological, inflatable furniture from the late 1960s paralleled, in the sense of body feedback and in the correlation of subjective and objective psychophysiological states, the self-referring mental consciousness induced by video feedback. Pneumatically inflatable plastic furniture constructed from topological forms was thought to unite tactile body sensations and internal mental states. Soft furniture could function as a model of a new consciousness within, inside, or outside or the separation of bounded individual ego from group experience:

Consciousness might be invested in . . . soft control systems using plastic membranes where awareness is immanent in the structure and its relation to its users. A (topological) Kleinform couch is a possible way of moving in that direction. It could be built of strong polyurethane, filled with air. People might interrelate kinetically through the changes in the air pressure.[6]

Dan Graham, *Video Piece for Shop Windows in an Arcade,* 1976.

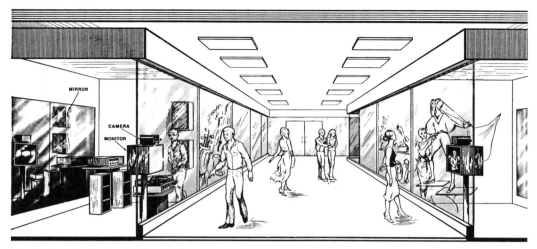

Dan Graham, *Video Piece for Shop Windows in an Arcade,* 1976.

Soft Furniture and TV

Artist John Chamberlain's exposed foam rubber couches have an effect similar
to that of inflatable furniture; kinesthetic body sensations equate to the sense
of the state of consciousness of the sitter. This feeling is distinct from the
merely visual, traditional position of the viewer's ego, observing the design or
art form. Foam rubber has a humanlike feel. As it is usually used for the un-
derpinning of chairs, mattresses, or couches, foam rubber is rarely experienced
as a visual surface alone; rather it is experienced as tactile, cool, or warm, by
the body surfaces and internal musculature.

By eliminating the usual leather, rubber, or cloth covering "skin," and
using raw foam rubber exposed to air, Chamberlain's chairs and couches even-
tually flake off at the surface. This built-in obsolescence relates them to late
1960s pop art and architectures's notion of the disposable. They ironically took
the modernist aesthetic of reduction one step further. A Mies van der Rohe
chair or couch, despite its look of having reduced itself to other has material
means of support that still hides a body-supporting material (such as rubber)
beneath its surface. The raw foam rubber surface of Chamberlain's furniture re-
veals this.

Unlike film, which is watched in a darkened space by viewers sitting on
individual chairs, television is usually viewed in groups in a family or family-
like setting, most commonly in the living room and most usually on a couch
or comfortable chair. Chamberlain combined the television-viewing context
with his foam rubber furniture in an installation for the large *Westkunst* exhibi-
tion in Cologne, Germany in 1979. An oversized foam rubber couch with two

televisions placed on opposite ends allowed groups of visitors comfortably to sprawl on the oversized couch/"sculpture" and watch a video program. Joining the TVs to the ends of the couch resembled the coin-operated TVs attached to chairs in the waiting rooms of many U.S. bus stations. The exhibition was a survey of the period in Western Europe dominated by American art from the end of World War II until the end of the 1970s. At first glance, the video images appearing on the screens of Chamberlain's TV couch seemed "All-American"—fast-paced TV commercials depicting the good life of the "American Dream." But this initial impression was ironically contradictory; on closer inspection, the viewer recognized that each of the TV commercials was an unusable "take" from commercials that had to be redone before being broadcast. Each "blooper" or bad take revealed, unconsciously, the ideologically determined conventions that construct the advertising industry's artificially engineered version of the American consumer's "dream."

Video as Social-Psychological Model

Portable video equipment, which became widely available for university use in the 1960s, was used initially in teaching and research studies by psychologists, sociologists, and anthropologists. Informal social groups were recorded and the results immediately replayed to give the subject(s) feedback of their behavior. Video feedback was also used in teaching psychologists and social workers about their skills in interacting with patients. Similarly, field anthropologists would take notes through video and replay these "studies" with (for) their subjects. At the same time, the anthropologists would be able to see their own behavior in terms of whatever cultural/scientific biases they imposed on the sit-

Feature 7: Two Consciousness Projection(s) (1972)

A woman focuses consciousness only on a television-monitor image of herself and must immediately verbalize (as accurately as possible) the content of her consciousness. The man focuses consciousness only *outside himself* on the woman, observing her objectively through the camera connected to the monitor. He also verbalizes his perceptions. The man's and the woman's self-contained conscious, unconscious, or fantasized intention—*consciousness*—is projected. The audience sees on the video screen what the man and woman "objectively" are seeing at the same time they hear the two performers' interior views.[a] Because of each of the performer's different time-process of perception, verbalization, and perception-response to the other's verbalization, there is an overlap of consciousness (of the projections of each upon the other). Each one's verbal impression, in turn, affects the other's perception: the man's projection on the periphery of the woman's affects her consciousness or behavior.

A field is created in which audience and performers place reciprocal controls on the other. The audience's reactions to the man's responses (his projection of the woman) may function for him as a superego, inhibiting or subtly influencing the course of his behavior or consciousness of the situation. Likewise, the man's responses on the periphery of the woman's consciousness interfere with her self-consciousness so that her behavioral responses, including those of self-perception, may be subconsciously affected. Each of the three elements functions mutually as a feedback-device governing behavior—a superego, or subconscious to the consciousness, and response of the others. An abstractly presupposed psychological[b] (or social) model is physically observable by the audience. The specific results of the piece vary according to the context in which it is performed, with changing historical circumstances, locale, or use of different social classes of audience or actors.

a. While an audience might initially assume that the woman was being made into an object, it becomes apparent that her position is more powerful than the man's, as her subject and her object are *not* separated (separable). Whereas, the more the man (to himself) strives to be objective, that much more does he appear unconsciously subjective to any observer from the outside (the audience).

b. The Freudian axiom that one person is always projecting himself or herself into his or her observation of a second person.

c. Imposed behavioral (psychological) differentiations between men and women.

uation. Video replay enabled social scientists to discern the way in which their own "objective" observations actually reflected their "subjective" observation point and position as an interacting participant. The goal was for both the subjects and the scientist to use the experience through the mediation of video feedback as a learning process.

Various early video works of mine were presented informally in art schools as part of teaching situations as "performances" involving the largely student audience. I used sociopsychological models as underlying schemata. These "scientific" models also referred to art and art-critical positions often cited as theoretical supports for art-making methodology at the time. Lacanian psychology, feminism, and phenomenological description were examples of such theoretical positions.

Video Feedback II

When observers see their image immediately, continuously replayed on the screen through videotape loops, their self-images, by adding temporality to self-perception, connect their self-perceptions to their mental states. This removes self-perception, as in the mirror image, from the viewing of a detached, static image. The feedback creates both a process of continuous learning and the subjective sense of an endlessly extendible present time in flux, but without a fixed future or past states. In general, feedback was defined (by von Bertalanffy) as "a circular process where part of the output is monitored back, as information on the preliminary outcome of the response, into the input, thus making the system self-regulating . . . a feedback mechanism can 'reactively' reach a state of higher organization owing to 'learning' information fed into the system."[7]

In the situation of watching/being part of a video feedback loop, there is no longer any split between observed (self) behavior and supposedly unobservable, interior, mental intention. When the observer's responses are part of and influencing their perception, the difference between intention and actual behavior as seen on the monitor immediately influences the observer's future intentions and behavior. Two models of time are contrasted in Present Continuous Past(s), the traditional Renaissance perspective static present-time, which is seen, in this work, as the (self) image(s) in the mirror(s), *and* the time of the video feedback loop.

Use of video time-delay in conjunction with the mirror allows the spectator to see what is normally visually unavailable: the simultaneity of his or her self as both subject and object. As Huebach has noted, a spectator realizes her/himself as acting and acted upon: in causing a reflection and at the same time finding the self reflected, he/she divides into subject and object, into an aware-

Feature 8: Present Continuous Past(s) (1974) Collection: Musée National d'Art *rt*
Moderne, Centre Pompidou, Paris

The mirrors reflect present time. The video camera tapes what is immediately in front of it and the entire reflection on the opposite mirrored wall.

The image seen by the camera (reflecting everything in the room) appears eight seconds later in the video monitor (via a tape delay placed between the video recorder, which is recording, and a second video recorder, which is playing the recording back).

If a viewer's body does not directly obscure the lens's view of the facing mirror the camera is taping the reflection of the room and the reflected image of the monitor (which shows the time recorded eight seconds previously reflected from the mirror). A person viewing the monitor sees both the image of himself or herself of eight seconds earlier, *and*

what was reflected on the mirror from the monitor eight seconds prior to that—sixteen seconds in the past (the camera view of eight seconds prior was playing back on the monitor eight seconds earlier, and this was reflected on the mirror along with the then present reflection to the viewer). An infinite regress of time continuums within time continuums (always separated by eight-second intervals) within time continuums is created.

The mirror at right angles to the other mirror-wall and to the monitor-wall gives a present-time view of the installation as if observed from an "objective" vantage exterior to the viewer's subjective experience and to the mechanism that produces the piece's perceptual effect. It simply reflects (statically) present time.

ness and an image. The image separates the individual, but is it he/she who forms the image or is it the image that describes him/her?[8] A premise of 1960s modernist art was to present the present as immediacy—as pure phenomenological consciousness without the contamination of historical or other a priori meaning. The world could be experienced as pure presence, self-sufficient and without memory. Each privileged present-time situation was to be totally unique or new. My video time-delay, installations, and performance designs use this modernist notion of phenomenological immediacy, foregrounding an awareness of the presence of the viewer's own perceptual process; at the same time they critique this immediacy by showing the impossibility of locating a pure present tense.

Feature 9: Musical Performance and Stage Set Utilizing Two-Way Mirror and Time-Delay: A Collaboration with Glenn Branca (1983)

An earlier performance set design involving video and a two-way mirror screen done in collaboration with the composer Glenn Branca involves both the performers' and the audience's self-awareness of their perception process. *Musical Performance and Stage Set Utilizing Two-Way Mirror and Time-Delay* was presented in 1983 at the Berne Kunsthalle as part of a Dan Graham exhibition.

The audience is seated on the right; the three musicians are on the left arranged in a triangle with Branca at the front or apex. Audience and performers face a wall-sized two-way mirror. Behind this two-way mirror is a video monitor, whose image is luminescent enough to be seen through the mirror. The monitor image displays a view of the entire space. Its image comes from a camera mounted behind the two-way mirror, next to the monitor. A tape delay system causes the image to be delayed six seconds in the past.

The musicians must look toward the two-way mirror for cues from each other. They also may look to the six-second delayed image as a compositional metronome.

The audience's best view of the musicians comes from looking at the mirror and monitor projecting behind it. They see other members of the audience gazing as well as their own looks. When the musicians look toward the mirror image to see other musicians playing or to see the six-second delayed video, the audience's views are placed between the intersubjective gazes on the three musicians.

Future in the Just-Past

Memory of the past (in the present) is dependent upon each unstable moment's projection of an anticipated future. This future is not certain or determined, but only a set of changing probabilities. The present moment is nothing but a series of fragmented memories of the past that gain meaning by their projection into a possible future. There is a link between futurology and archeology. *Past Future Split Attention* is a performance exercise related to R. D. Laing's theory of the "divided self" (current in 1972) and an extrapolation of the effect of the video feedback loop in a videotaped performance situation.

Historical Memory

My goal in recent video works, such as the 1983-86 *Rock My Religion,* is to restore historical memory. My intention is in opposition to the historicist idea

Feature 10: Past Future Split Attention (1972)

Two people who know each other are in the same space. While one person predicts continuously the other person's future behavior, the other person recounts (by memory) the other person's past behavior.

Both are in the present, so knowledge of the past is needed to continuously deduce future behavior (in terms of causal relation). For one to see the other in terms of present attention there is a mirror reflection (of past/future) cross of effect(s). With one's behavior being reciprocally dependent on the other, each's information of his moves is seen in part as a reflection of the effect their just-past behavior has had in reversed tense as the other's view of himself. For the performance to proceed, a simultaneous, but doubled attention of the first performer's 'self' in relation to the other('s impressions) must be maintained by him. This effects cause-and-effect directionality. The two's activity is joined by numerous loops of feedback and feedahead words and behavior. This is made into a videotape.

that everything we know about the past is dependent upon the interpretation of the fashion of the present. In historicism there is no real past, only an overlay of interpretations or a simulation of the past. In opposition to this notion of history as a simulation, there is possible the idea of an actual, although hidden past, mostly eradicated from consciousness but briefly available in moments not obscured by the dominant ideology of newness. This myth of evernew is linked to the role of the commodity. Commodities produce a dream of eternal newness—which devalues and makes antiaphrodisiacal and amnesiacal the period of time just prior to the newest present. It devalues and cuts off connection with the implications (of unfinished ideas and projects) associated with the commodities of this just-past period. The mythic dream produced by the new commodity—the dream of eternal "progress" in the near-future—is never achieved, for it is always superseded by next "new."

The Rio Experience:
Video's New Architecture Meets Corporate Sponsorship

Dara Birnbaum, *Rio Videowall,* 1989.

THE PULSE OF PEACHTREE: Developer Charlie Ackerman says Rio "will hit town like a wired rock band. . . ."

—Ron Hudspeth, *The Atlanta Journal-Constitution,* February 1987

Although it hasn't yet broken ground, Rio has already made waves: for its central plaza, Rio's owners have commissioned the nation's first large-scale, outdoor, permanent and architecturally integrated work of video art.

—*The Atlanta Journal-Constitution,* May 1987

This is a genuinely important event in art history. This is the first time a commercial enterprise has made use of monumental video and video art not as a piece to plop down into a mall but rather a central element in the design of the architecture.

—Linda Dubler, Curator, Film and Video The High Museum, Atlanta

Although the use of media arts in public spaces has been increasing, the commissioning of a piece of this scale for permanent installation "is really a first," according to John Hanhardt, Curator of Film and Video Art at the Whitney Museum of American Art.

—Catherine Fox, *The Atlanta Constitution,* February 3, 1987

"The Rio Experience," provides a chronology of the various stages, both in terms of design and the surrounding legal agenda, involved in the production of the permanent video installation, *Rio Videowall,* whose production started in 1987 and was completed in 1989, for Ackerman & Company at the newly developed Rio Shopping Complex in Atlanta, Georgia. It is hoped that by delineating the changing concepts, definitions, and decisions that occurred after my design was originally accepted, the reader will better understand the needs and requirements of such a work, including the complex contractual negotiations involved. For it is only with a clearer understanding of the issues raised at this particular intersection of the worlds of art and commerce that future collaborations between the media arts and commercial developers can work successfully.

Background/History

Summer 1986

Some friends had brought me to a club in San Francisco where I saw video art in operation for the first time. It was 2:00 in the morning and I'm looking at this thing, I'm mesmerized by it . . . 30 seconds later I said "this must be in Rio!"
Charles Ackerman, Developer

The idea of including a permanent outdoor video installation in the overall design of the Rio Shopping Complex was initiated by its developer, Charles Ackerman.

Previously Ackerman "was among the first Atlanta developers to decorate office parks with outdoor sculpture"[2] and was now seen as turning to a new art form for his proposed Rio retail/entertainment complex. His proposed commitment to placing a permanent public artwork of large scale, with video as its featured element, into a public plaza was seen as unprecedented in the United States.

Late Summer 1986

Ackerman & Co. had not previously been exposed to the range of videoworks now being produced by artists and independents, nor did there seem to be a realistic vision of how video would physically fit into the Rio shopping center either

Robin Reidy, then Executive Director of IMAGE Film/Video Center, a nonprofit center for artists based in Atlanta, was consulted by Ackerman during the first drafts of the project.

At the suggestion of Reidy and others, Ackerman agreed to privately finance an open international competition. In order to accommodate the relatively short time line of

*as an installation or simply
as a series of monitors/video
theater.*[3]
Robin Reidy,
Executive Director,
IMAGE Film/Video

the project, self-funding became a necessity. The effect of this arrangement was to then strengthen Ackerman's ability to exert sole control over how the winning project would be executed.

IMAGE FILM/VIDEO CENTER
75 Bennett St. Suite J-2
Atlanta, GA 30309

CALL FOR ENTRIES
INTERNATIONAL COMPETITION FOR PERMANENT OUTDOOR VIDEO INSTALLATION & TAPES
Co-sponsored by Ackerman & Co., the Arts Festival of Atlanta, and IMAGE Film/Video Center

Ackerman & Co., a major Southeast developer, is planning a unique shopping and restaurant complex called Rio, designed by the internationally-reknown architect firm Arquitectonica. Rio, an outstanding example of a festival-type shopping and entertainment center, will be built in Midtown Atlanta, with a projected opening in Spring, 1988.

Ackerman & Co. is co-sponsoring, with the Arts Festival of Atlanta and IMAGE Film/Video Center, an international competition to select artists to (1) design and produce permanent outdoor video installations for Rio's central plaza, and/or (2) produce original single-channel videotapes that will be exhibited in outdoor video viewing booths at Rio. Panelists will give preference to works that include an interactive element in the design, including videodisc. In addition, the winning artists and their designs will be presented at the 1987 Arts Festival of Atlanta.

This contest consists of two phases. PHASE I is an open call for entries which any artist can enter. PHASE II is invitational, where selected artists from PHASE I will present their proposals. A panel of five experts will oversee both phases.

WHO SHOULD ENTER?
1. Artists who wish to design and produce a permanent outdoor video installation with an emphasis on some form of interactivity.
2. Artists who wish to produce an original single-channel videotape for display in an outdoor exhibition area.

Original call for entries for international competition for permanent outdoor video installation and tapes, Winter 1987.

Fall 1986

*The audience will be people
who never had any experience
with art, or a limited experi-
ence . . . and this will be-
come a major focus of their
attention. . . . They're going
to take it in very virginally,
so to speak. . . .*

I think it's important that

IMAGE Film/Video was to administer the competition, with Reidy assisting Ackerman personnel and the artist(s) with the production of the winning proposal(s). An initial budget totaling $125,000 was to cover the total costs of the competition and the creation of one or two permanent, outdoor video installations at Rio. A panel of four experts in the arts was selected to form the jury for the international competition (Linda Dubler, Curator, Film and Video of Atlanta's High Museum; Patricia Ful-

the artist understands the context of this whole project, because they've got to know the power that we're trying to create here—and I think that word is very important—because we've used some phraseology like "electric." We want this project to create the feeling of power and high-energy and electric quality. . . .

There is a whole new culture that is just beginning to evolve, and it is really in that age group, of twenty to thirty-five. . . .

We want to touch it and we want to be able to penetrate into the subconscious of these people and then draw them out by saying: "Hey, this form, this expresses your emotional feeling about where life is today!" . . . There aren't many places where people can express that. . . . It's a language that remains unexpressed. . . .[4]
Charles Ackerman, Developer

ler, Public Art Consultant; John Hanhardt, Curator, Film and Video at the Whitney Museum of American Art; and Robin Reidy Executive Director of IMAGE Film/Video). Two rounds of competition were held (September 1986 and March 1987). In the second round, each of the finalists was presented with a short video-document of the initial meeting that was held with the developer, architect, and judges who discussed and defined the parameters of the project.

Ackerman emphasized the relationship of the video art to the sociological and cultural context of Rio. He abstractly described his vision of how visitors would pass through a densely landscaped "video forest" with the video installation as the main landmark of the center, replacing the "anchor" department store as a major reason to visit Rio. He envisioned the installation as capable of drawing visitors into the space and eventually even expressing their emotional feelings about the world! In other words, Rio was to be a *state of mind* :

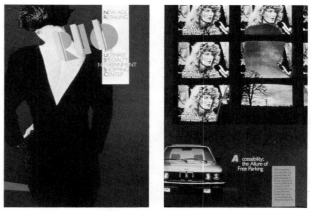

From publicity for Rio Shopping/Entertainment Complex, two photographs, 1988.

Bernardo Fort-Brescia, of the architectural firm Arquitectonica, delineated the design concept for Rio as *"a microcosm of what the city center would be . . . like a stage-set of what the city could be transformed into."[5]* According to Martin Wander, Vice President, Arquitectonica, *"We are creating a focus which is like something you have never seen before . . . expect to have all your senses bombarded, including smell and touch. . . . Rio is a small city . . . and a real exciting entertainment space."[6]*

The judges on the other hand, emphasized the importance of what they saw as a unique collaboration, at the planning stage, among the developer, architect, and artist. It was noted that the artist would be given equal importance to the developer and architect yet the artist was still expected to accomodate the specific needs of this commerical development.

Proposals Due by Finalists in Competition, March 5, 1987/Commission Awarded, May 1, 1987

In the final selection round several of the finalists emphasized that the originally assigned budget of approximately $35,000 per installation was too limiting. The judges then determined that funds could be made available to commission only one of the proposed video installations at $70,000.

Siting of *Videowall* in plaza as indicated on the architectural plans, 1989.

Dara Birnbaum, drawing for proposal of 3 × 3 grid: landscape imagery, 1987.

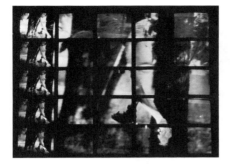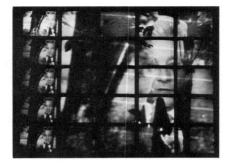

Dara Birnbau, Close up of *Videowall*, 1989.

Winning Entry—
Installation as Described
in Final Round of
Competition and Contract

The installation consists of twenty-five monitors, each approximately 27" diagonally, placed in a grid system of five by five. The unit is supported by metal framework which situates the grid at a level of approximately four to five feet from the ground level of the center square/plaza area of the mall. The entire unit is to be a floating wall. The twenty-five monitors will be fed with two different sets of imagery/information. One set of visual imagery will be broadcast and/or cable news. The source of this news imagery may be a direct feed from one, or several, cable, satellite, or broadcast news stations. This would be the news of the moment, just as it is broadcast, without any delay or prerecording. The second set of visual imagery will be images of landscape, specifically from the site, before construction, on which the Rio shopping mall is now placed.

It is possible to interrupt one set of visual information, such as the landscape imagery, by means of a "key-hole" which would then admit live satellite-transmitted images of the news. The "landscape" images were recorded in May, 1987, directly on the site of the Rio shopping mall, before its construction, and thus depict some of Atlanta's indigenous natural landscape. News information will be keyed into this landscape imagery by (via) the activity of a pedestrian's body crossing in front of a live camera. The forms (silhouettes) of such pedestrians/shoppers will become a "key-hole" which allows for a hole to be cut into

Dara Birnbaum, Electric light box, used as backdrop for key element, entryway, Rio Shopping/Entertainment Complex, April 1989.

the landscape "natural" imagery, which is then filled by the news. This process produces a continuously changing flow of imagery.

In keeping with the traditional role and function of the shopping square, as a daily public meeting place and a potential center of community activity, the installation would serve, in part, landscape as atrium (Citicorp, etc.) and, in part, as an information system comparable to the role of an electronic kiosk, or urban news reel. Here large groups of people, in the midst of daily activity, can look to find fragments of the news of the moment, in its non-repeatable role of the instant headline or bulletin. The model for this installation was the set of two, twenty-five monitor systems designed for and in place at the nightclub Palladium, in New York City. In a similar way the monitor banks at the Palladium become a central focus and attraction of the particular place, and the viewing of them becomes interwoven with the other activities of the club. The size and scale of the system allow the experience to reach architectural proportion and this becomes significant in determining the entire feel and experience of the particular place.

The use of on-going transmissions of the Atlanta-based Turner Cable News Network, and/or other (cable or broadcast) news, re-asserts television's historic ability to deliver instantaneous, of the moment, broadcast information. By definition these news images, which I believe should be ever present in our environment and exposed during our daily activities, are "non-repetitive." Atlanta's history, as home of CNN/Turner Broadcast, is especially intertwined with this historical development by having furthered the forms of news broadcasting. The images for the landscape section will be treated, aestheticized and intensi-

fied through processes such as slow-motion and re-framing. It is this treatment which allows the material to describe a video-art or art world use and codification of video, as opposed to the language of television exemplified by broadcast and/or cable news. Lastly, the application of the interactive ability of this particular medium, the ability to engage a viewer in terms of a simultaneous temporal and spacial exchange, is seen through the use of the interactivity of the keying mechanism.

The installation is also meant to align itself with the attempt made by the architect and the landscape architect to bring some element of the natural landscape into the urban environment. The images used here will create an "electronic memory" of the exact site upon which Rio is built, resurrecting the landscape which was existent before construction. This will directly acknowledge where the shopping mall itself entered into the landscape and fabric of Atlanta.

Dara Birnbaum, Site before construction, April 1987.

The recognition of a direct relationship between the work's function, its potential audience, and the mall site in general, have motivated me to conceive of an installation that would not only be about the particular contemplative space usually afforded by video art, but which would become a more active component of the mall. The installation demands no prescribed viewing time in terms of a cycle of beginning, middle and end. Instead, it is continuously being made in terms of its content and its information. This seems essential in such an environment both because of the flux and constant change of activity within the shopping mall itself, and because of the installation's permanence. It is my intention that the installation should become an active and functional component of the shopping mall, and provide a pivotal point for its activity.[9]

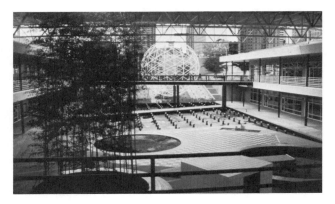

Dara Birnbaum, View of Plaza, (*Videowall* to be placed at right), August 1988.

Contract Negotiations/Definitions

The "Art" is comprised of computer software, laser discs, and master tape.
Contract draft (11/18/87)

1. Art. The art (hereinafter referred to as the "Art"), consists of the video artwork described in Exhibit A.... The Artist shall use her best efforts to deliver the edited master video disk and software and other items comprising the Art and one (1) copy of the disk comprising the Art to the Purchaser, on or before the "Art Delivery Date."
Final Contract (6/3/88)

The parties acknowledge and agree that the Art is a "work for hire" for all purposes under the U.S. Copyright Act and related Federal and State laws, and the Purchaser has commissioned the artist to create the Art and to provide the Services specifically for the Purchaser. . . . To this end the Artist hereby assigns to the Purchaser all right, title, and interest, including without limitation, all copyrights and moral rights. . . . The Art, upon delivery to Pur-

My first conflict with the developer appeared during our contract negotiations and centered on our differing definitions of what constituted the "Art" in the work that I was constructing at Rio. Originally, Ackerman & Company (hereinafter referred to as "the Purchaser") saw the artwork as consisting solely of the software package. This, of course, disregarded the fact that the project was to be site–specific. By confining the definition to a software package, the Purchaser felt that they had the right to display the Art on any of their other property. They argued that had this been a painting surely they would have the right to hang it wherever they pleased. An important "winning point" for the artist, within the final contract, is that the definition of the "Art" includes the artist's original proposal as defined in the final round of competition and it includes the specific relationship that

chaser, shall become Purchaser's sole property, without limitations to time or territory."
Contract draft (11/18/87)

*Whereas, Artist desires to create and license to Purchaser and Purchaser desires to receive a License from Artist for Artist's said video artwork, which was selected by the panel of experts, and to obtain the Artist's services relating to aspects of the construction, installation and exhibition of the video art in the shopping mall plaza, all as more fully set forth below:
. . ."*

*6. Transfer of Rights.
(a) The Artist, in consideration of Purchaser's payment in full of the Artist's Fee and the Production Fee, hereby grants to the Purchaser, throughout the State of Georgia, the perpetual right and license to (a) exhibit the Art in a single location only within the State of Georgia at any one period of time. . . ."*

6.(b) . . . The Artist shall retain all copyrights and moral rights in the Art, and Artist agrees to secure, register, renew and extend all such copyrights, and to take or to cause others to take all reasonable steps to protect all such copyrights from infringement by authorized parties. . . .
Final contract (6/3/88)

the work provides between the shopping complex, the site, and the video imagery.

This basic disagreement over the definition of the Art signaled the basis for the lengthy period of negotiation yet to come. Additional disagreements included an important battle over copyrights to the completed project: to whom did the Art belong? The position of the artist was that the completed project was to be "licensed" to the Purchaser without assigning the copyright to Ackerman & Company. Since I was left with no representation from the original art organizations participating who would advocate my position, nor did I have the expertise and power to forcefully cite other contractual precedents for sculpture in public spaces, Ackerman & Company could assume, without opposition, that they were entitled to the copyright.

Clearly, part of the confusion resulted from Ackerman & Company's understanding of contractural engagements as they related to the building trades rather than to the arts. For example, looking at this project as a "work for hire" similar to the way other jobs might be "contracted out" could have easily caused them to confine their definition of the "Art" solely to the material product in difference to the site–specific and inter–active nature of the work.

What their model did not account for was the important fact that I had been "hired" to construct a plan *and concept* for how the work was to engage its environment; "Art" as an *independent* statement/critical dialogue rather than a suitable commercial product designed *for the employer.*

Dara Birnbaum, *Videowall,* 1989.

Logistics

It became immediately evident to me that a "team" would be needed to develop and carry out a project this technically and logistically complex. I decided it would be best to work through Crawford Communications, a post–production facility based in Atlanta, which had an existent "on-line" (artists reduced rates) program and whose president was on the board of IMAGE Film/ Video, suggestive of the fact that he might be more supportive of my position in the arts. In addition, Crawford Communications was actively involved with video disk production, a necessary component of the artwork. Their director of Draw Disc Services, John Mabey (who initiated their "on-line" program), agreed to become directly involved with the project, initially serving as a consultant and later becoming technical producer. However, because of the huge technical, logistical, and legal implications, an engineer was also hired. This team then worked with Robert Foah (Atlanta Audio/Visual), hired by Ackerman & Company as vendor for the system, and as an additional consultant.

It was originally assumed that low-cost production assistance could be arranged for through contributions from supporters of the non–profit arts sector, particularly in Atlanta, since Robin Reidy as Executive Director of IMAGE Film/Video, was originally to act as producer of the project. However, Reidy dropped out of the project within the first few months, and as a result, I was forced to concurrently take on the roles of artist, producer, and project supervisor since no attempt at replacement of the producer had been made by either Ackerman & Company or Reidy herself. This situation presented numerous difficulties. I had entered into the project assuming that my interests as an artist would be represented by IMAGE Film/Video, a nonprofit arts organization, as well as securing representation within Ackerman & Company, and that this would facilitate my dealings with the developer, the architect, and the necessary video production facilities. With the loss of this support I was directly assigned the tasks of organization and proper representation in addition to creatively producing a work.

Outcome of Reorganization: Need for a Producer, New Definitions, and a Fight for a Common Language

The original intent for this project was for there to be a "marriage" between the two interests: the arts and the commercial sector. What developed, however, was the emergence of two distinct, and often incompatible, sets of expectations. It is clear that much of this confusion could have been mediated through the role of a strong producer, who would have articulated and fought for the needs of the artist and then articulated those needs in relation to the desires of the client. In the gap created by the absence of such a facilitator and promoter, there was left the conflict on such diverse issues as: legal advice, promotion, mediation, agreement on organization of schedules, fund-raising and the solicitation of additional support necessary for the successful completion of the project, and an educated spokesperson for the interests of the artist/arts.

The sources for the terms used by Ackerman & Company related to their prior experiences as developers and was appropriate to their dealings with labor unions, vendors, trades people, and so forth. This terminology, including the legal agenda, was built around the concept of "work for hire" but was inadequate for expressing the more complex relationship to the artist. Thus, the devel-

Dara Birnbaum, Original architectural model
of Rio Shopping/Entertainment Complex as
presented to finalists of Rio Video Competi-
tion, April 1987.

opment of a common language surrounding the work
became increasingly important. This was further compli-
cated by such issues as cash flow and the ability, or not,
for an independent artist to represent oneself in business,
especially *financially*. Here the artist's position differs
from that of, for example, the architect's, because there
is no organization or company to absorb costs, even tem-
porarily. This places the artist in the position of indepen-
dently supporting such needs or independently forging
an adequate financial arrangement with the corporation.

In the art world, a work of art rarely is considered to
have an actual *commerical* value. Its monetary worth is rel-
ative—dependent upon the economy and current trends
in the art market. However, in the Rio project, the situ-
ation was different since the video installation was seen
as a potential source for measurable revenue by attracting
customers to the mall. When viewed in this way (as a
unique advertisement gimmick), Ackerman & Company
could quickly see the advantage of being able to run
commercial programming through the videowall in addi-
tion to the "Art." It was because of these two facts that
in a January draft of the contract, Ackerman and Com-
pany introduced as a condition for possible termination

of the Artwork: "failure to generate satisfactory operating profit."

Development of Some Possible Conclusions

An imbalance occurs when an independent artist engages in a complex set of interactions with a large commercial corporation. This opposition should not be taken for granted. It is well reflected here by the complex set of contractual negotiations that made blatantly apparent differing definitions of wants, needs, and desires. The artist, if unrepresented by an organization with sufficient resources and muscle to match that of the corporation, truly remains an *independent*. The artist is thus isolated and without financial resources, legal advice, aesthetic or contractual advocacy. The result of this dilemma was that the *Rio Videowall* remained in a gray area, unable to receive the benefits afforded to a noncommercial art endeavor, while at the same time, unable to attract the kind of financing appropriate to most commercial undertakings. The original budget for the project had been defined in relationship to "Art," but it was unable to gain the benefits of lower "artists' rates" once the producer, representing the nonprofit arts sector, dropped out. Lacking nonprofit arts representation, the costs became those of a commercial undertaking with the result that the price for services such as post–production escalated far beyond the original estimates. In-kind services and the hopes of donated equipment also disappeared. Unfortunately, mechanisms were not immediately in place to deal with the financial problems created by an art project let loose in the commercial sector.

As an artist still involved in the final stages of resolving a complex marriage between video art and real estate/commercial development, a central question still remains to be answered: Can commercial money and sponsorship give to the artist involved with video—a culturally loaded and complex form, given its contemporary historical context and its immediate cultural *and* industrial usages—the ability to create *independent* and *critically responsive* statements that work and function differently in terms of their goals from the limitations imposed on them by commercial ventures alone?

The nature of the video medium itself, and the con-

texts it has become known in and developed through, have clearly informed the working process throughout this project. In addition to the problematic nature of a project with this broad a base, and the complex level of a collaboration needed from the various sectors involved, this project also points to the place where work of this kind can be most successful. It delineates what the possibilities of that success are and focuses attention on an area into which video, because of its broad base, has the potential to move. It is exactly its placement within divergent interests and applications that initiated the Rio project and motivated the artist to become involved in a situation where the possibilities of production, in terms of costs and in terms of placement within a different kind of space (not television, not exhibition space, but a placement that could call on video's applications in these spaces), were available.

The judges discussed the importance of this unique collaboration between developer, architect, and artist at the conceptual stage, rather than after the shopping center was already built, noting that the artist was given equal importance and expected to take into account the specific needs of a commercial development as well as those of the architect.[10]
Robin Reidy

Because of the high costs of production, particularly if one chooses to address or employ the most current visual language and technology of video, such projects would be virtually impossible without sponsorship of this kind. It is also impossible to carry out projects of this scale without the creation of an extensive team which can handle the various phases of this type of production (the video disc, the wall, the interactive capacities, and the wall's relation and integration into the architecture of the plaza). In itself this produces a challenge to any singular definition within the arts of the artist. All of the roles must be seen very clearly as to how they interrelate and how none of them can exist within an isolated context.

However, it should be noted that the need still exists for such collaborations to include a fuller understanding of the needs, both creatively and financially, *of the artist.* Specifically, this implies an understanding of the position of an independent artist/producer and calls for the need of producers in the arts who are skilled and invested in the carrying through of the artwork; such a producer was, unfortunately, left out of the above mentioned chain of roles. With adequate representation a project such as this will be able to be more easily realized, rather than put into a situation where the "art" interests and the "commercial" interests become locked into an opposition that does not promote or foster the realization of increasingly interesting work.

Dara Birnbaum, *Rio Videowall*, 1989.

The Art of The Possible

FRANCESC TORRES

The text that follows is a ground-level view meant to be a point of departure for a dialogue, not a dissertation. I will begin by bringing up something that may appear unrelated to the subject of this book. When I was in Paris in the late 1960s the art and technology movement was strong and, perhaps because of the movement's allegiance to industrial production modes, generated the concept of the multiple work of art, that is, mass-produced artworks made available to the public at reasonable prices, Henry Ford's revolution applied to art. It was widely thought at the time that the multiple form frontally attacked the bourgeois notion of the sanctity and uniqueness of the original work of art. It was assumed that as soon as art-through-multiplication became available to everyone, people would want it. To the contrary, the indiscriminate majority continued to prefer the art that went with the sofa while the affluent discerning collectors continued to buy originals indicating that the issue was not one of art's accessibility but one involving cultural premises. Video suffers from similar misconceptions about its audience. It also suffers from misconceptions about its context by those who assume, in many cases, that television is the basic, if not the only, vehicle for experimental video, since both television and video share a given technology and the illusion of a common space. The dynamics of society cater to a broadest middle ground, that territory in which simple basic needs are met by direct, uncomplicated services, comforts, and commodities. The bottom line is that there is not a broad audience for challenging ideas. Further, video, as a multiple, does not satisfy the art market's demand for a unique and valuable object. Rankling to the purveyors of "good taste," it references that which is most common: TV.

In my opinion, there are three main obstacles facing video that complement each other formidably: one is of political nature (access), another of economic nature (distribution), and the third, and perhaps most sobering, is cultural (demand). However, the access issue is particularly significant, for those who control the means of mass communication control political and economic power. The idea of a pluralistic, open, horizontal mass communications system challenges the stability of the dominant political and ideological power in any given society. Illuminating the tight relationship between political power and the media is the fact that during the presidential campaigns in the U.S. only political organizations with the money to buy air time on television have a shot at the White House; the acquisitive power of the main political parties functions as a filter that leaves out all potential ideological contenders. Because

Francesc Torres, *Dromos,* Indiana, 1989.

of the forbidding obstacles and in spite of significant efforts by WGBH and the Contemporary Art Television (CAT) Fund in Boston, WNET in New York, ZDF in Mainz, West Germany, and others who have tried to bridge the gap between video and television, single-channel video has remained a widely marginalized practice.

My reasons for linking political processes to art processes are based on the phenomenology of both activities; in both politics and art we start from intangible propositions which can only prevail either by consensus, or by imposition. In both cases, the conditions that make a particular proposition viable are considerably fluid and unstable so there is always an interplay between what is manufactured artificially and the objective conditions that may exist. The Nielsen's rating system that controls what we see on TV has its equivalent in the art world, in which changes and the management of newness are governed by economic factors subject to the vicissitudes of taste and fashion. While posing as progressive, the art world is, in fact, conservative and resistant to substantive change that might undermine its presumptions about art and the artist.

Within the context of video's ambivalent relationship to the art world, video installation has fared better than single-channel works. As sculpture, video installation expands beyond the television frame and utilizes the museum space as its natural context. Still, video installation has not been perceived as a particularly marketable form for traditional galleries. Museums, on the other hand, have been less constrained by direct market fluctuations (although they are crucial in helping to consolidate them) and have been able to offer a wide and, supposedly, more pluralistic view of art world practices. They have provided the infrastructure of space and the technical and conceptual means needed for video installation. Nevertheless, the museum's involvement in this field, until very recently, has been to show the work, even to produce it, but not to collect it.

To give some perspective to the context occupied by video installation, it is necessary to consider a wider and often overlooked category, *multi-media installation,* precedents of which can be found as early as works of the Russian Revolutionary Avant-garde (Alexander Rodchenko, Vladimir Tatlin and Gustav Klucis) and the Dadaists (as, for example, Duchamp's *Twelve Hundred Coal Bags Suspended from the Ceiling Over a Stove,* 1938). I would also agree with Umberto Eco when, in his book *Travels in Hyperreality,* he links the Christmas crèche and the eighteenth-century European diorama with contemporary wax museums, Californian three-dimensional reproductions of Leonardo's *Last Supper,* and the work of Edward Keinholz.

The fundamental characteristics of multi-media installation are its formal flexibility and its capacity to incorporate new media as they have become available and establish links with other disciplines. Multi-media installation provided an existing structure into which video was able to expand (and by so do-

Francesc Torres, *Oikonomos,* 1989.

ing, to help define). In return, video has been enriched by uses that freed it
from its association with television.

There has been a correlation between technological development and art
making throughout history; inventions such as oil paint and linen canvas were
agents of change comparable to the emergence of chemically, and later elec-
tronically-based image making. What this correlation implies is that artists
have consistently, not accidentally, worked with the tools of their time. De-
spite the tools available to art through technology, the art world hangs on to
its conventional practices and aesthetic strategies. Thus technology-based art
exists in a marginal area in a technology-based society. Seen in light of this
century's history, science and technology are perceived more as deliverers of
death and ecological crime than as purveyors of insight and well-being.
Within this perceptual frame, technological art is seen in an unflattering light
while the traditional arts are viewed as a redoubt of the human spirit. How-
ever, technology-based art has a key role to play in clarifying the difference in
the *uses* of technology that are harmful and ill-directed and those that are an
expression of constructive and humanistic concerns.

In the cultural, political, and economic spheres, stasis is a guarantee of
death whereas change, as a by-product of curiosity and the desire for knowl-
edge, is a clear indication of creative vitality. Biological and genetic evolution

show us a direct relationship between the level of complexity of a particular species behavior and the duration of its members' infancies—infancy being no less than a period of apprenticeship, learning, and preparation for adulthood. Biological and genetic evolution also show us a direct relationship between survivability and the capacity of a species to adapt to novel situations, and humankind has demonstrated a unique skill at that. In view of this, I think that the role of art should be to preserve a perpetual state of curious play geared to the manipulation of ideas (content) and tools (aesthetic strategies). Technology is uniquely suited to provide the tools to create a genuinely novel art that is, in turn, able to give technology a humanistic dimension otherwise lacking. Video is precisely one of those technological tools that has enlarged the horizons of art making in perfect tune with the very visual and impatient biped who created it.

Mobility, As American as . . .

When I studied architecture in the mid-1960s, modernism was the dominent ideology, but Robert Venturi's *Complexity and Contradiction in Architecture* had just been published. It threw open the shutters in the mausoleum of modernism, and I studied carefully. Reading it again twenty years later, I found that Venturi's statements about architecture parallel my feelings about art. I quote here from his first chapter, "Nonstraightforward Architecture: A Gentle Manifesto":

I like complexity and contradiction in architecture. I do not like the incoherence or arbitrariness of incompetent architecture nor the precious intricacies of picturesqueness or expressionism. . . . I like elements which are hybrid rather than "pure,"

compromising rather than "clean," distorted rather than "straightforward," ambiguous rather than "articulated," perverse as well as impersonal, boring as well as "interesting," accommodating rather than excluding, redundant rather than simple, inconsistent and equivocal rather than direct and clear.

But an architecture of complexity and contradiction has a special obligation toward the whole: its truth must be in its totality or its implications of totality.[1]

Every major American city has an airport, a stadium, and a convention center that function as symbols of civic pride but really have very little to do with community. The airport, which is designed as a space to be moved through, is a model of a little town with stores and traffic and cafés,

1.

but no permanent population. As Paul Virilio has stated, "The airport has become the new city. At Dallas–Fort Worth they serve thirty million passengers a year. People are no longer citizens, they're passengers in transit. When we know that every day there are over one hundred thousand people in the air, we can consider it a foreshadowing of future society: no longer a society of sedentarization, but one of passage; no longer a nomad society, in the sense of the great nomadic drifts, but one concentrated in the vector of transportation."[2]

The Executive Air Traveler locates himself in such a place. He sees this "city" as public spaces, newsstands, safety precautions, processed food, security checks, plate glass windows, white courtesy telephones, computers, baggage areas. A place of high-speed movement contrasted with waiting and leftover newspapers from distant cities. A place that creates for him an artificial importance that is his citizenship.

He assumes the identity. He wears a business suit, carries a briefcase, polishes his shoes, and rents cars. He fits the demographic mold—he is a white, educated, male between 35 and 55 years old. United Airlines defines and validates his experience. They send him "city tokens" representing destinations that he attaches to a wood-grained, plastic plaque. This plaque is a trophy that celebrates his loyalty to United and his status as an Executive Air Traveler. He displays it in his office, proof of his citizenship, his power, and his freedom to visit and thus define as his own various points on the globe.

Flying into one of these city-airports, he looks down, and noticing a suburb in an active, outlying area, he thinks, "It's an easy living!" Below him things are happening in an orderly fashion, without plot or real characters. Cars pass each other on their way to the mall or the golf course, and people gather at the beach. At a driving range, golfers hit one ball after another toward signs marking distance. By nightfall, the same cars are at home or at the drive-in, lined up in rows as a movie flickers into life. They are passive

2.

spectators in their private theaters.

The last shot they see is of an in-animate couple sitting on a sofa watching late night TV—the only movement in the frame is the kinetic technical virtuosity of a furniture commercial, as a clock strikes two.

The concept of production not only includes the manufacturing of the film but also its exhibition and appropriation by the imagination of the spectator who actually produces the film, as the film on the screen sets in motion the film in the mind of the spectator.[3]

—Alexander Kluge

A child narrates his own movie while pushing plastic cars up and down "streets" defined by the patterns of a Persian rug. His materials are toys that are mass-produced by industry and consumed by children, but he is investing these consumer objects with dreams that are his own. He lines up

his models on both sides of a road at night so their headlights illuminate the racetrack for a '54 Chevy and a late model Camaro. They accelerate in slow motion toward distant darkness, the sound of their racing V-8 engines fading into a song of crickets —the sound of the night. He names his dreams Easy Living.

Several years later, in a parking lot of a fast-food restaurant, across the street from Miramar Naval Airstation, a man emerges from a 1962 Ford Thunderbird. He is wearing an aviator-style jacket. He looks up as a jet crosses the sky above him, its noise filling the screen. He is an amateur expert who sets out to lecture, in military fashion, about the scale of U.S. military spending in relationship to the Hollywood movie *Top Gun*. "Not *Top Gun* the music video, not *Top Gun* the Diet Pepsi ad, not *Top Gun* the T-shirts, caps, and an-

3.

4.

5.

cillary products," he says, "but, *Top Gun* the movie."

Inside the restricted area of Miramar Naval Airstation, a U.S. Navy enlisted man kicks a can of grease across the tarmac toward a $36 million F-14 A Tomcat fighter plane. He is crossing the marginalized space that supports the massive military operation necessary to keep twelve squadrons of F-14's flying. He is part of the hidden support structure. He is not top gun, and he is not eroticized or expertly fetishized. He is thinking about a Christmas in 1978 when he and his uncle built a model of an F-104 Starfighter. He remembers saying, "I like the sound it makes when the parts click together. That's really neat."

Sleek, fragmentary, and expertly fetishized, Top Gun *is state of the art warnography. It's the sort of suave, go-go propaganda you'd expect to be shown to kamikaze pilots.* Top Gun *doesn't posit sex as aggression, it reformulates aggression as sex.*[4]

A 1962 Thunderbird is moving along the interstate through the desert. The driver is solitary and contained, reflective, both a cynic and a believer, a victim and the exploiter, but he thinks of himself as a motorist. He is talking to himself while he crosses Arizona, "I think I've positioned myself as an American. I am not a celebrity or an expert, but I appear on TV. I see the dark side of speed and power as well as the thrills. I see the manipulative power of media along with the pleasures." A truck passes him going 75, stirring up dust from the side of the road.

He thinks about the Ford Taurus, and the pride he felt when Ford introduced it in 1985, and how he

6.

cheered when Ford's profit margin surpassed General Motors' for the first time since 1929. "I'm still a Ford man," he says. "I'm loyal to a gigantic multinational corporation! But my loyalty won't buy nothing."

He tries to imagine the Thunderbird navigating the narrow streets of Tokyo, but the only image he can call up is of a 1963 magazine ad. There is a photo of a small island in a blue expanse of ocean. It is night, and on this island stands a couple dressed in evening clothes. She is wearing a gold floor-length gown, and she appears to be looking over the edge of the island, as if it is a decorated barge crossing to Key Biscayne and she is watching the patterns made in the water by its wake. He is wearing a black tuxedo and leaning against the hood of the car in this dreamscape of corporate fantasy. The motorist says, "When I was fourteen, that was my idea of romance."

Captions

1. Chip Lord, from the series *Executive Air Traveler*, 1981.
2. Chip Lord and Mickey McGowan, *Easy Living*, 1984.
3., 4., and 5. Chip Lord, *Not Top Gun*, 1987.
6. Chip Lord, *Motorist*, 1989.

Aligning *The Museum Reaction Piece*

The Museum Reaction Piece, Everson Museum, Syracuse, NY, 1978. Pictured "Number One and Number Two Hosts," Richard Simmons and Camille Rykowski.

I'm quoting from the University Art Museum brochure for my 1983 retrospective in Berkeley, California:

The Museum Reaction Piece was first installed in 1978 at the Everson Museum of Art in Syracuse, New York. At that time, the piece consisted of its architectural components and a text addressed to two museum employees—the "number one" and "number two" hosts—who each lunch with seven staff members during seven days of the exhibition. The text is written in the form of a recipe explaining in a general way how to conduct each of fourteen lunches.

The piece is set in two adjoining kitchenettes with a common wall that houses two exhaust fans. The fans and lights are wired in such a way that when a light in a room is turned on, the fan moving air out of that room is also turned on. Consequently, after a meal has taken place in one room, the resulting odors are transmitted to the other room. Fried uses these and other architectural devices, as well as two sets of T.V. programs (The Number One Host's Host and The Number Two Host's Host) to direct the activity through a list of procedures found in his 1978 text. This document is exhibited on the wall in the present exhibition.

After the seven episodes were videotaped, a regenerative process began that continued for five years. The tapes of the original lunches were transcribed and used by the original participants to play themselves while Fried reshot the lunches in a highly controlled manner. This process was frustrated when several of the participants became unavailable. Fried decided to replace these people with others of the same sex and same occupation, but using the scripts developed by the original participants (i.e., a director's female secretary

The Museum Reaction Piece, University Art Museum, Berkeley, CA, 1983.

The Museum Reaction Piece, axonometric projection. Main gallery entrance is the single door (right front). The rear right TV monitor will be referred to as monitor 1; the front right camera will be referred to as camera 1; the front left monitor will be referred to as monitor 2, and the rear left camera as camera 2. In the current computer model the taped component is represented by perspective drawings constructed from eyepoints and target points inside the kitchenettes. (The actual sequences on the tapes were shot either in the Everson kitchenettes or in sets derived from their interiors.) The pictures generated by the cameras in the installation are represented by perspective drawings wherein the eyepoint is the pickup surface of the camera and the target the screen of the playback monitor displaying the perspective drawing equivalencing the recorded image from the VTR.

was replaced by another director's female secretary; a male security guard was replaced by another male security guard). At this point the production was moved from Syracuse to San Francisco and completed in the artist's studio.

The Berkeley show took place in galleries three and four of the University Art Museum (UAM). *The Museum Reaction Piece* (1978–86) was one of six large pieces installed at that time. Three of the pieces (*The Schizophrenia Projects* (1973–83), *Sociopath* (1983), and *All My Dirty Blue Clothes* (1969–83) involved specifications objective but flexible enough to correctly situate the pieces conceptually within any architecture large enough to accommodate them, while another, *The Edge of the Forest* (1983), was specific to a particular kind of architecture that is unique to the UAM but which is found in six locations within it. Of the remaining two, *Derelict 4* (1983) had evolved from a site-specific piece into something that might be called a large object; an architecture really, but one whose relationship to any other larger host architecture (an architecture wherein it might be located) was incidental. Such a piece must be placed subjectively, the way one might a vase of cut flowers on a coffee table in a living room; but my aesthetic interests had by then turned to instructing someone else in placing, for instance, coffee tables in closets, closets where clothes were already hanging, clothes I cared about, valuable clothes. In such cases it is not wise to trust a functionary's

judgment uninstructed; albeit such a confidence might nonetheless prove completely predictable for a time.

I was preoccupied with the editing of *The Museum Reaction Piece* and expected . . . well I expected nothing by the time I thought about how and where to arrange the double unit housing within the gallery. What I mean to say is that I should have had requirements, but by then there was a space problem and the UAM galleries are such odd shapes. Unmitigated taste, rationaleless subjectivity really (less than an option of last resort); it enlisted itself. I couldn't object. Circumstances prevented me. The result of this type of decision making stood opposed to my evolving methods and position, then most clearly represented by that set of specifications in which I had evolved to place *Sociopath.*

So the specific placement of the furniture and the electromechanical architectural devices in the two kitchenettes, their metaphorical significances implied in the wall text and effected in the tape, as well as the hundreds of operations necessary to maintain continuity during the shooting and reshooting of the fourteen episodes of the videotaped elements of *The Museum Reaction Piece,* had for me obfuscated the lack of resolution in my placement of the playback monitors and wall text(s). Well aware of this condition I, nevertheless, waited two years to approach the problem.

In 1986 I installed the piece in New York at the Whitney Museum. I placed two opposite corners of the

Top: First view of monitor 1 inside entrance to gallery. The taped component of the piece, "The Number One or Number Two Host Creates," is displayed on monitor 1, while the picture generated by camera 1 is on monitor 2. Bottom: Detail of monitor 1.

Top: Inaudible track 3 audio signal triggers program switch wherein monitor 1 displays picture generated by camera 2, while monitor 2 displays taped component from VTR. Bottom: Detail of monitor 1.

Top: View from area under camera 2 (near text on rear wall) directed at monitor 2, which displays VTR program. *Bottom:* View from area under camera 2 directed at monitor 2 after switch has occurred. Monitor 2 displays the picture generated by camera 1. It is assumed that after the switch a viewer's attention would move from monitor 2 to the rear wall text beside the viewer or to the actual kitchenettes or to the text on the front wall, which would be in the viewer's peripheral vision during the time his or her attention is directed at monitor 2.

HOWARD FRIED

long rectangular box that was the two kitchenettes equidistanced from the ends of a line that laterally bisected the gallery. The leading corner of the box (the one nearest the gallery entrance) was formed by the intersection of the box's back and side walls. In other words, the doorways to the kitchenettes are turned away from the entering viewer who is presented with a large unfenestrated rectangular solid. The positioning of the playback monitors counterbalances the skew of the kitchenette housing relative to the museum gallery. Consequently programs of actions occurring in the kitchenettes are not immediately connected with the back of the large box confronting the viewer. Comprehending the various levels of this piece is at least a matter of physical penetration.

The fourteen episodes of the taped component of the piece are highly edited and of relatively great duration. (Its final length will exceed three hours.) The Whitney installation included only the first four episodes. These together are fifty minutes. While all fourteen had been shot prior to the UAM exhibition, at the time of the Whitney exhibition only these four were fine cut. One aspect of my original conception of the tape's dynamic vis-à-vis the entire sculpture was that its density, length, repetitiveness, and vantage would sooner or later exhaust anyone watching it. A viewer's physique if not his conscious processes would release him from the grip of the television set from where, I reasoned, one later if

not sooner would wander through the gallery, possibly enter the kitchenettes, find the other monitor, find the wall texts, and move through the gallery sampling its aspects; only as systematically as each might consume those individual parts of a good meal. The piece would work like a cocktail party rather than a religious ceremony. In other words, people would relate to my art the way they relate to the non-video-involved art in the museum. I wanted people to realize that the tape was inapprehensible in one viewing, that it was a thing to be reapproached and looked at again and again as one might a Seurat; that it was, more than a contemplative object, a detail of a contemplative structure.

I underestimated television. People congregated along the exterior side wall of the kitchenette closest to the gallery entrance. Many sat on the floor. Others stood in one spot for the entire fifty minutes. While the tape rewound they might approach the other side of the housing as one might a lobby at an intermission.

Some months after the Whitney installation I arrived at a solution. I added two video cameras to the installation. Each is situated perpendicularly to the screen of and at equal distances from one of the two playback monitors. Video signals from each camera and the VTR are routed to a switcher. A tone signal on audio track 3 of the tape is fed into a tone decoder from where a control signal fed to the switcher emanates. The switcher determines which video sig-

nals appear on the two playback monitors. When the video from the VTR is on one monitor, the signal from the camera trained on that monitor is displayed on the other monitor. At the tone signal from audio track 3 this arrangement is reversed. The VTR signal appears on the monitor that had previously displayed the camera signal, and the other monitor displays the signal from the other camera that is trained on the monitor which now displays the VTR signal.

The effect of the switch to the viewer is a match cut wherein (in the case of the monitor with the VTR signal) the picture the viewer is seeing becomes drastically smaller on the screen as it is subsumed by the physical context in which it is seen. The viewer now sees on a large part of the screen the gallery space in which he or she is standing while the program is apparently thrown out of focus (as the raster acquires certain characteristics of aerial perspective) by the lack of resolution of the monitor's screen and the viewer's position in the room.

View from area under camera 2 directed at text on front wall. Upon approaching the text the viewer realizes that the text on the front wall is a reversed or mirrored representation of the text on the rear wall. It is assumed that if a viewer hadn't already read the text on the rear wall a motivation to reapproach it would now exist. When monitor 2 is switched back to the VTR program the viewer's attention might once again be divided.

"The Museum Reaction Piece" first came to me as a vision about myself. I thought of it as a reaction, my reaction, a need - a desire to balance the flow of what passed. That was my reaction - to react. For instance, if I was a fan and was placed next to another fan - I would probably blow in the opposite direction - Forget it; I simply perceived the structure. I didn't connect it to any real meaningful movement of air. I saw it as a symbol. Possibly installed on an overhang - blowing air around in one big room, a great hall. I held no illusion of there being anything in the wind but the wind.

a great hall

This happened in a real space. It was an artwork; other than that, in the beginning my vision really had nothing else whatever to do with museums. So - in my silence (only silence is reasonably possible without specifics) - I called it just "Reaction." I can't pretend that I didn't think about what the term had come to mean in politics. It usually seems separated from liberal to conservative; but I think they are much closer, liberals and reactionaries. They like the same games; and mightn't either stoop to employing the delusion that conservatives really understood them better than the other and were by virtue of this quick-silverish perception more likely colleagues or more appropriate confidants in a special but nevertheless meaningful sense of the word (unlike a brother or sister; having no real familiarity; virtually without contempt).

One day a museum contacted me about a show. I needed a piece; and my piece needed a place. This was my reaction. Now it had become "The Museum Reaction Piece." Everything fell into place. God, do we delude ourselves? God, do we delude ourselves? God? do we delude ourselves? Especially me. Take me for example. It's my suspicion (or rather my method) that one day "The Museum Reaction Piece" will once more simply be "Reaction." Art work, by art work (I won't generalize) has a way of shaking itself down.

Summarily: "The Museum Reaction Piece" began as a whim. In theory at least, it acquired a minimal amount of mass in the form of an overhang. To explain its growth from that moment on - which from a maternal point of view might have begun its true blossoming - (although this type of growth is often called carcinogenic)-Anyway - to explain the largest part of it's growth curve to date I must at least say (whether it's true or not I can't know) that when I set a date and then begin to finish a work with the deadline on my mind, I begin to bulk up. It's a neurotic impulse. The work grows appendages. The appendages acquire an etiquette of their own. I joke about it with my friends. I've begun to joke about it in public. It's overkill. I spill my guts and only then do I begin to sort things out. I can put myself in a hypnotic state by mulling over my work while I wait for it to decompose. At times I've become so dizzy with hunger or vertiginous acrophobia that I am unable to distinguish the source of my disorientation more precisely than that. By now, by the time you see the work, some of it has dried up and is already gone. I don't mean that what's not happening now is completely extraneous. They're calisthenics, movements built on themselves - a presence implied by absence - the body bent, the fingers touching toes. This is man erect affirmed by his ability and desire to stretch.

"The Museum Reaction Piece" is set in two kitchenettes, each of which will be the lunch place, the lunch room, for each of two characters respectively during ___ days of this exhibition. Inclusive dates are to be announced by the museum staff and posted. The rooms are not interchangeable. Tastes may vary. My lunch rooms don't. Each character, henceforth to be known as number 1 host and number 2 host (my hosts), must be employed by the museum while the piece is installed.

Each day the hosts (professionals in some museological sense), let's call them professional host - each day the professional host will prepare and eat lunch in his or her respective kitchenette. Also during lunch this person will plan the following day's meal. The number 1 host will make this decision while watching a television program called "The Host's Host" (or something like that) which will become the habit of both professional hosts by definition. The professional host, among other things, is a person who habitually watches a television program called "The Host's Host" (or something like that) during lunch.

Professional hosts may have guests for lunch if that is their wish since it is not my wish to upset or inhibit their regular routines any more than is the effect of those of my compulsions that are substancially involved in my personal aesthetic and which I in consequence refuse to conquer at this time. When you make art (at least) you must always draw the bottom line. In fact it is my wish that everyone enjoy themselves. Here's how it works:

Don't overcook a lunch cold. A satisfying lunch should be cooked up. Yes, it has to be cooked up. I want the participating professional hosts to cook up whatever it is that's for lunch. That's why the stoves are there. Use them. And no working in the dark. That's what the lights are for. Use them; and please turn them off when you leave your room. That's what the switch on the wall is for. It also turns one of the fans on and off. This convenience (of your lunch room's exhaust fan and will contribute to your comfort. The fans are connected to the lights, so take the fans for granted. Let's concentrate on the lights.

Don't stare into the light. The light can hurt your eyes. There are times to remain in the dark - when the exposure is wrong. Not that the light in the kitchen could ever show you off in a way that would hurt

you. That is, the perceptions of others are ultimately incidental. Rather though, there are times that without the cover of the dark (on the coldest nights for instance) you might burn yourself - possibly to test yourself - proof often eludes us by hiding in pain. Sometimes we take pain for proof. Proof is always a possibility; all processes can be redesigned to manufacture it. You may find it captivating to test and retest yourself unmercifully-Perhaps to prove that the temperature of the air can't be influenced by fourty watts of incandescent light. You may have forgotten that it is the temperature of your body that really makes the day pleasant and that even a fan (especially a fan)- not blowing in your direction at all - (not incidentally) - might induce a fever and damage your lunch. But nevertheless, as a professional courtesy, don't cook in the dark. Use the lights. That's why they're there.

"The Museum Reaction Piece"

This is not a conversation piece. It's a reaction piece; and more deplorably, it employs two separate standards to achieve its intentions. Part of which is the production of a video tape. The standards I speak of identify two separate systems which can be used to communicate placement or position in either of two kitchenettes. These standards are based on architectural arbitrators which are themselves parts of the kitchenettes. Regrettably we can't be sure if these shells have a magnetic field of their own. If they did; and our instruments responded only to it, we could use our instruments as the one system by which to maintain a sense of order - which is the basis of serenity - the best foundation for good health. If these rooms by their very natures do necessitate two standards by which we may know anything about them, then I have reason to believe something truly inspirational may be the result of this venture-because voids by their very natures beg to be filled by anything other than apathy, which is itself a void; and good health has a hold on all of us; and it is my wish that everyone enjoy themselves. I might suggest the magnetic field of the earth as the resolution of the frustration I have just mentioned; but I should never really be sure in that case that it was not in reality the magnetism of these kitchenettes that actually guided my compass. How do I know what it responds to? How I mistrust rhetorical questions. The best I can do under these circumstances is to suggest these two standards by which one might orient oneself:

1. orientation based on proximity to or divergence from the common wall; that is facing into the room(s), the right wall of the left room and the left wall of the right room.

2. orientation based on proximity to or divergence from walls chosen by parallel methodologies using the concepts of right and left; or assuming the posture of a caveman one might say, based on proximity to or divergence from walls chosen by parallel methodologies which use the location and position of the human heart as a constant. Of course that is really to say the same thing twice but I don't mind reminding whosoever may forget certain of their resources of the constancy of these consultants.

Now if it may serve anyone's purposes, and it does mine, and I shall explain how it does mine soon, one may divide the objects in the rooms into two camps by deciding which of these two systems any object and its compliment in the adjoining room you have in common. These camps align themselves in the following manner:

things specially oriented to the common wall	things specially oriented to right or left hand walls
the electrical outlets	the doors
the fans	the lights
the stoves	the switches
the tables and chairs	
the vents	

Beside watching "The Host's Host" (or whatever it's called)-(something like that; it is my wish that both of my professional hosts contribute themselves in the form of their recorded images to the video work associated with "The Museum Reaction Piece." I'd like you to help me make this tape. Please! Consider its scenario: As a professional host, one of you plays a tape, makes a tape, then eats lunch. Later your counterpart makes a tape, plays a tape and eats lunch, and finally makes more tape. We'll call the segments that you produce "The Host Creates" or something like that. Now let me suggest some detailed plans or scripts for you to follow. Please employ my suggestions. That's what they're for!

In the first place, in lunch room number one, the number one host arrives at 12:00 noon carrying something that he or she will cook for lunch. Hill State air? You can overlook small matters. You can, can't

you? is the atmosphere in here really worth considering? - maybe - huh? Turn on the TV.. turns on the television set and plays "The Number 1 Host's Host" (first episode). The Number 1 Host's Host series each day relates a description of the dining room in a different unidentified restaurant and offers some observations or conclusions about the proprietors of each of these restaurants.

While watching "The Number 1 Host's Host" or as a result of watching it, host number 1 decides what he or she will prepare for lunch the following day. These matters having been attended to, host number 1 is now free to make "The Host Creates," or in his or her particular case, "The Number 1 Host Creates" (first episode as well as lunch. Incidentally, if you aren't planning a fixed tripod shot during lunch or if you aren't comfortable o perating video equipment, perhaps you will invite someone to lunch who is; if that be your wish. Do you know what I mean? I want everybody to enjoy themselves.

The # 1 Host Creates

Have ready:

video camera and recorder (and a camera person if that is your wish)
raw materia for today's lunch
a list of the architectural devices oriented to the common wall

After "The Number 1 Host's Host" has ended and you have decided what's for lunch tomorrow, begin today's recording and perform the following operations: 1. Cook today's lunch and spend some time describing what you are preparing and what and how you are doing what you are doing when you are cooking. 2. Add generously adulatory comments about architectural devices oriented to the common wall. These should be made randomly and without premeditation. Their interjection is intended to perk up ears. Actually thinking about them can only have a depressing effect on everyone involved, including future audiences. They are merely for fun, possibly a thrill at most; but they are absolutely not contemplative devices. Don't misuse them. They're not to be taken seriously. 3. Finally for that thoughtful touch (which may be just the thing to round out your television image) perform a viewer response. Speculate about the kitchen and the cook at the restaurant described today on "The Number 1 Host's Host." This will compliment that program nicely on that even larger program on which we are all working. 4. Finally, eat your lunch. Turn out the lights when you leave. That's what the switch is for.

Secondly, that is in room number 2, host number 2 arrives at 12:30 or thereabouts. My sense of order requires that you wait for the departure of the first host before entering the second room; albeit both of you have entirely different rooms for your midday convenience. The second host, like the first, brings food to be prepared today for lunch. There is no beating around the bush with host number 2. You immediately prepare to record "The Number 2 Host Creates."

The # 2 Host Creates

Have ready:

video camera and recorder (yes, and a camera person
if that is your wish)
your food
and a list of the architectural devices oriented to
right or left hand walls

Turn on the camera and consider the atmosphere in the room. How's the weather? What's in the air. Make comments. Seem flighty. I want you to talk about ethereal issues even if they make your eyes water. Sniff the air; and then before going on to your next task I want you to decide what you'll prepare for lunch tomorrow. Speak up! think out loud. Keep the camera running. OK, start cooking today's lunch. Keep the camera running. Now make adulatory comments about architectural devices oriented to right or left hand walls. Come on, put your heart in it. Talk about what you're cooking. Keep the camera running. Now turn on the television. Play "The Number 2 Host's Host." (first episode), (first day)- OK, cut the camera, finish watching your program. "The Number 2 Host's Host" series each day describes the kitchen and the cook of the same restaurant featured on that day's version of "The Number 1 Host's Host (Show)."

Finally, after you've finished watching the program resume taping today's episode of "The Number 2 Host Creates." In this concluding segment you speculate about the dining room and proprietor of the restaurant featured in today's version of "The Number 2 Host's Host." Remember to turn out the lights when you leave. Thanks.

The two professional hosts participating in this season's version of "The Museum Reaction Piece" will perform the routines I have described during ___ successive episodes on ___ prearranged days. The ___ programs produced during these sessions will be edited and arranged in chronological order with the ___ episodes of "The Number 1 Host's Host" series and the ___ episodes of "The Number 2 Host's Host" series. The result, which I think I will call "Reaction" may be seen at another museum sometime in the future. -oh, don't be frustrated. If it's your wish I'm sure they'll be rerun here too. Ultimately professional hosts are quite sensitive to the reactions of their guests.

The Feminism Factor:
Video and its Relation to Feminism

MARTHA GEVER

Large tracts of the common ground currently occupied by feminism and art were delineated in two essays that circulated widely in the 1970s. In keeping with feminist investigations into the implications of gender for all cultural forms, the titles of both articles were framed as questions: "Why Are There No Great Women Artists?"[1] and "Is There a Feminine Aesthetic?"[2] The former was written by art historian Linda Nochlin and published in a 1971 anthology of feminist writings surveying a variety of social institutions—from the law and the family to literature and advertising. Although Nochlin agrees with the verdict that there have been no "great" women artists—even though there may have been some very good ones—she indicts the arrogance and prejudice that inform the question posed as a "problem" by established bourgeois art historians and critics. Not only does Nochlin point out the disadvantages faced by aspiring female artists in terms of education, social expectations, and critical reception, but she extends her argument to challenge one of the concepts at the heart of Western art: artistic genius. In the process, she exposes the convergence of the values associated with artistic genius and with conventional masculinity—and thus the advantages accorded men in pursuing the career of Great Artist. And, rather than providing an answer to her title's interrogation, she suggests that feminist art historians and critics research and write histories of art institutions, not histories based on accounts of individual successes and unexamined concepts of what constitutes artistic success.

Sylvia Bovenschen's 1976 essay "Is There a Feminine Aesthetic?" published in *New German Critique* in 1977 and reprinted later that year in the feminist art magazine *Heresies,* examines the proposition that women possess a distinct "feminine sensibility." Not afraid to generalize about women, Bovenschen nevertheless found that "no formal criteria for 'feminist art' can be definitively laid down." She concludes by restating her original question: "Is there a feminine aesthetic? Certainly there is, if one is talking about *aesthetic awareness* and *modes of sensory perception.* Certainly not, if one is talking about an unusual variant of artistic production or about a painstakingly constructed theory of art." Like many other feminist intellectuals, she favors materialist, historical methods in her analysis of the conditions within which art is produced.

In recalling these two examples of cultural criticism, I want to acknowledge several points of departure for my discussion of feminism, women artists, and video in the United States, which includes neither annunciations of any

Great Women (video) Artists or a search for a feminine aesthetic operating in videotapes made by women. Rather, my approach here will be akin to those recommended by Nochlin and Bovenschen, adapted to the specific productions and different historical circumstances of the late 1980s. My emphasis will be on social institutions—rather than individual careers—and the ways in which these have been incorporated or addressed in videotapes by women. By means of this method, I hope to chart the intersections of this work with feminist debates about the meaning of gender in our culture. Previously, I have covered similar territory. In one article, four feminist documentary videotapes made in the 1970s formed the basis for my analysis of parallel developments in alternative media production and feminist-defined issues like female sexuality, wife abuse, the cult of beauty, and the politics of housework. A second article was written as a sort of sequel that traced interest in myths of feminine passivity and masochism among women making videotapes about women in the early 1980s. This article, then, will pick up some of the threads from those earlier pieces while allowing me to take yet another look at the tentative, contingent relationship between video, the work of women artists, and feminism.

All of the videotapes discussed here are works that have sustained my interest in the relationships between feminism and video—relationships that are not intrinsic, or often readily apparent, in most videotapes made by women. All were made during the mid to late 1980s. I have further confined the topic within the national boundaries of the United States, because, to a large degree, the conditions of production and distribution of noncommercial, unconventional video are determined by national policies—whether policies regulating telecommunications or those governing arts funding. Interestingly, all of the tapes—even the most overtly personal—examine intersections of identity, U.S. culture, and often, national politics. Aside from this and female authorship—although not always without male participation—these tapes do not fit within one topical or stylistic category. Still, there are other connections of interest to a feminist critic, and these provide the structure of as well as the subjects for this survey.

Looking back at the events of the two decades, the social climate and political culture in this country seem to have changed profoundly since Nochlin's and Bovenschen's essays first appeared. Starting in the late 1960s and gaining momentum throughout the 1970s, feminism in the United States attempted to effect a sweeping upheaval of the power relations between men and women. Organized feminism, popularly known during that period as the Women's Liberation Movement, provoked strong reactions against, as well as impassioned defenses for, numerous political programs designed to improve the social situations of women. Necessarily, the process of undoing entrenched prejudices was revealed to be much more complicated and its achievement less immediately

attainable than what was implied in the manifestos and broadsides published by advocates of women's rights in the late 1960s and early 1970s. From a different perspective, the feminist movement in this country has also been hampered by the controlling positions assumed by white, middle-class, often homophobic women and their political strategies. But, despite the consequences of this domination, their definitions of feminism have been repeatedly challenged by women of color, lesbians, and others.[3]

With those limitations and biases, and depending on the context where it has taken root, the political agenda of feminism in the late twentieth century has met with varying degrees of acceptance and has been transformed accordingly. Feminist campaigns against institutionalized sexism continue to alter myriad aspects of the public and private lives of people in this country. Although reactionary attacks on women's reproductive rights have been successful recently, such issues as comparable worth and affordable day care are supported by large sectors of the populace, and changes in social practices continue to occur. At the same time, in this decade the "feminization of poverty" has increased dramatically and right-wing backlash against every minor shift in power achieved by feminists persists, often with the support of the highest government officials.

Thus, feminism in the United States at the end of the 1980s presents a contradictory scenario where women of color, lesbians, working-class women, and others with a profound commitment to women's rights and a feminist critique of political power inject feminism into radical or progressive projects not necessarily concerned with traditional "feminine" interests. However, for those concerned solely with attaining the goals of white, heterosexual, middle-class feminism—increasing the number of women working in professions like business, law, and medicine, for example—the challenges presented by feminists aligned with anticapitalist, anti-imperialist, antiracist, and/or antihomophobic politics are frequently ignored or discounted. On the other hand, feminist theory has become a key component in literary and cultural studies conducted by intellectuals working in the liberal academy (also largely white, straight, and middle-class), even if some of its proponents remain embattled within their academic institutions. On yet another hand, in the art world (likewise white, straight, and middle-class) feminism and feminists, if not aspects of feminist theories, are considered passé, an attitude signaled by the recurring use of the stylish adjective "postfeminist" in the art press.

Insofar as any critique of video in the United States must be linked to the institutions of art (and mass media, the other primary institutional affiliate of video), the present coolness toward feminism in most quarters of the art world might indicate that a study of recent videotapes made by women could easily forego any discussion of feminism. Indeed, in the late 1980s, the celebrated "superstars" of the art world are still entirely male and white, and it may seem

that feminism has left little imprint on art institutions or those who partici-
pate in them. Feminism survives, however, in the domain of progressive or
left-wing art criticism, where there is increased interest in what has become
designated "feminist theory." No doubt feminist, both in its sources and its
emphasis, this brand of cultural theory is, nevertheless, limited to elaborations
of the psychic construction of "sexual difference."[4] Cloaked entirely in the lan-
guage of psychoanalytic literature, the feminism most frequently articulated in
art institutions concentrates on the unconscious processes that inform the for-
mations of gender identity of individual subjects, establishing the problems of
"femininity" and "feminine representation," as well as "female spectatorship"
as the central issue for feminism. The importance of psychoanalytic theory for
feminists is that it recognizes the power of the unconscious structures that up-
hold oppressive standards of masculinity and femininity. A major drawback, in
the context of art criticism, is its foundation in heterosexual, Western, bour-
geois models of psycho-sexual relations, a model that seems inadequate to ac-
count for cultural factors apart from gender identity.[5] Additionally, this kind
of feminist theory—restricted to the psychic constitution of sexual difference
and devoid of materialist or overtly political contextualization—frequently runs
aground because of its inability to displace men, white and straight, of course,
from their central position.

Although the influence of psychoanalytic theory on contemporary feminist
criticism may be the most striking features of its recent development, the dis-
tance between this approach and the materialist criticism recommended by
Nochlin and Bovenschen is not as great as it might sometimes seem. For in-
stance, questions about a "feminine aesthetic" continue to be raised by work
that posits a relationship between voyeuristic pleasure and gender. Nochlin's
suggestion, too, that explaining the absence of women from the ranks of great
artists requires more than an introduction of talented but forgotten women
into the annals of art history is echoed in discussions about works by contem-
porary women artists that expose the masculinity embedded in the concept of
the "masterpiece" and the "great artist."[6]

Despite such similarities, sexual politics has not remained a static field.
Likewise, the video work done by women in the 1980s looks quite distinct
from that made in the 1970s. Low-cost, portable video production equipment
was introduced in the United States at approximately the same time that femi-
nism reactivated a large-scale women's movement in this country. The kinds of
equipment that became available in the 1980s—cheaper, more versatile, ex-
tremely light-weight, more reliable, easier to operate—in short, more accessi-
ble than the hardware on the market throughout most of the previous dec-
ade—allow much greater flexibility for videomakers. Thanks to the economic
success of the home video industry, videomaking by individuals and groups
not affiliated with broadcast television has become relatively ordinary, no

longer esoteric like in the era of half-inch, reel-to-reel portapaks. Video practitioners now work in an environment where the production and distribution of small-format tapes is part of the social landscape. The greater economy of video production, as opposed to film, also recommends this medium for women, since the collective economic status of women in this country has barely improved in this period in spite of increased participation by women in the waged and salaried work force.

The most significant differences between the videotapes from the women's liberation era and those made in the 1980s, however, have little to do with the greater availability of the means of production or improved technical quality of images. Many of the earlier feminist tapes were documentaries that mixed techniques of cinéma-verité with television journalism.[7] But during these same years—while feminists established a grass-roots movement that could be translated into a formidable political lobby—many women artists recognized that the project of counteracting descriptions of "reality" that routinely objectified women would not be effective if the concept of "reality" itself was not overhauled. That meant initiating a thorough and specific examination of the ways in which "real" events and people were represented. The challenge to ideas of a universal, unchanging, "true" or "natural" relationship between men and women—such as the "truth" that women "naturally" aspire to marriage and motherhood and those who do not achieve both are failures—seemed to require modes of representation that unsettle perceptions of reality rather than confirm its inevitability.

Recognition of the artificiality entailed in documentary representations made this form doubly suspect: First, it falsely claimed to reproduce reality without distortion, free from the ideological baggage that comes with processes of mediation; second, it perpetuated the positivist ideology of empiricism, which has been regularly enlisted to rationalize systematic violence directed against social groups deemed inferior. Ideas and topics related to women that might have seemed apt subjects for documentary realism in the 1970s have been treated with some level of stylization, dramatization, or other devices that indicate awareness of these issues in more recent work.[8] None of these problems originated in or were limited to feminist uses of video. But the association of video with television, together with television's social function as the most popular source and interpreter of information and entertainment, provides a particular constellation of techniques, histories, and reference points for women artists working with this material. And those works that deal with women can then contribute to feminist debates about the connections between systems of representation and gender identity, between representations of sexuality and sexual politics.

One of the striking features of the seven tapes discussed here is a sus-

tained attention to problems of performance, just as performance has remained a form at the heart of much feminist art practice. Indeed *Fuego de Tierra* (1987), by Nereyda Garcia-Ferraz and Kate Horsfield, in collaboration with Branda Miller, chronicles the life of Cuban-born artist Ana Mendieta, whose work mainly consisted of performances and sculptural earthworks that often entailed elements that can be considered performance. Mendieta, who died in 1985 at the age of thirty-six, was a dedicated feminist as well as an accomplished artist. During the 1970s and early 1980s she executed a number of site-specific sculptural pieces using indigenous, natural materials that she worked into shapes abstracted from female body forms. Documentation functioned as an integral part of her art, and—in addition to interviews with Mendieta's various friends, relatives, and professional colleagues—*Fuego de Tierra* includes Mendieta's film footage of dramatic interactions between several of these sculpted forms and elements like flammable powder or tidal seawater that she staged and then recorded.

Just as Mendieta's films provide visual evidence of her ephemeral projects and thus illustrate aspects of her artistic development, the various people interviewed provide information about her life and confirm her expressive engagement with natural forms and environments. Many of them also relate Mendieta's intense involvement with these materials and settings to events in her adolescence, when she and her sister were sent to live in the United States by parents fearful of the influence Communism might have on their vulnerable young minds. Brief moments from newsreels show scenes from the early years of the Cuban Revolution, while dozens of snapshots supply visual referents for the reminiscences concerning Mendieta's life—from childhood to shortly before her death. The long takes of silhouettes of female bodies smoldering in the earth or flaming against a night sky in Mendieta's footage, however, repeatedly interrupt and redirect the flow of retrospection in the tape. Unlike archival materials introduced in order to invoke an irretrievable past, these records of Mendieta's art do not refer to an implicit narrative. The interviews and photographs that supply the tape's documentary information augment but never fully explain Mendieta's performances. Her dramatic images of transformations of energy defined or contained by material female forms—often enacted in relation to her identity as an uprooted Cuban—suggest numerous metaphors linking social relations and questions of national identity with acts of representation. The striking images produced by Mendieta's performance pieces propose a blurring of the boundaries between what's taken for granted as natural and thus immutable and what's regarded as subject to change.

The story of Mendieta's life, nevertheless, dominates *Fuego de Tierra* and accordingly the tape adheres to narrative documentary structures. In this regard, the work attests to Mendieta's artistic contribution by making her the subject of a detailed biographical study. But there are wrinkles in its narrative

fabric—disconcerting extreme close-ups of several interviewees and musical elements that refuse to remain in the background, for example—that serve to underscore the unorthodoxy of such a project. This aspect of *Fuego de Tierra* allies Garcia and Horsfield's tape with media projects where techniques that stress theatricality have been used to denaturalize—and thus politicize—accepted social arrangements. Ayoka Chenzira's *Secret Sounds Screaming* (1986) stands out as another hybrid documentary that exhibits some of these traits. In the half-hour tape, producer/director Chenzira combines interviews with various individuals and scenes of actual events with moody slow-motion shots accompanied by discordant, ominous music and material that is clearly staged or labeled as reenactments.

Chenzira's subject—the sexual abuse of children—and the description of the social dimensions of this problem in the tape could easily have become an appeal for state intervention on behalf of "social purity." Instead, she avoids concessions to campaigns for a normative morality and concomitant attempts to legislate virtuous behavior by consistently working against clichés. For example, early on in the tape a rape counselor explains that the belief that abuse occurs more frequently in black and Latino families is false. This, she emphasizes, is a problem that affects all socioeconomic groups, rich as well as poor, white as often as black. Thus the actress who recounts a story of molestation and terrorization by her father, her pregnancy in fifth grade, and the subsequent criminal prosecution of her father could be repeating the words of myriad women living in communities across the country while simultaneously conveying the dramatic intensity of a first-person voice.

Similar to feminists' analysis of rape and wife battering as forms of sexist social control, sexual abuse of children is presented here as a consequence of unequal and exploitable relations of power between adults and children. Just as feminists in the 1970s refuted the guilt attributed to victims of rape or battered women—who, it was frequently said, provoked attacks because they secretly want to be raped and beaten—*Secret Sounds Screaming* both reveals similar commonly held ideas about children's sexual provocations and refutes their veracity through dramatizations of children's subjective experiences. Gender is also introduced as an important factor, since patterns of abuse almost always involve male adults or older male children (most frequently brothers) who make sexual approaches to and/or rape younger girls and boys. A central moment in the tape occurs when a young man first tells how his mother's male friend raped him and how he then tried to obviate his anger by raping his younger brother. In order to prevent such rape, another boy's voice explains, he quickly mastered the gestures and costume associated with macho behavior.

Secrecy about intimate relationships governed by socially sanctioned abuses of power and the attendant ignorance—fostered by institutions, not merely guilty individuals—are Chenzira's identified culprits, which she repeat-

edly counters metaphorically as well as with demystifying information. Like the open secret of sexual abuse of children, she disguises the identity of speakers à la *Sixty Minutes*—even when they are played by actors. Her method visually as well as verbally underscores the need for anonymity stemming from the combination of shame and guilt that plagues anyone who is subjected to sexual abuse. Moreover, Chenzira's strategy of maintaining a realist style interrupted by passages that exaggerate that style to the point of confusion effectively underlines the anxiety bred in children who have been abused. By employing such techniques, she stretches the conventions of realist video documentary to encompass a political analysis of subjective experiences and support a position of political advocacy that the mass media would never allow—one that counsels active resistance to unwanted sexual involvements and refusal of masculine assertions of privilege.

Chenzira's tape bears structural and stylistic resemblances to public affairs documentaries found on mainstream, mass-media television, but her social perspective on the topic and the aspects of her approach just outlined are probably better situated in relation to other independent productions broadcast only in the independent video slots programmed by a few local public television stations or in subsidized series of independent media on cable, if shown in such venues at all.[9] *Secret Sounds Screaming* translates what are perceived as isolated personal traumas into the idioms of social documentary in order to cast a political light on one area where sexuality and power meet. In contrast, Vanalyne Green's *Trick or Drink* (1985) turns inward to stitch together intimate autobiographical details of her childhood relationship with her alcoholic parents and the connections between their compulsive drinking and her own obsession with eating and dieting.

Yet there are significant overlaps between Chenzira's exposé of the social irresponsibility toward abused children and Green's personal account of her unhappy childhood and adolescence. Most prominently, both tapes dissect pathological dynamics common to the twentieth-century Western nuclear family. In *Trick or Drink*—after a recitation of entries from a diary she kept as a thirteen-year-old in 1962, illustrated by snapshots and illustrations from the same era—Green's voice explains the project: to make sense of "the emotional inheritance of my parents." She continues, "Had I known there were other children like myself for whom no one intervened, other children who saw things that should never have been seen, perhaps my life would be different." What follows is a synopsis of how her parents' alcoholism profoundly shaped her life, presented in short sections, each employing different devices to elicit meaning from scraps of memories. In one section, she pronounces lists of words and associated images from her childhood—"whiskey," "ice," "smoke," "television," "vomit," "urine"—while the camera picks out details of illustrations picturing white, middle-class, Mom-Dad-and-the-two-kids at home among all the trap-

pings of the idyllic American Dream circa 1960. These storybook illustrations alternate with gritty black-and-white photos of the interior of Green's family home littered with booze bottles. She employs the very different mode of anecdotal presentation in a later section, when she appears on-camera and narrates episodes from her history as an adult "binge eater."

Green's conscription of different dramatic strategies to trace different facets of her emotional odyssey in *Trick or Drink* exhibits an interest in performance similar to Chenzira's in *Secret Sounds Screaming*. In each, personal recollections of individual family histories are central to the tape's purpose, but such statements are bracketed by signs of their invention. Since neither tape seems overly concerned with exploring the fiction of autobiography, but rather with describing and analyzing distinct social phenomena, these signs can be read as connections between the emotional content of individual stories and larger social configurations of power. In employing this method, both tapes recall many of the feminist performance artworks that appeared and flourished in this country during the 1970s and that frequently used the body of the performer as an emblem of both particular and general social effects—Mendieta's work, for example. (Green's artistic career includes performance work, and an earlier film by Chenzira is about a dancer.) Since the connotations of femininity and images of the mute compliant female body go hand in hand in Western culture, the female performer who presents herself simultaneously as speaker and as spectacle has afforded feminism a metaphor for opposition to such sexist representations as well as a foundation for alternative modes of representation.

Performances by two women, one a dancer, also figure prominently in Linda Gibson's multilayered *Flag* (1989). Although mediated by elaborate camerawork and editing, these scenes demonstate an interest in recording performance similar to that seen in *Fuego de Tierra*. But Gibson also employs autobiographical material akin to that in Green's tape—family snapshots, diary entries—intercut with typical Americana-like pictures of the national monuments in Washington, D.C., and the patriotic texts of the Declaration of Independence, the Girl Scout oath, and the Pledge of Allegiance. As her title indicates, the U.S. flag is the tape's central motif. Its image, lore, and symbolic functions are used to highlight the points of intersection and disparity between the formation of a personal identity and the ideal of U.S. national identity. Although no less emotional than the parental betrayal described in *Trick or Drink,* Gibson sketches a process of disillusionment that occurs not as a product of malignant family dynamics but as unexamined patriotism giving way to a more ambivalent relationship with citizenship. The sound track names public, historical reference points like President Kennedy's assassination and the 1965 uprisings in Newark (Gibson's home), as well as a memorable personal

incident when two white boys chased her and yelled, "Fucking nigger, get out." In the same naive tone she uses to remark upon her crush on a boy in her class, she confides to her diary. "At first I was scared, but later I wanted to kill them."

Three different flags serve as central props in the performance scenes Gibson interweaves in the *Flag*. At the same time, the role assumed by each of the two performers remains constant: the white woman makes the flags; the black woman dances with them. The first flag is the traditional banner composed of carefully sewn strips of red, white, and blue fabric with appliqué stars, mounted on a pole and swung about with pseudo-military movements. As the political chronicle embedded in Gibson's autobiography hints at a more troubled relationship between the state and the individual, a batik flag is dyed in a symbolic "melting pot" of color and displayed more as an idiosyncratic garment than as an object of uniform design and nationalistic reverence. The third flag is a crude, ragged burlap construction, with the white areas created with bleach. This metaphor, like others in the tape can be read for multiple meanings: the impoverishment of the symbol of national unity, the production of U.S. national identity by removing color, and so on. Toward the tape's conclusion, the two women abandon their separate roles mediated by pieces of cloth when they cover their own and each other's bodies with red, white, and blue paint. This act once again relates national identity with skin color while it concurrently offers a visual metaphor for the identification of individuals with the body politic.

In addition to such gestural maneuvers, Gibson also employs an elaborate electronic pallet to construct her collage. For instance, she uses a circle wipe to replace Marilyn Monroe's face with her own school graduation portrait. Later, she repeats the move, but with Angela Davis assuming the place previously occupied by Monroe. Superimpositions, too, and intricately edited sequences form montages—both within frames and sequentially—which constitute visual rhetorical structures allowing Gibson to articulate the contradictions between the ideals of U.S. citizenship and her awareness of the depths of racism in U.S. culture.

"Average American family"—a prosaic phrase indicating the mythical site where rigid rules governing gender divisions prevail and the meanings of those divisions are persistently reproduced—acts as the centerpiece of Sherry Millner's *Scenes from the Micro-war* (1985). As in all the tapes cited here, Millner's work is constructed as a textual collage, in this case a combination of political imagery from popular culture—war movies, toys, and comics; a speech by Ronald Reagan—and scenarios based on the mundane events of everyday life— eating, bathing, lovemaking. Staged as a series of tableaux and vignettes but

claiming to be a narrative—the story of one family's "battle to survive"—the tape presents a dramatization of unsettling correspondences between official proclamations about the endangered institution of the nuclear, biological family and public diction about "national security."

All of this is played for satiric effect in Millner's tape. Many of the short episodes are shot and edited in a style that mimics the tension-inducing protocols of television action dramas, sometimes accompanied by a deadpan off-screen narration reminiscent of film noir: Fred McMurray's commentary in *Double Indemnity* or William Holden's in *Sunset Boulevard*. But Millner invariably includes elements that render absurd the assertions made in the tape's text. The first indication that the reality depicted in *Scenes from the Micro-war* might be exaggerated appears in the first scene. A man's voice introduces the cast of characters: "the wife and I, and the two kids." When the family walks toward the camera, however, it becomes evident that the "son" is a mannequin.

The most elaborate visual/verbal pun in the tape, however, revolves around the green, brown, and beige motif of military camouflage. Immediately following the titles, the narration continues, "We could be any family, living in any town U.S.A.—just blending right in." Then the bizarre family group gets into a car painted in a spotty camouflage pattern, which quickly becomes the ever-present emblem of the family's dedication to a regime of military preparedness. Their clothing, their faces, their TV set, and other items in their home, including their shower curtain are camouflaged. While the man (played by Ernest Larsen, who coauthored the script with Millner) takes a shower wearing a gas mask, Millner (who plays the wife) observes off-camera, "Camouflage as a way of life differs only in degree from the way people already live." Instead of enlisting camouflage as a method of concealment, however, every reference in the tape—a camouflage outfit for the Cabbage Patch Kid, camouflage cake boxes, camouflage condoms—underscores its deceptive purpose and, by analogy, the deceptions used to engender the patriotic sentiments that ensure popular support for military programs.

Since World War II, the mythical nuclear family has become the preeminent unit of consumption in this country. Millner recognizes the importance of gender in the domestic economy by locating her burlesque "micro-war" in the home of a hyperpatriotic, monomaniacal American family. While she covers a cake with army-green-colored icing and then decorates it with six-penny nails, her voice intones, "Oh, yes, a man's home is his castle. That's an idea as strong as the country itself. But wherever you look—whether it was on the old one-family farm or out on the prairie when the pioneers were out there with the twenty-mule team—I ask you, what was always the true last frontier? Why, it was the home. And who keeps the home fires burning? Why, it's the woman." Millner rapidly turns this hyperbolic reiteration of women's privi-

leged relationship to domesticity—the mainstay of right-wing antifeminist and "pro-family" arguments such as those advanced by Phyllis Schlafly and her anti-ERA Eagle Forum—into an unambiguous feminist critique. Proudly displaying her repulsive, olive drab, nail-studded "land mine cake," with half of her face smeared with camouflage makeup, Millner presents a perverse image of the domestic division of labor along gender lines married to ideas of nationalist, imperialist power mongering.

Although the positions taken by the actors and speakers—and, by implication, spectators—in *Scenes from the Micro-war* are varied and sometimes contradictory, all parts are played by Millner, Larsen, and their three-year-old daughter Nadja Millner-Larsen. The tone changes markedly, however, in the penultimate scene, when an electronically distorted recording of Millner's voice recounts her daughter's confusion about participating in the tape. She recounts how their adoption of fake military gear and militaristic behavior led Nadja to ask, "Are we bad people now, Mommy?" Tentatively, Millner answers with her own question: "Can you pretend something so that the something never happens, sketch out the implications of that something before it becomes real?" In other words, is it possible to counter the fantasies produced by dominant ideology with a critical fantasy? And, Millner wonders, "Does even entering into that discourse alone make us bad people?"

These questions about the relationship between culture and cultural criticism, are also suggested by the investigation into the popular appeal of television melodrama enacted by Joan Braderman in *Joan Does Dynasty* (1986).[10] After illustrating and interpreting the ideological and economic interests at work in the TV series, Braderman comments, "I confess my unreconstructed *Dynasty* delectation, though I have the intellectual tools to deconstruct its odious subtext. Does this tell you anything? Is deconstructing it merely a new way to love it? . . . This is what we want to know as feminists in the eighties." Again the institution of the family—in this case the extended family dynasty of Carringtons—provides the ideological and emotional frame for a critique of contemporary culture. And, like Millner, Braderman assumes a comic stance—augmented by a few costumes and props—to probe the political significance of and personal fascination with the characters and plots of *Dynasty*.

Although Braderman might qualify for membership in the *Dynasty* fan club, her cutting, humorous analysis is performed as an idiosyncratic, electronically choreographed monologue, enacted within scenes from actual *Dynasty* episodes. In some instances, holes revealing only her eyes, nose, and mouth appear to be cut as a mask from the TV frame itself. Peering through these chroma-key constructions, Braderman seems to hover above the goings-on of Alexis and company while she interjects her commentary. In other segments shot in front of chroma-keyed backdrops, her body appears at an angle within the perspective of the frame seen from above or below, so that she seems to lie

Joan Braderman, *Joan Does Dynasty,* 1986.

suspended in or towering over the action. Elsewhere, she speaks from the edges of the frame as if occupying a ringside seat. The various uses of this device—whereby Braderman pastes her own animate image onto scenarios from the prime-time soap opera—enable her to produce what she describes as "stand-up theory," featuring herself in the role of "TV infiltrator, media counterspy, and image cop." As a result, her images occupy a plane separate from that of the *Dynasty* sets and thus graphically emphasize the two-dimensional, stilted representations of the standard TV mise-en-scène even as she engages with it.

As her remark about her own ambivalent status as a politically astute critic who is, nevertheless, a *Dynasty* devotee indicates, Braderman doesn't shy away from the areas where political understanding and voyeuristic enjoyment clash. Commenting on a beauty parlor confrontation between Alexis and Krystal, providing an example of "one of our favorite Dynastic motifs: the cat fight," Braderman says, "As an aging feminist, I've got to ask myself, why do I love these things so much?" One of the refreshing effects of *Joan Does Dynasty* resides in is its refusal to make premature pronouncements about the ideological complexities entailed in gender identity while tracing the show's continual

elision of family relationships and corporate power. Joan Collins/Alexis Carring-ton Colby's central role in this configuration is, as Braderman notes, "pseudo-pro-gressive." That is, Alexis's recurrent grabs for power depend on her personification as *"the* phallic woman," which places her as the "center of power and desire in this show."

Many of the premises Braderman brings to her analysis of *Dynasty* are based in feminist, socialist, and anarchist cultural theories, although she avoids adopting a singular theoretical posture. Instead, she collages theories in a manner analogous to Millner's collage of modes of address or Gibson and Green's mélanges of associative imagery. And Braderman's entertaining delivery does not dilute the tape's didactic function as an exemplary exercise in honing critical consciousness in relation to mass media. Information about the practical side of *Dynasty*'s production is uttered along-side speculations on the significance of various narrative currents. She knowledgably describes sociological aspects of the program—its syndication in seventy-eight countries, some of the titles it has been given abroad, the number of viewers world-wide, and so forth. At other moments, she unravels the myriad psycho-sexual dy-namics that are best explained in the psychoanalytic language of unconscious desire. Throughout she sprinkles references to theories of commodity fetishism and the rela-tionship between commodities, style, and power so important to *Dynasty*'s popular appeal. By performing her on-screen, variegated interpretation of *Dynasty,* Brader-man both enacts and embodies the participation of the spectator in producing mean-ing, the spectator's role as consumer of media representations, *and* the ability of the spectator to think critically about what's on the screen. The tape ends with a shot of Alexis in jail, screaming from behind bars, "Let me out of here!" Standing next to Alexis, Braderman addresses the audience: "We're the spectators. We're outside the box. She's inside. Indeed, the question of our times, ladies and gentlemen, is, who's in the box? Because that's where power lives. . . . She *says* she wants to get out. . . . The problem is we *need* to get in."

The "we" addressed in *Joan Does Dynasty* is clearly defined as feminist. Not only does Braderman's analysis draw upon and elaborate feminist studies of melodramatic fiction,[11] but she employs the vocabulary of feminist theory throughout the tape. In contrast, Martha Rosler's *A Simple Case for Torture, or How to Sleep at Night* (1983) does not concentrate on feminist texts or problems understood in terms of feminist theory. Even so, her tape poses a set of ques-tions that cannot be fully considered without an awareness of the inflections of gender within the field of political theory. This is signaled early in the tape, when the camera scans a cover of the June 7, 1982, issue of *Newsweek* featuring a painting of a bare-breasted woman—William Bailey's *Portrait of S*—accom-panied by the headline, "Art Imitates Life: The Revival of Realism." Here feminist arguments about realist modes of representation and sexist objectifica-tion—including traditional portrayals of the nude female figure—are brought up to date. But Rosler also presents the magazine cover as the outer wrapping

of the work's central text: a polemic supporting the use of torture, written by City College of New York philosophy professor Michael Levin, published in a column entitled "My Turn."

Rosler's multilayered dissection and refutation of Levin's defense of torture is formulated as a montage of visual and audio material from a variety of sources: newspaper clippings, television ads, radio interviews, news reports, and the like. The relevance of feminist thinking to this project could be described in language similar to that Rosler used to explain the significance of gender in an earlier videotape, *Vital Statistics of a Citizen, Simply Obtained* (1977): "[I]t isn't a 'work about women'; it *is* a work about women, but it is also *not* a work about women. It's a work about personhood, and intrusive violation."[12] In *A Simple Case for Torture,* the converse can be said—that it is *not* a work about women, but it also *is* a work about women, insofar as the social position of *women* vis-à-vis the state differs from that of men. In a passage detailing the correlation between repressive police activities abroad and U.S. police training, for example, a radio reporter describes specific cases of Latin American death squads' systematic use of rape to intimidate women suspected of subversive activities. Elsewhere, Rosler builds a sequence of newspaper and magazine articles and pictures—from a *Time* magazine cover featuring Patty Hearst/Tania, superseded by an ad for *Time* featuring a photo of a woman headlined "Fear" to a full-page photo of Nancy Reagan overlaid with a magazine photo captioned, "Mother with photographs of her missing children in San Salvador." While this series of images occupies the screen a voice describes death squad organizations and the same radio reporter recounts another woman's story of rape and torture.

This inundation with mass-media fragments occurs immediately following a section of the tape where off-screen voices and on-screen texts describe a procedure Rosler calls "leveling": the eradication of "the difference between public and private . . . between the individual and the state." Later she adds another important distinction applicable to feminist political theory: "When we confuse the individual with the state we eradicate all notions of politics. The social 'we' seems to be just a swarm, a random mass, and one can imagine that public decisions, like private ones, are made on the basis of desire. But terrorist acts are political acts, and the state's response is the result of political policy in the exercise of power." By scrutinizing just one item from a mountain of mass-media products, Rosler then marshals a seemingly endless set of clippings and quotes to chart the intersections between the fault lines that crisscross political discourse in this country. And, insofar as political power informs the textual operations of the mass media—and vice versa—she reassembles her collection of text fragments to reveal how this exchange works. Particularly germane to a feminist analysis of these issues, *A Simple Case for Torture* never overlooks nor underestimates the key role played by the female body in ideolo-

gies of domination and the repercussions of these ideologies on actual, living women. At the same time, Rosler complicates what is sometimes imagined to be an easy equation between the personal and the political.

No matter how elusive definitions of a "feminine aesthetic" may be, to discuss a collection of works by women artists without inventing one may be even trickier. Still, none of the connections between the tapes mentioned here is aesthetic. Surely, formal relationships may be noted, but the political meanings of such features often govern their use. Rosler's attention to the policies of state terrorism, mass-media representations of political relations, and crucial differences between individuals and the state in *A Simple Case for Torture* resonates with a number of similar concerns in *Flag* and *Scenes from the Micro-war*. Chenzira's investigation of the links between sexual aggression and domination in *Secret Sounds Screaming* can also be read in relation to *A Simple Case for Torture*. The similar autobiographical components of *Flag* and *Trick or Drink* have already been pointed out, as has the attention given to problems of performance in all of these tapes.

Thirteen years after Sylvia Bovenschen published her provocative essay on feminine aesthetics, it may be possible—and necessary—to contradict her conclusions while crediting her contribution to feminist criticism. Not only are there no aesthetic principles common to artworks by women, but women's "aesthetic awareness and modes of sensory perception" cannot be categorized either. Indeed, the tapes discussed in this essay exhibit no formal characteristics whatsoever that can be isolated as specifically feminine. But there is, perhaps, a set of critical terms that may be said to be feminist—terms that are historical and inseparable from other political discourses. Conceptions of public and private spheres, the nuclear family, racial identity, national identity, consumer culture, corporate power—none of these are strictly feminist concerns, but a cogent analysis of any of these topics must contain a feminist component, although few feminists will define the questions at stake in identical terms. Feminists may agree on one question, however. As this video work suggests, inquiries about whether there have been—or ever will be—any "great women artists" have been effectively displaced by the critical voices of feminism.

The Medium Is the Mess ... age

Societies have always been shaped more by the nature of the media by which men communicate than by the content of the communication.

Marshall McLuhan,
The Medium Is the Massage,
1967[1]

[T]he message which the objects [as commodities] deliver is radically simplified and is always the same—their exchange value. And so, deep down the message has already ceased to exist, it is the medium which imposes itself in its pure circulation. Let us call this ecstasy.

Jean Baudrillard,
The Ecstasy of Communication,
1988[2]

It has been a quarter of a century since McLuhan gazed at the cathode ray tube and glimpsed the dawn of a new age. In the youth of the day he saw a generation that "instinctively understands the present environment—the electric drama."

{TV has transformed} . . . American innocence into depth sophistication, independently of "content.". . . TV has changed our sense-lives and our mental processes. It has created a taste for all experience in depth. . . . And oddly enough, with the demand for the depth goes a demand for crash-programming {in education}. Not only deeper, but further, into all knowledge has become the normal popular demand since TV."[3]

As members of the first media generation, a generation once intoxicated by a bubble of limitless possibility, unparalleled affluence, and unrestricted hedonism, we feel compelled to re-examine the positions of medium and content in the late 1980s. Echoes of McLuhan continue to reverberate through media theory, though the liberal, optimistic outlook of the 1960s has given way to dark sobering shades of interpretation. The bubble has burst, but the memory of the medium as a path to electronic enlightenment still vibrates in the air around us.

But is content only "the juicy piece of meat carried by the burglar to distract the watchdog of the mind"[4] so that antiquated modes of perception may steal out the back door? Or is this de-emphasis of content an excuse, a rationalization, that encourages abdication from all responsibility of the mind?

What's on TV?

The discrete programs, in the perspective of the vernacular, the carriers of TV's content, actually exist to provide a suitable environment for the commercial message, advertising, the central mediating discursive institution that links TV's text with its relevant context. It is the advertiser's demand for viewers that is the fundamental criterion of why a program occupies a particular slot in the schedule, the supertext.

Television presents and sustains consumption as an answer to the problems of everyday life. It articulates and, at the same time, dissolves the difference between the "supertext" and "supermarket."

**Nick Browne,
"The Political Economy of
the Television Supertext"[5]**

But after accepting this model, why do we still find ourselves in a "pathetic" state during moments in front of the TV, a state outside of and at times opposed to a trip to the supermarket? Is it possible TV contains an object that is still opaque, something other than the ecstasy of pure and transparent commodities? Is there still a content independent of the unyielding and inevitable form of the electronic medium?

The confusion we feel when confronting television does not come from focusing on the "content" we have come to accept, the varying subjects of media's traditional composition, but from ignoring the composition that transmits these vestiges of

pathos and thus emerges as the medium and the actual content, the message.

But composition in this meaning, as we comprehend it here, is also a construction which, in the first place, serves to embody the author's relation to the content, at the same time compelling the spectator to relate himself to the content in the same way.

Pathos shows its affect—when the spectator is compelled to jump from his seat. When he is compelled to collapse where he stands. When he is compelled to applaud, cry out. When his eyes are compelled to shine with delight, before gushing tears of delight. . . . In brief—when the spectator is forced "to go out of himself."

**Sergei Eisenstein,
Film Form[6]**

The pathetic, for its part, involves these two aspects: it is simultaneously the transition from one term to another, from one quality to another, and the sudden upsurge of the new quality which is born from the transition which has been accomplished.

Hence movement, perceived or made, must be understood not of course in the sense of an intelligible form (Idea) which would be actualized in content, but as a

sensible form (Gestalt) which organizes the perceptive field as a function of a situated intentional consciousness.

Gilles Deleuze,
Cinema 1[7]

Eisenstein's intentional consciousness perfected a composition, a manipulative behavioral model, that duplicated within the spectator through manufactured pathos the author's relationship to his predominantly Marxist content. This composition, this particular organization of the perceptual field (personal only to Eisenstein and the other media manipulators of his time), now dominates the supertext.

Because the nature of this construction depends on juxtaposition and opposition for its effect and the resulting effect is greater then the sum of its component parts, the subversion of the original intent of the construction is assured. For what could happen and indeed has happened is that the system produces an object with no qualities, a transparent object, an invisible object that is still recognized, a ghost. The process of "transition from one term to another, from one quality to another" became a process of annihilation. The most powerful new quality produced by the pathetic construction is no quality. Any juxtaposition, any opposition between any quality and this no quality results in zero. The supertext renders every object invisible, in effect, transparent.

$Y \times 0 = 0$, whatever Y is.

THERE'S NOTHING ON TV.

Patti Podesta, Untitled, 1989.

Who's Watching Whom?

According to Bergson, we perceive those parts of an object that are useful to us and suppress the perception of those parts of an object which are not. "Everything thus happens for us as though we reflected back to surfaces the light which emanates from them, the light which had it passed unopposed, would never have been revealed."[9] It is as if we were conscious mirrors selectively reflecting those parts of an object that appeal to action and letting the light from the rest of the object pass through us. It follows that if an object no longer appeals to any action on our part, we would not reflect any light back to the object and that object would be invisible.

There is another process that renders us ever more transparent as mirrors, habit.

As habits are acquired through repetitive conscious choices of action on a given object, conscious perception of the object ceases; "it is stored in a mechanism which is set in motion as a whole by an initial impulse."[11] The supertext is a continuous flow of these habits (clichés) acquired and being acquired. What was once a mirror becomes increasingly transparent, a screen.

What About How I Feel

Faced with the obscene transparency of the electronic media we feel impotent, unable to act, unable to con-

struct models of composition outside our "customary equilibrium and condition." Either we are transfixed by the transparency, accepting the constant dissolution of our values and ideals as something innate, without history, always of the present; or despite the fact that we are able to perceive the acquired nature of our fascination, we are still unable to act consciously, becoming like Nietzsche's Dionysian man as he "resembles Hamlet: both have once looked truly into the essence of things, they have gained knowledge, and nausea inhibits action, for their action could not change anything in the eternal nature of things; they feel it to be ridiculous or humiliating that they should be asked to set right a world that is out of joint."[13]

Irony can no longer today be simply the subjective irony of the philosopher. It can no longer be exercised as if from the outside of things. Instead, it is the objective irony which arises from things themselves—it is an irony which belongs to the system, and it arises from the system itself because the system is constantly functioning against itself.

Jean Baudrillard,
The Evil Demon of Images[14]

Thus we rescue ourselves from complete transparency by evoking the tenuous, ghostly opaqueness of objective irony. We cultivate an awareness of the acquired mechanisms within ourselves. We see in the television object a bright reflection of that dissolution process that we have become. And dimly we perceive the last

vestiges of personality, political identity, and personal acts other than the action (virtual and actual) of the supertext become supermarket. However, objective irony can only guarantee the observer participation in the agony and defeat of Eisenstein's composition, his omnipresent montage of opposition. We have become the monitors we watch.

And when we participate, when we attempt translation of our personal content into the acidlike solution of electronic media we convince ourselves we must use the existing dominant composition.

Like many American progressives, he believes in popular culture. Unlike the intellectuals of the left who returned to academia and tried to find in semiotics, psychoanalysis and political theory the reasons for the failure of '68, those who believed that progressive content could be packaged in traditional forms found the mass media a possible arena.

Amy Taubin,
"Independent Daze"[15]

Appropriating historical compositions for contemporary personal con-

A Sugar Cube Dissolves in a Glass of Water

I must wait willy-nilly, wait until the sugar melts.

Henri Bergson,
Creative Evolution[16]

But why wait? Why not stir with a spoon?

That the movement of translation which detaches the sugar particles and suspends them in the water itself expresses a change in the whole, that is, in the content of the glass; a qualitative transition from water which contains a sugar lump to a state of sugared water. If I stir with a spoon, I speed up the movement, but I also change the whole, which now encompasses the spoon, and the accelerated movement continues to express the change of the whole.

Above all, what Bergson wants to say ... is my waiting whatever it may be, expresses a duration as mental, spiritual reality. But why does this spiritual duration bear witness, not only for me who waits, but for the whole which changes? According to Bergson the whole is neither given nor giveable ... if the whole is not giveable, it is because it is Open, and because its nature is to change constantly, or to give rise to something new, in short, to endure. So that each time we find ourselves confronted with a duration, or in a duration, we may conclude that there exists somewhere a whole which is changing, and which is open somewhere.

Gilles Deleuze,
Cinema 1[17]

tent presents two problems. First, since these compositions "compel the spectator to relate himself to the content in the same way" as the original author of the compositions, the artists mastering the compositions can be unknowingly indoctrinated into the archaic structures of thought dictated by the compositions. Second, the historical compositions create precise, particular relationships between content and spectator, twisting the contemporary personal content into forms that were never intended. Thus when the work of translation is complete the artist finds that the content was compromised from the outset. If historical composition guarantees instantaneous transparency and dissolution to any perceptions however uniquely personal and contemporary they may be, then the resulting marriage of composition and perception is invisible, already dissolved, obscene.

But if this is true, even if we were to create our own personal compositions, wouldn't they also dissolve (albeit more slowly) into the acid of the media? Is there a solution?

Nechelle Wong, Untitled, 1989.

As videomakers we find ourselves creating work that inevitably dissolves into the solution of the media. Whether that duration is instantaneous or has a process of decomposition that is observable over time depends on the composition the artist chooses. We can compel the spectator to view the dissolution, the transition from opaqueness to transparency, from conscious perception to habit; from our angle of perception and over our duration of the dissolution, but it is not given to us to change the whole. We cannot halt the process of dissolution. We must wait. For somewhere, as United States citizens (and increasingly the rest of the world's people) sit in front of the TV six hours a day, day after day, year after year watching the sugar cube dissolve, the whole is changing; beyond the media, beyond our control, perhaps beyond our understanding.

As we wait impatiently for the change that is always happening, for a glimpse of the opening that exists somewhere, we can sweeten the sour acid taste of dissolutionment with our art.

This Is Not a Paradox

JUDITH BARRY

Recently, I attended a conference on television and the media where there were
no people from the media giving presentations. The participants, many of
whom were converts to mass culture from film theory and related discourses,
gave papers that applied the methods of textual analysis, with a sprinkling of
Jacques Lacan and Jean Baudrillard, to the practice of television genres. As I
listened to arguments developed fifteen or so years ago in relation to literary
texts and classical HW film, reworked to fit with television, I realized that
perhaps textual analysis with its endless discursive meanderings was peculiarly
suited to the "flow" of television itself.

In describing television as a flow rather than a discrete narrative, as is the
case with the classical HW film, TV analyists have identified the continuous
nature of television's structure, the way in which it is the desire for plentitude,
insatiable by definition, and endlessly deferred, that holds the viewer's atten-
tion. Textual analysis is a method in which the reader becomes an active par-
ticipant, rather than a passive consumer, of the meanings of a text, such that
the reader, through reading, becomes, in effect, the writer of the text.
Through this process the reader often experiences the thrill of discovery com-
bined with the sensation that the text itself is actually being transformed. But,
for the listener (in the audience), this is rarely the case. . . . A critical point
about textual analysis in relationship to practice is this: As an analytical
method, it does not seem to lend itself *to* or to be productive *of* transforma-
tion, particularly vis-à-vis the text it is querying. Instead, that text serves as a
kind of wellspring out of which meanings flow. This is not an attack on tex-
tual analysis, but more a question of the efficacy of its impact.

In Gayatri Chakravorty Spivak's essay, "The Politics of Interpretation,"
she wonders if Julia Kristeva was quoting Marx's eleventh thesis on Feuerbach
when she said, "Of course, no political discourse can pass into non-meaning.
Its goal, Marx stated explicitly, is to reach the goal of interpretation: interpre-
ting the world in order to transform it according to our needs and desires."[1]
Although Spivak was concerned with the ideological implications of Kristeva's
"wishful thinking," her misuse of Marx in relation to her privileging of the
analyst/analysand dyad against the "vastly multitudinous, multi-
racial, and multinational political arena" struck me as the way in which
textual analysis as an ideology has become indistinguishable from its method-
ological uses in the arguments of both writers. Identifying a politics in relation
to analytic strategies has been a question that has circulated around many con-

temporary discourses. Defining a practice for that politic has been problematic, particularly in relation to television/media because it has not been tied to an oppositional movement or struggle per se.

In the dismantling of modernism and its turn to strategies and textual systems, the ability to posit "constructions" that embody specific programs seems to be temporarily paralyzed. Could this be because of the overvaluation of signification and its workings at the expense of an equally meticulous interrogation of the working of the referent as it is manifested in lived social practice—the "multitudinous, multiracial, and multinational"? Or could it be that the hoped for union between Marxisms and other post-1968 theories of subjectivity including psychoanalysis, literary theory, and feminism, to mention but a few, were failures, leaving us beyond alienation in the "post" stage—postmodern, postfeminist, and the rest? Or could it be that the social circumstances surrounding present conditions in the West under George Bush and Margaret Thatcher have made ideas about social progress seem implausibly naive, so much so that we turn to so-called emerging cultures where the stakes are seemingly more real, and the horizon is less clouded by discursive formations, to see how we might begin to empower ourselves. Is there something amiss when the colonizer looks to the colonist for liberation?

Edward Said, in a recent lecture on the culture of resistance, noted that before a territory can be taken over, its culture must be controlled and that this is a strategy that must be recognized by both the oppressor and the oppressed; for example, the situation of western Europe and Asia from 1750 to 1850, which corresponds to romanticism. He argued that culture prepares societies for domination just as it also prepares them to relinquish domination through a process of resistance. One of the first stages in the development of this resistance is the recuperation by the oppressed of forms already carved out by the dominate cultures.[2]

It is interesting to think about this concept as it might apply to broadcast television and its relation to video artists/producers working in alternative media. For example, the terms *elitist* and *populist* might take on new meaning if we considered the artist/producer as a populist in the sense of attempting to recontextualize a dominant media form, and simultaneously we might consider broadcast television elitist for excluding alternative ideological positions. This is nothing new, but it does somewhat undermine the way art history tends to look at artist-media production, even though there is an art history that calls into question the notion that art making is an elitist activity. This is a history that traces its legacy from the work of Dziga Vertov and Sergei Eisenstein in the 1920s through dada and surrealism in the 1930s, from the Bauhaus and its legacy in the 1940s to pop art of the 1950s, from situationalist activities of the 1960s to conceptual and feminist art of the 1970s—and to now. I am mentioning these moments not to imply that there is a kind of inevitable con-

tinuum in which video art is to be located—on the contrary, each moment, was historically specific—but rather to stress how in each of these examples there was the possibility of cohering a social momentum that extended the reach of cultural discourse into the domain of the political discourse. In each instance, a culturally specific place was constituted that was "different" from dominant discourse, yet simultaneously able to engage with that discourse. Certainly, one reason for this had to do with the way in which critical practice was reflected in the strategies of the above interventions.

The video maker/artist working in dominant media risks internalizing the psychic positions of the oppressor (dominant media) within the materiality of his or her practice as she or he is forced to negotiate the difficult terrain in which the television-flow context determines the readings that an audience constructs around the work. This is particularly true for those artists who incorporate video effects into their production as MTV and rock video has transformed the ways audiences view short-format works. In a market where money buys effects and the technology allows for few shortcuts, the "art" on MTV is virtually indistinguishable from other programming produced by other artists.

In considering oppositional practices or strategies of resistance, it is important to emphasize that it is *how* these strategies work to produce a collective space for oppositional practice to occur that is important. In the absence of a clearly defined oppositional sphere, attempts to focus on the artwork's ability to question, to contest, or to denaturalize the very terms in which it is produced, received, and circulated must be located in the work's ability to contain within its boundaries the possibility of its own metacritique; as well as constantly to address those economic and social forces that perpetually threaten to eradicate its critical differences. A look at the relationship between art/video and art/photography may illustrate this.

In March 1985 Lucinda Furlong published one of the first essays on "New Television."[3] In this essay she notes that many proponents of New Television believe that they can buy into the industry's system of production and distribution without necessarily replicating the commercial product. Video art and television art were increasingly polarized in conferences across the United States. Video art was identified with the contaminated museum structure, seen as elitist and in need of institutional support; while television art was seen as populist and hence more radical, because it might possibly reach a larger audience. One of the problems that Furlong saw in relation to "new" television's ability to maintain a critical stance and actually change television was her fear that programming produced by art-world artists for broadcast TV would be indistinguishable from other broadcast programming. She recognized that by 1985 the idea had taken hold that it was impossible to make a good videotape unless you were using state-of-the-art effects. This has progressed to the point where, instead of the commercial broadcast sector looking to the art world for

new ideas, we have a reverse situation in 1988 where artists in video or "new" television are looking to the commercial sector, in particular to ads and rock videos, to see what effects are most recently available.

Abigail Solomon-Godeau charts in "Living with Contradictions" and in discussing the appropriation practices of "oppositional postmodernism" (to cite Hal Foster's notion of a critical postmodernism) the seamless and rapid recuperation of this strategy into advertising and television media and finally its re-canonization as part of art photography—the practice it initially set out to counter. This assault was bound up with modernist orthodoxies of immanence, autonomy, presence, originality, authorship and its engagement with the simulacra; and its recuperation has been so rapid that it might be characterized as a sort of deconstruction in reverse.[4] Douglas Crimp, in a catalog essay called appropriately "Appropriating Appropriation," asks how this operational mode can articulate a specific reflection upon the culture if all aspects of the culture use this same mode.[5]

Within the practice of video art as it elided into "new" television, it does not seem to me that strategies of opposition to dominant television were identified; similarly no critical discourse describing this movement developed beyond one or two articles.[6] Are video art-identified producers who work for broadcast television and who lack a theoretical discourse just waiting to be quietly absorbed into the mainstream? With the absence of a defined movement, who will notice?

Remember the early 1970s when anyone with a half-inch portapack camera and deck was considered an artist? Looking at the articles and books that have been produced about this period, it is hard not to see in the manifestos and writings a genuinely revolutionary impetus, a reflection of the social currents that seemed to be transforming daily life as well as cultural life to such an extent that anyone with a video camera could be an artist. Working collectively, sharing equipment and authorship, such groups as Videofreex, TVTV, Video Free America, AntFarm, and others set out to transform the way television was used. Dissatisfied with the one-way direction of broadcast and eager to include a heterogeneous group of people from a number of disciplines, these groups and others like them produced tapes on a variety of subjects that were meant to be broadcast on cable networks or shared via the mail. Many of their ideas seemed to come directly from an analysis of the "info-revolution"; in particular, they dealt with the way decentralization and economies of scale in computer production were making the computer smaller and less expensive. They saw that these economies would make it possible for everyone to become a video producer and that new modes of distribution would have to be put into place, notably cable. Well, they were correct, but it didn't work out in quite the way they had imagined. Home video, despite mail clubs, will never

take the place of dominant media in the daily lives of most people. And as for cable, with the exception of local-access programming, it is as monolithic and as dominated by corporations as the networks.

As Michael Shamberg has stated, "what we're attempting to do is to put together a network that replaces the network. . . . They go out with five man crews. They sit above the crowd. If they want to talk to someone, they drag him of the crowd, and they make sure you don't get in their way while they talk to him. . . . We don't go out of the crowd—we're part of the crowd. The experience of being part of an event has never been considered news on broadcast television. So that the whole system is deaf. There is no way to get into it.

What we want to replace it with is like the most interactive system possible, which is basically a two-way system. Not only are you a passive consumer, which is what the culture is trying to be, but you can also produce for it. Basically, it's a process rather than a product notion. . . . What we are banking on is that what people {will} pay for is access to this process . . . If I send a tape out, anybody is welcome to copy it. What you're paying for is access to that tape originally."[7]

How did we get from there to "new" television? It might be interesting to reconsider Peter Wollen's essay from 1975, "The Two Avantgardes." This essay addressed the ways in which a structuralist film practice over the decade 1965 to 1975 represented a displacement of concerns from the art world to the film world, rather than an extension of filmic questions. This displacement is one in which the filmmakers, here Peter Gidal and Malcolm Le Grice, shared concerns with mainstream painters and other visual artists; they transposed, in a sense, the concerns of visual arts into film "such that the tendency for the visual arts to be self-reflexive has been translated into specifically cinematic terms, pushing them into a position of extreme purism or essentialism."[8] In the case of Le Grice and Gidal, this took the form of work on the picture track so that there was an ever-increasing tendency to deal with film as pure film: a "dissolution of signification into objecthood or tautology."[9]

This argument could also be appled to "new" television, particularly work that relies upon video special effects. It could be argued that this work has internalized this tendency toward self-reflexiveness replacing questions about changing the medium with a desire to be accepted. Self-reflexive video art might be characterized as being all dressed up with nowhere to go.[10] Wollen's article is also about another avant-garde, the avant-garde of the Soviet directors of the 1920s. Within this avant-garde practice it was the signified, content in the conventional sense, not the signifier (as in the structuralist film) which was always dominant. He found in the Soviet filmmakers a recognition of a new type of content, a new realm of signified, which demanded a new signifier for its expression. Eisenstein developed an aesthetically derived content—radically

transformed through montage theory, which itself was dialectical and which allowed the signifier to slip from bondage from the signified. In a similar way, Jean-Luc Godard forty years later worked with the theory of dialectical montage, pushing the disjuncture between signifier and signified. He was able to move beyond the boundaries of naturalism, to which Eisenstein had confined himself, so that *Le Gai Savoir* represents not just another world view, but a methodology for investigating the whole process of signification out of which a world view (read ideology) is constructed. Godard was considered political (at the time of the making of this film, 1975), while the structuralist filmmakers are not, even though, as Wollen pointed out, they do claim a political stance for their work. But claiming a political stance is not enough, there must be a break with bourgeois diegesis and a subversion of the cultural codes they embody. And, Wollen cautioned that if this break is not theoretically constructed within a deconstructive/subversive politic it leads right back to the problems of the pure signifier, i.e., excessive work on the image track.[11]

Where are television's historical avant-gardes? To a certain extent the early history of portapak TV implied a radical break with the signifying systems of bourgeois ideology. *Guerrilla television,* to use Paul Ryan's term, didn't want to be accepted by broadcast television; it wanted to change the entire apparatus—from production through distribution and reception. But guerrilla television was predominantly documentary and, as the 1960s changed to the 1970s, there was the sense that this approach could not generate signifying systems that would recover the radical implications of montage theory. This was especially clear as questions of gender and its representations were articulated within feminism and film theory. Feminist video and film strategies collapsed the separation between mediums, replacing what Wollen called the self-reflexiveness of filmic codes and their emphasis on the materiality of the signifier with an understanding of *how* the plane of expression is embedded in the ideological through complex discourses that set a place for the consuming and reproduced subject.[12] However, in narrative terms, these strategies have been absorbed by the broadcasters eager to attract the female audience.[13] And it could be argued that the feminist analysis of ideological positions inscribed within bourgeois subjectivity never constituted itself as critique powerful enough to resist co-optation. This has left feminist film/video producers in a quandary: if alternative video/film practices reproduce the same subject-positions for the viewer to inhabit as dominant media (this dominance is not homogeneous, but specific to the demographics it serves), then what kinds of differences can film/video makers posit? Valorizing deviance as a kind of outlaw subjectivity?

In the unlikely event that the work is broadcast, how do these videotapes construct a rupture with mainstream subject-positions if they are simply *better* television or in many cases *worse* television. By *better,* I mean more nuanced

characterization, higher production values, quality stories (not "junk"), and by *worse,* I mean not productive of enough pleasure to be watchable, too difficult for a mainstream audience, or too ideologically overt for such an audience.

To a certain extent this is a problem faced by both MTV and Deep Dish (DD), to mention two diametrically opposed approaches to the possibilities of another kind of television. Just as video artists are people who say they are artists, so Deep Dish can be a network if it is willing to present itself in that way. That it is more closely related to a syndicated series is perhaps a question of being too reliant on the immateriality of the referent. Ideologically speaking, that it would make that claim is hopeful, not cause for despair. Both DD and MTV present alternatives to mainstream media for the viewer as well as for the producer of video and film productions. Both networks embody in their avowed philosophies oppositional strategies that seek to undermine and anarchistically upset the boring sameness embedded in the dogged flow of television. Both of their aesthetic styles—DD's low-tech antitech and MTV's special effects emphasis—might be seen as a "form of refusal," which initially might elevate what is shocking into art, to borrow a phrase from Dick Hebdige.[14]

There are a number of factors that make this a ridiculous comparison, of course. DD is available sporadically and at the whim of local cable programmers, whereas MTV runs in seventeen countries for as many hours a day as TV is on the air. Ideologically, MTV represents the triumph of advertising over art as the art programming is indistinguishable from the ads (and often not as interesting) and from the station IDs that surround it. It is rarely as long as the rock videos, so there is little chance of confusing the two. Recently, MTV dropped the "art-break" lead-in to their artist sequences, going instead for name recognition for artists such as Robert Longo and Randi of the Redwoods, to mention two. This has effectively fed the consumer orientation of the network as it functions to turn the artists into star commodities, similar to bands. Ultimately, the art on MTV functions as just another type of programming, not even distinguishable as a genre except in those rare instances where the work is able to contain within its structure its own metacritique. One example is an art-break where the artist is seen in a number of situations destroying his MTV, saying, "I hate it, I hate it," then in the end, saying, "Only Kidding."[15] Another example is Julian Temple's recent Neil Young video, which innercuts Young's antiproduct endorsement song with sequences showing well-known stars' look-alikes endorsing the same products. Initially, MTV refused to air this tape, which generated a lot of negative publicity for MTV as well as guaranteeing airplay on other music shows.

DD, the network brainchild of Paper Tiger producers, is mandated to attack the ideologically contaminated consumer/marketing base of the mass media through the syndication of program series produced by a wide range of people, some of whom identify at some times as artists, but many of whom are

in other fields including sociology, psychology, economics, and academia. DD attempts to counter the ways in which the dominant media distort information on a wide variety of subjects from South American/South African relations, information technology, the U.S. government, and so on. And in keeping with its mandate, DD allows no advertising, although there are occasional public service announcements. As a network, it has benefited because other syndicated series running on public television seem uninterested in any programming that is even remotely political. But the inability to pay producers, coupled with the eventual depletion of available politically correct programs, plus the lack of funds to generate many new programs, may make it difficult for DD to live up to the network part of its name.

In the case of both networks, these are problems of reception and should not be taken as necessarily constituting a dismissal of individual tapes—as screenings in other, nonnetwork contexts have shown.[16] Often these tapes can more than adequately live up to their promise of rupture.

Independent video's inability to theorize a coherently inclusive position has often seemed to pit proponents of "image-track investigation" against those who are more obviously interested in content. Surely the old form/content debate need not be reiterated now after twenty years of semiotics and analyses of how the ideological is embedded within the structures of representational practices. Both Deep Dish and MTV challenge media makers to produce works that intersect with their prevailing contexts in such a way as to create a difference. As producers they ask us to construct a different mode of address, to use the tools that we have to question what Jean Baudrillard called in his early article, "Requiem for the Mass Media," the structural communication grid. But in trying to preserve this grid, one obviates the possibility of a fundamental change and risks condemning oneself simply to manipulating the structure. For Baudrillard, what is strategic in this sense is *only* that which radically checkmates the dominant form. This is an impossible position for an independent producer to be in—even if his analysis is correct—that it is the entire apparatus that is contaminated because of the inherent properties of the media. I bring up Baudrillard because it seemed for a while that he would be able to provide what media producers need: a theory of the ways in which mass media cultures function that goes beyond the Frankfurt school and film theory. Unfortunately, such an analysis has not been forthcoming, and his writing has become for many pessimistically tautological or cleverly postmodern.[17]

One interim strategy that might be more appropriate is Homi Bhabha's concept of colonial discourse based in ambivalence. Through mimicry, the colonized receives the message and appropriates the meaning. "In order to be effective mimicry must continuously produce its slippages, its excesses, its differences. Mimicry is a strategy of resistance available to the colonized subject. For instance when the colonist uses the word 'master,' it may signify to him:

protector/civilizer/cultivator. When used by the colonized, the same word may signify 'oppressor/exploiter/genocide.' "[18] This is interesting not only in terms of strategies of appropriation, mimicry, parody, or pastiche (to mention but a few of the ways in which this strategy has been viewed), but also in terms of how audiences are positioned and how identificatory subject positions are taken up. Both MTV and DD sometimes use parody or pastiche. For instance, Frederic Jameson distinguished parody as a modernist position that still maintains a critical, historical style, which is subversive; whereas, for Jameson, pastiche is a neutral practice of mimicry lacking in the sense that there exists something normal "out there" to which it bears some relation.[19] For Jameson, pastiche signifies the end of a historically grounded cultural position—the loss of a place from which culture can be evaluated using the modernist models. Yet, I think in the dynamic play between these two positions something else is at stake, and that is the potential to develop new signifying relations—relations that would challenge the way we receive media information.

In his recent discussion of colonial discourses, Edward Said developed the concept that the relation between discourses of oppression and discourses of resistance is a parasitic relation; for it is through the discourse of oppression and its reworking through the practices of literature and cultural inscription that a resistance develops into an oppositional strategy, then into a culturally empowering form of address and possibly a strategy of liberation. Said noted that one stage in the development of a postcolonial discourse is the shift in terms from nationalism to the dialectics of liberation.[20] In a milieu as diverse as the United States, this involves reframing these terms through forms that address contradictions expressed through cultural hegemony as well as locating a terrain in which differences among representational cultures can be explored.

In terms of alternative media practices, this might take the form of recognizing how the construction of *networks,* to return to the examples of MTV and DD, might allow for the generation of oppositional spheres—arenas in which the contradictions of the U.S. experiences might be explored. In a culture as diverse and bifurcated as the United States and with many potential (and competing) oppositions, it seems important to recognize the power in the notion of a collective, even if they are as diverse in ideological intent and practice as MTV and DD. Television reduces all individual programming to the medium that it is; in its endless flow, context is everything. If we as video artists/producers look at our practice as a form of colonial discourse, a discourse that speaks to us much more than we are able to transform it, we cannot fail to acknowledge our position vis-à-vis the terrain that Said mapped. The organization of networks would begin to effectively change the way we receive (perceive) the media. Networks could define contexts in which strategies of opposition would be foregrounded, and practices in which individual tapes might have an effect.

Members of the Paper Tiger crew prepare for DEEP DISH TV, the first public access satellite network scheduled to begin in April, 1988.

The Wild Things on the Banks of the Free Flow

DEE DEE HALLECK

"... and we danced our terrible dance...."

There is an old saying that freedom of the press belongs to those fortunate enough to own one.[1] In this age of chip cameras and cheap condensor mikes, the number of those with the electronic equivalent of printing presses has grown exponentially. No, it's not the "global village" utopia envisioned by 1960s media gurus, particularly in the "third" world, where "Miami Vice" and Coke ads are spewing forth regularly on TV sets from Thailand to Venezuela and from Nepal to Ghana. It is a sad irony that many of those who nightly watch the glories of consumer life portrayed in the electronic effluence that floods their air waves are living in countries increasingly burdened with debt, the interest payments of which go into supporting the life-style of a "first" world whose affluence is farther away than ever. A relentlessly increasing poverty has accompanied the transnationalization of third world economies as ever greater amounts of raw materials and cheap labor power are exported to consumer centers in the North. The destruction of the tropical rain forest is perhaps the most lamented of these grabs, but it's the tip of the iceberg, to use a metaphor that may soon be an anachronism.

The increasing mass use of electronic transmission and recording is, however, full of contradictions. One of which is that here in the first world, despite the increased poverty for many during the Reagan years, electronic recording has entered a populist phase. The advent of affordable camcorders and the increasing use of community video through public access and local media centers have, indeed, increased public expression. Every block has a camcorder somewhere, as evidenced by the growing number of incidents in which neighborhoods have documented occasions of police brutality. Clayton Patterson happened to have a camcorder and let it roll for almost four hours during the police riot in New York City's Tompkins Square Park in August 1988. His tape has been the center of court battles with litigation against the police department stemming from the injuries of over a hundred persons.[2] Other incidents where tape was used as a defense by besieged neighborhoods have occurred in Los Angeles and San Diego. Larry Sapadin, director of the Association of Independent Video and Filmmakers (AIVF), was quoted in *The New York Times*, "It's the democratization of surveillance." Video has been a tool of police departments for years. Is this the beginning of a new era of empowerment for victimized neighborhoods?

This is not to suggest that the activism of popular video use can in itself counter the onslaught of corporate media that bombard us daily. But the level

of decentralized media activity in hundreds of cities and towns in the United States is perhaps more sophisticated and democratic than any of the global village scenarios theorized in past decades.

Global Villages with Sewers

The sixties dreams of a wired future were always vague as to what the content of global transmissions would be—some of early video art was aimed at providing beautiful visions of natural images, as in the work of Davidson Gigliotti, Mary Lucier, Paul Ryan, and Frank Gillette. Others concentrated on computer-generated video, such as in the work of Stan Vanderbeek, Nam June Paik, Ed Emshwiller, and Steina and Woody Vasulka. While the fate of image "enhancement" has been to enhance network logos and jazz up Olympic Games graphics, I don't think I am overstating the case to claim that some of the early video art was intended to be "universal" images that could bring aesthetic experiences, if not "global understanding," when transmitted across borders and time zones.[3]

Few would have suggested that the true democratization of video would end up in endless discussions of sewage runoff, Little League fields, and parking ramps. The tapes of these discussions, which blossom on public-access coverage of town council meetings, may not make it to the Whitney Biennial, but they are the stuff of which a genuine public sphere is created. True community media are usually hard work and often boring. Media democracy, like most forms of democracy, is a slow process. To paraphrase Susan Sontag, if you want fascination, try fascism.[4]

The more widespread use of video has raised certain problems for the state, the regulatory agencies, and the corporations that own and control the several thousand cable systems in this country. Community video and, in particular, local public-access channels have been the center of a debate about censorship and the scope of the First Amendment in the "information age." These debates are taking place in a situation of increasing restrictions on access to government information.

Q: Why is a microchip like the First Amendment?
A: Because GE/NBC knows how to use it better than you.

As information has become a profitable commodity, access to it for free has become more and more difficult. Donna Demac has documented how corporations, supported by the Reagan administration, have taken public data bases and made them into private archives, for sale at a cost.[5] One of the ways this has occurred has been by using laws and regulations that were set up to protect individual rights, but interpreting them so that they defend, not you

and me and the citizen's right to know, but megacorporations like IBM and General Electric (which now owns NBC), to gain access to information that was publicly gathered from publicly funded research and package it up for resale. The catch is that only other corporations can afford to buy entrance to these systems, not your local library or state university, both of which are reeling from budget cuts and escalating expenses.

First Amendment on the Wire

Likewise, the cable corporations have attempted to use First Amendment individual rights as a means of protecting their corporate profits. They have said that they are denied the right to freedom of expression by having to put programs on public-access channels that they don't editorially choose. What their public relations pamphlets leave out is the fact that except for public-access channels these cable corporations usually control as a monopoly the electronic information that enters your home. Public access was devised to be an alternative to that monopoly—to allow individual citizens the right to electronic expression. To equate the expressive rights of, for instance, the Times Mirror Corporation and Joe Schmoe down the block is absurd.

Cable corporations have tried many ruses to roll back the regulations that enforce public access. The channels that are used by access are wanted for profitable ventures. When the systems were first established, there were few cable services available, but now there are dozens, all competing for channels in community systems. Many of these cable services, like the Disney Channel or the Weather Channel, bring profits to the systems that offer them, either in direct payments or in donated local advertising time. Public access doesn't take ads and can't bring in bucks for the systems. However, public access is widely supported. Although there has been little actual research, preliminary studies suggest that access is widely watched as well.[6] The corporations that own the large multisystem chains have promoted an image of access as being full of cocaine-smoking decadents and sex perverts, which is why Ugly George's Manhattan series that lures naive young women into his studio to disrobe is the most often given example of public access in articles on access. Time, Inc., is one of the largest cable system owners. It stands to reason that they will not print an article that is favorable to public access. The attempt to give access a "loose morals" charge fits in with calls for repression of sexual information and a rollback of mores and morals to pre-1960s standards.

Free Flow

For decades, our society has boasted of its lack of censorship. The "free flow of information" has been the stated principle of U.S. foreign and domestic policy.

Countries that practice censorship are condemned as authoritarian, if not downright totalitarian. There is one area, however, in which many liberals and moderates are calling for censorship. This is surrounding a public-access program called "Race and Reason." The most difficult issue involving public access and censorship is the use of public access channels by neo-Nazis. In magazines, newspapers articles, and on such national programs as "Night Line," the issue has become collapsed into a struggle for the noble aspirations of cable executives and city officials (the good) to protect the public from offensive language and evil influences of public access (the bad). In discussions of cable regulations, "free flow of the cable company's information" becomes the standard under which the notion of the First Amendment is interpreted to mean the First Amendment for those with a cable system of their own. And the Nazis become the excuse for eliminating all forms of access.

It is true that Nazis have taken advantage of the cable-access policies in many cities and towns. The program "Race and Reason" is a despicable mixture of florid racism, homophobia, and anti-Semitism, and it is being broadcast weekly on over one hundred public-access stations in major cities. However, to read the press about public access, one would think that this program is the only show on the channels. The journalists who cover media have leaped on the issue of the Nazi programming as an example of public access at its worst. Meanwhile, they forget to cover public access at its best and neglect to mention the other groups who regularly use the cable in many cities: the League of Women Voters, the Boy Scouts, the high school news programs, the Welfare Rights Organizations, the Gay Men's Health Groups, and so forth. Nor do they address the way in which the racist programs have galvanized resistance to racism in many communities by local citizens and media producers. Many local cable systems have initiated panels and programs in direct response to "Race and Reason." The fascist series has made racism an *overt* issue in many communities. This is in itself quite an accomplishment in cities where racism can simmer under the surface for twenty years before boiling over in some angry manifestation. Many communities have formed antibias groups, stimulated by the need to answer the types of charges and irrationalities that pervade the racist series. In Pocatello, Idaho, a human relations committee has been formed that weekly looks at issues of local racism.[7]

Racism continues to be the most compelling unresolved issue of our country. The "Race and Reason" series did not invent racism, nor does the popularity of Bill Cosby mean that it has disappeared. The vehemence around the discussions of "Race and Reason" prove that this issue needs to be confronted and discussed. Public-access channels in this country have provided an important arena for these discussions. The programs and the counterprograms bring the issue to light to be tested and confronted. That this has happened on

public-access channels is, I think, a tribute to the vitality and currency of the access community.

There are no simple solutions to the problem of racism in the United States, just as there are no simple solutions to the censorship issue. The complexity is emphasized by the fact that Tom Metzger, the producer of "Race and Reason," is parading around supporting the First Amendment, while many of his adherents are trying to clean up school libraries, in some cases literally burning books. There have been persistent rampages of the extreme right wing (and in particular the religious right) to "cleanse" the school libraries and textbooks of "secular humanism." They have even gone so far as to say that Maurice Sendak is an agent of the devil and that his book *Where the Wild Things Are,* perhaps the most popular children's book of the last twenty-five years, is designed to lure children into satanism. Fundamentalists have pressured textbook publishers to eliminate passages of their history books and to rewrite sections to give equal time to defenders of segregation and to advocates of the biblical version of creation. These vigilantes of school libraries are fringe groups that are easily identified and confronted, but most forms of censorship in our society are embedded in our traditional institutions and are not readily perceived. The instruments of censorship are wrapped in the many layers of ideology and custom that shape and restrict not only the information we receive, but also determine the scope of what we are willing to express. There are economic forms of censorship for all who work in commercial media.

Television journalists know very well the parameters of acceptable "stories." They know what they have to say to keep their jobs. At *The New York Times,* even Pulitzer Prize–winning Sidney Schanberg was not immune.[8] He tried to report on corruption in New York City real estate and the scandals surrounding the West Way highway project. In his *New York Times* column, he had the effrontary to ask why *The New York Times* wasn't investigating these issues. He was summarily laid off, after a brilliant and prestigious career at the newspaper. Schanberg's surprising fate was actually well covered (he had just been portrayed as the principle protagonist of the Hollywood blockbuster *The Killing Fields*). Usually the punishments for breach of corporate censorship aren't so well documented nor so clear-cut. Punishments are often more subtle. Media corporations don't stoop to jail or exile; they merely change assignments, assign fewer stories, downgrade office space, or deny raises.

Down, Rover

Independent video producers are also victims of these less overt forms of censorship. The term *self-censorship* is often used, but it smacks of "blaming the victim" when placed against the economic realities of funding and distribu-

tion. *Prior censorship* is another term for survival: it comes from the knowledge of what is acceptable to power. Censorship begins with the very choice of subject and style at the grant-application stage. Ricky Leacock once said that writing a grant was basically sitting down at a typewriter and wagging your tail.[9] Grant applications are tailored to certain agencies and certain foundation personnel. Certain subjects are currently fashionable; certain styles are more acceptable. Even if we do get funding, we know what we have to do to get the video projects distributed. We know what gets shown at certain venues; we know that there are more and less acceptable themes and formats for the Public Broadcasting System, the Whitney Museum of American Art, the Museum of Modern Art, and so forth. Even the off-off-Hollywood venues like the Los Angeles Contemporary Exhibits (LACE) gallery or Boston's Institute of Contemporary Art have their acceptable styles and topics. Like familiar household pets, we know how and when to wag and, more important, what is off-limits. We don't jump up at the table.

These forms of censorship are invisible. But when censorship does become the focus of attention, it usually arises when the censors and the censored are enmeshed in other areas of contention. Censorship is often the foil for more problematic issues. Both racism and homophobia have contributed to increasingly overt censorship in recent years. A videotape by the Gay Men's Health Collective examines the controversy surrounding the publication by the group of a comic book on AIDS. This book so inflamed the passions and fears of the United States Congress, that an amendment was passed against it.[10] While the Helms Amendment does not directly *censor* the comic book, it attempts to ensure that the normal channels of *economic* censorship are operating. The law would deny any federal funds for AIDS counseling, information, or community work to any entity that would publish such a work. The comic did one thing wrong: it accepted the *fact* of a homosexual community and designed the AIDS information material to address the needs and practices of that community. That the comic is informative was never at issue. That it is realistic and effective was also never questioned. That it recognizes a community that the entire U.S. Congress (with two exceptions—there were only two votes against the amendment) would rather forget is the crime of this booklet.

It is appalling that this form of economic censorship is so enthusiastically endorsed by our official representatives. However, by becoming a *censorship* issue, the case deflects the authentic source of the controversy: the homophobia and AIDS paranoia that abound in our society.[11]

The videotape about the amendment and the struggle to publish the comic book was part of a package of videotapes on AIDS that was put together by John Greyson for the 1988 Deep Dish series. The Deep Dish programs were transmitted via satellite to over four hundred public-access channels. Many access directors received complaints about one scene in the AIDS show:

Paper Tiger Production, *Jean Franco Reads Mexican Novelas*, 1985.

it was a close-up detail of the educational comic. Of all the over two hundred tapes used in the entire Deep Dish series, this one segment elicited the most calls for censorship: the only tape that had as its theme a debate in the U.S. Congress. Although a few stations did refuse to air it, most ran it. Many received positive feedback on the program, and in particular on the fact that they ran it. It is relevant to understanding the importance of maintaining our besieged public access channels to realize that public access is the one venue where this tape could be transmitted to a mass audience. Many network news programs did stories on the Helms/AIDS education debate. Such is the state of censorship in this society that only on public access could the actual drawings that were the center of the controversy be shown.

The difficulties of simplistic solutions to censorship questions are particularly evident in the turbulence surrounding a painting that was confiscated by the Chicago board of aldermen from a student gallery at the Art Institute of Chicago. One of the painting students had painted a grotesque portrait of the late Mayor Harold Washington: naked except for a bra and a garter belt. Washington is a revered and much missed man in the political life of Chicago, especially within the African American community. Outraged city council representatives took it upon themselves to rescue his memory by forceably "arresting" the painting. Mindy Faber and Kate Horsfield have collected some of the

off-air TV material of this incident together with some street interviews with the art students. [12] What is sadly missing in the situation is any discussion of the isolation and racial segregation of the School of the Art Institute from the rest of Chicago—an isolation so complete that it allows a student to be so distant from his community he does not realize the extent to which this painting would create pain and agony for a very large proportion of Chicago's population. [13] That this controversial painting is probably the closest any Art Institute students have come to the political process of Chicago is a tragic comment on the level of engagement of students in our society. The visit of the council members to confiscate the painting is probably the first time they have ever attended a student exhibition at the school. Were they ever invited? Meanwhile the issue of censorship pits the outraged authoritarians (black) against the free-spirited defenders of the First Amendment (white). Both sides are depicted in the TV news footage as fringe elements: the uncool and obviously furious council members and the kooky, anarchistic art students. The discussion is painful, the participants offensive and untidy and the whole thing is neatly wrapped up with a couple of raised eyebrows as the reporter closes the news story with: "And now for a word from our sponsor."

In the Maurice Sendak book a little boy sails to a nightmare land where he dances with wild monsters. It ends with the little boy coming back home to a clean room and a warm supper, having purged the Wild Things in his dream. For most of us, censorship exists in the realm of the Wild Things: the Nazis, the gays, the radical right, the crazy artists, and the crazed-with-anger black council members. Censors and the censored cohabit a distant world: one easily shut away. We are left in our tidy bedrooms, our postmodern board rooms, our neat offices, where the limits of our public sphere are measured and drawn. And our supper is waiting. [14]

The Fantasy Beyond Control

LYNN HERSHMAN

A (pre)condition of a video dialogue is that *it does not talk back*. Rather, it exists as a moving stasis; a one-sided discourse; like a trick mirror that absorbs instead of reflects. Perhaps it was nostalgia that led me to search for an interactive video fantasy—a craving for control, a longing for liveness, a drive toward direct action. This total, cumulative, and chronic condition I suffered from is reputedly a side effect (or for video artists an occupational hazard) of watching television, a medium that is by nature fragmentary and incomplete, distanced and unsatisfying; like platonic sex.

My path to interactive works began covertly not with video, but in performance when in 1971 an *alternative identity* named Roberta Breitmore was created. She was a breathing simulacrum, a persona, played first by myself, and then by a series of *multiple* individuals. Roberta existed in both real life and real time and during the decade of her activity engaged in many adventures that typified the culture in which she participated. She had a checking account and a driver's license and saw a psychiatrist. That she existed was proved by the trackings of her psychiatric reports and credit ratings. Her construction included specific language and gestures as well as a stereotyped cosmetic ambience. By accumulating artifacts from culture and interacting directly with life, she became a two-way mirror that reflected societal biases experienced through time. Roberta was always seen as a surveillance target. Her decisions were random, only very remotely controlled. Roberta's manipulated reality, or bending of time, became a model for a private system of interactive performance. Instead of a disk or hardware, her records were stored on photographs and texts that could be viewed without predetermined sequences. This allowed viewers to become voyeurs into Roberta's history.[1] Their interpretations shifted depending on the perspective and order of the sequences.

Two years after ROBERTA's transformation,[2] *Lorna*, the first interactive art video disk was completed. Unlike Roberta, whose adventures took place directly in the environment, *Lorna* was a middle-aged agoraphobic, fearful of leaving her tiny apartment. The premise was that the more she stayed home and watched television, the more fearful she became—primarily because she was absorbing the frightening messages of advertising and news broadcasts. Because she never left home, the objects in her room took on a magnificent proportion, they were to her what Mount St. Victoire was to Cezanne. In the disk, every object in her room is numbered and becomes a chapter in her life that opens into branching sequences. Viewer/participants access information

"Americans show greater differences gesturally"

"Do crossed arms mean that 'I am frustrated?'"

"A hand to the face may serve as a barrier"

"Crossed legs point to each other."

"Crossed arms do the same thing"

"Crossing arms defines posture"

"Does she try to avert attention avoiding your eyes?"

"Is she sitting stiffly and not relaxed?"

"Covering legs reveals frigidity, fear of sex."

ROBERTA'S BODY LANGUAGE CHART

(photographed during a psychiatric session)

January 24, 1978

Lynn Hershman, *Roberta's Body Language Chart*, 1978.

about her past, future, and personal conflicts via these artifacts. Many images on the screen are of the remote-control device *Lorna* uses to change television channels. Because viewer/participants use a nearly identical unit to direct the disk action, a metaphoric link or point of identification is established between the viewer and referent. The viewer/participant activates the live action and makes surrogate decisions for *Lorna*. Decisions are designed into a branching path. Although there is only seventeen minutes of moving image in the disk, the thirty-six chapters could be sequenced differently for several days. There are three separate endings to the disk, though the plot has multiple variations that include being caught in repeating dream sequences, or using multiple sound tracks, and can be seen backward, forward, at increased or decreased speed, and from several points of view, like an *electronic cubism*. There is no hierarchy in the ordering of decisions. These ideas are not new. They were explored by such artists as Stéphane Mallarmé, John Cage, and Marcel Duchamp—particularly in Duchamp's music. They pioneered ideas about random adventures and chance operations fifty years before invention of the technology that would have more fully exploited their concepts.

Lorna literally is captured by a mediated landscape. Her passivity (presumably caused by being controlled by media) is a counterpoint to the direct action of the player. As the branching path is deconstructed, the player becomes aware of the subtle yet powerful effects of fear caused by media and becomes more empowered (active) through this perception. Playing *Lorna* was designed to have viewer/participants transgress into an inverse labyrinth of themselves.

Despite some theories to the contrary,[3] the dominant presumption is that making art is active and viewing it is passive. Radical shifts in communication technology, such as the marriage of image, sound, text, and computers, and consummation by the public of this consort, have challenged this assumption. Viewer/participants of *Lorna* reported that they had the impression that they were empowered because they held the option of manipulating *Lorna's* life. Rather than being remotely controlled, the decision unit was literally placed in their hands. They were not simply watching a narrative with a structure predetermined by an invisible omniscient. Implications of the relationship reversal between individuals and technological media systems are immense. The media bath of transmitted prestructured and pre-edited information that surrounds (and some say alienates) people is washed away. It is hosed down by viewer input. Alteration of the basis for exchange of information is subversive in that it encourages participation and therefore creates a different audience dynamic.

Interactive systems *require* viewers to react. Their choices are facilitated by means of a keyboard, mouse, or touch-sensitive screen. As technology expands, there will be more permutations available, not only between the viewer and the system, but between elements within the system itself. Some people feel

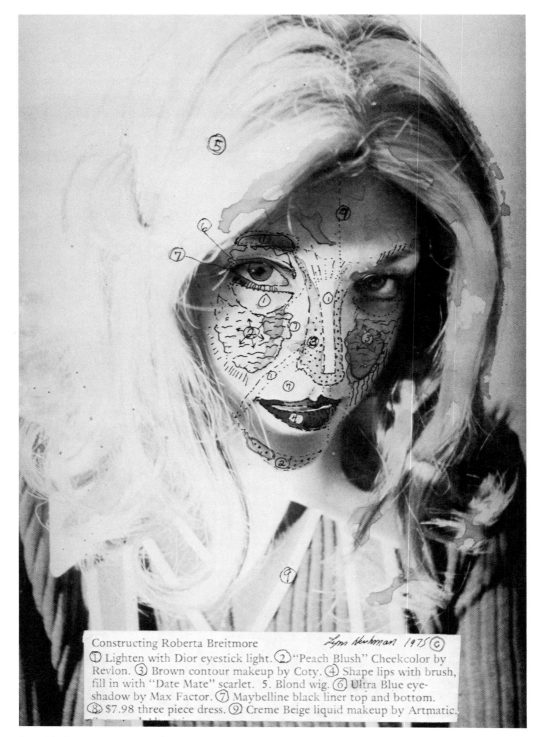

Lynn Hershman, *Constructing Roberta Breitmore*, 1975.

Lynn Hershman, *Lorna, Video Disk Design, Gartl/Hershman*, 1984.

that computer systems will eventually reflect the personality and biases of their users. Yet these systems only appear to talk back. That they are alive or independent is an illusion. They depend upon the architectural strategy of the program. However, there is a space between the system and player in which a link, fusion, or transplant occurs. Content is codified. Truth and fiction blur. Action becomes icon and relies on movement and plasticity of time—*icono plastics and logomotion*. According to Freud, *reality* may be limited to perceptions that can be verified through words or visual codes. Therefore perceptions are the drive to action that influences, if not controls, real events. Perceptions therefore become the key to reality.

Electronic media are based on the speed of information. The terminal, once a sign for closure, has become the matrix for information expansion. The introduction of new mass media in the late 1940s created an unparalleled opportunity to control mass perceptions. Immediate communication tended to increase the importance of media. Beaming pictures into millions of homes every night had the effect of speeding up time, of increasing the pace of life and destabilizing traditional communities, replacing them with a distanced *global village*. Individuals were left powerless to affect what was being imposed, other than simply turning off their sets and becoming even more alienated. A simi-

Lynn Hershman, *Lorna*, 1983.　　　　Lynn Hersman, *Lorna*, 1983.

lar sense of cultural time displacement had occurred with the invention of the automobile when traditional sense of distance shifted.

There is a debate among scholars of media about whether or not it is possible to observe phenomena without influencing them. In physics this can be equated to Heisenberg's theory. The very act of viewing a *captured* image creates a distance from the original event. The *captured* image becomes a relic of the past. Life is a moving target and any object that is isolated becomes history. Mass media redesign information by replacing the vantage point of the viewer with the frame provided by a cameraperson/journalist photographer. When information is presented beyond individual control, viewers are separated from the referent, resulting in a diminution of their identity. Personal identity is tenuous territory. According to Roman Jakobson, "personal pronouns are the last elements to be acquired in the child's speech and the first to be lost in aphasia."[4] When an area that was inhabited by a viewer is emptied by a displaced identity, it is replaced by a sense of absense. This loss of anchorage (perhaps healed by a contemporary shaman/anchorperson?) results in a suspension, a flotation, a feeling of discomfort or a low-level cultural virus, perhaps the locus of the nostalgia mentioned in the first sentence of this paper.

Lorna was developed as a research and development guide, but it is generally inaccessible. It was pressed in a limited edition of twenty-five, of which only fourteen now exist. It is only occasionally installed in galleries or museums. Creating a truly interactive work demands that it exist on a mass scale, available and accessible to many people. The Hypercard program works on most Macintosh computers and can be gen locked to a disk player or a CDV, or be used alone. It can access moving or still images and has a wide range of sound capabilities and is relatively inexpensive. The next two interactive works in progress, which I hope to complete in 1989, will use the Hypercard as a base. The motives of these two very different works are to explore ideas of con-

tact and perception, not only metaphorically but actually through the process of the playing.

The two in-progress works are, very briefly, the following:

1. *Deep Contact: The Incomplete Sexual Fantasy Disk*,[5] which is designed around historical icons such as Freud, Bach, Joan of Arc, and a vampire. The player will be able to change his or her personality or approach to these icons or change their personality. An *emotional joy stick* will be used in concert with a touch-sensitive screen. This piece will work with a real phone modem and programmed surveillance camera allowing the piece to transgress the screen (or distanced observer) into really contacting and interacting with other players as well as others seeing themselves as part of the manipulation.

2. *Paths of Inner Action*[6] involves a personal journey in which the viewer integrates into the system that he or she is looking at. The viewer will be guided by a shadowy figure that, like a Zen master, will direct the players' trail, asking questions about the meaning of experience or how the color of a leaf, eight frames past, balances with the textural opposites of the bridge in the future. By making surrogate decisions and routing their own paths, they will be given opportunities to understand perceptions about the media, technology, and the integration of both with individual personality. Trails will be designed to be reconfigured, or recontextualized, giving an evolving and essentially never-ending time frame to the piece.[7]

Because interactive media technology is becoming increasingly visible in all areas of societies (particularly outside the art world), the political impact is spectacular. Traditional narratives (beginnings, middles, and ends) are being restructured as genetic engineering advances simultaneously reshape the meaning of life. Participating personally in the discovery of values that affect and order their lives, allows individuals to dissolve the division that separates them from subversive control, and replaces some of the nostalgic longings with a sense of identity, purpose, and hope.

Bruce Davidson, Untitled, 1969.

Reach Out and Touch Someone:
The Romance of Interactivity

ANN-SARGENT WOOSTER

And what is an artifact? Artificial intelligence research suggests ... An artifact can be thought of as a meeting point—an "interface" in today's terms between an "inner" environment and an outer environment, the surrounding in which it operates. If the inner environment is appropriate to the outer environment, or vice versa, the artifact will serve its intended purpose.[1]

—Pamela McCorduck

The current fascination with interactivity by avant-garde video is a beneficiary of 150 year old avant-garde ideas about form and content and the relatively recent computer revolution. A little over a hundred years ago artists produced painting and sculpture and the most common form of symbolic interactivity was letter writing. Then, the phrase "reach out and touch someone" with its shrill note of aggressive intimacy would probably have suggested to anyone hearing it that they should go and actually visit someone, perhaps bringing food and good cheer to a shut-in. Today, the phrase is part of the telephone company's advertising campaign and everyone understands that the slogan means you should pick up a telephone and call someone. Increasingly, we live in a world where people are connected by an electronic interface. The current call for interactivity on the part of video artists is part of a larger societal development of machine-augmented simulacra of intimacy. Technology has shortened distances and accelerated communication so that widely separated individuals are no longer isolated and are now united in a global information net. Computer scientists and philosophers once dreamed of a world where people would be able to communicate with each other more effectively through machines than face to face. That dream is now a reality.

Whereas technology has created a new electronic community, it has also been part of the process that has witnessed the destruction of physical, social communities. Cars, airplanes, telephones, television, and computers have facilitated the decentralization of society. One kind of meeting has been substituted for another. In the late nineteenth century almost everyone played a musical instrument or sang, and people entertained themselves by playing music together. The phonograph and the radio brought a wide range of quality music and entertainment to a large audience but, in the process, has made public

music making a rare experience primarily limited to professionals. Instead of the coffee klatch, where neighborhood women would regularly meet around pine or Formica tables in each other's kitchens, women now share their hopes and problems by talking to each other one to one on the telephone. The communality of an outing to a baseball game with its noises and smells and mass joy and sorrow has now been replaced by each person's watching the game alone on television.

The telephone was introduced in 1876 and for the first time allowed people to be two places at once. Until fairly recently long-distance telephone calls were an exotic phenomenon and were only used in extreme circumstances such as a death in the family. I remember a time when it was a daring, almost erotic experience to call a boyfriend long-distance instead of writing a letter simply because the kind of intimacy the telephone makes possible was not yet the everyday experience it has become and long-distance telephone calls were regarded as expensive, extravagant luxuries on a par with a dozen long-stemmed roses. Today, we have to use the telephone "to reach out and touch someone" because families are fractured into ever smaller units separated by vast geographical distances. Atlas Van Lines estimates typical corporate managers move fourteen times during their lifetimes.[2] Transience and isolation have became characteristics of suburban family life, and only 5 percent of American children see their grandparents on a regular basis.[3] Physical intimacy is being eclipsed by an ongoing dialogue between computers and humans that has already lead to a symbiotic, co-evolution that is central to artists' dreams of interactivity.

Art

A work of art is an externalization of the artist's consciousness; as if we could see his way of seeing and not merely what he saw.

Whatever else art does it has to feed into an on-going discourse on the nature of art, or we will judge it trivial.[4]

—Arthur C. Danto

Video art is the heir of the new set of assumptions in art, science, psychology, and literature about what constitutes reality that developed in the nineteenth century. This was a time marked by a revolution in consciousness as notions of hierarchical order as expressed in Renaissance perspective and the proscenium stage were replaced by a multiplicity of spatial and temporal points of view. The causal or parallel developments in mathemathics (especially non-Euclidean geometry and the fourth dimension), physics (Einstein's theory of relativity), and philosophy, and the invention of new forms of transportation

and communication altered the previous linear and static perception of time and space to a simultaneous, fragmented, and conditional one. Based on developments in psychology from William James's concept of "stream of consciousness" and Freud's and other psychologists' work on dreams and the unconscious, artists, in their works from the novels of Proust to Juan Downey's *Thinking Eye* series of videotapes and Graham Weinbrun's interactive videodisk project *The Erl King*, have structured their images into chains of interleaved fragments corresponding to these psychological models of reality and their own experience of the world.[5]

Many artists from Marcel Duchamp, Guillaume Apollinaire, and Jean Arp on wanted to reduce the total arbitrariness of their increasingly subjective visions and to renounce specific goals in favor of a "pervasive openness to new impressions" by giving over control of part of their compositions to "external arbitrary forms"[6] through the use of chance or aleatory composition. Chance allowed them to create open-ended structures that produced "a kind of chaos characteristic of nature." It was also a device for bridging the gap between art and life because many like John Cage believed "art should not be different from life but an act within life. Like all of life, with its accidents and variety and disorder and only momentary beauty."[7]

Recent computer studies have shown that use of chance in art only symbolically reduced the artist's control by substituting one kind of order for another more limited one. McCorduck has noted that by "deliberately using chance, tossing a coin, we derive not uncertainty but a very large measure of certainty that can not be achieved otherwise. Chance produces not only certainty but simplification."[8] Artists' reasons for using chance anticipate the new reality models (the mainstay of postmodern science), which are concerned with such things as "undecidables, the limits of precise control, conflicts characterized by incomplete information, 'fracta,' catastrophes, and pragmatic paradoxes."[9] While denying us any sense of free will by showing us subject to unseen whirlpools of fate, mathematical theorems and computer modeling have shown that the nonlinear twists and wild disorder of chaos have their own structural logic, albeit one composed of infinitely spiraling subatomic coastlines of fractals.

Artists were prophetic in their understanding and acceptance of new mental and reality models. From cubism, surrealism, and the elaborate four-dimensional web of James Joyce's *Ulysses* to the films of Stan Brakkage, Yvonne Rainer, and Anita Thacher, artists have created artifacts that humanized the new reality postulated by science and technology. Until recently, their work was limited to static and/or linear media such as painting, sculpture, literature, and even film, and they could only create simulations of their vision of a mutable, fragmentary world. It was not until the development of computers' capacity for random access memory and the most complex interactive video-

disks that they could fully realize their vision of a complex simultaneous web of images and ideas.

One of the consequences of these intellectual and technological developments was the shift from an external, Euclidean, and generally knowable reality to a more private subjective one. The avant-garde and the bourgeoisie took up opposing positions on consciousness. The creators of such bourgeois art forms as realistic painting and sculpture or Hollywood films asserted that their works represented *imitatio naturae* and were the true mimetic art forms. Building on new notions of science, psychology, literature, and art, the avant-garde argued that their private visions of and manipulations of form, color, and space constituted the true mimesis.

Avant-garde art has had a strange, aloof, and often hostile relationship with its audience. While avant-garde artists have sought to render a more authentic and universal depiction of reality through their use of abstraction and disjunction, their abandonment of a shared visual language based on the illusion of a harmonious reality offered by enclosed forms and logical narrative of Hollywood film, television, and realist painting for a personal vision has isolated them in an ivory-tower solipsism outside the praxis of society. Alienated from common discourse, they are left to communicate with a small group of like-minded people. Not even in the last quarter of the twentieth century when we live in a world of ever greater speed and the pulsating beat of MTV, a world in which people nightly create their own kaleidoscopic collages by flipping channels and playing the channel buttons on their cable boxes like a rocket jockey on a race to the moon, is the artist's subjective mosaic available to a general audience. One hundred years of experimental art has taught us it is one thing to experience the world as parallel and simultaneous fragments and it is another thing to be able to decipher another person's nonlinear, kinetic tapestry. Placed in the position of being accidentally or deliberately an "outsider," artists have sought to break down the separation between art and audience and art and life. They have adopted various strategies to make the audience part of the creative process. This is most striking in artists' theater and performance throughout the twentieth century and the hybridization of art forms that occurred in the 1960s.

At the end of the nineteenth century the illusionistic fourth wall of theater was toppled and works by Alfred Jarry and Guillaume Apollinaire and others eliminated traditional distinctions between stage and audience with new and more environmental theater configurations. By the middle of the twentieth century happenings used all the available three-dimensional space, including that occupied by the spectator. In destroying theatrical conventions they anticipated the synesthesia of discotheques and the experience of participating in the mass spectacles from peace marches and rallies to rock concerts like Woodstock that characterized the late 1960s and early 1970s.

Marginalized by the hermeticism of their art and exempted from the needs of Hollywood films, Broadway musicals, and broadcast television to please an audience, some avant-garde artists decided that the opposite of pleasure was cruelty and assaulted their audiences. The futurists shouted at their audiences, bombarding them with noise and insults, and their audiences responded by pelting them with eggs and tomatoes. Susan Sontag has pointed out that one of the key elements in happenings was their assault on the audience:

Perhaps the most striking feature of happenings is its treatment (this is the only word for it) of the audience. The performers may sprinkle water on the audience, or fling pennies or sneeze-producing detergent powder at it. Someone may be making near-deafening noises on an oil drum, or waving an acetylene torch in the direction of the spectators. . . . There is no attempt to cater to the audience's desire to see everything . . . in fact it is often deliberately frustrated. . . ."[10]

Sontag saw the avant-garde's deliberate withholding of information as another form of attack on the audience:

The Happening operates by creating an asymmetrical network of surprises, without climax or consummation; this is the alogic of dreams rather than the logic of most art. Dreams have no sense of time. . . . Lacking a plot and continuous rational discourse, they have no past. And this with-holding of a sense of structure is, if sublimated, as much an attack on the audience as the physical menace of the lawnmower.[11]

Nam June Paik's early music performances featured screaming, throwing beans at the audience, smashing glass, and other violent and aggressive acts to disturb the passivity of the audience. During Paik's 1959 *Etude for Pianoforte,* he jumped off the stage and cut off John Cage's tie. Cage said of Paik's concerts, "You get the feeling anything can happen even dangerous things."[12] Paik, Chris Burden, and other artists incorporated danger into their art to add a "climax" to indeterminate, nonhierarchical work that lacked an internal conclusion by putting both themselves and their audiences at risk.

Audience participation was an integral part of the art/theater/music works of the 1960s. This incorporation of the audience into the work of art and letting them shape it is an important precedent for the role of the viewer/participant in current interactive video disk projects. Cage rejected the notion that music was entertainment that was passively received by the audience. He wanted the audience to be participants (active listeners) who must "realize that they themselves are doing it, and not that something is done to them."[13] Along with other Fluxus composers, La Monte Young was fascinated by the audience as a social situation. Three of his 1960 compositions were ostensibly "audience pieces." In *Composition 1960 No. 3* listeners are told for a specific period of time or other they may do anything they wish. *No. 6* reverses the per-

former/audience relationship—performers watch the audience in the same way as the audience usually watches the performers. Nonperformers are given the choice of watching or being the audience.[14]

The centrality of audience participation in Alan Kaprow's happenings and other work was extremely influential on later concepts of interactivity. Michael Kirby has defined three kinds of audience participation in Alan Kaprow's work:[15]

1. *Pseudo participation, in which plants in the audience come on stage and take part in the work.*

2. *"Token" or "selected involvement," for example in* Courtyard *the audience is offered brooms and invited to sweep on stage. Only a few members of the audience took advantage of the offer, but the few people who did take part symbolically represented the audience's participation.*

3. *Pieces in which there were only participants-performers and accidental spectators.*

To these three modes of audience participation, which are all found in current video disk projects, I would add a fourth, a variant of there being only participants, artworks in which the spectator is a necessary component of the work and completes it. In Michael Fried's 1967 essay, "Art and Objecthood," he observed that all work that does not have the "presentness and instantaneousness" of modern painting and sculpture tends toward theater, especially works like earthworks, and process art that extend into real time.[16] With some dismay he noted that instead of withdrawing into an aesthetic space, separate from that of the spectator, these works were clearly dependent on a situation in which the beholder of the works of art was actually their audience.

Many video sculptures and installations grew out of Fried's "theatricality." Paik's early video sculptures such as his 1965 *Magnet TV* and his later *Participation TV's* required audience participation to change them from static forms to dynamic variable ones. Early closed-circuit video installations by Bruce Nauman, Keith Sonnier, Peter Campus, Dan Graham, and others used the instantaneous feedback of these systems to make the viewer an integral part of their work. In the late 1970s Buky Schwartz switched from abstract sculpture to closed-circuit video installations involving disparities between the appearance of three-dimensional objects in a room and how they appeared as two-dimensional shapes on the television screen as a way of deepening the viewer's involvement in the work and compressing the distance between the sculpture and the viewer. As Rosalind Krauss pointed out, these projects with their use of lived time put "pressure on the viewer's notion of *himself* as 'axiomatically coordinated'—as stable and unchanging in and for himself."[17] In speaking of audience participation it is important to distinguish between film and theater's

Nam June Paik, *Robot K456*, 1969.

collective audience where a group of people have a shared experience in a common public space and the idea of theatricality in sculpture in which the audience at any moment is essentially one person at a time. This sequential audience is identical to time-sharing in computer terms and the one-at-a-time interactivity of computers or video disks.

Video Art

"Interface" originally came from the physical sciences, where it applied to events and properties peculiar to the boundaries between materials. The surface of the ocean, for instance, is an interface between air and water; and reactions occur there that do not occur in kind or quantity anywhere else in the air-water system. An interface is an area where substance or energy is exchanged.

The term was adopted by the computer industry as being excellently descriptive of the juncture at which information is exchanged between two processes. An interface is whatever happens to be the medium of that exchange; a piece of equipment, or a program that transfers information from one process to another.[18]

—Phil Bertoni

The genesis of video art in the late 1960s was directly attributable to the introduction of low-cost, portable, 1/2-inch consumer-grade video equipment to the United States by Sony in 1968. The early black-and-white portapacks were a far cry from today's home equipment. A portable recorder, black-and-white camera and monitor cost between $1,500 and $2,000 dollars, about the same price as the comparable low-end equipment today, but the dollar was worth more then and the tape had to be threaded on an open reel. Also, the unit produced an unstable signal that was adequate in closed-circuit situations but was close to "junk" compared with broadcast television. In spite of these disadvantages, this ugly duckling immediately appealed to several constituencies that were virtually identical at the time: artists interested in new art materials, especially sculpture in an expanded field; technological or kinetic art; conceptual art; avant-garde film; and political activists. These groups eventually separated into several different camps—documentary, video installations, and video art. However, elements of the issues and ideas present at the initial nexus remained.

Video art was born at a time when the monolithic power of broadcast television as a mass communication and entertainment medium was being examined critically. As David Ross pointed out, "Television was no longer viewed as the activity of the culture, it was the culture."[19] Video artists came

to their new medium with "seven channel childhoods."[20] Video art is more closely associated with broadcast television than a house painter is to Rembrandt. Not only do they share common tools and similar imagery and imaging systems, video art constantly compared itself to broadcast television and defined itself as being different from its jumbo elder relative while secretly yearning for a share of its power. Many video pioneers saw independent video as a revolutionary and utopian tool for giving power to the people and changing the world. "Video offered a means to decentralize television so that a Whitmanesque democracy of ideas, opinions and cultural expressions made both by and for the people" could correct the bias of broadcast television and enfranchise the disenfranchised.[21]

Almost a decade before Sony successfully introduced Betamax and Matsushita (JVC and Panasonic) introduced VHS (Video Home System), the videocassettes and recorders that turned television audiences into active participants, artists were farseeing in their immediate understanding of implications of the half-inch revolution. As Erik Barnouw has pointed out, videotape has become "low cost . . . reuseable and could be expended . . . as freely as a novelist uses paper. Suddenly all sorts of people—alone or in schools, churches, groups and businesses—were in video production."[22] The compact, paperback-book-sized 1/2-inch cassette offered many new possibilities of distribution. Artists were among the first to realize the liberating aspects of the new format and sense its value as both a political tool and a new art form.

The late 1960s witnessed a massive redefinition of what constituted "art." Many would have agreed with Paik, "There is no difference between ritual, classical, high art and low mass entertainment, and art. I *live*—whatever I like, I take."[23] Artworks often consisted of activities and situations and incorporated time and space. Drawing on the tenets of conceptual and performance art, which emphasized using the materials of mass communication to disseminate art to a wider audience and the concept of art as information, artists wanted to compete with television on its own turf to challenge and ultimately usurp some of television's ability to directly enter people's lives. Television and radio were perceived as one-way sending mediums that were passively received by machines in individuals' homes. Using symbolic actions, some video artists wanted to shake up the passivity of television audiences and make them aware of television's limitations and possibilities.

In 1974, Douglas Davis broadcast three works on Austrian television. In all of these he addressed the audience directly saying, for example, "Please come to the set and place your lips against it. Think about our lips meeting now." Davis described his goals at this time:

I don't hold with the performance aesthetic—that the art is only what happens to me. What happens to me is only a means of making contact with the viewer, and with the

world. . . . {M}y first thought about the television set was to activate, as a link in a live sending as well as receiving link. We are almost blind to the two way nature of television. Bertolt Brecht . . . correctly pointed out that the decision to manufacture radio sets as receivers only was a political decision, not an economic one. The same is true of television, it is a conscious (an unconscious) decision that renders it one way. My attempt was to inject two-way metaphors—via live telecasts—into our thinking process.[24]

Although calling for intimacy and interactivity, Davis's projects underline the isolation and limitation of intimacy the electronic interface imposes.

Video artists were not content with showing their work in lofts, art galleries, and museums. They wanted to be "on the air." The Television Labs at WGBH, WNET, and KQED provided early and substantial support both for the production and exhibition of artists' television on their channels. The development of cable and low-power television in the mid sixties seemed to offer a chance for even greater access. In 1968 the Supreme Court gave the FCC the right to regulate the cable industry. In 1972 the FCC's Cable Television Report ordered cable systems to have four different kinds of public access. To give this legislated "access" any real meaning, the cable facilities were required to provide low cost production facilities. This opened the door for artists. Soon video artists were asking, "How soon will artists have their own channels?"[25] There were many successful projects on cable television. These included the early TVTV (Top Value Television) and also Jaime Davidovich's Cable Soho, which began in New York City in 1976 and the next year became the Artist's Television Network. Another project also starting in 1976 was the Video Art show on Los Angeles, Theta Cable and Long Beach Cablevision. More recently, Paper Tiger Television in New York City has had a series on public-access cable television in New York City for seven years, examining the communications industry through a critical analysis of print media in a hard-hitting style that resembles aspects of performance art. None of these projects could be called truly interactive. In all of them the artists functioned primarily as senders on the same level of the many kinds of special-interest and personal programming that became a feature of cable television. Artists' programming generally lacks both the genuine interactivity of call-in radio shows and the less-well-understood interactivity of broadcast television's audience. Broadcast television can be regarded as advertising interrupted by programs, and one way the broadcast audience interacts with television and determines what they watch is by buying or not buying the products that are advertised on the air. Artists' Television does not rely on the financial support of the audience to stay on the air, so interactivity with the audience is immaterial. The act of simply being on the air is enough to satisfy the concept of increased communication.

Some of the more radical developments in interactivity made possible by cable television were found in social services and grass roots democracy. In

1971, the Lister Hill Center for Biomedical Communications, National Library of Medicine under the direction of Dr. Harold Wooster built the New Hampshire–Vermont Interactive Network complete with a television studio at each site to allow doctors in rural Vermont and New Hampshire to participate in medical meetings long distance. The doctors could hear the papers but also participate in the question and answer period as if they were present in the room where the paper was given. Here, the necessity for knowledge causes the development of real interactivity whereas artistic projects, with a few exceptions, merely play lipservice to it. The system is still is use today.

Soon after the communications satellites became available for private use, artists began to design projects that employed them. Douglas Davis's 1976 *Seven Thoughts* broadcast from the empty Houston Astrodome "to the global mind" is credited with being "the first attempt by an individual to use the global satellite in a personal way."[26] Most satellite projects—such as the ambitious interactive satellite teleconference *The Artist and Television* (1982), which interleaved performances and commentary in New York, Los Angeles, and Iowa City via the communications satellites West Star 3 and 4 and Sat Com3R—have focused on the artist's ability to be in several places at one time, the reconciliation of lost or "ghost" selves, and symbolic expressions of an expanded sense of "community." Only Kit Galloway and Sherrie Rabinowitz's *Hole in Space* (1980) extended their projects to a more liberal form of interactivity. Galloway and Rabinowitz set up a live satellite link between New York City and Los Angeles and, by placing large video screens in the street, provided a free videophone between the two cities. Many ordinary people spontaneously took advantage of the occasion to visit with friends and relatives on the other side of the continent.[27]

With the exception of Nam June Paik's *Good Morning Mr. Orwell* (1984), artists' satellite projects lack the polish of broadcast television. Their shoestring budgets impart a homemade, hand-touch quality that not only distinguishes art from industry but also reveals the fragile and artificial nature of the electronic mosaic of time and space made possible by the latest technology business. In all particulars they are virtually identical to teleconferencing or TV coverage of a global news event. The significance of the satellite projects lies less in their quality as good "art" and more in the fact artists managed to access commercial technology for the relay of personal and aesthetic information, thereby demystifying the hegemony of corporate technology, saying, If I can do it, you can do it.

A branch of twentieth-century art has always been interested in machines and a machine aesthetic that was an artistic response to new technologies and new ideas of perception. On a practical and theoretical level groups such as the Raindance Foundation and publications such as *Radical Software* and *The Spaghetti City Video Manual* sought to demystify the technology of television so

that it was easily accessible. Many video artists were dedicated to achieving sufficient machine literacy to be able to use their tools effectively and imaginatively. A small group concentrated on video's soul and hardware, inventing new machines that, freed from television's constraint to generate recognizable universal product, produced new and often abstract images. Woody Vasulka has stated, "There is a certain property of the electronic image that is unique. . . . [I]t's liquid, it's shapeable, it's clay, it's an art material, it exists independently,"[28] These artists saw video's special properties as the basis for a new art form, the art form of the future. Along with Paik they believed, "As collage technique replaced oil paint, so the cathode ray tube will replace canvas."[29] Borrowing the ideas and terminology of computer programming, they began to think of these manifestations as a kind of language, and their work with video hardware as, in Vasulka's words, a "dialogue with the tool and the image, so we would not perceive an image separately. . . . We would rather make a tool and dialogue with it."[30] This led to the development of new machines such as colorizers and synthesizers, which, in turn, affected the development of special effects generators used today in the television industry.

Video art's ongoing acceptance of the latest technologies has left it committed to exploring the cutting edge of an almost science-fiction vision of art. Because they are unfettered by the necessities of the marketplace, video artists are often the first to see an artistic application for technologies developed for information processing, storage and retrieval (computers), or communications, advertising, and entertainment (television). Since the first years of the twentieth century, artists have produced visual expressions (artifacts) of how they felt about the way new technologies have changed time and space. In addition to producing artifacts, video artists frequently follow a model of production and creativity that more closely resembles that of science, especially the think tanks of computer science where research consists of "having ideas" and new projects are invented by imagining what might be possible from each new technological advance.[31] Video artists' ongoing involvement in exploring what machines can produce has led to the recent fascination with high-end technologies such as computer graphics, special effects and editing, and current experiments with interactive video disks. Video art is well on its way to losing its earlier democratic promise because high-end technologies are more expensive to produce than low-end ones. Only a few artists will receive the funding to complete interactive video disk projects from state and local arts agencies, limiting the possibility of artistic success to an elite few. The rarity and high cost of viewing mechanisms further limit the accessibility of interactive video disk projects because only a few places will be able to afford the elaborate, high-end playback mechanisms and only a small number of people will be able to have a firsthand, hands-on experience of this new art form. Video art's current tango with interactive video disks puts the field in danger of falling into modern

medicine's Catch 22, where limited resources are squandered on expensive, state-of-the-art equipment at the expense of more basic and needed health care because high-end equipment is more glamorous than spending money on nurse's salaries or bed-pans.

Computers and Artificial Intelligence

Collections of facts, memories, perceptions, images, associations and predictions are the ingredients in our mental models, and in that sense, mental models are as individual as the people who formulate them. The essential privacy and variability of the models we construct in our heads create the need to make external versions that can be perceived and agreed upon by others.[32]

—Howard Rheingold

The advent of each new technology potentially increases our ability to reach out and access an ever-widening world. Technology alters our picture of the world and fundamentally transforms us as well. Widespread literacy and the advent of printed books changed us from intuitive to analytical thinkers and expanded our ability to generalize and reason about cause and effect.[33] The development of computers in the post–World War II era has brought profound and far-reaching changes in our social interactions and our concept of the universe. Although it is possible to trace current involvement in interactive video disks as a new art form primarily to the history of avant-garde art and its aesthetics, many of the issues in contemporary art and life can be traced more directly to the evolution of computers and the structures and terminology necessary to facilitate relationships between people and machines.

In the late 1940s and early 1950s the air was buzzing with "new scientific ideas having to do with what had not yet been called information theory." In a 1948 publication, "A Mathematical Model of Information," Claude Shannon showed through a series of theorems that "any message can be transmitted with as high a reliability as one wishes, by devising the right code. The limit imposed by nature is concerned only with the limit of the communications channel."[34] Howard Rheingold pointed out, "The key to life itself proved to be information theory . . . information- and communication-based models have proved enormously useful to the sciences because so many important phenomena can be seen in terms of messages. Human bodies can best be understood as complex communications networks than as clock-like machines."[35] Norbert Weiner coined the term *cybernetic*, based on the Greek word for "steersman," to describe the new field, and cybernetics were "the science or mechanism of maintaining order in a disorderly world."[36]

It was less than thirty years ago when the term *interactive* was first used in reference to computers, and it was used to describe the then breathtaking but now humble function of being able to interrupt a computer run. Computers were primarily thought of as number crunchers in the 1950s, and programming consisted of converting information into boxes of cardboard cards punched with holes (IBM cards). These cards were "batch processed" by a computer the size of a room and you received a printout of the information several hours later. In the late 1950s, Dr. J.C.R. Licklider discovered while working on a mathematical or electronic model of the brain to simplify the task of understanding the complexities of the brain that he spent more time gathering information than using it. He began to imagine a sort of electronic servant who could take over these tasks and not only calculate but formulate models for him. In 1960 Licklider got to try out his ideas for the first time on the Digital Equipment Company's new PDP-1, a minicomputer (a fast, compact computer the size of a refrigerator). Instead of "programming via boxes of punch cards over days," the data could be feed into the machine by high-speed tape and it was possible to change the tape while the machine was running, "allowing the operator to interact with the machine for the first time."[37] From this small beginning Licklider and others focused on interactivity as the way to achieve a partnership between people and computers that will produce computers capable of learning and, in Doug Engelbart's words, "augmenting man's intellect."[38]

It is not well known that the United States government has been in the information business since the late eighteenth century when the first patent act established a governmental committee to review and grant patents in 1790, and the Library of Congress was established in 1800.[39] In the 1950s the government was concerned with how the huge quantities of new technical information being generated could be quickly and easily available to increase our scientific and military capabilities. The Soviet Union's launch of Sputnik in 1957 made the government realize the inadequacies of the current system of information storage and retrieval. The Soviet Union's scientific prowess was attributed to the superiority of their educational system (Why Ivan can read and Johnny can't) and their All-Union Scientific Technical Information Apparat, VINITI. The first reason spawned the 1958 Defense Education Act, which authorized a Science Information Service and Council in the the National Science Foundation NSF. The same year the National Aeronautics and Space Agency was established and NSF established the Office of Science Information Service, OSIS. Beginning with the Baker Panel's 1958 report to President Eisenhower's Science Advisory Committee, which urged that a large research and development program in information sciences and technology be mounted by the federal government, some thirty-five studies, reports, and congressional hearings have attempted "to create VINITI-on-the-Potomac." The Department of De-

fense began to extensively fund both applied and basic work in the computer field. The development of greater interactivity was given priority because the ability to have a dialogue between user and computer increased the user's productivity and facilitated the development of ever more sophisticated machines and software.

In the days before personal computers, a significant obstacle to developing a fruitful human/computer symbiosis was the lack of easy and flexible access to computers. A key element of the development of interactive computing was the concept of time-sharing, computer systems capable of interacting with many programmers at the same time. Time-sharing gives each of 20, 30, or 1,000 people the illusion that he or she has the computer's exclusive attention, while the computer is actually switching from one user's task to another in tiny fractions of seconds. Programmers were able to submit their programs a piece at a time and receive their responses in the same way. By eliminating the "wait and see" aspect of batch processing, time-sharing made it possible for "programmers to treat their craft as a performing art."[40] The first time-sharing computers were primitive, but soon individual keyboards and simple forms of graphic display made interacting with computers more comfortable, or *user friendly,* a term coined in the 1980s.

In the late 1960s and the early 1970s the way individuals shared information in time-sharing communities (a group of people using the same central computer) was seen as a model for a global network of computers connected by common carriers (telephones) interacting freely with each other, united by a commonality of interest even before they existed.

These new computer systems we are describing differ from other computer systems advertised with the same label: interactive, time sharing, multi-access. They differ by having a great deal of open-endness, by rendering more services, and above all by providing facilities that foster a working sense of community among their users.[41]

It was believed that the dialogue caused by the free exchange of information would lead to the rapid development of new ideas because as Licklider and Taylor have pointed out, "When minds interact, new ideas emerge."[42] A few people realized that instead of being more democratic, computers might simply substitute one kind of power for another and create a new subclass of people made up of those who did not have access to information.

For the society, the impact will be good or bad depending mainly on the question: Will "to be on line" be a privilege or a right? If only a favored section of the population gets a chance to enjoy the advantage of "intelligence amplification," the network may exaggerate the discontinuity in the spectrum of intellectual opportunity.[43]

The utopian dream of a world united in an equalitarian web of free-flowing information has not materialized. The computer networks have become a reality,

but the passage of the Mansfield Amendment in 1970, which stated the government could only spend money on research that had a direct military application, ended the days of free-form experimentation. As the government withdrew from the business of information and reduced or abolished the dissemination mechanisms and increased the cost for the information it continued to supply, the information business was taken over by the private sector. Unlike the public library system, which is equally accessible to rich and poor alike, there is always a user fee for computer information, and that information became a commodity that was bought and sold like any other.[44] Even in 1988, media philosophers like Gene Youngblood continued to imagine a world where global communications networks made possible by computers would allow people to communicate with each other freely. The reality is different. In our society power lies in the hands of those who control information, and since the government went out of the information business information is an expensive controlled substance. Aspects of computer networks have become an integral part of society from electronic mail to the folk culture that has sprung up around computer bulletin board systems and electronic magazines.[45] Even when the networks are used primarily for business, as they almost exclusively are, they also become vehicles of interpersonal exchange. As the movie *Jumping Jack Flash* clearly illustrated, it seems that whenever people are offered an opportunity to talk to each other, they take advantage of it to exchange ideas, sell a car, find a date, or just chat.

Fundamental to the evolution of the computer from a number-crunching tool to a dynamic medium for creative thought was the ability to talk to the computer in a version of human language rather than the programmers' mathematical hieroglyphics. If you can type a command in simple English and receive a reply from the machine or it prompts you with a question, you feel as if you are dealing with a person and not a thing and this in turn fosters greater involvement with the computer. One of the first steps toward creating "a genuine language understanding program" was the program Joseph Weizenbaum created for ELIZA at MIT in 1964. This program and a later variant called DOCTOR mimicked human interaction and created the illusion of being "a wise, all knowing computerized psychiatrist." The program encouraged people to talk to the machine by playing the users' thoughts back to them. Weizenbaum was surprised that even sophisticated people "were drawn into conversations with the machine about their lives."[46] The users' belief that they are dealing with a responsive entity that they can communicate with in their own language has facilitated the widespread use of computers and the development of more complex forms of interactivity. Computers have gone from the most basic form of interactivity, INTERRUPTION to SELECTION, where the user can choose to do something; to the highest current form of interactivity, RESPONSIVENESS, where there is an exchange between users and computer (I do

something, you do something).[47] Today, high-end, "expert systems" tailor information to the user's specific needs based on a conversation between the computer and its user.

Human beings are highly visual, and it was not until the first crude graphic display screens were introduced in the late 1960s that computers began to change our relationship to information and forge a new kind of space. Computers are largely based on the structure of the way the human brain processes information. It is one thing to understand that human memory is organized in lists and lists of lists cross-referenced by associations between them, and it is another thing to see that system on a screen "modeled not on pencils and printing presses but on how a human mind processes information."[48] The computer's new "informationscape" presented a world atomized into relatively equal permutations and choices. Within this world, which is both real and not real, the user can freely rearrange that information and impose new structures on it or make it vanish. Seeing ideas as visual objects changes your view of the world because "when everything is visible: the display becomes the reality."[49] Partially because of the way children were observed learning programming with the graphic displays of the LOGO system a greater emphasis was placed on developing interactive graphic displays. Scientists observed that the visual display of information psychologically created a better human machine interface, which in turn improved the quality of thinking and made the users more productive. With the advent of user-friendly personal computers, bank machines, computerized offices and schools, and electronic cottages in the 1980s, the experience of the world seen through the window of a computer is a commonplace one.

For most people the computer remained a tool for processing information until the video game fad of the 1970s demonstrated the computer's ability to create external symbols and artifacts and actively engage people in their manipulation. While most of these new forms were primarily toys or games, many of the advances in artificial intelligence have occurred by watching how children learn by playing games. Games such as interactive fiction, which lie between play and literature, suggest the possibilities and drawbacks of aesthetic uses for computers' responsive, branching structures. Interactive fiction promotes itself as "a whole new dimension in storytelling. Think of your favorite story. Now think of the main character in the story. And imagine YOU have become the character. . . . The decisions are yours and so are the consequences. . . . The plot unfolds as you decide what to do next, drawing you into a world so involving that it taps your adrenaline as much as your intellect."[50] Interactive fiction does not live up to its promises. The stories are presented in a series of short blocks of text that appear on the screen. At frequent intervals the story is interrupted by a problem, danger, or puzzle for the viewer to solve. The player has to then step out of their identification with the characters and the story

and type instructions on the screen in short phrases made up of the computer's 700-word vocabulary like, "PICK UP THE STONE" or "KISS GEORGE," to which the computer may reply, "George takes you in his arms and kisses you. You soon discover he is as masterful at kissing as he is a swordsman . . ." or "I don't know the word kiss."[51] Depending on the viewer's response to that dilemma, the story continues to the next problem or the player may be killed. The narrative stops if you cannot decide on an appropriate course of action. Interactive fiction offers neither the pleasure of being swept away given by watching a film or reading a book nor the joy of creating something new. But by breaking the story into paragraphs that must be interpreted by the viewer, interactive fiction presents a relationship to narrative different from that presented by conventional media (books and films), one that is more like critical exegesis than a video game like *Space Invaders* or *Pac-Man*. Although viewers are ultimately trying to solve a puzzle by figuring out the game designer's mind, in the process they experience a world that is fragmented, conditional, and subject to their control, if only by their ability to turn the story off and on.

Novelist Thomas Disch has written an interactive novel, *Amnesia*, and his experience offers insights into the dynamics of interactivity as an art form and the resemblances and differences between designing a story to be experienced interactively and other forms of writing. He said that the processes of writing a novel and a work of interactive fiction were highly dissimilar. Interactive fiction is filled with stops and starts for both the writer and the reader. Unlike the streak of good writing that is the author's closest approximation of the entrancement the reader feels reading a book, the process of writing interactive fiction is extremely calculated, "like a tennis game in which the whole game has to be figured out in advance."[52] The narrative has to be written in small units of high-impact, vivid prose that is always "going toward overstatement." Every few screens the story has to be interrupted with "significant interactivity and then the story branches and then goes off in a wholly irrelevant direction."

Disch observed that the writer's relationship to the reader in interactive fiction is similar to that of a writer of a whodunit. In both genres the author is playing a game with the reader, and they both focus on manipulating the reader by trying to figure out what a clever person's response to a particular situation might be and stepping a little sideways and pulling the rug out from under their feet. Readers, he noticed, become involved in interactive stories in ways different from reading. They are often driven with a compulsion to finish the story and fill up the imaginary space the author has created by searching for the key to it, which the author has hidden like a grown-up's teasing a child by hiding candy in their closed fists. As long as readers cannot add new words to the story and change it, Disch has felt that the creativity of interact-

ive fiction lies solely with the author. While acknowledging that interactive fiction in its present form is extremely limited, Disch imagined a future where puzzles and stories will be geared to your own psychology and then he said, "[T]he possibilities for vicarious involvement are total."

A drawback to seeing interactive fiction and other video games as a model for a possible future is their current sexual exclusivity. The vast majority of computer games are geared toward men, and interactive fiction is no exception. Most stories feature a male hero engaged in typical male genres of science fiction and action adventure stories. So far only Amy Briggs has written an interactive fiction that deals with a woman's genre, a romance and has a heroine as the main character. Except for these novelties, *Plundered Hearts* is identical in structure to other kinds of "interactive fiction." Yet, these changes in gender and genre did make some difference. I found myself instantly at home in the plot and liking the characters and becoming involved with them for the first time. Games from *Wizardry* to *The Leather Goddesses of Phobos* require the ability to create elaborate maps of the characters' journey. These maps involve an analytical relationship to an imaginary space that is more masculine than feminine in our culture. Perhaps this will change when learning how to use computers becomes as central a childhood experience as learning how to read, and the structures and imaginary space computers create will be available to everyone. Kristina Hooper of Apple Computers observed that when there was a computer available for every student, boys and girls were equally involved with them, but when there were not enough computers to go around, more boys than the girls used the computers. She also noted because of the different socialization of boys and girls, boys were more likely to be allowed to become obsessed with computers, whereas girls were given less latitude for self-absorption and were expected to interact with people more and help around the house.[53] This means that boys tend to develop advanced computer skills by being allowed to play with them freely, whereas girls have less access to computers because of socialization and gender typing (girls aren't good at mathematics and machines) causing their computer literacy to lag behind.

From the time of Marcel Proust's *À la recherche du temps perdu* artists have created works of art expressing the mind's ability to wander and think of many things at the same time. Only recently has technology caught up. Recent developments in computer software such as Dynabooks, expert systems, and Hypercard have made it possible to duplicate the mind's "jumps and lands and flights of consciousness"[54] and "completely randomize your access to a body of data."[55] Computer theoreticians such as Brenda Laurel, formerly of Atari, have been working on programs that would let you experience *Hamlet* from six different points of view by being able to see the world through each of the characters' eyes. They see a world where the viewer can become an active partici-

pant in the story by being able to intervene in it and make decisions that affect the course of the story. The viewer would then become a creator who would be able to remake an imaginary world to satisfy his or her own needs and desires. As yet, that is not possible because it requires a marriage of three cultures: cinema, storytelling or narrative, and computers. Although not able yet to achieve this level of interactivity, video artists have begun to dream about it and make work based on its promise with the tools at hand.

Interactive VideoDisks

Interactive processing "Conversational" style re-al-time processing, wherein a user issues instruc-tions and queries and the computer responds in a timely way, in many cases prompting or setting up further user queries or instructions.[56]

RAM (Random Access Memory)—A memory unit wherein one given location is as accessible as any other (unlike a serial access medium, a tape for example, where you must proceed through or past a series of elements to get to the elements of interest).[57]

—Phil Bertoni

Currently, video art is under the glamorous spell of interactive video-disks. In many ways interactivity is a chimera. Not only is it expensive to produce, but there are virtually no playback mechanisms available so that the few projects that have been completed are virtually impossible to see. The current romance of interactivity promises such things as being a better or more demo-cratic art form and/or the art form of the future. Many of these siren songs are based on a false understanding of the term *interactivity*. The word *interactive* sounds like it will alleviate the alienation of modern life by generating a dy-namic alliance between artists and their audiences, joining them together in a splendid waltz that lets viewers become equal partners with artists in creating art. Yet interactive videodisks do not empower the viewer to create a wholly new work with the materials they are given, and they only appear to eliminate the alienation of artist and viewer present in most avant-garde art. Finally, in-teractivity is primarily a computer term and has historically had specific and limited meanings based on the degrees of interface[58] between computers and people made possible by developments of computer hardware and software over the last thirty years.

At the same time Japanese engineers were developing "first one inch and half inch helical scan recorders, then three quarter and half inch cassette re-corders,"[59] American and European engineers were concentrated on videodisk

technology in which visual information was stored on a disk like a phonograph record. When videodisk players were introduced in the 1970s, they were heralded as a revolutionary new advance in technology. Low-end players such as the pressure-transduction system jointly developed and marketed by Germany's Telefunken Company and Britain's Decca Company featured a limited, physical playing mechanism that employed a stylus like a phonograph needle. Each 8-inch diameter disk only had ten minutes of material and a symphony or a movie required multiple disks. The high end, reflective disk systems jointly developed by MCA, which owns Universal Studios, and Phillips, the Dutch electronics firm, were another story. A reflective disk the size of an LP could hold a feature length movie or 100,000 or more separate frames in a nonperishable format. Visual information was laid down in concentric circles on the disk, and "the computerized, laser read videodisc player could"[60] either read the information linearly from the disk spinning at 1,800 RPM or if the arm was stopped over a single circular groove (equal to the two interlaced fields of one video frame) it could produce perfect freeze frames in an instant. When I first heard about videodisks in the late 1970s, I was fascinated by the idea that all of the slides I would need for a year of teaching art history could be available on a videodisk and instead of pulling slides from the drawers of the slide library and arranging them in carousels I could look at the disk's index and type in the numbers of the slides I wanted for each class. Although Jerry Whiteley has recently finished a videodisk of the National Gallery of Art's collection for Pioneer Video Disc and is currently working on a similar project for the Metropolitan Museum's collection, both disks and players have so far remained too expensive to revolutionize college teaching.

Contrary to expectations videodisk players did not become the next must-have electronic appliance when they were introduced in the 1970s. They failed in their initial foray into the consumer market for various reasons: both disks and players were expensive, and although widely discussed in the trade press, not many of them were actually available; they offered only a playback function, and they were able to do something (play movies) that people did not yet know they wanted to be able to do. Videodisk manufacturers took a conservative wait-and-see attitude, while Betamax and VHS cassettes and recorders were introduced in 1975 and 1976 and aggressively marketed for their ability to give the viewer greater control/freedom by allowing viewers to record television programs off the air and time-shift them to a more convenient viewing time. After some initial consumer confusion over formats, with VHS becoming the popular favorite because it offered two hours of recording time versus Beta's thirty minutes, 100,000 Beta and VHS recorders were sold in the first year and three years later over a million had been sold.[61] Videotape and the home VCR came to occupy the place manufacters of videodisks had hoped

their product would occupy because videotape is more flexible and democratic than videodisks are and because, by allowing viewers to assemble their own programming, videotape turned the television audience into active participants. Simultaneously, with the widespread acceptance of VCRs, the rental videotape market grew out of almost thin air to mammoth proportions by providing a new way for viewers to control and domesticate entertainment by renting almost brand-new movies and seeing them at home.

The recent proliferation of compact disks and compact disk players may create a new climate of acceptance for videodisk players. Although the majority of videodisk players permit only playback, a new format called W.O.R.M., "write on once and record and play many times" permits limited recording. In recent months several computer companies have introduced magneto-optical disk drives as a rival for hard disk drives in computers. These computers use a laser-read and written "optical storage system,"[62] which allows the user to place information on a removable, erasable magneto-optical disk. Just as compact disks store more information with a higher fidelity in a smaller space, magneto-optical discs make it possible to store a whole library of information on a single disk. It is possible to imagine a future in which videodisk players, CD players, and computers will all use the same format and be able to work in tandem, making subtle, interactive videodisk projects accessible to a wide audience.

It is important to understand that most of the interactivity of current videodisk players has been present in other electronic forms of entertainment. Retrospectively, we can see the degree of interactivity that already exists in the world. Traditionally, handling video artists' equipment has been taboo for the audience. One significant difference between current interactive videodisk projects and older video art is that interactive projects relinquish some of the artist's control and the audience is now permitted to touch the machines, something that may be an everyday experience at home, but up to now has been one of the distinguishing differences between public and private entertainment. These projects also offer the novelty of open-ended structures and multiple endings that are partially determined by the viewer.

An understanding of current videodisk system architecture reveals what is actually possible in an artistic use of this medium. Currently there are three levels of videodisk players and two different videodisk formats. Videodisks come in two different formats: Constant Linear Velocity (CLV) and Constant Angular Velocity (CAL) and each offers different advantages.

CLV disks are able to hold a large quantity of real-time information because the disks do not have to be uniformly formatted. Information is placed on the disk in concentric circles, rather than the graduated spiral of a phonograph record, and the whole surface is available to hold information. Each side holds approximately one hour of linear material, and a movie usually fits on

two sides of the disk. Because of its high visual fidelity, many video artworks will be placed on these videodisks in the future, especially work that requires repeated play such as installations. CAL disks hold less information, but that information can be accessed in a more complex way. The disks have to be uniformly formatted so that the random access memory (RAM) of the videodisk player can locate each frame address. Uniform formatting can be visualized as fitting a square grid inside the circle of the disk and some of the space on the disk is lost this way. Other space is taken up by the extra information placed on the disk so the videodisk player can access the frames. Level II (level-two) and above videodisk players use the CAL format.

A level I (level-one) videodisk player is primarily a R.O.M. (read only memory) playback unit with the same level of interactivity possible with a home VCR. Interactivity at this level is a form of viewer-initiated interruption. Viewers can stop, start, and pause the tape/disk at their own volition. Games such as Penn and Teller's *Dirty Tricks for Dearest Friends* have been designed for videotapes with this degree of interactivity.

A level II (level-two) video player has an internal computer (CPU), which is operated by an external key pad. To access a frame or chapter, users press a search button on the key pad and enter the number or chapter they wish to see. Level-two videodisks use the CAL format, and still images can be combined with brief real-time sequences such as documentaries or interviews. When the section is finished, it returns you to an on-screen menu. This level has been very successful in presenting art and training people to use forklift trucks or M-16 rifles.

In 1984, Lynn Hershman used a level II system in *Lorna,* generally credited as being the first artistic use of interactive videodisks. *Lorna* is a branching narrative about a 41-year-old woman with agoraphobia. At key plot points the viewer is allowed to choose the direction of the narrative from a series of options including three different endings for the story. Although all of the branching structures that interlock the various versions of the story together are predetermined, Hershman gives viewers the feeling that they are collaborating with the author in making decisions that affect the outcome of the story. Hershman feels handing the controls of the story to the viewer provides "a new area of individual freedom and empowerment."[63] Because of the clarity of the narrative and the transparency of its structure, Hershman's work speaks more to the potential of interactivity as a new, populist art form than do most other artists working in this medium.

A level III system multiples the quantity and complexity of information that is available because it is controlled by an external computer (CPU) with a larger memory. Based on software and a wide range of possible input devices including touch screens, a mouse, or even sensors in your shoes, the computer translates the information (the signal) it receives from input devices to instruc-

tions (frame addresses) to one or more videodisk players. One way to under-stand the different levels of interactivity possible between level II and level III videodisk players is to compare how the National Gallery of Art videodisk functions differently in each kind of player. When the disk is used in a level II player viewers are offered an on-screen video catalog produced by Anne Marie Garty that allows them to chose which artist or work of art in the collection they want to see from Chapters 1–16, and frames 1–3,353. Using an external key pad you type in the number of the painting you want to see and the painting then appears on the screen. It may be accompanied by a brief, real-time documentary on the artist. Played in a level III system, you could do what has just been described, and in addition, you could select a painting, de-liberately or at random. When the painting appeared on the screen, you would be asked to give it a name such as "lovers " or "figure in a field." Based on the painting and the name or category you supplied, the computer then offers you a group of similar works of art from the museum's collection for your pe-rusal.[64]

Using a level III system combining a Macintosh and a videodisk player, Jerry Whiteley and Andrew Phelan have produced an electronic version of Jo-seph Alber's book, *The Interaction of Color* for Pratt Institute. Albers often stated COLOR IS THE MOST RELATIVE MEDIUM IN ART, and in his courses he as-signed problems such as, "Make three colors look like four" or "Make warm colors look cool." The interactive program graphically demonstrates these con-cepts and others. Whiteley and Phelan say the system is capable of producing 16 million variations of true color. While it is impossible for the human eye to distinguish all those colors, the project does offer a more dynamic experi-ence than listening to a teacher or reading Albers's book. The computer-gener-ated colors are also richer and more complex than the clay-coated papers nor-mally used by students to execute color theory assignments based on Albers's teaching.[65]

In a world where the sum total of human knowledge has doubled in the last five years, the most common usage of interactive videodisks is informative and/or instructional. Ordinarily, videodisks are used to customize information on a one-on-one basis. The viewer is given a menu or decision screen listing options. and manually or verbally the viewer selects the information they want to know. In subsequent screens they are led from general to specific, detailed information by their choices. At any point they can choose to go ahead or re-turn to the beginning. Ideally, the goal of the interactive videodisk designer[66] is to make the structure underlying the progression of choices transparent to the viewer. Leo Steinberg has pointed out that unlike the clear, direct message of a street sign, one of the qualities of great art is its ambiguity. When artists use interactive videodisks as an art form, they bring a different system of goals

Juan Downey, *Bachdisc*, 1988.

and values to its use. A technology that has up to now been primarily used for the semicustomized transfer of information visually in a clear, easily understood manner has become subjective and opaque in the hands of artists.

While offering brave new worlds, the new technology is a different and often more demanding mistress than either single-channel tapes or video installations. There is a big difference between offering the viewer an opportunity to experience the the artist's personal vision of the world as a variable mosaic and the backstage work necessary to create. Instead of just creating images and editing them into linear sequences that are permanently fixed, the artist must now either alone or working with a computer programmer design complex branching structures that up to now have been the province of computer scientists to interlink multiple stories into a mutable electronic web that is open to change by the viewer.

Artists like Juan Downey are drawn to interactive videodisks because they allow them to express a fragmented, disjunctive vision of reality that they previously had to approximate in linear forms such as the single-channel videotapes of Downey's *Thinking Eye* series. For Downey, interactivity opens up the

potential of storytelling. Unlike a single-channel videotape, which is physically linear, he no longer has to compose an artifical spine for interactive videodisks and make either/or editing decisions about the placement of material. The RAM memory of videodisks allows him to have both/and in a kind of narrative structure he first experienced in the layered and open-ended narratives of Latin American authors such as Borges, and *Hopscotch,* an interactive novel by Julio Cortazar that was the basis for Antonioni's movie *Blow-Up.* Most computer programmers describe the design of an interactive videodisk as being like a branching tree. Downey has visualized his narratives as rhyzomic structures resembling the way potatoes and strawberries grow. "Every unit or module of the story is the whole story and if you have more than one you have a network."[67]

Downey looks forward to a time when he can do a melodrama based on six characters' variable, interlocking triangular relationships on videodisk in which the viewer or chance determines who kills whom, but *J.S. Bach* (1978), his first videodisk project, has limited level II interactivity. Side one of the disk is his single-channel biography of J.S.Bach. It's divided into chapters that could be watched in any order the viewer chooses, but there is no reason to restructure Downey's already idiosyncratic, fractured biography. Downey explored several ways to use interactivity on the second side of the disc. He found himself repeatedly drawn to the fugue, a musical form featuring short subjects or themes that are varied and played against each other. The second side of the disk offers "fourteen versions or possible ways of interpreting Bach's Fugue #24 for three voices and harpsichord. These choices include hearing Elaine Comparonb, the harpsichord player, playing it through alone or each of the voices alone or in combination with other voices as well as upside down and backwards."[68] An on-screen menu lets viewers choose which one they want to hear. Downey has acknowledged that interactivity does not democratize media and that the viewer/player only has the illusion of choice. In *J.S. Bach,* the extended artistic control interactivity offers gave him an opportunity to share his personal enjoyment of listening to counterpoint and allows the viewer to briefly experience the world through his eyes and ears.

Grahame Weinbrun and Roberta Friedman's *The Erl King* is the only level III project to be completed to date. Weinbrun has seen *The Erl King* as being about "a relationship with a machine. The machine imposes certain forms. It tells you what it wants in a way that conventional media doesn't."[69] His goal was to find "images that are conglomerates of not necessarily consistent themes and then letting the apparatus make the viewer aware of the interlocking elements."[70] Using the structure of dreams and "the way the mind can coalesce different lines of thought, images, beliefs, desires and memories into a single image," Weinbrun and Friedman have combined an updated version of Schubert's lied *Erlkoenig,* a fairy tale about a father who would not listen to his

son's fear of the evil king, and about his three daughters, and "The Burning Child" from Freud's *The Interpretation of Dreams*, another story of a father's failure to pay attention to his son's premonition of danger. Using three videodisk players controlled by a microcomputer and software designed by the team, the viewer can touch the screen at any moment and the story will branch to a relevant tangent, allegory, metaphor, or commentary. Shot in 16mm film, the *mise-en-scènes* have a rich sumptuous surface like a tapestry that constantly shifts from figure to ground—a living person becomes a bust on a shelf, a myth becomes real.

Weinbrun and Friedman's project is both the most complex to date and the most opaque. The viewer has to explore *The Erl King*'s structure or lack of it by exploring what they are given, a journey made more difficult by the lack of any of the conventional hooks to guarantee viewer involvement such as wanting to know how the story comes out or solving a puzzle or beating a machine playing a game. Since there are no right or wrong decisions, no past or present and Weinbrun and Friedman have supplied all the elements and have created the pathways linking them, ultimately *The Erl King* is about the experience of the world as a series of permutations. Although very beautiful, this kind of abstract, open-ended video project will only appeal to a very small group of people.

From using bank machines to being able to participate in choosing the name of the new baby on the nighttime soap opera *Santa Barbara*, or deciding whether Robin lives or dies in the first interactive comic books, a certain level of interactivity has become normal in our society. Is it logical to predict a future in which entertainment and art are primarily participatory and interactive based on the evidence of expanded interactivity in our society? I wonder. The single greatest change in American life, especially family life, over the last forty years, I might argue, has not been computers but the increased number of women earning money. Where once it took one salary to achieve our parents' standard of living, it now takes two salaries, not to surpass them but merely to remain at the same level. In 1950 only 12 percent of married women with preschoolers worked. Between 1960 and 1972 "the number of mothers of children five and under who worked outside the home tripled," and today, nearly half of all children under the age of six have a mother in the work force.[71] In a world where simultaneously you may be getting ready to go to work; the baby-sitter is late; the phone rings; the dog grabs your sandwich from the counter; the baby cries; a siren is heard outside; you are worrying about whether you can make your mortgage payment this month and whether your mother will survive her operation scheduled for tomorrow, there is such a thing as too much excitement and activity. I question whether people, especially women, will have the time or inclination to enjoy the luxury of creating their own stories. Soap operas and regular series such as *Star Trek* or *Family*

Ties are popular because they allow you to get to know the characters in time just as we get to know real people, but without all the hassles. The characters' ups and downs become part of your life, especially when seen on a daily basis, but unlike your family's or friends' problems, they do not directly affect you. Watching the ongoing stories of soap operas and regular series unfold at a certain time every day or week supplies a sense of constancy and order in otherwise chaotic times.

I can imagine a world like the one described in Ray Bradbury's 1953 science-fiction classic *Fahrenheit 451* where the electronic "parlor walls" showing an ongoing soap opera surround the viewer and parts are written into the show for the viewer at home who interacts with the characters by filling in the missing bits of dialogue.

"{T}his is a play {that} comes on the wall-to-wall circuit in ten minutes. They mailed me my part this morning. I sent in some boxtops. They write the play with one part missing. . . . The homemaker, that's me, is the missing part. When it comes time for the missing lines, they all look at me out of the three walls. . . . Here, for instance, the man says, 'What do you think of this whole idea, Helen?' "[72]

You might also be able to rent the interactive equivalent of a photo-novella which would allow you to alter the relationships between the characters and choose your own endings and make Rhett Butler give a damn. Yet, I doubt if, in the near future, people will be able to spend the concentrated, self-absorbed time necessary to fully engage in this kind of work.

What might really happen now that we are no longer tourists in McLuhan's global village and Orwell's *1984* has come and gone? In the near future computers will definitely be able to learn the way you think and act and intuit what we need based on that information, somewhat like the perfect nineteenth-century servant. As a friend pointed out, "anything that intuits down to this level of interactivity is potentially addictive and dangerous and whether that is good or horrible depends on who controls it."[73] Similar technologies could be used for a fantasy amplifier that creates customized stories based on what it has learned about you. "Every spectator would be in conversation with the spectacle,"[74] and you would participate in a story that changed according to your actions. What is the artists' role in this? Although many video artists are committed to incorporating the principle of interactivity and viewer involvement in their work, most artists' video continues to be a personal vision that is not readily accessible to a general audience because of the opacity of its structures. Most uses of interactivity will probably be confined to mass-market populist entertainment like soap operas, and rigidly controlled by media merchants because the cost of producing them will be very high, and only "stories" that appeal to a wide audience will be profitable. The artist's role will re-

main what it has always been, going boldly where no one has been before, being the first to see the artistic potential of new technologies and, as Nam June Paik said in 1969, "The real issue is not to make another scientific toy, but how to humanize the technology and the electronic medium . . . and also, stimulate viewers' fantasy to look for the new, imaginative and humanist ways of using technology."[75]

Ethnicity, Politics, and Poetics:
Latinos and Media Art

COCO FUSCO

We cannot speak for very long, with any exactness, about 'one experience, one identity,' without acknowledging its other side—the differences and discontinuities which constitute, precisely, the Caribbean's 'uniqueness.' Cultural identity, in this second sense, is a matter of 'becoming' as well as of 'being.' It belongs to the future as much as to the past. It is not something which already exists, transcending place, time, history, and culture. Cultural identities come from somewhere, have histories. But, like everything which is historical, they undergo constant transformation. Far from being eternally fixed in some essentialised past, they are subject to the continuous 'play' of history, culture, and power. Far from being grounded in a mere 'recovery' of the past, which is waiting to be found, and which, when found, will secure our sense of ourselves into eternity, identities are the names we give to the different ways we are positioned by, and position ourselves within the narratives of the past.

— Stuart Hall, "Cultural Identity and Cinematic Representation,"
Framework No. 36, 1989

As a critic who has concentrated primarily on film, I find myself out of place writing here about video art, but there are far more peculiar things in the encounter between Latinos and media art in the United States. In framing the issues this encounter generates, little can be taken for granted. Neither category—Latino or video art—offers the security of being fixed. Coincidentally, they both emerge from the cultural turmoil of the 1960s. One is associated with ethnic pride movements of the period, but acquired institutional legitimacy as a racial classification that facilitated social engineering by homogenizing immigrants of several nationalities, races, and cultures. The other stands as an art historical formality that separates craft from industry, calling forth processes of definition that often clash with video's entrenchment in other social and cultural practices, foremost being its inextricable ties to television.

But this assignment is also a bit strange because rather than being asked to write about video, I was asked to write about race—not an atypical request given the art world's current multicultural imperatives. It is safe to assume that it was my participation as a Latina as much as the subject matter that was desired. At this stage of multiculturalism, those designated as "other" operate in a situation in which the relationship between what they are and what they

express is systematically underscored and scrutinized. In a racially hierarchical society in which people of color are positioned as "other," I live between two possibilities—that my relationship to ethnic "otherness" makes my knowledge either too subjective or too authoritative—knowing I do not have the ultimate power to determine which one it is.

Despite frequent references to race in the alternative arts sector, the term should not be taken as a formal category in itself, nor as an ontological condition. The experience of race is relative to who and where we are, to other categories of experience we may inhabit, such as gender and class, to histories of differentiation, prevailing attitudes and political exigencies. That it is most frequently presented as a "minority" issue is above all indicative of a desire to make it one. We avoid conceiving of ourselves as products of interracial and intraracial interaction, or of the white mainstream culture (and perhaps the largely white field of video art), as equally implicated, however unconsciously, in a rhetoric of race. Inasmuch as the current self-conscious attempts at inclusion and "diversity" signal a shift from previous exclusionary practices, the extent to which they represent an emancipatory altering in power relations is questionable, as is the nature of that change.

The ways we have been positioned and subject-ed in the dominant regimes of representation were a critical exercise of cultural power and normalization, precisely because they were not superficial. They had the power to make us see and experience ourselves as "Other." Every regime of representation is a regime of power formed, as Foucault reminds us, by the fatal couplet 'power/knowledge.' And this kind of knowledge is internal, not external. It is one thing to place some person or set of peoples as the Other of dominant discourse. It is quite another thing to subject them to that 'knowledge' not only as a matter of imposed will and domination, by power of compulsion and subjective con-formation to the norm. That is the lesson—and the sombre majesty—of Fanon's insight into the colonising experience in Black Skins, White Masks.[1]

Latinos' urge to explore and define one's culture may indeed be integral to the social, political, and colonial experience of subordination; at the same time, the means of doing so have evolved together with the very concept of identity and culture. To develop these themes as objects of aesthetic inquiry in media art is rarely considered in this country as a separate category from conventional documentation. This is due in part to the overwhelming predominance of documentary material over fictional, and also to the already mentioned legacy of conflating the experiences, testimonies, and self-conscious expressions of those designated as "other."

In the 1980s a combination of factors have created the possibility that competing perspectives and modes of approach will flourish. Cultural nationalism as an organizing concept in Latin American thought has undergone serious questioning. Though it persists in this country in various sectors, post-nationalist, anti-essentialist, syncretically oriented critiques are dislodging ahistorical

concepts of racial and ethnic identity. The protracted discussion of ethnic stereotyping, one of the most important "minority" oriented intellectual debates of the last two decades, heightened awareness of the role of mainstream media in shaping a sense of identity. It also led to a "positive image" imperative for alternative media, and has more recently undergone reevaluation through diversified critical and aesthetic strategies. And finally, due in large part to sociological statistics the mainstream media has often repeated—that Latinos are the fastest-growing minority population in the United States, and that a substantial middle class has established itself—our numbers in media fields have increased.

It might be considered evasive or at least sufficiently exclusive to focus on Latinos when I was asked to write about race. Nonetheless there is a particular set of conditions involving Latinos that illustrates the artificiality of this mode of categorization, one that affects all ethnic minorities in this country. Despite whatever convenience the terminology may offer governmental bureaucracies or cultural theorists, Latinos are not a race, nor do we together constitute a unified culture. Our unprecedented prominence in representational arenas such as the mass media, the entertainment industry, advertising, and even academic discourses in the last decade have as much to with the commodification of ethnicity in this postmodern, postindustrial society as they do with any collective experience or grass-roots efforts. We are bound politically and historically by the experience of North America's adventurist foreign policy. Our immigration to this country, and the development of ethnic self-consciousness is directly connected with that political reality. But the fact that we may be objectified or seen as desirable in certain intercultural contexts does not necessarily mean that we have somehow surpassed or transcended that reality.

The surge of interest in Latinos in the last decade is also connected to the rise of North American awareness of Latin America, particularly Central America, and the (white) liberal and left sympathies for, and even identification with, Latin American critiques of the Reagan administration's foreign policy. At times this has led the alternative media sector to cast Latinos as inherently oppositional. In independent media, the non-Latino response to these issues has been widespread enough to exacerbate an already existent competitive situation vis-à-vis the production of images about Latinos, and the allocation of resources.

In independent media most non-Latinos have focused on Latinos in conventional documentary format, but a small experimental sector has been active over the last few years as well. During the mid-1980s, several non-Latino video artists produced tapes ranging in format from the ethnographic vérité style of Louis Hock's *The Mexican Tapes* (1986), to experimental pieces such as Lyn Blumenthal's reflections on Cuban television, *Horizontes* (1983), and Sherry Millner's (made in collaboration with Ernie Larsen) video essay on her child's

language acquisition and Reaganite political (un)consciousness, *Out of the Mouth of Babes* (1986). Generally speaking, Latinos and Latin America act as signs in these works that animate a roving critique of North American policy on immigration, Central America, and the rules of commercial television. Cultural identity, when presented, establishes a difference from a North American norm, but is not subject to critical interpretation. Even in the case of *The Mexican Tapes,* the most detailed look at actual peoples' lives, the choice to single out the subjects' modes of existence, the presence and desire of the outsider/documenter, and his function as catalyst for recorded actions is never examined by Hock himself, or questioned on camera by the immigrants.

Growing exposure to Latin American issues in the United States in the 1980s has also generated an anthropological curiosity and increased demand for media from Latin America, often resulting in the "artworlding" of materials purely on the basis of origin (and in a broader sense, widespread marketing of Latin American materials on the basis of their origin). I do not mean to suggest that conventional documentaries have no place in an art world context—particularly in the case of video art, which has only in rare moments been absolutely separable from documentary. Nor do I mean to suggest that programs such as X-change TV's sampler of Nicaraguan television, or grass-roots video documentaries distributed through Karen Ranucci's *Popular Video in Latin America,* or the work of El Salvador Media Project, or Women Make Movies' *Punto de Vista Latina* series should never by exhibited in a video art context. What is at issue here is the nature of the desire for the material, and to what extent it conforms to notions of what aesthetics and objectives Latino video artists should express. For more often than not at this stage of multiculturalism, documentaries by US-based Latinos, material from Latin America, and video art from both areas compete for exhibition space and funds.

This highly competative state of affairs does not mean that there have been no significant improvements in the 1980s for Latinos in independent media. As multiculturalism grows more sophisticated and more Latinos assume positions of power in the field, possibilities diversify. And yet the legacy of a reductive populism that conflates sociological, ethnic and aesthetic categories does surface regularly (inside and outside Latino communities), often affecting video artists adversely. Their work, in certain contexts, is rejected for not being "Latino" enough; experimental formats are at times eschewed for their elitism, while an interest in ethnography or the employment of pop cultural forms in some cases has been deemed unsuitable; Latino panelists in grant reviews are called upon to speak for their race in a manner that conforms with populist dictates (as a defense against institutional racism in some instances, but also as controllers of intracultural diversity). One artist interviewed for this article mentioned that he had made several substantive changes in his work to avoid becoming a "professional Latino"; another was told during the 1970s that ma-

terial on indigenous Latin American cultures was inappropriate for video art, while in the 1980s another felt pressured to change styles in order to produce ostensibly and acceptably "Latino" work with the first grant received from public funds.

Cultural bureaucracy's need to legislate cultural identity can also translate into artists' competing critical perspectives within work. One can see, for example, a subtle contest in Nereyda Garcia-Ferraz and Kate Horsfield's documentary on the late Cuban artist Ana Mendieta, *Fuego de Tierra* (1987), over whether her feminism or her experience as a Cuban in exile was the determinant influence on her art. This debate has been carried on in subsequent writing on the tape.[2] The multiculturalist movement's encouragement of reflection on ethnicity and cultural specificity in analysis of the arts has resulted, in the worst of circumstances, in a kind of anthropological treatment of all work by "others" as revelatory of some discrete cultural identity or social reality. And unfortunately, multi-culturalism's current trendiness has accelerated the reduction of complex experiences to buzz words, facile and often inaccurate assumptions. It has been suggested for example that the middle-class, thoroughly Westernized Chilean artist Juan Downey was exploring his own roots in taping the rituals of the Yanomami Indians of southern Venezuela, the indigenous people who are perhaps the most resistant to Western influence. On the other hand, his notion that Chilean culture is based on appropriation and profoundly informed by classical mythology has yet to be viewed as integral to his sense of identity.

As with any other ethnic group, there are Latino video artists who produce works bearing little apparent relation to issues of Latino cultural identity: Puerto Rican Edin Velez began his career searching for a video equivalent of abstract expressionism, and in 1987 produced a visual collage based on impressions of Japan, *The Meaning of the Interval*. Carlos de Jesus's tapes include a video synthesis of photographs, *Christmas with La Volcancita* (1988). And Virginia Quesada's *Pictures That Sing* (1986) combines a variety of visual representations of sound. Downey and Velez are known as much for tapes on themes unrelated to Latin America as for their work in Panama, Guatemala, Venezuela and Chile. All this is to say that the sum total of production greatly exceeds material on the issue of cultural identity. But the issue of cultural identity is still one that captures the imagination of many and plays a powerful role in the cultural politics that determine the possibilities of Latino artists, regardless of the nature of their work.

After this protracted but necessary preamble, I will now focus on Latino artists using video in a number of ways that articulate, analyze, and interpret cultural identity, cross-cultural encounters, and the influence of media on their acculturation. Edin Velez, Juan Downey, David Avalos, Gloria Ribe, Carlos Anzaldua, The Border Art Workshop/El Taller de Arte Fronterizo, Merián

Soto and Pepón Osorio, Ela Troyano, and several others, have all distinguished themselves from mainstream media practices, but have also appropriated from and expanded upon traditional documentary forms. The political views they express toward Latin America and U.S. foreign policy, or toward Latinos in the United States are not monolithic, but rather fragmented, quite specific, localized, and often personal. Their worlds are marked by nuances, distinctions and contradictions brought forth by generational, class, and racial conflicts, internalized biculturalism and nostalgia. Not all of them work in video exclusively or even primarily—most have a flexible attitude toward the medium they employ. Some view video as a cheaper option than film, others as an art form relatively free from the historical legacy of older traditions such as painting. Others are more focused on video as television, and on television as an institution that shapes their sense of the world, and of themselves. Deeply aware of working between cultures, these artists do not isolate cultural identity from difference, whether they explore their connection to and distance from indigenous groups, popular culture, mainstream media stereotypes, or fictions of self and homeland generated out of the experience of exile.

It is perhaps no coincidence that two pioneering and best-known Latino video artists, Edin Velez and Juan Downey, turned their attention to indigenous Latin American peoples in the early stages of their careers. Both were coming from art backgrounds at a nascent stage of documentary media in Latino communities in the United States. For both, working in Latin America did not involve a return to a literal "home," nor did that interest absorb all their creative efforts; indeed, Velez claims he ceased to make tapes on Latin American subjects after *Tule: The Cune Indians of San Blas* (1978) and *Meta Mayan II* (1981) to avoid being pigeonholed. Downey, one of the original members of the Raindance Collective, made over a dozen videos and installations in the 1970s, drawing themes from indigenous Latin cultures, the most hotly debated ones being his work with the Yanomami of southern Venezuela.

Though both are artists who have explored the formal specificities of electronic technology, much of their early work in Latin America comes out of an ethnographic documentary tradition that the facility of video extends but hardly changes. And yet, to root their visions in ethnographic discourses in itself seems like a telling admission: They choose the posture and places that make the distance and difference between themselves and their subjects—both Latin American—most apparent. Assuming such a position, they seem to suggest that absolute knowledge of a univocal identity might be a powerful source of inspiration, but in actuality virtually impossible.

For Velez, who launched his documentary career with his work on the Cune Indians, the ethnographic context was his way of imposing the role of the outsider on himself so as to sharpen his sense of what to concentrate on visually.[3] In his *Yanomami* tapes (1977) and *Guahibos* (1976), also shot in Vene-

zuela, Downey is also constantly measuring himself against that which he posits as the radical other. He envisions the Yanomami as "an example of a society that rejects the political."[4] His black-and-white, rather straightforward *Yanomami* tapes documenting healing rituals lack any explanatory text, short-circuiting conventional information transmission, and subverting the supposed transparency of the documentary image by highlighting its cultural difference. In the same way that he laughs at his own presence in the tape, Downey plays with the viewer, inviting him/her to attempt to decipher the image and/or invent meanings as s/he watches. In *Guahibos* Downey makes his search for the "pure" indigenous referent more explicitly and reflexively directed at himself. Stylistically, this tape resembles later works in the juxtaposition of personal and cultural themes with political ones, as Downey interjects images and comments relating to the local government's impeding his efforts cross from one culture to another.

Velez's two documentaries involving indigenous groups are imagistic portraits. Technically accomplished, they evoke more than explain, in keeping with Velez's inclination to take an intuitive approach to the themes and subject matter. *Tule* traces daily life activities such as food preparation, craftsmaking, dance, and song. The eye of the camera is curious, selective but not probing, seemingly resigned to maintaining distance, allowing the action to seem to be determined by quotidian patterns. No drama develops, and in fact no speaking in the tape is translated, and no voice-over interprets. Like Downey, Velez also seems to be intent on highlighting cultural difference by rendering the other's language enigmatic. To what extent the objectification underscored by that silencing is reflexive is, as always, questionable, but Velez's increased formal play in his subsequent tape only heightens that ambiguity. *Meta Mayan II* is more abstract, making Velez's editorial presence more apparent. The difference between urban industrial and rural Mayan custom is expressed through high contrasts in speed and image which, together with excerpts from radio news broadcasts, convey radical differences in world views. Velez once again sets himself at a contemplative distance, creating a frame through which his Mayan subjects float silently, though they look repeatedly and questioningly into the lens. However inadvertently, these documentary experiments draw attention to the illusory quality of the quest that brings the maker to the subjects. They undermine the myths of Latin origin as cultural coherent, presenting us instead with material that foregrounds the problem of the colonial encounter.

To begin to reevaluate one's relationship to the very concept of precolonial society is at the heart of a critical evaluation of cultural identity, but the process extends to the contemporary. Several multi-media works produced in the 1980s have taken on identity as a process, and examined the power rela-

tions involved in its making. They have analyzed mass media deployment of "Latinness," as well as looking at and often parodying Latino visions of cultural purity. The psychological and political registers that concomitantly forge separation and construct ideas of homeland appear in Juan Downey's *Motherland* (1986) and *The Return of the Motherland* (1989). Both tapes were recorded largely in the home where the artist was born, redoubling the significance of return. Home here is as disorienting as it is inviting, a dreamspace filled with allegorical figures and obtuse, highly personal signs. In these two works, actors embody mythological figures such as Leda and the Swan, caught in a recondite world that is juxtaposed with the rigid militaristic reality of the street. In *The Return of the Motherland,* Downey appears almost literally to be rummaging through a storehouse of memories, contrasting lamentatious monologues on love affairs with images of neo-classical sculpture, and televised images of General Pinochet. Capturing the ambivalence of exile, the tape conveys a sense of being neither here nor there, interweaving different times and spaces with "real" documentary and "imagined" allegorical actions.

Downey seems genuinely puzzled by his own predicament, and allows that sensibility to shape his themes and approach. Cuban-American videomaker Tony Labat, on the other hand, seems bent on exploiting it. With his stand-up comic style treatment, he reduces culture to superficial references to Santería and refugee difficulties in such tapes as *Ñenn-yay* (1982), *Babalú* (1980) and *Room Service* (1980). Here, self-mocking parody subverts itself, reproducing those stereotypes, rather than expanding upon them. Critical evaluation of mainstream media's representation of Latinos and Latin American issues is nonetheless well-trod territory for media artists in this last decade, though the majority of Latino producers have turned to neo-realism and investigative reportage as counterhegemonic strategies.

One of the most interesting exceptions to this fare is Carlos Anzaldua's *It's a Dictatorship, Eat!* (1983), one of the most pointed critiques of Reagan's Central America policies to emerge from the arts sector. The Mexican-born, U.S.-educated Anzaldua produced the tape as a graduate student at the University of California, San Diego. Focusing on the network documentary, which was aired just as the Reagan administration began to enact a more aggressive foreign policy initiative, Anzaldua rearranges a variety of appropriated images to recast the vision of Central America in turmoil as an effect of Reaganite ideology. However, unlike many other activist documentaries on these issues produced during this period, Anzaldua does not seek to undermine mainstream media information by providing an alternative, or "truer" story. The object of his project is not Central America, but North American fictions of its southern neighbor and their effect on the viewing public. Humorously rendered, the tape's semiotic analysis weaves together North American news, advertising,

and fictional images of Latin America to foreground how each affects the other and ultimately influences major political decisions. Working in mock reportage style, Anzaldua inserts a talking-head commentator and uses repetitiveness and high contrast montage to drive his message home.

For Anzaldua, *It's a Dictatorship, Eat!* was partly a way to expurgate his assimilationist education, which might explain the critical emphasis on reception. He explained in an interview that his experience as a Mexican in the United States and his personal investment in the issues imbued the tape with its intensity and critical acumen, but he also sees the work in retrospect as a transitional intellectual exercise.[5] He has since changed his sense of purpose and strategy, concentrating now on cultural programming on Mexican and Chicano subjects for local television.

Mexico City-based Gloria Ribe's tape *De Acá de Este Lado* (From Here, From this Side, 1988) has already circulated widely in U.S. alternative venues, fitting quite easily, with its bicultural theme and collage style, into this country's "meta-television" genre. Like Anzaldua, Ribe is interested in how the cultural distortions propagated in mainstream media are informed by and shape political and economic relations between the United States and Mexico. Her technique, less overtly parodic than Anzaldua's, opts for a simulated sociological documentary that draws on Hollywood and Mexican films, statistical charts, and a convincingly smooth but critically informed voice-over. Intellectually inspired by such writers as Octavio Paz, Ribe locates her analysis in the psychological projection, focusing on the entertainment industry's renderings of each culture's cliches about the other. Finding perfect illustrations of how the United States is constructed as Superman and Mexico as the undecipherable, the work is particularly strong in its analysis of how the oil boom in Mexico led to demonizing images which in turn contributed to the United States's crippling policy measures toward Mexico.

Ribe and Anzaldua push their formats to well-tempered extremes to strengthen their irony and distance themselves from that which they critique. These artists, however, have little effect on or control of the circulation of their material, and the works themselves can do little to alter the relative marginalization of video art in relation to the mainstream television programs they critique. San Diego-based multi-media artist David Avalos, on the other hand, is interested precisely in using media to insert alternative viewpoints into mainstream mechanisms, rather than opting for a parallel venue. Trained in communications, a political activist in the Chicano movement since the 1970s, and a founding member of the Border Arts Workshop/El Taller de Arte Fronterizo, he has produced several public art pieces designed to create controversy and thereby provoke public debate in non-artistic contexts, including the mainstream media.

Avalos's most recent controversy, documented in a video installation at

his INTAR solo exhibition, *Cafe Mestizo* (Summer, 1989), involved a poster he designed with Louis Hock and Liz Sisco for the backs of 100 San Diego buses during the Super Bowl in January 1989. The poster displays three photos of the hands of individuals who are presumably Mexican, and who take on the identity of undocumented workers by virtue of the photo arrangement and accompanying text: one is washing dishes, another is opening a hotel room door to clean the room, and the third is being handcuffed by a uniformed officer. The poster maps out the positioning of illegals within the local economy, formally rendering the reduction of their identities to the status of illegal labor. The result demonstrates the white majority's resistance to confront the de facto existence of neo-colonial exploitation. Barbara Kruger-style graphics spell out the polemical message, "Welcome to America's Finest Tourist Plantation." The furor generated by the piece catapulted it into the print and television news, generating debates on the constitutional rights of the artists and to a lesser extent, the dependency of San Diego's local economy on undocumented labor.

Avalos sees his efforts as exercises in public debate and activist democratization of the airwaves. Avalos does not consider himself a "video artist," and in fact his media interventions concentrate more on documenting strategic subjugation to media mechanisms than on taking a hands-on approach. His video installation extends the public art project by capturing the process it engendered—the interactions between the work, the public, and the powers it implicitly or explicitly contested. It employs a provocateur-style method akin to Hans Haacke's deconstructions of the power relations supporting the Euro-American art market. Amassing the news reports and special talk shows that accrued around the posters, the video installation not only documents the process by which the event was constituted by the mainstream media, but also prevents the introduction of the original poster into a gallery context, thereby preventing its being abstracted from a vital and integral context. Avalos pointed out in an interview, however, that although the work succeeded in shifting terms of public debate by intervening into the mass media, the same mass media had the capacity to deflect attention from the social and political issues concerning the undocumented work force raised by the video project. Instead, the media was able to direct attention to the issues of free speech and use of tax monies by focusing on the artists rather than their subject.[6]

Ever since the technology was made available outside the TV industry, video has been used by artists in a variety of purposes and art forms, contributing to the emergence of multimedia and process-oriented aesthetic practices over the last three decades. Latino interdisciplinary artists such as Harry Gamboa and Ela Troyano, members of the Border Art Workshop/El Taller de Arte Fronterizo, and Merián Soto and Pepón Osorio have begun in recent years to explore popular cultural forms and cross-cultural themes. They have taken an

interest in both the sociological significance of television in Latino contexts and in television formats such as cabaret and telenovelas. Probing and playing with these forms, these artists underscore how they shape the public image of Latinos as much as the private sphere of interpersonal relations.

Writer/director/producer Harry Gamboa is a founding member of the interdisciplinary arts collective ASCO, a group of Chicano artists based in East Los Angeles who have worked together since the early 1970s. The group's conceptual orientation, raw urban and oftimes nihilistic outlook and its extremist gestures set them apart from the populism and activist bent of the Chicago art that has predominated in the last twenty years. Since the mid-eighties, Gamboa has produced several short videos that draw heavily in subject matter from ASCO's performances and Gamboa's work as a playwright. Roughly shot and edited, these works were produced for public access virtually without budgets. Brief pieces such as *Baby Kake* (1985), *Blanx* (1984) and *Vaporz* (1984) explore the alienating underside of conventional social relations, which are usually seen as linchpins of Latino communal stability. His more recent video piece, *No Supper* (1987), is more theatrically staged, presenting the archetypical nuclear family's decay in decelerated slapstick style. His mother, father, and son, absorbed in unsuccessful food preparation and consumption, are framed by deadpan commentary by a sardonic announcer who makes the work seem like a parodic cross between family sitcom and "Twilight Zone"-like tales of supernatural disaster.

The San Diego/Tijuana-based Border Arts Workshop/El Taller de Arte Fronterizo has used video consistently since its inception in 1985.. The loosely knit collective has over the past five years included media producers Isaac Artenstein and Berta Jottar, both Mexican, and Americans Michael Schnorr and Liz Sisco. Most of their video work documents site-specific performances such as Jottar and Emily Hicks's *I Couldn't Reveal My Identity*, which follows the masked and costumed Hicks across the US/Mexico border. Other tapes deal with aspects of Chicano street life in the border area.

The group's interest in combining genres and formats does occasionally find its way into their media work. A 1986 collaboration between producers Schnorr and Artenstein and performance artist Guillermo Gómez-Peña resulted in *Border Realities,* a piece that integrates a performance about binational encounters into the context of syncretic visual culture at the border, and actual politically colored legal transgressions involved in crossing the line daily. The video consists of a slightly chaotic array of images underscored by melodramatic ballads and tropical music. The video opens inside a vehicle with a uniformed officer talking about border crossing, and proceeds with a metaphorical journey that includes Gómez-Peña assuming the persona of a drunken visionary to recite from his poem "Califas," photos of Mexicans being arrested, and scenes from the hybrid street culture at the border where the Virgen de Gua-

dalupe can be coupled with the likes of Michael Jackson. Slightly disjointed and raw-edged, the tape does succeed in intertwining the different registers of bicultural experience from the political to poetic.

Working in a completely different context, the Cuban-born, New York-based Ela Troyano exhibits similar flexibility of approach in her expanded cinema and multimedia performances (the latter have been largely co-produced with Carmelita Tropicana and Uzi Parnes). Her early work reflected the sensibility of the East Village underground out of which she emerged. Since her association with the INTAR workshops in 1986, she began to incorporate themes, characters, and eventually dramatic formats from Cuban-exile pop culture. Economic and exhibition constraints have led her to take a guerrilla approach to the media employed, often showing her films in video venues, and switching back and forth between video and film depending on available resources. In the mid-1980s, Troyano brought several "expanded cinema" media performances to New York clubs, where abstract images on large video screens functioned as a primarily visual layer over which she projected filmed sequences set to music.

Troyano's more recent focus on Cuban popular culture has brought about a gradual altering of approach. Due perhaps in part to collaborating with performance artist Carmelita Tropicana (her sister Alina), the sensibility has shifted from punked-out malaise to high-strung comedy in which popular television formats such as cabaret variety shows and telenovelas have become the structuring principle for the material. Multimedia pieces such as *Memorias de la Revolución* (1987) and *Candela y Azucar* (1988), both of which follow the antics of wandering Cuban spitfire Carmelita and her brother Machito, employ little video technology in themselves, but are reminiscent of live television performances of the 1950s (the crucible decade for Cuban-exile pop culture), with their vignette structures, improvised lines and intentional campiness, here wrought into high-pitched kitsch.

These projects demonstrate how parody, when done well, is far from lacking in acuity. For Troyano's generation of deracinated post-revolutionary Cuban-Americans, living on the other side of a blockade that occludes information, *la Cubanía* has been transmitted largely through the exaggerated gestures of televised and familial melodrama. Carmelita's open-ended adventure story etches out a path that quite significantly lacks beginning or end, or clear placement in past or present, symbolizing the state of cultural identity frozen in nostalgia.

Puerto Rican artistic collaborators Merián Soto and Pepón Osorio have also begun in their last two works to incorporate video and film into their dance-theater installations exploring Caribbean pop culture. Television is integral to their recreation of the transplanted Puerto Rican context. Their works take place in replicated TV rooms decked in kitsch splendor and in barrio so-

cial clubs where TV is a permanent fixture. Like Troyano's works, Soto and Osorio's pieces such as *Wish You Were Here* also resemble the variety show formats of Spanish-language television, combining dance, dramatic skits, and comedy routines. Their more recent work, *No Regrets* (1988), is a telenovela with a feminist twist, refracted through dance, video, and slide projections. Written by Lourdes Torres Camacho, it recounts the story of María, a mother of two, wife of a bodega owner, who's bored with her life, meets Roberto the taxi driver and has to decide whether to have a fling. The tale begins as film and acted story, becoming projected foto-novela, dance, and mimed skit. What gives the intertwining of different media its sense of cohesiveness beyond the story line is in the showing of how their interaction quickly becomes a metaphor for the ways in which televised melodrama shapes people's ways of acting, thinking, and behaving.

The projects I have examined in depth are largely those of artists in the early stages of their development. They are working in a period in which issues of cultural identity are undergoing accelerated change and achieving unprecedented prominence. The danger that identity-based politics will be recuperated for market needs is more pronounced today than ever before. Relating to their senses of culture with comic, acerbic, reflective, and affectionate attitudes, these artists have made significant contributions to expanding a field of investigation that is both sociological and aesthetic. Their efforts will doubtlessly continue to diversify the possibilties for understanding the other within ourselves, and the rich and varied history that shapes our very eclectic, but nonetheless Latino, visions.

Behind the Image

Images are as ancient as civilizations, as ancient as the need for people to express themselves through the representation of images.

* * *

As the images have been constructed and made, they remain in intimate relation with their context, and with diverse historical, cultural, social, political, and economic circumstances.

* * *

For the artist, the image is the result through which different concerns are constructed and transmitted.

* * *

Techniques and technologies deal with two processes: construction and transmission. They both affect the production and reproduction of images at conscious and unconscious levels.

* * *

The image has gone through historical periods when it has produced more significant samples of a socially committed attitude. Hence we regard the production of images at an anthropological level and as part of our cultural legacy; the works are dealing with and are related to contemporaneous events; they are their production.

* * *

The task and responsibility of artists (and I am referring to such a task in an inclusive rather than exclusive way) is by means of their work, to observe, reflect, and comment upon the times in which they live. It is one of the tasks of today's artist to make visible the invisible side of the image.

* * *

The relation with the audience defines and also constrains the personalization of image in terms of form (style) and content (discourse); this adjustment is particularly true when obvious consequences (especially political or economic) are involved.

* * *

Referring in a general, generic way to the "Image Industry" (cinema, television, advertisement, publishing, and—in its most commercial circles— we could include the art market), it is evident that there is the need to gain an audience: readers, consumers, public, rates, sales. . . . This is the great challenge, the great competition orchestrated by the mass media. A complex and problematic issue.

* * *

AMERICA

Jean Baudrillard

Translated by Chris Turner

The issue is the impossibility of considering an image in itself, outside of the context of production and reproduction. Maybe this has always been the case: the work cannot be detached from its context. But here the emphasis is placed on the appearance of roles, techniques, and strategies that create a complex network of interests (primarily political and economic) which exist and are situated behind the image: the context and its actors.

* * *

Work produced by me in the last few years (audiovisual construction) has used a variety of media and situations (series of photographs, installations, videotapes, billboards, publications); these constitute observations/commentaries on contemporary facts, particularly on the mass media as subject, form, and content. Context is considered an integral part of this work.

* * *

Against limits. Limits always exist—all sorts of limits. It would be naive to ignore them, pretentious to think that we are beyond them. With respect to audiovisual media, limits exist beginning with the screen frame, the distance of projection, the time span, the degree of darkness or lighting, the space. . . . We must be aware of all of them, as in painting we are aware of the limits that a "40 portrait" or a "60 landscape" produce. Limits anyway you see it.

* * *

Formats influence the work starting with its possible distribution. Video formats have implications that go beyond problems of form. I am talking about 30- or 60-minute programs for TV that have to be tailored into 28 or 58 minutes so they will have space for the 2 minutes of commercials.

* * *

The complexity of both the creation of images and their distribution from the private to the public sector affects a series of decisions and filters that mediate the entire process politically and economically.

* * *

Forms appear—categories and genres that are clearly the product of circumstances: speed, market, efficiency, synthesis, and referencing. Forms that are hybrids and subgenre.

* * *

Genres have been created to satisfy needs for information and commercial needs. These are functions of the corporate world, what is the "Before" and "After" of the image. In some cases, they are its replacement; in others its explanation.

* * *

Interventions of the Present:

Three Interactive Videodiscs, 1981–90.*

Peter d'Agostino, *DOUBLE YOU (and X,Y,Z)*, interactive videodisc, 1981–86.

I.

Imagine a place, a corridor containing a series of rooms within rooms: with a beginning, an end, and the present as an intervention within this highly struc-tured environment.

Each room represents a segment of time, a linear history of Western art, of painting and sculpture. We enter a room containing a small painting by Giotto. Or is it by a follower of Giotto? For if we truly wanted to begin with Giotto, he would need a room of his own such as the Arena Chapel, with fres-coes painted directly into the plaster walls.

So if we happened to enter at the beginning of the Renaissance, and we con-tinued along that corridor, where would it end? There could, of course, be several possibilities for its culmination point. But, if this corridor which be-gins with a small painting by a follower of Giotto is in the Philadelphia Mu-seum of Art, it ends with a room within a room by Marcel Duchamp.[1]

Intervene: to come between as an influencing force; to come in to modify, settle, or hinder some action, argument, etc.[2]

Conceivably, an intervention takes place every time someone walks down that corridor. And we can also say that art like life is an interactive experience. Like handprints on the walls of the caves of our prehistoric imagination, marks, images, and sounds all potentially intervene from the past to the present and from the present to the past. The particular intervention to which I refer, however, took place along that corridor, between the Giotto and the Duchamp, just outside the doorway to the Arensberg Collection in the museum's Twentieth Century galleries.

II.

DOUBLE YOU (and X, Y, Z.)

Two doorways, a W-shaped accordion wall, a facade, built in to the physicality of the room, suggesting the multiple viewpoints of a Chinese scroll painting, set the stage for an elaborately structured series of "events."

The words **DOUBLE YOU,** form a single frame of the interactive videodisc that plays on four monitors positioned on each of the four sections of the W-shaped wall. Continuously intercut with these stills are motion sequences from four parts of the videodisc. Once a selection is made on a touch screen, two of the monitors interspersed among the four show the

selection while the others continue to display the preprogram without interruption.[3]

Ordered sequences, random juxtapositions, selections, and interventions. Sound on, off, on again; four video monitors, a touch screen. Walk through, look, listen, stop, and touch?

The "events" are modifications of the spatial and temporal relationships within the space which can be instantaneously realigned through the act of touch. It is this act of touch that significantly alters and transforms one's perceptions of the experience, that of symbolically opening and entering the work.

While the subject of **DOUBLE YOU (and X, Y, Z.)** is the acquisition of language, the underlying structure is derived from an another source— physics.

"It is now believed that there are four forces that cause all physical interactions in the universe: light, gravity, strong, and weak forces."[4]

Through analogy and metaphor, logic and absurdity, these concepts are used to parallel four stages of early language development. They make up the four-part structure of the work:

1 Light/birth
2 Gravity/words
3 Strong force/sentences
4 Weak force/songs

Sound is the primary motivation for this progression—from cries at birth

to first words, sentences, and finally to songs sung at age two. This last part also reveals that the source of the title, **DOUBLE YOU (and X, Y, Z.)** is from a children's song that concludes with "now I know my ABC's next time won't you sing with me."

Viewer/participants create a personal montage of associations and meanings from a variety of sounds, words, and images. After the initial selection, a complex set of possibilities emerge and the selections can be random or even played like a game. The game, however, is not predicated on winning or losing but on making various "discoveries."[5]

Different experiences of the work are derived from the different physical viewpoints in the room. One seemingly privileged view is that of the viewer/participant at the touch screen who intervenes in the established order of the piece. Another view, afforded by being near the cen-ter of the room, provides the otherwise "passive viewers" with an overview of the juxtapositions created by both channels of video and sound alternating on the four monitors.

The asymmetry of the installation, with the touch screen set to one side of the display instead of in the center of the space, reinforces the asynchronicity of time experienced in the continuing "ordering" and "disordering" of the piece.

Once having discovered the touch screen, the dilemma faced by the viewer/participant is whether to keep making selections or to move toward the center of the space in order to fully comprehend the results of his/her interventions. This, in effect, frees up the touch screen for others to participate in the selection process. The dynamics between viewer/participants and their social interaction is an integral part of experiencing the work.

Peter d'Agostino, *DOUBLE YOU (and X,Y,Z)*, 1981–86.

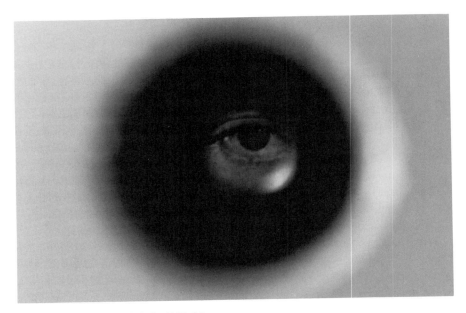

Peter d'Agostino, *TransmissionS*, 1985–90.

III.

Of Art and Science

The Renaissance is an immense fact in the history of mankind! Artists knew how to plunge themselves into a scientific reality, to appropriate it to themselves, to rethink it and make it accede to the rank of superior art.

—Roberto Rossellini[6]

For over five hundred years the Renaissance has been a model of an ideal synthesis of art and science. The scientific reality represented by its two great inventions, perspective and the camera obscura, has, however, placed ideological, technical, and aesthetic constraints on the development of Western art and culture. To this day, for example, photographic lenses are still constructed to suit the laws of a classical perspective derived from a world view that is based on a monocular vision fixed in space and time.

The cinematic apparatus that emerged at the end of the nineteenth century is a direct descendant of the camera obscura and a psychological extension of Plato's "analogy of the cave." In a situation similar to that of the modern film spectator, a prisoner views a reality that is reduced to mere shadows projected on the inner wall of a dark cave. The prisoner and the film spectator are both in the dark with no control over the sounds and images or the mechanism of the projected simulated realities. In both cases, the spectator can be considered an unwitting voyeur, an aroused receiver (consumer) of ideas beyond his or her control.

Two images come to mind. Pir-
anesi's *Villa dei Cavalieri di Malta*
and Duchamp's *Etant Donnés*. . . . At
first glance both works are strikingly
similar. Both have closed wooden
gates, doorways, leading to idealized
landscapes with entrance prohibited.

Piranesi's door to the villa has a
peephole, which reveals a view to a
garden that frames Michaelangelo's
dome of St. Peter's in perfect one-
point perspective. Duchamp's door
has two holes providing a binocular
view of a diorama that eventually
leads to a landscape with a waterfall
in the background. But when you
first look through the holes you see a
nude woman spread out before you,
(his perennial "bride stripped bare"),
holding up a lamp appearing to illu-
minate her sex.

In each case, you must take the
first step to the door. Looking
through the hole/s is a surprise, even
to those who are aware of what the
view may reveal. What is somewhat
unexpected is that this positioning
transforms the viewer into a voyeur.
In the latter case, you are, in fact,
made to feel like a Peeping Tom.

While the content of the message
in both circumstances is different, the
mechanics at work on the spectator
are quite similar. You are, in effect,
trapped by the conventions of a clas-
sical perspective that is represented
by the camera obscura.[9]

Peepholes and touch screen are
both invisible to the uninitiated and
extremely inviting once you are aware
of their presence. Whereas *Villa dei
Cavalieri di Malta* and *Etant
Donnés*. . . . exploit the camera ob-
scura and diorama, the **DOUBLE YOU
(and X, Y, Z.)** installation conjures up
new modes of viewer/participation be-
yond the limitations imposed by the
cinematic apparatus to a spatial and
temporal cybernetic transformation.

Peter d'Agostino, *DOUBLE YOU (and X,Y,Z)*, touch screen, 1981–85.

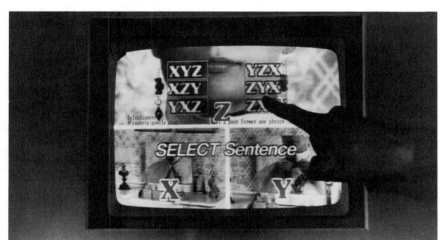

Peter d'Agostino, *TransmissionS*, 1985–90.

IV.

In 1986 when Halley's Comet returned within view of the Earth on its 76-year cycle through the solar system, a spacecraft was launched to take close-up pictures of the comet's nucleus. Before it was destroyed upon impact with the comet's core, the spacecraft *Giotto* transmitted live television pictures that revealed that the comet was made up of bits of dirty gray ice.

Over 500 years earlier, the artist Giotto painted a comet (later to be called Halley) in a Nativity scene on the wall of the Arena Chapel. Giotto's image of that red fireball is still considered to be a significant beginning.

The double-edged implications of art and science and emerging technologies, cutting on both sides of utopian/ dystopian ideology, continually re-emerge in the art-making process. As a commentary on this process, the epilogue to **DOUBLE YOU** concludes with the following quotation:

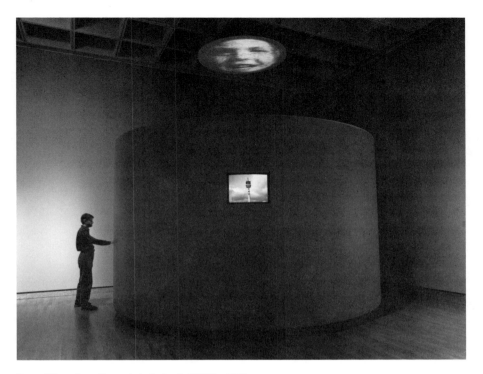

Peter d'Agostino, *TransmissionS: In the WELL*, 1990.

*The focus of this essay is on the viewer as participant in *DOUBLE YOU (and X, Y, Z.)*, (1981–87). This installation, along with the other two videodisc projects, *TransmissionS* (1985–89) and *STRING CYCLES* (1988–90), forms a trilogy of works based on the broader concept of interactivity and intervention. All of these works refer to specific types of "beginnings."

DOUBLE YOU (and X, Y, Z.) is based on an individual's birth and acquisition of language.

"In the Beginning was the 'S' " is the initial segment of *TransmissionS*. It charts the development of the camera obscura to Marconi's first trans-Atlantic wireless transmission in 1901 (merely an 'S' . . . three dots in Morse code). It continues with "Deus Ex Machina," concerning the first reception of radio waves, traces of photons emitted over 15 billion years ago, attributed to the "big bang," which is thought to be the origin of the universe. The third segment, "Parable," is a critical allegory based on an explosive splash, "the fall," or the downside of our technologically determined culture. "Eclogues (The Selections)" provides an interactive base of material to leap back and forth in time between the various segments of the videodisc.

This work represents the shift from a fixed perspective and multiple viewpoints to the transmission of ideas and images "in the air."

STRING CYCLES is, on one level, an oral history project documenting various cross-cultural manifestations of string figures or "cat's cradle" stories. From their origin in the oral tradition of tribal cultures, string figure games are universally known and are played primarily by children throughout the world to the present day. Three interrelated threads (or themes) running through the work are the connections between the string figure stories, the recent developments concerning "Superstring Theory" in physics, and the "strings" or "loops" of letters and symbols that are mathematical constructs integrated into the design of computers.

It is precisely this weave of new technology with the oral tradition that reveals the range of this trilogy of interactive projects.

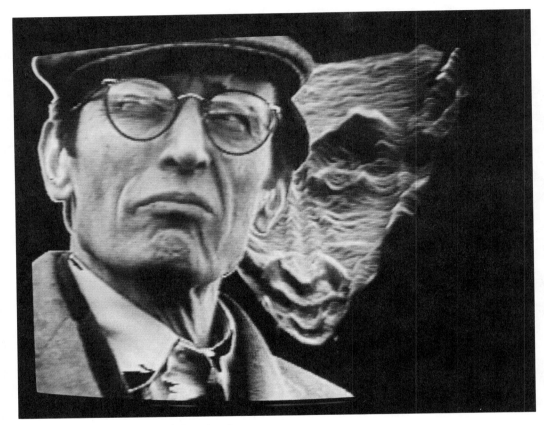

Woody Vasulka, *Art of Memory: The Legend*, 1987.

The Cultural Logic of Video

MAUREEN TURIM

The cultural logic of video—the echo of Frederic Jameson's "The Cultural Logic of Late-Capitalism"—is obvious in my title, but less directly and less completely as a borrowing than it might first appear.[1] My turning of his phrase questions the relationship of cultural forms and what might be called their "logic" or their functioning. For Jameson, political economies possess a distinctive cultural logic. Cultural practice within late-capitalism can, therefore, be shown to obey certain laws, certain governing principles. Although the internal ordering of his essay disguises it (he does not explicate his borrowings of categories from political economy until midway through, leading the reader to believe that his inspiration lies primarily with the cultural object), Jameson starts from the facts of late-capitalism and lights on the objects of culture that he believes illustrate its logic. His title signals that the Ernest Mandel book *Late-Capitalism*, withheld as reference until nearly the end, was always the point of departure.[2]

In Jameson, the split between high modernism and postmodernism in culture is one of a periodic history corresponding to Mandel's stages in the development of capital. As Jameson notes, Mandel divides the fundamental movements of capital into three stages, "each one marking a dialectical expansion over the previous stage: these are market capitalism, the monopoly stage or the stage of imperialism and our own—wrongly called postindustrial, but what might better be termed multinational capital." Jameson then states that his "own cultural periodization of the stages of realism, modernism and postmodernism is both inspired and confirmed by Mandel's tripartite scheme."[3]

Instead of assuming that the culture of our epoque follows from and illustrates the economic and social changes we are experiencing, I wish to investigate the logic of what has repeatedly been called the most postmodernist of cultural forms, video. I wish to pose this as question, rather than as postulate: *What cultural logic does a form, an artistic practice, a means of expression, embody today?*

One of the things at issue here is reflection theory. It is infinitely seductive to assume, as does reflection theory, that all instances of what we might call culture are bound by a logic, a logic that emanates from a larger state, a surrounding condition, the times, the economic system in place. The logic can be presented as an active figure—conditions determine culture, the means of production of each object or utterance are always identical to the totality of the production system. Or the logic can figure passively—culture reflects condi-

tions—the artist by some sort of overdetermination inherent in poetics crafts only one type of object, a mirror in which self and society are caught, together. From here, Georg Lukács moved to the proscriptive position that champions that art which best reflects a given class or political perspective, be it proletarian or simply concretely "real" and therefore exposing bourgeois values.[4] If earlier in his career Jameson held more closely to such a Lukácsian version of reflection theory, he now extends reflection theory so that even "abstract" or "escapist" art can be viewed symptomatically. However, elements of the proscriptive evaluation remain as one senses that his attitude toward the culture he terms postmodernist is quite negative.

It is perhaps equally seductive, though to a different sort of theoretical personality, to follow the lead of the formalists and deny either an active or passive reflective relationship of the artwork, to simply term all aspects of reflection theory critical fallacies. Each of these positions is seductive because each is absolute and avoids the very messiness I feel compelled to confront. Instead, let's consider the untidy acknowledgment that aspects of both the passive and the active formulations of reflection theory metaphorically articulate something of how cultural objects and practices emerge and operate, but that other possibilities also exist. These instances and circumstances frustrate our desire to be so content that we know where culture comes from and how it functions. On one hand, we may wish to grant that the theory of reflection articulated a certain insight into the relationship of cultural forms and historically determined socioeconomic changes, but we cannot do so without tempering theories of reflection with a notion of heterogeneity and multiple determination, using the findings of textual analysis and theories of reading and spectatorship. Methodologies for the study of culture such as psychoanalytic theory and deconstruction through their respect for the specifics of textual study and the value they place on attention to differences, have in various ways made the kind of categorical generalizations put forward by Jameson seem like a new totalizing theory whose roots in Lukács are philosophically clear. If anything, what has occurred is an expansion of reflection theory away from its core privileging of realist traditions and content to include all cultural expression through an increased use of metaphorical and structural readings and a greater investment in the a priori idea that all cultural production reflects the economic system.

Sometimes the terminology of postmodernism has allowed a kind of side-stepping of issues of method. Postmodernism tends to homogenize all issues of culture within the internally contradictory, but nonetheless fixed, present social order. Technology becomes a monolithic construct, a tower of Babel built with computors, lasers, interactive disks, built with the hardware and software of information exchange. It is monumentalized by a curiously awestruck and beleaguered intelligentsia. It is this *wonder* that one senses in attempts to revise

culture theory in order to account for this decentered Moloch of our metropolises, the monstrous multitentacled beast who survives as a network laced with modems and receivers, whose assigned place for the subject is as she or he who interfaces. Symptomatically, much postmodern criticism looks to the comic strips and B science fictions of the 1930s through the 1950s as prophetic visions prefiguring a fantasy of this sort. A generation groomed on such mythologies is condemned perhaps to see the world in their terms. Technologies are represented as determinant, and their mode of functioning is viewed ontologically. Television is in this context granted the same ominous power that paranoid patients bestow on it. When it interfaces with computors as in video art, the fantasy could congeal into video's vocation as a postmodern mechanism of late-capitalist feedback.

Our view of video art just won't support such fantasies. If a theory of postmodernism can in any way coincide with a theory of video's functioning, it will not be by taking technology to be determinate or by reference to the ontology of the medium of television. In fact, postmodernism itself will need to be defined differently.

Postmodernism remains suspicious as a critical category, but its terminology is now so pervasive that it is hard to escape. Jean-François Lyotard chose to borrow the terms for his *La Condition Postmoderne*, which is less concerned with a periodization of the twentieth century than are most texts circulating in art criticism and sociology concerning postmodernism; instead, his study examines lines of force that were exerting themselves in concert with the industrial and scientific revolutions, lines of legitimation, narratives meant to replace earlier myths with a new series of justifications.[5] His is a book of deconstruction and one of its most fascinating challenges is that it forgets neither Michel Foucault nor Jacques Derrida; it keeps in mind both the historical function of discourses with which Foucault was concerned and the philosophical investments at stake that Derrida reveals. It seeks out the same ground tread by Jürgen Habermas as he pursued his theories of legitimation, in which discourses and cultural expressions were examined for the way that they serve to validate ideologies, or failed in their attempts to do so. Yet Lyotard seeks to deconsecrate that ground as territorial sanctuary for certain cultural suppositions of the Frankfurt school, those surrounding the subject, enlightenment, humanism, and a totalizing philosophy.[6] Lyotard uses the term *legitimation* in a broader sense than does Habermas, for his use of it addresses the very foundation of truth in scientific discourse and in ethics and politics.

The only sense in which Lyotard finally mobilizes the term *postmodern* is to address the process of *delegitimation,* in the present and the future. This is far afield from the Baudrillardian postmodern and even the Jamesonian postmodern.[7] Unlike nearly everyone else writing about postmodernism and art, Lyotard strategically updates and reworks an analysis of avant-gardes and of the

sublime. This contrasts with Jameson's contention that the period of avant-garde movements has ended with high modernism and monopoly capital. Less pessimistic in general and less enamored of mass culture, Lyotard feels mass culture need not be seen as laying down the rules of all cultural games in its video arcades. A difference can be sought even given the material conditions of the present in *immaterial art,*" (the French is *les immatériaux*) a term Lyotard has introduced to refer to art that calls into question the logic and philosophy of computorized societies.[8]

This position strikes great affinities with my own desires. Now, more than ever, we need art, we need an avant-garde, one open to change, one not mired in merely repeating. The press of commerce on art has never been more extensive. Recently, a rescreening of Bertolt Brecht's *Kuhle Wampe* (1932), brought to mind the power of alternative forms, generated by Brecht's analysis of the reasons that commercial viability can inhibit artistic historical validity; this point of view is in danger of being suppressed by the postmodern embrace of commercial culture in the name of anti-naïveté or, ironically, anti-elitism.[9] However, when Jameson speaks of the decline of the avant-gardes, this also hits a chord of recognition. For in looking at the art of the 1980s, we sense that, despite continued activity, a sense of purpose and direction as might be presented by fresh and meaningful manifestos is absent. Some of this may be, in fact, a result of postmodernist theory's assimilation by the art world. Any theory of art that insists that all is repetition and simulacra is bound to be a self-fulfilling prophesy, for logically, there can never be a first time such a position is taken nor any vectors of development. Even if the ontological formation of art forms remains ultimately a fiction, it has historically served as an enabling fiction, helping to produce the creative energy of modernism. Though indeed some art is inspired by the absorption of postmodern theory, a considerable portion of this is actually conceptual art and/or collage and montage work quite consonant with the work in these modes in an earlier avant-garde. A lot of what passes as postmodern art is a pastiche of pastiche, a glut of style over form and substance that chooses at most to illustrate the themes of a theory rather than embodying a theoretical intervention. If we want to replace the enabling fictions of art movements with a more deconstructive view of the history of representation, then we have perhaps more to learn from the history of culture in the twentieth century than the concepts of modernism and postmodernism will allow. Perhaps we should replace the term *postmodernist* with other terms that shed the cynicism and superficiality that has accrued to *postmodernist* in its application to art.

If we start with the artifacts, like an archaeologist not only puzzled by their shape, curious, but not yet certain of all aspects of the structure of the society that produced them, or the use or role they have in that society, and if we watch vigilantly to see that our method does not merely serve to confirm

major themes of an already-believed narrative about our condition, we may learn from contemporary artifacts such as video art in all its myriad manifestations. So while it is tempting to say that video as our most recently invented art form can be conceived as an art wholly developed as postmodernist, let us look seriously at what this might mean. It certainly acknowledges that video is unique in its evolution out of the most advanced apparatus of mass culture, the most commercial and/or state-power-controlled instrument to date, television. Video comes after television, taking its hardware, but more or less abandoning its vocation as commercial mass communicator.

Early on, David Antin discussed this parentage, this begetting of video from what he took to be its evil parent.[10] The child that he described, however, would come to be understood only as one mutation, or put differently, an early embryonic form. The portapak video that was his frame of reference in 1975 was a low-resolution image that could not be edited without leaving traces. Video, as deployed by artists was, according to Antin, in a rather pleasantly shabby technical state. Glitches viewed affectionately as marks were not so much cumbersome, as they were the romantic, contestatory inscription of human fabrication and low budgets, features Antin wishes to preserve as fundamental to artistic video.

Of course "precision editing and smoothness" are no longer "out of the question" for video artists; indeed, internal montage, collage, and reduplication of video frames within the image, are now the state of the art. Video went from being less malleable than film to becoming far more seamlessly constructivist. It displayed its technology, its grounding in machinery, timing devices, impulses, switches. It is tempting to make a distinction between what we might call first-stage video, video before editing, image processing, and computor control and a second-stage video where more of the technical capacities that have come to characterize the specificity of the video image are in place.

Antin's position can now be seen as historically circumscribed. Video has gone beyond his primitive and apparatus-bound definition of what it should be. Yet before we bifurcate the history of video, a reviewing of those early tapes is in order. What we find is that several, by purely amateur low-tech means, the improvised realignments of camera and monitor playback, prefigure the reshaping and embedding of the image to come. Consider for example, Steina Vasulka's *Signifying Nothing,* (1975) where generations of imagery are embedded by simply aiming the camera at a person carrying a monitor bearing the image of a person carrying a monitor. The *bricoleur* quality of such explorations should not deflect our attention from the fact that little differs on a theoretical level between this and elaborate collages of multiple temporalities through frame-buffed window inserts. In fact, these first-stage videos with their sometimes awkward, sometimes overly serious, sometimes comic perfor-

mances are, if considered from the perspective of image manipulation, remark-ably evocative of the future. That the artists chose to people these images, to "humanize" them, or to mark them as self-portrait signatures, represents the contradictions operative between art of the past and the technology of the present and future.

Signifying Nothing—the title emblemizes the attack on modernism and its formalist concerns. The title snubs and beckons the semiotician, using her or his language while contrarily insisting that such a thing as the total absence of signification is possible in an image whose signifiers are both self-referential and complex. The title attempts to both defy and sarcastically confirm ideological critiques of works like this one that avoid referential social commentary. But if the title confronts the other, the semiotician, the ideologue, it is not the standard self-effacing title "Untitled" but a strongly suggestive verbal overlay, as are the titles of Paul Klee and René Magritte works. Yes, it signifies nothing (of immediate decipherability); no, it does not escape signification and never really pretended to do so.

Where does this leave the notion of video as antitelevision? In the years since Antin, this theme has remained central to video criticism, not necessarily as grounded in the low-tech conception of the video apparatus but reworked both by artists who directly addressed or attempted to deconstruct the TV image or to create ideologically inspired alternatives to TV, radical educational TV such as Paper Tiger Video. However, the forms of video that are most directly antitelevision are paradoxically those that remain closest to it, their images preoccupied with it or their form not so different from it. This is not to say that such closely attached deformation isn't vital, only that it doesn't give us more than one component of video's cultural logic, one limited as it describes only certain video works, and describes those only partially. Also it fully reinforces the mass culture/high culture split in its mass culture and anti-mass-culture definitional terms.

In rethinking the matrix by which culture is mapped in relationship to the larger social sphere, let's also avoid granting autonomy to a single aspect of psychoanalysis seen as defining the essence of the medium. As concerns video, the singular element of psychoanalysis has been narcissism (while for film it has been a combination of fetishism, voyeurism, and disavowal, more complex, but still limiting psychoanalysis to a diagnostic blindness). Rosalind Krauss in 1978 argued that video art was in essence narcissistic.[11] Her position has since been construed as determining why video as essentially narcissistic is postmodern, in a strategy that subsumes the psychoanalytical as itself a reflection of economic forces. This argument holds that art constructs a narcissistic posture as the only outlet of libidinal force in late-capitalism.

Krauss was right to point out how a video camera and monitor can function as an electronic mirror, in light of how this property was used and exam-

ined in a number of early videotapes and installations. However, her argument rests on equating the mirror property of video with narcissism as such, using a definition of narcissism vaguely derived from Jacques Lacan. Granted, the mirror is part of the allegory for narcissism; however, that is not the only role the mirror has played metaphorically in psychoanalysis (consider its complex role in the mirror stage) nor can the mirror function as a literal symptom of narcissism. Further, we can take a lesson from Foucault's analysis of *Las Meninas*.[12] The artist and spectator do not necessarily occupy the same position. Even if the artist is narcissistically performing for the video-mirror, the spectator of the image of this behavior is not. Conversely, if the spectator is performing for the mirror in a video installation, then the artist is not himself or herself seeking narcissistic gratification nor is the nature of the spectator's interaction with the installation necessarily narcissistic. Nor are all artists who appear in their own tapes simply seeking the self-affirmation of a narcissistic involvement; Martha Rosler's performing self, for example, is a complex fiction in which her performance is to be seen in relationship to other women. The mirror shatters, at least as guarantor of a metaphor that would contain the sole key to subject positioning in video art, even of the type Krauss is addressing, let alone for all the transitive or nonmirroring possibilities of video image making.

Early attempts to define video's cultural logic, then, posited a directly socially determined logic on one hand (the antitelevision vocation of video) and one internally determined logic, narcissism, that itself was soon posited as overdetermined by social conditions. Each explanation was in turn grounded in a view of the video apparatus. Each was partially valid for its time, but only partially. Each explanation has been further invalidated by what has transpired since, in both the elaboration of the video apparatus and in the multitude of approaches taken to making and displaying video tapes.

So let's return to our question. What cultural logic does a form, an artistic practice, a means of expression embody today? What is the cultural logic of video?

My transformation of Jameson's formulation does, in fact, still operate as a borrowing, but one that is of phrases rather than of the lines of Jameson's political geometry, phrases which for me resonate and deviate from the line in which they are printed. I like many of Jameson's phrases, not only his title, but also of many of the subheads: "Deconstruction of Expression," "Waning of Affect," "pastiche eclipses Parody," "Historicism effaces History." Every one of these phrases evokes a work or body of works in contemporary video as illustration: the pastiche of Dara Birnbaum; the absence of affect in Woody Vasulka's computer montages and, differently, in Max Almy's monologues; the deconstruction of expression in works by Bill Viola or Gary Hill. Yet, even here, I am not sure of the alignment, the characterization. For Jameson's terms are meant to distinguish these recent works from the avant-garde movements of

the past, for example from Munch's *The Scream,* he tells us. The problem with these lines of demarcation and periodization is precisely the oppositional polarity through which they obtain. The absence of affect, for example, is not a single entity, a like strategy in all instances. At times, it marks a libidinal investment elsewhere—not in the referential functions of representation that we normally associate with affect. At times it marks a self-conscious posture, at times a sarcastic attack on the absence of affect. Further, each of the recent works has precursors in what Jameson might call high modernism, a lineage through which they can be understood. "Historicism effaces History" suddenly appears to be a commentary on what has happened to our sense of the history of art and culture. The history of modernism, the history of the avant-gardes from the mid-nineteenth century through the 1960s, has been distorted into a one-dimensional opposition to the present, an opposition that may not be nearly as pronounced as this approach insists a priori.

It is perhaps time to rethink the terms *culture* and *logic* as these concepts connect to video. Part of my attraction to the phrase the "cultural logic of video" is to underscore how the components of the structure of what we might provisionally call the second stage of the video apparatus implicate "logic" in its mathematical sense. The image submits to analogue shifts or digitized fragmentation and recombination. The inner logic of the computer can be externalized, given visual figuration.[13] This marks the video apparatus as a unique contributor to what might be seen as not postmodernism, but the as yet unfinished project of modernism. For if one of the impetuses for modernism in the arts was to create artistic forms responsive to the dynamic changes of industrialization, as celebration or as critique, then video deeply internalizes this vocation and this to a greater degree than photography and film, arts that also have a modernist component of their basic structure. Rather then being affected by technological conceptualizations primarily through the secondary means of an artist's reapplication and redesign of artistic materials, video as an apparatus has inscribed the logic of modern technologies as a primary element of its development.

Jameson couples the spatialization of time to the disappearance of historical consciousness characteristic of postmodernism. Video certainly can participate in the transmission of events as they occur and thus display time as a spatial configuration, giving new concreteness to our sense of instantaneity and simultaneity. In fact, the ability of video to spatialize time, while seemingly borderline magical, is inscribed in the display system, as the frame in video is a discretely bounded unit of time. Yet we cannot follow the logic of Jameson in simply assigning this to postmodernism rather than to modernism, nor can we accept that this is a major factor in diminishing our appreciation of history. Instead, let me suggest that modernism already implied an interactive relativism to temporality and spatiality. Time and space were seen as categories af-

fecting one another, so that multiple temporalities could be imposed on one space (futurism) and multiple spatial views seen in one superimposed temporality (cubism). This interaction of categories traditionally kept discrete in such monumentalizations of history as the nineteenth-century history painting have the potential to transform the very concept of history into one far more dynamic and more global than a linear series of events. The phenomenon to which Jameson seems to be reacting is a television-image environment that overwhelms us with images systematically extracted from their context, where juxtaposition effaces any cause and effect in favor of mere shock value. Video lends itself to this kind of collage, but in saying this we should note that nothing is intrinsic to video's treatment of temporality that makes such usage obligatory, nor does collage have to perform counter to historical understanding and commentary. Rather one can see video's ability to spatialize time and temporalize space as potentially a means to continue the dissection of the apprehension and meaning of an event.

The temporalization of space in video is accomplished by both video switching and editing; each process bears a strong relationship to crosscutting in film, though since switching can "edit" in "real time" (simultaneous to the occurrence of events being represented), there is an extra dimension to montage in video. Similarly, embedding images within images, each with its own discrete temporality, through keying or digitalization is different from photo or filmic montage; the electronics of video heighten the fluidity of temporal and spatial representations beyond the edited mixture by creating the mixture as ongoing process. Photography and film serve as the cultural premonition of video, forecasting its electronic means of display through their mechanical approximations. Yet video also seems to look nostalgically back at the modernist heritage of photography. With what can be called a cultural lag, it makes more immediately accessible the properties the avant-gardes in earlier media already explored and provides a fresh way of sorting through and redefining much of the flurry of new visual and auditory thinking proposed in this century. Video, then, exists simultaneously in a space of cultural lag and premonition, through which it strives to articulate a meaningful interaction with the present.

At any rate, the full perceptual and philosophical impact of video is hard to ascertain. If it can virtually deconstruct spatiotemporal order, it can also reconstruct it. Video has the potential to participate in the delegitimation of the functionality of actions and narratives of causality. It can question the "natural" order of things by and through which legitimation is grounded. We must remember, however, that we are talking of potentialities to be actualized in specific usages. To assign an "essential" cultural logic to a medium rather than analyze its use begs many of the issues we have been raising here.

Two videotapes that propose a more deconstructive look at the spatializa-

tion of time and the temporalization of space than Jameson's view of postmod-
ern dehistoricization are Thierry Kuntzel's *Still* (1980) and Woody Vasulka's
Art of Memory: The Legend (1987). *Still* is minimalist and subtle in its evoca-
tions of space and movements, a world apart from the baroque collage of a
television-commercial aesthetic of elements colliding and combining so rapidly
that concentration is dispersed. Here the rythym is that of the controlled sin-
gular occurrence, shiftings that change the entire field of vision dramatically
enough to occupy focused attention. Electronic manipulations, the windows,
colors, and snows of the video image are mixed with the traces of the human
body in representation in a room. Time almost stands still, but of course does
not. Our sense of duration is prolonged; duration and change themselves are
indicated by primarily spatial cues.

A very abstract sense of temporality as indeterminant, tentative, and
fluctuating emerges. *Still* evokes a deconstructed representation of a phenome-
nology of temporality. It suggests to me how very little we know theoretically
about how we perceive time, except by natural cycles (days, lives, the narrative
conventions of closure). The viewer of this video watches in a relationship to
the depicted figure, who watches, not outward at the viewer, but into spaces
that seems interior and even imaginary.

For this reason, *Still* seems to stand outside of history; the time and place
of this passing of time are not disclosed or enclosed within the reference points
necessary to the writing of history. Yet the history evoked by *Still* is the his-
tory of photography and cinema—the still picture and the moving pictures.
Still creates a video somewhere in between the spaces implied by those media,
showing their histories to be interwoven, each written in the space already as-
signed to the other. This deconstructive view of history as not so clearly linear
has nothing in common with what Jameson calls "Historicism." It is instead a
contestation of a narrative of history that separates phenomena along the con-
stant of a time line, therefore assuming, always, that their inscription can only
meaningfully be seen in this way alone. To look backward through history
(what every historian must inevitably do) is already inverting historical linear-
ity; to look back at the still photograph as a frame through which we locate
the historical moment is a much more self-conscious retrospection. Time is
spatialized here in a manner that poses questions about the very conception of
temporality and history. Far from simply flattening or deforming the sense of
what we mean by historical time, such works challenge our conceptualizations.
They address the abstract logic by which we photograph events, record time,
and know our histories through references to such instances without looking at
the paradoxes of temporalities and event structures.

Though quite different, *Art of Memory* shares certain spatial and temporal
qualities with *Still*. Prolonged and repetitive, duration is nonetheless marked
by variation, somewhat more pronounced here. *Art of Memory* evokes the icono-

graphic heritage of the thirties and World War II in the form of found footage (UFA films and footage from the Spanish Civil War) laced through shapes and multiple frames that digitalized video can create within the video screen. A landscape of displacement and fantasy, the wilds of the Southwest, are not so much background, but overlay, interposed in a tension with these haunting images from the past. Imaging the past, memory and history, was the subject I addressed in my study of the filmic flashback, a study that investigated how narratives in film have positioned the past.[14] Certain formulas repeat across film history as means of subjectivizing history or of defining memories either through the positive uses to which they can be put or the ways their negative charge can be overcome. Most film flashbacks are clearly narratives of legitimation, construing a position from which history can be worked into the present and/or the future. *Art of Memory* intrigues me as it points to video as a support through which the logic now operative in the flashback vis-à-vis the conjunction of memory and history might be undone or at least rethought, a process begun by such modernist films as Resnais and Duras's *Hiroshima, mon amour* and Andrej Munk's *Passenger.* Vasulka's work shows the haunting of images that cannot be entirely worked through or forgotten and the ironies of our fascination with visual power. It introduces an intense subjectivity, the drifting of personal memories of historical events or their representations that lie beyond the controlled subjectivity of history that narrative film uses to frame and legitimize the past. I would argue that it also opens the possibility that a sense of history can emerge out of a different presentation of the icons of history, though it must be stated that here much is dependent on the spectator bringing to the text both points of reference and active critical engagement. The tape unfolds against our knowledge of history, but not in opposition to it; it calls to mind all our associations with these images and allows us to imagine how these images evoke another's memory, the imagistic autobiography of an emigré, an artist.

No historicism is suggested here that could substitute for our reckoning with representations as both subjective and historical. If history is not narrated, it is also not imbued with its own determinate logic nor cleansed of associational and ideological value. The evocation of history as images is, however, a suggestive exploration of how we now receive history and how that imagistic representation of the historical event has transformed our consciousness of it.

Still and *Art of Memory* together stir up our constrained meanings of temporality, subjectivity, and history. Space certainly has a strong function in both tapes beyond representation. Spatialization becomes a device through which time and order can be questioned.

Works such as these allude to a possible cultural incursion of video into our logic of our natural order. If we take the term *logic* quite seriously in the

phrase "cultural logic" we see that, in fact, cultures do produce logic systems, binding logics, grand narratives, patterns of thought that simultaneously are deemed legitimate and that serve to legitimize other patterns of thought. One of the potentials of artistic expression in our present culture is to give us access to other ways of conceptualization. Video has the potential to become a conceptual technology, one that can look at the history of the image, of sound/sense articulation in language and speech, and of narrative through a refiguration of space and a multiple mapping of time. The possibilities here should not be foreclosed by a version of postmodernist theory that can see these operations only as an imprint, disallowing any active intervention on their part in the reformulation of contemporary consciousness.

The Smell of Turpentine

JUAN DOWNEY

I do not recall whether I read or dreamt that Marcel Duchamp had said that some artists continue painting because they are addicted to the smell of turpentine. Their activity is therefore not aesthetic, but is instead a biological dependency of the chemistry of that medium.

Smell of Turpentine

Wall to wall air conditioning, the hum of decks at high speed rewinding, dim lights, corporate paradise, the electrons shot to flash against the phosphorescent screen. . . .

That is my turpentine!

The need of video emerges like the dependence on turpentine, from an urging desire of connectiveness. Like the burning electron's desire inside the vacuum tube sparking from the darkness within toward the exterior eye. And all that is in fact communicated is this desire for connectiveness: a deferred communication. A difference of potential, after all, generates the electron flow.

The will of something personal made public. A fragile signal is tenderly revealed, with the meaning of a bomb. An internal fact is unconcealed, like removing a glove with guts.

The Islander

Communication is attempted while trying to find the world-wandering flock of exiles that constitute my country.

At age twenty-two, I traveled through the cold German winter. Everything was foreign, beginning with the spoken tongue. Chance brought me into a Gothic church during a mass said in Latin. Suddenly I felt at home. I felt mother in the folds of a language I hardly understood.

At age forty-five, I already confuse what I read with what I think, and what I dream with what people tell me. So, maybe, I read or dreamt the following:

Since I arrived from the underdeveloped world, it was the constant culture shock within the electronic media environment that made me strong—just as the Islander has a more encompassing perspective since he or she is the only one who knows the continent, having arrived at its coasts from a distantly

Juan Downey, *Bachdisc*, 1988.

launched boat. Because electronic media were foreign to me, they became instantly a clear mapping, a sensuous texture: I felt mother in the folds of a text. The relative strength of my video works hinges on the fact that I had never watched TV until age twenty-one, and hardly any for the next two decades. Since I had no formal film education, it took me longer: not only had I to invent a video language but also the fields it fed from. I even reinvented the jump cut with a particular power to trigger consciousness and proceeded to reinvent disrupted narrative lines, a desire of short-circuiting signifiers for the audience to spark personal brand-new meanings.

Subjectivity

Deep inside the roots of each video work lies on obsession with culture in tandem with its sociopolitical organism. This obsession links vigorously the videomaker or the subject of enunciation with the subject matter or documented object under observation. Actually, one floods the other; or better still, they are immersed in each other's liquidity. Then, the work of art itself constitutes an attempt to decipher the obsession. But to decipher through art is a foggy occupation, and to deify obsessions is in itself obsessive.

You Do Not Decipher Anything Specific by Making Video About It

In the still-open series of video programs entitled: *Video Trans Americas* (1971), the wish to explore my ethnic cultural roots led to the decision to document a personal interaction with the diverse peoples of the American continents. On that occasion, I failed, since the intention was to decipher that continental bond subjectively. I failed again in more recent videotapes: this self-deciphering reached a dead end. For example: the numerical structures of J.S.Bach's music physically affects me, since for me they weave tightly "self-as-child" and culture. In spite of this video work concerning Bach and his music, the visceral dependence on Bach's music remains still undeciphered: a visceral dependence.

People often ask me if I have gone anywhere lately. They mean to other cultures, to other lands; my art is an on-going concern with going somewhere or about a renovated culture shock in the articulation of a dialogue. I, in fact, do not really go anywhere, trying to bridge across to that distant metaphor that will display or stand for the inner root. I stay here at home in my studio and wait until I get lost in my thought vapors. Through the smoke, I dream of a trip to Burma. . . . Again using the remote to signify an inner search.

The Others

Once upon a time we believed that video would balance world politics. Global neg-entropy: the communal relaying of survival data would recondition circumstances for planet Earth to blossom. We had expected to subvert the pyramidal corporate mind manipulation. Now, the dream collapsed and the world ever more hungry, more tortured, I question why such foreign policies on the part of the imperial industrial giants? Why pain and coercion? Why a State? Maybe a million minds making their subjectivities go public might do more!

For as long as video art remains depoliticized, it will remain sterile. For an art to exclude its political context is to place itself outside its boundaries of operation. Thus elitism: to place itself outside. What is left but the will of a song materialized in the far-reaching power of video? A stream of inner visions can be shared. Why through that specific manner of arranging electrons on a magnetic coat over a moving plastic ribbon—why through video—was my vision more readily communicated?

Toward Interactive Media

Many times during hot muggy afternoons in Washington, D.C., during the late 1960s I invited DeeDee to my studio to watch soap operas on three different TV sets grouped together showing three different soaps. Relations, opposi-

Juan Downey, *Bachdisc,* 1988.

tions, and simultaneity flashed even on the level of casted actors (sometimes
the same actor appeared on two soaps) and also in terms of content, where re-
current themes (such as abortion, bankruptcy, divorce, and suicide) would of-
ten coincide or at least overlap on two channels. But DeeDee then still pre-
ferred commercial TV and kept turning two sets off to assert that video-art
experiments would not lead me to make money. Or was it that he turned
them off spontaneously because he was subconsciously mesmerized by the mag-
netism of a single story line?

Bachdisc: An Interactive Videodisc

*When you were a child, your father brought you to piano lessons. At age seven, above
all you preferred playing Bach. Soon you discovered that the second minuet was just an
inversion of the first one; in other words, that the left hand plays in the second piece
what the right hand plays in the first. You were told that this was due to Bach's being
fully ambidextrous; but you imagined this balanced dexterity not resident in the brain
alone; but rather as an outgrowth of the brain. You could visualize the tree of red veins
pulsing on the glossy skin of the brain's hemispheres or inside the greasy pulp: the phos-
phorous flesh. You could imagine some form of calcination that bridged successfully the*

two brains in equal balance. As a child, you imagined this specially developed mind as a by-product of musical counterpoint. Thus, through baroque counterpoint you could enter another environment. The door to clarity, the exit to inner peace, the arrival.

She said, 'and God?' He vacillated, 'Maybe, I don't know.' It is somewhere, perhaps. But counterpoint is like a geometric drawing, it is like the patterns that are inverted and backwards and then erased by a river that is not there.

The impulse, sometimes of a wind instrument, insists on the cutting desolation of the bass, which, a few octaves lower, delays the theme. An otherness is manifested in some themes or voices that appear reversed or backwards.

The minor keys, particularly, reveal an offness, while the notes fall individually into related positions. The polyphony of voices or the loneliness of a soprano might bring, yes, the presence again that could be called mystic. There's an order that speaks of a consciousness without borders. Something is flooding me; someone is breathing.

Those mental promenades through numbered geometries lifted my consciousness to enlightenment, to a precise space where disorder vanishes.

What discharges those harmonies in my head? Proportions in their relationships? Or is it the selective games of a theme layered on top of itself? Or the silhouette of a theme with its mountains and valleys? Or, perhaps, the mathematical game of a theme extended in time, augmented, compressed, diminished, or inverted, upsidedown or backward. What profound wave in the brain do these relations touch? A sensation of light, white and intense. The collapsing in reverse of a phrase to precede the forward uplift of a dramatic voice. It appears as perfection, a clear organization, a higher order; a white grid. The password to a better life. What was religious in those emotions? I don't know, but if not mystic, what was the nature of the trance?

It seemed to be the code to an elevated landscape.

PBS, Chicago, *The Best of Ernie Kovacs*, 1984.

The Importance of Being Ernie:
Taking a Close Look (and Listen)

BRUCE FERGUSON

The television programs produced by Ernie Kovacs (often acted in, written by, and directed by him, too) from 1950 through 1962 on all three television network broadcasting systems in the United States, as well as Kovacs's appearances on other programs, constitute a major and singular contribution to the history of North American television as an entertainment communications medium. Kovacs's productions, usually made with a group of long-standing collaborators, and his intermittent guest appearances are even more important to any consideration to developing an aesthetics of the medium. Such a claim is not hyperbolized. There is a large body of journalistic responses through four decades, a series of TV and home video "tributes" to Kovacs and his works, a made-for-TV feature film on Kovacs's troubled personal life, a substantial number of productions and comedic sight gags that rely on his innovations, an archival collecting of the Kovacs productions and memorabilia at museums and libraries dedicated to television history, and a wealth of academic histories and critiques that affirm his seminal achievements in the medium. There is also Kovacs's own 1957 novel *Zoomar,* which centers on a protagonist in television advertising who acts as a surrogate to present, in almost manifesto fashion, many of Kovacs's principal ideas concerning the nature of TV and its limits and freedoms. Today there is a Kovacs discourse that is a shorthand way of registering the complexity of certain identifiable productions within the environment of network television at certain historical moments and some of the kinds of values and propositions that seem to be both affirmed and distressed within the larger discourse of television itself by Kovacs's productions and the responses to them. The Kovacs discourse is distinctively important as its discursiveness is registered in both elite and popular manifestations and at the often separated levels of both theory and practice. Its very heterogeneity is worth attending to for its relevance today when the power of the networks is waning and vulnerable, while other video aesthetic possibilities, earlier aborted or suppressed by professional codes, are being reconsidered in the new arrays of linkages and markets.

This text has divergent strategies for approaching the Kovacs material; in recognition of its rich complexity as a series of sign-functions, I begin, reasonably enough, then, in a spirit of disobedience or resistance to the linear narrative of chronology, a resolve that is gained from the experience of the material at hand—particularly the humor within the productions—which itself always

deliberately resists a textual unity and which would frown upon too ordinary a method of description or presentation.

Much of what is privileged as independent, irregular, or "off-beat" in relation to the predictability of television programming—Pat Paulson's appearances on the *Smothers Brothers* as a TV executive or presidential candidate; the satirical *SCTV* programs; the pre-Python program *Do Not Adjust Your Set*, written and performed by Eric Idle, Terry Jones, and Michael Palin on BBC; today's *Gary Shandling* or *David Letterman* shows, which break with the "fourth wall" of television; and what is loosely referred to as "artists' video"—all took up the challenge set by Kovacs in his sporadic and sometimes sustained productions (which isn't to say that they were all directly influenced by him). These kinds of "oppositions" or "resistances" are understood as such precisely because they differentiate themselves from *real TV* as a horizon of understanding; however, they remain equally "fascinated" by network TV's determining codes and cognitive style, just as the Kovacs productions did before them.

It is my hope that this text registers some interruptions of current meta-theory, which so negatively dominates discussions of TV, and also interrupts cultural studies based in singular versions of ideology. It also attempts to interrupt the autonomous discourse of art video by showing some relations to TV often neglected. Taking my cues from the aspects of Kovacs productions and sketches of Ernie Kovacs and his collaborators from excerpts of television shows of the 1950s and early 1960s as they appeared in graphic black and white, and mostly gray, on the three national network systems, I am attempting to sunder transparency.

The analysis is based on a much wider viewing of other Kovacs material including his spot involvement with other programs like *The Perry Como Show*, *The Festival of Magic* (in which his TV "magic" is contrasted to physical tricks) and his hosting activities on *The Tonight Show* and other talk and game shows. It does not take into account his film career (ten motion pictures) nor does it investigate his complicated relationship to the financial, administrative, and sponsorship determinants of all his productions—the institutional factors.

Beyond Perfection

The "Eugene" episode (November 24, 1961, ABC) primarily directs us to one Kovacs production technique and to a major thematic preoccupation of most of his other programs. The program announces itself with a rolling English text (like a silent movie insert, which reminds us that Kovacs himself once hosted a program called *Silents Please* devoted to rerunning early films on TV) to tell the audience that in the usual cacophony of noise that is television, this program will be *dedicated* to silence. Kovacs's sustained thirty-minute sketch *isn't* completely silent, showing how much we can trust what we read, as sound effects

are used sporadically and effectively to underscore many of the motions and gestures of the actors and of the props (e.g., an absurdly small phonograph player accompanied by a full-volume orchestra). But, even with these obvious and deliberately contradictory aural exceptions, the introductory text does announce *difference* as a consciously exercised meaning-structure, and it announces that difference in relation to the already established conventions of television.[1]

The form and content of the rolling text draw attention to the medium of television itself. It presents a notion of self-referentiality—of pointing back to itself—which is a standard project of modernism as understood in aesthetics.[2] In other words, Kovacs's text is used to announce the creation of a consciousness of the process of perception as reception or of the program's self-consciousness of production or, in short, it announces itself as critical reflection.

But the use of written text does not necessarily privilege literature as Kovacs's difference from other television. It also announces clearly that television is usually a medium of *sound*. And this is where self-referentiality is emphasized throughout this production. For all that it is advertised, sold, and theorized as a *visual* medium, network television, in particular, is primarily an *aural* medium—to the point that silence is considered a defect by both audiences and producers. Audiences, confronted with silence, will assume that the hardware isn't working properly. And TV professionals have gone to great lengths to assure the fidelity and constancy of sound tracks. The increase in volume, which is built into "short-burst" commercials is sure testatment to the professionals' understanding of the vital importance of sound, and the history of showing the boomed mike as a mistake of production is a cliché icon of this deeply embedded value.[3] This simple, but unusual, idea of televisual difference as critical reflection, acts to foreground the structural considerations of production with a knowing audience complicity (in itself a unique concept of the audience as receptive and intelligent) is the rare cornerstone of all the productions under consideration.

Television does not require the sustained gaze of films—TV is far too encumbered with environmental context to fill our perceptual field of vision, which is one of its major ontological differences from film at this time. Nevertheless, this, too, is shifting with the technological convergence occurring through large high-definition TV (HDTV) formats. TV is conventionally *full* of sounds that hyper-realize the identity of the visual (by repeating what is being seen or by using cliché musical cues to *overdetermine* the image). This, plus the traditional codes and genre formats, which are internalized by the culture to seem almost "natural," makes the visual content of TV easy to imagine by virtue of what is being heard. This is equally true of made-for-TV movies, although you may not be able to identify the color and type of car (or gun or girl) going over the cliff without a swift glance. A simple experiment for any-

one still convinced that TV is primarily a visual medium is to turn it against the wall and listen to a few programs. That many programs, like *All in the Family,* are directly simulcast on radio is further affirmation. Indeed, the earliest criticism of television as being nothing more than "radio with pictures" would still seem to have some critical currency in relation to much contemporary programming.

Thus, the beginning of "Eugene" acts like a manifesto of the Kovacs aesthetic—a concentration or privileging of *visuality* in the medium—effected paradoxically and necessarily by a careful attention to the role of *sound.* In "Eugene," TV's "little man," the persona played by Kovacs, like Charlie Chaplin's "little fellow," at one point pulls a tiny phonograph player from his sports jacket pocket. He then pulls a miniature record from another pocket and proceeds to plug the record player into an electrical outlet conveniently attached to his own trouser belt. With, then, no "real" source of power, Eugene puts the needle down on the record, and it immediately skips to the end. But, *despite this visual evidence,* we are still treated to a long excerpt from a full orchestra at full volume. This complete separation, the contradiction of the visual evidence from the sound evidence, is typical of Kovacs's humor or "crazy" or "formal" comedy in general.[4]

Kovacs invites a viewer to watch carefully as well as to listen attentively to TV by underscoring its separate modes of production, undermining the reliability of the gaze that covertly functions in the social conventions of watching films or television. When Eugene removes a book called *War and Peace* from the library shelf and begins reading it, each turn of a page brings a soundtrack effect of horses charging, bugles calling, cannons firing, and so on. He (we) hears the explictly mass-media sounds of warfare as he "reads." With *Camille,* another book he "reads," Eugene hears the sounds of soft consumptive coughing. Then, as he takes *The Old Man and the Sea* down from the shelf, Eugene is deluged by rushing water accompanied by the sounds of ocean waves until he can push the book back into its slot whereupon both the water and the sound end. And so on. The highly conscious use of the rupturing of the aural and the visual dichotomies in Kovacs's productions act to *foreground the techniques and technology of production by pointing to the interdependence of mediated signs in the creation of meanings.* Kovacs consciously exposes the *technological* "nature" of a television production, emphasizing that this construction is not essentially natural, not necessarily *real,* but, instead, that our understanding is dependent upon and constituted by technological mediation. This full disclosure of the operations of television production to and for the audience permeates the Kovacs material and suggest a thematic unity to all the works, one which raises it beyond a simple gag structure that is equally common to vaudeville performance and film.

A viewer has only to look at the introductions to other Kovacs programs to know that the same notion—a structural unmasking or releasing—is used to announce them *all*. One program begins with the camera out of focus (a technical difficulty common to early television); then, as it gradually comes into focus, it is possible to see Kovacs rubbing one of his eyes and saying that, although we thought it was our set, it was really just him adjusting *his* retina's focus. Not incidentally, Kovacs is wearing a black-and-white vertically striped shirt, a literal "vertical-hold" sign. This identification of the camera, not as a transparent window but as an *acknowledged mediator,* guarantees viewers an awareness of what it is that they are partaking of with him. In this and other program beginnings, Kovacs is often sitting in the control room in front of a technician complete with headphones and a set of monitors recording each of the camera views. It is obvious, then, how a Kovacs production answers the understanding of the imposed force of TV's technical imperative through, at least, the practice of the "live" aesthetic.

With the majority of Kovacs's productions, neither the technology of the production nor even its producers are hidden. Rather, they are celebrated, put to the foreground, exposed as intimate and discrete parts of the construction of the program. *As Kovacs used to say in an often quoted sign-off, "It's been real."* Of course, it wasn't, and that was just his point.

Percy Dovetonsils is another Kovacs persona—a poet laureate who dresses in a leopard-skin lounging jacket and is usually partially drunk. He was an obvious send-up of the conservative host of the program *Omnibus,* Alistair Cooke, by virtue of the set.[5] In one sketch, Percy introduces his cameraman Norman and talks about how Norman had mentioned Percy's weight problem before they came on the air. This serves to emphasize the cameraman's role and his individual identity, as well as the (historical) time that existed before the production we are seeing. All of these sightings, and there are many more, work against the tendency (which is really an ideology) to see the camera point of view as "natural," as a transparent window onto a scene, which is a characteristic of the then-prominent anthology dramas. They were seen from an "audience point of view" camera that relied on the theatrical tradition of the "suspension of disbelief." To be against the automatic disposition encouraged by any symbolic system of constructing meanings, whether it be language or television, understandably emphasizes the role of the spectator in creating meanings by encouraging participation in the determination of meanings' destinations and densities.

An extreme case of the showing of sound is the "Submergo" program, where, between other short bits and visual puns, a second camera concentrates on an oscilloscope of a real-time recording of "Mack the Knife" being sung in its original German, as a transitional *leitmotif* from sketch to sketch. The pro-

gram is a good example of the Kovacs productions' intuitive and prescient understanding of the segmented nature of television production, which was much later identified by John Ellis as "short-burst" aesthetics, especially in commercials. Because the separation of the sound and the visual has affinities to theories and practices associated with modernist projects, it is tempting to over-theorize Kovacs's use of the Kurt Weill material from *Three Penny Opera* as a direct reference to the loaded and debatable concept of alienation proposed by Brecht. Kovacs was certainly aware of Brecht and Weill, but he may have hit on similar techniques simply through the practice of humor—a deconstructive art in itself—which has much in common with the techniques and aims of Brechtian theory. Sound and image are forced to *betray* each other in a double-cross that results from cross-referencing.

One of the most sustained and pervasive versions of this technique is offered in a six-minute piece that is a continuous shot from a camera mounted on a boom and dolly. Using a repertoire of cliché gestures from American popular art stereotypes, the camera zooms and pans, dollies in and back from the propped street scene and painted city backdrop, with its theatrical lights producing a simulation of dawn and other times of day. The camera finds a cat, a newsboy, a black-leather-jacketed "hood" with a switchblade, a street grocer, a cop on the beat, a lady of the night complete with an evidently madeup "beauty spot," and a blond woman in a slip seen through an apartment window. The piece carries a multireferential set of associations. The mise-en-scène conjures up a full score of historically relevant connotations from the realms of popular entertainment to those of "serious" drama and literature: from William Inge to Samuel Beckett, from *Dragnet* to *Naked City,* from *West Side Story* to *Seven Year Itch,* from *Marty* to *Man with a Golden Arm, Dark at the Top of the Stairs, Room at the Top,* or *The Rebel.* Shot live and stylishly choreographed so that each character appears and disappears in time for the camera's attention, the entire piece is timed to music which conveys the various expressive moods that triggered the partial inventory just mentioned.

Using Bartok's music from his native Hungary, Kovacs creates a second-order system of narrative without even a perfunctory nod to dialogue. Both these works, the unsynched sound piece and the one-camera dolly-shot piece, among others, were produced over ten years before a film like Michael Snow's *Wavelength, La Région Centrale, Breakfast a.k.a. Table top Dolly,* or the much-acclaimed *Rameau's Nephew,* (now) classics of avant-garde structuralist (to use P. Adams Sitney's term) film work. And Kovacs's productions clearly evidence the very qualities that Regina Cornwell has established as being so critically important to Snow's film work.[6]

Kovacs's work serves to point to how specifically the autonomy of discourses or, in this case, the defensive lines between the "fine" and "popular"

arts are constructed and maintained. As most versions of the avant-garde are deliberately pitted against mass media as its romantic enemy, certain convergences are scrupulously avoided. By rescuing their similarities here, the protective devices necessary to preserve sterility in either discourse can be disturbed and openings for aesthetic work, which today deliberately blurs such distinctions, can be maintained. But too close a linkage may impair the pleasure of looking at the Kovacs productions, which, while similar, seem to inherently mimic the seriousness of such institutionalized avant-garde hermetic practices and the attendant seriousness of critical texts (like this one). And they are all the sweeter for knowing that they mimic them *before* they were produced.[7]

Privileging the visual took another form that is less dependent on sound as an independent factor and that simply revolves around conventional visual expectations ("perceptualism"), which are confronted with unexpected reversals. Or it might be said that the appropriate encoding of a message is subsequently inappropriately decoded—the essence of humor à la Jerry Lewis, surrealism à la André Breton, and deconstructionism à la Jacques Derrida. For instance, a typical seascape painting on a wall is shown leaking from the illusory ocean down the wall and onto the floor. Or, in one of the many "defying gravity" sketches, Kovacs, as a lumberjack, administers the final axe stroke to a tree. As he looks up to watch the tree fall, the stump underneath falls away leaving the tree suspended in the air, with its top out of the frame. In his most famous "trick," performed in many variations, the Kovacs crew built complete studio sets at a radical angle. Reconstructed via a prism on the camera to appear to obey usual vertical and horizontal axis alignment, performers could appear to defy gravity as liquid would pour out at angles and everything put on a flat table would roll off the "horizontal" surface at tremendous speed. As the camera appeared to be recording a naturalistic set, these defiances have all the illusion of stage magic but are simply a camera/set disjunction, which Kovacs "rights" at the end, for the benefit of any baffled viewers.

The Kovacs productions present the technology and its complementary techniques revealed and adapted as new creative strategies for the production of signs and, significantly, the production of a critical audience. In using a comedic convention that is antic and prop-oriented, Kovacs might seem at first consideration to be merely returning vaudeville to television as the earlier shift from vaudeville to radio had had serious consequences for comedians. In a discussion of the limits of radio for comedians, one early practitioner said:

{H}e can't depend on any stage properties to bring out an absurd point. . . . The hardest thing for the comedian to bear in mind when talking over the radio . . . is that the audience is looking at him through ears and the he must appeal to them through their mental eyes.[8]

But, *vaudeo,* as some TV comedians and journalists called it, returned this visual information system directly to the performer in the arrival on TV, producing both a new generation of comedians and significant adaptations from those who had been radio stars—some of whose visual style had already been handicapped on radio. A list of these stars would include Milton Berle, Ed Wynn, Dave Garroway, Red Buttons, George Gobel, Red Skelton, and Ernie Kovacs. But a careful look at Kovacs's gravity trick or the "miniature" girl on his shoulder during one of his introductions or the slow-motion bullet that "drills" a cowboy and creates a "hole" in his body through which an audience can see the victorious protagonist's celebration, shows what is at stake with Kovacs, what is available to audiences beyond a vaudeo type comedy, and what distinguishes his productions from theirs.

Michael Nash has inventoried some of these televisual techniques, such as "keying, matting, miniaturization, split screens, double exposures, negative images"—techniques that were being discussed in terms of magic by the journalists at the time of production.[9] These techniques, being both the possibilities and the limitations of the electronic medium of editing, low-light-level cameras, three- and four-camera studios, live performance, and so on, break with the ontology of film and its dependent postproduction constructions to develop a visuality hardly explored by network television of the day and later mostly regenerated by video artists productively concerned with developing a "language" (although occasionally and significantly also explored in film, i.e., the director/acting expertise of Jerry Lewis or Buster Keaton). Kovacs as Eugene makes a door by affixing a tape to an invisible (to us) sheet of plate glass and then subsequently opens a prepared set's door from another camera; or slits a wall and appears to disappear, predating the kind of consciously experimental, structural poetics of an early pioneer video artist: Peter Campus in *Three Transitions,* for example. And, as Nash, among others, has pointed out, this is a relation particularly important to the notion of producing a critical audience:

> . . . *often encouraging interactive anticipation. His "snap shot" campaign invited viewers to take stills of the program, which were sent Kovacs and then displayed on the show, closing the feedback loop. Another "quasi-ontological routine," as J. Hoberman described them, anticipated Douglas Davis' one-to-one "hands against the glass" appeals for direct contact with viewer: Kovacs placed a pane of glass between himself and the camera so that he would appear to splatter the viewer's TV screen with eggs.*[10]

And we could add to the list of predates, the "interactive" video installations of Nauman or Acconci (as well as the candid simplicity of their videotapes) or even, later, Jerry Falwell's brilliant adaptation of the "hands against the screen" technique for religious *media* redemption (itself a precursor of the Howard Beale prophet in Paddy Chayefsky's *Network*) as similar intensities in

the creation of new audiences and breaks with both formalist art's and network television's hegemonies of understanding.

Kovacs's production of *Swan Lake* danced by gorilla-outfitted ballerinas, his doctor's operation on a turkey perfectly camera-edited to the opening rhythms of Stravinsky's *Firebird Suite,* and his wind-up mechanical monkey toys, which beat the percussion in time to the grand finale of the *1812 Overture* (and provide an iconic doubling of his own *Nairobi Trio*), all acts as satire—of *Ben Casey* or *Doctor Kildare* or of *Omnibus*—and often achieve a cartoonlike distortion. The cartoon quality is especially evident in a work entitled "Jealousy" in which an entire office is thoroughly animated by the visual and technical possibilities of television crews to the music of *Sentimental Journey* or in another episode in which whirling wheels and bows and arrows are animated by a quick, rhythmic, musical underscoring. Like Disney's *Fantasia,* but with an incredible economy of narrative means, these productions draw attention to a virtual enumeration of the medium's meaning production capabilities.

His "opera," staged by an Italian cable station's amateur team—their first broadcast—has no matching costumes and has a chorus that resembles a *herd* of operatic and television types, including a basketball player. It is played out within a tradition of comedy genre that is willfully destructive of commodities and purposefully anarchical toward cultural traditions (ideologies). But, even here, the Kovacs ensemble draws on the understanding of *television* to develop the reckless humor of the piece. The lead singer, Edie Adams, and the camera play hide-and-seek with a fountain, with her trying to position herself in the camera's gaze and the camera cumbersomely being out of synch with her movements. The cameraman moves in front of the camera's vision (twice), and the swinging microphone on a boom is more dangerous to anyone than any evil character might be. The early camera and, by extension, the camera operator become obvious and individual characters within this generally undignified movement. Another production shows a cowboy's bullet moving from within the field of the narrative fiction to outside of it, breaking the glass in the cameraman's lens (and our physical field of vision), further destroying yet another convention of transparency (ouch!)—that of the presumed relation between fiction and fact.

Beyond Genre

Another reason for identifying these productions so singularly, in tandem with the structural disclosures they perform, is that Kovacs took on television; that is, he interrogated its content, its genres, its mundanity, and its reductive entertainment narratives. On one program, Kovacs, in the technical control booth, explains conspiratorially to an audience the secret of the television industry's polemic of success. He says that if a program has shown itself to be

PBS, Chicago, *The Best of Ernie Kovacs*, 1984.

successful the industry will respond with the production motto "Beat it to death," pointing to TV's endless formulaic repeatability. Referring to the three American networks' competitive procedures and the redundancy of formats (genres), he proceeds to offer an alternative to us—excerpts from next year's Westerns.

First and most important, he gives a *history* of the Western form to date by showing a series of fictional excerpts. His theory is that a TV director's only way of combating the industry's admonition to redundancy is innovative style. The director must develop camera points of view that are progressively less boring (Kovacs's illustration of this hypothetical development is a synopsis of the Western from Griffiths to Ford to [somehow predictively] Leone). Kovacs narrates a series of different camera placements that are more and more inventive, all using the obvious vignette of the *High Noon* gun duel. He shows the reactions of the fictional Western's street audience including, eventually, a horse's reaction, to each camera shot; then he takes us, via the camera, through a hole in the hero's hat coincidentally brought to us by a hat manu-facturer, to a miniature cowboy, to a colossal cowboy who destroys a whole

PBS, Chicago, *The Best of Ernie Kovacs*, 1984.

town with his boots, to the props surrounding the battle, and so on. After
each of these worlds is explored, the camera returns in live time to a deadpan
Kovacs who explains the camera choice and the genre's reference to itself or to
its newly explored extensions in 'adult' Westerns. He carefully introduces the
foreign Long Ranger called *Das Einsam Aufseher* who has silver "kugels" and is
addressed by his sidekick with *"Gutentag, Kemo Sabey,"* followed by the *Twi-
light Zone* Western as though written by Rod Serling (with flowers coming out
of a gun and landscape enveloped in smoke clouds like today's music videos);
followed by his psychiatric cowboy version in which *what* the villain does isn't
as important as *why he does it.* They all refer to the conventionalized meanings
of commercial television through a sustained reflection of the Western genre as
history. When Kovacs walks from the back of the studio over the sound stage
littered with male bodies, to introduce another program, he says, "Sometimes
they don't clean up after *The Untouchables* so good," cross-referencing his pro-
gram to another program that is known to the viewer and that is on another
channel at the same time. The announcer at the beginning of another Kovacs
production mentions that the girl you saw on Ernie's shoulder last week wasn't

there and that it must have been your TV set. These internal textual references set up a history of production within the production of another production, cross-referencing the interconnectedness of this program with its antecedents. Such self-consciousness underlines its and their existence in the history of productions, creating an internal historical sense that is paramount to any understanding necessary for critical relations.

But, the Kovacs productions do not stop there. Not only do they offer alternatives by example, but one segment is a deliberately constructed intervention into the primary discourse that has surrounded the subject of TV since its beginnings and that continues to provide fodder for endlessly repetitious and inconclusive research—the twin axes of sex and violence. Again, setting up from the technical booth and acting as narrator to the segments, Kovacs says that he thinks that the criticism of "too much sex and violence on television is wrong." He proposes the opposite: that there isn't enough and that if there were more, it wouldn't be such a contentious issue. A series of bits then shows an Archie-like kid reading *Little Women* with a "sexy" cover and *Peter Rabbit* as a pimp similarly illustrated, and a woman reading an "unexpurgated" version of the dictionary. Or the weathergirl *Cloudy Faire,* lying on a divan, is shot from high above by a gradually descending single-boom shot right to her mouth while she gives the weather conditions using a kind of come-on beatnik speech: "Like there's this *low* pressure area and there's this *high* pressure area." And violence is represented in an exaggerated cop killing by a ruthless mobster who then advertises Fluffy Slicebread.

The further linking of violence to the commercials is a subtle one, but it is a sporadic thematic of the Kovacs productions' send-ups. In another program, a new product called Jiffo, used and introduced to us by a typically stereotypical fifties housewife, is in reality a gun used to kill Junior so that he won't dirty the floors. Similarly, a shot-through cowboy, who had been smoking one of the sponsor's cigars, "smokes" through his many holes like an Al Capp's Fearless Fosdick cartoon character, Capp's satire of the Dick Tracy cartoon character.

Even the "straight" commercials are not spared this internal interrogation of clichés and are equally interventionist and integral to the larger aesthetic. In one, Kovacs plays John Smith with a cigar, whose head is about to be decapitated by a "noble savage." We wait patiently with Ernie through "accelerated time" as Pocohontas tries to light the cigar in his mouth—presumably his last wish. Finally she succeeds and the threatening male villain Indian likes the smell, steals the cigar, and walks away. Smith and Pocohontas are united in an embrace looking at the "moon," which is then revealed to be a theater spotlight that pans down and shows us his hidden reservoir of cigars.[11]

It would be possible simply to list the techniques utilized in a further series of descriptions as indicative of the dialectical structures that reflect on the

nature of production and content of television as seen in these reconstructed versions. Favorites like the Nash Rambler going through the floor (which cost Kovacs over half of his week's budget for this 15-second gag), Percy Dovetonsil's poem on dieting, which includes the memorable line "Hawaii's a nice place to vacation but Alaska's meant to be baked"; or the Nairobi Trio's solfege theme to calypso music, all of which form a whole set of potential critical reflections on the cultural domain of the United States of America during the 1950s and early 1960s.

Or one could theorize more blatantly Kovacs's productions in terms of semiotic deconstructions—both cognitive and affective responses by identification of discursive symbols in relation to those of a poetic, phatic, and emotive nature. However, a thorough investigation of the works at the level of signs would soon discover that they are also as deeply embedded in the negative aspects of their culture as any other productions of the time. If the disclosing features discussed above and related to modernist ideology are "radical," then the sign level also contains and reveals "conservative" elements. Sexism, racism, ethnicism, and other characteristics of cold war United States are all enforced by character stereotypes, for instance. Women are often scantily dressed for no other reason than male voyeurism or they are denigrated outright as in the musically animated "eating" sketch where the only woman present is dressed in baby clothes and shown repeatedly and rhythmically sucking on a baby bottle. The character dressed in a Chinese Hollywood "Fu Man Chu" outfit complete with Mandarin pigtail sits at a separate table, while Native Americans are always shown as the noble savage clichés of Hollywood film's iconic representations of empire building. Children are always stupid pests, and so on.

There is a way in which these conservative elements, which strongly mitigate against a fully "progressive" interpretation, are simply endemic to the traditions of comedy itself. As Stuart Hood pointed out:

Comedy—whether in the form of a verbal joke or in the form of a situation comedy—is of great importance. To criticize the use made of it is not to deny its place in human communication or to overlook the fact that comedy is probably always unfair.[12]

Or in the words of Henri Bergson, a much earlier theorist of comedy, we are reminded that comedy is always involved in an indiscriminate morality.

Laughter punishes certain failings somewhat as a disease punishes certain forms of excess, striking down some who are innocent and sparing some who are guilty, aiming at a general result and incapable of dealing separately with each individual case.[13]

The very injustice of comedy does not, however, cover over the specific kinds of injustices that it performs. Another factor for consideration would be audience. I have tried to show here how at least one audience can be constructed

by the historical responses to Kovacs in both practices and theories. Further investigation would have to try to account for the elusive intentionality in concert with readings that I have alluded to here as empathetic to audiences. Kovacs's own consideration of audiences seems to have strayed from the dominant preoccupations with audiences of industry procedures (where they are thought of as demographics only) and theoreticians (where they are thought of as dupes of determination) alike. At the time of the so-called crisis in comedy on TV, Kovacs was quoted as saying:

Say that you have four neighbors on this floor. Three of them come over to talk at the same time on Friday night after dinner. The fourth guy happens to be a great wit and comes in the door with his pants rolled up and a lamp shade on his head. With the others you don't have to get involved. You sit here and talk or play cards. But with the man who thinks he is funny you have to laugh. And the fact is that sometimes you just don't feel like laughing.[14]

There is, however, justification for a consideration of Kovacs's work at the levels of representation of the surface in that his works seem to be consensually regarded as representational anomalies to many registers within television practices and criticism. And this difference is noted from within *both* the video art and the network television discourses at the levels *both* of engaging production practices (to produce nonstandardized commodities) and of theoretical options. The oxymoronic term *radical conservatism* is meant to suggest a tension or polyvalence that could be called a Kovacs aesthetic, or discursive practice, which was noticed at the time of production and which has been continually reinterpreted as radical or transgressive of conventional ideas of the codes of network TV. As early as 1957, *Life* magazine was describing him as an "inventive, uneven but frequently inspired entertainer" and pointed to his unusual "use of tools of television." As late as 1985, in *High Performance*, his work is described as "visionary performances" and "subversive satire," and it is added that "Kovacs delighted in toying with the medium's technology of illusion."[15] In other words, then and now, almost three decades apart, both to writers in a broadly based mass-circulation magazine and those of a marginal subcultural group, Kovacs's productions seemed and continue to seem exemplary and anomalous to the assumptions of insufficient standard fare that have permeated most intellectual responses associated with television codes.

Yet, despite this homologous acceptance of attributes of disjunction, *this unfamiliar conformity toward defamiliarization*, which is uniformly cited, the Kovacs works were produced *within* an industry that is widely considered to be conservative, at best, and that is always deeply implicated in "unprogressive" values in the cultural domain (the litany of racism, sexism, ethnicism, national protectionist chauvinism, etc., are today not significantly different from what they were in the 1950s). At worst, this industry is held to be hegemonic, par-

ticularly by academics in the spirals of critical theory and especially today by individual video producers or independents who emerged in the late 1960s as part of an avant-garde art practice or community services industry. The industrial production of TV with its gatekeeping and agenda-setting functions of maintaining social hierarchy is even more particularly considered to have *become* eminently conservative, or even reified, by the joint interests of regulatory bodies and the network/advertising industries in the United States at the end of the 1950s. And this reification is seen to be put into place at *precisely* the time that most of Kovacs's works under consideration here were produced.

The term *radical conservative* is meant to invoke this forceful tension between Kovacs's productions of meanings; between the signifying systems understood as subversive and the networks' processes of production and distribution in general, which have been seen as a conservative aesthetic discourse of American imperialism by even its most optimist and allied commentators. The right wing and the left wing have often agreed as to what TV does; they just have disagreed as to who has the right to do it.

My interest in this friction stems from a professional and personal interest in the emergent practices of television production, variously called video art, alternative television, television by artists, or independent television. These terms are often conflated into the single term *video,* currently enjoying inflated currency because of the salesmanship associated with, ironically, home markets for videocassettes of *films* and the recent popularity (in home and broadcast markets) of rock music video clips as a tertiary level of consumption of musical signs. It would appear from the writings and practices of many people in the art/video discourse (but not all, for it is an elitist social group) that Kovacs's works and a consequent understanding or misunderstanding of his legacy of "independence" act as a kind of talisman or privileged moment within the history of North American TV. This moment is often taken as an affirmative, positive, or even emancipatory event suggesting the real possibility of a nonautonomous discourse for other video practices (i.e., nonmuseum). The body of Kovacs's work is the single most visible *historical* precedent for independent television work within the broadcast structure—an earlier moment of hope or breakthrough or cross-over—a transgression of the art/entertainment dichotomy—a counter-TV which precedes postmodern concerns for the construction of a larger audience.

Because Kovacs occupies this seemingly privileged position for practitioners, theoreticians, historians, and journalists of video, it it tempting simply to perpetuate an *auteur* status for him, but two cautions should be remembered. The first is that such video producers as Zbigniew Rybczynski, whose Polish cultural experience could not have included Kovacs references until very recently, if at all, also points to sources as diverse as Nicolai Gogol, Charlie Chaplin, Walt Disney, and Stanislaw Ignacy Witkiewicz, the Polish painter,

writer, and dramatist of the Absurd. Kovacs is only one of a myriad of cross-cultural influences whose list could easily be expanded in reference to any of these artists. It also, not incidentally, shows these video practitioners' disregard for the ontological differentiations—like Kovacs's productions, for example—of film from TV from literature, differentiations that are passionately protected in only academic discourse.

Second, such *auteurship* privileges the one person within a collaborative effort to the exclusion or reduction of other persons, as well as considerations such as administrative, advertising, labor, or technical determinants, among others. But, in avoiding a pure *auteur* theory, while nevertheless, admittedly, contributing to its mythology simultaneously by using Kovacs's name to cover an extensive and complex set of productions, I do not wish to undermine or underestimate Kovacs's own contributions in his various roles as performer, writer, producer, director, and executive producer, often occupying many of these positions simultaneously within one production. There is a methodological and theoretical tension here, then, not unlike the tension in the aesthetics discussed.

Besides playing a seminal role for some contemporary artistic video production, the productions of Kovacs also occupy a clear and central place within the larger surveys of early television. An example is the academic and museological interest that Robert Rosen, television archivist at the University of California, Los Angeles, pays to the productions. Another and perhaps more surprising example is the PBS production *The Best of Ernie Kovacs,* which forms one material base for this inquiry; this production is an indication of his unusually high position and acceptance in the industry. This PBS program is singular in its recontextualizing of his productions as a mini-history of television within the broadcast format, within, that is, an industry notorious for effacing history and traditions. From such diverse points as the academy, the museum, the art world, and the industry of commercial TV and film, there is this consensus about the placing of the Kovacs material.

A further reflection on this singular status is the relation that Kovacs's productions have to a trend to either sentimentalize or historicize the period of American television usually referred to as the "Golden Age." This period is one in which certain values, usually literary-theatrical and liberal-reformist in kind, are often inscribed with a collective regret, a loss, and a despair. These values are separated out to stand in contradistinction to the later values perceived to be overwhelming on the three major networks since the early 1960s, the period that begins network bashing of the "wasteland" variety.

Although Kovacs continued to produce, making the transition to Los Angeles beyond the Golden Age parameters, it is still fair to assume that Kovacs's work is associated with this period and thus with some of the nostalgia toward it, although close inspection and viewing has revealed distinct differ-

ences from the predominant notions of the the narrower and strictly genre-oriented classifications of it as live and oriented toward drama.

To give a slightly more skewed, or theoretical-formal, history to this universally regretted Golden Age, it is also possible to point to an idea put forward by communications theorist Marshall McLuhan. The early period up to 1957 seems to fulfill one of his insightful identifications empirically. This period is represented by television writers, writers on television, as well as journalists of the day; that is, it is represented by *writers* who culturally privileged genres of theatrical-literary performance or ("vaudeo") comedy—in other words, they privileged the *previous* art forms televised. In retrospect, we can see that they constantly rehearse the stages of a medical chronology that McLuhan applied to the conditions of acceptance when a new communications technology is introduced.[16] McLuhan was pointing to the misunderstanding and to the cultural lag that occurs through resistance when a new communications mode is insinuated into a society, and his analysis provides a structural fit for the associations of the literary "shock" toward the new medium. This is particularly true regarding a period that ended, by all descriptions, in exhaustion, fear of diminishing audiences, fear of saturated markets, and fears of audience mistrust of "live" programming prompted largely by the quiz-show scandals. But the Kovacs team survived all of this, in part because they did understand the fundamental changes wrought by the medium.

Looking (and listening) closely to the Kovacs productions, with their solid reputation for problemizing notions of passive reception, might lend some modest insights without necessarily generating a new totalizing theory or a generalized formula for methodology. Kovacs's critical and popular status over three decades, and his particular "mutant" adaptation of radical conservatism, might lend entry into a practice for *this* time of transition. Today is another period when a shift in communications is taking place—from the imminent death of TV as the privileged form and the birth of digital information processing systems with "virtual images" and hidden relations of power. The Kovacs productions represent a moment of multivalent and dialectical practices that predated and continue to outdate many assumptions concerning the limits of aesthetic inquiry into the communications and art discourse surrounding the television medium. They are a legitimate legacy that video artists have already taken as important to interventionist production.

He Saw Her Burning

Fragments of a video performance, 1982
Video, writing and live performance by Joan Jonas
 (woman A)
Additional writing: Shawn Laughton
Assistant, and super 8 film: Cynthia Beatt
Performers on videotape: Y Sa Lo (woman B)
 Shawn Laughton (man)
Produced by the Deutscher Akademischer Austausch-
dienst (DAAD)

Joan Joans, *Organic Honey's Visual Telepathy*, 1972.

As a student I studied art history and sculpture. In 1968 I made my first performance piece. In performance I was able to work with time in many layers, combining different elements—sound, gesture, object. My concerns were mainly visual, involving issues of space and how to alter it for the viewer. I was inspired by various rituals and ways of dealing with iconography—for example, the Minoans, early Rennaissance painting, magic shows, early French films, the circus, dances of the Hopi that I saw in New Mexico, and the Noh theater I saw in Japan.

I developed a form based partly on filmic structure, music, and the tradition of poets drawn to Eastern literature and theater—Yeats, Artaud, and the American imagists—H.D. and William Carlos Williams.

From the beginning the mirror provided me with a metaphor for my investigations as well as a device to alter space, to fragment it, and to reflect the audience, bringing them into the space of the performance. These events were rituals for an audience that was included by this reflexion, or by their immediate involvement in the process of making a moving picture.

Later, after visiting Japan in 1970 I bought a portapak and began to make video tapes. This device enabled me to add another reflexion, and to relate to the audience through close-up on the live transmission, closed circuit video system. The monitor is an ongoing mirror. I also translated the method of desynchronization from the use of the sound delay in my outdoor works into video, via the vertical roll—an out-of-sync frequency.

Often tapes and performances begin at the same time, video being a simultaneous detail. However, the tapes have always finally developed as autonomous works. I continue to investigate the potential language of film, video and movement.

While in Berlin on a DAAD fellowship, I read two disturbing news stories that represented my sense of the city and inspired *He Saw Her Burning*.

The performance space occupies one end of a large room, taking up one wall. A "living room" is on the left with a big chair surrounded by objects wrapped in newspaper. Next to that is a large TV monitor on a pedestal. The piece begins on the left and moves across to the right—a weaving of video, film, sound, dance, and text. On the right is a second monitor and a large rectangular transparent window of plastic framed in wood, catching the light. In front, set on wheels are movable fragments of an old car door and a fender. Various props are carefully arranged to be reassembled during the performance.

Until the last section of the performance the two monitors generate the same image.

Live Action	Dialogue	Video, Film, Sound

Woman A, facing the camera, addresses the audience and reports the news. {*She sits on the living room chair.*}

Close-up of Woman A's face: "An American soldier stole a 60-ton tank and drove it down the main street throwing traffic and pedestrians into a state of panic. There was no explanation for his behavior.

A woman walking down the street burst into flames for no apparent reason. There was no evidence of any accelerant at the scene."

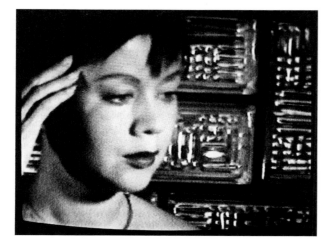

Joan Jonas, *Mirage.* 1978.

'News' room turns into living room with Woman A surrounded by objects wrapped in newspaper. She begins to unwrap them, sometimes reading the headlines. She moves in relation to the actress on the monitor; going in and out of sync with image and rhythm—

A melodic phrase by the Residents is repeated throughout this sequence—adding to the mood of nostalgia—live and taped action is slow in tempo.

Woman A unwraps a blue globe, holds it, spins it, cradles it, studies the

Woman B stands in front of a glass brick wall {*translucent in the day light*}

Live Action	Dialogue	Video, Film, Sound

continents, and places it
on the monitor.

Woman A unwraps a
large crystal goblet and
finds a parrot feather. She
examines them both, turn-
ing them in the light.

Woman A holds a red
veil over her face and looks
through it at the audience.
She drapes it over the
chair. . . .

Woman A unwraps and
holds a large red lacquered
Chinese fan; she fans the
audience, hiding and re-
vealing her face. . . .

Woman A unwraps a
large yellow vase. She
holds it on her hip as if
she were pouring water.
Then she unwraps and
empties the ashes from a
small tin box into the yel-
low vase. She places the
vase on the monitor.

With a sheet of newspa-
per, Woman A makes a
fire in the tin box and
warms her hands.

Woman A has a dia-
ogue with the Man on the
nonitor.

in a red strapless chiffon
dress. She seems to be
waiting. She looks ner-
vously from side to side,
biting her hand—in a
close shot the camera
moves slowly over her face,
hands, torso.

Woman B takes a parrot
feather from the same gob-
let and touches it to her
face, remembering some-
thing. [Close-up]

Woman B dances slowly
in place, holding the folds
of the chiffon skirt—she
sways from side to side.

Woman B continues to
dance; a light is turned on
and off; she appears and
disappears.

Close-up of same vase
on a yellow table. Woman
B fiddles with her skirt,
visible at edge of frame.

Cut to close-up of
Woman B's face—she
looks anxiously from side
to side from behind the
vertical white venetian
blinds that sweep back and
forth across the screen,
opening and closing.

Close-up of Man's face
as he speaks to Woman A.

Live Action	Dialogue	Video, Film, Sound

Woman A: What does this remind you of?
{She holds a transparent screen mask in front of her face.}

Man: What do you see?

Woman A: *{She rubs a toy car against her shoulder making a harsh sound.}*

Man: Yes, that's the car.

Woman A: What does this remind you of?

Man: Yes, I saw her burning.

Woman A: And this?
{She holds a plastic toy tank.}

Man: Do you remember her?

Woman A: *{She offers him the yellow vase.}*

Man: And the house?

Woman A: The one beyond the border? *{She spins the blue globe.}*

Man: If I thought about the consequences, I wouldn't be in the business.

Woman A: There's an old saying—Morning tasks are of-

Joan Jonas, *He Saw Her Burning*. Genazzano, Italy, 1983.

Live Action	Dialogue	Video, Film, Sound

ten mixed. I have washed, but you have killed.

Man: A giant woman walks across the lava field, "Beware, beware," she says. But no one pays attention.

Woman A picks up a pair of golf clubs, "Weapons?" she asks the man on the monitor moving across the stage to where the projected light of a 16mm film projector creates a flickering effect with syncopated shadows, she swings the clubs madly like batons in time to the music—banging the floor—a war dance—holding the clubs over her eyes she looks buglike. . . .

Music by Peter Gordon. Close-ups of golf club dance—woman looks like bug, like a soldier, etc.

Joan Jonas, *He Saw Her Burning*, 1983.

Armed Forces Radio Spot: An American voice describes the pill box maneuvers of Jack Teagarten, a World War II hero. Followed by Lily Krauss playing Schubert piano sonata. . . .
Close-up of old car on monitor.

Woman A turns to the monitor and asks, "What's your side of the story?"

The man on the monitor tells his story, looking at the camera in documentary style:

"Well I was just waiting in my car to meet her. We were going to have a round of golf up at the course over there at the base, and I saw her about a block or a block and a half away just crossing the street. I heard a noise behind me. I looked around and it was only a second or two, and when I looked back it was as though flames—I suddenly saw flames coming out of her body and she was

on fire. It was freaky. All those flames. She walked a bit and stumbled and then she fell. I don't know. I never saw anything happen. I only looked away a second or two. I never saw anybody near her or anything. She wouldn't be carrying anything that would be flammable. We were just going to have a game of golf. She was going to do a bit of shopping. It was so weird. It happened all of a sudden—flames coming out of her body. She fell and people started gathering around. I got out of the car and started running. We got an ambulance, but I could hardly recognize her."

Woman A, during the Man's monologues, seems to burn in the car wreck, using red and yellow cloth as flames, she slowly sinks.

Super 8 film with music by Penguin Cafe:

A black-and-white film with romantic overtones begins with footage of old factory buildings in East Berlin shot from a moving car. Cut to Man and Woman B walking arm and arm through the winter woods by a lake. Three times they come upon a sign that says, "The Border Lies in the Middle of the Lake." They look at a house on the other side. He asks. "Do you . . . remember?" She answers, "Yes." He hands her a small parrot feather. She touches it to her face.

The film switches to color. They find a toy tank and a car in the autumn leaves. They climb into a small red car and drive away.

During the film, Woman A moves a 12-inch wide strip of white paper that hangs from the ceiling through the projection, catching the images, moving them, dividing the screen.

Woman A turns to Woman B on monitor and asks, "What's your side of the story?"

Close-up of Woman B telling her story:

"He stole a 60-ton tank. I saw him. He was trained to fight, and was stationed four miles from the center of

Live Action	Dialogue	Video, Film, Sound

Mannheim. He told me he could drive a tank. He broke the lock on Saturday just before 2 P.M. I saw him from the golf course overlooking the base where we were supposed to meet, but he never came. I waited, and then I saw the tank crash through the gate and drive at 60 kph toward the center of the city. I saw a sergeant jump on the tank, but he was thrown to the ground. He ran amok, the soldier I mean. He went berserk. He drove straight into a streetcar full of people, flattened eight cars, and light poles, broke numerous plates, cups, and glasses—he careened down the main street. I watched the people flee in panic. They ran for their lives before the rolling tank. He reached the bridge, stopped, turned the gun turret around and around, put the tank into reverse, and tipped off the bridge into the river. He probably lost control. He was a good driver. What was going on in his head I will never know. He fell into the water. The tank fell into the water. How through a miracle were not more people drawn into the suffering."

Woman A puts on an old transparent theater mask with lightly painted features of a mustached man through which her face can be seen making a double image, off-register. She dresses in a fire coat made of painted canvas.

Addressing the audience, she says: "He watched her burn and stole a tank. She saw him steal a tank and burst into flames. Which happened first?"

Joan Jonas, *He Saw Her Burning*, Ganazzano, Italy, 1983.

Live Action	Dialogue	Video, Film, Sound

A Seven-Minute Double Channel Tape

Each of the two monitors plays a different tape that interacts. The Man and Woman B have a conversation in words and pictures. The stories and images from the performance are fragmented and rearranged, reminding the audience of what they have just witnessed. New scenes occur involving a model tank, a model car, and a golf sequence—effects of spatial ambiguities psychological and real. Woman B holds up objects: the yellow vase, the mask, a toy car, a globe, a tank, asking each time, "What does this remind you of?" In each case, an answer is implied. The red fan fans the flames of the fire dance in the red dress as the man tells his story; the tank reminds the man of his business, and so on. Drawings of images traced off the monitors on transparent paper remind us of how the photos were used. A Scottish song is played on an electric keyboard. Gabor and Vera Body sing a Hungarian folk song.

Holding a red fan and a big silver tassle, Woman A dances for the camera, smiling.

Big Band Reggae music, Pavlov Black "Mr. Music," flashes of red and silver—close-up of a smile.

Audience Culture and the Video Screen

NORMAN M. KLEIN

Let us imagine Alexis de Tocqueville arriving from France today, instead of in 1830. He spends many evenings visiting American families as they sit in front of their screens during prime time. Then, at his motel afterward, he keeps a journal. His nineteenth-century elliptical handwriting is little changed by ballpoint. And the literary tone is the same: arch, ironic, like a lapsed *philosophe*. He writes:

In America, all political and cultural matters seem to be arbitrated on the lit surface of a convex piece of glass. Americans sit for hours, rather like fish outside their fishbowls. They stay in partial darkness within their homes and watch faintly resolved images flickering from the glass.

Since there is relatively little continuity between one half hour and the next on these television shows, even between ten-minute intervals, one can only wonder what the larger mental process has become for the television viewer.

Various odd benefits coming from TV interest him. He explains:

After generations of television and movie watching, as well as other electronic entertainments, Americans have developed a considerable visual maturity. They seem to be able to diagram all objects, even paintings, and perhaps their own personal lives, as if these were televised moving images.

This is my eccentric way to introduce yet another article on video aesthetics, without going through the familiar rhapsody—about cable, or artists turning to broadcast, about electronic communities, and video avant-gardes. It seems that any article on video has to suggest a position in the general debate, so I will be brief. At the moment, I do not see an Elysium of new video markets opening up. Cable seems as centralized and corporatized as network. While the distribution of video is changing rather quickly—and this represents a crucial turning—what interests me most of all at the moment is the visual literacy of the television viewer. A discussion of that literacy could be a useful companion to an anthology on video art.

Visual Literacy

Gestures, images, lighting effects repeat so often on television, they apparently are received more as a rhythm than a coherent statement. Flashes of information must be highly abbreviated, so familiar to the viewer that only an outline

Bruce and Norman Yonemoto, *Green Card: An American Romance*, 1982.

or a phrase is needed. To manage this pictography, television has devised a grammar of foreshortening. Backgrounds tend to be very shallow. Action must be interrupted often. Pauses must be slipped in to allow for direct address to the audience—the expensively packaged word from the sponsor. Contradictory messages can be layered at once—through inserts, dissolves, or simply dialogue too redundant to belong to any one show. Let us call this process simply "manipulated imagery," where the interruptions guide the story, and the characters remain thin at best. Backgrounds tend to use *trompe l'oeil* or figure-ground ambiguity—and very little of the photographic naturalism so essential to film theory since Andre Bazin. It is, therefore, an alternative form of narrative, one so ominously tied to visual literacy that it can be both visually complex and seemingly mindless. What is a narrative based on manipulated imagery? That is what I will examine in this essay.

Television is hardly the first medium to emphasize manipulated imagery. Many other forms use direct address constantly, as well as *trompe l'oeil,* and plural story lines squeezed ambiguously on to a shallow background. A sample list would seem to be borrowed from Bertolt Brecht on epic theater; satyr plays, Renaissance *masque,* commedia del l'arte, vaudeville, radio, movie serials, trick films (Méliès, not Lumière), special effects films since 1977, stand-up comedy, and the quintessential medium for manipulated imagery—the animated cartoon. This seems a cacophony of gags, puns, costume gimmicks, scatological asides, upside-down allegory—farce as defamiliarization. And yet,

Bruce and Norman Yonemoto, *Green Card: An American Romance*, 1982.

these forms are capable of enormous power, a pathos in slapstick. Chaplin stops miraculously on point in the midst of a chase and casts a grin directly at the audience. It suggests manipulated space as well, where backgrounds belong purely to a rolling screen of audience memory. Consider visual literacy in the English court of 1630. We are an audience watching a "machine" for a *masque:*[1] The sky is painted on wood, with plaster angels, and even a baroque face of god, like a guiding spirit on a world map. The cherubs, who are ten-year-olds attached to the machine, are cranked high into the painted air, pulled by gears, from a design by court architect, Inigo Jones.[2] Indeed, these manipulated surfaces must play with the formulas common to daily life. They shape robots that make us uneasy in their phantasmic tangibility. They use articles abstracted from courtly spectacle or old movies, from market day or shopping windows, from artificial ruins or tourist brochures—even to a robot dressed to look like god. The ambiguity is both charming and, like a Freudian theory of the dream, filled with displaced objects.

The Topology of the Screen

To begin, let us return to the surface of the screen itself. I mean surface literally. The flat electronic lines that the viewer sees have become a topology, a graph of associations with a complex history and a peculiar style of narrative. This was not yet true in the 1950s. Television at that time was often broadcast

theater. There were dramatic anthologies, modeled on short cinematic plays; and the variety show was king. Live TV moved like late-1940s vaudeville, when presentation houses offered live comedy, dancing, and magic before a feature film. Gradually, the television screen presented its unique problems. First of all, the viewers were essentially alone in their own living rooms. Television became a metonymy for privacy at home. These were not Saturday matinees at the neighborhood movie house (no dishes to be won at the movie raffle, no popcorn camaraderie). Television was very live, quite literally, which made it intimate. Jerry Lewis interrupts the script during a *Colgate Comedy Hour* to scream that they have run out of time and weren't going to finish the show. Then he and Dean Martin laugh and hug. The tiny screen enhanced that intimacy. Television was a casual visitor after dinner. But television also ruined conventional camera composition. It could not record the tonal gradation of thirty-five millimeter stock. Its picture was grainy, often wavy—and there was essentially no depth of field. Murderous faces lurking in the shadows were often lost in broadcast snow. Thus, the television surface became opaque. Ironically enough, this became its first advantage. One had to learn to read badly cropped images—from the corners of the screen, or the label on a quivering Firestone tire. The screen became a kind of a topological plane, a map, where cues for front and back, image and text, were made legible in curious ways. Increasingly over a period of fifteen years, information had to be delivered on a screen that was divided into sections. It was divided at first at the television studios, where two or more cameras ran at once. These synchronous impulses went into a panel, where a device called the switcher essentially selected one or the other. The image broadcast to the viewer appeared on the line monitor.

The switcher came to synthesize a growing number of "special effects." The viewer's screen could be split, divided horizontally or vertically, in wipes and corner inserts. Keys, chroma-keys, and mattes broke the surface into textual ideograms. The fader bar could expand or shrink these inserts, and then break them off again at mid-screen (or along horizontal and vertical axes). With the split screen-editing used in news broadcasts, comedy variety-shows, and advertising copy inserted directly into TV commercials (among many examples), the viewer learned to perceive text and fractured images very easily. Even as telefilms increasingly came to replace live anthologies (after 1954), the various video effects increased, with more film mattes and montages for commercials and TV titles and logos. Once computers entered the video screen, however, these effects increased beyond any brief summary. The multi-sectored quality was emphasized considerably more, as for example, with the Apple Computer Inc.'s Macintosh, a "user friendly" PC computer, where the "menu" and applications are presented in vertical and horizontal sectors along the edges. Sectors become islands on a geographical surface, a mix of hieroglyphic cues on the sides, with an interactive play area in the center. With computers,

it seems that any quantifiable sum or theory can be displayed visually, in quadrants, or in blocks of color and stylized shapes. Depth of field can be abstracted into dreamy relief maps, distances can be measured like rifle targets. When space probes sent back radio signals of the rings of Saturn, computers recreated these instantly into video animation. Similarly on *Kid-vid* sword-and-samurai TV shows, lines of laser fire split the screen erratically.

Speed of response to this topology has increased, and the viewer has become more aware of the fractional differences in the height of the screen, rather than the perceptual depth. The eyes learn to see contrasts quickly, rather than the extended narrative fluidity (as on the traditional "big" screen model; of course, big screen video is also on its way). Images abstracted into formations of electronic lines become patterns, in video games, or even certain music videos, where a curious effect is reprised in sequence with the music— not the story. These patterns repeat; rather like the repetition on a player piano. Children learn these patterns by heart. In video games nine-year-olds bat away space invaders with lightning gestures.

Television can enhance the speed by which children manipulate objects. In experiments, children watched an animated television version of how to sort pieces of a wooden puzzle. When they were shown non-TV images, rather like a slide show of the same problem, they learned the puzzle more slowly. On the other hand, television viewing does inhibit the length of time a child concentrates. Short, rapid flashes of activity are easier to manage. One might say we are indeed a society of consumer impulse, not so much in how we purchase, but in how we visualize.

In the most literal sense, television topology is a diagram of cues, like the map of the globe flattened onto a single sheet and infused with fantasy and psychological information. What cues are added when a theatrical movie is viewed on a television screen? (We all know how much is lost: the theater, the density of color, the composition.) Television audiences are very alert to split-second references to old films, and old plots. They have a very complex genre memory, down to details of dress and behavior. Holmes and Bogart, merely by gestures, are as clear as statues on a cathedral, and this memory brings comfort. Layers of genre can play simultaneously, like multiscreen assortments from different films. This is very much how music videos are designed, an homage to watching movies on TV, a world of highlights, peripeties, flashes of old Technicolor. Films on TV become like mental antique stores: far less awesome than on the big screen, they become more like tracking shots of walls of old movie stills, or differences in sets; action becomes stylized. For example, in *Miami Vice,* detectives operating within drug violence on the streets, are color-coordinated, including costumes, slum wallpaper, and the palette for watery backgrounds.[3] Location shots at the beginning and end integrate Miami into the look of a commercial for tourism. We have a blend of upscale imagery

with the exotic downbeat of street violence, rather like a "gentrification" of vice.

Narrative on the Surface

One thing you can't distract the television viewer from is who is on the screen. Television is a personality medium. Viewers relate to the performers in their favorite TV shows as surrogate friends. Many hits are a sheer byproduct of a breakout performer bursting onto the small screen—a Robin Williams, Gary Coleman or Tom Selleck. A magical performer can often transcend an ordinary concept or so-so writing and create a hit. However, a show that has an unusual concept and good writing but has only adequate casting is destined for trouble. My own litmus test is that in order for a show to be a hit, there must be somebody in the show who could land on the cover of People magazine in a year. Call this the human element in hit making.[4]

Brandon Tartikoff

Another aspect of surface is the way that viewers are expected to see a television narrative. By the late 1960s, television completed a significant narrative shift that had begun by 1955, when live action anthologies like *Goodyear Playhouse* were replaced by the filmed weekly series (often produced by Desilu), as television shook loose of the influence of radio serials. Increasingly, it had become easier to sustain a show with continuing characters, rather than anthologies. In the 1950s, single sponsors often took on a single show. Advertising agencies represented these sponsors by designing that program from week to week. As television grew as an advertising medium, the omnipotence of agencies gave way. Networks, film and TV studios began to control programming considerably more. The cost of advertising increased enormously. To accommodate, air time had to be broken down into smaller and smaller units. The allusions to theater and radio vanished altogether. Even the borrowings from cinema were reduced (except for movies that appeared on TV), as the TV producers found a rhythm that synchronized with prime-time programming: fewer dissolves, more straight cuts, and after commercials, the camera went directly into the middle of a scene. The dialogue was boiled down into fractured scenes in family settings, punctuated further by car chases, interrupted by a roar from the orchestra as the commercial break was announced.

The television viewer learned to sustain interruptions and still retain a story (at least before the arrival of VHS). For generations now, TV shows have been designed in narrative fragments that are quite different from stories shaped for feature films

One can even plot graphs according to commercial breaks. Here is a chart used in a text that advised budding screenwriters how to plot a two-hour television movie (see Fig. 1). Notice the synchronic model of the TV version,

DEVELOPING THE STORY OR TREATMENT

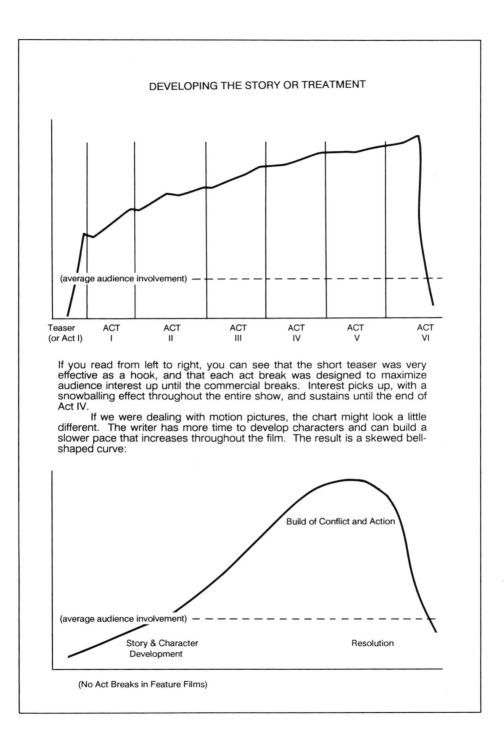

| Teaser (or Act I) | ACT I | ACT II | ACT III | ACT IV | ACT V | ACT VI |

(average audience involvement)

If you read from left to right, you can see that the short teaser was very effective as a hook, and that each act break was designed to maximize audience interest up until the commercial breaks. Interest picks up, with a snowballing effect throughout the entire show, and sustains until the end of Act IV.

If we were dealing with motion pictures, the chart might look a little different. The writer has more time to develop characters and can build a slower pace that increases throughout the film. The result is a skewed bell-shaped curve:

Build of Conflict and Action

(average audience involvement)

Story & Character Development

Resolution

(No Act Breaks in Feature Films)

compared to the mountainous Hollywood screenplay. What kind of narrative patches sustain this jagged-toothed gradual story? What does the audience remember most clearly—the procession of hooks and teasers or a conflict moving inexorably to its conclusion? Characters also live on the surface. Only certain types can survive there; but to call them flat, and simply move on, is inaccurate. They must exhibit an emotional complexity, and at the same time, a machinelike instrumentality (hop in the car, get beaten up, forgive, forget, remember, jump, punch, do two-second double takes). Clearly, not every character can manage this special balance and keep going every week, for years, even generations, if the show goes into syndication.

"Appeal" is the central ingredient for a character in a hit series. This sounds like the old glamor system we know since the publicity days at MGM, keeping Greta Garbo under wraps, and so forth. How else does a studio merchandise an actor? Clark Gable had appeal, so did Jean Arthur, James Stewart and Lassie; who on a star contract was not merchandised that way? But television is sold and seen differently. Television appeal lives on that convex surface and is not supported by a Loew's movie chain. TV characters would not fit in the anthology dramas of the 1950s. They are too imperturbable for stories on *Alfred Hitchcock Presents* or *Studio One*. They have to be too resilient to be changed by conflict. If they were not resilient enough, the concept of the show would have to change every week. That, obviously, would be a merchandising nightmare. The episodic character lives like a special weekly house guest, the kind who doesn't expect the bed made up anymore. As Todd Gitlin wrote:

Plainly, the route to syndication was in characters who became little household gods. All the more motive for suppliers to concoct characters who promised to wear well. Perhaps most of all, the networks care which actor is going to realize the character. Only as flesh and blood, as an actor, does the character exist for the audience.[5]

There is an identifiable difference between this kind of celebrity and the celebrity of Clark Gable. More particularly, film and TV "live" in different fictions. Grant Noble, a psychologist who has worked with children and their reception of television, devised separate terms to clarify the difference: *identification* and *recognition*. Here is a summary of his work (written by Patricia Greenfield):

Noble . . . suggests that children, through recognizing *television characters as similar to people they know, reduce uncertainty about the outcome of the plot and are able to predict what will happen next. Noble contrasts* recognition *of a character with* identification, *in which children, losing themselves in the (movie) screen, become the character. (Movie)* identification *does not lead to skills in predicting what will happen next, because, in Noble's words, 'Children who have* identified *with a film hero, who share the here and now of his ongoing film experiences, do not need to look forward in the plot.'*[6]

Apparently, children who "recognize" the character also learn quickly how to predict the plot; they fill it in rather easily and therefore do not find it very important. On the other hand, "identification" in a movie, where the conflict can turn unpredictably, still perpetuates a mystery for the viewer.

The Narrative and the Audience

This topological surface determines television experience in yet another way: in the transactions that occur between the audience and the character, those that occur in the living room space between the screen and the viewer, not inside the TV story. The episodic show is built around a "buddy system," where the family, the small crew of pals, or the co-workers meet each week to renew their bond. The conflict involves how the system (standing in for the viewer's relationship to the characters) survives from show to show. Relationships go on the rocks, but marriages go on forever if the marriage still has high ratings. The concept of a show is essentially about how hospitality survives at the clinic, the taxi garage, or the police station. Only guest stars "resolve" their conflicts (particularly on *Love Boat* or *Fantasy Island,* dubbed by their producer "bubble gum for the mind"). If *Oedipus Rex* were a weekly series, there would always be a Tiresias, who would be struggling to keep Oedipus from finding out the truth, and therefore from ending the show. The plots would nestle each week on how friends or strangers got close to the truth about Jocasta. Will Oedipus get wise? Is Jocasta starting to wonder? How is the mood at court? Any new studs around?

Essentially there are two dramatic models. In the continuing series model (comedy or melodrama), the characters must wind up precisely as they began, once the final minutes close in. Then after the 1.03 commercial time, and forty-seven-second network identification, there is the cute epilogue: the cast chats casually once again. Relationships are back to normal. Only micronic changes in the buddy system are allowed over an entire season. Thus, the epilogue of chatting reestablishes the concept of the show and makes conflict circular. Soap operas handle their concepts quite differently. Soaps cannot afford any epilogues. Characters must end each show without any hope of immediate resolution. In soaps, everybody chats constantly, but deviously. In talk shows, the chatting continues in an endless epilogue. Everyone remembers how they've been friends together or tries different modes of behaving casually (also on game shows, as in the sequences isolated from *Hollywood Squares* in Dara Birnbaum's *Kiss the Girls: Make Them Cry*).[7] That is the keynote—casual; it is even an acting technique, elaborate double takes, broader gestures, to keep the identity more constant. Television is much more volatile from week to week than the film industry. The casual manner becomes the story itself, very often, to allow for limited alterations in concept. Star mystique is played down. After

all, a good house guest has a better chance if he or she bowls you over with modesty.

Thus, what we interpret as this restricted surface is actually the merchandising of privacy. Talk shows are commercials for celebrities, handled in the casual style. It is the way we have abstracted our private life (celebrity is a packaging of the personality for consumption: in gestures, or in knowing how to spontaneously change the script; in comparing scripts, reading the cards wrong). It is a form of narrative where the audience is the *subject* more than the plot. Talk shows and weekly series live on the same spectrum of consumer hospitality. What becomes of character development after some twenty thousands hours of this peculiar kind of story saturation (the average, cumulative-viewing time of the eighteen-year-old American)?

This is the legacy of television (and many other consumer sources) as of 1980 the concluding year for this section of the essay, though the issues certainly remain apt in the late eighties as well. Marc Elliot wrote a perceptive coda on this epoch, entitled *American Television, The Official Art of the Unofficial.* It is primarily a chart of TV programming since the 1940s, in effect, the diagram of this friendly continuum. In his introductory essay, there is a revealing paragraph:

What is often referred to as "form" on television is actually "format"—a combination of genre (Western), length (one-hour Western), schedule (one-hour Western every Wednesday evening at nine o'clock, seven o'clock Central). A script for a half-hour situation comedy must fit a format of twenty-two minutes and thirty-five seconds, with little, if any, allowable variation.[8]

Places Where Audience Enters the Narrative

Marketing is surface as well, and form is indeed *format* on television. Story is marketed like the rack space in franchise bookstores (Mystery, Gothic Romance, Classics, Cookbooks). The formats dissolve into recognizable mythologies—mindless jingoisms, and nonsense truisms about consumer memory (or amnesia). Elliot lists a few (a few is enough):

Money doesn't exist. The sixties never existed. The fifties began in the seventies. Heroes are handsome. Anything funny happens indoors. All problems are solved in slightly less than half an hour.[9]

Detective formats or situation comedies (the two dominant forms on network TV) break down into recognizable syntagms (*syntagm* means here: gestures, articles of clothing, identifying shots that repeat weekly, like rules of habit in a story vocabulary). That is why they are so easy to appropriate in video art, but

what indeed are we isolating in a few seconds of TV? That becomes the question at last.

Characters in these formats are relatively fixed. Their gestures are highly formulaic, or rather, very repetitive. Many signify the ties with the audience at home, like winks at the movie camera before the final credits roll or behavior that is particular to the buddy system of the show (phrases, antics, redundant complaints). Like screwball comedies of the Hollywood era, or even Hitchcock films, there are pauses where "bits of business" occur—chatting, insults shared, old jokes remembered. These pauses are particularly crucial to the TV episodic series; they add more than local color, or ironic turns of plot; they are the intimate payoff, in many ways, where the audience enters the story.

The story is the day's viewing, in real time, and these pauses identify the audience, or rather, the sponsor who brings the show. They renew the bond and promise continuity, as well as foreshadow the epilogue. They emphasize the larger, umbrella buddy system—the programming.

Programming as Narrative

The TV narrative form is sprawling because it involves a full day of programming. The day's schedule is the audience-culture narrative (how many viewers watch only one show and turn off the set immediately, etc.?). Thus, these interregnums are like gestural logos, identifying the synchronic pattern of the day (from show to show). Consider the problem this creates for five-minute video tapes by artists. If the show offering a few "artistic" videos is U.S.A.'s *Night Flight*, these deconstructive breaks might read simply as a commercial parody of a genre (and many commercials do this anyway) or as another bouncy five minutes, another syncopated stop, a blur of product, a wink, or an interregnum where the characters chat without the plot.[10] There lies the hazard of "laboratory" video in a day's programming.[11] Since television narrative is "deconstructive" to begin with, what meaning does the audience receive? It is a narrative continuum, where the night of television viewing is the story itself. The space between the viewer and the screen, the random events in the viewer's living room are the site of the narrative (or transaction). All TV programming must play to this room.

Let me repeat myself in a slightly different way: TV narrative revolves around audience life in the home, the reification of the viewer's privacy, and above all, the continuum of a *full day of programming*. Much has been written on the ways that programming defamiliarizes plots on TV, how styles of editing jump from scene to scene, break to break, leaving a heterogeneous mass. Much has been written on how the fluid synchronic mode has a hypnotic effect on the viewer.[12] What does "fluid" deconstruction mean? It sounds like a con-

tradiction in terms. It refers to the various modes within the system of programming. There is a centralized, or vertical mode (the network offerings), then a horizontal mode (the local or the affiliate shows, what is left of community TV); all of these exist as signposts along the path of *real time*—not fictional time. Real time is the night's (or day's) programming, as selected by the viewer (and the selection process has grown immeasurably in the past five years). Thus a single show fills a programming slot, like notches on a sundial.

Audience Memory as a Composite Narrative

If this is true, however, why do TV and film studios struggle so mightily to hone their characters and shape their story concepts? I am not assuming that television executives are barometers for where America is going—that withered adage we can live without. And yet, if the TV audience is indeed visually very sophisticated, why is the TV product often so inert (and intentionally so)? We seem to be confronting a glacial order of electronical ritual, changing only by fractions of inches each year, layer by layer. The night one spends at the video screen is a diachronic spectacle of audience memories. It refers to old and new Hollywood films, to commercial advertising since the 1920s, to brand-name promotions since the 1880s (1891 if *Sunkist*), and to TV programming itself since the 1950s.

Thus, format is ritualized not because of the repeated characters, but because the audience remembers thousands of TV transactions, and their glacial differences, one from the other. *Magnum P.I.*[13] began as a new twist on a *Rockford Files*[14] concept (actually, as an ironic aside, Tom Selleck occasionally appeared on *The Rockford Files*, playing a very anticasual parody, a Tom Terrific who could never chat). But as Magnum, he is another Sunbelt private eye who is always in trouble with his buddy system. The gestures he repeats must be very precise (the tantrums, as well as the smiles). In the same sense, the audience knows what to expect as soon as Columbo begins digging into the pockets of his wrinkled raincoat once again.[15] For detectives, it begins with Sherlock Holmes's hat and pipe, and brusque gestures, once "something is afoot."

Body language and familiar apparel refer literally to audience memories; in short, the eras of consumerism and fashions are indexed as audience history. Bits of forties and fifties nostalgia compete in hat styles: a pork pie hat for Mike Hammer, a slouched hat for Indiana Jones. For *Blade Runner*, costumed with forties films in mind, Harrison Ford could not wear the Bogart slouched hat because he had just finished wearing one (more or less) for *Raiders of the Lost Ark*. Instead, Ford had to settle for a modified Depression haircut, to go with his hard-boiled voice-over. Each placement of gesture and clothing ties

the story to the narrative continuum of audience memories, not to the plot of the show.

Even Aristotle's *Poetics* has entered the sequence of the programming, given the tens of thousands of films and shows that have "rediscovered" Aristotelian narrative since the 1920s. In the 1930s and 1940s, even the 1950s, Aristotle's formulae crept increasingly into American films, even into comedies. Vaudeville gags were replaced steadily by "character" comedy. As Fitzgerald gathered notes for *The Last Tycoon,* the influence of the screenwriter was ever on his mind, as he scribbled "action is character." Today, the serious film student who dreams of writing for "The Industry" will study Aristotle's *Poetics* as if it were written by Irving Thalberg.[16] But to what end—surely not simply to make a good story conflict, but to make a product that is familiar and that fits into the consumer process. Ultimately, to be honest about screenwriting, how much can these burnished characters register on film, outside of the continuum of programming? Programming itself is simply an extension of marketing. Do these TV scripts serve primarily as memory stops, standing in for old consumer transactions? Do they really signify products spread over the past seventy years, and even longer?[17]

And indeed, modernist defamiliarization has a very paradoxical relationship to this narrative (by modernism, I mean essentially the Russian and German models of defamiliarization, as practiced in the 1920s, and then, through numerous transfers, applied to video in the 1970s). The language of modernism, at least part of its formal vocabulary, seems to share features, as we saw earlier, with format, syntagms, surface, and the self-reflexiveness of audiences watching themselves on TV. But a displacement in formal terms alone certainly does not make TV audiences see the familiar in a new way. On the contrary, this synchronic anti-narrative is precisely what comes out of high consumer culture, as it has been consolidated over the past thirty years or more. The subject is not the story, but the stylized transaction between consumer/audience and the television program. In the shopping mall, one begins as audience, then finally purchases. In the movie theater, one purchases first, then becomes an audience. On commercial TV, one is asked to dream as *both* consumer and audience simultaneously. Television is merely the machine, of course; and the convex screen is simply the site of exchange.

Among various script formats, two stand out as peculiarly "modernist." First, there is the Variety Show telescript, clearly the remnant of generations of vaudeville, even centuries of variety theater, and decades of variety TV (borrowed also from forties radio). Screens are referred to as "segments" and can be written as a cluster of syntagms, not as scenes; also, any knowledgeable producer, I presume, would read them comfortably. Second, there is another established format that resembles—if dropped on the wrong library table—a script for a futurist cinematic poem or for a multimedia remake of a dada *man-*

ifestation. It is called Double-Column Format and is used almost exclusively for TV commercials. In this double column, as literal as surface itself (like many terms by TV technicians), the page is split vertically. One side of the page lists the camera directions. The adjoining column, the other side, shows the dialogue, as if the two were a-synchronic.

The Double-Column Format resembles what Eisenstein meant by the contrapuntal uses of sound in cinema. Wait a minute . . . haven't I committed an error by association? Does twenties modernism really look like a TV commercial? This seems a cheap profundity at best, but it brings into relief the unique problem faced by video artists, also some tolerance, I trust. How does one de-familiarize story (as in Russian formalism) or distance the character (as in Brecht) while inside the TV continuum?

Go outside TV, someone might interject. Would that mean art institutions, festivals, dance clubs, any overhead, oversized monitor in a public place? Here modernist audiences presumably flourish, amid replays and refinements. Modernism is not dead; it has gone into syndication. But the art initiate who visits museums, galleries, video biennials or who admires contemporary architecture will not be liberated from the rituals of the consumer transaction, nor from the narratives that define it. There seems to be very little sanctuary; that is what many video artists have discovered in the past few years, primarily in the period after 1982. The experience of visual complexity can coexist with that of the most degenerated commodity fetishism. And I am certainly not the first to suggest how this degeneration manages to create complexity—not an encouraging prospect for the mandarins among us.

In the past decade or so, the impact of TV commercials has begun to be seen in the pacing of the TV narrative itself, in a new rash of comic detectives, *Saturday Night Live* formats, and stand-up comics. The highly typed characters and movie allusions defamiliarize key scenes where peripeties might take place. Basic reversals in character relationships occur in the midst of chases, or are simply suggested. The agony of identification is avoided. As Aristotle wrote: "The comic mask is something ugly and distorted, but painless." And painless they are, ranging in format from variety comedy to designer jeans-commercials, to MTV, even to *Sesame Street* (modeled apparently on *Laugh In*). [18] How does this farcical style of narrative look in terms of its editing, even when used in serious drama? Clearly, it is highly disjunctive, using erratic wipes, rapid-fire montage, inserts of all sorts, satirical applications of chroma-key, and exaggerated contrasts.

Recent films that center around rock music as the text are particularly apt to use the audience culture format (referring as well to dance clubs and special effects at rock concerts). As one sample of the genre, let us examine a movie that specifically exploited the editing used in TV commercials—the film *Flashdance.* [19] In *Flashdance,* we see a tight shot of a foot pumping. Then, there is a

long shot of an empty warehouse where Alex, the heroine, lives. These contrasts register to the eye like a metronome, to record tempo rather than a character's point of view. I am not suggesting that this film format dispenses with character altogether, but it reduces character to odd narrative patches. The rhythm drives along. Audiences found this breakdance mood exhilarating: Rocky goes aerobics, in the relentless physical workouts that stand in now for the American Dream struggle. The American Dream is presented as a bouncing ball cartoon. It seems a far cry from *Flashdance* to video tapes of the early 1980s. A very broad spectrum of films and videos use TV syntagms in editing and story. The list alone would swamp an essay like this, and TV viewing habits are so volatile right now that the list is expanding every week.

What then can one say in conclusion, when the issues are still very much in transition? To borrow a phrase from Baudelaire, how do we "extract from fashion the poetry that resides in its historical envelope?"

The Audience as It Watches

Let us conclude with a look at Dara Birnbaum's tapes (also keeping in mind expressions she used in 1978, like "the staged family," or "the audience as it watches").

Announcing the Audience

These tapes are filled with ciphers (or syntagms) that announce the presence of audience. Reaction shots repeat in cycle. Bits of dialogue seemed directed at an audience, for example: "It's just the way he looks at me. Is that not crazy?" Celebrities squirm at the studio audience. A lightning ray attacks a Wang computer, as the secretary watches the screen.

To be more precise, with the exception of *Kiss the Girls/Make Them Cry* (1979), she rarely uses direct address. We do not find a character talking to us as if we were sitting across a table, as in talk shows, on earnest Bell Telephone commercials. Instead, she appropriates moments from adventure series, quiz shows, soap operas. She treats these syntagms like citations on a musical score: the well-made gesture in soap operas, down to the tilt of the head. Then, she turns them into a scrambled grammar lesson on audience memories. They become a sort of video rebus set to music, intercut with text, and contrasted with other syntagms.

Audience Culture, 1978–81

Of course, we must see these syntagms in terms of the years when they were first broadcast on network TV, from 1978 to 1981, a strange pleistocene mo-

ment for mass culture. It began with the success of *Star Wars* and concluded with the emergence of cable networks. It was also a period battered by soaring inflation, revolutions in Iran and Nicaragua, and the death of American liberal politics, to name a few. But for our narrow goals here, let us say only that it inaugurated a narrative style that I have labeled "audience culture." Only now are we beginning to see its full cycle (that is, with decades of precession, and artifacts everywhere).

It is narrative synchrony, built with nostalgic ornaments or movie syntagms. Downtown neighborhoods are "rehabbed" into Disneylands. Shopping interiors are designed like colonial delicatessens. And even more obviously, we have a rash of special-effects movies that feast on syntagms; these appear from two sources: (1) the school of high suburban fantasy (Lucas, Spielberg, Landis, Zemeckis, Howard), developing after 1977; (2) the remnants of sixties "new" cinema reaching toward audience formats (Coppola, Roeg, Lynch, Gilliam). "Trivial Pursuit" becomes a working scenario in comic horror films in particular. And we have the now venerable MTV (all of five years old).

It is a narrative style that often examines the erosion of our power to act, through gags about audience reverie, whether in shopping windows, or films. It exploits syncopated rhythm (or exaggerated ornament) and flat characters in disjointed formulaic stories.

Filling the Gaps

Similarly, in all the Birnbaum tapes from this period, one feels the ellipses of stories (cut away). The gaps are so wide, they seem devoted primarily to what the audience can fill in, out of a storehouse of old images. In Birnbaum's work, the viewer imagines many stories all at once, they bounce as sequels, re-makes, clones, spin-offs. They use mattes, costumes, and interiors directly referring to other movies. In other eras, this process has been called persistence of memory; that is, the viewer joins two scenes by imagining a story.

Like reading a good fairy tale, one does not need more text than a guiding phrase, with a familiar ring ("Once upon a time . . ."). We synchronize the fairy tale with other stories we know like it or from memories, the ellipses allow us to fill in from our childhood.

Thus, Birnbaum simplifies the story into the shortest ritual elements she can find, or so it seems. Then she sends a single instant into a vibrating loop. In *Pop-Pop Video: B. Kojak/Wang* (1980), we see Kojak grill a prisoner who won't squeal ("I did wrong. . . . But don't ask me to give his name."). Kojak keeps the heat on. Then, suddenly we hear the prisoner howling, obviously taken from the final shoot-out later in the show. Then, a minute later, we hear the baleful howl repeat (over and over again).

With that scream, we enter the precise moment when the character gets his comeuppance, a crucial syntagm. How well we know that point, like a phrase from weekly mass. Here's a kid with some heart, but misguided; he needs to be offered as blood sacrifice, in order to set up the right tone for the ending—that gritty indignation at the epilogue (the kid went sour, but he was a good guest star)—followed by a Ford commercial. Meanwhile, aided by the ellipse, we reminisce about other howling deaths from other cop shows.

Similarly, Wonder Woman spins like a top, as she gets into her cape. Then she blocks bullets with her magic bracelets (also bumps into ineffectual men, then says in a bone-dry delivery: "We've got to stop meeting this way"). We see her robotically at work, like the title of the tape, *Technology/Transformation* (1978)—spinning and sparking. She resembles a Wonder Woman doll abandoned by a child. She keeps running without a story or a (dramatic) purpose, except the memory of old games.

In *PM Magazine* (1982), the lyric "Cops and Cars and Topless Bars" reprises, like a backup group practicing without a lead singer. Meanwhile, we watch yet another woman syntagm, a woman skater, robotized like a twirling logo. Or we see another at her "moment of triumph" during the Winter Olympics in *Pop-Pop Video: A. General Hospital/Olympic Women Speed Skating* (1980), In Birnbaum's tapes, we seem to be turning the dial endlessly, while we follow in fact her highly structured juxtapositions (in this instance of the coverage of the Olympics and the soap opera material). In her videotapes *Fire!/Hendrix* (1982), we see endless variations of the consumer window, from the McDonald's counter-to-corner inserts as windows: the TV surface as a shopping window.

I am reminded of Roland Barthes's description of a man staring blankly at a window in the novel *The Erasers,* by Alain Robbe-Grillet. The character, Bona, was a mobster who, under the pressures of the "chosiste" style of this disjointed detective novel, has lost his purpose in the story, and watches the landscape roll by, much the way TV programming rolls by. Barthes compares it to sitting in a movie theater, and calls the process "cinematographic vision"; however, it applies equally well to the relentlessly abstracted TV surface.

TV is indeed an anesthetizing narrative form (we've heard that a few hundred thousand times). TV narrative flourishes on Brechtian disjunction but applies it like a sedative. It uses sharp contrasts regularly, but to induce reverie or get the audience in the mood to shop.

But beneath the seeming immutability of television, there are smaller elements—"neutrinos" of light—that make up a syntax about audience memory. Gradually, filmmakers and video artists like Birnbaum are looking cynically at this bag of visual ciphers. I suspect from this process, a modernity is beginning to emerge, where the simple agonies and material conditions of our expe-

rience, as well as the whimsy of our world, may become less like rock videos about foreign wars, and more, in their way, like journeys into what is most immediate about the complex act of watching television.

Let us try a summary using Birnbaum's tapes: they were designed originally to function in both art institutions and public sites, particularly places of high consumer activity, like film theaters, rock clubs, even Grand Central Station. They used installational strategies of the 1970s, gallery system, and syntagms from broadcast television. Since they refer as much to a public viewing space as to a home video screen, they have appeared in both areas. They use the modernist devices of defamiliarization as political commentary and as formal deconstruction. On the other hand, they isolate the syntagms that audiences remember from popular shows. Her pieces are caught between two worlds. Birnbaum's tapes lie directly at the center of a ruthless video modernity, where the form becomes literally a process of merchandising the personality of TV characters. Who stays, who goes? Her work of this period confronts the paradox of how modernist devices of defamiliarization resemble by now the selling of familiarity on the video surface. I suppose if I had to summarize conflict inside TV story, it would be man/woman against the elements; that is, the show against the programming. And this, in turn, stands in for the viewer's struggle to maintain some degree of community and comfort in the consumerist environment.

Modernity as Amnesia: The Problem of Making Video Art About TV Watching (1980–83)

Of course, this "comfort" often feels like partial amnesia. And the "community" exists purely as an electronic nonscape. Video techniques that describe this amnesial nonscape are very familiar to us now, in rock videos particularly. But when they first appeared, in video art from the late 1970s, they seemed ripe with potential. In a rhythmic collage, the TV screen was fractured, or layered, with ad copy. The camera orbited in exaggerated zooms. Through jump cutting, jittery images kept revolving. Blips of dialogue arrived like radio messages from deep space. They were epiphanies about inaction, cues that make us imagine we responded vigorously, when, in fact, we only sat passively in our chair.

In Max Almy's *Leaving the 20th Century* (1982), a man sleeps while a pair of lips emerge in an oval (like an extra eye) at the center of his forehead. He must remain semiconscious, while the lips begin a TV countdown. The screen takes over and zips through the morning news. In what Almy called "fragmented narrative," a passive central character is invaded by a drumming sensation, like a low-voltage cattle prod, with reminders that he is supposed to for-

Max Almy, *Leaving the 20th Century*, 1982.

get something (but what?). Is the character undergoing electronic senility? Is he experiencing brain surgery under a localized anesthetic? Later in the tape, a woman's face breaks up, like fading reception. Her voice lowers into an electronic echo, encouraging the central character to forget, as a matter of moral principle.

Bruce and Norman Yonemoto compared this sensation to "existing within the reality of reruns." In the mock soap opera *Green Card: An American Romance* (1982), a boring temptress says: "Stop thinking, Jay. It's a way to fail."

In the tape *Episode* (1982), by John Sanborn and Kit Fitzgerald, random dialogue circulates around a TV couple kissing, as if they lived in a TV commercial or kept the set on as a friend to watch, forgetting most of what TV said, except for a brief sound bite here and there. "Why do we do the things we do?" These videos point toward a new style of voyeuristic cinema that is emerging, along with films later in the 1980s, like *Blue Velvet, House of Games, The River's Edge,* or from Spain, *Matador,* from Japan, *Tampopo.* Characters forget to undergo motivated conflict and, instead, just study tapes about their own passivity or vault into films more dangerous than their daily life only to discover that they are still unable to act. We observe a civilization that is overstimulated and desensitized simultaneously.

A child stares at the flickering TV surface. We only see the TV at three-quarter angle, like a face hidden behind a wooden hood. In *Why I Got into TV and Other Stories* (1983), Ilene Segalove's little girl lives through epiphanies achieved through the art of watching TV. The voice-over remembers those wonder years in front of the tube. "Almost everything looks better on a tiny TV screen." The drama of watching is parodied: "Turning off the TV when I had mononucleosis was like dying every night."

That style of hyperventilated exhaustion reminds me of how the *Geraldo Show* leaves the viewer—in an exaggerated state of inactivity, with energy to burn, but only a mild fever to show for it. Obviously, the visual artist wants to capture this eerie sensation and give it the power of fable and allegory. Even in mainstream cinema, many film comedies over the last twenty years include a scene with a TV blasting away climactically, while the camera pans to the enervated viewer, often a bald, fat man munching, and staring like a cow in the meadow.

Is that also a portrait of the American public watching twenty-second sound bites during a presidential election? Perhaps, but certainly in video art, this pleasurable boredom has been translated into fast-changing narrative style, like montage about short attention span.

Certainly, this jumpy style of editing becomes very important in video art after 1977 and loses its priority about 1984, once rock videos, cable, and half-inch video sales had rearranged the viewer market, leaving the video artists less certain of the potential of broadcast as a way to reach their audience. The earlier techniques also began to feel a bit naive, since they looked uncomfortably similar to MTV. Its political uses seemed much more ambiguous.

While many art video techniques appeared suddenly on commercial television, no one could argue very well that the quality of the shows overall had improved all that much. Only the number of stations had increased. Artists were less inclined to fight TV as the fascist monster, even to seek ways to offer alternative programming, as they had in the early 1980s, when a new flock of late-night PBS shows appeared ready to promote video art.

By the late 1980s, however, the selling and grantsmanship for videos has grown more familiar. Video editing has begun to settle down into an established language, some feel too established.

Probably, the term *television* needs to be updated into "the material culture of electricity and glass." Parallel to television, there are a variety of consumer areas that also require a glass surface as part of their narrative: shopping windows; glass mall arcades; auto windshields; computers. In that sense, television has now officially become a style of architecture, perception, even city planning. The new downtown monument planned for Los Angeles was conceived specifically to honor the international meanings of electricity, autos, and

glass, like a million-square-foot glass screen hovering over freeway inter-changes.

The glass surface has entered the world economy, far more than ten years ago. With its emergence, we see an epoch passing and make our judgments about how it changed our culture. Clearly, as a result of electronic media governing our lives for generations, classic distinctions about the nature of experience need adjusting; public and private experience have become infinitely more integrated into each other—one might say blurred. And the visual allegory for this blur is electricity under glass, the simultaneity of the magic box. So when TV editing looks like an anesthetic, we are, in fact, witnessing a blind mix of intimacy and public life. Media have begun to feel like a Byzantine plot concocted by someone who lost track of what he or she was trying to do. Apparently, the media are owned by the Right, twisted by the Left, handled by advisers, premarketed by salespeople, and guided by advertisers—in short, a kind of mental dumping ground for toxic waste. And yet, it is what we have instead of boulevard life, to shape our unique modernity.

News shows specialize in analyzing how insoluble political problems are, as if TV journalism were simply another form of soap opera. The TV announcer stares at the TelePrompTer in what passes for the scientific attitude today. But even she or he is watching a glass surface, in order to deliver eye contact to another glass surface—the audience. In fact, journalistic objectivity is being rapidly dissolved, into a cross between *People* magazine and the *Pentagon Papers*. The model for TV objectivity is closer to a quiz show host than a journalist, as all forms of variety entertainment overlap increasingly into all forms of political life.

In a similar vein, a little bloodless I admit, shopping and tourism have become the models for education and decision making. Ask any professor how many students judge a lecture as if it were a PBS special. As host-lecturer, President Reagan said good-bye to the press in precisely the same voice that he said hello. Beginnings and ends become indistinguishable, more like seasons on a hit show, year five, year six, year seven.

So we arrive momentarily at a cynical impasse, quite different from the sense of video art in the early 1980s. The strange entropy of the TV audience, often the subject in those tapes, has now become a running joke in newspapers, dinner conversation, and stand-up comedy. Of course, clearly television did not invent the problem; it is merely one instrument among many, in a world economy built around consumer service marketing.

And certainly, as problems go, we could do much worse (and probably will, within the next few years). We could be sitting in trenches during World War I or hiding from the bubonic plague with Boccaccio's friends in the fourteenth century (AIDS is tragic enough!). Instead, we face a consumer

civilization that is erasing distinctions between public and private life, between marketing and reception, between electronic imagery and real space. Video art of the early 1980s witnessed an earlier stage in this process; it reminds us, in fact, how rapidly these changes are taking place.

Epilogue

There are many issues that an essay ending with 1983 (in its original version) will neglect. The two that trouble me the most, as of 1985 were: the meaning of an interactive video community and the need to include a materialist model at the conclusion, to avoid mystifying the video process. With the reader's indulgence, in the spirit of a television epilogue, I would like to introduce both of these briefly.

The Video Community

There is little need to review the coming of cable, computers, and VCRs as catalysts in changing viewer habits. With the new technology on the way, much of the criticism in the late 1970s focused on the "loss of privacy" it would bring, as in John Wicklein's *Electronic Nightmare:* "With the system (of new TV technology) lie serious threats to our privacy and our individual liberties."[20]

At the same time, many hoped that cable would allow viewers to escape from "standardization" and conformity. The fifties image of the "passive" viewer seemed about to end, and this meant the rise of new marketing strategies. The president of J. Walter Thompson, the giant advertising agency, explained:

Today, we are on the threshold of the most complex and comprehensive media revolution of all. . . . Previous media revolutions were quite different from this one, because they represented a consolidation of audiences. . . . The direction of the new media is exactly the opposite—instead of consolidation, fragmentation. Smaller and smaller audiences, and more and more sharply defined by their interests and attitudes.[21]

An era of electronic regionalism seemed in the making, the return at last of the small town to modern life. The "narrowcasted" show would increase access to local communities, artists, and private viewers. Even by 1985, such predictions seem a bit lame. Cable programming was corporatized almost immediately. Electronic regionalism, it turns out, cannot meet the high start-up costs for cable nor compete with MTV or multiple service outlets. And while advertising prices for TV are still a bit shaky, the TV oligopoly has adjusted easily enough to the competition. Viewer habits changed, but the established video syntax did not reverse at all. On the contrary, cable and VCRs further intensi-

fied the ties between the viewer and the "recognizable" TV friend. But now, the principal continuing character becomes, in fact, clearly the viewer in various fantasy video communities.

Video *recognition,* as I defined it earlier, has grown ever more self-contained. One could say that the viewer enters the video surface itself. More accurately, the space between fictional time on the screen and real time in the living room is collapsed even further than on network prime time before 1982. Let me explain, first using a few viewer scenarios in fantasy community settings—narratives where the viewer enters the screen:

Video Game

Along with Han Solo and Luke Skywalker, the viewer controls the space artillery, as the Empire's war ships attack. The ships may be animated (flat electronic lines) or live-action (narrative syntagms). Instead of firing from a window facing on to hyperspace, the viewer has a video screen.[22]

Interactive Novel

A computer program recites an abridged version of *Huckleberry Finn* out loud. When the computer voice breaks off, the viewer is allowed to change the plot, according to predesigned options. Once the choices are made, the space between the screen and the viewer vanishes into a single computerland surface. To rephrase Roland Barthes, once the work of art becomes a text, both writer and viewer merge into the same role. Story becomes a self-perpetuating trivia game. Narrative and real time become indistinguishable.

"A World of Choice"

So reads an advertisement for a cable service. Cable is a much expanded menu, with an attractive merchandising of the synchronic narrative. The consumer puts the programming together and, with VCR added, even plays with special effects at home (freeze frame, slow motion, search).

The viewer's privacy is not invaded. What we find instead is the synchronic narrative interpreted as solitude. More specifically, with the diverse uses of the video screen, privacy has come to stand in for community altogether. The "creative" consumer invents his or her own community. Instead of painting by number, the viewer buys by menu.

The Political Community on the Video Surface

The fantasy community is a reification of those characters who visit the home each week and are recognized, rather than identified. Interactive video comes of age: computers merge with television, as coaxial cables and software allow for narratives the viewer can enter.

Politics can be arbitrated as can interactive video. What is the result?

Reagan makes a speech defending the Contras in Nicaragua. He uses his "cookie-jar" grin, and other television syntagms, to inspire hospitality. He discusses the situation in Central America comfortably, as if he were remembering it in a flashback. The event feels already to have happened, beyond analysis. Reagan, as the continuing character, floats above it all, beyond conflict. Interactive video and democratic process meet not at the polling booth, but at the video poll. Politics resembles another talk show, with endless epilogues.

Video Workplace as a Fantasy Community

In recent years, many films are set inside the computerized workplace. Some, like *Videodrome,* or *Looker,* are horror tales about video literacy as biomorphic fascism, or even a brain tumor. For the most part, however, despite the occasional monster, these films show us a friendly community of screens, a buddy system apotheosized by *Star Trek* episodes in the late 1960s.

By blending the hospitality of synchronic narrative with computers, we have found ways to feel at home with the computer surface. We are beyond the sixties jeremiads about "don't bend, fold or multilate."

If this is a fantasy community, then who controls this world of TV story and computers, once we leave the synchronic narrative?

Synchronic Narrative Is Not Sublime in Its Opacity

Here, as economic analysis, I feel my argument is weak. It is caught in a paradox of its own, another case of resemblance between fine-art practice and TV narrative. The romance of the floating signifier: in the arc of poststructuralist criticism, the critic will often invent possible readings for the scrambled messages in the culture. To borrow from Roland Barthes, the pluralism of the text makes the reader a creative consumer. And so, the critic—standing in for the reader—can wander through fictionalized scenarios, as in this epilogue. It is a very liberating role, I must admit, but when applied to video criticism, a potential disaster.

In the case of video, the economic forces shaping TV programming are too nakedly present to be rolled inside something as irreducible as a message that never arrives. We probably should take "real time" more literally, and find our paradigms there, rather than in the picaresque of the broken message.

Much as I find Jean Baudrillard's notion of the simulacrum inviting, passages like the following seem to mystify the video process:

There is no longer any (television) medium in the literal sense: it is now tangible, diffuse and diffracted in the real, and it can no longer even be said that the latter is distorted by it.

Such a mixture, such a viral, endemic, chronic, alarming presence of the medium, without our being able to isolate its effects—spectralized, like those publicity holograms sculptured in empty space with laser beams, the event filtered by the medium—the dissolution of life into TV—an indiscernable chemical solution.[23]

Passages like these create, at first, an antic pleasure, a release from causal analysis into the ironies of consumer fictions. But ultimately, synchronic fiction is pleasurable because it engages directly the way power determines meaning, and does not imagine it into specters. The fascination lies in correspondences, not mystification.

The "New" Corporation: Synchronic Narrative

Synchronic narrative guides the autonomous worker at the screen. The message is neither broken nor opaque. It is simply a replacement for management. On the level of business management, synchronic narrative has two utterly unambiguous meanings. First: it is the pattern workers and consumers adjust to. It refers to how viewers adapt to conglomerate marketing, to changes in job requirements, and to much expanded uses for communications (in the exercise of political and economic power). Above all, mass culture is a form of socialization to the skills needed in the job market. One might call this video literacy, the complement to computer literacy. Second: it is the way the workplace and the corporate system are organized, increasingly. One might call this the synchronic corporate continuum. The communications divisions within the defense industries, space industries, banks, oil companies, and generic communications giants themselves (like AT&T) pioneered video technology, and still dominate the way it is distributed, or the major markets are divided. And these conglomerates also define the way corporate "programming" works, to twist that phrase a bit. Because of telecommunications and computers, the management hierarchy is expected to change in many corporations. To no reader's surprise, it will become more horizontal. According to experts, the corporate ladder may, quite literally, "flatten out" (their term, not mine), and with computers, a "circular," or even an asymmetrical model for management may replace it. In other words, the narrative of corporate power will become oddly democratized, but not the fact of power itself.

After all, managers control offices through information. But basic managerial advice can be supplied through the program. And with telecommunications, the work units will undoubtedly get smaller, inside conglomerates. We imagine the viewer/worker of the future to become increasingly solipsistic. Projections suggest "atomized" squads of ten to twenty persons, instead of large offices. Each squad will manage itself, with each worker more self-contained, because the master program on the video screen provides guidance.

In the same sense, the "liberated," or upscale consumer is really playing a highly restricted game of solitaire. The viewer can change the puzzle, but the pieces are still precut. Thus, autonomy is increased—in atomized work units or electronic solitude—but never strays from the narrative continuum.

Privacy and work begin to collapse into each other. In the isolated privatism of the work screen, the viewer can practice the skills learned from creative programming, particularly interactive video. The creative consumer, mastering an impressive menu of choices, can enter the earthbound version of the *Starship Enterprise*, or so the mythology might read (for a while).

Work dissolves into fantasy narratives, and privacy feels like community. The synchronic narrative is given a spectral romance, as in Jean Baudrillard:

Reality no longer has the time to take on the appearance of reality. It no longer even surpasses fiction. . . . The cool universe of digitality has absorbed the world of metaphor and metonymy.[24]

Or Gilles Deleuze:

This machine in its turn is thus not the State itself, but the abstract machine that organizes dominant statements (énoncé) and the established order of society. . . . The abstract overcoding machine assures the homogenization of different segments, their convertibility and translatability.[25]

Or Vincent Leitch:

The world is text. Nothing stands behind. There is no escape. Here in the prisonhouse of language.[26]

Except, quite clearly, a great deal stands behind it, very unexceptionally, and not all that disguised. It all sounds rather gothic, like a diorama of a surface memory, and that is precisely what many of the films and videos on television-memory are beginning to feel like. Solitude begins to look like a lonely walk down an empty shopping mall, where all the windows scintillate with memories of old shows and old purchases. Then, all at once, we realize that we work in one of those shops. Behind the surface is a simple loading dock where trucks bring in merchandise, or a bank of computers, or simply the creative consumer in an embrace with a program. It is simple, and ultimately this is the source of the narrative power of the synchronic video screen.

The Art of Watching: Additional Notes, November 1987 (based on a museum catalogue published 2087)

A hundred years from now, a consortium of German and Japanese investors build a museum about American audience memories—a seven-story cylindrical high-rise, with a corkscrew of screens inside, like Hadrian's mausoleum behind

glass. It overlooks the abandoned remains of the Los Angeles downtown freeway exchange. Of course, the most popular displays there are a series of seven-second sound bites on misremembered history from the 1980s, particularly the sequences where Rambo wins the Vietnam War.

"The 1980s were a turning point for the art of watching television," the opening wall announces, followed by dozens of curiosities.

"After forty years of home viewing, Americans had learned to adjust their economic and political life according to television programming models. Events in the world did not make sense unless they were scripted like television. Public crisis could be contained entirely within a simple, relatively portable space, the geometric fantasy of what lay inside the television screen. The art of watching properly came into its own, altering the act of reading, the act of entering a public place, the training required for a job, the way distances were perceived, the way rooms were designed, and so on."

Next to a roomful of eighties automobiles, in front of wall-to-wall video backgrounds, the following text appears: "By 1987, it became apparent that the act of driving a car was a more natural way to examine landscape than walking; and so, cities were redesigned in the spirit of driving—even pedestrian areas. The spirit of signs flying by, and the picaresque of seeing streets as dioramas, maps turned into theme parks, became central to urban planning. In effect, one was always driving, even on foot. Similarly, streets sheeted over in glass replaced the older notions of the city downtown experience. All architecture came to resemble photographs or movie stills; and to do so, the perspective became flattened, rather like a camera obscura, much the way photographs alter distances or the windshield of a car plays tricks with light."

Playing whimsically with such a museum helps me understand the events of the past month—October 19 to November 19, 1987. In the first week after the stock market crash, a strange neutrality entered the nightly predictions for our economy. Newscasters were shocked, plainly, but experts were brought in to announce that the Christmas season would *not* be an economic disaster. We should float on the surface of our Visa cards. Beyond these demands for a bullish Christmas spirit, the economic facts of our condition seemed impossible to identify in the newspapers, and certainly not on television. The film industry was hoping for a mild recession, because financial malaise always fills movie theaters. Outside of Wall Street and Manhattan, the financial traumas seemed to have the immediate impact of a special segment for *Entertainment Tonight.*

President Reagan explained, like a grandfather embarrassed by nasty relatives, that all indicators were still good. Clearly, no one would yell fire. We were supposed to save ourselves by forgetting quickly, and not responding. Speeches about stock prices were reported alongside polls on their popularity, like spread sheets for gambling on basketball playoffs. Something in the "ar-

chitecture of media" (Baudrillard's term) was clearly subverting the possibility of exchange.

The museum of 2087 explains the situation this way: "In the midst of financial panic, the sound bite on TV was the liturgical unit that saved the Christmas season in 1987. Through various sound bites taken from speeches, and bright Christmas commercials, comforting gestures, dislocated phrases, the threatening events became so condensed, they acquired an innocence, and became, very quickly, forgettable."

These sound bites are operating very much like the syntagms I described earlier in this essay:

1. The sound bite presents us with our own memory, not a story, or a plot. We are given displaced moments from shows we have seen, products we have bought. Our pool of consumer memories (movies, TV, shopping, driving, touring) make narrative vignettes where we are the central character.

2. Sound bites tell stories about hospitality, about an electronic friendship (or about the reverie when we shop; or when we browse through ads).

3. Sound bites are, in effect, flashbacks to a time that only exists as merchandising promotion.

4. Merchandising promotion leaves room for the audience, but little else. It simply presents us with an imaginary space, which we, as audience then inhabit. We are reminded of a street, a highway, or a room next to ours, because, like TV programming, sound bites register in strands of fractured memories, impulses that feel familiar, harmonies snatched from famous operas.

After the stock market crash, friendly TV settings fostered a sense that Americans should continue shopping, to erase the symptoms that might lead to depression. If the symptoms were ignored, the crisis might never get scripted.

Through sound bites, we receive news of economic crisis in a medium that expects us to lose track of what we see. The Max Headroom face is a useful allegory here, or Max Almy's *The Perfect Leader* (1983): the remnants of marketed memory. Events cross the screen like streaks of rain on a window: a shopping window, a TV window, a car window.

The facts seem straightforward enough. On October 19, the market dropped over five hundred points. But for a few weeks, TV programmers seemed unable to script shows around this intrusion. By mid-November 1987, however, I scan the news, and the TV listings; this Thanksgiving will look quite normal, at the threshhold of another Big Feed in December.

Even I am hoping that after the smoke, there's no fire. We all stand to lose; so my little jeremiad is also scripted like television. I am another lapsed radical dressing for the theater, perhaps in Moscow, 1917, when audiences sat

through an entire opera while the Bolshevik Revolution took place outside, unscripted, distant. There is an aristocratic charm to this profound insulation, but beneath the inertia, events are beginning to overtake us. One wonders how these narratives based on sound bites will change politics in the decade to come (particularly the presidential election that is coming), much less how they will be remembered, in place of traditional history, over the next century.

Helen DeMichiel, *Consider Anything, Only Don't Cry*, 1988.

Significant Others:
Social Documentary as Personal Portraiture in
Women's Video of the 1980s

CHRISTINE TAMBLYN

Omnivorously, or even cannibalistically, the video medium seems to be capable of accommodating any synthetic aesthetic strategy, production method, or format that artists have managed to devise. Several factors have fostered the development of hybrid genres in video. Often trained in a variety of pragmatic and academic disciplines, video producers bring complex skills and aspirations to the operation of technologically sophisticated equipment. Unlike the film image, the video image never stabilizes; this electronic capriciousness may account for the eclectic range of its discursive applications. Video's lack of an established tradition undoubtedly promotes experimentation, and its capacity for multichannel sound and image transcription predisposes artists to produce layered works. Perhaps the ubiquitous domination of television as a vehicle for propagating popular culture concomitantly privileges video as the quintessential postmodern apparatus for reformulating aspects of the old as the new.

When video portapacks were initially marketed in the late 1960s, these tools seemed so easy to use that an illusory belief in the transparency of the representations they produced was fostered. The notions of documentation and truth were inextricably linked in the ideology of grass-roots "guerrilla television," with its self-proclaimed adversarial relationship to the broadcast networks. During the two decades that have elapsed since then, the theoretical premises underlying such an unproblematic attitude toward representational veracity have been invalidated. Abandoning any pretenses of objectivity, some video artists have recently contributed to the burgeoning hybridization of genres by grafting documentary formats onto other expressive modes.

In this article, I will focus on work by six artists who conflate the genres of portraiture and social documentary. Paradoxically, these artists utilize video as a vehicle for reflecting on the world in a manner that also renders an image of themselves; by "looking out," they are able to "look in." The six artists whose videotapes I will examine are all women: Nancy Buchanan, Cecilia Condit, Helen DeMichiel, Jeanne C. Finley, Laura Kipnis, and Sherry Millner. Although some of these artists present themselves as feminists, others do not. Nevertheless, feminist theory and the history of feminist performance video seem relevant to the concerns they address in their work.

One of the many insights gleaned from feminist consciousness-raising

techniques of the 1970s was the dictum "The personal is political." In the performance video that was influenced by these consciousness-raising methods, autobiographical themes, including the exorcism of constraining female stereotypes in confessional monologues or the expansion of self-potential through projective role-playing predominated. Women's inferior social and economic status had been linked by feminist theorists to their linguistic inequality; women were not afforded the same opportunities to attain a mastery of language as were men. By exercising their right to function as speaking subjects, the feminist artists who made autobiographical videotapes were thus using the medium for both aesthetic and political purposes.

Low-tech production values characterized the emergent feminist video art of this era: long, unedited takes, minimal camera angles or movements, and a reliance on sync sound were among its consistent stylistic features. This work therefore falls under the rubric of "narcissistic" video that Rosalind Krauss identified in her influential 1976 article, "Video: The Aesthetics of Narcissism."[1] Krauss's theory of narcissism as the medium of video was derived from an analysis of tapes and installations that had been produced primarily by male conceptual or body artists like Richard Serra or Vito Acconci. However, the model seems equally applicable to 1970s feminist performance video, even though the artists' intentions were quite different.

In narcissistic video, according to Krauss, "The electronic equipment and its capabilities have become merely an appurtenance. And instead, video's real medium is a psychological situation, the very terms of which are to withdraw attention from an external object—an Other—and invest it in the Self."[2] Because video technology enables the image to be simultaneously recorded and displayed, the performer can use the video monitor as a mirror. The video camera and the monitor form a "parenthesis" that surrounds the body of the performer, who is thereby "self-encapsulated" in a continually renewed feedback loop.

Feminist performance video was usually produced in an intimate setting: either in the artist's home or while the artist was alone in a production facility. This privatized space, along with the uncompromising focus on the artist's own body as both the subject and object of her gaze, made these tapes intrinsically narcissistic, in the sense in which Krauss defined this psychologically loaded term. Although Krauss did not seem to intend her attribution of narcissism to be interpreted pejoratively, it is difficult not to see the situation she described as an entropic cul-de-sac. Fortunately, Krauss concluded her essay by citing examples of works that prefigure other alternatives for video: tapes that adopt a critical stance toward the medium itself or tapes that interfere with the psychological hold of the video mechanism through a physical disruption, such as Joan Jonas's *Vertical Roll* (1972).

What Krauss could not have foreseen are the radical innovations that have

altered the video apparatus itself, permitting artists to work in ways that were not possible previously. Most notably, improvements in the quality and portability of cameras now allow video artists to explore the world outside of the studio on a par with filmmakers. And elaborate postproduction equipment facilitates decisive retrospective interventions in the presentation of sounds and images. A critical deconstruction of the material the artist has collected can be effected by overlaying multiple audio or visual tracks on the original footage.

The six artists whose work I will discuss in this article have invested external objects with libido, rather than transforming object libido into ego libido in the closed circuit of narcissism. Krauss offered a concise description of the psychoanalytical transaction that "cures" the narcissistic fixation: "The analytic project is then one in which the patient disengages from the 'statue' of his reflected self, and through a method of reflexiveness, rediscovers the real time of his own history."[3] Video still functions as a mirror, or a "method of reflexiveness" for the artists who employ it to combine portraiture and social documentary. However, their self-portraits are achieved by using video as a wedge that can be inserted between their lived subjectivity and their fantasy projections on objects. Instead of employing the video mechanism of camera/ monitor to encapsulate their bodies, these artists employ it to calibrate the gap between their egos and the representations of the external world in which they have a libidinal investment.

The particular subjects these artists have chosen to document are varied. Nancy Buchanan begins *Sightlines* (1988) by translating a first-person narrative by a woman who was unjustifiably arrested and tortured in El Salvador. In Cecilia Condit's *Beneath the Skin* (1981), the "other" into whom the narrator (played by Condit) projects herself is her boyfriend's former girlfriend. The narrator recounts her discovery that her boyfriend has been implicated in the murder of this woman. For Sherry Millner, the "other" is her young daughter, Nadja. *Out of the Mouth of Babes* (1987), a collaboration between Sherry Millner and Ernest Larsen, explores the connection between Nadja's acquisition of language and a network of power relations that extends from the family to the United States's involvement in Central American politics.

Because Helen DeMichiel, Laura Kipnis, and Jeanne Finley do not appear in their respective tapes, their work may be more readily classified as portraiture than self-portraiture. However, each artist focuses on a central protagonist or metonymic device to constellate a biographical subject or stand-in. *Consider Anything, Only Don't Cry* (1988), DeMichiel's paean to video's capacity to serve as an external memory system, returns obsessively to the figure of an unnamed woman and the voice of a female narrator. Although the woman's image and this voice are rarely presented simultaneously, they remain closely identified.

Kipnis's *A Man's Woman* (1988) surveys the career of a fictional antifeminist writer and politician, Clovis Kingsley, in a postmortem evaluation that

Laura Kipnis, *A Man's Woman*, 1988.

takes Kingsley's assassination as its point of departure. A series of silhouetted male figures narrate Finley's *Common Mistakes* (1986). Instead of organizing her tape around a central presence, Finley utilizes a unifying imagistic trope; she shrouds her informants in darkness as they relate instances of human fallibility that range from the administration of lobotomies to treat mental illness to the nuclear meltdown at Three Mile Island.

Postproduction plays a crucial part in the fabrication of all of the tapes I have mentioned. Material collected in the field or found footage is combined with patently set-up studio shots to produce a densely fabricated tapestry of the natural and the artificial. This conflation of "truth" with fiction more closely corroborates current poststructuralist theoretical work on the status of representation than the confessional mode earlier feminist artists employed to unproblematically assert themselves. The space of nonresemblance between the signifier and the signified alleged by numerous poststructuralist writers from Jacques Lacan to Jacques Derrida may be demarcated, even if it cannot be represented, by the gaps and slippages the six artists I have mentioned have interlaced into the imbroglio of their portraits.

The temporal concurrence of the artist and the medium that produces a claustrophobically collapsed present in Krauss's model of narcissistic video dissolves in the temporal displacements of the editing process. Editing ipso facto unravels the bond that linked the artist to her material like an umbilical cord; her retrospective labor shapes the material she has accumulated into a newly differentiated corpus.

One of the examples of narcissistic video that Krauss analyzed is Richard Serra's *Boomerang* (1974). In this tape, Nancy Holt hears her own words fed back to her over headphones after they have been electronically delayed. Krauss explained, "Holt is severed not only from the prior words she has spoken, but also from the way language connects her both to her own past and to a world of objects."[4] But the historicizing function of language to which Krauss was alluding is not preempted in the work of the six artists under consideration here. They all make extensive use of prefabricated texts, both by inscribing

texts over images and by enunciating scripts or directing their iteration on the soundtracks of their tapes.

In an interview conducted by Micki McGee for *Afterimage,* Sherry Millner discussed her attitude toward the incorporation of texts into her tapes:

I was trying to figure out how to make meaning, to engage, invert, or refuse a world of references. For me the big change came when I realized that I wanted to deal with language—both language and juxtaposition—to actually bring a specificity to my images instead of a kind of vague generalized reading. Of course images with text elicit more than one meaning, even a range of possible meanings, and even the possibility of layering differing social and aesthetic representations.[5]

The connection between linguistic competence and personal and social efficacy is iconized in *Out of the Mouth of Babes,* since language is a key element of the tape's content and its formal construction. Midway through the tape, Millner intones in a voice-over ostensibly addressed to her child: "Words are physical things for you now, more evocative than the place names on a map. But they are slowly beginning to become a way for you to gain control over your environment." The image that accompanies this text is a shot of Millner's daughter playing with an inflatable globe in the grass. A drawing of a circle is inscribed over the round shape of the globe, and the word "ball" is Chroma-keyed into this circle. Then "ball" is crossed out and replaced by "map" to coincide with Millner's pronunciation of this word. Finally, "map" disappears and the "x" that negates "ball" is removed. Thus, the images that Millner generates serve as playful demonstrations of aspects of becoming fluent in a language. Mastery of the abstracting function of language enables the speaker to construct the metonymic chain of globe/ball/map, and to manipulate all three signifiers to interchangeably designate the same referent.

Millner is acutely conscious of the methods by which the human subject is inscribed through language. One of the most cogent images in *Out of the Mouth of Babes* is a superimposition of Millner's entire head over Nadja's mouth that revitalizes the clichéd phrase quoted in the tape's title. On the soundtrack, Millner's voice queries, "Is it always a version of my words coming out of your mouth?" A series of analogous diagrams of hierarchical power relations are intercut with vignettes of Nadja resisting her mother's attempts to set up the scene as she has envisioned it. The power relations that are named in handwritten digitized titles include "daughter/mother," "worker/boss," "3rd World/1st World," and "private/general." In each case, the first word is inscribed above the second, with arrows pointing to the upward or downward directions of the two appellations that constitute each complementary pair.

By examining the parallels between her everyday life and more far-reaching political conflicts, Millner has imbued the feminist slogan about the

personal being political with renewed significance. Her focus occasions a reversal of the terms of equivalence in the equation; she investigates the personal implications of political issues, rather than using her personal experiences as political templates. In the interview cited above, Millner clarified her position:

As a feminist, it seemed important to insist that daily life is as much a site for art making as all the other apparently exalted realms, that the mundane is no less significant a subject matter than the metaphysical. But I'm not so much interested in individual psychology or in starting from autobiography in its narrowly psychological basis, but rather from my material life as a representation of social—sexual, emotional—contradictions.[6]

The reciprocity of the public and the private realms is analogous to the collision of documentary and fictional modes in *Out of the Mouth of Babes.* Without abrogating their real identities, the people who appear in the tape enact fictional tableaux. As Millner indicates in an audio voice-over, Nadja is incapable of following a script because she can't read yet. Nevertheless, she participates in the creation of a Brechtian distancing effect by gleefully jumping on a trampoline covered with a map of Central America. Her imperviousness to the intricacies of the symbolic corresponds to the unwitting culpability of U.S. citizens who ignore their government's interference in Central American affairs.

In *Sightlines,* Nancy Buchanan implicates herself as a witness to human atrocities, both in Central America and the United States. The tape is organized around the faculty of sight, in both a literal and metaphorical sense. Shots of a massacre of civilians by soldiers on a Central American street are Chroma-keyed into the iris of an eye framed in a close-up. Male and female voices on the soundtrack recite truisms about vision while an array of postproduction effects are used to enhance or synthesize juxtaposed images of eyes. Some of the images are surreal or humorous: dough being kneaded in a bowl is studded with plastic eyes, and a hand closes to capture an eye that is electronically imprinted on its palm. Associations between sight and vulnerability dovetail with connections between insight and wisdom.

If Millner and Larsen's tape extends the feminist preoccupation with women having the right to a discourse of their own, Buchanan's piece updates their corollary insistence on having a look of their own. *Sightlines* concludes with Buchanan narrating the story of her exchange of looks with a vagrant she encounters on the street. Her audiotaped voice-over speaks of noticing a man who is collecting cans in a plastic garbage bag as she sits in her car waiting for a red light to change. Rather than averting her eyes from his, she meets his gaze in an acknowledgment of their shared humanity; his eyes afford her a momentary glimpse of his soul.

Intertwined with Buchanan's stated and reenacted interpretation of this

scene, traces of a deeper motivation can be discerned. By meeting the eyes of the man who gazes at her, Buchanan resists being transformed into a passive objective of controlling surveillance. *Sightlines* is structured as a montage of eyes searching for ocular engagement with the viewer. Their aggressive gazes transfix the viewer with the same active regard that Buchanan turns on the vagrant, subverting the traditional fetishistic relationship of the camera to the female subject.

By addressing the topics of international relations and homelessness, Millner/Larsen and Buchanan bring a feminist perspective to issues that extend beyond the domestic sphere or the scope of specifically women-identified issues like rape, pornography, and abortion. In an article titled "Women and the Media: A Decade of New Video," William Olander contended that recent feminist video productions have begun to address the arena of culture and the consciousness industries at large. He elaborated on the theoretical basis of this shift in emphasis:

Second generation feminist artists have resisted specifically the creation of "woman as sign," or woman constructed as a commodity, of which, obviously, there is no lack in Western society. Rather, their aim has been to investigate the means by which a female subject is produced and to effect the "ruin of prepresentation," precisely on the grounds of what has been excluded, of the unrepresentable object, creating a significance out of its absence.[7]

The content of the work of the documentary portraitists I am concerned with here does not invariably encompass overtly feminist concerns. However, I would argue that they use feminist strategies to devise alternatives to dominant patriarchal modes of discourse. The impact of feminist theory on their work can be discerned in their hybridization of heterogeneous genres to convey their ideas.

As even male poststructuralist thinkers have recently discovered, a feminist perspective offers insights into areas that have remained unacknowledged in Western conceptual systems. Feminists have tended to valorize difference rather than homogeneity, fragmentation instead of wholeness, and fiction versus abstract discourse. Current anxiety over the decline of paternal authority has occasioned a complementary repudiation of dialectical thought buttressed by reinterpretations of Freud, Nietzsche, and Heidegger. A decentering of the polarities proliferating from the basic opposition of male/female (i.e., mind/body, culture/nature, same/other) has replaced the stabilized model of a centrifugal structure.

Poststructuralist philosophy has consequently afforded the insight that the inferior social and political position of women has been reinforced by the logical processes through which meaning is produced. As long as dichotomies gov-

ern conceptual processes, one term will inevitably be privileged over its opposite. Attempts to reverse the positive and negative poles will have no effect on the maintenance of a hierarchy of oppression. As Nietzsche observed, no matter how often masters trade places with their slaves, the institution of slavery itself will continue to be perpetuated.

The crisis in legitimization between discourse and reality is a major theme of Jeanne Finley's *Common Mistakes*. Although Finley has not been directly influenced by poststructuralist theory, her indictment of institutionalized foibles exhibits a comparable skepticism about authoritative mastery. *Common Mistakes* opens with a slow-motion sequence of a hand opening a refrigerator, removing a carton of milk, and dropping it on the floor. As if hyperbolizing the old adage about not crying over spilled milk, amplified noises of a thunderstorm occur on the soundtrack. This sonorous punctuation is followed by an excerpt from a grainy black-and-white 1950s educational film on accident prevention. A cautionary scenario depicts a boy being injured after his companion encourages him to jump from a roof. The definition of *fallacy* appears as a text superimposed over the film: "a mistaken idea derived from incorrect or illogical reasoning."

Like Millner and Buchanan, Finley makes extensive use of found footage in her tapes. By collaging home movies with excerpts from narrative feature films, Millner and Larsen conjoin private and public information. Buchanan enfolds her documentary source material in layers of electronic processing; her images fissure and cohere in a bricolage of truth and fiction. Static pictures and diagrams are juxtaposed with the instructional film clips Finley has included in *Common Mistakes*. For example, photographs from the Carlisle Indian School accompany a verbal narration about this disastrous experiment. The Carlisle Indian School was founded in 1879 by Richard Henry Pratt, who believed that American Indians should be seamlessly assimilated into white culture. Thus, he forced his students to wear Anglo clothes, forbade them to speak their native language, and insisted they cut their hair. A factual recitation of the oppressive practices of this colonizing institution precedes a fictionalized tableau performed by a silhouetted figure who represents an American Indian. Although his testimony is intended to be blatantly inauthentic, he discusses how he was affected by his participation in the experiment.

The nonspecificity of the identities of the series of shadowy personages who provide first-person accounts of the institutional abuses they have supposedly suffered or perpetuated in *Common Mistakes* operates as a concrete demonstration of poststructuralist notions about the decentered author. Roland Barthes postulated in "The Death of the Author" that the author's text creates him or her just as much as he or she creates it.[8] Feminist semiotician Kaja Silverman provided a concise formulation of Barthes's theories in *The Acoustic Mirror*, her treatise on the female voice in psychoanalysis and cinema:

The author is here subjected to a double displacement: First, the "voices" of culture re-place him as the speaking agency behind the text, and as a consequence unitary meaning gives way to discursive heterogeneity and contestation. Second, because this plurality is achieved only and "in" the reader, he or she supplants the author as the site at which the text comes together.[9]

In *The Acoustic Mirror*, Silverman catalogued various techniques feminist filmmakers have employed to subvert theories of subjectivity constructed by vision. Commenting that synchronous representations of the female body and voice subject women to the constraining power of the male gaze, Silverman adduced that filmmakers like Yvonne Rainer and Bette Gordon tend to separate the soundtrack from the image track. In their films, the voice is multiplied, temporally distanced or otherwise displaced from the site of enunciation. Interludes of silence alternate with a reliance on voice-overs and intertitles. The voice-over plays a crucial role, since it represents the power to contextualize images from an indeterminate location, permitting the speaker to be heard without being seen, and thereby disrupts the specular regime of dominant cinema.

Although they work in video rather than film, the six artists I have alluded to likewise avoid the synchronization of images and sound. The voice-over narrator of Cecilia Condit's *Beneath the Skin* never appears on camera. Like Millner and Buchanan, Condit uses her own voice. By speaking in the first person, she raises doubts about the authorial provenance of the tape. Her story is so implausible that it is difficult to credit her pretense of autobiographical genuineness. Nevertheless, her discursive manner is so guilelessly lacking in professional polish that it is also impossible to entirely discount the veracity of the uncanny tale she tells.

Oscillating precariously between a feminist confessional monologue and a lurid tabloid exposé, Condit's account of the murder of a young woman dwells on the disposition of the body, which was decapitated and hidden in a closet. Although they are gruesomely graphic, the images she uses to illustrate her tale are obviously reconstructions. Photographs of mummies and documentary film footage of epileptic fits are inserted as quasi-subliminal flashes into a montage of shots of beautiful women sleeping or frolicking in a dreamy landscape. A densely layered effect is achieved by videotaping projected film; the layers function as veils that simultaneously hide and reveal. Condit manipulates the viewer's contradictory desires to look and not look at the tape's unspeakable forensic evidence by adding or subtracting these optically superimposed veils.

The narrator of *Beneath the Skin* manifests symptoms of a narcissistic identification with the murder victim. Not only were they both romantically involved with the same man, but the narrator admits she has also courted sexual violence. The tape ends with the narrator's allusion to a dream she had in

which it turned out to be her who had been killed instead of the other woman. Visual motifs of doubling occur throughout the tape; one woman's face is often projected over another's, and close-ups of a living woman's smile are edited with shots of the teeth of a grinning skull. However, the tape serves to sever the bond between the narrator and the dead woman. It operates as a therapeutic exorcism that liberates the narrator from the neurotic repetitions of her story by increasing her self-knowledge. The videotaped representations the narrator has purportedly fashioned open up a gap between her own subjectivity and the experience of the other woman. This gap consists of the narrator's realization that she cannot depict her own death, unless she is dreaming.

Such acknowledgment of the slippage between the signifier and the signified subverts accepted patriarchal modes of discourse in the manner theorized by poststructuralist writers like Jacques Derrida. *Glas,* Derrida's philosophical reverie about Hegel and Genet, contains this self-reflexive passage on his own methodology:

The art of this text is the air that circulates among its partitions. The links are invisible, all appears improvised or juxtaposed. It induces by agglutinating rather than by demonstrating, by placing things side by side or by prying them apart rather than by exhibiting the continuous, and analogous, teachy, suffocating necessity of discursive rhetoric. [10]

Helen DeMichiel's *Consider Anything, Only Don't Cry* exhibits a comparably open, agglutinating structure. The tape is an intricately patched electronic quilt comprised of fragments of both personal and collective memories. In the voice-over narration, De Michiel outlines her compositional techniques:

I rob the image bank compulsively. I cut up, rearrange, collage, montage, decompose, rearrange, subvert, recontextualize, deconstruct, reconstruct, debunk, rethink, recombine, sort out, untangle, and give back the pictures, the meanings, the sounds, the music, that are taken from us in every moment of our days and nights.

The woman who vocalizes DeMichiel's text serves as a surrogate authorial presence; she is often portrayed in the act of writing or editing videotape. She is also shown teaching her skills in operating video equipment to several prepubescent girls. Together, they explore various representational formats ranging from Victorian photographs to home movies and old magazine advertisements. These diverse sources constitute the image bank DeMichiel refers to. "External" mechanical and electronic reproductions vie with the characters' "internal" memories, just as public myths intermingle with private daydreams. In a humorous monologue that accompanies shots of a train station, the tape's protagonist concocts a helter-skelter melange of mass media-induced fantasies that veers from marrying Son of Sam to being pregnant with the Son of God.

The title of *Consider Anything, Only Don't Cry* is derived from advice Alice

Helen DeMichiel, *Consider Anything, Only Don't Cry,* 1988.

receives in Lewis Carroll's *Through the Looking Glass.* Near the beginning of the tape, a passage from this book is cited in which the queen attempts to distract Alice from her homesickness by listing other thoughts she ought to entertain instead. Concomitantly, the tape itself might be interpreted as a pastiche of simulations constructed to evade the nostalgia that accompanies the loss of the real. The tape resists closure, circling back instead to a sing-song litany based on repetitions of the word *keeping:* "Keeping my looks, keeping my money, keeping my heart and keeping my man." This litany, which goes on to encompass functional objects, mementos and plants and animals may be conceived as a list of objects that have been invested with libidinal energy. DeMichiel utilizes the video medium to inventory this collection of narcissistic displacements.

The plurality of both quoted and enunciated voices on the sound track of *Consider Anything, Only Don't Cry* erodes certainty by obviating the possibility of a totalizing interpretation of the tape's significance. This sort of fragmentation of univocal authority is characteristic of much contemporary film and video. The valuation of difference is also a feature of recent feminist political discourse. The purview of feminism has expanded to encompass racial, economic, and cultural differences among women. Laura Kipnis's *A Man's Woman*

exemplifies this new theoretical stance by analyzing the behavior of a self-professed antifeminist ideologue from a feminist perspective.

Although Clovis Kingsley, the protagonist of Kipnis's tape, is a fictional construct, Kipnis adopts a pseudo-documentary format to convey her life story. A television news reporter has supposedly been assigned to interview Kingsley's friends, family, and associates. The interviews dissolve into flashbacks that show Kingsley at crucial public and private turning points. The paradoxical gap between her own successful career and her advocacy of restricted domestic roles for women is explored.

In a statement she wrote about the tape, Kipnis addressed the political contradictions that stem from Kingsley's assertion that women can achieve power only by being obsequious to men:

It may be that a leader like Clovis Kingsley is socially effective because she has feminist recognitions of the way men in power work and has formulated a strategy to deal with that reality, even while refusing a feminist politics that would disrupt the deployment of that power. All women have to have a strategy, and what looks simply like self-limiting behavior to those who would view a woman like Clovis with a certain feminist horror, might effectively be understood as a limited strategy of empowerment, and thus a common ground between right-wing women and feminists.[11]

As this statement indicates, Kipnis eschews the didacticism of some earlier feminist rhetoric. *A Man's Woman* raises sticky issues about whether profamily women have been excluded from the feminist orthodoxy. The tape daringly focuses on a woman who is not a positive role model, presenting her antifeminist position in a manner that is both empathetic and ironic. From Kingsley's perspective, feminism can be interpreted as another index of female failure. Her alternative, outlined in a book titled *The Power of Total Submission*, is to counsel wives about how to engage in kinky sex while continuing to uphold traditional Christian values. In one humorous scene, Kingsley demonstrates her practice of greeting her husband at the door of their house wearing nothing but saran wrap, and then suggesting that they pray together.

Parody figures prominently in *A Man's Woman*, as it does in *Out of the Mouth of Babes, Common Mistakes,* and *Beneath the Skin*. Millner speculates in the *Afterimage* interview cited earlier that humor can work subversively by suggesting that accepted hierarchies may be controvertible. Humor is one of the rhetorical strategies the artists I have mentioned use to make their work more accessible. Adopting popular culture formats as Kipnis does when she emulates the conventions of the television documentary is another method these artists have employed to reach larger audiences.

In their messages and modes of address, these artists inscribe themselves in the discourse of the other. Kipnis ferrets out the feminist aspects of an antifeminist theoretical position. Buchanan implicates herself as a witness to politi-

cal atrocities, just as Millner acknowledges the ways in which her own family relationships replicate oppressive patterns of hegemony. Finley stockpiles bits of evidence to undermine the legitimacy of institutionalized practices of education, medicine, politics, and the mass media. She couches her critique of the credibility of official discourse in rhetorical modes that undercut their own veracity. Condit violates the taboos that seperate the living from the dead by merging the identities of *Beneath the Skin*'s narrator and her slain counterpart. DeMichiel fuses public and private memories in a lyrical tribute to the nostalgic potency of historical documentation.

Video seems ideally suited to serve as a vehicle for the heterogenous discursive practices of contemporary women artists. Its capacity for accommodating hybrid expressive modes facilitates the feminist project of constructing alternatives to the dominant dichotomous patriarchal world view. Modernist-inspired attempts to identify intrinsic properties of the video medium failed not only because of the medium's fluidity, but also because technological advances are continuously altering its physical apparatus. By taking advantage of video's potential to function as a palimpsest for the inscription of multiple messages, the artists I have mentioned here have forged a new hybrid of the genres of social documentary and portraiture. Since video is used to broadcast public information within the private environment of the home, it serves as an appropriate medium for investigating the imbrications of the personal and the political in our increasingly regulated society.

Gary Hill, *In Situ,* 1986.

Video Writing

RAYMOND BELLOUR

Everything attests to the fact that video is more deeply rooted in writing than is cinema, that it gives real life to Alexandre Astruc's prophecy hailing after the war the birth of an avant-garde he defined as the age of the "pen-camera." This is conveyed in essentially two different ways. First, the presence of the image in real time, which puts it at the disposal of whoever wants it and thus traces between the image and language a common line, fragile yet real, around the idea of reserve, of stock: we will always have an a priori image in front of us since we are naturally immersed in the matter of language. Then there is the possibility, here again linked more or less to real time, of treating this image and transforming it, that is, of freeing it in an all the more natural way from photographic reproduction, since the very principle of its formation is in part foreign to it. We can say in a sense that the image is "written," in varying degrees, when its preexisting matter is modulated with the aid of various machines, as well as when it is even more deliberately conceived with the aid of a graphic palette or a computer. One might just as well say that it is "painted": this is true, and I believe that the profound discomfort that comes across us when we are face to face with one of these new images stems from the way they force us to reform, together, and to project into a still unlikely future the two oldest gestures of expression linked in the human hand: the lines of a drawing and of the letter. In video, however, the metaphor of writing has an advantage over the metaphor of painting. On one hand, it is more directly inscribed, be it in negative, in the circuit of communication characteristic of television, with which video and video art maintain the close and conflictual ties we are well aware of. On the other hand, and this goes back to the previous point, the register of writing is larger, in the sense that language has a hold on everything and can even speak of painting (without, for all that, having a privilege over it).

In this sense I thought it would be interesting to bring together, afterward, a series of short, very diverse texts that were sparked by video works—four installations, one tape—whose only point in common is their drawing out and inscribing in diverse manners the metaphor of writing, even if this is done in a diverted or apparently secondary fashion. Thierry Kuntzel's *Nostos II* (1984) does this by borrowing the theme of the letter from cinema, the letter that is written, is sent, or is burned, but in any case the letter that burns those to whom it is addressed or those who see it burn. *Video Letter,* a unique case, is a real exchange of letters; it is a new kind of exchange that has been

made possible by video. The two installations by Bill Viola and Gary Hill rely directly on two authors' texts: the first, on the poems of Saint John of the Cross, of which the almost absent murmuring illustrates a writing situation through which the video creation, made emblematic by the installation, is highlighted; the second introduces a narrative by Maurice Blanchot at the heart of both the installation's apparatus and the tape which is its center, and its words, literally, become image and support both the body and the theme. As to Muntadas's installation, it bears witness to a dimension that has become essential in the overlapping that is taking place between video and writing: words are inscribed, write themselves on the screen, as is the case more and more often in so many tapes and films, for example in the work of Godard. As they also do then and again, as will be seen, in a particularly striking manner in the screen of *Video Letter*.

Something strikes me, running once again through these works brought together in this way by the presence of a power, both literal and metaphorical, which comes from writing: in three of them (Kuntzel, Muntadas, Terayama-Tanikawa), this upsurge is linked to the thrust specific to an image force, which following various modalities ties photography to painting. This confirms, if necessary, that video is par excellence one of the places of passage where ancient gestures, more or less specific, change their meaning and become one by unceasingly intertwining one with the other.

The Burning Memory

There are images that burn. Already in Hollis Frampton's *Nostalgia* one sees photos consumed one by one in front of the lens, traces of a life recaptured in voice-over each time after the photo has already disappeared. In *Nostos II* (1984) the image burns in its very essence, the return of the return of nostalgia, up to the insupportable. Six years ago in *Nostos I* (1979) Thierry Kuntzel began his work on the traces that memory leaves behind, wipes out and recaptures again, the agitation and pain of a memory at work. Now he shows us a memory burns. This is the unique effect of his installation. The mental image, the true image that consumes the body, builds itself up there in time, yet still retains its instantaneity.

Nostos II tells a story. But the only subject of that story is time. Four parts, four times, four aspects or functions of time. The woman, the unknown, smokes a cigarette: the pure time that passes, time consumed. More and more photos are accumulated, piled up, disappear, return: the time of memory, the anamnesis of time lost. Pages of a book turning incessantly: time leafed through, the conjugated time of culture and idleness. The unknown throws letters into the fire, into the fireplace, the image which serves as the leitmotiv

Thierry Kuntzel, *Nostos II Sequence 2*, 1984.

of the four parts: through this action, which unites present and past, as in the time of the photos and the book, we again enter, in a different way, the time consumed.

How does this story of time become a spectacle of our mental activity? How does the spectator, projected outside herself or himself, come to experience the functioning of her or his own mind? First of all there is the "drag" of the *paluche* [a new French camera] brought out of adjustment, which gives the black-and-white image a material of its own, sluggish light tracing round each movement (of the camera, of the actress's body, of the objects manipulated) contours of a ghostly character. This white material duplicates all the elements in the representation and binds them together: it accentuates what one sees, but at the same time it makes it unreal, while making one believe all the more in that very unreality. Strictly speaking, there is never an image in the frame, but layers of images, each level with its own internal time, which does not correspond exactly with its duration, but rather with the mixing of the layers of material. In the sequence of photos for example, which are substituted for one another. There are moments when this reaches the point of vertigo, when this fusion takes place against a window frame that appears to

come from another image but is, nonetheless, part of the same one: this mobile, fluctuating, fugitive, but nonetheless present framework is the open space, the material and psychic screen on which all the images deposit themselves and from which they spring.

The light is sluggish, but it also irradiates. The smoke of the cigarette, the flames in the fireplace, for example, grow inside the frame, invade it, and die there, making time into a material of which the energy rises and falls from too much white to its vanishing into the black. This time of traces, of layers, of impressions is full of intensities.

But these layers, these intensities, this time that will not pass or finish its transformations; all this has the violence and brilliance of a snapshot. Or rather, starting with the snapshot, an elusive and indefinable time is created. Nine scenes: the image appears here or there, here and there, just as the reminiscence arises in the memory logically or, equally, arbitrarily. There are 1, 2, 3, 4, 5, 6, 7, 8, or 9 images, always more or less different and playing on those degrees of difference (with the sole exception of the shot of the fireplace), which supplement each other, cross each other, react to each other, spin around on this screen of screens. A block of images that fill it completely (sometimes: the fireplace again), because emptiness regulates their circulation. The black is fundamental, blacks largely preserved, from which the images can be born, a bit more, a bit less, always unexpectedly. Thus the montage of the nine tapes is the patient, skilled, and implacable operation whereby the explosion of psychic time installs itself in space, in all the excess and arbitrariness of its insistence.

This makes *Nostos II* one of the most direct expressions of the "magic block," posited by Freud in his attempt to represent the psychic mechanism. A few years ago Thierry Kuntzel asked himself whether the "film mechanism" (the "unconscious" of film, the displaced, condensed analyzed film, the film of the film, "the other" film) might not be this magic block that Freud was not able to discover in it? From his first tape onward (the working title of *Nostos I* was "Wunderblock" for a long time) Kuntzel has thrown all his energy into making visible this question via which the video film gives a new turn to the destiny of the image machine and completes the cinema film. But he has never quite hit the mark until now, in this installation. That is why the cinema film can draw on it.

The last time in *Nostos II:* the cinema film as memory and quotation. And with unbelievable violence: the call of the fiction. All that is needed is, at the beginning and end of the film, a bit of music and a voice (and on the leitmotiv image a few short rising scales). Anyone who has not recognized the film will, I think, get from this a confused, but very vivid impression of *déjà vu.* As if at a hypnotic click, he or she will at once enter a space from the past:

the fantasy on which the American feature film is based. The spectator familiar with *Letter from an Unknown Woman* will experience something more piercing: he or she will remember with a shudder that in that film (along with *Vertigo* perhaps the cruelest ever made in America) a dying woman—the unknown—is writing an immensely long letter out of which the film flows. A letter addressed to a man who could not love her and who could even end up by not recognizing her because he had never seen her as anything but an image.

The Last Man on the Cross

Why Blanchot? Why *Thomas the Obscure?* Because in the first chapters of this book, in the chapters read by the hero, the actor-author of *In Situ* (1986), there is an extraordinarily violent clash between sight and language. Thomas—and this is perhaps where he gets the name Obscure—Thomas loses himself, disappears, in the intimacy of his own gaze, which he experiences as coming not from his body, but from outside, from the night, from the very silence of things. And the words, because Thomas is also a reader, the words enter into this triumphant and threatening gaze, they radiate from it like the eyes of living beings, of animals ("a gigantic rat, with piercing eyes, gleaming teeth"), exercising a hold over him that is like the hold of a fight to the death. It's understandable that Gary Hill, so haunted by the materiality of language that for years now he has made it the principal tool of his compositions, was tempted by a work of fiction that he opposes here, in both a metaphorical and real manner, to the fiction and the apparatus of television.

What does the implied spectator, to whom Gary Hill offers a comfortable chair, see in the tape that appears and disappears, in short sequences, on the single monitor of *In Situ?* First the ocean. Then the eyes of the man we'll call the hero: the left eye and the right eye, in turn, in extreme close-up, wide open, yet twice closing violently, too violently, as if to nullify an intolerable sight that must nonetheless be tolerated. A zoom-in pictures a fragment of a page from *Thomas the Obscure,* the words "staring into the . . ." can be made out. Then again, the ocean, the sky. And close-ups of the hero's forehead and his feverish hands, which are suddenly interrupted by an inaudible voice on the soundtrack playing backward. This sound introduces the tape's second series of images: television images, on the Irangate crisis, the sale of arms to the Contras, we see Reagan, and so on. Twice these images intertwine with those of the first series: first in a long series of double exposures and dissolves; then in parallel editing (or the two great implication principles of any narrative told in images). In between these two interventions of television, the hero, seated at a table, eats while reading *Thomas the Obscure.* And twice he collapses in his chair and falls back. The first time he begins reading again while lying on the

floor. But the second time he shoots back up as if surfacing from an underwater dive and then swims with difficulty for a long, long time (this is when the parallel editing is used).

It's obviously very simple, too simple, to see in this editing a criticism of information, of televised disinformation, skillfully set up by the elements of the general apparatus. In this room that reproduces the proportions of the monitor, the carpet (a stylish gray) is lined with stripes that bring to mind the lines of the video frame, and the armchair (covered in gray velour) is so comfortable that its occupant slides naturally toward the TV set, lets himself glide into the image. To underline this, Hill thought of modifying the monitor and the armchair in the same way, by reducing the size of the cushion in the armchair and by placing the monitor in a frame that exceeds it in exact proportion. From this comes the reinforced effect of the TV images themselves, most often reduced to a partial frame in the center of the image. What's more, they move backward in this frame, with the same movement that makes Blanchot's reader fall back. It is done so thoroughly that when the hero swims, and seems about to drown, he swims in information, it is information that lures and then smothers him. But it is also (this is where the criticism is really interesting, that is, intelligent) Blanchot's text that he crosses, in which he swims and floats. *Thomas the Obscure*'s reader will not have forgotten that Thomas, in the first chapter of the book, is so wrapped up in his effort to resist the swell of the ocean that there is a moment when he almost lets himself be killed. And a very careful reader of Hill might have made out, in the numerous pages of the book that are centered and wavering in such a way that we can't really read the text, part of the story's first line: "(Thomas sat down) and looked at the ocean". The ocean that appears in the tape's very first shot and comes back several times (already, in 1979, the first line of *Processual Video* (1980 "He knew the ocean well").

And so there are two deaths at work here, both metaphorical yet, nonetheless, full of significance: one comes from television (here Gary Hill puts himself in a well-known position that has been developed at length by American artists); the other comes out of Blanchot's text and is much more original, reproducing in a very exacting manner (I don't know to what extent Hill was familiar with the text or even aware of it) the way in which Blanchot introduces the relation between the literary word and something he calls the "rumor" or the "foreign voice" into his essays. He opposes the two, obviously, in the same way this has been done since the nineteenth century in the name of the specificity and autonomy of art. But he introduces the idea that from this point on literature comes into its own and can show its difference only when it confronts, head on and even excessively, this rumor and even risks being confused with it. Because the two are cut from the same cloth, their difference being that the literary word exists only to oppose this rumor, to oppose all forms

of dictatorship contained within it, by confronting it with the only force it has left: its silence. From this comes its power to withdraw, its special intimacy with death.

Gary Hill knew how to give direct expression to this intimacy in an installation whose elaboration went on before and after the creation of *In Situ*. In *Crux* (1983-87), in a desolate island landscape featuring a castle in ruins, five monitors reproduce the partial images from five cameras attached to the author-actor's body: two on his feet, two on his hands and one at his waist, aimed toward his face. The text that accompanies the gait of this disconnected body is itself a "blank" text, it doesn't have the essentially machinelike quality of most of Hill's other tapes: it is a text of desperation and of wandering, close to some of the writings of the *nouveau roman,* and in particular to those of Blanchot, whose dislocating and decentering force is captured by Hill. From this solitary destiny, that in fact isn't a destiny at all because it has neither beginning nor end, the hero bears the cross, alone (a cross designed in the installation by the five monitors). He becomes one of many possible Christs (there are *Four Hundred Men on the Cross*) which Michaux made into one of the key points in the domain of modern literary imagination, and Blanchot's *Last Man* who is his counterpart. Christ as the last man. The last two shots in *In Situ,* seemingly detached from the rest, have this same erratic quality: a quick—we almost want to say running—overhang, in a park where the ground is covered with dead leaves; followed by the resumption of a similar movement, this time showing to the contrary the trees, and centered on the character's back, which seems to carry the weight of the world. With the difference that his cross is shown here when he turns around and presses the remote control, and when the image disappears: his cross is at once his wild race, the equivalent of his wandering word taken over by Blanchot, and television.

This is what comes out of the very subtle confusion brought about between the acts and the positions that bring together these two series of opposing images. But Hill, in order to arrive at the conceptualization that he wants to produce in this manner, included the first device in a second one without which it would have only a limited meaning and through which it expresses something that Blanchot cannot say in the same manner, because it has to do with seeing and touching. Hill has, in fact, arranged in his space four pillars that can suggest the cardinal points of the field of information. But above all, each of these pillars has a ventilator, which is tied to another, stronger one, which intervenes between the spectator and the TV set. Their main function is the dispersal of the leaves that fall in regular intervals from a machine and are strewn little by little over the ground by turning haphazardly around the spectator. These leaves, and this is the installation's true stroke of genius, these leaves reproduce the images (and the texts) of the tape that is playing at the same moment on the screen.

I prefer to leave to the imagination all that can be said about the way the cinema—or video—device (here it is all the same, with the difference that video, once again, is able to say or to show better than cinema itself what cinema is, and what it becomes through video) is illustrated by this effect of doubling. These swirling leaves are photograms, the successive impressions of the "magic pad" in which Freud saw the truest representation of the subconscious, they are the stratum of the "film apparatus" made visible, the layers in which Thierry Kuntzel so clearly saw a more exact replica of what Freud was trying to imagine. They are also the pages of the Book (all books and any book) in its uncertain fall, its dispersal, its cast of the die. But above all, I would like to express the jubilation that comes over the spectators/guinea pigs when we understand that these leaves, which are more or less falling on our heads, are the images that are entering into our brains, something like the layers of skin on the skull. Gary Hill told me that during the creation of *In Situ* in Los Angeles, the eye that is the first image reproduced on paper became stuck, in falling, on the eye that appeared at the same moment in the monitor. It stayed there until a spectator got up to take it off. A matter of not letting our perceptions wreak too much havoc in our ideas. Or maybe it's just the opposite.

Video According to Saint John

The room is completely dark (or almost), immense. On a large screen half covering the back wall, black-and-white pictures of mountains file by one after the other, moving in an unsteady, rapid, never-ending rhythm. The wind blows, the noise is deafening. In the middle of the room a cube, just barely as tall as a person, reproduces the cell where Saint John of the Cross was shut away for nine months in 1577 (abducted by monks who couldn't stand his excess of godliness, of asceticism, his pretension in drawing too close to the divinity). Intrigued, the spectator's gaze passes through—if we bend down—a small opening, taking the place of an imaginary window, into the interior of the poorly lit cube: a table, a glass, a pitcher of water, a minuscule color monitor. The spectator sees a mountain, filmed in a still shot and in real time. (It comes from *Ancient of Days* (1979–81), one of Bill Viola's strongest tapes. It's one of those where the metamorphosis of time that so obsesses him is expressed in its purest state: the passage from the time of sight and then recording, to the time of imagination in the final editing. This editing tries to retrieve in perception itself the condition of memory and the condition of the anticipation of mental images, in order to enter into the absolute, global time of the sensorial-conceptual affect). We can barely make out the movement that stirs the trees and the bushes in this image, the slow, very slow mutation of the clouds. Still in the cell, a voice that seems to rise up from the floor recites poetry in Spanish, fragments of the *Dark Night of the Soul* written by Saint John during

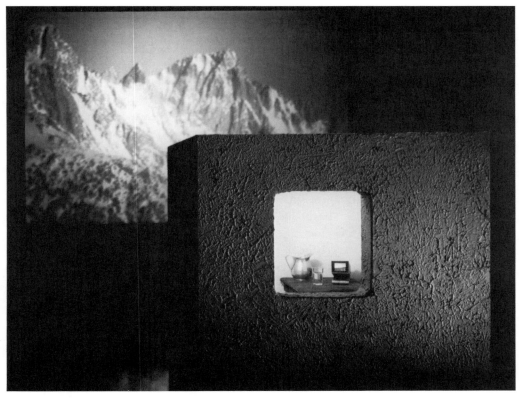

Bill Viola, *Room for St. John of the Cross,* 1983.

his long reclusion: a voice just barely audible if we make the effort to bend
down just a little more, but always covered over by the howling of the wind
that blows outside.

All of this, we understand it, is about the relation between two spaces. In
the same way that we hear the voice in the cell, we can't see the entire image
on the large screen without difficulty, without being "bothered" by one of the
angles of the central cube. Unless we cross to the other side of the cube, and
then are too close to the overly large image, which we leave behind in order to
find a feeling of unity, in order to decompose and reconstruct a route along the
various "stations." A route whose quality as tangible mass is in no way dimin-
ished, because it concerns perception, the body and memory all at same time,
and presents a virtual conception of their relations. Everything depends on the
position (physical and psychological) that the spectator comes to invent, di-
vided throughout these wanderings between an inside and an outside, numer-
ous insides and numerous outsides.

But why Saint John of the Cross? Let's say: to try to express what has
taken the place of God in our day. We suppose that in his windowless cell,

which he leaves only to go to the refectory where he is subjected to psychological and corporal trials, Saint John has kept the memory of a landscape: he keeps deep inside himself the image of a perception. This, above all, is what the presence of the small color monitor can suggest, if only in an overly realistic manner: what remains of the world, unshakable, when there is no more world, when it has been reduced to a still (almost still) image that acts as an inner ascension toward the light. This is the point Saint John would depart from to plunge into the "Dark Night," there to meet God. Metamorphosis of image into poem, of any overly visible image into an indirect image of breath and of verb, once all organic mass has been abolished.

Haunted by the "irresistable power of the landscape," Bill Viola strives to invent a relation of the same order through video. By putting the small monitor in the cell and the cell in an enormous black box, Viola is constructing a machinery that attempts to represent the functioning of imagination and inspiration, like the functioning of the video tool that simulates and produces them. Viola reminds us in this way that video is itself a permanent double of the landscape, of everything that the camera—which has become the potential eye of the new mystic—looks at in real time. This is the second thing suggested by the small color picture of the mountain. Viola then tell us that this continual perception is connected to an inner rumbling: a kind of organic furor, an uninterrupted flow of images-sounds. Out of the live, raw image, as it were, comes a type of body-image without which not a single transmutation would be possible. In welcoming this force, perception-video undergoes a metamorphosis, is transformed into a poem. Through this process we go back and forth from the inside to the outside of the image, we transform its theoretical exteriority into a form of visionary animation.

This is what is implied by the continuity made up of such clear contrasts between the organic, black-and-white image (founded on a kind of breathless panting, as if it were always just about to overflow the frame of a screen to which it doesn't really seem destined) and the color image (framed, placated, immobile and silent, almost too simple, displayed on the monitor, on the table, in the cell).

The confusion experienced by the spectator-stroller, if we take the time to think about it, comes from the respective position of the two images, which can't be seen at the same time and are, nevertheless, sent to us as a whole, and what's more are sent one in the place of the other. But this only happens in one direction, when we go from the large image to the small one, from the immense camera obscura to the lit-up cell. Obviously the archaic, nocturnal image gives a more direct material representation of the inner turmoil, which is resolved in a mystical poem, than does the technological vignette. In this sense it occupies the place of God, or rather fulfills the function of the image (and body) state that leads to God. This is why the sound of the wind, which

enters with the spectator inside the cell, is so important. It allows the spectator to experience the two images at the same time. We are haunted by the memory of the large one, carried by the sound, at the very moment we look at the small image and confuse this double vision with the murmur of the poem, which seems to rise up from the ground. But for the analogy to work, the image on the monitor in the cell must appear to be simultaneously a calm relaying of the large image and a television image. Only then will the journey that leads to the poem's "Obscure Night" be credited to video, capable of reproducing this experience because its capacity of assimilation almost offers a guarantee that it can be relived and metamorphosized. This is exactly what happens when the spectator leaves the cell, from this moment we could say that its memory haunts us. And facing this immense, vibratile and dark image, in the installation's second (yet for the spectator previous) night, we find both the obscurity of Saint John's cell and a psychological freedom (translated by our freedom of movement). And thus it is a tumultuous version, before and after, of the Kantian adage, without any (moral) law but that of potential ecstasy, the star-studded sky transformed into a sky of images above our heads.

The Art of Demonstration

The art of demonstration has its own kind of sensual pleasure. It's all in the way of doing it, in the choice of the material. Demonstration is then the art of living, of surviving among the monsters. An art of defense and of/*de* monstration. The art put into practice for example by Godard in *France Tour Détour Deux Enfants*. Here he travels regularly among monsters: among those who have forgotten the very meaning of words, the meaning of the most elementary questions, adults, television viewers; this is what he and the two children demonstrate. Everything depends on the way of doing it. On the material. These monsters can't be underestimated. The demonstration is accurate, that is to say effective, only if it is sensual and generous, able to compete with what it deals with, to use seduction to go beyond the appeal of monstrosity itself. In Godard it's the art of colors. Also, a great lesson from Brecht: the dialectic of conflict will be all the more clear if the poor really seem to be poor; and so their costumes will have to be made from the richest fabrics, as rich as the clothing of the rich, perfectly catching the light.

 The Board Room (1987) relies from the start on the sensual pleasure of pedagogy. A luxurious and calm atmosphere envelops the visitor who wanders into this dimness lit up by a warm, shimmering light. Lit from underneath by an invisible red light, a long oval table seems to float. Like a large mirror, its surface reflects the blurred images of the thirteen portraits that surround it. The glow from the portraits reflects off the metallic structures of the thirteen chairs arranged around the table. An attentive spectator will notice (thanks to

Muntadas, *The Board Room*, 1987.

the central portrait, in the background, the only one placed exactly in line with the seat at the end of the table) that the backs of the chairs were designed in proportion to the size of the portraits. As if a board of directors, mythically called together in absentia in this room, would have liked to endow themselves, in their own eyes, with a maximum of symbolic efficiency.

The second movement goes toward these portraits, collectively and then one by one. The brightest light radiates from them. Its two sources: a small lamp, hooked onto the top of each image that gives out a constant glow; and the varying flame bursting forth from each of the micro-monotors that take the place of each speaker's mouth. A well-ordered gaze should cross through three stages, thus passing through the three most important (historical) modes of representation and portraiture. First it comes to rest on the gilded frame of a painting. Next it enters into the "real" image of a photograph. But everything has been set up here so that the emblems linked to the portrait since the Middle Ages and the Renaissance are represented here (and so that painting then continues in photography): clouds, drapings of red velvet, blurred landscapes, inscriptions, images within the image, one or two uniform backgrounds. Finally, the spectator enters *Television*. Displaced in this manner, it becomes par-

adoxically one more pictoral element inside the photo-painting: the art of video art, of mixing and turning back onto themselves the different levels of representation.

In *Television,* in each of the small monitors, the spectator initially sees light. A bluish white that flashes and leaps out from the screen, in contrast with its surroundings. A very attentive spectator will next make out acts: scenarios, lessons, appeals, strategies of seduction. Each one seems even more incredible than the last, and at the same time oddly natural. The thirteen charismatic leaders brought together by Muntadas to represent a board of directors, a sort of central committee of political-religious delirium and of audiovisual communication, are engaged in their great maneuvers. Two of them are included here to widen the scope, to extend it from America to the rest of the world and to make us wonder about this projection: Khomeyni, John Paul II. The eleven others are American evangelists who have become surprising businessmen, holders of an immense power that comes mainly from *Television.* In these tapes edited in loops (of varying length: from 5″ to 45″), we feel the shock of advertising strategy in its purest form (several of the tapes were conceived by the leaders themselves, they can be purchased or rented). Here we come across the persuasive force of a proven rhetorical style, oscillating between mythical autobiography and the lives of famous men. The power is distributed here in couples, in descendants, in families (Billy Graham and Schuller have sons already prepared to take over the helm). We marvel at the mix of races (Maharishi comes straight from India, the Reverend Ike is black, Rabbi Schneerson is Jewish, Moon is Korean). It goes from California cool (Schuller) to intellectualized manipulation (Erhard), from all-purpose prophesy (Graham) to the strong-arm right (Falwell, Robertson, Swaggert). We hear enormous budgets being set forth here by a new type of corporation, one that owns television stations, hospitals, and universities (Robertson has an annual budget of $50 million to $70 million; Falwell, $100 million). In fact, the things we see here are inconceivable. Swaggert in overflowing stadiums, attracting up to 90,000 people. Moon marrying 4,000 couples at one time. Falwell, fully dressed and up to his knees in water, blessing the letters from his followers, preparing small bags of water that they can use to rebaptise themselves in front of their TV sets, and his son blessing his father's wallet. The Reverend Ike sending out handkerchiefs to be left overnight under a pillow and sent back to him the next day (preferably with a check). Pat Robertson, candidate for the presidency of the United States, head of the country's fourth largest network (Christian Broadcasting Network) is there, improvising (or pretending to) on a board an advertisement/general science lesson about the origins of the Creation, God, and the greatness of man, of which the almost sublime stupidity fulfills in one fell swoop the dreams of Flaubert and of Godardian pedagogy.

Muntadas, *The Board Room,* detail, 1987. Muntadas, *The Board Room,* detail, 1987.

But above all, in all of these tapes that parade by like waking micro-nightmares, the truly attentive spectator will discover bodies. Real bodies at work. Believing, active, hysterical bodies. Bodies full of violence, of hatred, uncultivated bodies. Bodies greedy for visible power, for crude manipulations, for short-term profit. Look closely at Roberts in his baptismal waters. Watch Swaggert, striding across the stage, stopping, howling, handling his microphone like a rocker (he is to top it all a cousin of Jerry Lee Lewis). Listen to all of them, renovating the oldest ideologies in the world. God. Jesus. The prophets. Morals. Purity. Power. Money. It brings back old memories. Very recent ones, too. Le Pen's body is made of the same matter. The two Serges of *Libération* (July and Daney) repeated it at leisure during the French presidential campaign: this man pleases, he believes in the sensuality of the word, he hits you in the guts; his success is not only due to the real conflicts that are poisoning French society, but comes from his knowing how to play with them, to play them, directly, with a disarming vulgarity, a deep understanding of the body-as-show, by using television like a sexual caress. The voluptuousness of horror. We, also, could see a new school of preachers (we already have, for a short time now, our apostolic Christians). This is what strikes us if we draw close enough to these little screens, if we stay around long enough. We can't help but notice, each time we again step back to set out on our way, the effect produced by these so tranquilly obscene images in relation to the entire image, the paintings that they puncture: they are the natural complement to idealized

poses, with their eyes fixed either on our own or along the thin blue line of sky that they promise. The image in movement is at the service of the still image, the stereotype, the icon image that hides in it (in that the second receives from the first its body, its true grain of reality), which accordingly founds its (illusory) exchange and communication values.

Finally, the spectator will see words appear on these screens. In capitals, key words, proper names, abstract terms, in a varying rhythm (REPENTANCE, MONEY, FINANCIAL, POLITICAL POWER, TELEVISION, GIFT, EDUCATION, DEGREE, PROPHESY, RESOURCE, PACKAGE, for Falwell, for example; others have more, Khomeyni has only one: REVOLUTION). These words have an analytical, catalytic function. They speed up the relating of moments of discourse, the production of effects of discourse on the bodies of the actors. In this way the words inscribe the moments and effects in our imagination on the bodies of the spectators, these tens of millions of unfulfilled Americans who regularly send to their gurus the money necessary to their prosperity. These words have their own efficiency, their own sensuality. They prove once again to what extent video's function of inversion passes through writing. Writing is conceived here as a particular type of image, fragmented, intermittent, a network of raw significations that allows the image to become unstuck from itself without, for all that, causing it to lose its seductive force. A minimal critical discourse that holds together a comprehensive apparatus, itself entirely conceived as a doubling over.

In *Monkey Business*, Howard Hawks found a gentle way of taking a caustic view of the falsely majestic set of the board room of an American company specializing in the pursuit of dreams and illusions. In this room he united Cary Grant and Ginger Rogers, returned to the state of childhood thanks to the virtues of a potion of youth, Marilyn in the natural state, and a monkey, the unknowing inventor of the product, B 4 (the "Before"!). Powers of fiction and of comedy. It was the time when movies still knew—in the mode of playful reinvention—how to integrate social criticism into the development of their own myth, into the American society it mirrored, which hadn't yet been numbed to the bone by *Television*. Today, this video installation offers Muntadas the bias of a sensuous pedagogy founded essentially on mimicry. Its critical liveliness comes from its capacity to carry out displacements between elements and to make them insistent, so that they seduce by signifying, even by oversignifying; but only if the discourse thus produced also manages to maintain a quality of silence. The journey depends on this. In the catalogue of his recent retrospective in Madrid ("Hybridos"), Muntadas brought three photos together 28 times on a double page: one shows a motif of urban architecture, the next a board room, or a meeting room or work space. The third frames in close-up, and in a smaller format, one (or two or several) hand(s) caught in the quick of life, with their grain of reality, thus imprinting a circulation between the

Shito Terayama and Shuntaro Tanikawa, *Video Letter,* 1982–83.

other two images. As in *The Board Room,* where we go from the screen to the portrait then to the entire room, after having followed the opposite route, if we choose to, thirteen times.

"The Letter goes on . . ."

The letter goes on and on. It never stops saying, wanting, wanting to say more, if it is a real letter.

In film, the letter is often unique. Relentlessly, it points to one of the essential qualities of the letter—that elliptical space of loss around which some of the greatest films have constructed their scenarios: Ophuls's *Letter from an Unknown Woman,* the ultimate example of a letter driven to vertigo; or Mankiewicz's *Letter to Three Wives,* where three letters—addressed by one woman to three other women—carve a furrow of secrecy into the placid surface of things. The letter is like a one-way street. Even when it names a supposedly "real" interlocutor and through this tends to multiply, to become fragmented and thus relative, it always steers toward an ideal vanishing point, an empty place around which its words can come together, because it was here that they came into being (for example, the empty bed in Frédéric Mitterand's *Lettres d'amour*

en Somalie). And even when the letter becomes one degree "truer," that is, leads to a real exchange (between a mother and daughter who write and respond to each other, as in Chantal Akerman's *News from Home*), in the image—and thus in the most vivid point of the "letter" addressed to the spectator—we see only one point of view (in *News from Home,* the geography of New York, where the daughter is thrown off balance, leading to the correspondence with her mother).

So the advantage of the video-letter (should we see this only as a stroke of luck?) is having permitted (at least once) a "real" exchange. Those vanishing points that are common to all letters are traced unpredictably here, along the lines of an everyday life that is quite obviously simulated, disguised, elaborated (it's not a matter of a simple correspondence, published afterward, etc.), but which is no less decisive when it comes to what we might call the inner body of the letter.

For almost two years (Tokyo, 1982–83), Shito Terayama—poet, man of the theater, avant-garde filmmaker (of sorts)—and the poet Shuntaro Tanikawa jointly conceived this video-letter that comes sadly but "naturally" to an end with the death of one of the two correspondents. Katsue Tomayama, producer and cofounder of "Image-Forum," pushed these two old friends to experiment in this format popularized in Japan by the extraordinary growth of consumer video (although their attempt also recalls the ancient tradition of the exchange of poems, one of the equivalents of the occidental ritual of the literary correspondence). At home, with minimal equipment, each one filmed letters made up of images and sounds that would be sent to the other as they were finished, like so many answers. The tape consists of sixteen letters-fragments that are linked together by a very simple principle of alternation. Each one opens with a heading bearing the names of the sender and the addressee. And yet, the greatest strength of *Video Letter* is the way it introduces doubt into what would seem to be above question in an exchange of letters: the identity of each of the correspondents.

It isn't that we don't recognize them. We see them appear very distinctly, physically, in at least two sequences. Numerous marks of enunciation punctuate the exchange (Terayama says several times: "Mr. Tanikawa . . ."). And above all, the difference in the voices, the tones, and even the registers of language, imperceptible to the European spectator, clearly establish who is speaking for the Japanese spectator, to whom this correspondence is initially supposed to be addressed. Two lives are also sketched out here, and through them, two styles, two modes of relation to time: for Tanikawa, a kind of zero biography, drier and more disconcerting, seeming to focus on instants; for Terayama, a few fragmented yet very strong signs that develop a story over time—photographs of youth and childhood, of sickness, of a mother's aging.

And yet a certain uneasiness persists (I hope that I'm not the only one to

feel it). Now and then, for a brief or lasting moment, we find ourselves in a strange in-between: we're no longer quite sure who is speaking. Even if its modes vary, this effect comes almost entirely from the power of the autonomy of the image, which cannot guarantee in and of itself the separation of identities at moments when it isn't made clear elsewhere.

This slipping of identities is made possible from the outset by the fact that, contrary to a published correspondence where each name appears on every page like a running title, here the name is mentioned only once, at the beginning of the letter, making it more difficult to find than in a book. This arrangement is in no way mandatory: we could just as well imagine names inscribed on the page/video-screen and thus given a stability analogous to the one they have in a book. It can happen then that we forget the name. We forget it all the more readily in the letters without words (there are several of them), or of few words (there are many of these) and moments when the image becomes at once ambiguous, opaque, and open to too many meanings. It also often happens that we see fragments of bodies appear in the frame instead of faces or recognizable bodies: legs, a back, mainly hands, doing tasks, holding objects. This is one of the ways we lose the thread of the exchange, hanging onto names that flee, onto bodies that don't support them. But this fragmentation goes well beyond the bodies and touches the representation as a whole. It contributes to a general uncertainty about what is seen in the image, and above all about the point of view that makes it visible. This, in turn, reinforces the natural tendency of the image to become "objective," to retreat into its opacity—that is, to open itself up to infinity, without being attributed to anyone. The numerous marks of identify that punctuate the exchange conflict with this ambiguity, to the point where we find ourselves in a strange situation: we clearly hear two men who are really speaking to one another, and yet from time to time we don't believe that we're hearing either one of them, and it is precisely this that leads us to doubt the identity of the one writing, as if they were one and the same.

Two sequences are particularly disquieting in this way: the first, where Tanikawa is writing and yet for a long time we see Terayama in a photo album (that Tanikawa has come across, he makes clear only afterwards, once the uneasiness is felt); and the next to last, where again Tanikawa is writing, but in the image we see (how is it possible?) Terayama speaking, though we can't hear him, to an indefinite offscreen space, where a woman's voice cries louder and louder.

So, it's that much more understandable when one of the correspondents tries at a certain moment to define for himself this shifting and mixing of identities unique to this exchange of video letters (yet perhaps going beyond it, touching upon the effect specific to any exchange of real letters). Terayama is writing. In the image we can make out signs of writing, and the voice asks

itself: "Is it me? No. Is it my name written in letters?" We see the face of a man, then the camera draws back and the voice says: "No, it's only a photograph." And the question is displaced from one sign to the next as it attaches itself to various identity cards. On some we recognize the name, on others it's illegible (invisible). And the voice asks: "Maybe I'm a poet. Maybe I'm Shuntaro Tanikawa. Maybe I'm just a man." We see it: this confusion of identities implies an essential, haunting, and at the same time very simple questioning of subjective nonidentity, which is the second of *Video Letter*'s attributes. Identity is reduced here to what appears, to the questions formulated (in the text) and suggested (to the spectator-reader) by the content of the images, which means at the same time a great deal and very little: signs scattered like grains of sand, oscillating between pure contingency and one or two anchoring points.

"Am I an invisible man? No doubt," Terayama asks himself, while a camera moves through his apartment. This implies that Terayama can be both himself and the other to whom he writes (or pretends to write), and it's their shared nonidentity that unwinds in the image. When sheets of paper covered with signs collapse and fall to the ground a few seconds later, Terayama again asks himself: "Maybe I have liver trouble. Maybe I'm an earthling. Whoever comes up with the best answer, could you swear that it's me?"

Three sequences surrounding this one (near the end of the tape) provide answers bit by bit that really aren't answers at all, dissolving, scattering, reducing the image of self to an essential flatness. In the first, Tanikawa lets the objects that identify him drop one by one to the ground (ending with his left foot), naming them in turn ("This is . . ."). He covers all of them with a large piece of plastic and says: "This could be my blue sky." And as the image fades to black he asks himself: "Who am I? Is this my poem?" In the second sequence, this time facing the camera-screen-mirror, Tanikawa recreates one of the gestures characteristic of American video of the 1960s and 1970s ("video as an aesthetic of narcissism," etc.). He takes visible pleasure in the few words he pronounces ("Mint tea"; he tells us what he's drinking), illustrating the level of pure denotation that his bodily presence inscribes all the while in the image. In the third sequence, a voice asks everyone in the street: "Who is Tanikawa?" This produces unexpected answers, a scattering of identities that in the end turns absolutely opaque when he questions a flower and then a dog.

The first two of these three sequences are letters from Tanikawa. The third letter is from Terayama, but has Tanikawa as its subject. The uneasiness of the other two sequences comes to mind, where we see Terayama in the image even though it is Tanikawa who is speaking to him and to us. And so by speaking to the other, each man questions himself about the other's identity in order to define—or to undefine—his own. Tanikawa leans more to the side of the nonperson, Terayama to the side of the nostalgic subject. But both of

them, together and separately, aim toward and realize states of presence that have the effect of reducing the imaginary part of subjectivity. So we find ourselves faced with these exact, successive, fragmented states of presence that are constantly defining themselves, and those that cross their path, by way of this process of indexing life as such—that is, life only insofar as it exists and is maintained. The correspondence of these two men, their dialogue, which is at once very concrete and very enigmatic, holds open precisely this possibility.

The third merit of *Video Letter* is having known how to find, through a rather uneasily dispersed physicality, a way of inscribing inside the image what the two friends are trying so desperately to understand and to evaluate.

A debate drives them on, trite and yet impossible to avoid: the debate between meaning and nonmeaning—meaning and nonmeaning of the words, opening up onto the question of what would be beyond them, in the body and in the image, but also (the very strength of the tape lies in this wavering) in the words themselves as body and image.

And so on one hand appear, as prior to meaning and to nonmeaning (even if they do emerge from that conflict) the "themes" (which are obviously so many images compelling attention): the ailing body, unique in its undivided identity; the animal, limit to the definition of characteristic humanness. (Both Terayama and Tanikawa own dogs that we come to care about. Nietzsche also comes to mind, throwing himself onto the neck of a battered horse. Or the "pity" Barthes saw in this gesture and which seemed to him the very essence of feeling as both uniquely individual and the degree zero of identity); the mother, the primal body of affect, the affect coming from things themselves, flat and irreducible.

On the other hand, the words display their uneasy presence: a word that is not a "letter" or a "voice," but is a "meaning," a word that has its share of body, its share of logic. The power of the tape is in rendering this neverending debate visible, like the diagram of letters that is composed in such a way to make appear in the image (thus at once matter and idea) what is carved out in words between the two correspondants around meaning and nonmeaning.

But the tape's most intimate strength comes from the respiration of the image itself, from its matter, its skin. "I don't hold my camera right and can't

focus the right way. Does that prove I'm alive?" This flaw converted into strategy is one of three ways the image has of telling us the same thing while at the same time more than the words. The frequent, emphatic change from focused to blurred, from blurred to focused, translates both the presence of the body and the materialization of the idea (we go back and forth between one and the other "like" we move between meaning and nonmeaning). An equally suggestive instability between fixity and movement also runs through the tape. Very often—and it is only afterwards that we become aware of the effect of this hesitation—we don't know if the image is moving or not, like when someone's breathing is unsteady (which doesn't mean that the image doesn't know how to be still or to be mobile when it means to be). Finally, the third point: the numerous fades to black which constantly dissolve and recompose the image, an image confronted every second of its tenuous and stubborn existence with the conjugation of meaning and nonmeaning.

Video Letter's fourth great accomplishment is to create fusion—or confusion—between the various means of expression, the same type as the one created between the variations in the image and between the speakers.

It would seem that the photograph is privileged. And, if anything, it serves "Terayama's side." I know very few images as unsettling as the one where a very small child, huddled against his mother's body, stares at us. But this steady gaze seems little by little to become mad, because at the same time, as in faked political photos, the part of the photo with the mother's body breaks off, falls away and slides off screen. The maternal body seems an image of the film-video apparatus, the spectator engulfed in the child's gaze. The representation hits us with all the more force because it is coupled with Terayama's insistence on the photos of his mother when she was young and beautiful, strewn across the very bed where we next see her, old and sickly, suspended between life and death. What's more, the tape's first images are all photographs. Tanikawa is the one writing (we saw this), but a series of photos of Terayama wordlessly appears, photos taken from an album that parade by with a slow and halting movement, like so many photograms. So the photo is privileged. It is a sign of the image-apparatus that shapes the way the letter is written. It is also analogous to the letter as an object of loss and thus becomes the index of the letter of time.

And yet photography doesn't really play a pivotal, overarching role. It is still only one object among many, one sign among others. Photography mingles with painting, from which it is not always distinguishable (for example, the image that we finally recognize as a painting from the Flemish school, distorted by objects that hide and transform it, tinted blue like the photos). It is compared with the words of poems written on the screen-page and associated with mixed representations with more or less definable shapes (posters, calen-

dars, books, sculptures, collages). It is at times even difficult to distinguish from the landscape, as is the painting itself. Photography is thus part of the general universe of signs that have been tinkered with, doctored up, which is the last and perhaps the most distinctive quality of *Video Letter* (in that it seems to bring together all of the others).

In this, this tape is very close to those literary or pictorial works that function as bridges between the worlds of language and image, where a general process of sign fragmentation, dissemination, confusion, produces a double effect of disconnecting and of reconnecting. The sign—fractured, crushed, mixed—loses some of its hardness, its definition while it gains in coalescence. Everything is endlessly resolved in *shifts* and *intermediaries*. Klee, Michaux, Barthes.

There is one or more thing that *Video Letter* makes possible, one that I hesitate calling a quality: the possibility of death as an ending and interruption of the tape, and by the same token, death as a sign of life, because the death is real, not acted, as in a real correspondence. When Terayama dies, Tanikawa writes two letters one after the other, thereby upsetting the alternation that had served as rule and rhythm of the tape. The camera wordlessly follows for a long, long time a line, an EKG line which, freely reinterpreted, becomes at once writing and design. We realize very quickly that this is a lifeline. When it runs straight, Terayama is dead. And so we are left with only one possible metamorphosis, that of the poem. In Tanikawa's last letter, we hear Terayama reading one of his poems. As the image goes from blurred to focused, the camera fixes on a sheet of paper covered with words-signs attached to a post in the middle of a wasteland.

Postscripts

I find a message on my answering machine from my friend Liz Lyon. I've just shown her *Video Letter*. She says: "Look at page 165 in *Roland Barthes by Roland Barthes*, it's incredible." I look, and in fact, it is incredible. And yet so normal. Japan, signs, languages, images, poetry, utopia of language. This is what Barthes writes in this fragment (entitled "The shifter as utopia"):

He receives a card from a faraway friend: "Monday. Returning tomorrow. Jean-Louis." *Like Monsieur Jourdain and his famous prose (moreover, a more or less Poujadist scene), he marvels at discovering in so simple an utterance the trace of those double operators,* shifters, *analyzed by Jakobson. For if Jean-Louis knows perfectly well who he is and on what day he is writing, once his message is in my hands it is entirely uncertain:* which Monday? which Jean-Louis? How would I be able to tell, since *from my point of view I must constantly choose between more than one Jean-Louis and several Mondays? Though coded, to speak only of the most familiar of these*

operators, the shifter thus appears as a complex means—furnished by language itself—
of breaking communication: I speak (consider my mastery of the code) but I wrap myself
in the mist of an enunciatory situation which is unknown to you; I insert into my dis-
course certain leaks of interlocution *(is this not, in fact, what always happens when*
we utilize that shifter par excellence, *the pronoun I?). Which leads him to imagine*
shifters (let us call shifters, by extension, all operators of uncertainty formed at the
level of language itself: I, here, now, tomorrow, Monday, Jean-Louis) *as so*
many social subversions, conceded by language but opposed by society, which fears such
leaks of subjectivity and always stops them by insisting on reducing the operator's du-
plicity (Monday, Jean-Louis) *by the "objective" memorandum of a date* (Monday,
March *12*) or of a patronymic (Jean-Louis B.) *Can we even imagine the freedom*
and, so to speak, the erotic fluidity of a collectivity which would speak only in pronouns
and shifters, each person never saying anything but I, tomorrow, over there, *without*
referring to anything legal whatsoever, and in which the vagueness of difference *(the*
only fashion of respecting its subtlety, its infinite repercussion) would be language's most
precious value?[1]

In 1982 Tanikawa wrote a deeply moving book that is like a (solitary) double
of *Video Letter: Solo* (Daguerreo Press). Having rented an apartment in order to
write, he finds himself far from home, alone, and wonders only that much
more who he is. He brings together signs, every possible sign (only a few of
them as proof) of his fleeing identity: images (mainly photos, numerous Polar-
oids pinned to the wall, but also a grab bag of what he sees, in his home and
outside), words (poems, newspaper clippings, pages from reference books). Im-
ages that can be reduced to a few words, and words framed like images.[2]

Translated by Alison Rowe

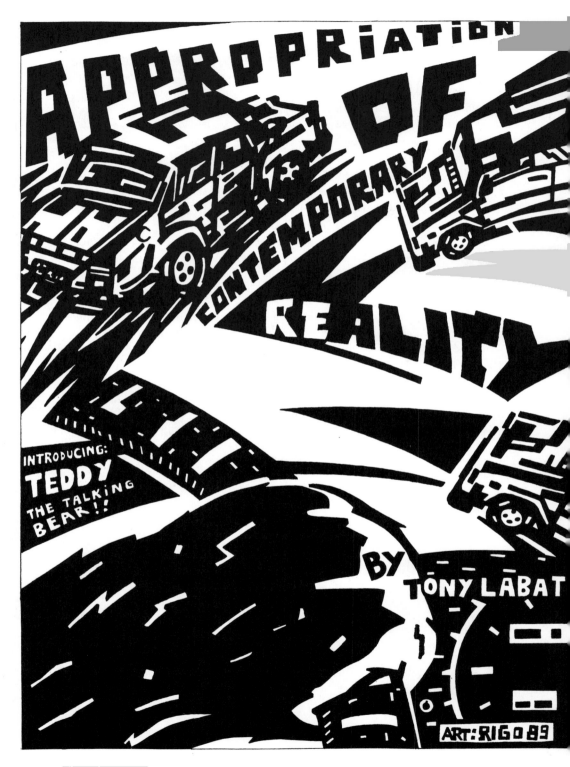

444

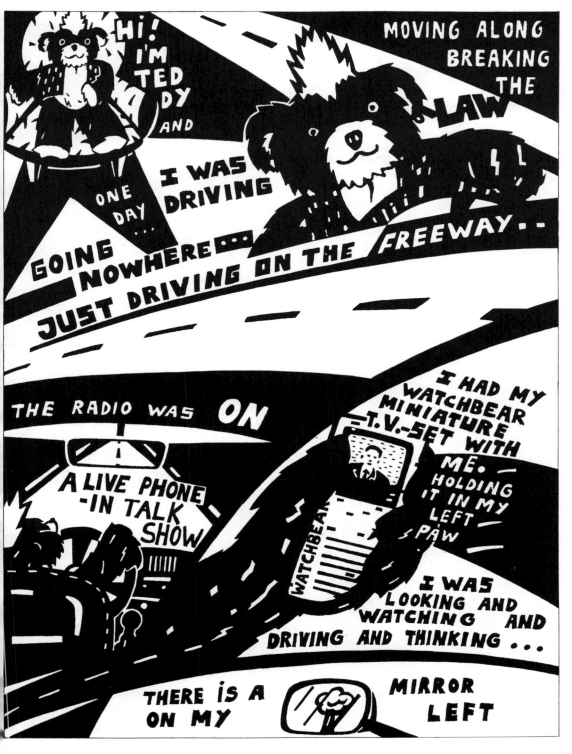

445

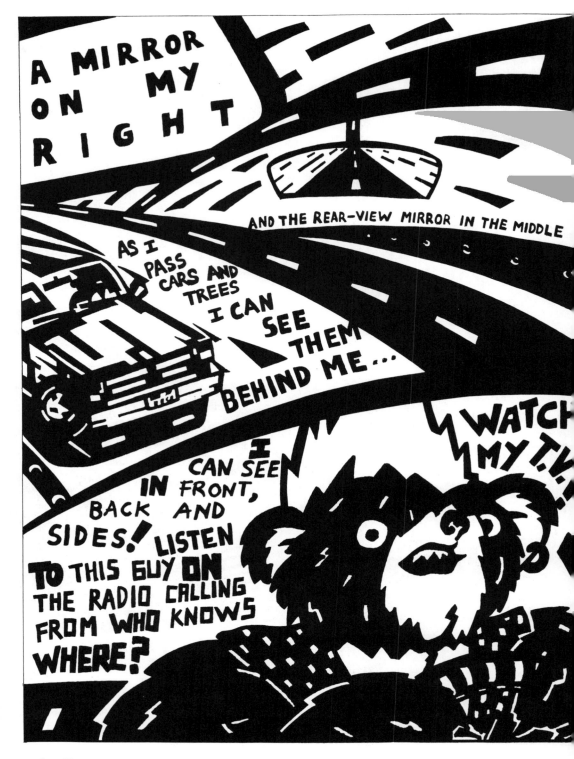

446

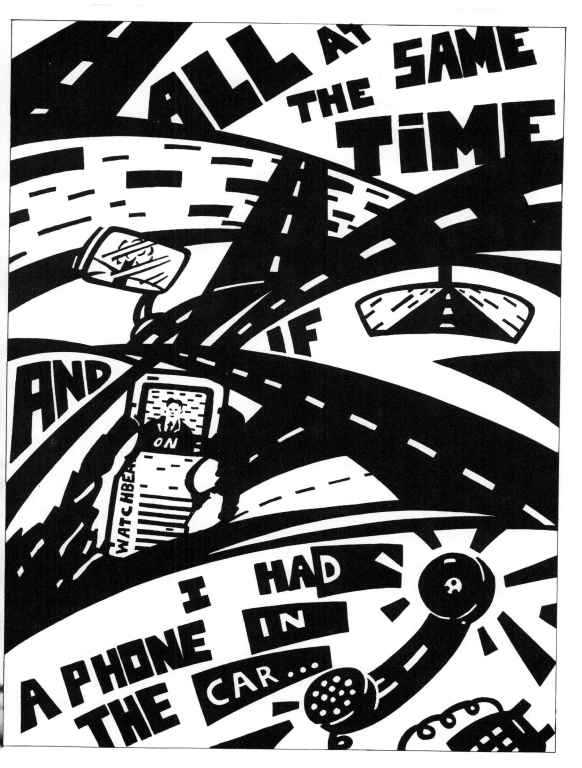

447

Directions/Questions: Approaching a Future Mythology

R I T A M Y E R S

It is twilight. A small band of men, women, and children wander across a dusty, relentless plain. They are searching for a new habitat. This is but one of many such journeys. Their shadows lengthen before them as the sun sinks into a distant mountain range. For them, this landscape is a void. An essential transformation must precede habitation. A young man carries a ritual pole, believed to hold magical powers. Fashioned from the trunk of a gum tree, it is the Kauwa-auwa, possessed by the Achilpa people, an Australian aboriginal group. It corresponds precisely to the first such pole, which the god Numba-kula climbed to enter the sky. Guided by the direction toward which the Kauwa-auwa bends, the small group is led to their new territory. A space is delineated and in its center, the Kauwa-auwa is planted, establishing once again a communication with the sky realm. In this way, the void is overcome. The world itself is actualized and human existence is realized. The void can become world only when a break at its center into the infinite is made through the sacred pole. The landscape devoid of this transformation cannot support life. "Life is not possible without an opening toward the transcendent."[1]

It is the dead of night. The landscape is composed of precise rows of dwellings, organized into the pattern of a grid. Artificial light competes with a pale moon. Inside one of the dwellings, a woman lies sleeping. Suddenly a disruption occurs in the form of a rapid succession of images. Breathing comes in short gasps. She is falling, and as she falls, fragments of her dreamed surroundings seem to break away, hurling themselves into space. As the fragments disappear, the shape of her surroundings narrows and darkens. It is a dry well, a cave, a hole that plunges to the center of the earth. The darkness is impenetrable. A whistling sound steadily rises in pitch. Her fall now is dizzying. All orientation is lost. Terror. She is dying. The sound escapes the range of hearing and breaks off. Silence. Suspense. A thread rises from her mouth. It is made of spittle. Another from her navel. Made of gut. And another from her vagina. Made of blood.

It is morning. In a pastoral village composed of garden plots and tumular huts, stands a re-creation of the universe itself. Within the sacred lodge of an Algonquin tribe, space and time are coordinated into a perfect metaphor for the harmony between transcendent and finite realms. The roof is the dome of the sky. The floor is the earth. And the four walls are the four directions of cosmic space. Around the implied center, the still point of infinity, finite existence is manifested through a threefold symbolism of four doors, four windows, and four colors signifying the four cardinal points. To walk through the lodge is to be delivered into

cosmic time. Within this universe, space and time are homologous constructions. Temporality is experienced as a journey through the four cardinal directions, represented by the windows and doors of the lodge, symbolizing the world itself. "The Year is a circle around the world."[2]

The axis mundi is an archetype of protean dimensions. In traditional form, it originates as a rupture, a cleavage in the smooth continuum of space and time, a penetration of the infinite into the quotidian. In the guise of numerous images, whether a pole, a tree, a mountain, a pyramid, or even an empty space inferred from the six sides of a room, the axis mundi symbolizes a break, and thereby, the possibility of a passage between the cosmic regions of the underworld, earth and heaven. It is the center. Around this cosmic axis lies the world. It signifies the sacred. Without this sacred axis, there can be no world. In vestigial form, it is a guide in a dream.

The genesis of the axis mundi lies in a moment of awakening consciousness, in a primal recognition of awe and dread. As such, it resides in a generative matrix of shared beliefs, behaviors, images, and stories that constitute the world's mythologies. Issuing spontaneously from the deepest recesses of the psyche, the mythological impulse is toward participation in "the mystery of this finally inscrutable universe."[3] Cloaked always in local forms and customs, the essential story is nonetheless universal. Through their vitality as metaphors, the gods and heroes of myths make present a sense of transcendence and ultimately relate the steps taken during "an enigmatical incursion into a world of solid matter that is soon to melt from us like the substance of a dream."[4]

Myth is the social stage upon which our innermost psychophysiological urges break through to visible reality. "Throughout the inhabited world, in all times and under every circumstance, the myths of man have flourished. It would not be too much to say that myth is the secret opening through which the inexhaustible energies of the cosmos pour into human cultural manifestation. Religions, philosophies, arts, the social forms of primitive and historic man, prime discoveries in science and technology, the very dreams that blister sleep, boil up from the basic, magic ring of myth."[5] Myth survives into modern times in disguised forms. Its rudimentary form is most apparent within the private dimension of dream. Emptied of contextual ritual, it surfaces like an ancient memory, perhaps to become the root substance of art.

Every mythology is essentially a cosmology. As space is sacralized through identifying its center, so time is sacralized through a return to its origins. Mythological time is circular time. It is reversible to the extent that it permits the recovery of a primordial time. If the world is created by discovering the infinite, then it must be maintained by continually approaching the infinite.

Periodically, the world declines into a state of decrepitude and edges toward a return to chaos. It must be rescued from this state. The ultimate threat is history. Historical memory, which derives from no primordial archetype and thus

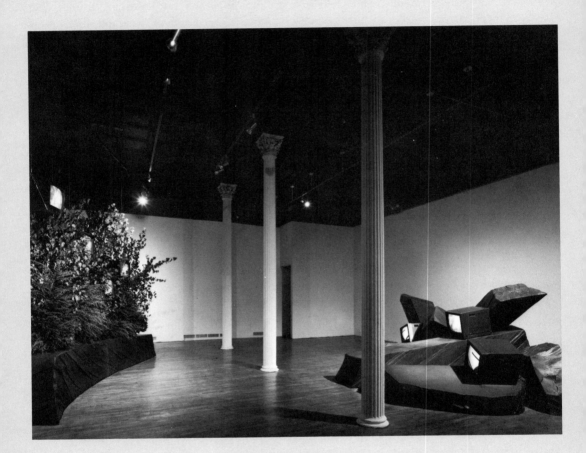

"For primitives, the End of the World has already occurred . . ."

Mircea Eliade
Myth and Reality

"The broken connection exists in the tissues of our mental life. It has to do with a very new historical relationship to death. We are haunted by the image of exterminating ourselves as a species by means of our own technology."

Robert Jay Lifton
The Broken Connection

Rift Rise is a meditation upon destructive force, upon its enduring attraction, upon its inevitability, whether it occurs within man-made or natural contexts, and upon its ultimate symbiosis with deeper cycles of being, as the inextricable link between decay and regeneration. *Rift Rise* expresses my sense of loss for a dream of both Utopia and Arcadia—perhaps these are meant to be merely transitory states after all.

The work is structured as a confrontation of landscapes. A chaotic mass of large fragments evokes a rupture in the earth while a gentle incline of young birch trees provides a contrasting serenity. Video images depicting the perennial motifs of destruction and renewal, principally through fire and water, are literally exchanged across the empty space which divides these two setting. The metaphorical identities of rift and rise thus become interchangeable. Both the fractured images of nature, as well as the decaying fragments of architecture, are transformed into reconstructive elements.

The writings of Mircea Eliade and Robert Jay Lifton have been a point of departure for this work. Eliade describes the conceptual world of primitive mythologies as an elegant symmetry of destructive and creative forces, as a series of transitions between catastrophe and renewal, decay and regeneration, and, most importantly, as the instrument of a continuous future.

Lifton reminds us of how far we have drifted from this model, of how we have externalized and refined our destructive capacities with wondrous precision while ignoring the need for a deeper sense of connectedness. To redress this imbalance, he suggests that "the place of death in the human" be explored. It would seem that an ancient memory needs to be awakened.

reveals the irreversibility of time, is intolerable. History supplants dread with ennui. The world can be regenerated only through a ritual enactment of the primal moment. "Through the actualization of the cosmic Creation, exemplary model of all life," the world can again exhibit the fullness of being and a sense of primordial plenitude.[6]

Daily existence itself is appropriated into this process. The lasting invention of the mythic mind is essentially a poetic one, the principle of analogy. By mapping one order of reality upon another, such as sleep over death or waking over rebirth, it takes the daily and repetitive examples of ordinary life as proof of our own continuity and that of reality itself. Thus, the mythic narrative always resolves itself in the same way. Returned to its origins and poised metaphorically at the beginning of time when any and all conditions are again equally possible, including its complete and final dissolution, the universe replicates itself. Randomness and chaos are conquered. Order and constancy prevail.

The cyclic resuscitation of existence through a return to its origins survives into the present as one of the dominant traits of the human mind. Its trace remains in the reservoirs of the individual unconscious as well as in the ambitions of the collective will. As a cultural phenomenon, it persists through the work of the cosmological physicist. As a tool for survival, it is the means of overcoming our sense of radical discontinuity with our surroundings. As a ground for art making, it is the constant re-creation of a mark in a prehistoric cave.

It is within the domain of art that a contemporary mythology will most likely be expressed. A new mythology, rapidly becoming both a social and a spiritual necessity as the structures of the past die out, is "already implicit among us as knowledge a priori, native to the mind which is brought to recollection by apparently external circumstance".[7] External circumstance is equally an environment of technological artifice as the jungles and forests of the ancient past or the temple compounds of the historical past. The sources of the mythological impulse remain unchanged, motivated by the universalizing conditions of archetypes that, originating in the psychosomatic processes of the body itself, are a constant.

How will we recognize the center? The locale of mythological stirring has undergone considerable transformation since an Achilpa elder guided his small tribe to safe passage by means of a sacred pole. In traditional societies, the landscape is the first determinant of folk forms and customs. Limited by the horizon, these mythologies are conditioned by local geography, flora, and fauna. In historical times, the engendering phenomena are shifted from the animals and plants to the cosmos itself. The orderly and predictable procession of the planets in the night sky form the model to be imitated in the monuments below. For the ground of a contemporary mythology, we look to a universe whose limits are not yet known. Once again, the focus has shifted, placing us

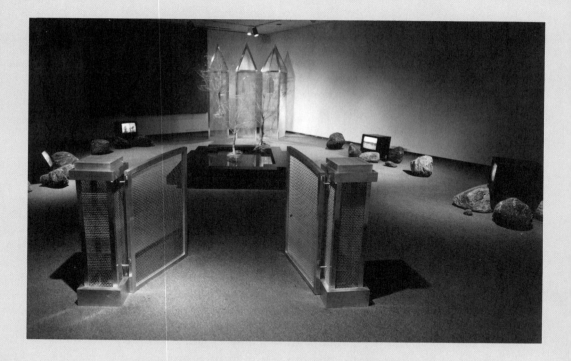

"The unfolding through time of all things from one is the simple message, finally, of creation myths . . ."

Joseph Campbell
The Way of the Animal Powers

A common childhood memory—A still pond in the heat of summer gives the illusion of infinite depth. Its surface reflects a canopy of trees and the sky above. A pebble hurled into its center creates a wave of concentric circles, and with it, a suspension of clarity which invites reverie. The inverted world is reduced to shuddering abstraction. Within the time it takes for the clear dome of the sky to reassemble itself, imagination travels great distances, conjuring the abstract shapes into bits of fiction—a canyon, mountains, the desert. An inchoate map, and yet one which uniquely satisfies a compelling need—to fill precisely the empty spaces decaying circles.

Using the decaying concentricities of water as its central paradigm, *The Allure of the Concentric* is an expression of the mythic desire for ultimate renewal and regeneration. It is an evocation of complementary states of being, the boundless and the transitory, and the patterns of transformation between these states. Its focal point is a reflecting pool, above which are suspended three small dead trees, recalling the "axis mundi" of archaic mythologies. Concentric circles created by water droplets cause the pool to metamorphose from an abyss into a source, metaphorically calling forth at its outer reaches the archteypal landscapes of the desert, mountain and forest, eternal, boundless, yet mutable.

Through the operation of its disparate metaphors, *The Allure of the Concentric* revives the mythic adventure as a search for origins. It is a reminder of how the enduring legacy of the mythic mind makes its presence felt—within the recurrent motifs, among others, of a dead tree, a tower, or simply a fragment of rock; through the cyclical patterns of the individual and collective imagination; and lastly, by the protean images of our own mortality.

this time around a minor sun at the edge of a galaxy surrounded by millions of other galaxies all hurtling through space. But our place now is primarily determined by theory, a system of mathematical signs that has no equivalent in the realm of perception. Insofar as this purely conceptual localization defies our daily experience, we come to recognize the essential message of the archetype, conditioned though it may be by any variety of external circumstance. We come to understand that the metaphysical center is ubiquitous. As it shapes states of being ultimately realizable only within the individual, the metaphorical language of myth unveils a center that is literally everywhere.

How will we tell the stories? The essential narrative remains unchanged. It is the course of an individual life mirrored in the world. But, as an exemplar of our own nature, our planet has evolved into an image of striking paradox. On the one hand, satellite photographs make visible what had until now been only a "conjectural and secret object. . . ."[8] It is an earth of swirling patterns, a glorious and celestial sphere suspended in space, an emblem of unity itself. On the other hand, this home site is "threatened by a new wave of millennial imagery—of killing, dying and destroying on a scale so great as to end the human narrative."[9] As we witness the structures of the past disintegrate, it is evident that a new mythology must be capable of withstanding the "intolerable" irreversibility of history while fulfilling its primal function as the threshold of the transcendent. "If history is a symbolizing treadmill, it is also the vehicle of our collective renewal."[10]

Time's irreversible disruptions are recapitulated in the desires and dreads of an individual life. For the self is the ground of the universal narrative and as such, the embodiment of a paradox. Undergoing the transformative stages of a human life, from birth, through childhood and adulthood, and into death, we are, now as always, living creatures fearful of the abyss and longing for infinity. This dual aspect is built into the human organism. Prefigured from the beginning, an imaginative awareness of both death and life structures evolves according to the sequence of human growth, from sensorimotor responses, to visualized imagery, to complex symbols. A dialectic is formed between images of cessation and continuity that parallels the trajectory of the life cycle. The fusion of these two selves, mortal and immortal, depends as much on an evolving inner pattern of breakdown and renewal as it does on a planetary design of threat and greater connection.[11] The narrative of the self thus reflects the goal of myth: "[K]nowledge of that transcendent source out of which the mystery of a given life arises into this field of time and back into which it in time dissolves."[12]

How are the stories initiated? For the Hindu, a pilgrimage is made. Walking the countryside, from the headwaters of the Ganges to the foothills of Mount Kailas, the pilgrim transforms the landscape of India into the body of the mother goddess, a symbolic entity whose anatomical parts become shrines

for the remembrance of the cosmology.[13] What symbolic entity, mapped over our world, is capable of yielding a similar path? Its shrines, it would seem, must be conceived as questions. How might they focus the points of harmony and discord between historical and mythical time? How will they distinguish the ultimate from the primordial? How will they reflect our personal crises of belief and experience? And how will they assemble these into a collective imprint? This symbol is nowhere at hand. After all, it is, in itself, a question.

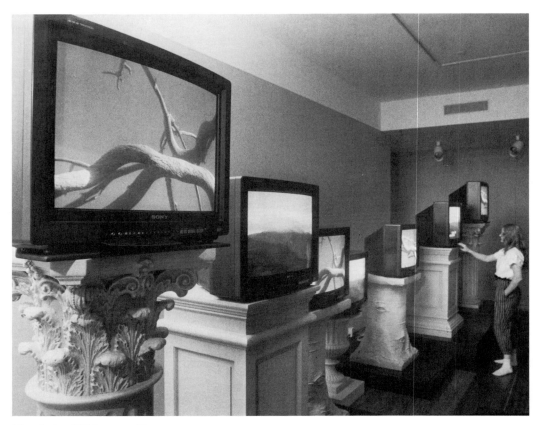

Mary Lucier, *Wilderness*, 1986.

Light and Death

MARY LUCIER

I.

Sometime around 1970 I became obsessed with the idea that video had been
invented to satisfy an ancient longing: to allow the human eye to gaze directly
at the sun without damage to the retina. Unlike Icarus, who died flying too
close to the sun, or Prometheus, who was punished for his appropriation of
fire, we have obeyed an old taboo out of a deep and instinctual fear of loss. Di-
rect, unmediated confrontation with the source of light means, paradoxically,
the death of vision—the clouding over of the eye that dares to look, that sur-
renders to the persuasion of desire over reason.

Video technology made it safe for the human eye to look directly into the
source of power but, at the same time, showed us that such an act of hubris is
not completely without penalty. The price one paid, until recent technology
replaced the camera's vacuum tube with state-of-the-art chips, was an irrevoca-
ble marking of the image-recording element itself, a permanent burn-scar in
the phosphors of the vidicon tube.

As the sun rises in Dawn Burn *(1975), giving heat and light and life to the
city below, it engraves a signature of decay onto the technological apparatus; thus, light
emerges as the dual agent of creation and destruction, martyring the material to the
idea, technology to nature.**

This scarring of the anthropomorphic camera eye serves as a graphic meta-
phor for the surrogate relationship between the lens/tube/VCR system and iris/
retina/brain. The result of this primal encounter is a trauma so deep that its
scars cannot be erased but, instead, accumulate on the image surface as a form
of memory, and any picture subsequently recorded by that camera must be
viewed through the scar tissue of prior trauma.

II.

Fire Writing

*The performer writes in air with a portable video camera, allowing an intense light
source such as a laserbeam to cross the vidicon tube. As she writes, the camera repeatedly
sweeping a given area, the laser light will cause bits of the text to be cumulatively re-*

* Writing in italics not identified as by another author, is from previous texts by Mary Lucier.

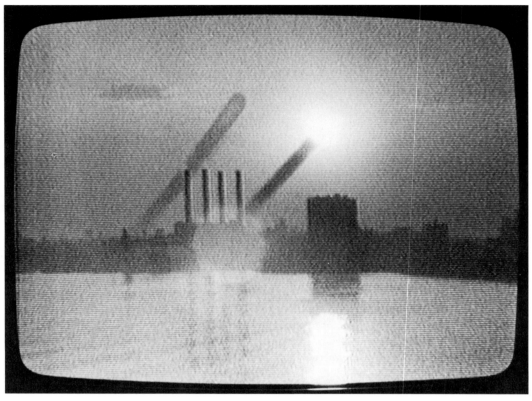

Mary Lucier, *Dawn Burn*, 1975.

corded until, in time, the surface of the tube is entirely inscribed with the burn calligra-
phy. The performer is situated on an elevated platform with the lasers placed in an arc
around the periphery of the space and focused directly at the camera. The video image is
viewed on monitors placed near the performer and facing the audience.

—*Mary Lucier, performance piece,* 1975[1]

Applying the methodology of writing to camera technique was a means
by which I sought to extend video's referents beyond its own limited history.
I was interested in the displacement that occurs when one tool is assigned the
function of another, the result being to infuse or enrich one set of aesthetic
practices with those of another system commonly thought to be incompatible.
The critic and artist Douglas Davis has been widely quoted for his manifesto
stating that "The camera is a pencil." The camera is a tool like any other tool
which an artist uses to render signs and symbols onto a receptive medium. By
equating it with one of the most elementary of artist's implements, we are able
to demystify the technology, to bridge the gap of specialness and privilege that
often adhere to an advanced technology, and at the same time, to elevate the
camera's status as a potential facilitator of great art.

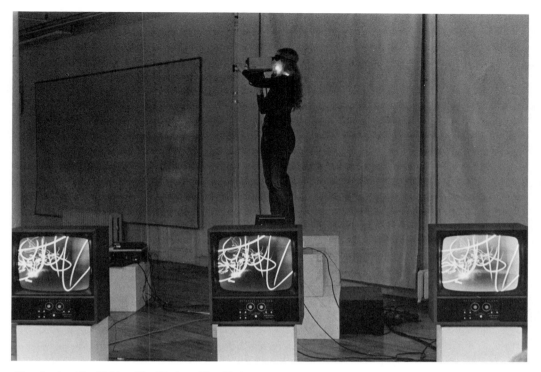

Mary Lucier, *Fire Writing,* The Kitchen, New York, 1975.

Beyond its physical accessibility and convenience as the handiest way to transpose images and ideas, the pencil functions as a conduit between brain and paper. It is an object whose very presence in the hand stimulates both an extraordinary reflectiveness and a highly organized kinesthetic response. Of course, a camera does not inscribe a mark by direct, physical abrasion on a surface; to accomplish its task, a conversion step is required between subject and instrument, during which the subject matter is, in a sense, absorbed into the instrument itself and its likeness imprinted onto a medium through electromagnetic recording. In *Fire Writing,* light seems to have been transferred into the camera and retained in the phosphors of the vidicon tube through the act of writing. The luminous inscription that results during performance consists of layers of text, each line of script fused with the preceding lines until time, space, and movement become compressed into a two-dimensional etching of scar tissue. The tube remains a permanent, displayable artifact of that process.

The scars on the vidicon tube represent a kind of knowledge. If an inanimate system can be said to have self-awareness, this is where it resides: embodied in the burn hieroglyphs of the damaged phosphors is a memory that will be imposed on every new subject placed before that camera until its tube is replaced with a fresh one that has not yet been exposed to the shock of its own limitations. Burn is the emblem of video's capacity for self-reflection and thus,

perhaps, a template for our own. It forces the viewer to investigate the technology, making us conscious of its boundaries and compelling us to ask questions about how a medium composes and decomposes itself.

III.

It is possible to argue, as Malevich did, that the twenty paintings which Monet made in the early 1890's of the facade of Rouen Cathedral, as seen at different times of day and under different weather conditions, were the final systematic proof that the history of painting would never be the same again. That history had henceforward to admit that every appearance could be thought of as a mutation and that visibility itself should be considered flux.

 —*John Berger, "The Eyes of Claude Monet," in* The Sense of Sight[2]

Monet painted outdoors facing the sun. Viewed this way, scenes seem to become irradiated from within as light and image mingle on the retina and are then "projected" back out, onto the canvas. Aim a camera toward the light and luminance becomes "caught" within the object, diffusing it through a veil of reticulation. As Monet gradually lost his eyesight, his brushstroke became more abstract, almost violent. His late paintings are charged fields of light and darkness, color, and pure energy—the anxious energy of a man yielding the familiar to the unknown, grasping a glimpse now and then of the light that irradiates, while plunging deeper into a world of darkness and mutable forms.

The new relation between scene and seer was such that now the scene was more fugitive, more chimerical than the seer.

 —*John Berger, "The Eyes of Claude Monet,"* The Sense of Sight[3]

Monet isolated himself from the world at large, creating an "eternal" motif that served as both art and nature. The garden fed his palette, which in turn, enriched the hues of his flower beds and lily ponds. Master gardener and master painter become indistinguishable in this hermetic universe where even war does not intrude. An intimate, constructed landscape, the garden is at once, natural and artificial, metaphoric and literal. Its fundamental service in human society is to familiarize us with the cycles of birth, death, and regeneration and to nourish some sense of power and control over our own ephemerality.

 Ohio at Giverny (1983) was an attempt to concretize ephemera and to link disparate entities—geographies, histories, and personnae—through a common exploration of light in landscape. The displacement of Ohio onto Giverny, suggested by the sweet but improbable union of my midwestern uncle and French aunt, to whom the work is dedicated, is but one of those linkages. Observation and memory, present and past, collapse and regeneration are all bridged by the act of recording. The juxtaposition of my Ohio birthplace and

Mary Lucier, *Ohio at Giverny*, 1983.

Monet's restored gardens anchors a circular journey that leads forward and backward in time, utilizing an accessible body of French paintings as signposts in a very personal adventure—one of confrontation and reconciliation between the "new" and "old" worlds, youth and age, art and life, representation and abstraction, technology and nature.

IV.

. . . the American artist cherishes in his innermost being the impulse to reject completely the gospel of civilization, in order to guard with resolution the savagery of his heart.
 —*Perry Miller,* Errand into the Wilderness[4]

Let me live where I will, on this side is the city, on that the wilderness, and ever I am leaving the city more and more, and withdrawing into the wilderness. . . . I must walk toward Oregon, and not toward Europe."
 —*Thoreau,* Walking[5]

Wilderness (1986) restages the Ohio-Giverny journey as an odyssey into a collective American past—a panoramic survey of landscape images with nineteenth-century visual and literary antecedents. It invokes Hudson River and luminist paintings as vehicles for revisiting a shared cultural and psychic history and, ultimately, as devices for reflecting upon the present time, while it poses an ironic view of the consumability of landscape as art in the face of the apparent frailty of the environment itself. Where Monet's garden was created as an eternal motif—a kind of endless and closed loop, continually regenerating both itself and the painter's palette—the American landscape is experienced as vulnerable, as having a brief though glorious life before being transformed by the forces of industrialization and development.

The tapes are structured as an adventure across coastal, inland, and upland geographies of the Northeast, ending with a coda in the icy waters off Newfoundland. Each of four major geographical sections is defined by a simu-

Mary Lucier, *Wilderness*, 1986.

lated gold picture frame that wraps around a receding landscape as a particular
motif is achieved. These motif episodes are laid throughout the piece among
longer sections of "narrative" exposition that carry the journey forward from
location to location.

*The camera travels over water, coming to rest on the decrepit mast of a wrecked schoo-
ner, dissolving through water (Davey Jones's Locker) into the vacant captain's bedroom,
dissolving back out again to the heroic little oysterman who becomes a cloud or the sun
itself in the sky, and is eventually obliterated in pounding surf. Later, the early Amer-
ican Peto-like pewter and letter rack still lifes emerge out of the snowstorm; then the
Beaux Arts Estate, eclectic mansion and gargoyles epitomizing the follies of the Robber
Barons, accompanied in the sound track by the call of crows and a hint of* Masterpiece
Theater, *fading into the faux American aristocracy at play with red coats, bugles, and
hounds, and an abundance of horses' ass and dogs' tails, dissolving into the Gothic ro-
mance of the estate in ruins, pausing at a contemporary anthem—"sex, drugs, and rock
'n' roll"—wiped away by the sound of fire transformed into rushing water, which be-
comes the woodland waterfall that segues slowly into the axis mundi—the still, deep*

pond that might be Walden itself 100 years ago, but becomes the lapping waters of Kensett's Lake George.

Technological "breaks" mirror the gold picture frames in reverse, puncturing the image from the center outward as a square wipe:

Horses break through the interior still life—the books, the little chest, the powder horn (symbolizing learning, savings, and battle); the paradigmatic iron horse charges out from the center of the snowbound luminist cove, its roar blending with the sound of the winter gale; the strip-mining truck blasts the mountain reverie but is reabsorbed into the twilight sky, itself etched with jet vapor graffiti.

The original American wilderness represented both the Garden of Eden and the Gates of Hell. To the puritan settlers, the new land offered the promise of bounty, beauty, wealth, and comfort, but not before its supposed evils could be tamed and the land opened up, weeded out, cleared of its terrifying "beasts and savages," converted to pasture, village and highway in the service of civilization. As the natural wilds did indeed begin to disappear, the concept of wilderness grew nostalgic, and the notion of preservation became a cause. In a complete about-face, nineteenth-century Americans began to conclude that it was important to preserve some concrete aspect of wildness in order to preserve an authentic national identity. Industrialization, the single most significant issue in the creative lives of nineteenth-century Americans, was viewed by painters and writers as an inexorable force, destined to transform the environment and forever alter man's relationship to "nature."

The dual aspect of modernity, with its mixed portents of enlightenment and destruction, is epitomized in the landscape, now a focus of the struggle. Like the graffiti-scarred vidicon tube—born of crisis, incorporating both hope and failed vision—the land has become an aestheticized ruin. Finally, what we have is an ersatz wilderness, a TV/video wilderness, that sits like sculpture on faux neoclassical pedestals: the faux pedestals that bear the "real" televisions which depict the video wilderness that becomes a simulated painting in a synthetic gold frame, within a frame, within a frame.

Woody Vasulka, Hybrid Hand from the series, *Didactic Video*, 1983.

The New Epistemic Space

WOODY VASULKA

While the agenda of a modernist has been to Innovate, to Negate, to Abolish, the effort (expended by artists, critics, and audiences) to undermine all traditional art forms has been driven by the fear of epigonism and conformity.
After all this tireless probing and experimentation, the final word should be given to the modernist assessment of Luis Buñuel: "We (the surrealists) set out to change the world—instead (regrettably) we changed art. . . ." Like monstrous and unforgiving puzzles, the excesses of experimentation have piled up at the doorsteps of the twenty-first century.

Despite the apparent confusion, a new situation has quietly emerged. We now have a new creative space, a system of aesthetic practice, and an audience ready for a new aesthetic discourse. We have moved from a relationship with technology in which we attempt to invoke the creative potential of a specific tool, to one with a technological environment invoking a new creative potential from human discourse. The more we understand this technological environment, the more we participate in the opening of this new epistemic space.

More recently, through experiments with systems (social, aesthetic, technological) and the deconstruction of their rules, a wealth of new principles of patterning and composition has appeared. Incredibly, some of us have chosen technology as an ultimate poetic source, material, and promise. We are comfortable with the abandonment of the vulgar "hero's journey" in favor of the delicate exploits of The Machine.

Though the immediate emergence of a new audiovisual aesthetic seems unlikely, the existence and use of an underlying coding sytem in machine-made or machine-assisted art suggest a "new" and tempting opportunity. By now we see that the utilization of technology largely dictates its own aesthetic, if not in the mainstream arts, certainly in its experimental forms. We have learned that aesthetic dialogue exists without strict regulation by intellectual supervision and concensus. While we can see a constant generational process of rediscovery of and confrontation with the past, the validity of ethical prescriptions, asserted by the participants in this process, appears specious when viewed in a later historical context. The way this creative process is mediated requires a certain acceptance of technological determinism, its structure being born in a variety of cultural domains, not specific to the developments in art.

Machines capable of organizing visual or auditory structures have emerged and established their lineage outside of art, or of strict aesthetic considerations, and their evolution does not necessitate artistic formulation. Watching closely

the development of machines, designed to articulate aesthetic languages, we can see how languages of such machines are derived primarily from the intrinsic nodalities of technological systems. These systems, presented as tools, summarize the generic options. In a similar way, the newest tools try to contain a generic set of mathematical options, some spectacularly fitted to the visualization of numbers.

Since technology provides an essential interface between human and machine, and since the technology proliferates its options rapidly, the technological environment by now has exceeded the dimensions of a tool and our relationship to it could be paraphrased "Man is but a guest in the house of technology. . . ." It seems necessary now to activate a core of creative excellence in order to oppose the cliché of resentment toward machine assisted creative processes. While computer-assisted work may not yet become the subject of high art, one should expect a new art form to be as challenging to the rest of art genres as was the influence of film on the early modernist movement.

Criticism of the machine-made or machine-assisted environment has been one form of traditional social dissent. While remaining reluctant to embrace such an antitechnological stance, despite the latest generational effort toward a broad integration with mass culture, artists have stood in opposition to social engineering. Today we do hear the dissenting voice of the legitimate art community, made powerless by the social structuring of the machine/state.

And what of the Critic in this debate? I do not accept the position of most critics just as I do not condone the enthusiastic promoter of the telephone or satellite! In desperate need of new modes of rhetoric, they evoke a gross terminological time-shift (modern then postmodern?), from a technological evil—the uncomfortably doubtful, tortuous—toward a psychological heaven of values, more politically exploitable, consumable, secure, and sentimental. Instead, I await a critic who learns, comprehends, inverts, and educates, one who sees far ahead of the practice of art.

Though any discourse concerning technology may appear to emphasize its physicality, my ambition here is to initiate a cultural interface between the creative processes of writing, imaging, composing, and scoring for an electronic stage, operating autonomously or interactively under human control. My ambition is to clarify the specialized media nomenclature so that an individual can participate creatively and intimately, with more rigorous control or organize the stage and execute her or his vision more authentically. This new understanding would contribute toward the specification of future participatory genres, and to more enduring, more stable creative strategies.

After a few years' experience with computer programming, my good friend Hollis Frampton called the specification of such a code, writing. At the time I did not agree with him, but the intervening years have educated me to

Woody Vasulka, Hybrid Studies from the series, *Didactic Video*, 1986.

Woody Vasulka, Hybrid Studies from the series, *Didactic Video*, 1986.

Woody Vasulka, Hybrid Studies from the series, *Didactic Video*, 1986.

an understanding of what he meant. Writing implies more than a literary product. Our current agenda can be viewed as the expansion of written language to include the articulation of an environment where an interaction between all our sensory modalities and those of technology may symbiotically unfold.

The latest digital graphic flirtation with formal mathematics plays an important role as a model for interpreting and mediating two domains: the auditory and the visual. While it is trivial to point out the daily human experience of perceiving the interaction of these perceptual domains, within both the real world and that of artistic formulation, the privilege of observing the emergence of a unified code system within all modes of perceptional representation is entirely unique. As a practitioner, I find this event extraordinary.

The intercourse with the machine has articulated essential coding systems: languages, protocols, scores, and procedures. We have constructed a complete set of symbolic and time-perceptual models and emulated the essential operations of analog electronic media (sounds, images, spatial strategies, temporal events, psychomodalities, chaos) by making the computer a total media machine. The consequences of a unity of code are enormous. Confined to specific categories by its academic, media, or nomenclature particularities, the material becomes cross-disciplinary and cross-referential. Now, let me pause here and confess that I tire fast of talking this and similar gibberish. Over the years, we have volunteered to give our ears and emotions to the voice of these beliefs. They have originated in the abstract utopian places of our minds, and in our struggle to redefine ethics in the shadow of the social and political disaster of the Left and of the emergent terror of religious bigotry.

It is good to remember Fyodor M. Dostoyevsky, the master of literary psychopathology, learning the art of understanding the human soul from all the professors giving testimonies at St. Petersburg' family court. His antiliberal agenda could not stop the onslaught of an upcoming century. His sincere cry for the true brotherhood of man under the icon of Jesus Christ fell heavy and with great embarrassment under the wheels of socialism. We cannot possibly see a lesser scandal ushering in the next, the twenty-first century! If we cannot see the true giant on the shining path, let us pray for the fool.

Amsterdam, May 19, 1989

Three Tapes by Steina

If the south Italian dance, the tarantella, was imagined to be the cure for tarantism, a malady marked by the uncontrollable urge to dance, what is the cure for video?

Voice Windows

On first hearing Joan La Barbara perform, objects began to disappear, memory fragments and fragments of words came blipping from the space-time continuum as if in anticipation of the act. Though I can't recapture the mannerisms of her singsong, a West-Fjordian dialect of Old Norse with classical Arabic inflections, I can tell you the gist of her message. Apparently there are entities, invisible to most of us, who spend much of their time tracking two or more visions at once, and by entering these interplanar points of friction, they access the mindfield of the psychophysical moment in time. These entities store the information gathered at the multiplanar points of friction on their backs in circular combs with uncovered hexagonal cells. She sang of spectral windows through which we may be overawed by the vision of a spinning donut engine that springs all phenomena; mathematical, topological, and dreamlike. She sang of the signature of the wave of the voice, and the intervals at which the voice produces these signatures, activating mechanisms for the points of friction. Obviously, La Barbara had hit upon a statistically impossible combination of the interval and wave signature to carry us tentatively into the mindfield. With subtle alterations we would gain irrevocable access to a place visited only momentarily by few enlightened inventors since beginningless time. Flashbacks of lightning storms and falling from breaking branches indicated to us the undeniable value of Joan's discovery and our febrile minds began their lightning calculations.

Photographs by Steina Vasulka
Text by Liz Rymland

<hr />

Lilith

The tape *Lilith* (1987) has been compared to figurines of the protocinematic culture, but looked at closely, we recognize that access to the mindfield may also be attained through topological analysis of the human face. If access may be attained through the wave signature of the voice, by planar analysis, or tracking two or more viewpoints at once, the movements of the face, and therefore the unique and private sentiments of individuals, may be sent intergalactically through space using an intradermal, intergalactic Morse code.

By preparing highly elasticized robots to read and imitate facial and gestural behaviors such as the behaviors of opera singers, deaf mutes, and mothers, we can catalogue and archive the motility of the facial planes and their correlation to mental and emotional states, thereby fashioning a sort of intradermal Morse code. The *Lilith* tape might instruct the robots in behaviors such as aerophagia, the abnormal swallowing of air, as well as the abnormal fear of air (especially drafts) called aerophobia.

Summer Salt

Summer Salt (1982) is a cognitive investigation of visual ballistics, that is, visual projectiles, their motion and their effects. It is believed that people with an abnormal fear of projectiles, called balistophobes, may be successfully operated on through the medium of video. It is worth mentioning that invisible to the average eye is a frightening variety of spacecraft that sometimes penetrates the human mindfield. These are low-flying, molecular-sized spaceships that cast about furiously and have seriously thrown into doubt the entire theory of chaos.

Steina Vasulka, *Summer Salt*, 1982.

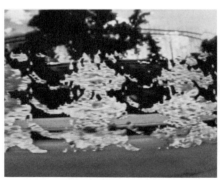 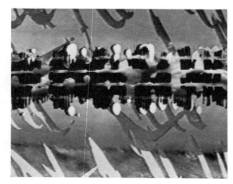

Steina Vasulka, *Voice Windows,* 1986.

Steina Vasulka, *Lilith,* 1987.

Bill Viola, *Information*, 1973.

Video Black—The Mortality of the Image

BILL VIOLA

Somewhere there is a video camera that has not been shut off for the last twenty years. Its rigid, unblinking eye has tirelessly been scanning a parking lot someplace, silent witness to all the comings and goings of the past two decades. It has seen the same man get out of his car each morning, his body gradually sagging, less resistant to gravity, as his gait imperceptibly slows over the intervening time. It has seen the unbroken procession of days and nights, the cyclic changes in the sun and moon, the growth of trees, and the perpetual variations of weather with the accumulation of its harsh marks. It has seen the parade of fashion in car design and clothing, and witnessed the evidences of human intentions and impulses in the sudden material alterations of the physical landscape.

However, this perpetual observer has no stories to tell, no store of wisdom, no knowledge of the grand patterns. Locked within a great immutable Now, it has no sense of past or future. Without a memory to give it a life, events flicker across its image surface with only a split second to linger as afterimages, disappearing forever without a trace. Today it will be shut off, the world abruptly ending in an arbitrary cutoff point as all endings are, and a new model camera installed. In another society, this camera, with its accumulated existence, would be graduated to an object of power to be venerated and reciprocated. In the least, the tubes of old cameras such as this should be installed in a shrine with the hope that someday some future technology could coax from their surface the subtle residue of a lifetime's experience. Today's event will pass with barely a notice.

The Eternal Image

It is difficult to imagine how the human mind could function without the conviction that there is something irreducibly *real* in the world; and it is impossible to imagine how consciousness could appear without a *meaning* on man's impulses and experiences. Consciousness of a real and meaningful world is intimately connected with the discovery of the sacred....

In short, the "sacred" is an element in the structure of consciousness and not a stage in the history of consciousness.[1]

—Mircea Eliade

The concept that objects can acquire power, that a human being's inner thoughts and impulses can have a residual effect on the outer physical world, is of archaic origin. Reflecting a time when the material elements of nature were effused with Mind or spirit, this timeless world view is confined today to vague subjective sensations, often described as emotional, of empathy and the awareness of a "larger-than-me" order that often mark encounters with the remnants of the natural landscape. The evolution in cultural memory (history) of the assumed location of the artificial image describes a progressive emergence from within the heart and mind of the individual outward to its current residence as a depiction of the external world.

Sacred art in the Western tradition evokes images of the gold-leafed painted panels of the Middle Ages, a time when Asian and European art shared a common ground. One of the most striking things about medieval religious art is that the landscape (for us the *materia prima;* the physical, hard, "real" stuff of the world) appears as an insignificant element, a backdrop subordinate to the religious vision or epiphany. Space is a radiant gold and is substantially less real than the spiritual reality (scene or events) depicted. From our point of view, the inner and outer worlds have reversed their roles.

The Indian, or Far Eastern icon, carved or painted is neither a memory image nor an idealization, but a visual symbolism, ideal in the mathematical sense. . . . Where European art naturally depicts a moment of time, an arrested action, or an effect of light, Oriental art represents a continuous condition. In traditional European terms we should express this by saying that modern European art endeavors to represent things as they are in themselves, Asiatic and Christian art to represent things more nearly as they are in God, or nearer their source.[2]

—A. K. Coomaraswamy

Paramount to the notion of the image as sacred object is the icon, a form found in both oriental and occidental traditions. The term *icon* (ancient Greek for "image") as it is usually understood refers more to a process or a condition rather than to any physical characteristics of an object. An icon can be any image that has acquired power through its use as an object of worship. In fact, the status of icon was the goal and even the measure of success of the majority of visual artworks created in the great religious traditions of ancient Christianity, Buddhism, and Hinduism. The presence of art critics was not required since devotees knew immediately at first glance whether the work in question qualified. The artists created their works for God, not for the art world, and therefore the work had to be exceptional and as close to perfect as possible, their personal devotion and insight being the main criterion and primary evidence of quality in the finished work.

Icons are timeless images, and in the West even though they often do depict a temporal event (the Annunciation, the Flight Out of Egypt, etc.) the mythic/religious existence of those events (i.e., their present tense) is far more important. Icons maintain their currency by being continually updated to the present, by sustaining a constant relevance to Now. They are necessarily functional objects, their function fulfilling a most basic primary and private need within the individual.

Images become icons either through content alone, i.e., images that were commissioned to perform such roles or, more importantly, through the cumulative power of use, itself a reaffirmation of an image's intrinsic power. It is as if the continuous act of worship/veneration leaves a residue that builds up over the years. This aspect of the Christian icon is an echo of the animistic world view of older tribal, "pagan" societies. No wonder such a strong backlash was unleashed in the home of the classical Christian icon, the Eastern church of the Byzantine empire. There in the eighth century, the so-called iconoclasts declared such practices pagan, initiating a conflict lasting more than a hundred years. Icon worship was finally restored by imperial decree.

Unlike the consumption-oriented mass media images of contemporary culture, icons maintain their relevance by remaining the same for centuries. Giving form to eternal realities, their affinity is toward the eternal themselves.

The Temporal Image

As the eye, so the object.

—William Blake

One day in 1425, Filippo Brunelleschi walked out onto the Piazza del Duomo in Florence, and standing at the main doors to the cathedral, facing the baptistry across the piazza, he set up a small wooden box on a stand. He had invited various influential friends and *cognoscenti* to witness his experiment. One by one they stepped up to this curious device and closed one eye to stare through a small hole in one side.

To a twentieth-century observer, the only interpretation of this scene could be that of a photographer demonstrating a new camera, and by expanding the definition of photography perhaps more than is acceptable, Brunelleschi's box could be considered a crude camera. For a citizen of fifteenth-century Florence, the effects of looking into this device were as mind-boggling and astounding as if seeing an actual camera for the first time. Peering into the small hole, they first saw the direct monocular view of the baptistry across

the way. Then, by the flip of a lever, a mirror was moved into position and a small painting of the baptistry appeared, exactly in line and proportional to the direct view. In fact, in regards to geometry and form, the two were barely distinguishable. Brunelleschi had made a sharp right hand-turn out of the Middle Ages.

That Brunelleschi's demonstration seems so obvious to us today is a measure of its intellectual achievement—the more a revolutionary discovery shifts or even shatters the world view, the more commonplace it seems to observers of subsequent ages. What he accomplished that day must have seemed to the others of his time to be at the very limits of knowledge, as incredible, for example, as some of the quantum physicists' descriptions of our world. Prior to 1424, no one had ever painted an image that way. Historians describe this event as Brunelleschi's public pronouncement of the laws of linear perspective, which he is credited with discovering, and there is no doubt that his new system, along with its formalization and publication by his friend Leon Alberti twelve years later, irrevocably altered the history of painting and accelerated the development of techniques of artificial image making.

However, describing Brunelleschi's breakthrough as simply the discovery of the vanishing point places an inordinate emphasis on the picture itself as the locale of this revolutionary change. What Brunelleschi achieved was the personification of the image, the creation of a "point of view" and its identification with a place in real space. In doing so, he elevated the position of the individual viewer to an intregal part of the picture by encoding this presence as the inverse, *in absentia,* source of the converging perspectival lines. The picture became an opaque mirror for the viewer, and the viewer, in turn, became the embodiment of the painter, "completing the picture" as art historians like to say, with the two points of view merging in a single physical spot. The painter now says when he or she paints, "See things as I see them. . . . Stand in my shoes. . . ." Consequently, the picture plane and the retina became the same surface. Of course, Whose retina? was the key question as the manipulation of the viewer, an early form of behaviorism, was added to the list of artistic techniques.

In the dialogue between viewer and image, there were now three entities created, where formerly there were two, or possibly even one. Since previously most images were diagrammatic and/or emblematic representations (i.e., thoroughly two-dimensional), their use as a sacred vehicle was to achieve a sense of union between the viewer and the divinity. The image was to be taken to heart within the individual, with the concurrent loss of self-identity, so common to religious experience, forming the single image of "self/deity." It was an evocation rather than a description (the picture evoked the god or goddess within, not described him or her without).

With the new identification of the viewer with the painter rather than the sacred object, however, came the placement of both of them relative to a third entity, the nearby physical object(s), or subject of the painting, and along with it possibly the inauguration of the process of encroachment of the individual ego (i.e., the artists's) onto the image in the visual arts.

In the Brunelleschian world, the mechanism is perception, the image retinal. When the emphasis is on the act of seeing at a physical place, then time enters the picture as well ("if it's here, it's not there—if it's now, it's not then"). Images become "frozen moments." They become artifacts of the past. In securing a place on earth, they have accepted their own mortality.

The Temporary Image

For the memories themselves are not important.
Only when they have changed into our very blood,
into glance and gesture, and are nameless, no
longer to be distinguished from ourselves—only
then can it happen that in some very rare hour
the first word of a poem arises in their midst and
goes forth from them.[3]

—Rainer Maria Rilke

More than 400 years after "the Fall" of the image, it was no coincidence that, just when the original powerful realization of the optical image was transforming itself into the physical form of the photographic picture machine, the painters were advancing their discoveries of light and image as palpable substances independent of the object. The physical act of rendering the visual world as-the-eye-sees-it was being taken out of their hands, while for their part, the image had once again diverged to begin a slow return to dematerialization and internalization.

The inevitable mechanization of the image made possible two things that led to its liberation from the prison of frozen time: machine nature introduced automated sequential repeatability, and advances in the material sciences made possible the fixing of light impressions on a durable surface, both necessary for the advent of the first moving pictures. It is important to note that the invention of photography was not the invention of the camera, but that of the process of fixing an image onto a plate. Real-time viewing boxes, similar to today's view cameras without the film, were available since the late eighteenth century, the projections of magic lanterns were known in the seventeenth century, and the camera obscura had been around for millennia, probably arising in ancient China. (It is most likely that Brunelleschi was aware of the camera obscura, but regardless he was certainly influenced by new concepts in all fields, including optics, then being imported from the Arabic and Persian cul-

tures of the East through the translation of the ancient manuscripts of the Greeks and more recent texts by great Arabic thinkers such as Alhazen (Ibn al-Haytham).

In this sense, moving images had been around for a long time. Technically, however, the first imparting of movement to artificial images (in this case drawings) occurred in 1832 with the simultaneous inventions of Joseph A. F. Plateau's Phenakistiscope and Simon R. von Stampfer's Stroboscope, soon followed by others, and leading up to the eventual integration of the photographic image into the process at the Edison laboratory during 1888–89 and the birth of true cinema. The emphasis of the term *moving image* is somewhat misleading, since the images themselves aren't really moving and the art of cinema lies more in the combination of image sequences in time (montage) than it does in making the images move.

Still, the question remains, exactly what is this movement in the moving image? Clearly it is more than the frenetic animation of bodies. Hollis Frampton, the great American avant-garde filmmaker, described it as "the mimesis, incarnation, and bodying forth of the movement of human consciousness itself." The root of the cinematic process remained the still picture, but images now had behavior, and the entire phenomenon began to resemble less the material objects depicted and more the process of the mind that was moving them.

A thought is a function of time, a pattern of growth, and not the "thing" that the lens of the printed word seems to objectify. It is more like a cloud than a rock, although its effects can be just as long lasting as a block of stone, and its aging subject to the similar processes of destructive erosion and constructive edification. Duration is the medium that makes thought possible, therefore duration is to consciousness as light is to the eye.

Time itself has become the *materia prima* of the art of the moving image. The "unsticking" of the image in time has been a gradual process, and its effects are permeating art and culture in the late twentieth century, moving beyond the domain of conventional cinematic form and serving to dislodge the dominant compositional model of the dramatic narrative (based on Aristotle's theories of 400 B.C.). This chapter in art history will potentially be as significant as the introduction of three-dimensional space originally was to painting. No doubt the first examples of time-based visual art in the twentieth century will be regarded by future observers as being clumsy and childlike, much in the same way that the modern eye tends to see the medieval painter's first attempts at three-dimensional representation.

If from the medieval vantage point, the post-Brunelleschi optical painting seemed not to be all here (the illusion of someplace else compared to the concrete, nondescriptive existence of the icon image), then cinema was "really"

not here. The physical apparatus of the moving image necessitates its existence as a primarily mental phenomenon. The viewer sees only one image at a time in the case of film and, more extreme, only the decay trace of a single moving point of light in video. In either case, the whole does not exist (except in a dormant state coiled up in the can or tape box), and therefore can only reside in the mind of the person who has seen it, to be periodically revived through their memory. Conceptual and physical movement become equal, experience becomes a language, and an odd sort of concreteness emerges from the highly abstract, metaphysical nature of the medium. It is the concreteness of individual experience, the original impetus for the story—"I went here and this happened. . . ." Sitting in the dark room, we sense a strange familiarity—an image is born, flashes before our eyes, and dies in blackness.

Once there was a train of images sequentially unfolding in time, there was "a moving image" and with it, by necessity, a beginning and an end; mortal images, with the camera as death. As long as perpetual motion remains an unrealized dream, there will always be a last image, usually with darkness as a final punctuation. Fade to black . . .

The Last Image

I raise the mirror of my life
Up to my face: sixty years.
With a swing I smash the reflection—
The world as usual.
All in its place.[4]

After writing these lines in 1555, the Zen priest
Taigen Sofu put down his brush and died. (From
the Japanese tradition of *jisei,* poems written by
Zen monks and Haiku poets on the verge of
death.)

In many countries throughout the world, black is the color of mourning. Echoing this ineffable finality, in European culture black is considered to be outside color, the condition of the "absence of light." The focal point for black in our lives is the pupil of the eye, portal to the tiny chamber in center of the eyeball where darkness is necessary to resolve the original parent of the artificial image.

When the means of the artistic creation of images are the laws of optics and the properties of light, and the focus is the human eye, it was only a matter of time before someone thought to hold up a mirror. The ideal mirror, around since the beginning of humankind, is the black background of the pupil of the eye. There is a natural human propensity to want to stare into the eye of another or, by extension of oneself, a desire to see seeing itself, as if the

straining to see inside the little black center of the eye will reveal not only the secrets of the other, but of the totality of human vision. After all, the pupil is the boundary, and veil, to both internal and external vision.

Looking closely into the eye, the first thing to be seen, indeed the only thing to be seen, is one's own self-image. This leads to the awareness of two curious properties of pupil gazing. The first is the condition of infinite reflection, the first visual feedback. The tiny person I see on the black field of the pupil also has an eye within which is reflected the tiny image of a person . . . and so on. The second is the physical fact that the closer I get to have a better view into the eye, the larger my own image becomes thus blocking my view within. These two phenomena have each inspired ancient avenues of philosophical investigation and, in addition to the palpable ontological power of looking directly into the organs of sight, were considered proof of the uniqueness and special power of the eyes and the sense of sight.

Staring into the eye is an ancient form of autohypnosis and meditation. In the Alcibiades of Plato, Socrates describes the process of acquiring self-knowledge from the contemplation of the self in the pupil of another eye, or in the reflection of one's own.

Socrates *(describing the Delphic inscription "gnothi seauton"):* I will tell you what I think is the real advice this inscription offers. The only example I find to explain it has to do with seeing. . . . Suppose we spoke to our eye as if it were a man and told it: "See thyself". . . would it not mean that the eye should look at something in which it could recognize itself?

Alcibiades: Mirrors and things of that sort?

Socrates: Quite right. And is there not something of that sort in the eye we see with? . . . Haven't you noticed that when one looks someone in the eye, he sees his own face in the center of the other eye, as if in a mirror? This is why we call the center of the eye the "pupil" (puppet): because it reflects a sort of miniature image of the person looking into it. . . . So when one eye looks at another and gazes into that inmost part by virtue of which that eye sees, then it sees itself.

Alcibiades: That's true.

Socrates: And if the soul too wants to know itself, must it not look at a soul, especially at that inmost part of it where reason and wisdom dwell? . . . This part of the soul resembles God. So whoever looks at this and comes to know all that is divine—God and insight through reason—will thereby gain a deep knowledge of himself.[5]

The medieval Neoplatonists practiced meditating on the pupil of the eye, or *speculation,* a word that literally means "mirror gazing." The word *contempla-*

tion is derived from the ancient practice of divination where a *templum* is marked off in the sky by the crook of an auger to observe the passage of crows through the square. *Medi*tation and *concen*tration both refer to the centering process of focusing on the self.

The black pupil also represents the ground of nothingness, the place before and after the image, the basis of the "void" described in all systems of spiritual training. It is what Meister Eckhart described as "the stripping away of everything, not only that which is other, but even one's own being."

In ancient Persian cosmology, black exists as a color and is considered to be "higher" than white in the universal color scheme. This idea is derived in part as well from the color of the pupil. The black disc of the pupil is the inverse of the white circle of the sun. The tiny image in "the apple of the eye" was traditionally believed to be a person's self, his or her soul, existing in complimentary relationship to the sun, the world-eye.

"There is nothing brighter than the sun, for through it all things become manifest. Yet if the sun did not go down at night, or if it were not veiled by the shade, no one would realize that there is such a thing as light on the face of the earth. . . . They have apprehended light through its opposite. . . . The difficulty in knowing God is therefore due to brightness; He is so bright that men's hearts have not the strength to perceive it. . . . He is hidden by His very brightness."[6]

—*Al-Ghazzali (1058–1111)*

So, black becomes a bright light on a dark day, the intense light bringing on the protective darkness of the closed eye; the black of the annihilation of the self.

Fade to black . . .

[Silence]

A voice is heard in the darkness: . . . but wait, fade to black is just one of the blacks in video—there are actually three states of video that can be black like what you're talking about.

Narrator: And what are they?

Voice: Well, there's video black, as in "fade to black." Then there's snow, when the set is on but there is no signal present—you can also see this as a blank, dark screen on video monitors. And then there's nothing, when the plug is pulled out and the set is cold. In terms of our bodies, these are like closing your eyes, sleep, and death.

Narrator: I see. So, if I understand what you're saying, as long as there is the kernel of self-consciousness, as in the first two stages and sometimes

even in the darkest depths of the intermediate zone between stages two and three, the "near-death" or "beyond-death" experiences, then there is always the possibility for renewal.

Voice: That's it. Self-consciousness is the awareness of context—you know . . . the view from above, the motivation to keep flipping the power switch back on.

Narrator. That reminds me of a recurring dream I have.

Voice: Tell me.

Narrator: There is nothing but black. I am awake. Lying on my back, I sense my breathing, quiet and regular. I roll over and stare upwards. I see nothing, or rather I am trying to understand what I am seeing. There is the sensation of space, palpable in the blackness, but it is depth without the reassuring content of an image. There is the sensation of my body, its extension and weight pressing downwards. And there are these questions in silent dialogue with the darkness. I bring my hand up to my face. There is nothing. I turn it over, wave it and the slight brush of the movement of air is felt against my cheek. I lie motionless. There is a slight ringing sensation in my ears, and my mouth feels dry because I haven't wanted to move, not even to swallow. Without motion, I slowly am aware of the loss of sensation in my limbs. I don't know how long I have been lying like this. I imagine the darkness as an immense soft black cloud of cotton wool, silent and weightless, gradually pressing in around my body. Everything seems to be closing down to a small opening just around my face; outside of this small area, the oblivion of nothing. Finally, like a body under water focused on breathing through a tiny straw, I let that go and feel myself submerged in the great comfort of the senseless and weightless void.

Voice: [Dumbfounded silence]

Fade to black.

In two minutes, the tape runs out and the screen is plunged into snow. The hissing sound jars the viewer from sleep. A hand slowly comes in and fumbles for the power button. There is a click, silence, and the snow on the screen abruptly collapses into a momentary point of light, which gradually fades while the glass screen quietly crackles, dissipating its static charge, and the internal circuits begin to lose their heat to the cold night.

Phototropic

Tony Oursler, *Video Dream*, from *Spheres of Influence*, 1989.

The spectrum of tragedy brings people together. Its many jagged colors, together, make a white light . . . or so they say. He takes his broken dreams to the congregation at the TV show in hopes of illuminating many homes. The contestants, suffering from a range of sexual maladies, a major problem in the modern world, volunteer to be artificially stimulated to orgasm. With the aid of the highest technology the images which run through their minds at the exact point of orgasm are presented for all to see. These visions are scrutinized and re-warded according to their entertainment value.

—Tony Oursler, *Spheres of Influence* (a video tape and installation)

Evidence of a Narrative MetaSystem: The function of the NMS can only be described by its effects upon the lives of its Hosts and by the traces left by its subsurface ebbs and flows as they emerge through psychomimetic technologies. The NMS, coupled with these technologies, acts as a construc-

tive corrosive and dissolves physical boundaries to form the Screened World.

What has happened to my body? First, I would like to match the two clocks.

Zita Mellon, Artist (1897–).	Advents
	Electricity
Born	
	Radio
	Automobile
	Flight
42nd year	TV
	Atomic
	DNA
	Moon
	Synthetic
	Virus

The bowerbird family, Ptilonorhynchidae, is closely related to the bird of paradise. The satin, stagemaker, and all other members of this species are known for their remarkable *bowers*. These chambers, arenas, and runways are constructed for the sole purpose of mating. Within his bower, each male bowerbird performs an elaborate "dance" until he attracts a mate. The bowers are built of various decorative, color-coded (by plumage) materials such as insect bodies, shells, feathers, creepers, grasses, mosses, orchids, and other flowers. The decorations, as they become withered or faded, are cleared from the site and replaced. Recently, the bowerbird has added brightly colored synthetics that fit into its building palette. Some bowerbirds are festooned with bright plumage, while others are rather dull and inconspicuous. This range of coloration is reflected in the process of bower building; the more colorful the bower the less colorful the bird and vice versa. (There is a continuing debate surrounding this phenomenon in relation to theories of evolution. Some say the bird is a freak of nature, constantly struggling to make up for a lack of adequate gender marking while others see its habits as a "neo-natural" mutation with far-reaching implications.)

The Screened World has facilitated the displacement of the "natural" eco-system by the "artificial" Echo-System. Thus, a shunting of life force transpires.

Artifice redefined.

One of the most interesting things about TV is that people spend so much time watching something that has nothing to do with their lives.

—Unknown member of the medical industry

Federal Communications Commission (FCC) broadcasts, once received, cause the location of their reception to undergo a transformation of psycho/architectural fusion: electronic prison. FCC narratives and their codification can be seen as a shape. Alternatives to these transmissions can be deduced by perceiving the negative of that shape.

An inside look at the FCC Electronic Prison:

There is a distinct presence of Christianity here, an adulterated

brand of Christianity, suffering from a perversion of its founding doctrine resulting in the shift of its primary symbolism from the resurrection to the crucifixion. This shift in emphasis and its endless contradictions is central to the schizophrenic predisposition of the American. The FCC piggybacks its narratives on this predisposition, exploiting it as a means of supplying the public with an endless stream of capitalistic verisimilitude. The FCC, acting as both the pusher and the drug, profits by narcotizing viewers and keeping them addicted.

Within the confines of this prison the viewer is conditioned to automatically and unconsciously enter into a state of willing suspension of disbelief. The viewer sits as a nullity, hypnotized by the light and synced to the electromagnetic waves of the Utility of Television.

A body may live long underground conserved by the Astral Light in a complete state of lucid somnambulism. Their souls are then bound to the sleeping body by an invisible chain, and if those souls are greedy and criminal they can draw on the quintessence of the blood in the persons who are naturally asleep; they can transmit this sap to their interred bodies for their longer preservation, in the vague hope that they may be restored ultimately to life.

—Colin Wilson, *The Occult*.*

While under the influence of the Utility, the viewer manifests one of the predominate signs of schizophrenia: the inability to identify the per-

imeter of the body or to perceive the point at which the body ends and the rest of the world begins. . . .

To induce the out-of-body experience, a symbolic species identification is evoked within the viewer. To achieve this, a visualsonic code is projected that can be decoded or constructed by the viewer to resemble a human form known as a Surrogate. Electronic Animism is triggered by the presence of the Surrogate, followed by a remarkable degree of viewer empathy, decapitation, possession, and, finally, the most damaging result of FCC transmissions, repression of the Evolving Collective Unconscious.

There is no such thing as an actor.

What are these empathy-inducing entities? To understand the psychoactive cipher the code must be broken. To begin, we must identify some of the elements that retain the characteristics of the Surrogate.

A period.
A period screaming.
A hole with language coming out
 of it.
Effigy.
Six Japanese dressed in black, all
 operating one small puppet.
A piece of meat moving around
 . . . in sync with language.
Any evidence of life.
Excrement.
Anything in the foreground.
The whole picture.
Anything that moves.
Anything more interesting than
 you.

* See the writings of Constance DeJong.

Mirror.
Anything mind altering.
Anything mood altering.
Frankenstein.
Empathy.

One encodes sensory experience by means of a rearrangement of neural electronics and chemistry, resulting in the physical imprint of a neural narrative.

When I was a young child, I was convinced that what was shown on the Utility was real—even the scenarios depicting death. I thought that prisoners on death row were given the choice to die as a TV cowboy or army man or to die in a gas chamber or electric chair.

"Oh, looks like I killed her."

—Robert Chambers, from his untitled videotape

[The tape was produced by Mr. Chambers and four "girlfriends" before the start of his trial for the murder of Ms. Levin. Ms. Levin, whose body was found in Central Park (cause of death: strangulation) near the Metropolitan Museum of Art, was at one time a "girlfriend" of Mr. Chambers. He claimed that he killed her by mistake during "rough sex" in what became sensationalized in the press as the "Preppie Murder Trial."

After a protracted debate regarding Chambers's guilt or innocence, during which the defense mounted a campaign of character assassination against the late Ms. Levin, Chambers was convicted and sentenced for manslaughter to a minimum term in

prison. Soon after he began serving his sentence, one of the "girlfriends" who helped make the videotape sold it to a local New York TV station for $10,000. No one, except Chambers and friends, knew of the existence of the videotape until the announcement of its sale. The video, which showed Chambers committing mock strangulations while the "girlfriends" acted as victim, judge, and jury, won top prime-time ratings and, as was noted by the press, outstripped *Wheel of Fortune* for two days in a row. The Chambers statement quoted above, was made on the videotape while removing a doll's head from its body. (It has been brought to my attention, by filmmaker Joe Gibbons, that if the security cameras at the Metropolitan Museum had been in working order at the time the original murder was committed the event would have been captured on video for all to judge.)]

In *Manslaughter,* the heroine was a speed demon. In one scene, her car was to be chased by a motorcycle policeman. Then her car was to skid around and be hit dead center by the motorcycle.... The stunt man somersaulted over the car, landing on the other side with broken ribs, pelvis, and collarbone. Later the actress commented, "They shouldn't have risked a man's life for that shot. When you see it on screen, it looks exactly like a dummy!"

The director of the first *Ben Hur* carried the use of real people to the fatal extreme.... It was the fiery clash between the slave ship and the pirate ship that really upset newspapers and public opinion. When the Italian extras had

Form for Reporting a Violent Copycat Media Event

Part II: ORIGINAL EVENT

Medium ' Film _____

TV _____

Cable _____

Other _____

Title of Media Event: _____

Description of Media Event: _____

Part II: COPYCAT EVENT

Date of Event: _____

Time of Event: _____

Location: _____

Description of Copycat Event: _____

been hired for that scene ... each had been asked if they could swim. A simple "Yes" got a job for each peasant paying more money than he could ever make in the fields. To make sure the ships would burn well, they had been liberally doused with oil— without warning the passengers. No one ever combed through the conflicting stories of the filming enough to prove how many extras drowned that day....

—Susan Hilton, *It's Smart to Use a Dummy*

The word *television* comes from the Greek word *tele,* meaning "far" and the Latin word *videre* meaning "to see."

Transportation.
Perspective.
Elf.
Giant.
Filter.
Bunker.

It is well known that Elvis Presley had violent reactions to the Utility. During the singer's wild viewing parties he would become enraged at something he saw on the TV, produce a loaded twelve-gauge shotgun, and shock his house guests by firing both barrels at the offensive appliance. As was often the case with many of Elvis's impulses, his TV shoot-outs were prophetic. [Please note the singer's use of two-way mirrors (stealthily installed around his home to his specifications) during masturbatory sexual activities. Also, later, the "viewer interactive" works by artist Dan Graham. Although it was Little Richard ("Richard the Watcher," to his friends) who laid the foundation, it was the King, followed by Mr. Graham, who produced the primary works of Architectural Video Interactivity.]

Soon after the news of the shoot-outs hit the tabloids, there arrived, on the wings of a new technology, the first popular interactive video game—Tank Commander. The player of Tank Commander stands, control stick in hand, head partially surrounded by and facing into a dark chamber. This chamber houses a screen that acts as an opening in a tank used to sight the tanks' guns. This simulated gun turret looks "out" onto a hostile environment. Using the controls, the player can gain the illusion of moving in any direction on the horizontal battlefield. The landscape is pictured in hard-edge, phosphorescent green, computer-generated lines on a field of jet black. The horizon remains constant, to be broken only by motion: the approach toward an angular mountain range or the onslaught of a multitude of geometric enemy projectiles and vehicles. The computer keeps the player's point of view at the perspective center of this world; wherever the player "moves," the surrounding objects fall off sharply, diminishing perfectly toward the distant horizon. The object of the the game is to destroy the enemy by firing at them before they destroy you. The frightful sounds of tanks exploding seems strangely familiar; through these explosions Elvis and his twelve-gauge song live on.

After Tank Commander and other similar-in-theme, eye-hand-dexterity-intensive games had been around awhile, a conspiracy theory was hatched in the arcades and malls around the nation. The word was this: The Pentagon was behind the deployment of the games. They were in fact the mechanical embodiment of a domestic propaganda campaign. The goal was to develop a consciousness sympathetic to that of the military. Other theories went on to speculate that they were part of a pretraining process targeting recruitment age youths. At this point the word branched out, into a general history of camouflage, and made a fuguelike cycle. . . .

> Trojan Horse
> The hand-painted cardboard sets of
> buildings that Mussolini had
> erected along roads to be toured
> by Hitler.
> Inflatable Tanks.
> Biosphere relation to surface coat-
> ing color theory.
> Clandestine integration of propa-
> ganda into popular entertain-
> ment forms.
> Computer War Game Centers.
> Interactive flight simulators.
> The CIA's use of LSD as a truth/
> amnesia drug.
> Subliminal video messages.
> Tank Commander.

"Everything is true," he said. "Everything anybody has ever thought."

—Philip K. Dick, *Do Androids Dream of Electric Sheep? (Blade Runner)*

It is estimated that the human body completely rebuilds itself every decade, systematically replacing its intricate structure on the molecular level. Although this subtle process of biological reinvention is largely ignored by the cultural-military complex, its significance is noted within certain sectors of the medical industry. It is there that we find the American pioneer spirit at its finest, engaged in deadly battle, returning the Citizen to the Body.

. . . Take some time to observe whatever image appears as carefully as you can . . . if you would like it to become clearer, imagine you have a set of controls like you do for your TV set, and you can dial the image brighter or more vivid . . . notice the details about the image . . . what is the shape? . . . color? . . . How big is it? . . . How big is it in relation to you? . . . How close or far away does it seem? . . .

. . . notice any feelings coming up, allow them to be there . . . look deeper . . . are there any other feelings present as you observe the image? . . . When you are sure of your feelings let the image know how you feel about it—speak directly and honestly to it (you may choose to talk out loud or express yourself silently) . . .

Then in your imagination, give the image a voice, and allow it to answer you . . . listen carefully to what it says . . .

—Martin L. Rossman, M.D., *Healing Yourself: A Step-By-Step Program for Better Health Through Imagery*

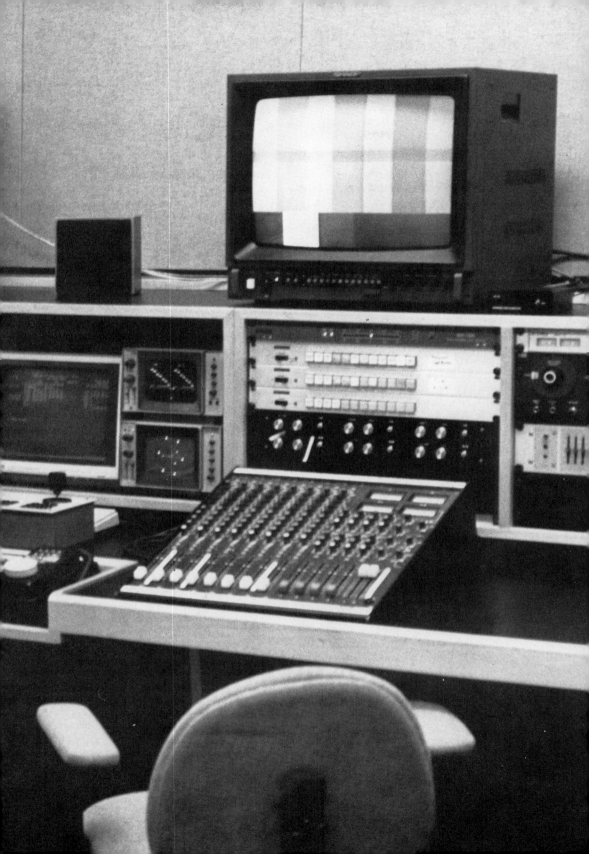

Notes

Doug Hall and Sally Jo Fifer
Introduction: Complexities of an Art Form

1. In contemporary popular culture, the word video has numerous meanings. For the purposes of this introduction, we have used it to refer to the works of independent producers, usually documentarians or artists, who make videotapes or video installations that are not intended for the mass market of broadcast television. Similarly, we have distinguished between the television set, which receives the broadcast signal of television, and the video monitor, which is used for the playback of independently produced videotapes for single channel works or video installations, or for the transmission of a live feed from a camera.

2. Coates, Nigel, "Street Signs," in *Design After Modernism*. ed. John Thackara (New York: Thames and Hudson, 1987), p. 98.

3. Our appreciation to John Rapko for his assistance in developing this description of modernism.

4. Fried, Michael, "Art and Objecthood," in *Minimal Art: A Critical Anthology*, ed. Gregory Battcock (New York: E. P. Dutton, 1968), pp. 116–147.

5. Lewitt, Sol, "Sentences on Conceptual Art, 1968," in *Conceptual Art*, ed. Ursula Meyer (New York: E. P. Dutton, 1972), pp. 174–175.

Martha Rosler
Video: Shedding the Utopian Moment

Originally published in Block, *Winter 1985/86 and, in slightly different form, in* Vidéo, *René Payant, ed. (Montréal: Artextes, 1986). An abbreviated version of this paper was delivered at the association of Art Historians Conference, The City University, London, Easter, 1985.*

1. Alvin Gouldner, *The Dialectic of Ideology and Technology* (New York: Oxford University Press, 1976). p. 7.

2. William Wordsworth, "The World is Too Much With Us; Late and Soon" (1806)

3. In *Mirror Image: The Influence of the Daguerreotype on American Society* (Albuquerque: University of New Mexico Press, 1971).

4. John F. Kasson, *Civilizing the Machine: Technology and Republican Values in America, 1776–1900* (Harmondsworth: Penguin, 1976).

5. John Fekete, *The Critical Twilight: Explorations in the Ideology of Anglo-American Literary Theory from Eliot to McLuhan* (London: Routledge & Kegan Paul, 1977), pp. 15–16.

6. In *Camera Work,* cited by Sally Stein in "Experiments with the Mechanical Palette: Common and Cultivated Responses to an Early Form of Color Photography," unpublished paper (1985). Stieglitz wrote: ". . . on the *Kaiser Willhelm II,* I experienced the marvelous sensation within the space of an hour of marconi-graphing from mid-ocean; of listening to the Welte-Mignon piano which reproduces automatically and perfectly the playing of any pianist . . .; and of looking at those unbelievable color photographs! How easily we learn to live our former visions!"

7. Peter Bürger, *Theory of the Avant-Garde,* Michael Shaw, trans. (Manchester: Manchester University Press, 1984), p. 34.

8. Ibid.

9. Allan Kaprow, "The Education of the Un-Artist, Part I," *ArtNews* (February 1971).

10. Gouldner, *Dialectic.*

11. See Max Kozloff's mid-1970s article in *Artforum* on abstract expressionism and the Cold War, and Eva Cockcroft's subsequent re-reading of the situation in the same magazine. See also Serge Guilbaut, *How New York Stole the Idea of Modern Art: Abstract Expressionism, Freedom, and the Cold War* (Chicago: University of Chicago Press, 1983).

12. Kaprow, "Un-artist."

13. Jane Livingstone, "Panel Remarks," in *The New Television: A Public/Private Art,* Douglas Davis and Allison Simmons, eds., based on the conference "Open Circuits," held in Janu-

ary 1974 in association with New York's Museum of Modern Art (Cambridge: M.I.T. Press, 1977), p. 86.

14. Christopher P. Wilson, "The Rhetoric of Consumption: Mass Market Magazines and the Demise of the Gentle Reader, 1880–1920," in Richard W. Fox and T. J. Jackson Lears, eds., *The Culture of Consumption* (New York: Pantheon, 1983), p. 47.

15. Martha Gever, "Pomp and Circumstances: The Coronation of Nam June Paik," *Afterimage*, Vol. 10, No. 3 (October 1982), pp. 12–16.

16. *Zeitschrift für Sozialforschung*, Vol. VI. Reprinted in English translation in Herbert Marcuse, *Negations* (Boston: Beacon Press, 1968), pp. 88–133.

17. See T. J. Jackson Lears, *No Place of Grace: Anti-Modernism and the Transformation of American Culture, 1880–1920* (New York: Pantheon, 1981).

18. John Fekete, *The Critical Twilight*, p. 178.

19. Roland Barthes, "Myth Today," in *Mythologies* (New York: Hill and Wang, 1972), p. 143.

20. Alvin Gouldner, *Dialectic*, p. 175.

21. See Lucinda Furlong, "Getting High-Tech: The 'New' Television," *The Independent* (March 1985), pp. 14–16; see also Martha Rosler, " 'Video Art,' Its Audience, Its Public," *The Independent* (December 1987), pp. 14–17.

Deirdre Boyle
A Brief History of American Documentary Video

I would like to acknowledge my gratitude to the New York State Council on the Arts, the John Simon Guggenheim Memorial Foundation, the Port Washington Public Library, Yaddo, and the MacDowell Colony for the Arts for the invaluable support I received in researching and writing this essay.

1. In differentiating various phases of documentary video's history, I have taken the liberty of assigning terms to certain periods which were not used so exclusively at the time. For example, *alternative television, guerrilla television,* and *grass-roots video* were often used synonymously, and *underground video* was also called *cybernetic guerrilla video warfare.* In order to identify and track the rapidly evolving styles and goals of documentary and to avoid the many confusions such divergent work presents, these distinctions, however arbitrary, were employed.

2. David Ross, "Television: Bringing the Museum Home," *Televisions* 3:2 (May 1975), pp. 6–7.

3. Jud Yalkut, "Frank Gillette and Ira Schneider, Parts I & II of an Interview," *Radical Software* 1 (Summer 1970), pp. 9–10.

4. David Armstrong, *A Trumpet to Arms: Alternative Media in America* (Boston: South End Press, 1981), pp. 20–21.

5. Parry Teasdale, interview with author, April 18, 1984.

6. Chloe Aaron, "The Alternate-Media Guerrillas," *New York* (October 19, 1970), pp. 50–53; "The Video Underground," *Art in America* (May–June 1971), pp. 74–79.

7. Author's interviews with the following: the Videofreex—Skip Blumberg (April 22, 1983), David Cort (November 9, 1983), Davidson Gigliotti (1983), Carol Vontobel and Parry Teasdale (April 18, 1984), Ann Woodward (April 10, 1984); CBS—Don West (May 21, 1984). See also Les Brown, *Television: The Business Behind the Box* (New York: Harcourt Brace Jovanovich, 1971), pp. 134–135.

8. John Reilly and Stefan Moore, "The Making of 'The Irish Tapes,' " *Filmmakers Newsletter* (December 1975), pp. 17–21.

9. Russell Connor, "Rebuttal: Up with 'Irish Tapes,' " *Soho Weekly News* (December 20, 1973).

10. Michael Murray, *The Videotape Book* (New York: Bantam, 1975), p. 213.

11. Chloe Aaron, "The Alternate-Media Guerrillas." See also Marco Vassi, "Zen Tubes," *Radical Software* 1 (Summer 1970), p. 18.

12. Deirdre Boyle, *Return of Guerrilla Television: A TVTV Retrospective* (New York: International Center of Photography, 1986).

13. Deirdre Boyle, "Cuba: The People," in *Video Classics: A Guide to Video Art and Documentary Tapes* (Phoenix: Oryx Press, 1986), pp. 28–30.

14. Deirdre Boyle, "Truth or Verisimilitude? evolution of the Raymonds," *Sightlines* (Winter 1981/82). pp. 4–5.

15. Hugo McPherson, "A Challenge for NFB," *Access Newsletter: Challenge for Change/ Societe Nouvelle* 1:1 (Spring 1968), p. 2.

16. *Appalachia*, "Homegrown is Fresher: Broadside TV Pioneers in Regional Video Programming," (April–May, 1974), pp. 12–23.

17. Ski Hilenski, "Mountain Guerrilla: The Life, Death and Legacy of Broadside TV," unpublished paper.

18. Pat Aufderheide, "The Movies," *Minnesota Daily* 75:89 (January 25, 1974).

19. Craig Sinard, "Television and Public Access," unpublished thesis, Iowa State University (1979).

20. Author's interview with Andy Kolker and Louis Alvarez (January 30, 1984).

21. Author's interviews with the following: Lynn Adler (October 3, 1983), Wendy Appel (October 17, 1983), Vicki Costello (October 14, 1983), Julie Gustafson (April 13, 1984), Joanne Kelly (October 7, 1983), Susan Milano (June 15, 1984), Kath Quinn (February 3, 1984), Keiko Tsuno, (May 8, 1984), Ann Volkes (April 25, 1984), Carol Vontobel (April 18, 1984), Megan Williams (October 18, 1983), and Ann Woodward (April 10, 1984), among others.

22. Author's interview with Bill Stephens (May 10, 1984).

23. Elizabeth Weatherford, ed., *Native Americans on Film and Video* (New York: Museum of the American Indian, 1981).

24. Deirdre Boyle, "Skip Blumberg Warms Up TV," *Sightlines* (Spring 1982), pp. 6–7.

25. Martha Gever, "Victory for Independents: Congress Creates an Independent Production Service," *The Independent* (December 1988), pp. 4–8.

26. Jon Alpert, telephone conversation with the author (November 16, 1988).

27. Pat Thomson, "Under Fire on the Home Front," *Afterimage* 14:9 (April 1987), pp. 8–10.

28. Michael Shamberg and Raindance Corporation, *Guerrilla Television* (New York: Holt, Rinehart and Winston, 1971), p. 32. See also David Armstrong, *A Trumpet to Arms*, p. 162.

29. Megan Crowley and Skip Blumberg, "Disarmament Video Survey: Project Report," press release, 1982.

30. Deirdre Boyle, "Home Video Review: Paper Tiger Television," *Cineaste*, 14:2 (1985), p. 46.

John G. Hanhardt
Dé-collage/Collage: Notes Toward a Reexamination of the Origins of Video Art

1. Erving Goffman, *Frame Analysis: An Essay on the Organization of Experience* (Cambridge: Harvard University Press, 1974), p. 21:

> Whatever the degree of organization . . . each primary framework allows its user to locate, perceive, identify, and label a seemingly infinite number of concrete occurrences defined in its terms. He is likely to be unaware of such organized features as the framework has and unable to describe the framework with any completeness if asked, yet these handicaps are no bar to his easily and fully applying it.

2. Umberto Eco, "The Frames of Comic 'Freedom,'" *Carnival*, ed. Thomas A. Sebeok (Berlin: Mouton Publishers, 1984), p. 8:

> Humor does not pretend . . . to lead us beyond our own limits. It gives us the feeling, or better, the picture, of the structure of its own limits. It is never off limits, it undermines limits from inside. It does not fish for an impossible freedom, yet it is a true movement of freedom. Humor does not promise us liberation: on the contrary, it warns us about the impossibility of global liberation, reminding us of the presence of a law that we no longer have reason to obey. In doing so it undermines the law. It makes us feel the uneasiness of living under a law—any law.

Kathy Rae Huffman
Video Art: What's TV Got To Do With It?

1. In 1960, there were 44 noncommercial television stations (in comparison with 515 commercial stations). This number grew to 99 (in comparison with 569 commercial TV stations) in 1965. Christopher H. Sterling and John M. Kittross, *Stay Tuned: A Concise History of American Broadcasting*, (Belmont, CA: Wadsworth Publishing Co., 1978), p. 439.

2. Carnegie Commission on Educational Television, *Public Television: A Program for Action* (New York: Harper & Row, 1967), pp. 3–4.

3. Commercial television aired the wacky comedian Ernie Kovacs between 1950 and 1962 on a variety of stations. He was an original, an innovator, and ". . . given the environment of

1950s broadcasting, Kovacs was the sole perpetrator of anything we can reasonably refer to in retrospect, as video artistry." John Minkowsky, "An Intimate Vacuum: Ernie Kovacs in the Aura of Video Art," in *The Vision of Ernie Kovacs,* the Museum of Broadcasting exhibition catalog, May 30– September 4, 1986, p. 38.

4. David Atwood, in conversation, "The WGBH New Television Workshop, The 20 Year Challenge", a public program at The Institute of Contemporary Art, Boston, November 1987.

5. Fred Barzyk, in conversation, The ICA, ibid.

6. Douglas Davis, *Art and the Future* (New York: Praeger Publishers, 1973), pp. 67–90.

7. Marita Sturken, "Private Money and Personal Influence," *Afterimage,* January 1987, p. 9.

8. Joanne Kelly, "The National Center for Experiments in Television KQED," in *Transmission,* ed. Peter D'Agostino, (New York: Tanam Press, 1985), p. 282.

9. Fluxus was an anti-high-culture movment with its roots in the European Dadaists of the 1920s. It was centered in the Soho area of New York City. In fluxus style, Nam June Paik's first videotape from a taxi created a half-inch documentary video of the Pope's visit to New York. This "action" would become the point of departure for artists and televison and signaled a future apart from ponderous television equipment and the ability to subvert TV's politically conservative attitudes.

10. Douglas Davis, p. 90.

11. Susan Dowling, "The New Television Workshop WGBH," in AFI's *National Video Festival* catalogue, 1983, p. 64.

12. Susan Dowling, "The New Television Workshop," in *Transmission,* ed. Peter d'Agostino, p. 276.

13. Fred Barzyk in conversation at The ICA, Boston, ibid.

14. Marita Sturken, "The TV Lab at WNET/Thirteen," in *Transmission,* ed. Peter d'Agostino, p. 272.

15. Carol Brandenberg, "The TV Lab WNET Thirteen" in *AFI National Video Festival* catalogue, 1983, p. 60.

16. Sergio Borelli, "Introduction and ten year report," *International Public Television Screening Conference (INPUT)* catalogue, Granada, Spain, 1987, unpaginated.

17. John Reilly, "Independents, Media Arts Centers, and Public Television," in *Independent Television-Makers and Public Communications Policy* (Working Papers), The Rockefeller Foundation, December 1979, pp. 35–45.

18. Arlene Zeichner, "Rapping About Wrapping," *L.A. Weekly,* November 28–December 4, 1986, p. 20.

19. "Victory for Independents: Congress creates an independent production service," by Martha Gever. *The Independent,* December 1988, p. 4.

Gary Hill
And if the Right Hand did not know What the Left Hand is doing

1. Maurice Blanchot. *The Writing of the Disaster (L'Ecriture du Désastre.* Translated by Ann Smock. (Lincoln and London: University of Nebraska Press, 1986) p. 87.

2. George Quasha. "Dialogos: Between the Written and the Oral in Contemporary Poetry." New Literary History (Vol. VIII, 1976–1977) p. 488.

Marita Sturken
Paradox in the Evolution of an Art Form

I would like to thank the many people who offered suggestions in reading this manuscript at its various stages of development, especially to Paul Ryan, Rita Myers, Robert Beck, Lori Zippay, Nathalie Magnan, and Vivian Sobchack. This article is a revised version of an article that was published in French in Communications No. 48 (1988), *edited by Raymond Bellour and Anne-Marie Duguet.*

1. Michel Foucault, *Power/Knowledge: Selected Interviews & Other Writings 1972–1977* (New York: Pantheon Books, 1980), pp. 81–82.

2. Bill Viola, "History, 10 Years, and the Dreamtime," in *Video: A Retrospective,* ed. Kathy Rae Huffman (Long Beach, Calif.: Long Beach Museum of Art, 1984), p. 19.

3. That Nam June Paik has played the role of video's protagonist will be examined further in this paper. However, in recent years it is apparent that Bill Viola has eclipsed Paik as video's central hero. He has been the subject of the most recent array of solo exhibitions and a

spate of superlative-laden and highly uncritical articles. There are many very talented women working in video, yet its historical narrative is still conventionalized on the notion that the hero is male.

4. The situation of preserving videotapes is actually already one of crisis. A major reason for this is not only the short life span of video-tape in general, but the way in which formats have changed so rapidly. Many half-inch reel-to-reel tapes from the early 1970s have deteriorated to the point that they are no longer transferable to other formats, and many early one-inch videotapes are now unviewable be-cause there are no existing functional decks in those formats. As time goes on, the issue of preservation becomes one of selection. A trac-ing of video history has already been skewed by what was preserved and what was not. The selective process of video history is not only human, tied as it is to the illogic of human memory and institutional agendas, it is also technological.

5. That a specific technology is designed ex-pressively with limitations was perceived quite early on by such artists as Eric Siegel, Bill Etra, Dan Sandin, and Steina and Woody Va-sulka, among others, who began working in video by designing their own imaging ma-chines that could open up the capabilities of-ten negated in industrially designed machines that were based on cinematic codes and con-ventions of imaging. For instance, the Vasul-kas' first step was to release the frame so that the video image would drift horizontally. That industrially designed machines did not utilize this capacity was because they adhered to the codes of the film frame.

6. See Martha Rosler, "Video: Shedding the Utopian Moment," pp. 31–50.

7. The Museum of Modern Art's *Video Art: A History* show was, in fact, a historical chroni-cle, that is a listing of the events that could then be used as the skeleton for the historical narrative. (See the *Circulating Video Library Catalog* [New York: Museum of Modern Art, 1983.]) Chronicles are, of course, both selec-tive and arranged according to a specific agenda—here, the bias was toward events in video history that had taken place under the auspices of credentialed institutions.

8. See Lucinda Furlong's "Raster Masters" re-

view of the Museum of Modern Art show, *Afterimage* 11:8 (March 1984).

9. Hayden White, *Metahistory: The Historical Imagination in Nineteenth-Century Europe* (Balti-more: Johns Hopkins University Press, 1973), pp. 6–7.

10. The specific institutions and critics that have contributed to the writing of video his-tory are most notably the Museum of Modern Art, the Whitney Museum of American Art, the Long Beach Museum of Art, the Institute for Contemporary Art in Boston, with their respective curators Barbara London, John Hanhardt, David Ross, and Kathy Huffman, among others. However, lest this seem to be simply finger pointing (I myself wrote several versions of the standard history in certain ca-pacities as a writer), I should note that these are simply the most obvious names in what in a small field becomes the reigning discourse. These museum curators, for instance, write in-numerable catalog essays for exhibitions by other institutions, and what they say is reiter-ated by other curators and writers. Many Eu-ropean critics and curators have also replicated the American version of video history.

11. Rosler, "Video: Shedding the Utopian Moment," pp. 31–50.

12. Frank Gillette, in an unpublished inter-view with Robert Haller, November 1980.

13. Steina Vasulka, quoted in "Notes Toward a History of Image-Processed Video: Eric Siegel, Stephen Beck, Dan Sandin, Bill and Louise Etra," by Lucinda Furlong. *Afterimage* 11:1&2 (Summer 1983), p. 35.

14. Michael Shamberg and Raindance Corpo-ration. *Guerrilla Television* (New York: Holt, Rinehart and Winston, 1971), p. 8 (of "Offi-cial Manual" section).

15. Rosler, "Video: Shedding the Utopian Moment," pp. 31–50.

16. Much has been made of the fact that many members of TVTV now work in the in-dustry, including Michael Shamberg, who is a Hollywood producer (of such films as *The Big Chill*) and Allen Rucker, who is also a pro-ducer. However, there is a tendency to con-strue from this that all of the members of video collectives have "sold out" to the indus-try, that they were just waiting to do so (a scenario that fits neatly into the overall narra-tive that all of the radicals from the 1960s are

now yuppies). This is simply not true. Many of the artists and activists who were making socially concerned work in the collectives are still doing so today—some choose to do so through public television and independent channels of distribution and others at local community levels.

17. From the inside cover of *Radical Software* No. 1 (1970).

18. Gene Youngblood, *Expanded Cinema* (New York: E.P. Dutton & Co., 1970), p. 264.

19. The issue of whether or not electronic technology is inherently accessible (hence democratic) is a difficult one that needs further elaboration. This question is rooted in the ideologies from which technologies are developed. While it would appear that video allows unprecedented access to moving-image technology, television is still one of the most hegemonic and monolithic systems of representation in our culture. (The promise and disappointment of cable shows precisely this conflict.)

20. See Marita Sturken, "Private Money and Personal Influence: Howard Klein and The Rockefeller Foundation's Funding of the Media Arts," *Afterimage* 14:6 (January 1987).

21. This is not to say that socially concerned and documentary video is not historicized at all, simply that it is historicized separately from video art." See Deirdre Boyle, "A Brief History of American Documentary Video, pp. 51–69.

22. It should be noted that a similar focus on properties is evidenced in the theory of film history.

23. David Antin, "Video: The Distinctive Features of the Medium," in *Video Culture: A Critical Investigation,* ed. John Hanhardt (Rochester, N.Y.: Visual Studies Workshop, 1986), p. 147.

24. Martha Gever, "Medium Cool," *The Independent* 9:8 (October 1986), p. 20.

25. Rosalind Krauss, "Video: The Aesthetics of Narcissism," in *Video Culture: A Critical Investigation,* ed. John Hanhardt (Rochester, NY: Visual Studies Workshop, 1986), p. 182.

26. Rita Myers, in a letter to the author, Spring 1987.

27. While historical events like Vietnam and the Kennedy assassination were seen on television, they were recorded on film and were not seen live. The Zapruder film of the Kennedy motorcade, for instance, is coded very heavily as a film, especially when it is shown again and again slowly crawling forward frame by frame. The Vietnam footage has the grainy faded color quality of the photographic image, not the electronic image.

Vito Acconci
Television, Furniture, and Sculpture
This essay originally appeared in an exhibition catalog, Det Lumineuze Beeld (The Luminous Image), Stedelijk Museum, Amsterdam, September 1984.

Kathy O'Dell
Performance, Video, and Trouble in the Home
Special thanks: to Vito Acconci, Dan Graham, and Joan Jonas for conversations regarding their work; to Therese Lichtenstein for her editorial suggestions; to Shari Calnero, Ivar Smedstad, Stephen Vitiello at Electronic Arts Intermix, and Eileen Clancy and Daniel Minahan at The Kitchen for their generous and warm assistance in screening dozens of videotapes and their insights on the subject of this essay; and to the television producer quoted at the beginning of the essay who wishes, under the circumstances, to remain anonymous.

1. I shall be using the term *performance-based video,* the original author of which is unknown to me (and so, therefore, is its originally intended meaning), to describe video made as an integral part of a performance piece. Such a definition necessarily excludes videotapes produced as straightforward documentation and assumes the maker's interest in complicating viewers' preconceived notions of difference between presentation (generally associated with performance) and representation (associated with video).

2. It is interesting to note that it was a rare series of episodes of *The Honeymooners*—entitled "Trip to Europe"—that became the basis for the sixties musical, in-color resuscitation of the show. This series was not included in the group of "Lost Episodes" released in 1985, nor was it put into reruns earlier. (See Donna McCrohan and Peter Crescenti, *The Honeymooners Lost Episodes* (New York: Workman Publishing, 1986), pp. 133, 189.) Perhaps it was because of the latter that "Trip to Europe" was

chosen as the basis for the sixties show, but a more likely reason is that by the 1960s the idea of taking a vacation outside the home would have seemed more socially and economically plausible to the viewing public.

3. Mikhail Bakhtin, *Rabelais and His World*, trans. Hélène Iswolsky (Bloomington: Indiana University Press, 1984), p. 33. Also see Natalie Zemon Davis's assessment of Bakhtin's home-holiday, power-"topsy-turvy" power schema in *Society and Culture in Early Modern France* (Stanford: Stanford University Press, 1975), p. 103.

4. Useful in formulating this brief synopsis was E. Ann Kaplan, *Women & Film: Both Sides of the Camera* (New York and London: Methuen, 1983), pp. 13–14, 19–20. Also, I am indebted here (and throughout my text) to Jacqueline Rose's introduction to Jacques Lacan, *Feminine Sexuality*, trans. Jacqueline Rose (New York: W. W. Norton and Pantheon Books, 1985), pp. 27–57. Note that Lacan spoke of what I am calling "equivalent figure" as "paternal metaphor" in a quotation on p. 39 of Rose's introduction.

5. Jean Laplanche, *Life and Death in Psychoanalysis*, trans. Jeffrey Mehlman (Baltimore and London: The Johns Hopkins University Press, 1976), p. 81.

6. Laplanche ambiguously conflated these two developmental levels, but I find one of his greatest contributions to be his implicit separation of them as I have articulated it.

7. Rose, introduction to Lacan's *Feminine Sexuality*, p. 30.

8. Jacques Lacan, "The Mirror Stage as Formative of the Function of the I as Revealed in Psychoanalytic Experience," in *Écrits*, trans. Alan Sheridan (New York and London: W. W. Norton, 1977), p. 4. For discussion of the mirror stage not necessitating the actual technical device of the mirror, see Laplanche, *Life and Death*, p. 81 and Rose, introduction to Lacan's *Feminine Sexuality*, pp. 30–31.

9. Rosalind Krauss, "Video: The Aesthetics of Narcissism," reprinted in John Hanhardt, ed., *Video Culture: A Critical Investigation* (Rochester: Visual Studies Workshop Press, 1986), pp. 179–80. Fundamental to the examination of the mirror stage in relation to film is Laura Mulvey's "Visual Pleasure and Narrative Cin-

ema," *Screen* 16: 3 (Autumn 1975), pp. 6–18. Also see Kaplan's *Women & Film* and various essays in Teresa de Lauretis and Stephen Heath, eds., *The Cinematic Apparatus* (New York: St. Martin's Press, 1985).

10. In Krauss's "Video," compare her analysis of the mirroring aspects of video, especially feedback, pp. 181–85. She writes: "Narcissism is characterized . . . as the unchanging condition of a perpetual frustration"—i.e., one's frustration over his or her consistently unsatisfied "fascination with the mirror," p. 185. In this essay, I look at the possible value of this frustration.

11. Jacques Lacan, "The Freudian Unconscious and Ours," in *The Four Fundamental Concepts of Psycho-Analysis*, trans. Alan Sheridan (New York and London: W. W. Norton, 1981), p. 20.

12. For a different reading of *Claim*, but still conducted within a Lacanian framework, see Stephen Melville, "How Should Acconci Count for Us? Notes on a Retrospective," *October* 18 (Fall 1981), pp. 83–84.

13. Lacan would also refer to these concepts as phantasy; see Rose, introduction to *Feminine Sexuality*, pp. 30–32.

14. There were more drastic interruptions staged by many body artists in self-mutilating performances in the early 1970s. This practice is addressed in my forthcoming doctoral dissertation: "Toward a Theory of Performance Art: An Investigation of Its Sites," CUNY Graduate Center, New York.

15. See the distinction Graham drew between "The mirror image/the video image," as well as his synopsis of the Lacanian mirror stage ("Mirrors and 'self' ") in *Video-Architecture-Television*, ed. Benjamin H. D. Buchloh (Halifax and New York: The Press of the Nova Scotia College of Art & Design and New York University Press, 1979), p. 67.

16. Simon Field, "Dan Graham, an Interview with Simon Field," *Art & Artists* 7:10 (January 1973), p. 19.

17. For a transcription of the dialogue for *Past Future Split Attention* see Dan Graham, *Theatre* (Ghent, Belgium, n.d.).

18. For an excellent survey of seventies performance-based video dealing *not* so obliquely with feminist issues, see Chris Straayer, "I Say

I Am: Feminist Performance Video in the '70s," *Afterimage* 13:4 (November 1985), pp. 8–12; and for feminist video documentaries of the same period see Martha Gever, "Video Politics: Early Feminist Projects," *Afterimage* 11:1 & 2 (Summer 1983), pp. 25–27.

19. This condition can be integrated into feminist discourse and the Woolfian concept of a need for a "room of one's own." Ruth E. Iskin, a founder of Womanspace, an early alternative space for women artists in Los Angeles, explored this concept in "A Space of Our Own, Its Meanings and Implications," *Womanspace Journal* 1:1 (February–March 1973). See also her "The Contribution of the Woman's Art Movement to the Development of Alternative Art Spaces," in *The New Artsspace, A Summary of Alternative Visual Arts Organizations Prepared in Conjunction with a Conference, April 26–29, 1978* (Los Angeles: The Los Angeles Institute of Contemporary Art, 1978), pp. 24–27.

20. I am not addressing the role of museums here since they did not make themselves widely available in this time period as a context within and/or from which performance-based videos could be produced.

21. There were exceptions to this. Jonas had found Lo Giudice Gallery, for example, to be a viable commercial gallery in which to present *Organic Honey's Visual Telepathy* (1972) because the space was suitably "rough."

22. *Adjunct space* is a very efficient term, which I have borrowed from a conversation with Dan Graham.

23. Jeffrey Lew as quoted in Robyn Brentano and Mark Savitt, *112 Workshop/112 Greene Street* (New York: New York University Press, 1981), p. 2.

24. Kay Larson attributed the coinage of the term to Brian O'Doherty, who was at the National Endowment of the Arts when such spaces started applying for funds; see "Rooms with a Point of View," *Art News* 76:8 (October 1977), pp. 34–35.

25. To be attempted in "Toward a Theory of Performance Art" (see note 14). For a substantive contribution to such an assessment, see Stephen Kahn's thesis "Communities of Faith, Communities of Interest," Wesleyan University, 1986, which, unfortunately I discovered

after the writing of this essay, thus excluding the possibility of giving it adequate attention here.

26. Bakhtin's delineation of historical periods is slippery, but see his *Rabelais,* p. 33, where he traces the decline of positive usage of the grotesque to the seventeenth century. I am suggesting that the initiation of the modern period (Bakhtin actually uses the term *bourgeois* more often than *modern*) can be dated to the seventeenth century in Bakhtin's theorizations not only because of this inference on p. 33, but because of the fact that the modern concept of the home dates to that time period as well. See Philippe Ariès, *Centuries of Childhood, A Social History of Family Life,* trans. Robert Baldick (New York: Vintage Books, 1962) and Witold Rybczynski, *Home, A Short History of an Idea* (New York: Penguin Books, 1987).

27. Bakhtin, *Rabelais,* pp. 10, 11.

28. Vito Acconci, "Television, Furniture & Sculpture: The Room with the American View," in *The Luminous Image* (Amsterdam: Stedelijk Museum, 1984), p. 21, and reprinted here, pp. 125–51. Thanks to Doug Hall for pointing out this essay to me.

29. See Acconci's own psychoanalytic interpretation of the dynamics conjured up by TV in the home, "Television," p. 17 and also on pp. 125–51 of this book. Also, I am indebted here to Kristine Stiles's teachings and writings on performance art in which, since the late 1970s, she has established the premise that the performing body has the capacity to perpetrate threat (see note 49 for citations for Stiles's work). It is upon this premise that I am pursuing, in this essay and elsewhere, an investigation of the precise nature of that threat along psychoanalytic, feminist lines. Lastly, Castelli-Sonnabend Tapes and Films should be considered as a complicated type of adjunct or alternative situation. Such a consideration is, unfortunately, beyond the scope of this essay, but will be examined elsewhere.

30. I am thinking here of Peter Bürger's use of the term *neo-avant-gardiste* to describe a type of art that "negates the avant-gardiste intention of returning art to the praxis of life," in *Theory of the Avant-Garde,* trans. Michael Shaw (Minneapolis: University of Minnesota Press, 1984), p. 58.

31. Thanks to Judy Moran and Renny Pritikin, who pointed out this permission-to-fail function, along with many other functions of alternative spaces, in an invaluable paper entitled "Some Thoughts: Artists' Organizations Contrasted to Other Arts Organizations" originally presented at "The Visual Artists' Organization: Past, Present, Future" conference held in 1986 and transcribed in *Afterimage* 14:3 (October 1986), pp. 16–17. *Alternative spaces* have been referred to officially as "artists' organizations" since about 1982, when many such spaces joined together to form NAAO (the National Association of Artists' Organizations). Other papers from the conference appear in this issue of *Afterimage.*

32. Davis, *Society*, p. 98. See her entire chapter on "The Reasons of Misrule" (pp. 97–123) as well as "Women on Top" (pp. 124–51), which point out the complicated nature of this permission-giving relationship and the variety of positive and negative results it may yield.

33. Umberto Eco, "The Frames of Comic 'Freedom,' " in *Carnival!* ed. Thomas A. Sebeok (Berlin, New York, Amsterdam: Morith Publishers, 1984), p. 6.

34. This is not to say that Eco's theories are simplistic. See, especially, his distinction between carnival *in* Bakhtin and "hyper-Bachtinian [sic] ideology of carnival," in "The Frames of Comic 'Freedom,' " p. 3.

35. Bakhtin, *Rabelais*, pp. 8–11.

36. Katerina Clark and Michael Holquist have argued that because of the social and political context in which Bakhtin was writing, "*Rabelais* presents, *inter alia*, a critique of Soviet ideology," offering "a counterideology to the values and practices that dominated public life in the 1930s." However, they acknowledged that this counterideology does not stage "a frontal attack on Stalinism." Rather, Bakhtin negotiated "a dialogue with it." See their *Mikhail Bakhtin* (Cambridge, Massachusetts, and London: The Belknap Press of Harvard University Press, 1984), p. 307. For Bakhtin's theorization of the grotesque see *Rabelais*, pp. 18–34, 303–67.

37. In a broader study, one would also need to consider the relationship between early independent video production and such funding agencies as the Rockefeller Foundation.

38. Peter Stallybrass and Allon White, *The Politics and Poetics of Transgression* (Ithaca: Cornell University Press, 1986), p. 202.

39. Stallybrass and White, *The Politics.*

40. Bakhtin, *Rabelais*, p. 19.

41. Ibid.

42. Douglas Crimp's writings on Jonas's fragmenting, repeating, and splitting of imagery were integral to my interpretation of *Vertical Roll.* See his "De-Synchronization in Joan Jonas's Performances," in *Joan Jonas, Scripts and Descriptions, 1968–1982*, ed. Douglas Crimp (Berkeley: University Art Museum and University of California, 1983), pp. 8–10. Also, see Krauss's reading of *Vertical Roll* in "Narcissism," pp. 187–88.

43. Bakhtin, *Rabelais*, pp. 19–20.

44. Ibid.

45. Mary Ann Doane, "Film and the Masquerade: Theorising the Female Spectator," *Screen* 23:3–4 (September–October 1982), pp. 81–82.

46. Crimp's comments on Jonas's play with closeness and distance through the use of monitors and mirrors were particularly useful in this section; see *Joan Jonas, Scripts and Descriptions*, pp. 11, 19, 41.

47. Unpublished, but documented response to a panel entitled "Images and Ideologies of the Body," part of "The Scholar and the Feminist XV" conference held at Barnard College, New York, March 1988. For an extensive historical, theoretical, and critical assessment of Morris's work see Maurice Berger, *Labyrinths: Robert Morris, Minimalism, and the 1960s* (New York: Harper & Row, 1989).

48. Carolee Schneemann, *More than Meat Joy* (New Paltz, N.Y.: Documentext, 1979), p. 63.

49. Kristine Stiles, "Synopsis of The Destruction in Art Symposium (DIAS) and Its Theoretical Significance," *The Act* 1:2 (Spring 1987), p. 29. Stiles has conducted the most thorough historical reconstruction of DIAS events, and evaluation of the destruction-creation dialectic in art, written to date; see her Ph.D. dissertation, "The Destruction in Art Symposium (DIAS): The Radical Cultural Project of Event-Structured Live Art," University of California, Berkeley, 1987 (forthcoming as *World Without End: The Destruction in Art Symposium/DIAS*, from Pont La Vue Press,

New York, 1991) and, more recently, "Sticks and Stones: The Destruction in Art Symposium," *Arts* 65:5 (January 1989), pp. 54–60.

50. Stiles, "Sticks and Stones," p. 30. See Stiles's "Synopsis" and entire dissertation where she spoke at length of events of the post–World War II nuclear era and ways in which this history has influenced artists to use the body in art. Also, in "Sticks and Stones," Stiles discussed "situationnisme," whose proponents did, indeed, target hierarchical power for critique, but not the *psychodynamics* inherent to hierarchical situations.

51. See Krauss, "Video," p. 186, for a brief analysis of economic (i.e., art-market) motivations for artists turning to video. Also, for an examination of connections among events of the Vietnam War, artists' works of the era, and developments within the field of psychotherapy, see Maurice Berger's excellent catalog essay for the exhibition entitled *Representing Vietnam 1965–1973, The Antiwar Movement in America* (New York: The Bertha and Karl Leubsdorf Art Gallery, Hunter College, 1988).

Margaret Morse
Video Installation Art: The Body, the Image and the Space–in–Between

Composed while in residency as a Rockefeller Fellow at the Whitney Museum, Spring 1989. Thanks to John Hanhardt, Curator of Film and Video; Lucinda Furlong, and Matthew Yokobosky at the Whitney Museum; JoAnn Hanley, Curator of Video and Performance at the American Museum of the Moving Image; and to the installation artists who discussed the art form with me in meetings over February 1989: Judith Barry, Dara Birnbaum, Ken Feingold, Dieter Froese, Doug Hall, Joan Jonas, Shigeko Kubota, Mary Lucier, Antonio Muntadas, Rita Myers, Curt Royston, Julia Scher, and Francesc Torres. While I cannot presume they share or endorse any or all of my conclusions, I could not have arrived at this construction of the form without the insights gained in conversation with each of them.

1. I saw it at in retrospective at the Long Beach Museum in 1988. The piece is discussed in detail in Rosalind Kraus, *Passages in Modern Sculpture* (Cambridge, Mass., and London: MIT Press, 1981), p.24 of and in a recent paper by this writer, "Closed Circuits and Fragmented Egos," given at the Society for Photographic Education, Rochester, 1989.

2. To clarify, naturally all of the elements that make up a video installation, such as sculptural objects and the video tapes themselves, are art, too—they are not yet an installation. Another practical consideration for artists is that what is left over when the space-in-between is removed may, however, be of considerable bulk. Thus, installation artists have in common their storage problems, sometimes solved by living amid the sculptural remains of up to two decades of work. As a consequence, some artists have been exploring smaller, more compact forms that do not enclose the visitor. Shigeko Kubota has always considered her work sculptural and self-contained—so the change in her most recent work is largely in scale. Rita Myers, is exploring a type of Duchampian peep-hole-on-a-scene in future work.

3. However, there is such a thing as *performance video*, which may have sets and the presence of a "live artist," as well as electronics.

4. The fact that space-time can be rented to the installation visitor (via a museum fee) suggests a relation to popular kinds of rental institutions such as movie theaters or fun houses, to which Ken Feingold compared the form in a conversation with me. Yet, what the installation visitor rents is not so much a seat as the right of passage. One might find the popular shadow of this art form in an experience somewhere between the didacticism of a multimedia display and the bodily experience offered by a fun house. (Cf. the discussion of the exhibition form by Judith Barry, "Designed Aesthetic: Exhibition Design and the Independent Group," in: *Modern Dreams: The Rise and Fall and Rise of Pop* (Cambridge, Mass., and London: MIT Press, 1988), pp. 41–45.

5. Not that installation art today is not for sale—a number of Paiks, a Kubota, several Grahams, a Lucier, a Birnbaum, a Royston, a Torres, and perhaps far more installations figure in American and European museum, corporate, and private collections—though many respected artists of the installation form have yet to realize income from their work.

6. Film installations are rare. One example is Roger Welch's simulation of the drive-in movie apparatus, *Drive-In: Second Feature* installed at the Whitney Museum, 1982. However, there are video installations which use filmic constructions of space within the monitor image. Marie-Jo Lafontaine's *Victoria* installed at the Shainman Gallery, 1989, is one example. Slides with inserts of other (sometimes moving) image material are a more common reference to our frozen image culture, reminiscent of billboards, posters, and walls. See my "The Architecture of Representation: Video Works by Judith Barry," *Afterimage* (Oct. 1987), pp. 1, 8–11, for a detailed interpretation of two installations in this medium.

7. Dara Birnbaum's work has been the most directly related to the reworking and critique of the televisual representational forms per se, in such installations as *P M Magazine*. See *Dara Birnbaum: Rough Edits: Popular Image Video*, ed. Benjamin Buchloh (Nova Scotia Pamphlets: Nova Scotia College of Art and Design, 1987). In a very different vein, Judith Barry's *Maelstrom* (installed in the show *Video Art: Expanded Forms*, Whitney Museum of Art at Equitable Center, 1988), places the body of the visitor within a new construction of spatial representation seen primarily on television, the forced perspectival space of motion control and image processing.

8. Curated by Chip Lord, Mandeville Gallery, University of California, San Diego, 1987.

9. Language here is used in an inclusive sense to encompass all forms of expression, including the nonverbal and artistic. Emile Benveniste theorized about these two planes in *Problems in General Linguistics* (Coral Gables: University of Miami, 1971). Gérard Genette extended this distinction to literary genres in "Frontiers of Narrative," *Figures of Literary Discourse* (New York: Columbia University Press, 1981), pp. 127–44. In subsequent writing on the subject, Genette has stressed that these planes of language are not massive and either/or distinctions, but rather coexist in subtle shifts even within a narrative form. These planes in art, undoubtedly as complex and co-present, are presented here in global form for the sake of introducing the distinction between them.

10. Ann-Marie Duguet in "Dispositifs," *Communications: Vidéo* 48 (1988), pp. 221–42 treats video installation at the end of the 1960s and the early 1970s as a period in which the apparatuses of representation since the Renaissance were systematically explored and critiqued. She views the closed-circuit installation form of video as the privileged tool of this exploration, as it models representation itself. While this interpretation of the period is enlightening, it neglects the problem that the video camera and monitor actually introduce different rules into Renaissance representation. Cf. "Closed Circuits and Fragmented Egos."

11. The deconstruction of presence and identity is also the project of poststructuralist philosophy (Derrida and Foucault) and psychoanalysis (Lacan), as well. In "Talk, Talk, Talk: The Space of Discourse in Television News, Sportcasts, Talk Shows and Advertising," *Screen* 26 n.2 (March/April 1985), I introduce the notion of the fiction of discourse as it operates in American broadcast television. In my view, installation video deconstructs rather than furthers this fiction.

12. Martha Rosler critiques this predominant belief in the Utopian function of video art.

13. Cf. this writer's "An Ontology of Everyday Distraction: The Freeway, the Mall and Television," in *The Logics of Television*, ed. Patricia Mellencamp (Bloomington, Indiana: University of Indiana Press, in press).

14. In Michael Fried's "Art and Objecthood," *Minimal Art: A Critical Anthology*, ed. Gregory Battcock (New York: Dutton, 1968), pp. 116–47. The description of the sculpture as surrogate person and Smith's ride on the New Jersey Turnpike are addressed in this article as well.

15. My analyses of television representation show that it is discursive in this way as well, but not self-consciously or in a way that questions its own process. I have addressed the multiple levels of discourse in particular videos in several places: "Video Mom: Reflections on a Cultural Obsession" in *East/West Film Journal* June 1989; "Cyclones from Oz: On George Kuchar's *Weather Diary 1*," *Framework* (April 1989), and reviews of AFI Video Festivals of 1987 and 1988 in *Video Networks* (Jan. 1988 and March 1989).

16. Cf. John Searle's revision of Austin's theory of speech-acts.

17. The world created via interaction can be digitized on a computer screen, but it is not one that a visitor can enter bodily. Unless there is charged space outside the screen or a passage for the body, we have left the realm of installation art per se. To questions about how interactive interactive video actually is, again the analysis of experiential subjects is illuminating: the visitor interacts with what or whom? Is the interaction dialogic (i.e., between two subjects) or does it amount to a range of choices within a system of organization (who is the subject then)?

18. *The Luminous Image* (Amsterdam: Stedelikjk Museum, 1984).

19. Cf. "The Architecture of Representation."

20. Described in *Nam June Paik* (New York: Norton and the Whitney Museum, 1982).

21. Cf. Kraus, "Sculpture in the Expanded Field," *The Anti-Aesthetic: Essays on Postmodern Culture,* ed. Hal Foster (Port Townsend, Washington: Bay Press, 1983), pp. 31–3.

22. A theme that continues in, for example, her installation, *Asylum, a Romance,* 1986. Cf. this writer's "Mary Lucier: Burning and Shining," *Video Networks* 10 n.5 (June 1986), pp. 1–6, and nos.6/7 (July/August 1986), pp. 3–7.

23. A plywood construction with mirror, two 5-inch TV sets, and five 13-inch TV sets. The four channels were a Grand Canyon helicopter trip; a drive on Echo Cliff, Arizona; a Taos sunset and mirage; and a Teton sunset. Cf. the description in *Shigeko Kubota: Video Sculptures* (catalog published by the Museum Folkwang, Essen, 1982), p. 37 and its interpretation by John G. Hanhardt, p. 39.

24. "Burning and Shining,"

25. Discussed in detail in Duguet, "Dispositifs," p. 233f.

26. Described in detail in *Bill Viola: Survey of a Decade* (Houston: Contemporary Arts Museum, 1988) and discussed in my "Interiors: A Review of *The American Video Landscape*," *Video Networks* (March 1989), pp. 15–19.

27. The piece had six to seven video and audio channels and from nineteen to twenty-three monitors on pedestals, plus a video camera when presented at the Kitchen, 1974, and the Whitney Museum, 1977.

28. Such was the hardware needed to make the serial comparison: to an audio loop add three half-inch reel-to-reel VHS recorders comprising two for pre-recorded playback and one live channel of input from a black and white camera, time delayed and displayed every four seconds. The live image appeared on the center screen alternating with four seconds of live broadcast TV. The switcher constantly changed the placement of the other channels of time-delayed, live images and pre-recorded playback (four of each) on the eight screens surrounding the center. Today, multiple-monitor, multiple-channel installations are commonly as complex.

29. Shown on three monitors set in a shallow 12-degree curve about two and a half feet apart.

30. Cf. the reproduction of her score in the description of the piece in *Video Art,* eds. Ira Schneider and Beryl Korot. Her subsequent installation, *Text and Commentary* (1977), made this weaving metaphor explicit. *Dachau* was one of the three pieces in the Long Beach retrospective of 1988 and is also included in the retrospective in Cologne, 1989.

31. The recent retrospective, *American Landscape Video,* three of the seven installations, Mary Lucier's *Wilderness* (1986), with its strong narrative dimension, Doug Hall's *The Terrible Uncertainty of the Thing Described* (1987), and Steina Vasulka's *The West* (1983), exploited these poetic possibilities in very different ways. Cf. Morse, "Interiors."

Dan Graham
Video in Relation to Architecture
Sections of this article are taken from my previously published writings: "Video-Architecture-Television," in Writings on Video and Video Works *1970–1978, edited by Benjamin H. D. Buchloh (Halifax, Nova Scotia, and New York: The Press of Nova Scotia College of Art and Design and New York University Press, 1979);* Buildings and Signs *(Chicago: The Renaissance Society of the University of Chicago/Museum of Modern Art, Oxford, 1981); "Art in Relation to Architecture/Architecture in Relation to Art,"* Artforum, *February 1979; "Signs,"* Artforum, *April, 1981; "An American Family,"* New Observations, *No. 31, edited by Barbara Kruger, 1985.*

1. Horace Newcome, *TV: The Most Popular Art* (Garden City: Doubleday, 1974).

2. *Andy Warhol* (Stockholm: Moderna Museit, 1968).

3. Anne Rorimer, "Introduction," *Buildings and Signs*, catalog (Chicago: Renaissance Society of the University of Chicago/Museum of Modern Art, Oxford, 1981).

4. Robert Venturi, "Learning the Right Lessons from the Beaux-Arts," May 1978, reprinted in Robert Venturi and Denise Scott Brown, eds., *A View from the Campidoglio* (New York: Harper & Row, 1984).

5. Paul Ryan, "Self Processing," *Radical Software*, Fall 1970.

6. Paul Ryan, "Attempting a Calculus of Intention," *Radical Software* 1972.

7. Ludwig van Bertalanffy, *General Systems Theory* (New York: George Braziller, 1968).

8. F. W. Heubach, unpublished essay on Dan Graham's video work, 1978.

Dara Birnbaum
The Rio Experience: Video's New Architecture Meets Corporate Sponsorship
Acknowledgments:
The author would like to thank the following for their assistance in article preparation: Molly Blieden, Thomas Burr, and Robin Reidy.

1. Charles Ackerman, "Rio's Hot Center: America's First Monumental Video Wall" (press release, Ackerman and Company, April 19, 1988).

2. "The Rio File: Media Clips—How the Press Is Responding to Rio" (press release Ackerman and Company, April 22, 1988). [The original source was the Atlanta *Business Chronicle*, February 1987.]

3. Robin Reidy, "General Statement Submitted by Robin Reidy as Project Description," December 1988.

4. These three paragraphs are translated from a video document presented to the competition's analysts for the Ackerman and Company Rio Videowall Competition. The videos were sent to the finalists in March 1987. The video consisted of a conversation between the developer (Charles Ackerman), the architect (Bernardo Fort-Brescia), and the judges of the competition (Linda Dubler, Patricia Fuller, John Hanhardt, and Robin Reidy). In these paragraphs, Charles Ackerman is speaking.

5. This quote also comes from the video document. Bernardo Fort-Brescia, the architect, is speaking.

6. Tom Walker, "If Rio Is a Shock, Blame It on Arquitectonica." *Business Monday, The Atlantic Journal and Constitution*, July 27, 1987, p. 1C.

7. This quote was taken from the video document of March 1987. John Hanhardt is speaking.

8. Robin Reidy.

9. The quote that goes from pp. 194–96 in this essay, is taken from "Revised Exhibit A" of the final contract, The Video Art agreement. Signed June 1988 between Dara Birnbaum and Piedmont-North Associates, Ltd.

10. Ibid., p. 2.

11. Robin Reidy, np.

Chip Lord
Mobility, As American as . . .
1. Robert Venturi, *Complexity and Contradiction in Architecture* (New York: Museum of Modern Art, 1966), p. 16.

2. Paul Virilio and Sylvere Lotringer, *Pure War* (New York: Semiotext, 1983), p. 64.

3. Jan Dawson, *Alexander Kluge and the Occasional Work of a Female Slave* (New York: New York Zoetrope, 1977), p. 31.

4. Hoberman, review of *Top Gun* (*The Village Voice*, May 27, 1986). *Top Gun* was directed by Tony Scott and released by Paramount.

Martha Gever
The Feminism Factor: Video and its Relation to Feminism
1. Linda Nochlin, "Why Are There No Great Women Artists?" in *Woman in Sexist Society*, ed. Vivian Gornick and Barbara K. Moran (New York: Basic Books, 1971), pp. 480–510.

2. Silvia Bovenschen, "Is There a Feminine Aesthetic?" *Heresies* 1:4 (Winter 1977–78), pp. 10–12.

3. For a survey of the ethnocentricities of white, Western feminism, see Hazel V. Carby, "White Women Listen! Black Feminism and the Boundaries of Sisterhood," in *The Empire Strikes Back: Race and Racism in 70s Britain* (London: Hutchinson University Library, 1982).

4. For example, the exhibition "Difference: On Representation and Sexuality," held in 1985 at the New Museum in New York City was wholly premised on psychoanalytic interpretations of sexual difference, a position maintained in the catalogue essays of curators Kate Linker and Jane Weinstock as well as other contributors. The show at the New Museum failed to include any work dealing with gay or lesbian sexual differences or the intersections of race and class with gender and sexuality; the film and video screenings, on the other hand, included a number of exceptions to a strictly psychoanalytic definition of the feminist critique of representation. Another example of the privileging of psychoanalytic theory in relation to feminist art criticism is Craig Owens's essay "The Discourse of Others: Feminists and Postmodernism," in *The Anti-Aesthetic: Essays on Postmodern Culture*, ed. Hal Foster (Port Townsend, Washington: Bay Press, 1983). Owens's claim for feminists within postmodernism is argued solely in the terms of Lacanian theory. And no other essay in the book addresses feminism.

5. I discuss videotapes that indicate some of the implications of this tendency within feminist theory in conjunction with a fascination with mass-media television in "Seduction Hot and Cold," *Screen* 28:4 (Autumn 1987).

6. The examples supporting this observation are numerous. For example, Owens's essay in *The Anti-Aesthetic*. op. cit., mentions the work of Mary Kelly, Martha Rosler, Dara Birnbaum, Sherrie Levine, Cindy Sherman, and Barbara Kruger, who, he argues, challenge both aesthetic theory and the masculine ideal of authority and mastery. Abigail Solomon-Godeau's various writings on photography and postmodernism employ a feminist critique of art institutions and practices.

7. I trace many of the parallels between the early years of independent video in this country and the reemergence of feminism, as well as the convergence of these two practices, in "Video Politics: Early Feminist Projects," *Afterimage* 11:1 and 2 (Summer 1983), reprinted in *Cultures in Contention* (Seattle: Real Comet Press, 1985).

8. There is no consensus that realist representations are absolutely corrupt. In the tradition of radical political media in this country, a number of feminist artists, especially filmmakers and photographers, continue to use realism to describe alternative versions of "reality," using the formal frameworks of realist representation to contradict the "facts" asserted in the mass media. Two works that typify this approach are *To Love, Honor and Obey*, Christine Choy's documentary film on battered women, and *Gotta Make This Journey*, Michelle Parkerson's profile of the a cappella group Sweet Honey in the Rock.

9. Two series currently televising unconventional videotapes are *New Television* on WNET–New York, WGBH–Boston, and KCET–Los Angeles on public TV and *Mixed Signals*, a series subsidized by the New England Foundation for the Arts on New England cable systems.

10. *Joan Does Dynasty* was produced as part of the *Paper Tiger Television*, a weekly series on public access cable. Braderman's earlier tape *Natalie Didn't Drown: Joan Braderman Reads the National Enquirer* (1983), was also a *Paper Tiger* production.

11. See, for example, Tania Modleski, *Loving with a Vengeance: Mass-Produced Fantasies for Women* (New York: Methuen, 1984).

12. Martha Gever, "An Interview with Martha Rosler," *Afterimage* 9:3 (October 1981), p. 12.

Bruce and Norman Yonemoto
The Medium Is the Mess ... age

1. Marshall McLuhan (with Quentin Fiore), *The Medium Is the Massage* (New York: Random House, 1967), p. 8.

2. Jean Baudrillard. *The Ecstasy of Communication* (New York: Semiotext(e), 1987), p. 23.

3. Marshall McLuhan, *Understanding Media: The Extensions of Man* (New York: McGraw-Hill, 1964), p. 323.

4. Harold Rosenberg, in McLuhan, *Understanding Media*, p. 199.

5. Nick Browne, "The Political Economy of the Television Supertext," *Quarterly Review of Film Studies*, Summer 1984, p. 3.

6. Sergey Eisenstein, *Film Form* (New York: Harcourt, Brace and World, 1949), pp. 166, 168.

7. Gilles Deleuze, *Cinema 1: The Movement Image* (Minneapolis: University of Minnesota Press, 1986), pp. 35, 57.

8. Henri Bergson, *Matter and Memory* (New York: Zone Books, 1988), p. 44.

9. Ibid., p. 36.

10. Ibid., p. 45.

11. Ibid., p. 80.

12. Baudrillard, *The Ecstasy of Communication*, pp. 22, 12.

13. Friedrich Nietzsche, *The Birth of Tragedy* (New York: Vintage Books, 1967), p. 60.

14. Jean Baudrillard, *The Evil Demon of Images* (Sydney, Australia: Power Institute of Fine Arts, University of Sydney, 1988), p. 41.

15. Amy Taubin, "Independent Daze," *The Village Voice*, September 11, 1984, p. 45.

16. Bergson and Deleuze, quoted in *Cinema 1: The Movement Image*, p. 9.

17. Delueze, *Cinema 1: The Movement Image*, p. 9.

Judith Barry
This Is Not a Paradox

1. Gayitri C. Spivak, "The Politics of Interpretation," *In Other Worlds*. New York: Methuen, 1987, pp. 118–133.

2. Edward Said, "Untitled Talk," DIA Art Foundation lecture from the series *Remaking History*, April 19, 1988, New York City, pp. 2–24.

3. Linda C. Furlong, "Getting High Tech: The New Television," *The Independent*, New York (March 1985), pp. 14–16.

4. Abigail Solomon Godeau, "Living with Contradictions: Critical Practice in the Age of Supply-side Aesthetics," *Screen* 28: 3 (Summer 1987), pp. 21–22.

5. Douglas Crimp, "Appropriating Appropriation," *Image Scavengers*, exhibition catalog, University of Pennsylvania, Institute of Contemporary Art, December 1982. In terms of video artists included in this group, Dara Birnbaum was the only one acknowledged during most of the activity, predominantly through international/national exhibitions. And as many people have noticed, the practice of questioning representation through feminist strategies was ideologically bound up with appropriation.

6. See Laura Rabinovitz, "Video Cross Dressing," in *Afterimage* 15: 8, (March 1988), pp. 3–5.

7. G. Roy Lewis, "An Interview With Michael Shamberg and David Cort," *Documentary*

Explorations, Garden City, New York: Doubleday, 1973, pp. 391–393.

8. Peter Wollen, "The Two Avant-gardes," *Studio International* 190 (Nov/Dec 1975), England, pp. 171–175.

9. Wollen, "The Two Avant-gardes," p. 173.

10. Rabinovitz, "Video Cross Dressing," p. 5.

11. Wollen, "The Two Avant-gardes," p. 174.

12. See Tania Modleski's *Loving With A Vengeance*, New York: Methuen, 1984; Claire Johnston's, "Notes on Women's Films," British Film Institute pamphlet, 1973; Elizabeth Cowie's, "Women as Sign; Laura Mulvey's "Visual Pleasure in Narrative Cinema," *MF* No. 1, 1978, London, to mention just a few seminal texts that posed these questions. Film and video tapes that reflected these questions include Mulvey, and Wollen's *Riddles of the Sphinx*, Yvonne Rainer's *A Story of a Woman . . .*, Dara Birnbaum's *Wonder Woman*, Sally Potter's *Thriller*, among numerous others.

13. Where the effects could be reabsorbed by broadcast, they have. This extends to interventions made within narrative structures, i.e., the open-ended, non-resolution-oriented structure of *Cagney and Lacey*, to working-class heroes such as Rosanne Barr, as well as to more amorphous, inner-life-oriented shows such as *The Days and Nights of Molly Dodd*. Perhaps what it is most crucial for independent producers to realize is that there is no longer an "out there," which represents the contamination of the "market," but that we are all effected by "it." It becomes a question of time.

14. Dick Hebdige, *Subculture* (London: Methuen, 1980).

15. Storyboard proposal for MTV art-break, rejected by MTV, artist wishes to remain anonymous.

16. See Simon Frith's column "The Adman's Loop," *The Village Voice*, May 17, 1988.

17. See *Seduced and Abandoned*, ed. Andre Frankovits (Australia: Stonemoss, 1984). Early Jean Baudrillard, *For a Critique of the Political Economy of the Sign* (New Mexico: Telos Press, 1981) and *The Mirror of Production* (New Mexico: Telos Press, 1975), should be distinguished from later Baudrillard *Simulations* (Semiotexte, 1983).

18. Homi K. Bhabha, "Sly Civility," *October* 34 (Fall 1985), pp. 71–80.

19. Fredric Jameson, "Postmodernism and Consumer Society," *The Anti Aesthetic,* ed. Hal Foster (Seattle: Bay Press, 1983), pp. 111–25.

20. Edward Said, paper given at the symposium *Remaking History,* sponsored by DIA Foundation, 1987.

Dee Dee Halleck
The Wild Things on the Banks of the Free Flow

This article had its inception as an introductory essay to a series of video tapes which I curated for the American Film Institute Video Festival in 1988. My thanks to Ken Kirby who first proposed the series and the article.

1. A. J. Liebling

2. Video evidence is not enough to balance a justice system tipped in favor of police authorities, however: Despite clear pictures of specific officers kicking and beating defenseless spectators, in the court proceeding following the Tompkins Square events there have been no indictments against the police and little departmental followup.

3. Ira Schneider once did an installation with a monitor for each time zone, each playing his *"Accidental Video Tourist"* home movies. (My title, not his.)

4. Susan Sontag, "Fascinating Fascism," *The New York Review of Books,* February 6, 1975. This essay on Leni Riefenstahl was reprinted in *Women and the Cinema, A Critical Anthology.* Edited by Karyn Kay and Gerald Peary, New York: E. P. Dutton, 1977.

5. Donna Demac, *Liberty Denied: The Current Use of Censorship in America* (New York: American Pen Center, 1988). This excellent text is a useful overview of censorship in many areas, including the music industry, the news media, and scientific research. See also Herbert Schiller, *Information in the Age of the Fortune 500* (Norwood, NJ: Ablex Publishers, 1981).

6. Diana Agosta, Abigail Norman, and Caryn Rogoff, *Participate Directory of Public Access in New York State* (New York: Media Network, 1988). This is a detailed report of how public access is used in one state, an excellent study of the institutions and organizations that coordinate the access centers and the community groups and individuals that make use of the channels.

7. Copies of the Docatello human relations programs that were made in response to *Race and Reason* may be obtained in writing: Randall Ammar, Pocatello Vision 12, 812 East Clark Street, Pocatello, Idaho, 83201.

8. Joseph Goulder, *Fit to Print* (Secaucus, NJ: Lyle Stuart Publishers, 1988), pp. 243–48. See also, "Shutting Up Schanberg," *Columbia Journalism Review* (September 1985).

9. Richard Leaock, in a presentation at the annual Robert Flaherty Seminar, Boston, Mass., August 1976.

10. Although the Helms Amendment passed with only two nays, it did not become law, because the bill to which it had been attached did not pass. I use it as an interesting example of the homophobia extant in our elected representatives.

11. This paper was written before the Mapplethorpe bruhaha; at this point in time Helms' homophobia is abundantly clear.

12. The collected newsfootage of this incident can be obtained from the Video Data Bank, c/o Art Institute of Chicago, 280 South Columbus Avenue, Chicago, Illinois, 60603.

13. An analogy might be drawn with two pieces that were made in connection with the Kennedy assassination: Paul Krassner's article about Lyndon Johnson fucking the bullet wounds on the president's body (*The Realist,* 1965) and T. R. Uthco and Ant Farm's *The Eternal Frame* (1976), with Doug Hall playing the president as an artist on his last ride. While both of these obviously played on the sentiment of millions of Americans for whom Kennedy was next to the pope on the wall, there was, in both works, a sense that the media were the real target. One wonders who was the target in the Washington painting lampoon? Incidentally, a new book brings convincing evidence that there was more to the Kennedy affair than press sentiment: a coverup of astounding proportions is recounted in Jim Garrison's new book, *On the Trail of the Assassins* (New York: Sheridan Square Press, 1989.)

14. Maurice Sendak, *Where The Wild Things Are* (New York: Harper & Row, 1963).

Lynn Hershman
The Fantasy Beyond Control

1. *ROBERTA* never was exhibited while she was in process. Rather she was invisible until she became history.

2. *ROBERTA* was exorcised in 1978 at Lucretia Borgia's crypt in Ferrara, Italy, where her victimization converted to emancipation.

3. For example, some ideas presented by Leo Steinberg.

4. See Roman Jakobson, "Child Language, Aphasia and Phonologica Universals," *Janua Linguarum* 71 (The Hague: Mouton, 1968) and "Studies on Child Language Aphasia," *Janua Linguarum* 114 (The Hague: Mouton, 1971).

5. This was originally conceived as a short-lived collaboration among Paula Levine, Starr Sutherland, Christine Tamblyn, and myself.

6. Much of this project derives from a collaboration with Ann Marie Garti.

7. Both ideas were completed in the videodisk installation *Deep Contact* completed in 1990 which premiered at the San Francisco Museum of Modern Art.

Ann-Sargent Wooster
Reach Out and Touch Someone: The Romance of Interactivity

1. Pamela McCorduck, *The Universal Mind* (New York: McGraw Hill, 1985), p. 280.

2. Steven Mintz and Susan Kellogg, *Domestic Revolutions—A Social History of American Family Life* (New York/London: Free Press, 1988), p. 185.

3. Ibid., p. 218.

4. Arthur C. Danto, quoted in Pamela McCorduck, *The Universal Mind*, p. 128.

5. For a more complete discussion, see the author's "Why Don't They Tell Stories Like They Use To?" *College Art Journal* (Fall, 1985), pp. 204–212

6. Peter Burger, *The Theory of the Avant-Garde*, trans. Michael Shaw, (Minneapolis: Univ. of Minneapolis Press, 1984), p. 67.

7. John Cage, quoted in Martin Duberman, *Black Mountain* (Garden City, N.Y.: Dutton, 1973), p. 369.

8. McCorduck, *The Universal Mind*, p. 250

9. Jean-Francois Lyotard, *The Postmodern Condition: A Report on Knowledge*, trans. Geoff Bennington and Brian Massumi (Minneapolis: Univ. of Minnesota Press, 1984), p. 60.

10. Susan Sontag, *Against Interpretation*, 1967, quoted in Rosalind Krauss, *Passages in Modern Sculpture* (Cambridge: MIT Press, 1977), p. 232.

11. Sontag, in Krauss, *Passages*, p. 232. At the conclusion of Alan Kaprow's, *A Spring Happening*, March 1961, at the Reuben Gallery, the audience was driven out of the gallery by someone operating a power lawnmower.

12. John Cage quoted in Michael Nyman, "Nam June Paik, Composer," in John Hanhardt, *Nam June Paik* (New York: Whitney Museum of American Art and W.W. Norton, 1982), p. 82.

13. Michael Nyman, *Experimental Music* (New York: 1974), p. 21.

14. Nyman, *Music*, p. 71.

15. Michael Kirby, *The Art of Time* (New York: E.P. Dutton, 1969), pp. 160–65.

16. Jack Burnham quoted in Krauss, *Passages*, p. 204.

17. Krauss, *Passages*, p. 240.

18. Phil Bertoni, *Strangers in Computerland* (New York: Vintage Books, 1984), p. 31.

19. David Ross, "A Provisional Overview of Artists' Television in the U.S.," *New Artists Video*, ed. Gregory Battcock (New York: E.P. Dutton, 1978), p. 139.

20. Bill Viola, 1972.

21. Deirdre Boyle, "Subject to Change: Guerrilla Television Revisited," *Art Journal* (Fall 1985), p. 229.

22. Erik Barnouw, *Tube of Plenty*, (London: Oxford Univ. Press, 1975) p. 496

23. Nam June Paik, "Video, Vidiot, Videology," in *New Artists Video*, ed. Gregory Battcock (New York: E.P. Dutton, 1978), p. 127.

24. Douglas Davis, interviewed by Davis Ross, *Flash Art*, nos.54–55 (May 1975).

25. Nam June Paik, quoted by Ross, "A Provisional Overview of Artists' Television in the United States." *Studio International* no. 191 (May–June 1976), p. 140.

26. Douglas Davis, *Arbeiten/Works 1970–1977* (Berlin, 1978), p. 96.

27. Lucinda Furlong, "Electronic Backtalk The Art of Interactive Video," *The Independent* (May 1988), p. 18.

28. Woody Vasulka in Lucinda Furlong, "Tracking Video Art: Image Processing as a Genre," *Art Journal* 45 (Fall 1985), p. 233.

29. Nam June Paik, in *Video n' Videology*, ed. Judson Rosebush (Syracuse: Everson Museum of Art, 1974), p.?.

30. Vasulka in Furlong, "Tracking Video Art: Image Processing as a Genre."

31. P. B. Medawar, in Jean-Francois Lyotard, *The Postmodern Condition: A Report on Knowledge,* trans. Geoff Bennington and Brian Massumi (Minneapolis: Univ. of Minnesota Press, 1984), p. 60.

32. Howard Rheingold, *Tools for Thought* (New York: Simon and Schuster, 1985), p. 215.

33. Pamela McCorduck, *The Universal Mind,* p. 31.

34. Rheingold, *Tools for Thought,* p. 126.

35. *Ibid.,* p. 126.

36. *Ibid.,* p. 112.

37. *Ibid.,* p. 136.

38. *Ibid.,* p. 182.

39. Information in this paragraph was presented by Harold Wooster, "Shining Palaces, Shifting Sands: National Information Systems," originally delivered as a speech, "Some Funny Things Happened on the Way to 1984," given at the meeting of the American Society for Information Science, 47th Annual Meeting, Philadelphia, October 22, 1984.

40. Rheingold, *Tools for Thought,* p. 211.

41. J.C.R. Licklider and R. Taylor, "The Computer as a Communication Device," April 1968, quoted in Rheingold, *Tools for Thought,* pp. 218–19.

42. *Ibid.,* p. 214.

43. *Ibid.,* p. 220.

44. Anne A. Armstrong, "The Information War," editorial in *ASIS Bulletin* (April 1982), quoted in Harold Wooster, "Shining Palaces."

45. Margia Kramer's three-channel installation and single-channel videotape *Progress (Memory)* (1983–84) offers one of the best discussions of computer culture and counterculture.

46. Rheingold, *Tools for Thought,* p. 211.

47. Remarks made by Kristina Hooper, cognitive pyschologist and senior researcher and engineer at Apple Computers, Inc., at the symposium *Continuity and Interruption (The Aesthetic Implications of Interactive Video),* The Kitchen, New York City, January 17, 1988.

48. McCorduck, *The Universal Mind,* p. 31.

49. Rheingold, *Tools for Thought,* p. 228.

50. *The Master Story Tellers,* Infocom Interactive Fiction Product Catalog, 1987.

51. Instruction manual for *Plundered Hearts,* Infocom, 1987.

52. Quotations in this and the next paragraph are from statements by Thomas Disch made in a telephone conversation with the author, December 1988.

53. Based on Kristina Hooper's response to the author's question at the symposium *Continuity and Interruption* (see n. 47).

54. Hooper, *Continuity and Interruption.*

55. Gene Youngblood at *Continuity and Interruption.*

56. Phil Bertoni, *Strangers in Computerland* (New York: Vintage Books, 1984), p. 241.

57. *Ibid.,* p. 242.

58. Kristina Hooper (see n. 47), described the three levels of computer interactivity as INTERRUPTION, SELECTION, and RESPONSIVENESS in remarks made as a panelist at the symposium.

59. Stuart M. DeLuca, *Television's Transformation: The Next 25 Years* (San Diego and New York: 1980), p. 258.

60. Eric Barnouw, *Tube of Plenty,* (London: Oxford Univ. Press, 1975), p. 496.

61. John Markoff, "The PC's Broad New Potential," *The New York Times,* November 30, 1988, pp. D1 and D8.

62. Lynn Hershman quoted in Lucinda Furlong, "Electronic Backtalk: The Art of Interactive Video," *The Independent,* May 1988, p. 19, from Christine Tamblyn, "Lynn Hershman's Narrative Anti-Narrative," *Afterimage* (Summer 1986), pp. 8–10.

63. The description of the National Gallery of Art videodisk used in a level III player is based on Juan Downey's experience and was told to the author in a telephone conversation, December 1988

64. Jerry Whiteley and Andrew Phelan's *Interaction of Color* was shown at the Guggenheim Museum, New York as part of *Joseph Albers: A Retrospective,* March 25–May 29, 1988.

65. Based on remarks made by Steven Meyer, one of the technical designers of Edwin Schlossberg, Inc.'s interactive videodisk system for the World Financial Center, New York City, in a telephone conversation with the author in December 1988.

66. Juan Downey in a telephone conversation with the author, December 1988.

67. Ibid.

68. Ibid.

69. Grahame Weinbrun, in remarks made at the symposium *Continuity and Interruption.*

70. Grahame Weinbrun quoted in Furlong, "Electronic Backtalk," *Afterimage,* p. 20.

71. Steven Mintz and Susan Kellogg, *Domestic Revolutions—A Social History of American Family Life* (New York: Macmillan, 1988), pp. 218, 22.

72. Ray Bradbury, *Fahrenheit 451* (New York: Ballantine, 1953 and 1979), p. 21

73. Meyer conversation.

74. Gene Youngblood at the symposium *Continuity and Interruption.*

75. Nam June Paik/Charlotte Moorman, "TV Bra for Living Sculpture," (1969) in "Video, Vidiot, Videology" in *New Artists Video,* ed. Gregory Battcock (New York: E.P. Dutton 1978), p. 129

Coco Fusco
Ethnicity, Politics, and Poetics

Research for this article was made possible through a grant for critical writing on media from the New York State Council on the Arts.

1. Hall, Stuart, "Cultural Identity and Cinematic Representation" in *Framework,* No. 36 (1989) p. 71.

2. See Liz Kotz's "Unofficial Stories: Documentaries by Latinas and Latin American Women," in *The Independent,* May, 1989, pp. 21–26); Martha Gever's "Feminism, Women Artists and Video in the '80's" in this volume, and Coco Fusco's "For Ana Mendieta," in *The Portable Lower East Side,* (1988) pp. 77–81.

3. Interview with the artist, June, 1989.

4. Ibid.

5. Ibid.

6. Ibid.

Muntadas
Behind the Image

Transcription and notes from the presentation: "Muntadas: Behind the Image," The IV Banff Lectures Series Inter-Arts; The Banff School of Fine Arts, Alberta, Canada, January 15, 1987.

Peter d'Agostino
Interventions of the Present: Three Interactive Videos, 1981–90

1. *Etant Donnés: 1. La Chute d'eav. 2. Le Gaz d'éclairage,* 1946–66. ("Given: 1. The Waterfall. 2. The Illuminating Gas.") Philadelphia Museum of Art, 1969.

2. *Webster's Unabridged Dictionary* (New York, 1983).

3. The preprogram can be described as follows: The title (W) plays for 1-minute intercut with 30 seconds of motion sequences from parts 1–4 (W:1:W:2:W:3:W:4:W:1, ad infinitum). All of the four monitors (ABCD) display the preprogram until a selection is made on the touch screen. When a selection is made, monitors A&C interrupt the preprogram to display the selection with synchronous image preprogram while monitors B&D continue to display the preprogram silently. After the selection plays, monitors A&C return to the preprogram, which is now out of phase with the program on monitors B&D, creating the random juxtapositions of order and disorder in the work.

4. From the prologue of the videodisc.

5. The forms of interaction incorporated into the design of *DOUBLE YOU (and X,Y,Z.)* include "an electronic book" where most of the 52 chapters (composed of approximately 48,000 frames) are directly accessible through an index. The surrogate travel portion of the disc (part 2) is used to create an analogy between words and place. The participatory "language games" employed in part 3 are composed of image icons representing words that form sentences. And part 4 can be described as a "video music box" where songs can be selected from the moving images of a carousel.

6. "The Age of the Medici," television film, Rome.

7. Arturo Schwarz, referring to *Etant Donnés. . .* in *The Complete Works of Marcel Duchamp* (London, 1969).

8. From an unpublished manuscript in the library of the American Academy in Rome, concerning Giambattista Piranesi's architectural work, "Villa of the Knights of Malta," Rome, 1764–66.

9. The interpretation of the Duchamp is more complex, representing closure to a fully articulated endgame. This peepshow that co-exists within the realm of high art, and patriarchal culture, vis-à-vis the male gaze, is a carefully orchestrated re-definition of perspective, which reveals Duchamp's interest and awareness of modern n-dimensional and non-Euclidean geometries.

10. *The Other Mexico: Critique of the Pyramid* (New York, 1972).

11. Bruce Cole, *Giotto and the Florentine Painting, 1280–1375* (New York, 1976).

12. *The Ascent of Man* (Boston, 1973).

Maureen Turim
The Cultural Logic of Video

1. Fredric Jameson, "The Cultural Logic of Late-Capitalism," *New Left Review* 146, July/August 1984, pp. 53–92.

2. Ernest Mandel, *Late-Capitalism* (London: New Left Books, 1975).

3. Jameson, "The Cultural Logic of Late-Capitalism," p. 78.

4. For a discussion of Georg Lukács and reflection theory, see Tony Bennett, *Formalism and Marxism* (London and New York: Methuen, 1979).

5. Jean-François Lyotard, *La Condition Postmoderne* (Paris: Les Editions de minuit, 1979).

6. See Jameson's "Forward' to the English translation of Lyotard in which he develops the Habermas and Lyotard comparison.

7. The Baudrillardian postmodern is presented in "The Precession of Simulacra," in *Art After Modernism: Rethinking Representation,* ed. Brian Wallis (Boston: Godine, 1984); *Amerique,* (Paris Grasset, 1986), and *Cool Memories* (Paris: Galilee, 1987).

8. Lyotard curated an exhibit and created the catalog *Les Immatériaux* for the Centre Nationale de l'art moderne, Beaubourg, 1985.

9. See Bertolt Brecht's discussion of *The Threepenny Opera* lawsuit and other essays in *Brecht on Theatre,* trans. D. Vesey (New York: Hill and Wang, 1964).

10. David Antin, "Video; the Distinctive Features of the Medium," Catalog to the exhibition *Video Art,* Institute of Contemporary Art, University of Pennsylvania, 1975, reprinted in *Video Culture: A Critical Investigation,* ed. John Hanhardt (New York: Peregrine Smith Books, 1986).

11. Rosalind Kraus, "Video: The Aesthetics of Narcissism," *New Artists Video,* ed. Gregory Battcock (New York: E. P. Dutton, 1978), reprinted in *Video Culture.*

12. Michel Foucault, *The Order of Things* (New York: Vintage, 1973).

13. I discuss this further in relationship to psychoperceptual theories in my article "Video

Art: A Theory for the Future," in *Regarding Television,* ed. E. Ann Kaplin (Frederick, Maryland: University Publications of America, 1983).

14. Maureen Turim, *Flashbacks in Film: Memory and History* (New York: Routledge, 1989).

Bruce Ferguson
The Importance of Being Ernie: Taking a Close Look (and Listen)

This essay is excerpted from a longer article first published in C Magazine, Fall 1985, Toronto, Canada.

1. Here is an example of a direct relation to video art, e.g., the character-generated texts of Richard Serra's *Television Delivers People* (1972), Tom Sherman's *The Envisioner* (1978), Martha Rosler's *Statistics of an Ordinary Citizen Simply Obtained* (1977), Joyan Saunders's *States of Being* (1981) or Nancy Nicol's *Sacrificial Burnings* (1981, to name a few—as well as to television productions. Many years later (1985) an Eastern Airlines one-minute advertisement presented a rolling script in silence for the similar effect of difference.

2. In literary critical terms, this reflexivity, which is so central to modernist art, is called by Charles Pierce "self-indexical signs," by Roman Jakobson "ambiguous and self-focusing" "poetic" signs and by Umberto Eco "the stuff of sign-vehicules" made "pertinent," and so on. In television terms, transliterated from these literary ones, John Fiske and John Hartley have called it the "metalinguistic" function in the sense that "[l]iterary criticism is all metalanguage, and many television programs, especially comedies, are 'about' the television message," in *Transmission,* ed. Peter D'Agostino, (New York: Tanam Press, 1985).

3. Although this *now* might be changing. Umberto Eco has suggested that showing the mike, or seeing the sound, today *is* again a value of authenticity in the age of 'neo-television.' See Eco, "A Guide to the Non-Television of the 80s," *Framework* 25 (1984), p. 21.

4. See Frank Krutnik, "The Clown Princes of Comedy," *Screen* 24:4 (1984), p. 50, where he described such humor as being "aware of language and works by deconstructing it and recombining it, the comedy of gags, illogicality and incongruity."

5. Cooke's television personality as a defender

of "taste" began in Great Britain as part of an official resistance to postwar Americanization. As Dick Hebdige wrote, "The content and quality of American comedy shows was apparently subjected to particularly intense scrutiny and ideally the image of America received by the British public was to be filtered through the paternalistic framings of professional commentators like Alistair Cooke," *Hiding in the Light* (London and New York: Routledge, 1988), p. 54. In America to perform the same function in the name of literacy, Cooke was later the equally conservative host of *Masterpiece Theatre*. Kovacs, in another program, describes Cooke as working "in an intimate vacuum," a description he held for Academia as well. A Cooke-like figure is the much later inspiration for Leonard Pinth Barnell, the pithy host of "Bad Ballet," created by Dan Aykroyd for *Saturday Night Live*.

6. That is, the cross structuring of essential elements in the medium as discrete bits or as autonomous items, which Regina Cornwell explained in a statement equally appropriate to Kovacs. "Film illusionism has an audial and a visual component. Through the film Snow has toyed with synchronous and asynchronous sound, often in humorous forms such as puns and comic clichés. He has made, in a sense, a comic book." Regina Cornwell, *Snow Seen: The Films and Photographs of Michael Snow* (Toronto: PMA Books, 1980), p. 146.

7. Kovacs's personal anti-intellectualism is prereminiscent of Peter Rose's videotape *The Pressure of the Text* in which an academically embedded language is laboriously made to perform pure phatic nonsense or Gary Hill's technically inventive *Happenstance* (1982–83) where objects and images and their relation to one another is made problematic.

8. Wertheim, Arthur Frank. *Radio Comedy* (New York: Oxford Press, 1979), p. 15.

9. Michael Nash, "In the Beginning," *High Performance* 30, Los Angeles, 1985, p. 19.

10. Nash, "In the Beginning," p. 19.

11. The advertising of cigars, of course, is an iconic redoubling, as Kovacs, like Groucho Marx and George Burns, two other comedians who made at least two successful transitions to new technological systems of broadcast each, and Karl Marx and Bertolt Brecht, two figures who Roland Barthes maintains were also interested in "pleasure," is most often televised or photographed chomping or smoking. His book jacket cover says, "Ernie Kovacs, TV's most original comedian takes a long look down his cigar at the industry that made him famous—a sizzling novel of sex and success," linking the promotion to Freudian insights, as well. The photo litho on the inside of the Dutch Masters cigar box is a reproduction of a Rembrandt group portrait of Dutch syndics, an image that already collapses the "classical" into the "commercial," or perhaps it returns the image from a historical discourse of autonomous aesthetics to a functional one; this is an image and an idea later developed and returned into the aesthetic by the peripheral pop artist Larry Rivers. The classical/autonomous undermined by the popular/functional, as we have seen, is a theme that underlines many Kovacs production sketches. The further redoubling of cigars, also underscores the sponsor-related nature of production during the Golden Age period when sponsors were implicated and thus responsible to the image of the programs themselves, although, here, they are subsumed to the Kovacs aesthetic, not vice-versa.

12. Hood, Stuart. *on Television* (London: Pluto Press, 1980), p. 26.

13. Bergson, Henry, *Comedy* (Garden City, NY: Doubleday, 1956), p. 188.

14. Ernie Kovacs, in *Life* magazine, April 15, 1957, p. 179.

15. Nash, "In the Beginning," p. 19.

16. Kroker described McLuhan's medical chronology as follows, "It was McLuhan's melancholy observation that when confronted with new technologies, the population passes through, and this repeatedly, the normal cycle of shock: 'alarm' at the disturbances occasioned by the introduction, often on a massive scale, of new extensions of the sensory organs; 'resistance' which is typically directed at the 'content' of new technological innovations (McLuhan's point was, of course, that the content of a new technology is only the past history of superseded technology); and 'exhaustion' in the face of our inability to understand the subliminal (formal) consequences of fundamental changes in the superstructure." Arthur

Kroker, *Technology and the Canadian Mind: Innis, McLuhan, Grant* (Montreal: New World Perspectives, 1984).

Norman M. Klein
Audience Culture and the Video Screen

Written originally in 1985, "Audience Culture and the Video Screen" accompanied a book on Dara Birnbaum's tapes, 1977–80, Rough Edits: Popular Image Video (Nova Scotia: The Press of the Nova Scotia College of Art and Design, 1987); it was revised a bit in 1988, to include work by other video artists during that period, in the section entitled "Modernity as Amnesia: The Problem of Making Video Art About TV Watching (1980–83)."

1. *Masque*, a costumed dance theater developed at European courts in the sixteenth and seventeenth centuries. In this form it was crucial that the audience become part of the spectacle.

2. Inigo Jones (1573–1652), the architect who designed many of the settings for *masques* at the court of James I. These settings resemble special effects today, even consumerist TV-manipulated imagery, oddly enough. Ben Johnson called them ". . . whirling whimsies, by a subtlety sucked from the veins of shop-curiosity."

3. *Miami Vice*, the weekly NBC detective series, which started in 1984 and which is notorious for its two glamorously dressed vice cops that take on the Miami underworld.

4. Brandon Tartikoff, "My Years of Living Dangerously," *TV Guide*, September 13, 1985, p.3.

5. Todd Gitlin, *Inside Prime Time* (New York: Pantheon, 1983), pp. 66–67.

6. Patricia Greenfield, *Mind and Media* (Cambridge, Mass: Harvard University Press, 1984), p. 37.

7. The blinking grids of *Hollywood Squares* are a strange architectonic fuse box, as if tiny synaptic circuits were breaking along an invisible path toward the audience. We are expected to feel a part of the electronic community, on the team. They are syntagms about circuses we think we went to, about county fairs, TV set design as urban planning, about parades along the city square. They serve as yet another reminder of how television "abstract[s] . . . our public life" (as I explained in an article on MTV and Birnbaum's tape *Kiss the Girls* (1982): "The Audience Culture," in *Theories of Contemporary Art*, ed. Richard Hertz (Englewood Cliffs, New Jersey: Prentice Hall, 1985). Among other syntagms about public community ritual: the wheels of fortune, Miss America costumes, and massive overhead projection in quiz shows, award shows and beauty pageants. I would guess that syntagms about public life are experienced mostly as a fantasy that one is really in a nationwide studio audience. One is a citizen of a place that can never exist. The effect of such syntagms on what we define normally as citizenship or community must be comical indeed.

8. Marc Elliot, *American Television: The Official Art of the Unofficial* (New York: Anchor/Doubleday, 1981), pp. 10–11.

9. Elliot, *American Television*, p. 20.

10. *Night Flight* is a weekly late night series on USA CABLE. It is an attempt at a New Wave television anthology that parodies network programming and remembers the campiest of audience memories (*Cocaine Madness*, and others in the "Camp classics" segments). Docu-interviews on rock videos, and farcical videos on movies predominate, among the experimental nuggets—also a few deconstructive video pieces in short segments. Format: the rhythm of campy programming meets the rhythm of rock video.

11. By laboratory, I am referring to three different issues, essentially. First, the laboratory art in Russia immediately after the Revolution until 1922 approximately, when experimental artists virtually managed many of the institutions of the Soviet art world (under the protection of Lunacharsky). Second, I refer to the experiments in video technology going on at various research centers today (Cal Tech, etc.). Third: the experimental video artist. Thus laboratory television is a utopian strategy, based on: the hope (1) that artists can control the means of TV broadcast, at least in one narrow-casted market; (2) that experimental video can be applied to ambitious "high art"; and (3) that video art can stand out as experimental within the continuum of TV programming. Only in a very limited way has this updated Saint Simonian-condition been realized, at least as of 1985.

12. I am using these terms rather eccentrically, since I consider them *both* as categories of TV narrative. For this essay, *synchronic* refers to the fractured, but "synchronized" story form of TV programming (or my sense of TV "supertext": the sum of many TV shows, commercials and public announcements together, as a continuity, over a three hour period). The term *diachronic,* by contrast, refers to a "chronological," or causal narrative, usually longer than the weekly TV show, more like a dramatic feature film, or the linear story-line within a novel.

Each term implies a specific type of viewing. For example, character identification in synchronic mode is infinitely less intense than in diachronic mode, as any viewer of nightly talk shows can attest. Also, the term has its own poetics, based on how it is received: diachronic story resembles TV novels; synchronic "story" resembles three hours of TV programming.

But more attention in the essay is devoted to synchronic devices on TV. They operate primarily as a form of advertising, where the ideal viewer is supposed to be made complaisant, while struggling to relieve anxiety during the three hour cycle of commercials and shows. The cycle may be delivered in pieces, but it is received like a walk through the park.

In synchronic programming, genres become part of the syntax (from detective shows to sitcoms), along with commercial interruptions, station identifications, all the way down to coded gestures on news shows, each genre and floating signifier criss-crossing into another, as a meta-story. The central character in this meta-story is essentially the viewer, at home, coping, thus the term "audience culture." (4/89)

13. *Magnum P.I.* is a successful weekly series with Tom Selleck in the role of the private eye. Selleck is a matinee idol transformed into a video/film star. Very much identified in the thirties mold, he was originally slated to play Indiana Jones in *Raiders of the Lost Ark*. Instead he stayed with the CBS hit *Magnum P.I.* where he plays a Vietnam veteran turned private eye, with old Nam buddies, and a batty, but lovable English army veteran.

14. *The Rockford Files* was NBC's private-eye

series from 1974–79. Former convict tracks fast-money crooks in southern California. Format: Rockford uses disguises to get background on crooks. He also uses his criminal friends (many from the "joint," to help, though he is also victimized by his larcenous buddies).

15. *Columbo:* the rotating detective series on NBC Sunday Night Movie from 1971 to 1977. Working-class police lieutenant catches wealthy murderers. Format: first the crime is committed, then the web is set around the wealthy.

16. Irving Thalberg, along with Louis B. Mayer, shaped the organization of MGM in the 1920s and 1930s. While the films he produced at MGM have not aged all that well (except for the Marx Brothers movies), Thalberg's myth continues. One can summarize the myth as follows: martyred genius dies at age 37; the corporate magician with the sensibility of the fine artist.

17. This reference to seventy years is rather glib, I must admit. "Seventy years" stands in for the memory left by electronic media, since the emergence of the movies in the late teens. The larger issue is, of course: how does one actually research "audience reception"? Or is it merely a speculative endeavor, stepchild of literary criticism? The stages of adjustment in consumerism (routines, marketing, visual literacy) can involve a search for primary sources and be made to run parallel to grander shifts in capitalism or urban history. In the end, I suppose, much of it must remain speculative however, possibly the germ of a new "narrative" form in itself (i.e., the critical monologue).

Still, a random list of potential sources should be mentioned, if only as a tight gray mass at the bottom of the page: the study of mass publishing; or of pedestrian consumer habits (e.g., arcades, shopping districts, urban planning); or the emergence of working-class consumer markets after 1870 (e.g., ready-to-wear clothing, vaudeville, the movies); or the shifts in visual literacy (what audiences can "read" as abstracted symbol); or even how critics define "folklore" or the "fine arts," as measures of what is half-remembered, like a Freudian screen-memory.

Always at the center of such studies is

the elusive canonical standard itself: what aesthetic forms must these issues (mass culture, consumer memory, even the fine arts) be made to resemble, in order to be validated as serious work? What aesthetic models are considered proper for mass culture from one era to another (e.g., in the 1920s, folklore studies were applied often to memories of nineteenth-century mass culture).

Thus, "seventy years" refers more to how we remember badly, in fragments of a historical process like a chaotically edited video riff, set to music, as if there were a singular story being told; but for the most part, electronic media specializes in erasure and displacement, and becomes a study in how much is forgotten, not remembered. The study of audience reception does indeed violate rules of objective scholarship, unavoidably. But there is no point in putting such conjecture in the body of this essay, except to remind us that video must often be edited as if pieces were forgotten, or left out.

18. *Laugh in*, a comedy series that began on NBC in 1968, capitalizing in part on the spirit of the late 1960s, particularly on political pranksterism as vaudeville gag. The look of this show (short straight-man gags, quick cuts, visual inserts of slapstick—similar to old Gleason shows and *Your Show of Shows* in the 1950s—and whimsical wipes) was borrowed in other shows as well, like the opening segments for *Love American Style*, or the anti-hip *Hee Haw* (rather like a Grand Old Opry answer to *Laugh In*), and, as I mention above, in *Sesame Street*.

19. *Flashdance* (1983) directed by Adrian Lyne, who is also a well-known director of English TV commercials. In trying to explain the astonishing success of this film $100 million gross, and related shifts in fashions and films afterward), many critics emphasized the obvious resemblance the film has to rock videos. A dancing silhouette highlighted by auroras of light from the background and the look of selling a life-style overwhelmed the need for complex characters. Format: Gutsy steelworker Alexandra Owens enters the fantasy of modern dance as video life-style. After hard solitary work, she overcomes her pride and auditions for an upscale dance school. She overpowers them with breakdance (and also wins her man).

20. John Wicklein, *Electronic Nightmare: The New Communications and Freedom* (New York: Viking, 1981), p. 265.

21. J. Walter Thompson, "Market Analysis," in *Cable Television and the Performing Arts*, ed. Kirsten Beck, sponsored by New York University, 1981, p. 17

22. Han Solo: the cowboy persona in the *Star Wars* trilogy. Like the traditional leatherstocking hero, he remains the half-civilized mountain man who leads the settlers through the prairie, but always remains unable to settle down himself. Luke Skywalker: the emblem of Anglo-Saxon America, refurbished for contemporary teenage audiences in the *Star Wars* trilogy. Young Luke uses The Force, rather than Protestantism, to give him strength to master a warrior code (borrowed loosely from samurai films, sixties mysticism, pulp science fiction, and forties Saturday matinee movie serials).

23. Jean Baudrillard, "The Procession of Simulacra," in *Simulations*, trans. P. Foss and P. Patton (New York: Semiotext(e), 1983), p. 54. Of course, Baudrillard has written more on television since 1985, when this citation was selected by the author.

24. Jean Baudrillard, "The Orders of Simulacra," in *Simulations*, p. 152.

25. Gilles Deleuze, "Politics," in *On the Line*, trans. John Johnston (New York: Semiotext(e), 1983), p. 79.

26. Vincent Leitch, *Deconstructive Criticism* (New York: Columbia University Press, 1983), p. 58.

Christine Tamblyn
Significant Others

1. Rosalind Krauss, "Video: The Aesthetics of Narcissism," *October* 1: (Spring 1976).

2. Ibid., p. 57.

3. Ibid., p. 58.

4. Ibid., p. 53.

5. Micki McGee, "Politics and the Everyday: An Interview with Sherry Millner," *Afterimage*, 15:9 (April 1988), p. 4.

6. Ibid., p. 5.

7. William Olander, "Women and the Media: A Decade of New Video," in *Resolution: A Critique of Video Art*, ed. Patti Podesta (Los Angeles: Los Angeles Contemporary Exhibitions, 1986), p. 77.

8. Roland Barthes, "The Death of the Au-

thor," in *The Rustle of Language,* trans. Richard Howard (New York: Hill and Wang, 1986) pp. 49–55.

9. Kaja Silverman, *The Acoustic Mirror: The Female Voice in Psychoanalysis and Cinema* (Bloomington and Indianapolis: Indiana University Press, 1988), p. 189.

10. Jacques Derrida, *Glas* (Paris: Galilee, 1974), p. 88.

11. Statement derived from a publicity release issued by the artist.

Raymond Bellour
Video Writing

Translation by Alison Rowe published courtesy of Camera Obscura: A Journal of Feminism and Film Theory. *This essay appears in* Camera Obscura/23, *"Unspeakable Images," (May 1990).* For Jackie, Takae, André, Barbara and Tone, who first told me about *Video Letter.*

1. Roland Barthes by Roland Barthes, translated by Richard Howard. New York: Hill and Wang, 1977, pp. 165–66.)

2. "The Letter goes on . . ." ("La lettre dit encore . . .") is a title from *Épreuves, Exorcismes* by Henri Michaux (Gallimard, 1946).

Rita Myers
Directions/Questions:
Approaching a Future Mythology

This essay was written while I was an artist-in-residence at the Mason Gross School of the Arts, Rutgers University, sponsored by the Mid Atlantic Arts Foundation.

1. Mircea Eliade, *The Sacred and the Profane* (New York: Harcourt, Brace & World, Inc., 1959), p. 34.

2. Ibid., p. 74, quoting a Dakota saying.

3. Joseph Campbell, *The Way of the Animal Powers* (New York: Alfred van der Marck Editions, 1983), p. 8.

4. Joseph Campbell, *The Hero with a Thousand Faces* (Princeton: Princeton University Press, 1949), p. 12.

5. Ibid., p. 3.

6. Mircea Eliade, *Myth and Reality* (New York: Harper & Row, 1963), pp. 28–38.

7. Joseph Campbell, *The Inner Reaches of Outer Space* (New York: Alfred van der Marck Editions, 1986), p. 27.

8. Jorge Luis Borges, "The Aleph," in *A Personal Anthology* (New York: Grove Press, 1967), pp. 138–154.

9. Robert Jay Lifton, *The Broken Connection* (New York: Simon and Schuster, 1979), p. 3.

10. Ibid., p. 284.

11. Ibid., p. 394.

12. Campbell, *Inner Reaches*, p. 31.

13. Eleanor Munro, *On Glory Roads* (New York: Thames and Hudson, 1987), pp. 18–23.

Mary Lucier
Light and Death

1. Mary Lucier, *Fire Writing,* performance piece, 1975.

2. John Berger, "The Eyes of Claude Monet," *The Sense of Sight* (Pantheon, 1985), p. 189.

3. Ibid., p. 191.

4. Perry Miller, *Errand into the Wilderness* (Harvard University Press, 1956), p. 216.

6. Henry David Thoreau, "Walking," *The Portable Thoreau* (The Viking Press), 1947.

Bill Viola
Video Black—The Mortality of the Image

1. Mircea Eliade, *A History of Religious Ideas* (Chicago: University of Chicago Press, 1978), p. xiii.

2. A. K. Coomaraswamy, *The Transformation of Nature in Art* (New York: Dover Publications, 1956), pp. 28, 30, 31 (reprint of original Harvard University Press edition, Boston, 1934).

3. Rainer Maria Rilke, *The Selected Poetry of Rainer Maria Rilke,* ed. and trans. Stephen Mitchell (New York: Random House, 1982), p. 91.

4. Yoel Hoffman, *Japanese Death Poems* (Tokyo: Charles E. Tuttle Company, 1986), p. 118.

5. Plato quoted in Wilhelm Fraenger, *Hieronymus Bosch* (New York: G. P. Putnam and Sons, 1983), p. 42.

6. Al-Ghazzali; quoted in N. Ardalan and L. Bakhtiar, *The Sense of Unity* (Chicago: University of Chicago Press, 1973), p. 47.

Contributors

Vito Acconci's early work made use of live activity, photographs, film, and video; it built up personal spaces and was the location for interpersonal relationships. His recent work makes use of public places like streets and parks; it builds up social spaces and is the location for an analysis of cultural conventions and power signs. In 1987, the La Jolla Museum of Contemporary Art organized a traveling survey, *Vito Acconci: Domestic Trappings;* in 1988, the Museum of Modern Art in New York exhibited *Vito Acconci: Public Places.* He was born in 1940 and lives in New York City.

Judith Barry is an artist and writer who works in a variety of media including video, sculpture, photography, performance, and theater. Her installations have been exhibited worldwide including the Museum of Modern Art, the Whitney Museum of American Art, the Museum of Contemporary Art, Los Angeles, the University Art Museum, Berkeley, the Whitney Biennial, the Venice Biennale, the Institute of Contemporary Art, London, and the Centre Pompidou, Paris. Her writing has been published in *Blasted Allegories,* edited by Brian Wallis; *Video by Artists II,* edited by Elke Towne; *The Un/Necessary Image,* edited by Antonio Muntadas and Peter d'Agostino; *Discourse,* and *Screen,* as well as in numerous catalogs.

Raymond Bellour is an internationally celebrated film, video, and literary theorist and critic. He is Directeur de Recherche at the Centre National de la Recherche Scientifique (CNRS) in Paris, France. He has authored six books, eight anthologies and special edition journals, and three critical editions.

Dara Birnbaum is internationally recognized for her work in video and the arts. She received the American Film Institute's Maya Deren Award as well as dual fellowships from Princeton University and special recognition from Harvard University. Her work has been exhibited in Documenta, the Whitney Biennial, and the Carnegie International as well as at the Museum of Modern Art, New York, The Museum of Contemporary Art, Los Angeles, and Centre Georges Pompidou, among numerous others. Other venues for her work have included broadcast television, MTV, video/music clubs. and public spaces such as Grand Central Station, NYC. She was one of the early video artists to appropriate and deconstruct television imagery. Her interactive Rio Videowall (1989) is being heralded as the first large scale permanent outdoor video installation in the U.S.

David Bolt, as the Executive Director of the Bay Area Video Coalition (BAVC) directs BAVC staff and budget for all programs. He has an extensive background in the multimedia arts which includes: work as development director of CPB's Pacific Educational network; professor of broadcasting at San Francisco State University; and producer and co-owner of New Pacific Productions. He holds a Masters of Arts degree in Radio and Television from San Francisco State University and has completed coursework towards a Ph.D. in public administration at Golden Gate University. He has served as producer/writer on a number of documentaries (e.g. *Ain't Misbehavin: the Coit Tower Murals. Guam: The Legacy of War. Coming of Age in America* and others.). He has taught numerous classes in interactive videodisk and consults regularly on interactive multimedia projects.

Deirdre Boyle is a critic, teacher, and curator of independent video and film. She is a faculty member in Graduate Media Studies at the New School for Social Research and is a Guggenheim Fellow. She has published articles in *Afterimage. American Film. The College Art Journal.* and *Sightlines.* Her most recent book is *Video Classics: A Guide to Video Art & Documentary Tapes* (Phoenix: Oryx Press, 1986). Her

forthcoming book, *Subject to Change: Guerrilla Television Revisited,* is scheduled for publication with Oxford University Press.

Peter d'Agostino is an artist who has been working in video since 1971, and is currently professor of communications in the Department of Radio-Television-Film, and co-director of the HyperMedia Lab, Temple University, Philadelphia. D'Agostino was a National Endowment for the Arts fellow in 1974, 1977, 1979, and 1989. He was also an artist-in-residence at the Television Laboratory, WNET, New York (1981); a fellow at the Center for Advanced Visual Studies, MIT (1983–85); and a visiting artist at the American Academy in Rome (1986). His work has been exhibited internationally in the form of installations, performances, telecommunications events, and broadcast productions. His work has been included in the 1981 Whitney Biennial, the Bienal de Sao Paulo (1983), the Festival des Arts Electronique, Rennes, France (1988), and is in the collection of The Museum of Modern Art's Circulating Video Library.

Juan Downey has received Rockefeller, Massachusetts Council on the Arts and Humanities, Guggenheim, New York State Council on the Arts, and NEA fellowships. His work has been seen on WNET, WGBH, and KQED. He is associate professor of architecture and video at Pratt Institute in New York.

Bruce Ferguson is an independent curator and writer from Canada who lives in New York. He writes for *C* magazine in Toronto, *Art in America,* and catalog essays in exhibitions, which he organizes worldwide. Ferguson has curated numerous video exhibitions in Canada and Europe.

Howard Fried is a sculptor whose materials include video and language. His complex installations and videotapes have been exhibited at the Institute of Contemporary Art in Boston, the Whitney Museum of American Art, and the Museum of Modern Art in New York and the San Francisco Museum of Modern Art.

Coco Fusco is a New York–based curator and critic and program officer for the New York

Council for the Humanities. Her articles have appeared in the *Village Voice, The Nation, Art in America,* and *Afterimage.* She curated the touring exhibition, "Young, British and Black: The Works of Sankoja and Black Audio Film Collective." She was the editor of *Reviewing Histories: Selections from New Latin American Cinema.*

Martha Gever is the editor of *The Independent Film and Video Monthly.* Her critical writings on video, media politics, and cultural institutions have appeared in *October, Screen, Art in America, Art Journal, Afterimage,* and elsewhere.

Dan Graham has been influential as an artist and as a writer about the arts and their relationship to larger social/political concerns. His work has been widely exhibited and, in 1985, was the subject of a retrospective exhibition organized by the Art Gallery of Western Australia. An anthology of his writings is being edited by Brian Wallis and will be published by MIT Press.

Dee Dee Halleck has been working in alternative forms of media since the early 1970s. She is a founding member of Paper Tiger Television, the grass-roots media collective, and is an eloquent spokesperson for populist video. She is a frequent panelist at symposia on media and has written several essays on video as a social act. She received a Resident Rockefeller Fellowship for her feature film *Uncle Sam's Tropical Review.* She currently teaches in the Communications Department at the University of California, San Diego.

John G. Hanhardt is both curator and head of the Film and Video Department at the Whitney Museum of American Art. His publications include books such as *Nam June Paik, A History of the American Avant Garde Cinema* and *Video Culture: A Critical Investigation,* as well as numerous articles.

Lynn Hershman's site-specific, photographic, and media-based works have been exhibited worldwide including the Venice Bienalle; the Pompidou Center, Paris; and the New Museum of Contemporary Art and the Whitney Museum of American Art in New York. Her work has been nationally broadcast in the United States. She has published numerous ar-

ticles and is the recipient of three grants from the National Endowment for the Arts. She is credited with having produced the first interactive laser art videodisk. Currently, she is on the faculty of San Francisco State University.

Gary Hill has been a recipient of Guggenheim, National Endowment for the Arts, and Rockefeller fellowships. He has had solo exhibitions at the Whitney Museum of American Art and the Museum of Contemporary Art, Los Angeles, and he is a faculty member at the Cornish School of Art in Seattle.

Kathy Rae Huffman is curator of Media and Performing Arts at The Institute of Contemporary Art, Boston. As curator/producer of The Contemporary Art Television (CAT) Fund (1984–1990), a collaboration between The ICA and WGBH, she commissioned and produced twenty new works by artists with video. As curator of video for the ICA, Huffman curates an ongoing video and performance art series. She is well known for her international collaborations. From 1979–1984, Huffman was curator at the Long Beach Museum of Art. She was executive producer of "Shared Realities" (1984), an 18-week arts cable series.

Joan Jonas is a multimedia visual and performance artist who has been performing in the United States and Europe since the late 1960s. She is the recipient of fellowships and grants for choreography, video, and the visual arts from the New York State Council on the Arts, the National Endowment for the Arts, the Guggenheim and Rockefeller Foundations, and the Contemporary Art Television Fund.

Norman M. Klein is a member of the faculty of Critical Studies at the California Institute of the Arts in Valencia. He has written extensively on film, television, and the arts. His work has been published in leading academic journals as well as in more popular periodicals. He is co–editor of *Twentieth Century Art Theory: Urbanism, Politics, Mass Culture* (Englewood Cliffs, NJ: Prentice Hall, 1990) and *20th Century Los Angeles: Power, Politics and Social Conflict* (Claremont, CA: Regina, 1990), and is completing a book on the history of animation.

Tony Labat is an artist who works in video installation and sculpture. He has been the recipient of the Engelhardt Award from the Institute of Contemporary Art, Boston and fellowships from the National Endowment for the Arts. His work has been exhibited at the Museum of Contemporary Art, Los Angeles, and elsewhere. He teaches at the San Francisco Art Institute.

Chip Lord was a cofounder of Ant Farm, a group of artists and architects whose works from the early 1970s deconstructed myths of popular culture. As an individual artist he has received grants from the National Endowment for the Arts and the CAT Fund for his work in video. His videotapes have been shown nationally and internationally and are included in the public collections of the Museum of Modern Art in New York, and the Long Beach Museum of Art in California. He is the author of *Autoamerica*, a personal history of the automobile at mid-century. He is an associate professor in Theater Arts at the University of California, Santa Cruz.

Mary Lucier is a multi-media artist and sculptor who has been working with video since 1973. She has had one-person exhibitions at the Museum of Contemporary Art, Los Angeles, the Dallas Museum of Art, the Neuberger Museum, and the Whitney Museum of American Art, among others. She has received grants and fellowships from government and private foundations, including the National Endowment for the Arts, the American Film Institute, and the John Simon Guggenheim Memorial Foundation. Her work is in the permanent collection of the Whitney Museum of American Art, the Stedelijk Museum, Amsterdam, Readers Digest Foundation, and the National Gallery of Canada, as well as private collections. She is represented by Greenberg Wilson Gallery in New York.

Margaret Morse has published articles on video art and network television and has recently completed a research project on video installation as a Rockefeller Fellow in Residence at the Whitney Museum of American Art. She is an assistant professor at the University of Southern California.

Muntadas was born in Barcelona in 1942 and has resided in the United States since 1972. From 1977 to 1984 he was a research fellow at the M.I.T. Center for Advanced Visual Studies where he also taught. He has been the recipient of numerous awards including fellowships from the John Simon Guggenheim Memorial Foundation and the National Endowment for the Arts. His work in installation, photography, and video has been shown internationally. He has just completed the installation *Stadium* in 1990.

Rita Myers has received numerous awards for her work in the video arts including fellowships and grants from the National Endowment for the Arts, the New York State Council on the Arts, the Massachusetts Council on the Arts and Humanities, and the Jerome Foundation. Her work has been exhibited internationally since the early 1970s.

Kathy O'Dell is a doctoral candidate in art history at the Graduate Center, City University of New York. She has written for *Art in America, Artforum, Arts, Art Com,* and *Critical Texts.*

Tony Oursler is one of the important investigators of narrative video arts. His paintings, sculptures, single-channel video works, performances, and large video installations are used as a means of extending narrative ideas. His installation *Spheres of Influence* (1985–86) was commissioned by the Pompidou Centre, Paris. His recent work, *Spillchamber 2* (1987–89), was included in the "Video Sculpture, 1963–1989" at the Kolnischer Konstrerein, Köln. He is represented by the Electronic Arts Intermix and Diane Brown Gallery in New York and the Delta Gallery in Düsseldorf.

Martha Rosler is an artist who works with video, photography, text, and performance, as well as writing criticism. Rosler teaches photography and media studies at Rutgers University in New Brunswick, New Jersey, and at the Whitney Independent Studies Program in New York City. Her most recent videotape, *Born to Be Sold: Martha Rosler Reads the Strange Case of Baby S M*(1988), was produced in collaboration with Paper Tiger Television, a New York-based local public access cable cooperative. It addresses issues of gender, class, reproduction, and representation.

David A. Ross has been the director of The Institute of Contemporary Art, Boston since 1982. Prior to assuming directorship of America's oldest contemporary art institute, Ross served four years as chief curator and associate director for Collections and Programs of The University Art Museum, Berkeley. Ross began his curatorial career as curator of video Art in 1971 at The Everson Museum of Art in Syracuse, New York where he started the first museum department devoted to the collection and study of video as an artist's medium. Ross has published and lectured widely on a broad range of topics in contemporary art, and has taught at the University of California, San Diego, The San Francisco Art Institute, and Harvard University. He is currently chairman of the Federal Advisory Committee on International Exhibitions, and serves on the Board of Trustees of The Tiffany Foundation.

Marita Sturken has written critical articles on video and monographs on many of the seminal figures in the field. Her work has been published in several periodicals, including *Afterimage*. She is pursuing her doctorate in the History of Consciousness Program at the University of California, Santa Cruz.

Christine Tamblyn is a video artist whose work has been exhibited nationally. She is a regular contributor to *Afterimage, Art News, High Performance,* and *Art Week*. She teaches video and interart theory at San Francisco State University.

Francesc Torres has received a Deutscher Akademischer Austauschdienst (DAAD), Berliner Kunstlerprogramm Fellowship as well as fellowships from the National Endowment for the Arts and the Massachusetts Council for the Arts and Humanities. His work has been shown at the Stedelijk in Amsterdam, and the Whitney Museum of American Art and the Museum of Modern Art in New York City.

Maureen Turim is an associate professor of Cinema at the State University of New York at Binghamton. She is the author of *Abstraction in Avant-Garde Films* and *Flashbacks in Film: Memory and History*, as well as numerous arti-

cles on film history and analysis. Her writing on video includes "Video Art Theory for a Future" in *Regarding Television* and the catalog "The Electronic Gallery" that accompanied an exhibit of process tapes she curated for the University Art Gallery, SUNY–Binghamton. An article co-authored with Scott Nygren, theoretically assessing the work of the Vasulkas, entitled "Reading the Tools, Writing the Image," is forthcoming.

Ann-Sargent Wooster is an artist and writer. Her paintings, videotapes, and performances have been shown at the Pompidou Center in Paris, the Institute for Contemporary Art in Boston, The Kitchen in New York, and elsewhere. She has been awarded grants and fellowships from the New York State Council on the Arts and the New York Foundation for the Arts. Her writings have appeared in *Artforum, Art in America, Art News, Soho News,* and *The Village Voice.* She is a contributing editor of *Express Magazine* and teaches at the School of Visual Arts in New York.

Steina Vasulka attended the Music Conservatory in Prague from 1959 to 1963 and joined the Icelandic Symphony Orchestra in 1963. She came to the United States the following year and has participated in the development of electronic arts since 1970, both as cofounder of The Kitchen in New York City and as an explorer of new possibilities for the generation and manipulation of the electronic image. Her tapes have been exhibited and broadcast extensively in the United States and Europe. She is the recipient of a Guggenheim Fellowship and other grants. Since moving to Santa Fe, New Mexico in 1980, she has produced a series of videotapes relating to the land and an installation entitled *The West.*

Woody Vasulka was born in Brno, Czechoslovakia, and studied metal technologies and hydraulic mechanics at the School of Industrial Engineering there. He later entered the Academy of Performing Arts, Faculty of Film and Television in Prague. He emigrated to the United States in 1965 and began his investigations into computer-controlled video. He cofounded The Kitchen with Steina and has participated in many major video shows in the United States and abroad. He is a 1979 Guggenheim Fellow and a former faculty member of the Center for Media Study at New York State University, Buffalo. Since moving to New Mexico, he has produced *Artifacts, Art of Memory,* and *The Commission.* His latest work is entitled *Brotherhood.*

Bill Viola is an artist who works with video. He has received fellowships from the National Endowment for the Arts as well as from the Guggenheim and Rockefeller Foundations. His work has been exhibited worldwide, including retrospective exhibitions at the Museum of Modern Art in New York, 1987; and the Contemporary Arts Museum in Houston, 1988. He lives in Long Beach, California.

Bruce and Norman Yonemoto have been creating films and videotapes for over a decade. Their feature-length videotape, *Green Card: An American Romance,* which uses the structure of the traditional television soap opera, brought them international notoriety and is in the permanent collection of the Museum of Modern Art in New York. They have been the recipients of numerous grants and their tapes have been broadcast on PBS in the United States, ZDF in Germany, and Channel 4 in Britain. They are currently working on a narrative video for ZDF entitled *Made in Hollywood.*

Selected Bibliography

COMPILED BY LUKE HONES

BOOKS

Abramovic, Marina, and Ulay. *Relation Work and Detour.* Amsterdam: Abramovic/Ulay, 1980.

Adler, Richard, ed. *Understanding Television: Television as a Social and Cultural Force.* New York: Praeger, 1981.

Adorno, Theodor, and Max Horkheimer. *Dialectic of Enlightenment.* New York: Seabury Press, 1972.

Althusser, Louis. *For Marx.* Translated by Ben Brewster. New York: Vintage Books, 1970.

——. *Montesquieu, Rousseau, Marx: Politics and History.* Translated by Ben Brewster. London: Verso Editions and New Left Books, 1982.

Althusser, Louis, and Etienne Balibar. *Reading Capital.* Translated by Ben Brewster. London: New Left Books, 1970.

Arendt, Hannah. *The Human Condition.* New York: Doubleday/Anchor Press, 1959.

Arlen, Michael. *The Camera Age.* New York: Farrar, Straus and Giroux, 1981.

——. *The Living Room War.* New York: Viking Press, 1969.

Arnheim, Rudolf. *Film as Art.* Berkeley: University of California Press, 1957.

Association Muse d'Art Moderne. *Vido.* Basel, Switzerland: Association Muse D'Art Moderne Stampa-Basel, 1977. In French, Italian, German and English.

Baggaley, Jon, and Steven Duck. *Dynamics of Television.* London: Gower Press, 1976.

Baldessari, John. *John Baldessari* with essays by Marcia Tucker and Robert Pincus-Witten. The New Museum: *New York,* 1981.

Barnouw, Erik. *Documentary.* London: Oxford University Press, 1974.

——. *History of Broadcasting.* 3 vol. New York: Oxford Press, 1970.

——. *The Golden Web: History of Broadcasting in the United States.* New York: Oxford University Press, 1968.

——. *The Sponsor: Notes on a Modern Potentate.* New York: Oxford University Press, 1978.

——. *Tube of Plenty.* London: Oxford University Press, 1975.

Barthes, Roland. *Camera Lucida.* Translated by Richard Howard. New York: Hill and Wang, 1981.

——. *Critical Essays.* Translated by Richard Howard. Evanston, IL: Northwestern University Press, 1972.

——. *Image, Music, Text.* Translated by Stephen Heath. New York: Hill and Wang, 1972.

——. *Mythologies.* Translated by Annette Lavers. New York: Hill and Wang, 1972.

——. *S/Z.* Translated by Richard Howard. New York: Hill and Wang, 1974.

Battcock, Gregory, ed. *The New American Cinema.* New York: E. P. Dutton, 1967.

——. *New Artists Video: A Critical Anthology.* New York: E. P. Dutton, 1978 (out of print).

Battcock, Gregory, and Robert Nickas, eds. *The Art of Performance: A Critical Anthology.* New York: E. P. Dutton, 1984.

Baudrillard, Jean. *For a Critique of the Political Economy of the Sign.* St Louis: Telos Press, 1981.

——. *In the Shadow of the Silent Majorities . . . or The End of the Social.* Translated by Paul Foss, Paul Patton, John Johnston. New York: Semiotext(e), 1983.

——. *Simulations.* Translated by Paul Foss, Paul Patton, Philip Beitchmann. New York: Semiotext(e), 1983.

——. *The Mirror of Production.* Translated by Mark Poster. St. Louis: Telos Press, 1975.

Bazin, André. *What Is Cinema? Essays selected and translated by Hugh Gray.* Berkeley: University of California Press, 1967.

Benjamin, Walter. *Illuminations.* Edited by Hannah Arendt. Translated by Harry Zohn New York: Schocken, 1976.

——. *Reflections.* Edited by Peter Demetz. Translated by E. F. N. Jephcott H. New York: Harcourt Brace, Jovanovich, 1978.

Berger, John. *About Looking*. New York: Pantheon, 1980.

———. *The Look of Things*. New York: Viking Press, 1972.

———. *Ways of Seeing*. London: British Broadcasting Corporation and Penguin Books, 1972.

Berke, Joseph, ed. *Counter Culture*. London: Peter Owen Ltd., 1969.

Birdwhistell, Ray L. *Kinetics and Context; essays on body motion communication*. Philadelphia: University of Pennsylvania Press, 1970.

Blanchard, Simon, and David Morley, eds. *What Is This Channel Four?* London: Comedia, 1982.

Bloch, Dany, ed. *l'Art et la Video: 1960–1980*. Locarno, Switzerland, Edizioni Flaviani Locarno, 1982. In French.

Bloch, Ernst, George Lukacs, Bertolt Brecht, Walter Benjamin, Theodor Adorno. *Aesthetics and Politics*. London: New Left Books, 1977.

Bluem, William A. *Documentary in American Television*. New York: Hastings House, 1965.

Body, Vera, and Peter Weibel, eds. *Clip Klapp Bum*. Koln, West Germany: 1987.

Boyle, Deirdre. *Video Classics: A Guide to Video Art and Documentary Tapes*. Phoenix: Onyx Press, 1986.

Bronson, A. A., and Peggy Gale, eds. *Performance by Artists*. Toronto: Art Metropole, 1979.

Brown, Les. *Television: The Business Behind the Box*. New York: Harcourt Brace Jovanovich, 1971.

Buchloh, Benjamin, ed. *Dan Graham; Video-Architecture-Television: Writing on Video and Video Works*. Halifax, Nova Scotia: The Press of the Nova Scotia College of Art and Design. New York: New York University Press, 1979.

———. *Rough Edits: Popular Image Video⟨197⟩ Dara Birnbaum*. Halifax, Nova Scotia: The Press of the Nova Scotia College of Art and Design, 1987.

Buck-Morss, Susan. *The Origin of Negative Dialectics: Theodor W. Adorno, Walter Benjamin, and The Frankfurt Institute*. New York: Free Press, 1979.

Burch, Noël. *Theory of Film Practice*. Translated by Helen R. Lane. New York: Praeger, 1973.

Burger, Peter. *Theory of the Avant-Garde*. Translated by Michael Shaw. Theory and History of Literature, vol. 4. Minneapolis: University of Minnesota Press, 1984.

Burgin, Victor, ed. *Thinking Photography*. London: Macmillan, 1982.

Burnham, Jack. *Beyond Modern Sculpture.: The Effects of Science and Technology on the Sculpture of This Century*. New York: Praeger, 1972.

———. *The Structure of Art*. New York: Braziller, 1970.

Castoriadis, Cornelius. *Crossroads in the Labyrinth*. Translated by Kate Soper and Martin H. Ryle. Cambridge: MIT Press, 1984.

Caughie, John, ed. *Television: Ideology and Exchange*. London: British Film Institute, 1978.

Cavell, Stanley. *The World Viewed*. Cambridge: Harvard University Press, 1979.

Cha, Theresa Hak Kyung, ed. *Apparatus*. New York: Tanam Press, 1980.

Chanan, Michael. *The Dream that Kicks*. London: Routledge & Kegan Paul, 1980.

Chomsky, Noam. *Aspects of the Theory of Syntax*. Cambridge: MIT Press, 1972.

Cole, Barry, ed. *Television Today: A Close-up View, Readings from TV Guide*. Oxford University Press, 1981.

Collier, John Jr. *Visual Anthropology: Photography as a Research Method*. New York: Holt, Rinehart & Winston, 1967.

Connor, Russell, ed. *Vision and Television*. Waltham, Mass.: Rose Art Museum, Brandeis University, 1970 (out of print).

Conrad, Peter. *Television: The Medium and Its Manners*. London: Routledge and Kegan Paul, 1982.

Curtis, David. *Experimental Cinema*. New York: Delta, 1971.

d'Agostino, Peter, ed. *Transmission: Theory and Practice for a New Television Aesthetics*. New York: Tanam Press, 1985.

———. *Coming and going: NEW YORK (Subway) PARIS (Metro) Washington (Metro)*. San Francisco: NFS Press, 1982.

d'Agostino, Peter, and Lew Thomas, eds. *Photography: The Problematic Model*. San Francisco: NFS Press, 1981.

d'Agostino, Peter, and Antonio Muntadas, eds. *The UnNecessary Image*. New York: MIT/Tanam Press, 1982.

Davis, Douglas. *Art and the Future: A History-Prophecy of the Collaboration Between Science, Technology and Art.* New York: Praeger, 1973.

———. *Art Culture: Essays on the Postmodern.* New York: Harper & Row Publishers Inc., 1977.

Davis, Douglas, and Allison Simmons, eds. *The New Television: A Public/Private Art.* Cambridge: MIT Press, 1977 (out of print).

de Certeau, Michael. *The Practice of Everyday Life.* Translated by Steven F. Randall. Berkeley: University of California Press, 1984.

de Lauretis, Teresa. *Alice Doesn't.* Bloomington: Indiana University Press, 1984.

de Lauretis, Teresa, and Stephen Heath, eds. *The Cinematic Apparatus.* New York: St. Martin's Press, 1980.

de Lauretis, Teresa, Andreas Huyssen, and Kathleen Woodward, eds. *The Technological Imagination: Theories and Fictions.* Madison, Wis.: CODA Press, 1980.

Debray, Regis. *Teachers, Writers, Celebrities.* Translated by David Macey. London: Verso Editions and New Left Books, 1981.

Delanty, Suzanne. *Video Art.* Philadelphia: Institute of Contemporary Art, 1975.

Deleuze, Gilles, and Felix Guattari. *Anti-Oedipus: Capitalism and Schizophrenia.* Translated by Robert Hurley, Mark Seem, Helen R. Lane. New York: Viking Press, 1977.

———. *On the Line.* Translated by John Johnston. New York: Semiotext(e), Inc., 1983.

Diamond, Edwin. *Sign Off: The Last Days of Television.* Cambridge: MIT Press, 1982.

Dickie, George. *Art and Aesthetic.* Ithaca: Cornell University Press, 1974.

Duguet, Anne-Marie. *La Memoire au Poing.* Paris: Hachette, 1981. In French.

Dworkin, Stephen. *Film Is.* Woodstock, N.Y.: Overlook Press, 1975.

Eagleton, Terry. *Criticism and Ideology.* London: Verso Editions, 1978.

———. *Literary Theory: An Introduction.* Minneapolis: University of Minnesota Press, 1983.

Eagleton, Terry. *Walter Benjamin, or, Towards a Revolutionary Criticism.* London: Verso Editions and New Left Books, 1981.

Eco, Umberto. *A Theory of Semiotics.* Bloomington: Indiana University Press, 1976.

———. *The Role of the Reader: Explorations in the Semiotics of Texts.* Bloomington: Indiana University Press, 1983.

Edelman, Bernard. *Ownership of the Image.* Translated by Elizabeth Kingdom. London: Routledge & Kegan Paul, 1979.

Edgley, Roy, and Richard Osborne, eds. *Radical Philosophy Reader.* London: Verso Editions, 1985.

Ellul, Jacques. *The Technological Society.* New York: Vintage Books, 1964.

———. *The Technological System.* New York: Continuum, 1980.

Epstein, Edward Jay. *News from Nowhere: Television and the News.* New York: Random House, 1973.

Esslin, Norton. *The Age of Television.* Stanford, Calif.: 1982.

Fell, John L., ed. *Film Before Griffith.* Berkeley: University of California Press, 1983.

Fisher, John, ed. *Perceiving Artworks.* Philadelphia: Temple University Press, 1980.

Fiske, John, and John Hartley. *Reading Television.* London: Methuen, 1978.

Forest, Fred. *Art Sociologique, Video.* Paris: UGE, 1977.

Foster, Hal, ed. *The Anti-Aesthetic: Essays on Post-Modern Culture.* Port Townsend, Wash.: Bay Press, 1983.

Foucault, Michel. *Power/Knowledge: Selected Interviews and Other Writings.* New York: Pantheon, 1980.

———. *The Foucault Reader.* Edited by Paul Rabinow. New York: Pantheon, 1984.

Fox, Richard Wightman, and T. J. Jackson Lears, eds. *The Culture of Consumption.* New York: Pantheon, 1983.

Frampton, Hollis. *Circles of Confusion: Film Photography Video.* Rochester, N.Y.: Visual Studies Workshop Press, 1983.

Gale, Peggy, ed. *Video By Artists.* Toronto: Art Metropole, 1976.

Gans, Herbert J. *Popular Culture and High Culture.* New York: Basic Books, 1974.

Ganty, A., G. Milliard, and A. Willener. *Video et Societe Virtuelle.* Paris: TEMA Communication, 1972.

Gardner, Howard. *Art, Mind, and Brain: A Cognitive Approach to Creativity.* New York: Basic Books, 1982.

Garnham, Nicholas. *Structures of Television.* BF1 Television Monographs #1 London: British Film Institute, 1964.

Gerbner, George et al., eds. *The Analysis of Communications Content.* New York: John Wiley, 1969.

Geuss, Raymond. *The Idea of a Critical Theory.* Cambridge: Cambridge University Press, 1981.

Gill, Johanna. *Artists' Video: The First Ten Years (1965–1975).* Ann Arbor, Mich.: 1977.

——. *Video: State of the Art.* New York: The Rockefeller Foundation, 1976 (out of print).

Gillette, Frank. *Aransas: Axis of Observation.* Houston: Points of View, 1978.

——. *Between Paradigms: The Mood and Its Purpose.* New York: Gordon and Breach, 1973.

——. *Video Process and Meta Process.* Catalogue. Edited by Judson Rosebush. Syracuse: Everson Museum of Art, 1973.

Gitlin, Todd. *Inside Prime Time.* New York: Pantheon, 1983.

——. *The Whole World Is Watching: Mass Media in the Making and the Unmaking of the New Left.* Berkeley: University of California Press, 1980.

——, ed. *Watching Television:* A Pantheon Guide to Popular Culture. New York: Pantheon, 1986.

Goffman, Erving. *Frame Analysis.* Cambridge: Harvard University Press, 1974.

——. *Frame Analysis: An Essay on the Organization of Experience.* New York: Harper & Row, 1974.

——. *Gender Advertisements.* Cambridge: Harvard University Press, 1978.

Gordon, George N. *Persuasion: The Theory and Practice of Manipulative Communications.* New York: Hastings House, 1971.

Graham, Dan. *Selected Works, 1965–72.* Cologne, New York, and London: Koenig Brothers and Lisson Publications, 1972.

——. *Video-Architecture-Television: Writing on Video and Video Works 1970–78.* Edited by Benjamin H.D. Buchloh. New York: NYU Press, 1979.

——. *Video-Architecture-Television.* Halifax-New York: The Press of the Nova Scotia College of Art and Design, 1979.

Gruber, Bettina, and Maria Vedder. *Du Mont's Handbuch der Video Praxis.* Koln, West Germany: 1982.

——, ed. *Kunst und Video.* Cologne, West Germany: Dumont Buchverlag, 1983. In German.

Grundmann, Heidi. *Art Telecommunications.* Contemporary Arts Press, 1985. In English, French, and German.

Gurevitch, Michael, et al, eds. *Culture, Society and the Media.* New York: Methuen Inc., 1982.

Gustafson, Julie, ed. *The Global Village Handbook for Independent Producers and Public Television.* New York: Global Village Video Resource Center, 1981.

Hadjinicolau, Nicos. *Art History and Class Struggle.* Translated by Louise Asmal. London: Pluto Press, 1978.

Hall, Doug. *The Spectacle of Image.* Catalog. Boston: The Institute of Contemporary Art, 1987.

Hanhardt, John G., ed. *Video Culture: A Critical Investigation.* Rochester, N.Y.: Visual Studies Workshop Press and Peregrine Smith Books, 1986.

Harari, Josue V., ed. *Textual Strategies.* Ithaca: Cornell University Press, 1979.

Heath, Stephen, and Patricia Mellencamp, eds. *Cinema and Language.* American Film Institute Monograph Series, vol. 1. Frederic, MD: University Publications of America, 1983.

Heidegger, Martin. *The Question Concerning Technology and Other Essays.* Translated by William Lovitt. New York: Harper Colophon Books, 1977.

Henderson, Brian. *A Critique of Film Theory.* New York: E. P. Dutton, 1980.

Herzogenrath, Wulf, ed. *Videokunst in Deutschland: 1963–1982.* Stuttgart, West Germany: Verlag Gerd Hatje, 1982. In German.

Himmelstein, Harold. *On the Small Screen: New Approaches in Television and Video Criticism.* New York: Praeger, 1981.

——. *Television Myth and the American Mind.* New York: Praeger, 1984.

Hohendahl, Peter Uwe. *The Institution of Criticism.* Ithaca; Cornell University Press, 1982.

Horkheimer, Max, and Theodor W. Adorno. *Dialectic of Enlightenment.* Translated by John Cumming. New York: Seabury Press, 1977.

Horrigan, Bill, ed. *The Media Arts in Transition.* Minneapolis: Walker Art Center, 1983.

——. *The Media Arts In Transition*. New York: National Alliance of Media Arts Centers, 1983.

Howard, Brice. *Videospace and Image Experience*. San Francisco: National Center for Experiments in Television, 1972 (out of print).

Ihde, Don. *Technics and Praxis*. Boston Studies in the Philosophy of Science, vol. 24, Boston: D. Riedel, 1979.

Innis, Harold. *The Bias of Communication*. Toronto: University of Toronto Press, 1951.

——. *Empire and Communications*. New York: Oxford University Press, 1950.

Jevnikar, Jana. *Video Services Profiles*. New York: Center for the Arts Information, 1983.

Kaplan, E. Ann, ed. *Regarding Television*. The American Film Institute Monograph Series, vol. 2. Frederick, MD: University Publications of America, 1983.

Kirby, Michael. *The Art of Time*. New York: E. P. Dutton, 1969.

Knabb, Ken, ed. *Situationist International Anthology*. Translated by Ken Knabb. Berkeley, Calif.: Bureau of Public Secrets, 1981.

Kracauer, Siegfried. *Theory of Film*. New York: Oxford University Press, 1965.

Krauss, Rosalind. *Passages in Modern Sculpture*. Cambridge: MIT Press, 1981.

Kriesche, Richard, ed. *Art, Artists, and the Media*. Graz, 1979.

Kruger, Barbara, ed. *TV Guides Twenty-one Essays on Television*. New York: Kuklapolitan Press, 1985.

Kuhn, Annette. *Women's Pictures*. London: Routledge & Kegan Paul, 1982.

Lacan, Jacques. *The Four Fundamental Concepts of Psychoanalysis*. Edited by Jacques-Alain Miller. Translated by Alan Sheridan. New York: W. W. Norton, 1978.

——. *The Language of the Self*. New York: Delta, 1968.

Lambert, Stephen. *Channel Four: Television With a Difference?* London: British Film Institute, 1982.

Lazlo, Beke et Miklos Peternak, eds. *Body Gabor⟨197⟩1946–1985: A Presentation of His Work*. Budapest, Palace of Exhibition, 1987.

Lechenauer, Gerhard. *Alternative Medienarbeit mit Video und Film*. Stuttgart, West Germany: Rowoholt Taschenbuch Verlag, 1979.

Lefebvre, Henri. *Everyday Life in the Modern World*. Translated by Sacha Rabinovitch. New Brunswick, N.J.: Transaction Books, 1984.

LeGrice, Malcolm. *Abstract Film and Beyond*. Cambridge: MIT Press, 1977.

Leyda, Jay. *Kino: A History of the Russian and Soviet Film*. Princeton, N.J.: Princeton University Press, 1983.

Livingston, Jane, and Marcia Tucher. *Bruce Nauman, Work From 1965–1972*. Los Angeles: Los Angeles County Museum of Art, 1972.

Loeffler, Carl E., and Darlene Tong, eds. *Performance Anthology: Source Book for a Decade of California Performance Art*. San Francisco: Contemporary Arts Press, 1980.

Long Beach Museum of Art. *Southland Video Anthology 1976–77*. Organized by David Ross. Long Beach, Calif.: Long Beach Museum of Art, 1977.

Lovejoy, Margot. *Post Modern Currents: Art and Artists in the Age of Electronic Media*. Ann Arbor: University of Michigan, 1989.

Lovett, Sharon, ed. *The Sixth International Video Exchange Directory*. Vancouver: Press Gang Publishers, 1978.

Lowe, Donald M. *History of Bourgeois Perception*. Chicago: University of Chicago Press, 1982.

Lunn, Eugene. *Marxism and Modernism*. Berkeley: University of California Press, 1982.

Lyotard, Jean-Francois. *Driftworks*. Edited by Roger McKeon. New York: Semiotext(e), 1984.

Macdonald, Dwight. *Against the American Grain*. New York: Random House, 1962.

Mamber, Stephen. *Cinema Verite in America: Studies in Uncontrolled Documentary*. Cambridge: MIT Press, 1974.

Mander, Jerry. *Four Arguments for the Elimination of Television*. New York: William Morrow, 1978.

Marcuse, Herbert. *The Aesthetic Dimension*. Boston: The Beacon Press, 1978.

Marsh, Ken. *Independent Video*. San Francisco: Straight Arrow Books, 1974 (out of print).

McArthur, Colin. *Television and History*. London: British Film Institute.

McLuhan, Marshall. *The Gutenberg Galaxy*. Toronto: University of Toronto Press, 1962.

——. *Understanding Media: The Extensions of Man.* New York: McGraw-Hill, 1964.

——. *Verbi-Voco-Visual Explorations.* New York: Something Else Press, 1967.

Mekas, Jonas. *Movie Journal.* New York: Collier Books, 1972.

Merrill, John C., and Ralph L. Lowenstein. *Media, Message and Men: New Perspectives in Communications.* New York/London: Longman, 1979.

Michelson, Annette, ed. *Kino-Eye: The Writings of Dziga Vertov.* Translated by Kevin O'Brien. Berkeley: University of California Press, 1985.

——. *New Forms in Film.* Exhibition catalogue. Montreux, 1974.

Miller, Branda. *Surveillance.* Los Angeles: Los Angeles Contemporary Exhibitions (LACE), 1987.

Miller, George. *The Psychology of Communication.* Baltimore: Penguin, 1967.

Mosco, Vincent. *Pushbutton Fantasies.* Norwood, N. J.: Ablex, 1982.

Neale, Steve. *Cinema and Technology.* Bloomington: Indiana University Press, 1985.

Nelson, Craig. *The Theatre of Images.* Edited by Robert Wilson. New York: Harper & Row, 1984.

Newcomb, Horace. *TV: The Most Popular Art.* New York: Doubleday, 1974.

——. ed. *Television: The Critical View,* 2 ed. New York: Oxford University Press, 1979.

Nichols, Bill. *Ideology and the Image: Social Representations in the Cinema and Other Media.* Bloomington: Indiana University Press, 1981.

Noble, David F. *Forces of Production.* New York: Alfred A. Knopf, 1984.

O'Connor, John E., ed. *American History/American Television: Interpreting the Video Past.* New York: Frederick Ungar Publishing, 1983.

Ong, Walter J. *Orality and Literacy: The Technologizing of the Word.* New York: Methuen, 1982.

Payant, Rene, ed. *Video.* Montreal: Artextes, 1986. In French and English.

Podesta, Patti, ed. *Resolution: A Critique of Video Art.* Los Angeles: Los Angeles Contempory Exhibitions (LACE), 1986.

Preikschat, Wolfgang. *Video⟨197⟩Poesie der Neuen Medien.* Weinheim, West Germany: 1987.

Price, Jonathan. *The Best Thing on Television: Commercials.* Baltimore: Penguin, 1978.

——. *Video Visions: A Medium Discovers Itself.* New York: New American Library, 1977.

Root, Jane. *Pictures of Women.* London: Pandora, 1984.

Rosebush, Judson, ed. *Nam Paik: Video 'n' Videology 1959–1973.* Syracuse, N.Y.: Everson Museum of Art, 1974 (out of print).

Rosenbach, Ulrike. *Videokunst Foto Action/Performance Femistische Kunst.* Cologne, West Germany: Selbstverlag, 1982. In German.

Rosenberg, Bernard, and David M. White, eds. *Mass Culture: The Popular Arts in America.* New York: The Free Press, 1957.

Rosenberg, Harold. *The De-definition of Art.* New York: Horizon Press, 1972.

Ross, David. *Artist's Video.* New York: 1975.

Roth, Moira, ed. *The Amazing Decade: Women's Performance in America, 1970–1980.* Los Angeles: Astro Artz, 1983.

Ryan, Paul. *Cybernetics of the Sacred.* Garden City, N.Y.: Anchor Press/Doubleday, 1974 (out of print).

Schiller, Daniel. *Telematics and Government.* Norwood, N.J.: Ablex, 1982.

Schiller, Herbert I. *Communication and Cultural Domination.* White Plains, N.Y.: International Arts and Sciences Press, 1976.

——. *Information and the Crisis Economy.* Norwood, N.J.: Ablex, 1984.

——. *Mass Communications and the American Empire.* Boston: Beacon, 1970.

——. *The Mind Managers.* Boston: Beacon, 1973.

Schneider, Ira, and Beryl Korot, eds. *Video Art: An Anthology.* New York: Harcourt Brace Jovanovich, 1976 (out of print).

Schramm, Wilbur, ed. *Mass Communications.* Urbana: University of Illinois Press, 1949.

Schramm, Wilbur, and Donald F. Roberts. *The Process and Effects of Mass Communications.* Urbana: University of Illinois Press, 1971.

Schutz, Alfred. *The Phenomenology of the Social World.* Translated by George Walsh, Frederich Lehnert. Chicago: Northwestern University Press, 1967.

Sekula, Allan. *Photography Against the Grain.*

Halifax: Press of the Nova Scotia College of Art and Design, 1984.

Shamberg, Michael, and Raindance Corporation. *Guerrilla Television*. New York: Holt, Rinehart and Winston, 1971 (out of print).

Shayon, Robert Lewis, ed. *The Eighth Art*. New York: Holt, Rinehart and Winston, 1971.

Sherman, Tom. *Ingnierie culturelle*. Ottawa, 1983.

Sitney, P. Adams. *Visionary Film*. New York: Oxford University Press, 1974.

———. *Film Culture Reader*. New York: Praeger, 1970.

———. *The Essential Cinema*. Anthology Film Archives, series 2, vol. 1, New York: New York University Press, 1975.

Sontag, Susan. *On Photography*. New York: Farrar, Straus & Giroux, 1973.

Sterling, Christopher, H., and John M. Kittross. *Stay Tuned: A Concise History of American Broadcasting*. Belmont, Calif.: Wadsworth, 1978.

Summer, Colin. *Reading Ideologies*. New York: Academic Press, 1979.

Thomas, Lew. *Structuralism and Photography*. San Francisco: NFS Press, 1978.

Thomas, Sari, ed. *Film/Culture; Explorations of Cinema in its Social Context*. Metuchen, N.J.: The Scarecrow Press, 1982.

Top Value Television (TVTV). *The Prime Time Survey*. San Francisco: TVTV, 1974 (out of print).

Town, Elke, ed. *Video By Artists 2*. Toronto: Art Metropole, 1986.

Tuchman, Maurice. *Art and Technology*. Los Angeles: Los Angeles County Museum of Art, 1971.

Tyler, Parker. *Underground Film⟨197⟩A Critical History*. New York: Grove Press, 1969.

Ulmer, Gregory L. *Applied Grammatology*. Baltimore: Johns Hopkins University Press, 1985.

Vaneigem, Raoul. *The Revolution of Everyday Life*. Translated by Ronald Nicholson-Smith. London: Aldgate Press, 1983.

Venturi, Robert, et al. *Learning from Las Vegas: The Forgotten Symbolism of Architectural Forms*. Cambridge: MIT Press, 1977.

Videofreex. *Spaghetti City Video Manual*. New York: Praeger, 1973 (out of print).

Vogel, Amos. *Film as a Subversive Art*. New York: Random House, 1974.

Vostell, Wolf. *Happening und Leben*. Berlin: Hermann Luchterhand Verlag, 1970.

Watkins, Peter. *The War Game*. New York: Avon, 1967.

Weiner, Norbert. *The Human Use of Human Beings: Cybernetics and Society*. New York: Avon, 1967.

Wheeler, Dennis, ed. *Form and Structure in Recent Film*. Vancouver: Vancouver Art Gallery, 1972.

White, Robin, ed. *Beyond Video: Media Alliance Directory I*. New York: Media Alliance, 1984.

Williams, Raymond. *Culture*. Glasgow, Scotland: Fontana Paperbacks, 1981.

———. *Television: Technology and Cultural Form*. New York: Schocken Books, 1974.

———. *The Year 2000*. New York: Pantheon, 1984.

Williamson, Judith. *Decoding Advertising: Ideology and Meaning in Advertising. (IDEAS in Progress)*. Boston: Marion Boyars Publishers, 1978.

Winner, Langdon. *Autonomous Technology*. Cambridge: MIT Press, 1977.

Wittgenstein, Ludwig. *Philosophical Investigations*. Translated by G. E. M. Anscombe, New York: Macmillan, 1953.

Wolff, Janet. *The Social Production of Art*. New York: New York University Press, 1984.

Wolin, Richard. *Walter Benjamin, An Aesthetic of Redemption*. New York: Columbia University Press, 1982.

Wollen, Peter. *Readings and Writings*. London: Verso Editions and New Left Books, 1982.

———. *Signs and Meaning in the Cinema*. Bloomington: Indiana University Press, 1972.

Woodward, Kathleen, and Anthony Wilder, et al., eds. *The Myths of Information: Technology and Postindustrial Culture*. Madison, Wis.: CODA Press, 1980.

Worth, Sol. *Studying Visual Communication*. Philadelphia: University of Pennsylvania Press, 1981.

Wright, Charles R. *Mass Communication: A Sociological Perspective*. New York: Random House, 1975.

Youngblood, Gene. *Expanded Cinema*. New York: E. P. Dutton, 1970 (out of print).

ARTICLES AND ESSAYS

Aaron, Chloe. "The Video Underground." *Art In America* 59 (May 1971) pp. 74–79.

Adams, Brooks. "Zen and the Art of Video." (Shigeko Kubota) *Art In America* vol. 72, no. 2 (February 1984): pp. 122–126.

Ancona, Victor. "Ed Emshwiller: Combining Inner and Outer Landscapes." *Videography* (September 1983).

——. "Nam June Paik: Portrait of an Electronic Artist." *Videography* 1, no. 4 (1976).

——. "Vibeke Sorenson: Demystifying Video Technology." *Videography* (February 1979).

Antin, David. "Television: Video's Frightful Parent." *Artforum* 14 (December 1975): pp. 36–45.

——. "Video: The Distinctive Features of the Medium." *Video Art* (1974); reprinted in *Video-Culture*, Rochester, N.Y. (1986): pp. 147–166.

Auping, Michael. "Nam June Paik: TV and Paper TV." *Artweek* 6, no 1, Video Art (1975): p. 1.

Barry, Judith, and Sandy Flitterman. "Textual Strategies: The Politics of Artmaking." *Screen* 21, no. 2 (Summer 1980): pp. 35–48.

Barzyk, Fred. "TV as Art as TV." *Print* 26 (January/February 1972): pp. 20–29.

Bathrick, David. "Affirmative and Negative Culture: Technology and the Left Avant Garde," in *The Technological Imagination: Theories and Fictions.* Edited by Teresa de Lauretis, Andreas Huyssen, and Kathleen Woodward. Madison, Wis.: Coda Press, 1980: pp. 107–122.

Battcock, Gregory. "Explorations in Video." *Art and Artists* 7 (February 1973): pp. 22–27.

——. "Nam June Paik Exhibition in New York." *Domus* 559 (June 1976): p. 52.

Baudrillard, Jean. "Beyond the Unconscious: The Symbolic." *Discourse* 3 (Spring 1981): pp. 60–87.

——. "The Ecstasy of Communication," in *The Anti-Aesthetic: Essays on Post-Modern Culture,* edited by Hal Foster, Port Townsend, Wash.: Bay Press, 1983.

Baudry, Jean Louis. "Writing, Fiction, Ideology." *Afterimage* (London) no. 5 (Spring 1974): pp. 22–39.

Bear, Liza. "Man Ray, Do You Want To . . .:

An Interview With William Wegman." *Avalanche* 7 (Winter/Spring 1973).

Beck, Stephen. "The Phosphotron." *SEND* no. 9 (Spring 1984).

——. "Video Synthesis." *The New Television,* Cambridge-London, 1978.

Beeren, Wim. "Video and the Visual Arts." *The Luminous Image,* Amsterdam; 1984.

Bellour, Raymond. "An Interview With Bill Viola." *October,* 34 (Fall 1985): pp. 91–119.

——. "Entretien avec Bill Viola La Sculpture du temps." *Cahiers du Cinema* no. 379 (January 1986).

——. "Entretien avec Bill Viola L'espace a pleine dent." *Ou va la video?* ed. Jean-Paul Fargier. 1986: pp. 64–73.

——. "La forme ou passe mon regard." *Marcel Odenbach: La vision . . . ,* 1987.

——. "Les bords de la fiction." *Video,* Fiction et Co, Actes du colloque de Montbliard, 1984.

——. "L'utopie video." *Ou va la video?* 1986.

——. "Thierry Kuntzel et le retour de l'ecriture." *Cahiers du Cinema* no. 321 (March 1981).

Benjamin, Walter. "The Work of Art In An Age of Mechanical Reproduction." *Illuminations.* Schocken Books, 1969: pp. 217–251.

Blumenthal, Lyn; "ReGuarding Video (Preservation)." *Afterimage,* vol. 13, no. 7. (February 1986): pp. 11–12.

Bordwell, David. "Textual Analysis, Etc." *Enclitic* (Fall 1981/Spring 1982): pp. 125–36.

Bové, Paul A. "Celebrity and Betrayal: The High Intellectuals of Post-modern Culture." *The Minnesota Review* no. 21 (Fall 1983): pp. 72–91.

——. "Intellectuals at War: Michel Foucault and the Analytics of Power." *Substance 37/38* 11, no. 4/12, no. 1 (1983): pp. 36–55.

——. "Mendacious Innocents, or, The Modern Genealogist as Conscientious Intellectual: Nietzsche, Foucault, Said." *Boundary* 2 9, no. 3; *10,* no. 1 (Spring/Fall 1981): pp. 359–388.

Boyle, Deirdre. "Edin Velez, Too." *Sightlines* (Spring 1985).

——. "Growing Up Wired." (Kit Fitzgerald and John Sanborn) *American Film* (July/August 1982).

——. "Juan Downey's Recent Videotapes." *Afterimage* 6 nos. 1/2 (Summer 1978): pp. 10–11.

——. "Skip Blumberg Warms Up TV." *Sightlines* (Spring 1982).

——. "Subject to Change, Guerrilla TV Revisited." *Art Journal* 45, no. 3 (1985): pp. 228–232.

——. "Who's Who in Video: Bill Viola." *Sightlines*, vol. 16, no. 3 (Spring 1983): pp. 22–24.

Brecht, Bertolt. "Radio as a Means of Communication, A Talk on the Function of Radio." Translated by Stuart Hood. *Screen* 20, no. 3/4 (Winter 1979–80): pp. 24–28.

Brenckman, John. "Mass Media: From Collective Experience to the Culture of Privatization." *Social Text* 1 (Winter 1979): pp. 94–109.

Broeckhoven, Greta van. "Marie Andre." *International Video Festival,* Ottowa, 1986.

Bruch, Klaus vom. "Logic to the Benefit of Movement." *Video by Artists* 2 (1986).

Buchloh, Benjamin. "Allegorical Procedures: Appropriation and Montage in Contemporary Art." *Artforum* 21, no. 1 (September 1982): pp 43–56.

——. "Moments of History in the Work of Dan Graham." *Articles.* Edited by R. H. Fuchs. Eindhoven, Holland: Van Abbe Museum, 1978.

Buckner, Barbara. "Light and Darkness in the Electronic Landscape." *The Cummington Journal* (1979).

Burch, Noël. "Avant-Garde or Vanguard." *Afterimage* (London) no. 6 (Summer 1976): pp. 52–63.

Burch, Noël, and Jorge Dana. "Propositions." *Afterimage* (London) no. 5 (Spring 1974): pp. 40–66.

Burnham, Jack. "Problems of Criticism: Art and Technology." *Artforum* no. 9 (January 1971): pp. 40–45.

——. "Systems Aesthetics." *Artforum* vol. 7, no. 1 (September 1968): pp. 30–35.

——. "The Aesthetics of Intelligent Systems." in *On the Future of Art.* New York: Viking Press, 1970.

Burnham, Linda. "The Ant Farm Strikes Again." *High Performance* 6, no. 4 (1983): pp. 26–27.

Camera Obscura. "Leaving the 20th Century: Interview with Max Almy." *Camera Obscura* no. 12 (1984): pp. 19–27.

Cameron, Eric. "On Painting and Video." *Parachute,* no. 11 (Summer 1978).

——. "Dan Graham: Appearing in Public." *Artforum* 15, no. 3, (November 1976): pp. 66–68.

——. "Structural Videotape in Canada." *Video Art* (1976).

——. "The Grammar of the Video Image." *Arts Magazine* 49 (December 1974): pp. 48–51.

Carr, C., "The Art of the 21st Century." (Abramovic/Ulay). *Village Voice* (February 25, 1986).

Carroll, Noël. "Joan Jonas: Making the Image Visible." *Artforum* 12 (April 1974): pp. 52–53.

Connor, Russell. "The Video Window of Davidson Gigliotti." *Arts Magazine* 49, no. 4. (December 1974): pp. 74–75.

Costello, Marjorie, and Victor Ancona. "Conversation With Jon Alpert and Keiko Tsuno." *Videography* (September 1980).

Cuba, Larry. "An Introduction to Computer Animation." *Video 80,* no. 4 (Spring/Summer 1982); reprinted in *SEND* 2, no. 1 (1983).

——. "Calculated Movements: An Interview with Larry Cuba." *Video Amid the Arts* no. 1 (1986).

Daniels, Dieter. "Between 007 and Joseph Beuys." *Mediamatic* 3, no. 1 (1987).

——. "Biennal de Video Barcelona." *Mediamatic* 3, no. 77/78, Koln, West Germany: 1985.

Davidovicht, Jaime. "Das Versagen der Videokunst⟨197⟩En Manifest." *Ars electronica* 1986 (Supplement), Linz, 1986.

Davis, Douglas. "Art and Technology; The New Combine." *Art in America* 56 no. 1 (January 1968): pp. 28–47.

——. "Filmgoing/Videogoing: Making the Distinction." *Video-Culture,* Rochester, N.Y., 1986.

——. "Media/Art/Media: Notes Toward a Definition of Form." *Arts Magazine* no. 46 no. 1 (September/October 1971): pp. 43–45.

——. "Television's Avant-Garde." *Newsweek* (February 9. 1970).

——. "Video in the Mid-1970's: Prelude To An End/Future." in *Video Art,* Harcourt Brace Jovanovich (1976): pp. 196–199.

———. "Video Obscura." *Artforum* 10, no. 8 (April 1972): pp. 64–71.

De Jong, Constance. "In Between the Dark and the Light" (Television/Society/Art: A Symposium). *Artforum* 19, no. 5 (January 1981): pp. 25–29.

———. "Joan Jonas: Organic Honey is Vertical Roll." *Arts Magazine* (March 1973).

DeMichel, Helen. "Speculations: Narrative Video by Women." *The Independent* 8, no. 3 (April 1985): pp. 12–14.

Dercon, Chris. "Entretien avec Williem Wegman: le maitre de sa voix." *Ou va la video?* (1986).

———. "J. L. Nyst: What a Story!" *Hyaloide*, Brussels, 1986.

———. "Keep Taking it Apart: A Conversation with Bruce Nauman." *Parkett* no. 10 (1986): pp. 54–62.

Dowling, Susan. "The Story of WGBH New Television Workshop." *Ars electronica 1986* (Supplement), Linz, 1986.

Downey, Juan. "Information Withheld." *SEND* 2, no. 4 (Spring 1982).

Drohojowsa, Hunter. "Whispers and Cries: Bill Viola at AFI." *Video 80* (Winter 1983).

Dubois, Philippe. "La boite magique⟨197⟩Hyaloide de D. et J. L. Nyst." *Videodoc* no. 82 (December 1985-January 1986).

———. "La boite magique." *Hyaloide*, Brussel, 1986.

———. "L'ombre, le miroir, l'index." *Parachute* no. 26 (Spring 1982): pp. 16–29.

Duguet, Anne-Marie. "Les videos de Thierry Kuntzel." *Parachute*, no. 38, Montreal (May 1985): pp. 25–31.

———. "Nam June Paik." *Canal* no. 49 (July–September 1982).

———. "The Luminous Image Video Installation." *Camera Obscura*, no. 13/14 (Spring-Summer 1985): pp 29–50.

Eagleton, Terry. "Capitalism, Modernism and Postmodernism." *New Left Review* no. 152 (July/August 1985): pp. 60–73.

———. "Ideology, Fiction, Narrative." *Social Text* 2 (Summer 1979): pp. 62–80.

Ellis, John. "Cinema and Broadcast TV Together." *Video Culture.* Rochester N.Y., 1986.

———. "Visible Fictions." *Cinema, Television, Video.* Boston: Routledge and Kegan Paul, 1982.

Eno, Brian. "Generating and Organizing Variety in the Arts." *Breaking the Sound Barrier*, 1981.

Essart, Don. "L'art video." *Video Info* no. 9.

The Everson Museum of Art. *Everson Video Revue.* Organized by Richard Simmons. Syracuse, N.Y.: Everson Museum of Art, 1979.

Fargier, Jean-Paul. "Derniere analogie avant le digital." *Cahiers du Cinema.* no. 341 (1982); reprinted in "Last Analogy Before Digital Analysis." *Video by Artists* 2 (1986).

———. "La face cachée de la lune." *Art Press (Special Godard)* no. 4 (hors serie) (December 1984, January-February 1985).

———. "La video gagne du terrain: C. Ikam, N. Croiset, N. Yalter." *Cahiers du Cinema* no. 322 (1981).

———. "Le grand ecart (Interview avec Jean-Andre Fieschi)." *Cahiers du Cinema* no. 310 (1980).

———. "Les videos de la cote Ouest." *Liberation* no. 21 (January 1982).

Fisher, Phillip. "Pins, A Table, Works of Art." *Representations* 1, no. 1 (February 1983): pp. 43–57.

Flax, Neil. "Fiction Wars of Art." *Representations* no. 7 (Summer 1984): pp. 1–25.

Foresta, Don. "Video and the Theory of Relativity." *Catalogue of the 12 Biennale of Paris*, 1982.

Foster, Hal. "Between Modernism and the Media." *Art in America* 70, no. 6 (Summer 1982): pp. 13–17.

Frampton, Hollis. "The Withering Away of the State of the Art." *Circles of Confusion.* Rochester, N.Y.: Visual Studies Workshop Press, 1983: pp. 161–70.

Freed, Hermine. "Video and Abstract Expressionism." *Arts Magazine* 49 no. 4 (December 1974): pp. 67–69.

French-Frazier, Nina. "Juan Downey: Chilean Ulysses." *Artweek* 7, no. 11 (1976): pp. 13–14.

———. "Lonidier and Steinmetz: Investigation and Introspection." *Artweek* 7, no. 17 (April 24, 1976): p. 13.

Fried, Michael. "Art and Objecthood." *Artforum* 5, no. 10 (Summer 1967): pp. 12–23.

Fry, Paul H. "The Image of Walter Benjamin." *Raritan* 2, no. 4 (Spring 1983): pp. 131–152.

Furlong, Lucinda. "A Manner of Speaking: An Interview with Gary Hill." *Afterimage* 10, no. 8 (March 1983): pp. 9–16.

———. "Getting High Tech: The 'New Television.'" *The Independent* 8, no. 2 (March 1985): pp. 14–16.

———. "Notes Toward a History of Image Processed Video: Eric Siegel, Stephen Beck, Dan Sandin, Steve Rutt, Bill and Louise Etra." *Afterimage* 11, nos. 1/2 (Summer 1983): pp. 35–38.

———. "Notes Toward a History of Image Processed Video: Steina and Woody Vasulka." *Afterimage* 11, no. 5 (December 1983): pp. 12–17.

Ganahl, Margaret, and R. S. Hamilton. "One Plus One: A Look at Six Fois Deux." *Camera Obscura* vols. 8, 9, 10 (Fall 1982): pp. 89–115.

Gardner, Paul. "Tuning in to Nam June Paik." *Artnews* 81, no. 5 (1982): pp. 64–73.

Gazzano, Marco M. "La videoarte alla ricerca di un nuovo linguaggio." *Cinemanuova* 33 no. 287 (1984).

Geller, Matthew. "Windfalls." *Just Another Asshole* no. 3.

General Idea. "Test Tube." *Video by Artists* 2 (1986).

Gever, Martha. "An Interview with Martha Rosler." *Afterimage* 9, no. 3 (October 1981): pp. 10–17.

———. "Meet the Press: On Paper Tiger Television." *Afterimage* 11, no. 4 (November 1983): pp. 7–11.

———. "Pomp and Circumstances: The Coronation of Nam June Paik." *Afterimage* 10, no. 3 (October 1982): pp. 12–16.

———. "Underdeveloped Media, Overdeveloped Technology." *The Independent* 8, no. 7 (September 1985): pp. 15–17.

———. "Video Politics: Early Feminist Projects." (Nancy Cain, Cara DeVito, Julie Gustafson, Optic Nerve) *Afterimage* 11, nos. 1/2 (Summer 1983): pp. 25–27.

Gever, Martha, and Marita Sturken. "Mary Lucier's Elemental Investigations." *Afterimage* 9 no. 7 (February 1982).

Gigliotti, Davidson. "Video Art in the Sixties." *Abstract Painting 1960–1969*. Long Island City, N.Y.: Institute for Art and Urban Resources, 1982.

Gilbard, Florence. "An Interview with Vito Acconci: Video Works 1970–78." *Afterimage* 12, no. 4 (November 1984): pp. 9–15.

Ginsberg, Merle. "Video Art's Greatest Hits: Kit Fitzgerald and John Sanborn." *Soho Weekly News* (November 17, 1981).

Gitlin, Michael. "Video: Approaching Independents." *Film Library Quarterly* 17, no. 1 (1984).

Gluver, Billy. "E. A. T.: Experiments in Art and Technology." *Paletten*, Sweden (February 1968).

Godard, Jean-Luc, and Anne-Marie Mieville. "France/Detour/Two/Children." *Camera Obscura* nos. 8/9/10 (Fall 1982): pp. 61–73.

Goldman, Debra. "A Decade of Building an Alternative Movement." *The Independent* 6, no. 7 (September 1983): pp. 18–24, 30.

Graham, Dan. "Rock My Religion." *Just Another Asshole* no. 6 (1983).

———. "Rock My Religion." *Video Artists* 2 (1986).

———. "Video-Performance-Architecture." *Art Present* no. 9 (Spring-Summer 1981).

Grossman, Peter. "The Video Artist as Engineer and the Video Engineer as Artist." *Videography* 3, no. 10 (September 1978).

Gruterich, Marlies. "Savoir vivre—savior se souvenir." *Marcel Odenbach: La vision. . . .*, 1987.

Hagen, Charles. "A Syntax of Binary Images: An Interview With Woody Vasulka." *Afterimage* 6, nos. 1/2 (Summer 1978): pp. 20–31.

———. "Breaking The Box: The Electronic Operas of Robert Ashley and Woody Vasulka." *Artforum* 23, no. 7 (March 1985); pp. 54–59.

Hagen, Charles, and Laddy Kite. "Walter Wright and His Amazing Video Machine." *Afterimage* 2, no. 10 (April 1975): pp. 6–8.

Hall, Doug. "Forgotten Tyrant." *Poetics Journal* no. 5 (May, 1985).

———. "Ronald Reagan: The Politics of Image," *Video 80* no. 4 (Spring-Summer 1982): pp. 28–30.

———. "Thoughts on Landscape in Nature and Industry." *Resolution: A Critique of Video Art*, LACE, (1986): pp. 36–42.

———. "Video Art: A Short History (On the Head of a Pin)." *Video Networks* 11, no. 1 (December/January 1986/87).

Hall, Sue, and John Hopkins. "The Metasoftware of Video." *Studio International* nos. 5/6 (1976).

Hamamoto, Darrell. "Bill Viola." *LBMAVIDEO* 2, no. 2 (1982).

———. "Computers & Video: Three Videos (by Vasulkas, S. Beck, G. Youngblood)." *LBMAVIDEO* 2, no. 3 (1982).

Hanhardt, John G. "Video/Television Space." *Video Art* (1976).

———. "Video/Television: Expanded Forms." *Video 80* no. 5 (1982).

———. "Paik's Video Sculpture." *Nam June Paik, Mostly Video*. Tokyo: 1984.

Harris, Neil. "Who Owns Our Myths? Heroism and Copyright in an Age of Mass Culture." *Social Research* 52, no. 2 (Summer 1985): pp. 241–67.

Heath, Stephen, and Gillian Skirrow. "Television, a World in Action." *Screen* 18, no. 2 (Summer 1977): pp. 7–59.

Herzogenrath, Wulf. "Attempts to Get Rid of the Damned Box." *Video 80* no. 5 (1982).

———. "Douglas Davis—Video im Fernsehen." *Douglas Davis*. (Arbieten, 1970–1977).

———. "Eight Pieces by Dan Graham." *Studio International* (May 1972).

———. "Fernsehen und Video—das Doppelgesicht eines neuen kunstlerischen Mediums." *Documenta* VI, no. 2 (Katalog) Kassel, 1977.

———. "Gespräch über Video—Kunst mit Ulrike Rosenbach." *Ulrike Rosenbach*. Frankfurt, 1982.

———. "Paik bei Bio." *Wolkenkratzer* 2, no. 4 (1984).

———. "Peter Campus." *Kunstforum* 20, no. 2 (1977).

———. "The Video Scene in the FRG and in North America: A Comparison." *LBMAVIDEO* 2, no. 6 (1986).

Hindman, James. "A Survey of Alternative Video." Part 1. *AFI Educational Newsletter* 4, no. 2 (1980).

———. "A Survey of Alternative Video." Part 2. *AFI Educational Newsletter* 4, no. 3 (1980).

Hoberman, J. "Jon Alpert's Video Journalism: Talking to the People." *American Film* 6, no. 8 (June 1981).

Hocking, Ralph. "Video Experiments." *Print* (March/April 1972).

Hood, Stuart. "Brecht on Radio." *Screen* 20, nos. 3/4 (Winter 1979–80): pp. 16–23.

Horitz, Robert. "Chris Burden." *Artforum* (May 1976).

Hulser, Kathleen. "Skip Blumberg's Great Performances." *American Film* (July/August 1983).

Huyssen, Andres. "The Hidden Dialectic: The Avant Garde-Technology-Mass Culture." *The Myths of Information: Technology and Post Industrial Culture*. Edited by Kathleen Woodward. 1980.

Jameson, Fredrick. "Reification and Utopia in Mass Culture." *Social Text* 1 (Winter 1979): pp. 130–48.

Jay, Martin. "Habermas and Modernism." In *Habermas and Modernity*. Edited by Richard J. Bernstein. Cambridge: MIT Press, 1985: pp. 125–39.

Jenkins, Bruce. "A Case Against 'Structural Film' " *Journal of the University Film Association* 33, no. 2 (Spring 1981): pp. 9–14.

Johnston, Claire. "The Subject of Feminist Film Theory/Practice." *Screen* 21, no. 2 (Summer 1980): pp. 27–34.

Junker, Howard. "Joan Jonas: The Mirror Staged." *Art In America*, 69, no. 2 (February 1981): pp. 86–95.

Kaprow, Allen. "Video Art: Old Wine, New Bottle." *Artforum* 12, no. 10 (June 1974): pp. 46–49.

Keil, Bob. "David Ross Thoughts on Video." *Artweek* 9, no. 33 (October 7, 1978): pp. 15–16.

———. "Marlene and Paul Kos: Video Collaborations." *Artweek* 9, no. 21 (May 27, 1978): p. 13.

Kemp, Peter. "Death and the Machine: From Jules Verne to Derrida and Beyond." *Philosophy and Social Criticism* 10, no. 2 (Fall 1984): pp. 75–96.

Kenny, Lorraine. "Waterlogged (The Water Catalogue/SHE, by Bill Seaman)." *Afterimage* 13, no. 1/2. (Summer 1985): p. 37.

Kipnis, Laura. "Refunctioning Reconsidered: Toward a Left Popular Culture." *High Theory/Low Culture: Analyzing Popular Television and Film*. Edited by Colin MacCabe. New York: St. Martins Press, 1986.

Koch, Stephen. "Andy Warhol's World and His Films." *Stargazer*. New York: Praeger, 1973.

Kolpan, Steven. "Bateson Through the Look-

ing Glass." (Gary Hill) *Video and the Arts* no. 11 (Winter 1986).

Krauss, Rosalind. "Video: The Aesthetics of Narcissism." *October* no. 1 (1976); reprinted in *Video-Culture*. Rochester, N.Y., 1986.

Kubota, Shigeko. "Shigeko Kubota: A Portfolio." *Video 80* no. 4 (Spring/Summer 1982): pp. 34–43.

Kurtz, Bruce. "Artists Video at the Crossroads." *Art In America* 65 (January 1977): pp. 36–40.

——. "Paikvision." *Artforum* 21, no. 2 (October 1982): pp. 52–55.

——. "Peter Campus." *Arts Magazine* (June 1973).

——. "Video is Being Invented." *Arts Magazine* 47 (December/January 1973): pp. 37–44.

Labat, Tony. "POV." *Video 81* 2, no. 1 (1981): pp. 19–20.

——. "The Hearing." *SEND* (Summer 1983): pp. 38–39.

Lacan, Jacques. "Television." *October* no. 40 (Spring 1987).

Lacan, Jean-Francois. "La video au musée." *Video Information* no. 7 (1974).

Lalanne, Dorothee. "Une conversation avec Tony Oursler: Merde alors." *Ou va la Video?*, 1986.

Larson, Susan C. "Los Angeles (J Sturgeon: Two Video Installations)." *Artnews* 77, no. 5 (May 1978):

Lavin, M. "Notes on William Wegman." *Artforum* 13, no. 7. (March 1975): pp. 44–47.

Levin, G. Roy. "Raindance (Michael Shamberg) and Videofreex (David Cort)." *Documentary Explorations*. New York: Anchor Books, 1971.

Levine, Les. "Camera Art." *Studio International* no. 190 (July/August 1975): pp. 52–54.

——. "Media Bio-Tech Rehearsal." *Video 80* no. 1 (1980): pp. 40–42.

——. "Small Format TV." *SEND* no. 10 (Spring 1985).

——. "The Information Fallout." *Studio International* no. 181 (April 1971): pp. 264–267.

——. "The Programmer's Genitals." *SEND* 2, no. 1 (1983).

Lewis, Louise. "Future Video: Max Almy." *LAICA Journal* no. 38 (Winter 1983).

Loeffler, Carl E. "TV: Popular Art Form." *Art-Com* 6 (1), no. 21 (1983).

——. "Toward a Television Art Criticism." *Art-Com* 6 (2), no. 22 (1983).

London, Barbara. "Selected US Chronology." *Circulating Video Library*. New York: MOMA, 1983.

——. "Independent Video: The First Fifteen Years." *Artforum* 19, no. 11 (September 1980): pp. 38–41.

London, Barbara, and Lorraine Zippay. "A Chronology of Video Activity in the United States: 1965–1980." *Artforum* 9 (September 1980): pp. 42–45.

Lorber, Richard. "Epistemological TV." *Art Journal* 34, no. 2 (Winter 1974/1975): pp. 132–134.

Lord, Catherine. "It's The Thought That Counts: Video As Attitude." *Afterimage* 11, no. 3 (October 1983): pp. 9–11.

——. "Video, Technology, and the Educated Artist." *The Independent* 8, no. 5 (June 1985): pp. 14–16.

Lord, Chip. "Abscam: Video in Crime and Justice." *Video 81* 2, no. 1.

——. "Guts and Fortitude: Video Art and K. Huffman Put the LBMA on the Map." *High Performance* 7, no. 1 (1984).

——. "TVTV/Video Pioneers: 10 Years Later." *SEND* (Summer 1983): pp. 18–23.

Löwy, Michael. "Revolution against 'Progress': Walter Benjamin's Romantic Anarchism." *New Left Review* no. 152 (July/August 1985): pp. 42–59.

Lyotard, Jean-Francois. "Les Immateriaux." *Art and Text* 17 (April 1985): pp. 47–57.

——. "Philosophy and Painting in the Age of their Experimentation: Contributions to an Idea of Postmodernity." *Camera Obscura* 12 (Summer 1984): pp. 111–25.

——. "The Dream-Work Does Not Think." Translated by Mary Lydon. *The Oxford Literary Review* 6, no. 1 (1983): pp. 3–34.

——. "The Postmodern Condition: A Report on Knowledge." Translated by Geoff Bennington and Brian Massumi. *Theory and History of Literature* 10, Minneapolis: University of Minnesota Press, 1984.

——. "Theory as Art: A Pragmatic Point of View." *Image and Code*. Edited by Wendy Steiner. Michigan Studies in the Humanities,

no. 2, Ann Arbor, Mich.: University of Michigan (1981): pp. 71–77.

MacCabe, Colin. "Principles of Realism and Pleasure." *Screen* 17, no. 3 (Autumn 1976): pp. 7–27.

Margolies, John. "TV The Next Medium." *Art In America* 57, no. 5 (September/October 1969): pp. 48–55.

Marshall, Stuart. "Television/Video: Technology/Forms." *Afterimage* (London) nos. 8/9 (Spring 1981): pp. 70–85.

———. "Video Art, the Imaginary and the Parole Video." *Studio International* no. 191 (May 1976): pp. 243–47.

———. "Video Technology and Practice." *Screen* 20, no. 1 (Spring 1979): pp. 109–119.

Martinis, Dalibor. "As for the artist . . ." *Mediamatic* 3, no. 1 (1987).

McGee, Micki. "Artists Making the News: Artists Re-Making the News." *Afterimage* 10, no. 4 (November 1982): pp. 6–9.

———. "Narcissism, Feminism, and Video Art: Some Solutions to the Problem of Representation." *Heresies* no. 12 (Spring 1981).

McMullin, Dan. "Interview with Kathy Huffman." *Artists News* 4 no. 2 (1979).

Mellencamp, Patricia. "Avant-Garde TV: Simulation and Surveillance." *Video*. Montreal, 1986.

———. "Video and the Counterculture." *Global Television*. Edited by Cynthia Schnieder and Brian Wallis. Cambridge: MIT Press, 1989, pp. 199–224.

———. "Postmodern TV: Wegman and Smith." *Afterimage* 13, no. 5 (December 1985): pp. 6–9.

———. "'Uncanny' Feminism: The Exquisite Corpses of Cecelia Condit." *Afterimage* 14, no. 2 (September 1986). pp. 12–15.

Melville, Stephen. "How Should Acconci Count for Us? Notes on a Retrospect." *October* no. 18 (Fall 1981): pp. 79–90.

Mercer, Colin. "Culture and Ideology in Gramsci." *Red Letters* no. 8 (1978): pp. 19–40.

Metz, Christian. "The Fiction Film and Its Spectator: A Metapsychological Study." *New Literary History* 8, no. 1 (Autumn 1976): pp. 75–105.

Mignot, Dorine. "Bill Viola's Room for St. John of the Cross: A Video Installation〈197〉

Viewed within the Tradition of Visual Art." *Video*. Montreal, 1986.

Minkowski, John. "The Videotape Collection at Media Study/Buffalo." *Afterimage* 5, no. 7 (February 1978): pp. 4–5.

———. "Bill Viola's Video Vision." *Video 81* 2, no. 1 (1981).

Moore, Alan. "Peter Campus, Andy Mann, Ira Schneider, Tom Marioni at the Everson Museum of Art." *Artforum* no. 12 (June 1974): pp. 77–79.

Morgan Robert C. "Who Was Joseph Beuys?" *High Performance* no. 33 (1986).

Mosco, Vincent, and Andrew Herman. "Critical Theory and Electronic Media." *Theory and Society* 10, no. 6 (March 1981): pp. 869–896.

Muchnic, Suzanne. "Eleanor Antin." *Artweek* 10, no. 6 (1979): p. 16.

Muntadas, A., et al. "60's Spirit, 80's Tech: Nam June Paik Home TV." *The Australian Video Festival*, 1986.

Noble, David F. "Present Tense Technology." *Democracy* 3 no. 2 (Spring 1983): pp. 8–24; 3, no. 3 (Summer 1983): pp. 70–82; 3, no. 4 (Fall 1983): pp. 71–93.

O'Pray, Michael. "Modernism, Phantasy and Avant-Garde Film." *Undercut* no. 3/4 (March 1982): pp. 31–33.

Osborne, Barbara. "New Wave on the Airwaves." *The Independent* 8, no. 9 (November 1985): pp. 14–17.

Owens, Craig. "The Discourse of Others: Feminists and Postmodernism (Dara Birnbaum)." In *The Anti Aesthetic: Essays on Postmodern Culture*. Edited by Hal Foster. Port Townsend, Wash.: Bay Press, 1983: pp. 57–82.

Paik, Nam June. "La Vie, Satelites, One Meeting〈197〉One Life." *Video-Culture*. Rochester, N.Y., 1986.

———. "Media Planning for the Postindustrial Society." (1974) *Nam June Paik, Werke 1946–1976*, 1976.

———. "Norbert Wiener and Marshall McLuhan." *Nam June Paik: Werke 1946–1976*, Koln, West Germany: 1976.

———. "Paper TV vs. Real TV." *Art Rite* no. 7 (1974).

———. "Random Access Information." *Artforum* no. 19 (September 1980): pp. 46–49.

———. "Seven Billion $ Is Spent Annually in America for the Beauty Business." *Art in Society* 7, no. 3 (1970).

———. "Stimulation of Human Eyes by Four Channel Stereo Videotaping." *EAT/LA Survey* (Fall 1970).

Penley, Constance. "Les Enfants de la Patrie." *Camera Obscura* nos. 8/9/10 (Fall 1982): pp. 33–58.

Perrone, Jeff. "The Ins and Outs of Video." *Artforum* 14, no. 10. (June 1976): pp. 53–57.

Pincus-Witten, Robert. "Nam June Paik at the Bonino Gallery." *Artforum* no. 12 (April 1974): pp. 67–70.

———. "Open Circuits: The Future of Television." *Artforum* no. 12 (April 1974): p. 70.

Pollock, Griselda. "Artists, Mythologies and Media⟨197⟩Genius, Machines and Art History." *Screen* 21, no. 3 (1980): pp. 57–59.

Pruitt, John. "The Video Work of Richard Foreman." *The Downtown Review* 3, nos. 1/2 (Fall/Spring 1981–1982).

Putnam, Hilary. "Reason and History." *Reason, Truth and History*. Cambridge: Cambridge University Press, 1981: pp. 150–73.

Rajandream, Jouke. "The Apparent Simplicity of Pieter Baan Muller." *Mediamatic* 3, no. 1 (1987).

Rajchman, John. "The Postmodern Museum." *Art in America* 73, no. 10 (October 1985): pp. 110–117, 171.

Rebouf, R. "Nam June Paik: Historical Juxtapositions." *Artweek* 13, no. 2 (1982): p. 4.

Reidy, Robin. "Pop Pop Video." (Dara Birnbaum) *American Film* (January/February 1980).

Reilly, John, and Stefan Moore. "The Making of the Irish Tapes." *Filmmakers Newsletter* (December 1975).

Reinke, Klaus. "Video Artists." *Studio International* no. 183 (February 1972): pp. 84–85.

Renzio, Toni del. "The TV Aesthetic." *Art and Artists* 9, no. 8 (1974).

Restany, Pierre. "The Videomonster: The Immense and Fragile Hope of Popular Art." *Domus* (June 1975).

Rice, Shelley. "Conjunctions: The Video Installations of Lauren Ewing." *Afterimage* 11, nos. 1/2 (Summer 1983): pp. 31–34.

———. "Francesc Torres: The Tyranny of the Past." *Afterimage* 10, no. 5 (December 1982): pp. 4–7.

———. "Mary Lucier." *Woman's Art Journal* (Fall/Winter 1984–1985).

———. "Mythic Space: The Video Installations of Rita Myers." *Afterimage* 9, no. 6 (January 1982): pp. 8–11.

———. "Video Installation 1983." *Afterimage* 11, no. 9 (December 1983).

Rorty, Richard. "Deconstruction and Circumvention." *Critical Inquiry* 11, no. 1 (September 1984): pp. 1–23.

Rose, Barbara. "Switch-On-Art." *New York Magazine* (December 20, 1971).

Rosler, Martha. "Video: Shedding the Utopian Moment." *Block* no. 11 (1985/1986). (Also published in *Video,* Rene Payant, ed.)

Ross, David. "A Provisional Overview of Artists' Television in the United States." *Studio International* no. 191 (May/June 1976): pp. 265–72.

———. "Bay Area Video." *Video 80* 1, no. 1 (1980): p. 5.

———. "Douglas Davis." *Flash Art* (May 1975).

———. "Douglas Davis: Video Against Video." *Arts Magazine* no. 49 (December 1974): pp. 60–62.

———. "Nam June Paik's Videotapes." *Nam June Paik.* Edited by J. G. Hanhardt. New York: 1982.

———. "Paik/Gillette/Downey: Process and Ritual." *ArtsCanada* 30, no. 4 (1973): pp. 41–44.

———. "The Personal Attitude." *Video Art* (1976).

———. "Postmodern Station Break: A Provisional (Historic) Overview of Video Installation." In *American Landscape Video.* Catalogue. Pittsburgh: The Carnegie Museum of Art, 1988.

———. "Truth or Consequences ⟨197⟩American Television and Video Art." *The Luminous Image.* 1984, and in *Video Culture.*

———. "Video and the Future of the Museum." *The New Television,* p. 144.

———. "Video at the Museum." *Art-Rite* no. 7 (Fall 1974).

Rugoff, Ralph. "The Brothers Yonemoto." *LA Style* (December 1985).

Ryan, Paul. "Design for Local Television Channels Dedicated to the Living Earth." *Is*

the Earth a Living Organism? (Conference papers), Sharon, CT: National Audubon Society Expedition Institute, 1986.

———. "Videotape: Thinking About a Medium." *Media and Methods* (December 1968).

Said, Edward. "Secular Criticism." *Raritan* 2, no. 3 (Winter 1983): pp. 1–26.

Schimmel, Paul, and Nam June Paik. "Abstract Time." *Arts Magazine* 49, no. 4 (December 1974): pp. 52–53.

Schwartz, Ellen. "Vito Acconci: 'I Want To Put the Viewer on Shakey Ground.'" *Artnews* 80, no. 6 (Summer 1981): pp. 93–99.

Sharp, Willoughby. "An Interview with Joseph Beuys." *Artforum* 8, no. 4 (December 1969): pp. 40–47.

———. "Paul Ryan⟨197⟩Video Pioneer: From Teen Age Monk to Video Bareback Rider." *Video 81* 2, no. 1 (1981): pp. 14–18.

———. "Telecommunications in the Space Shuttle Era." *Video 80/1* 1, no. 2 (1981): pp. 12–16.

———. "Terry Fox: Elemental Gestures." *Avalanche* (April 1970).

———. "The Artists Satellite TV Network." *Video 80* 1, no. 1 (1980): pp. 18–19.

———. "Videoperformance." *Video Art* (1976).

Sharp, Willoughby, and Liza Bear. "Terry Fox: Children's Videotapes." *Avalanche* (December 1974).

Sieling, Neil. "The National Alliance of Media Arts Centers." *Afterimage* 13, no. 4. (November 1985): p. 3.

Simmons, Allison. "For An Improbable Alliance." *The New Television: A Public/Private Art.* Cambridge: MIT Press, 1977.

Snyder, Joel. "Benjamin on Reproducibility and Aura: A Reading of 'The Work of Art in the Age of its Technical Reproducibility.'" *The Philosophical Forum* 15, nos. 1/2 (Fall/Winter 1983/1984): pp. 130–145.

Staiger, Janet, and Douglas Gomery. "The History of World Cinema: Models for Economic Analysis." *Film Reader* no. 4 (1979): pp. 35–44.

Starenko, Michael. "What's An Artist To Do? A Short History of Postmodernism and Photography." *Afterimage* 10, no. 6 (January 1983): pp. 4–5.

Stein, Ellin. "Ant Farm: The Last Interview." *Boulevards* (September 1980).

Straayer, Chris. "Say I Am: Feminist Performance Video in The 70's." *Afterimage* 13, no. 4. (November 1985): pp. 8–12.

Strickand, Hal. "Video-Visionaer (bei John Sanborn)." *Ars Electronica 1986* (Supplement), Linz, Austria, 1986.

Sturken, Marita. "A Narrative Conceit." *Afterimage* 9, no. 9 (April 1982): pp. 10–11.

———. "An Interview With Barbara Buckner." *Afterimage* 12, no. 10 (May 1985): pp. 6–9.

———. "An Interview with George Stoney." *Afterimage* 11, no. 6 (January 1984): pp. 7–11.

———. "Denman's Col (Geometry): Mary Lucier." *Afterimage* 9, no. 7 (February 1982): pp. 10–11.

———. "Feminist Video: Reiterating the Difference." *Afterimage* 12, no. 9 (April 1985): pp. 9–11.

———. "Howard Wise and Video Art." *Afterimage* 11, no. 10 (May 1984): pp. 5–9.

———. "James Byrne's Video Projects: The Aesthetics of the Subject." *Afterimage* 10, no. 9 (April 1983): pp. 7–11.

———. "Private Money and Personal Influence: Howard Klein and the Rockefeller Foundation's Funding of the Media Arts." *Afterimage,* 14, no. 6 (January 1987): pp. 8–15.

———. "Temporal Interventions: The Videotapes of Bill Viola." *Afterimage* 10, nos. 1/2 (Summer 1982): pp. 28–31.

———. "TV as a Creative Medium: Howard Wise and Video Art." *Afterimage* 11, no. 10 (May 1983): pp. 5–9.

———. "What is Grace in All This Madness: The Videotapes of Dan Reeves." *Afterimage* 13, nos. 1/2 (Summer 1985): pp. 24–27.

Tamblyn, Christine. "Whose Life Is It, Anyway?" *Afterimage* 15, no. 1 (Summer 1987): pp. 22–24.

Taubin, Amy. "For Nam June: Notes on an Oversight." *Resolution, A Critique of Video Art* LACE. 1986: pp. 99–104.

Thomson, Patricia. "Atomic Reactions: Film and Videotapes on Nuclear War and Disarmament." *Afterimage* 11, no. 9 (April 1984): pp. 5–10.

———. "Independents on Television." *Afterimage* 11, nos. 1/2 (Summer 1983): pp. 28–30.

———. "Under Fire on the Home Front: An Interview With Jon Alpert." *Afterimage* 14, no. 9 (April 1987): pp. 8–10.

———. "Video and Electoral Appeal." *Afterimage* 12, no. 7 (February 1985): pp. 8–11.

Tomkins, Calvin. "Profiles: Video Visionary." (Nam June Paik) *The New Yorker* 51, no. 11 (May 5, 1975): pp. 44–79.

Town, Elke. "Luminous Sites." *Vanguard* 15, no. 3 (Summer 1986): pp. 12–16.

Trefois, Jean-Paul. "From Video Art to Art." *The Luminous Image*. 1984.

———. "Pour une 'ecole belge.'" *Videodoc* no. 82 (December 1985-January 1986).

Trove, N. "Paik Exhibit Review." *Arts Magazine* 50, no. 9 (1976).

Turim, Maureen. "Desire in Art and Politics: The Theories of Jean-Francois Lyotard." *Camera Obscura* no. 12 (Summer 1984): pp. 91–106.

Turner, Ann, et al. "The National Center for Experiments in Television." *Radical Software* 2, no. 3 (1973).

Vasulka, Woody. "Syntax of Binary Images." *Afterimage* 6, nos. 1/2 (Summer 1978): p. 20. *Videography*. "The Movement Within: Images Created on a Video Synthesizer." 4, no. 12 (December, 1979): pp. 32–33.

Vasulka, Woody, and Scott Nygren. "Didactic Video: Organizational Models of the Electronic Image." *Afterimage* 3, no. 4 (October 1975): pp. 9–13.

Viola, Bill. "Sight Unseen: Enlightened Squirrels and Fatal Experiments." *Video 80* No. 4 (Spring/Summer 1982): pp. 31–33.

———. "Some Recommendations on Establishing Standards for the Exhibition and Distribution of Video Works." *The Media Arts in Transition*. Minneapolis: Walker Art Center, 1983, pp. 50–57.

———. "The European Scene and Other Observations." *Video Art*, eds. Ira Schneider and Beryl Korot. New York: Harcourt Brace Jovanovich, 1976, pp. 268–78.

———. "Will There Be Condominiums in Data Space?" *Video 80* no. 5 (Fall 1982): pp. 36–41.

Weibel, Peter. "Das orbitale Zeitalter." *Noema* 3, no. 7/8 (1986).

———. "Jenseits der Erde: Das orbitale Zeitalter." *Ars electronica 1986*, Linz, 1986.

———. "Pictorialer Raum in der elektronischen Kunst." *Ars electronica 1986* (Supplement), Linz, 1986.

———. "Zur Geschichte und Ästhetik der digitalen Kunst." *Ars electronica 1984* (Supplement) Linz, 1984.

Weinstock, Jane. "Interview With Martha Rosler." *October* no. 17 (Summer 1981): pp. 77–98.

Welling, James. "Gillette's Quidditas." *Artweek* 6, no. 21 (1975): p. 5.

———. "Landscape Video." *Artweek* 6, no. 36 (October 25 1975): p. 16.

Welsh, Jeremy. "Scratch and the Surface: Contemporary British Video." *Afterimage* 13, no. 6 (January 1986): pp. 4–5.

Werden, Rodney. "Sickness or Logic." *Video 80* (Winter 1983).

White, Robin. "Great Expectations: Artists' TV Guide." *Artforum* 20, no. 10 (June 1982): pp. 40–47.

Whitney, John H. "A Computer Art for the Video Picture Wall." *Art International* no. 15 (September 1971): pp. 35–38

Wiegand, Ingrid. "The Surreality of Video." *Video Art*, 1976.

Wolin, Richard. "The Bankruptcy of Left-Wing Kulturkritik: The 'After the Avant-Garde' Conference." *Telos* no. 63 (Spring 1985): pp. 168–73.

Wooster, Ann-Sargent. "An Armory of Mirrors: Juan Downey's 'Looking Glass.'" *Afterimage* 10, nos. 1/2 (Summer 1982): pp. 24–27.

Worth, Sol, and John Adair. "Through Navaho Eyes: An Exploration." *Study in Film Communication and Anthropology*. Bloomington: Indiana University Press, 1972.

Wortz, Melinda T. "An Evening with Chris Burden." *Artweek* 4, no. 44/45 (December 22, 29, 1973): p. 5.

———. "Collector's Video." *Artweek* 5, no. 23 (June 15, 1974): pp. 1 & 16.

———. "Cups, Ballet, Funny Video." *Art News* no. 72 (December 1983).

———. "Going to a Restaurant and Eating the Menu." *Art News*, no. 74 (October 1975).

———. "Jay McCafferty." *Artweek* 5, no. 17 (April 27 1974): p. 1 & p. 16.

———. "Southland Video Anthology." *Artweek* 6, no. 26 (July 26, 1975): pp. 1 & 20.

Wulffers, Albert. "Framing and Editing: Marie Andre." *Video*, Ottawa, 1986.

Yalkut, Jud. "Art and Technology of Nam June Paik." *Arts Magazine* no. 42 (April 1968): pp. 50–51.

———. "Electronic Zen: The Underground TV Generation." *Westside News* (August 10, 1967).

———. "Frank Gillette and Ira Schneider: Parts I and II of an Interview." *Radical Software* no. 1 (Summer 1970).

———. "TV as a Creative Medium at Howard Wise Gallery." *Arts Magazine* no. 44 (September 1969): p. 18.

Yonemoto, Bruce. "Survey Australia: Video and Bookworks." *Artweek* 11, no. 1 (January 12, 1980): p. 13.

Yonemoto, Bruce, and Norman Yonemoto. "Anti-Social: The Work of Ante Bozanich 1975–1982." *Video 80* (Winter 1983).

———. "Communication as Art." *Artweek* 13, no. 8 (February 27, 1982): p. 4.

———. "Criticism of Japanese Reality." *Artweek* 14, no. 43 (December 17, 1983): p. 12.

———. "Made in Hollywood: A Treatment for a Video Feature." *Resolution A Critique of Art Video*, Lace, 1986: pp. 47–50.

———. "Reality as Mirage." *Artweek* 11, no. 17 (May 3, 1980: p. 14.

Youngblood, Gene. "A Medium Matures: Video and the Cinematic Enterprise." *The Second Link*, 1983.

———. "Art, Entertainment, Entropy." *Video-Culture*, Rochester, N.Y., 1986: pp. 225–231.

———. "Computer Art as a Way of Life." *SEND* 2, no. 1 (1983): pp. 24–29.

———. 'Cray-1." *Ars electronica 1984*, Linz, 1984.

———. "Der virtuelle Raum." *Ars electronica 1986* (Supplement) Linz, 1986.

———. "Die neue Renaissance: Kunst, Wissenschaft und die universelle Maschine." *Ars electronica 1986* (Supplement) Linz, 1986.

———. "Die Wiederentdeckung des Amateurs." *Noema* 3, no. 7/8 (1986).

———. "Ed Emshwiller's Skin Matrix: An Interview." *SEND* no. 10 (Spring 1985).

———. "Ein Medium reift heran: Video und die Unternehmen Kinematographie." *Ars electronica 1984*, Linz, 1984.

———. "Erotic Amateurs." *Video 80* no. 5 (Fall 1982).

———. "Metadesign: Auf dem Weg zu einem Postmodernismus der Rekonstruktion." *Ars electronica 1986*, Linz, 1986.

———. "The Videosphere. *Show* (September 1970).

Young, Robert. "Post-Structuralism: The End of Theory." *The Oxford Literary Review* 5, nos. 1/2 (1982): pp. 3–20.

PERIODICALS

Afterimage (Rochester, N.Y.: Visual Studies Workshop).

American Film: Journal of the Film and Television Arts (Washington, D.C.: The American Film Institute).

Art Com (San Francisco: Contemporary Arts Press).

Art in America (New York: *Art In America*).

Artforum (New York: *Artforum* International Magazine).

Artweek (Los Angeles).

Avalanche (New York: Center for New Art Activities) (no longer publishing).

Cahiers du Cinema (Paris: Edition de L'Etoile).

Camera Obscura (Los Angeles).

Community Video Report (Washington D.C.: Washington Community Video Center, 1973).

East Village Eye (New York: East Village Eye, Inc.).

Film Library Quarterly (New York: Film Library Information Council) (no longer publishing).

Fuse (Toronto: Arton's Publishing).

The Independent (New York: Foundation for Independent Film and Video).

LBMA Video (Long Beach, Calif.: The Long Beach Museum of Art Foundation), Video Council Newsletter, 1981

Media Arts (New York: National Alliance of Media Arts Centers).

Mediamatic (Amsterdam, Groningen, 1986).

Parachute, revue d'art contemporain (Montreal: Parachute. revue d'art contemporain).

Performance Magazine (London).

Radical Software (New York: Gordon and Breach) (no longer publishing).

Screen (London: The Society for Education in Film and Television Ltd.).

SEND (San Francisco: San Francisco International Video Festival) (no longer publishing).

Sightlines (New York: Educational Film Library Association).

Studies in Visual Communication (Philadelphia: Annenberg School of Communications).

TV Magazine (New York: Artists' Television Network).

Video and the Arts (Formerly *Video 80*, *Video 81, SEND*) (San Francisco: San Francisco International Video Festival) (no longer publishing).

Video Doc' (Brussels: Video Doc').

Video 80 (new titles *SEND, Video and the Arts*) (San Francisco, 1980) (no longer publishing).

Video Guide—Vancouver's Video Magazine (Vancouver: The Satellite Video Exchange), 1979.

Video info—La revue international de l'image electronique (Collectif Video).

Video Networks (San Francisco: Bay Area Video Coalition).

Video Texts (New York: Anthology Film Archive).

Videoglyphes (Paris).

Videography (New York: United Business Publications).

PERIODICALS: SPECIAL VIDEO ISSUES

Arts Magazine. "Video Issue." 49, no. 4 (December 1974).

Art-Rite. "Video Issue." no. 4 (Autumn 1974).

Artscanada. "The Issue of Video Art." 30, no. 4 (October 1973).

Avalanche Newspaper. "Video Performance." (May/June 1974).

Belloir, Dominique. "Video Art Exploration." *Cahiers du Cinema* Special series, 1981. In French.

Canepa, Anna, ed. 'Video." *Art Rite*, no. 4 (Autumn 1974).

de Havilland, Robert, ed. *Print* (January 1972).

Hornbacher, Sara, ed. "Video: The Reflexive Medium." *College Art Association Art Journal* (Fall 1985).

Kunstforum. (Winter/Spring 1985).

Lightworks. "The Video Issue." (Ann Arbor, Mich.) 1, no. 5 (June 1976).

Studio International. "Video Art Issue." no. 191 (May/June 1976).

Telos. "El Video." no. 9, Madrid (March-May 1987).

Videodoc'. "Video Montbeliard Questions." Special series, no. 69 (April, 1984).

White, Robin, ed. *TV Magazine*. New York: Artists Television Network, 1983.

EXHIBITION AND FESTIVAL CATALOG

Acconci, Vito, A Retrospective 1969 to 1980. Museum of Contemporary Art, Chicago, 1980.

Acconci, Vito. Luzern, Kunstmuseum Luzern, 1978.

Albright-Knox Art Gallery. *Vasulka, Steina: Machine Vision/Woody: descriptions.* Organized by Linda L. Cathcart. Buffalo, N.Y.: Buffalo Fine Arts Academy (1978).

American Federation of Arts, New York. A History of the American Avant-Garde Cinema. Exhibition catalogue. 1976.

American Film Institute. *National Video Festival 1981.* Washington, D.C.: The American Film Institute, 1981.

———. *National Video Festival Catalogue.* Los Angeles: American Film Institute (1981 Annual).

Art Video—Retrospectives et Perspectives. Charleroi, palais des Beaux-Arts, 1983.

The Australian Video Festival. Sydney, 1986.

Athens International Film/Video Festival, *Athens International Film/Video Festivals Catalogue.* Athens, Ohio (Annual).

Berkowitz, Terry, and David Donihue. *Alternating Currents.* New York: Alternative Museum, 1985.

Borelli, Caterina, curator. *From TV to Video: Dal video alla TV.* Bologna, Italy: L'immagine Elettronica, 1984. In French and English.

Boyle, Deirdre. *Documentary Video: Decades of Change.* Long Beach, Calif.: Long Beach Museum of Art, 1986.

———. *Return of Guerrilla Television: A TVTV Retrospective.* New York: International Center of Photography, 1986.

British Council. *Recent British Video.* London: British Council, 1983.

Busine, Laurent, ed. *Art Video: Retrospectives et Perspectives.* Charleroi, Belgium: Palais des Beaux Arts, 1983. In French.

Campus, Peter. Video-Installattart contemporain, 1980.

Carnegie, Luiseur. *American Landscape Video: The Electronic Grove.* The Carnegie Museum of Art, Pittsburgh, 1988.

Cathcart, Linda, ed. *Steina Vasulka: Machine Vision/Woody: Descriptions.* Buffalo: Albright-Knox Art Gallery, 1978.

Clancy, Patrick, curator. *Video As Attitude.* Al-

buquerque, New Mexico: University Art Museum, University of New Mexico, Albuquerque and Museum of Fine Arts, Sante Fe, 1983.

Conner, Russ. *Vision and Television.* Catalogue. Waltham, Mass.: Rose Art Museum, Brandeis University, 1970.

Crimp, Douglas, ed. *Joan Jonas: Scripts and Descriptions, 1968–1982.* Berkeley, Calif.: University Art Museum, 1983.

Crystal, Curtis, ed. *Video: A Selection in the Art Form.* Garden City, New York: Firehouse Gallery, Nassau Community College, 1979.

Daadgallerie. *Joan Jonas: He Saw Her Burning.* Berlin: Daadgallerie, 1984.

Deecke, Thomas, ed. *Douglas Davis: Arbeiten Works 1976–1977, Berlin 1977–1978.* Berlin: Neuer Berliner Kunstverein, 1978. In German and English.

Delahanty, Suzanne, ed. *Video Art.* Philadelphia: Institute of Contemporary Art, 1975 (out of print).

Drew, Nancy. ed. *So There, Orwell 1984.* New Orleans: Louisiana World Exposition, 1984.

Duguet, Anne-Marie. *Be a Musician, You'll Understand Video.* Catalogue of the National Video Festival. Los Angeles: American Film Institute, December 1986.

Everson Museum of Art. *Peter Campus.* Syracuse, N.Y., Everson Museum of Art (January 15–February 15, 1974), 1974.

Falk, Lorne, ed. *The Second Link: Viewpoints on Video in the Eighties.* Banff, Canada: Walter Phillips Gallery, 1983.

Fargier, Jean Paul, ed. *Actes du Colloque Video Fiction et Cie.* Montbeliard: CAC de Montbeliard, 1984. In French.

———. *Ou va la video?* Paris: Cahiers du Cinema, Editions de l'Etiole, 1986.

Felix, Zdenek, curator. *Marcel Odenbach.* Essen, West Germany: Museum Folkwang Essen and Stadtische Galerie im Lenbachhaus, München, West Germany: 1981. In German.

———. *Terry Fox: Metaphorical Instruments.* Essen, West Germany: Museum Folkwang Essen, 1982. In German.

———. *Shigeko Kubota: Video Sculptures.* Essen, West Germany: Museum Folkwang Essen / DAAD/Kunsthaus Zurich, 1981. In German and English.

Global Village Video Documentary Festival. New York: Global Village Video Resource Center, 1975.

Gousselin, Claude, curator. *Nan Hoover: Photo, Video, Performance 1980–82.* Montreal: Musee d'Art Contemporain, 1982. In French and English.

Hanhardt, John G., ed. *Nam June Paik.* New York: Whitney Museum of American Art and W. W. Norton, 1982.

Herzogenrath, Wulf. *Klaus vom Bruch.* Bonn: Stadtisches Kunstmuseum, 1986. In German.

———. *Nam June Paik: Fluxus Video.* Munich: Verlag Silke Schreiber, 1983. In German.

———. *Video Tapes.* Cologne, West Germany: Kolnischer Kunstverein, 1974. In German and English.

Hoy, Ann. *Juan Downey: The Thinking Eye.* New York: International Center of Photography, 1987.

Huffman, Kathy Rae, curator. *California Video.* Long Beach, Calif.: Long Beach Museum of Art, 1980.

———, ed. *Video: A Retrospective.* Long Beach, Calif.: Long Beach Museum of Art, 1984.

Huffman, Kathy Rae, and Robert C. Morgan. *Muntadas: Exposicion.* Madrid: Fernando Vijande, editor, 1985. In Spanish and English.

ICC Studio. *Salade Liegeoise Antwerpen.* Belgium: ICC Studio, 1985.

Ingberman, Jeannette, ed. *Muntadas: Exhibition.* New York: Exit Art, 1987.

Kirshner, Judith Russi, ed. *Vito Acconci A Retrospective: 1969–1980.* Chicago: Museum of Contemporary Art, 1980.

Kohr, Klaus Heinrich, curator. *Marcel Odenbach.* Darmstadt, West Germany: Austellungshallen Mathildenhohe Darmstadt, 1985.

Livingston, Jane. *William Wegman.* Los Angeles: Los Angeles County Museum of Art, 1973 (out of print).

London, Barbara. *New Video: Japan.* New York: American Federation for the Arts and the Museum of Modern Art, 1986.

———. *New Video: Japan.* Catalogue New Video Japan, New York: MOMA, 1985.

London, Barbara, ed. *Video From Tokyo to Fukui and Kyoto.* New York: Museum of Modern Art, 1979.

Lyons, Lisa, and Kim Levin. *Wegman's World.* Minneapolis: Walker Art Center, 1982.

McClusky, Alan, ed. *l'ere Semaine Internationale de Video Geneve Suisse.* Geneva: Saint Gervais Maison des Jeunes et de la Culture

Geneve, 1985. In French with English summaries.

Michelson, Annette, ed. *New Forms in Film*, catalog. Montreux: 1974.

Mignot, Dorine, ed. *The Luminous Image (Het Lumineuze Beeld)*. Amsterdam: Stedelijk Museum, 1984. In Dutch and English.

Miller, Nancy. *Wilderness: A Video Installation by Mary Lucier*. Cambridge: New England Foundation for the Arts, 1986.

Minkowsky, John, curator. *Video/TV: Humor/ Comedy*. Buffalo, N.Y.: Media Study/Buffalo, 1983.

Musée d'Art Moderne de la Ville de Paris. *Art Video Confrontation '74*. Paris: Musée d'Art Moderne de la Ville de Paris, 1974.

Museum Fridericianum. *Documenta 6*. Kassel, West Germany: Druck Verlag GMBH. In German.

Olander, William. *Women and the Media*. Oberlin, Ohio: Allen Memorial Art Museum, 1984.

Oursler, Tony. *Spheres d'influence*. Paris, centre Pompidou (December 1985–February 1986), 1985.

Page, Suzanne, curator. *Bill Viola*. Paris: ARC/Musee d'Art Moderne de la Ville de Paris, 1984. In French and English.

Podheiser, Linda. *Revising Romance: New Feminist Video*. New York: American Federation of Arts, 1984.

Projekt '74. *Kunst bleibt Kunst, Catalogue Documentation for Projekt '74*. Koln, West Germany: Wallraf-Richartz-Museum, 1974.

Rankin, Scott. *Video and Language: Video as Language*. Los Angeles: Los Angeles Contemporary Exhibitions (LACE), 1987.

Richardson, Brenda. *Terry Fox*. Berkeley, Calif.: University Art Museum, 1973 (out of print).

Rifkin, Ned. *Stay Tuned*. New York: The New Museum, 1981.

Rosebush, Judson, ed. *Everson Video '75*. Syracuse, N.Y.: Everson Museum of Art, 1975 (out of print).

——. *Frank Gillette: Video Process and Meta Process*. Syracuse, N.Y.: Everson Museum of Art, 1973 (out of print).

Ross, David A. *Americans in Florence: Europeans in Florence*. Florence: Centro Di, and Long Beach, Calif.: Long Beach Museum of Art, 1975 (out of print).

——. *Southland Video Anthology: 1976–77*. Long Beach, Calif.: Long Beach Museum of Art, 1976 (out of print).

——, curator. *Douglas Davis: Events Drawings Objects Videotapes*. Syracuse, N.Y.: Everson Museum of Art, 1972 (out of print).

——, curator. *Peter Campus*. Syracuse, N.Y.: Everson Museum of Art, 1974 (out of print).

——. *Southland Video Anthology: 1975*. Long Beach, Calif.: Long Beach Museum of Art, 1975, 1977 (out of print).

Simmons, Richard, curator. *Everson Video Revue*. Syracuse, N.Y.: Everson Museum of Art, 1979 (out of print).

——. *From the Academy to the Avant-Garde*. Rochester, N.Y.: Visual Studies Workshop, 1981.

The Australian Video Festival. Sydney, 1986.

Turim, Maureen. *The Electronic Gallery*. Binghamton, N.Y.: University Art Gallery, 1983.

Van Assche, Christine, curator. *Marcel Odenbach: Dans la vision peripherique du temoin*. Paris: Centre Georges Pompidou, 1986. In French.

——. *Tony Oursler: Spheres d'Influence*. Paris: Centre Georges Pompidou, 1985.

——. *Nostros Il de Thierry Kuntzel*. Paris: Centre Georges Pompidou, 1984. In French.

Video about Video. Videoglyphes⟨197⟩ministre des Affaires étrangeres (July 1980), Paris, 1980.

Video '79. *Video '79: Video The First Decade/ Deci Anni Di Videotape*. Rome: KANE, 1979. In Italian and English.

Videokunst in Deutschland 1963–1982. Stuttgart, West Germany: Kolnischer Kunstverein.

Video: a Retrospective 1974–1984. Long Beach: Long Beach Museum of Art, 1984.

Wegman's World. Minneapolis: Walker Art Center. (December 5, 1982–January 16, 1983), 1982.

Wegman, William. Los Angeles: L. A. County Museum of Art (May 22–July 1, 1973), 1973.

Willoughby, Dominique, ed. *Steina and Woody Vasulka*⟨197⟩*Videastes 1969–1984: 15 Annees d'Images electroniques*. Paris: Cine-MBXA/ Cinedoc, 1984. In French.

World Wide Video Festival. *World Wide Video Festival Catalogue*. The Haag, Holland: Kijkhuis (Annual).

Youngblood, Gene. *Metaphysical Structuralism: The Videotapes of Bill Viola (Notes for videodisc edition)*. Los Angeles: Voyager Press, 1986.

Articles and Essays.

Videography and Video Index

————. *The Executive Air Traveler.* 1979–81. 18:00, color/b&w. *211, 211–12.*

————. *Motorist.* 1989. 69:00, color. *214, 214.*

————. *Not Top Gun.* 1987. 26:00, color. *212–13, 213.*

Lucier, Mary. *Asylum (A Romance).* 1986. Color. Installation. *162.*

————. *Dawn Burn.* 1975–76. 30:00, b&w. Installation. *26, 457, 458.*

————. *Fire Writing.* 1975. 40:00, b&w. Performance. *457, 459, 459.*

————. *Ohio At Giverny.* 1983. 19:00, color. Installation. *159, 460–61, 461.*

————. *Untitled Display System.* 1975/87. B&w. Installation. *160, 162.*

————. *Wilderness.* 1986. 21:00, color. Installation. *456, 461–63, 462.*

Masayesva, Victor, Jr. *Itam Hakim Hopkit.* 1984. 60:00, color.

Millner, Sherry. *Scenes from the Micro-war.* 1985. 24:00, color. *235, 241.*

————, and Ernest Larsen. *Out of the Mouth of Babes.* 1987. 24:30, color. *306–07, 407, 409–10, 412, 413, 416, 417.*

Muntadas. *The Board Room.* 1987. Installation. *159, 164, 431–436, 432, 434.*

————. *Exposición.* 1985. Installation. *164.*

————. *haute CULTURE, Part I.* 1983. Installation. *164.*

————. *haute CULTURE, Part II.* 1984. Installation. *164.*

Myers, Rita. *The Allure of the Concentric: Installation Documentation.* 1985. 5:00, color. *159, 453.*

————. *Rift Rise.* 1986. *450.*

Nauman, Bruce. *Video Corridor.* 1968–70. Installation. *152, 153.*

————. *Video-Skulptur.* 1969.

Optic Nerve: Lyn Adler, Sherrie Rabinowitz, and Bill Bradbury. 50 *Wonderful Years.* 1973. 27:00, b&w. *62–63.*

Oursler, Tony. *Diamond: The 8 Lights (Spheres of Influence).* 1985. 53:47, color. *487, 487.*

————. *Spheres of Influence.* 1985. Installation.

————. *Spillchamber 2.* 1987–89. Installation.

Paik, Nam June. *Cargo Cult.* 1989. Installation.

————. *Demagnetizer (or Life Ring).* 1965. Sculpture. *75.*

————. *Electronic TV, Color TV Experiments, 3 Robots, 2 Zen Boxes, and Zen Can.* 1965. Exhibition. *75.*

————. *Get-Away Car.* 1988. *162.*

————. *Global Groove.* In collaboration with John Godfrey. 1973. 30:00, color. *75, 161.*

————. *Good Morning Mr. Orwell.* 1984. 57:18, color. *76, 285.*

————. *Magnet TV.* 1965. Sculpture. *70, 75, 280.*

————. *Robot K456.* 1969. *281.*

————. *TV Bra for Living Sculpture.* 1969. Color. Installation. *110, 161.*

————. *TV Cello.* 1971. Color. Installation. *110.*

————. *TV Clock.* 1968–81. Installation. *161.*

————. *TV Garden.* 1974–78. Installation. *161.*

————. *Video Commune: The Beatles from Beginning to End.* 1970. 4:00, b&w. *84.*

————. *Video Flag X.* 1985. Installation. *162.*

————. *Video Flag Y.* 1986. Installation. *162.*

————. *Video Flag Z.* 1986. Installation. *162.*

————. *Videotape Study No. 3.* In collaboration with Jud Yalkut. 1967–69. 5:00, b&w. *75, 76.*

Paper Tiger. *William Boddy Reads the Communications Act of 1933.* 28:00, color.

Patterson, Clayton. *Tompkins Square Police Riot.* 1988.

Quesada, Virginia. *Pictures that Sing.* 1986. *308.*

Raindance. *Media Primers.* (Schneider). 1970. 23:07, color.

————. *Media Primers.* (Shamberg). 1971. 16:29, color.

Raymond, Alan and Susan. *The Police Tapes.* 1976. 90:00, b&w. *58–59.*

Reeves, Dan. *Smothering Dreams*. 1981. 22:05, color. 66.

Reilly, John. *The Irish Tapes*. In collaboration with Stefan Moore. 1971–74. 56:00, b&w. Video and installation. 54.

———. *Giving Birth, Four Portraits*. In collaboration with John Gustafson. 1976. 55.

Ribe, Gloria. *De Acá de Esta Lado*. 1988. 24:00, color. 312.

Rosler, Martha. *A Simple Case for Torture, or How to Sleep at Night*. 1983. 61:46, color. 30, 239–41.

———. *Semiotics of the Kitchen*. 1975. 6:30, b&w. 30.

———. *Vital Statistics of a Citizen, Simply Obtained*. 1977. 39:20, color. 240.

Ryan, Paul. *Video Wake for My Father*. 1976. 12 hours, b&w. 118.

Ryoston, Curt. *Flat World*. 1987. Installation. 164.

———. *Room with Blinds*. 1987. Installation. 164.

Schneider, Ira. *Manhattan is an Island*. 1974. 47:17, b&w. Composite tape. 163.

———. *Time Zones (A Reality Simulation)*. 1980. Color. Video and installation. 163.

———. *Time Zones: Documentation of an Installation*. 1980. 33:40, color.

———. *Wipe Cycle*. In collaboration with Frank Gillette. 1969. B&w. Video and installation. 109, 163.

Segalove, Ilene. *Why I Got Into TV and Other Stories*. 1983. 10:00, color. 394.

Serra, Richard. *Boomerang*. 1974. 10:00, color. 408.

Shulman, David. *Everyone's Channel: An overview of the history and development of the public access movement in the United States*. 58:00, color.

Simon, Freed, and Vince Canzoneri. *Frank: A Vietnam Veteran*. 1981. 52:00, b&w.

Soto, Merián, and Pepón Osorio. *Wish You Were Here*. 316.

———. *No Regrets*. 1988. 316.

T. R. Uthco and Ant Farm. *The Eternal Frame*. 1975. 23:00, b&w/color.

Tejada-Flores, Rick. *Low 'N Slow, The Art of Lowriding*. 1983. 29:00, color. 63.

Terayama, Shito and Shuntaro Tanikawa. *Video Letter*. 1982–83. 436, 437–43, 443.

Top Value Television (TVTV). *Four More Years*. 1972. 61:28, b&w. 32, 56–57, 57, 100.

Torres, Francesc. *Belchite–South Bronx*. 1987–88. Installation. 159

———. *Dromos*. 1989. Installation. 206.

———. *Oikonomos*. 1989. Installation. 208.

Troyana, Ela. *Candela y Azúcar*. 1988. Color. Performance and video. 315.

———. *Memoria de la Revolución*. 1987. Color. Performance and video. 315.

Vasulka, Steina. *Geomania*. In progress.

———. *Lilith*. In collaboration with Doris Cross. 1987. 9:12, color. 472, 475.

———. *Signifying Nothing*. 1975. 15:00, b&w. 335–36.

———. *Summer Salt*. 1982 18:48, color. 472, 473.

———. *Voice Windows*. In collaboration with Joan La Barbara. 1986. 8:10, color. 471, 474.

———. *The West*. 1983. Installation.

Vasulka, Woody. *Artifacts*. 1980. 23:00, color.

———. *Art of Memory: The Legend*. 1987. 36:00, color. 330, 340–42.

———. *The Commission*. 1983. 45:00, color.

Velez, Edin. *Meaning of the Interval*. 1987. 18:40, color. 308.

———. *Meta Mayan II*. 1981. 20:02, color. 65, 65–66, 309, 310.

———. *Tule: The Cune Indians of San Blas*. 1978. 27:35, color. 309.

Videofreex. *Subject To Change*. 1969. 60:00, b&w and color. Video and Installation. 53, 109.

Viola, Bill. *Ancient of Days*. 1979–81. 12:21, color. 428–31.

———. *Information*. 1973. 30:00, color. 476.

———. *Room for St. John of the Cross*. 1983. Color. Installation. 162, 429.

Vostell, Wolf. *TV Dé-collage*. 1961. Performance. 77, 78, 162.

———. *TV Trouble*. 1963. 77.

Weinbrun, Graham. *The Erl King*. In collaboration with Roberta Friedman. Interactive video disc. 271, 300–301.

Yonemoto, Bruce and Norman. *Green Card: An American Romance*. 1982. 79:15, color. 376–77, 393.

TELEVISION PRODUCTIONS

American Educational Television. *An American Family*. 1971. Produced by Craig Gilbert.

Deep Dish. *Angry Initiatives/Defiant Strategies*. 1988. 58:00, color. Produced by John Greyson. 169–70.
———. *Public Access Program*. 1986. 58:00, color.

KTCA. *Alive From Off Center*. (series) 1985. 88–89.
———. *Changing Channels*. (series) 1974–78. 61.

The Learning Channel. *The Independents*. (series) 1985–present. 88.

WGBH. *Artists Showcase*. (series) 1974–82. Produced by Dorothy Chiesa. 85.
———. *Collisions*. 1976. 30:00. Co-produced by Fred Barzyk and David Loxton. 85.
———. *Jazz Images*. (series) 1964–66. Produced by Fred Barzyk. 82.
———. *The Medium is the Medium*. 1969. 27:50, color. 105.
———. *Mixed Bag*. (series) 1966. Directed by David Atwood.
———. *The Very First On The Air 1/2″ Video-tape Festival Ever*. 1972. Produced by Fred Barzyk. 84.
———. *What's Happening Mr. Silver?*. 1967–68. Produced by Fred Barzyk.
———. *Video Commune: The Beatles from Beginning to End*. 1970. Produced by Nam June Paik. 84.
———. *Video: The New Wave*. 1974. 58:27, color. Written and directed by Brian O'Doherty. 85.
WNET/WGBH. *New Television*. (series) 1985–present. 89.

VIDEO TAPE SOURCES

Art Metropole
788 King Street West
Toronto, Canada M5V IN6
416-376-2304

Electron Arts Intermix
536 Broadway, 9th Floor
New York, New York 10012
(212) 966-4605

The Kitchen
512 West 19th Street
New York, New York 10011
(212) 255-5793

London Video Arts
23 Frith Street
London, England
W1V 5TS
071-734-7410

Montevideo
Buiksloterweg 3-5
1031 CC Amsterdam
Holland
020-23.71.01

Museum of Modern Art
Circulating Video Library
11 West 53rd Street
New York, New York 10019
(212) 708-9530

Neurer Berliner Kunstverein
Kurfurstendamm 58
D-1000 Berlin 15
(030) 323.70.91

Satellite Video Exchange Society
1102 Homer Street
Vancouver, British Columbia
Canada V6B 2X6
(604) 688-9644

Video Data Bank
School of the Art Institute
280 South Columbus
Chicago, Illinois 50503
(312) 443-3793

Western Front Society
303 East 8th Avenue
Vancouver, British Columbia
Canada V5T 1S1
(604) 876-9343

Picture Credits

Front cover. Doug Hall, *Prelude to The Tempest,* 1985. Video still by Kira Perov. Courtesy Kira Perov.

2. *The Human Television.* Created by Doug Michels. © Doug Michels. Photo by Jules Backus.

18. Doug Hall, *The Terrible Uncertainty of the Thing Described,* 1987. Installation view by Hansen/Mayer from the collection of the San Francisco Museum of Modern Art, courtesy Doug Hall.

28. Courtesy Petrified Films, New York City, New York.

30. Martha Rosler, *Semiotics of the Kitchen,* 1975. Video still. Courtesy Marita Sturken.

32. TVTV, *Four More Years,* 1972. Video still. Courtesy Marita Sturken.

55. John Gustafson/John Reilly, *Giving Birth, Four Portraits,* 1976. Video still. Photograph by Kira Perov, courtesy Marita Sturken.

57. TVTV, *Four More Years,* 1972. Video still. Courtesy Marita Sturken.

60. Jon Alpert for the *Today Show.* Courtesy Mary Ann De Leo.

65. Edin Velez, *Meta Mayan II,* 1981. Video still. Courtesy Kira Perov.

70. Nam June Paik, *Magnet TV,* 1965. Video Sculpture view. © Peter Moore, courtesy the Whitney Museum of American Art.

76. Nam June Paik and Jud Yalkut, *Videotape Study No. 3,* 1967–69. Video still. © Peter Moore, courtesy Peter Moore.

78. Wolf Vostell, *Dé-collage Performance,* 1961. Two performance stills. © Peter Moore, courtesy Peter Moore.

80. Peter Campus, *Three Transitions,* 1973. Video still. Courtesy Marita Sturken.

84. The WGBH Project for New Television, 1970. Courtesy of WGBH.

91. Gary Hill, *Happenstance (part one of many parts)* 1982–83. Courtesy Gary Hill.

94. Gary Hill, *Incidence of Catastrophe,* 1987–88. Courtesy Gary Hill.

99. Gary Hill, *Offering,* photograph in the moment a TV is turned off. Courtesy Gary Hill.

100. Nancy Cain, 1972. Courtesy Marita Sturken.

116. Vito Acconci, *Theme Song,* 1973. Video still. Courtesy of Marita Sturken.

122. Courtesy Petrified Films, New York City, New York.

124. David Cronenberg, *Videodrome,* 1983. Film still. Courtesy The Universal City Studios Inc..

127. "Television Programs Sent on Light Beams", illustration from *Wasn't the Future Wonderful,* New York: E.P. Dutton, 1979, p. 96.

132. Vito Acconci, *TV Lives/VD Must Die,* 1978. Installation view. Courtesy Vito Acconci.

140. Dan Graham, *Present Continuous Past,* 1974. Installation view. Courtesy Musée National d'Art Moderne, Centre Pompidou, Paris, France.

146. Joan Jonas, *Double Lunar Dogs,* 1984. Video still by Electronic Arts Intermix, New York, courtesy Joan Jonas.

148. Joan Jonas, *Organic Honey's Visual Telepathy,* 1972. Video still by Gwenn Thomas, courtesy Joan Jonas.

152. Bruce Nauman, *Video Corridor,* 1968–70. Installation view. Courtesy Bruce Nauman.

160. Mary Lucier, *Untitled Display System,* 1975/87. Video Sculpture. Photograph Bill Jacobsen Studio, courtesy Mary Lucier.

176. Dan Graham, *Video View of Suburbia in an Urban Atrium*, 1979. Line drawing. Courtesy Dan Graham.

176. Dan Graham, *Video View of Suburbia in an Urban Atrium*, 1979. Installation view. Courtesy Dan Graham.

181. Dan Graham, *Video Piece for Shop Windows in an Arcade*, 1976. Installation view. Courtesy Dan Graham.

182. Dan Graham, *Video Piece for Shop Windows in an Arcade*, 1976. Line drawing. Courtesy Dan Graham.

189. Dara Birnbaum, *Rio Videowall*, 1989. Installation view by Nick Arroyo, © Dara Birnbaum.

191. Original call for entries for international competition for permanent outdoor video installation and tapes, Winter 1987. Courtesy Dara Birnbaum.

192. From publicity for Rio Shopping/ Entertainment Complex, two photographs, 1988. Courtesy Dara Birnbaum.

193. Siting of *Videowall* in plaza as indicated on the architectural plans, 1989. Courtesy Dara Birnbaum.

193. Dara Birnbaum, Drawing for proposal of 3 × 3 grid: landscape imagery, 1978. © CMV news, courtesy Dara Birnbaum.

194. Dara Birnbaum, close up of *Videowall*, 1989. Two installation views. Photographs by Nick Arroyo, © Dara Birnbaum.

195. Dara Birnbaum, Electric light box, used as backdrop for key element, entryway, Rio Shopping/Entertainment Complex, April 1989. Two photographs. Courtesy Dara Birnbaum.

196. Dara Birnbaum, Site before construction, April 1987. Three photographs. Courtesy Dara Birnbaum.

197. Dara Birnbaum, View of Plaza, (*Videowall* to be placed at right), August 1988. Photograph by Scott Ehrens, courtesy Dara Birnbaum.

198. Dara Birnbaum, *Videowall*, 1989. Two installation views. Photographs by Nick Arroyo, © Dara Birnbaum.

200. Dara Birnbaum, original architectual model of Rio Shopping/Entertainment Complex as presented to finalists of Rio Video Competition, April 1987. Three photographs. Courtesy Dara Birnbaum.

204. Dara Birnbaum, *Rio Videowall*, 1989. Installation view © Dara Birnbaum.

206. Francesc Torres, *Dromos*, Indiana, 1989. Installation view. Courtesy Indiana State Museum, Indianapolis, Indiana.

208. Francesc Torres, *Oikonomos*, 1989. Installation view. Courtesy Indiana State Museum, Indianapolis, Indiana.

210. Photograph American Airlines, courtesy Chip Lord.

211. Chip Lord, from the series *Executive Air Traveller*, 1981. Video still. Courtesy Chip Lord.

212. Chip Lord, *Easy Living*, 1984. Video still. Courtesy Chip Lord.

213. Chip Lord, *Not Top Gun*, 1987. Three video stills. Courtesy Chip Lord.

214. Chip Lord, *Motorist*, 1989. Video still. Courtesy Chip Lord.

215. Howard Fried, *The Museum Reaction Piece*, 1978–86. Photograph by R. Lorenz, courtesy Howard Fried.

215. Howard Fried, *The Museum Reaction Piece*, 1978–86. Photograph by Ben Blackwell, courtesy Howard Fried.

216. Howard Fried with William Joseph, nine line drawings for *Aligning The Museum Reaction Piece*, 1986–1989. Courtesy Howard Fried. William Joseph is director of facilities management, Gensler and Associates Architects, San Francisco.

223. Howard Fried, *The Museum Reaction Piece* (text on rear wall), 1987, 1989. Courtesy Howard Fried.

224. Courtesy Petrified Films, New York City, New York.

238. Joan Braderman, *Joan Does Dynasty*, 1986. Video still. Courtesy Martha Gever.

242. From *Bizarro Superman Comics*, 1989. Courtesy Bruce Yonemoto.

242. From *Bizarro Superman Comics*, 1989. Courtesy Bruce Yonemoto.

244. Patti Podesta, Untitled, 1989. Courtesy Patti Podesta.

245. Nechelle Wong, Untitled, 1989. Courtesy Nechelle Wong.

246. Nechelle Wong, Untitled, 1989. Courtesy Nechelle Wong.

247. Nechelle Wong, Untitled, 1989. Courtesy Nechelle Wong.

248. Nechelle Wong, Untitled, 1989. Courtesy Nechelle Wong.

258. The Paper Tiger crew, 1988. Courtesy Dee Dee Halleck.

265. Paper Tiger Production, *Jean Franco Reads Mexican Novelas*, 1985. © Diane Neumaier. Courtesy Diane Neumaier.

268. Lynn Hershman, *Roberta's Body Language Chart*, 1978. Courtesy Lynn Hershman.

270. Lynn Hershman, *Constructing Roberta Breitmore*, 1975. Courtesy Lynn Hershman.

271. Lynn Hershman, *Lorna*. Video Disk Design, Garti/Hershamn, 1984. Courtesy Lynn Hershman.

272. Lynn Hershman, *Lorna*, 1983. Video still. Courtesy Lynn Hershman.

272. Lynn Hershman, *Lorna*, 1983. Video still. Courtesy Lynn Hershman.

274. Bruce Davidson, Untitled, 1969. Courtesy Magnum Photos.

281. Nam June Paik, *Robot K456*, 1969. Video sculpture. Photograph by Peter Moore, courtesy Peter Moore.

299. Juan Downey, *Bachdisc*, 1988. Video still. Courtesy Juan Downey.

318. ECU (European money), coin. Photograph by Antonio Muntadas.

319. Cover of Jean Baudrillard's *America*, 1989. Photograph by Antonio Muntadas.

321. Peter d'Agostino, *DOUBLE YOU (and X,Y,Z)*, interactive videodisc, 1981–86. Courtesy Peter d'Agostino.

323. Peter d'Agostino, *DOUBLE YOU (and X,Y,Z)*, 1981–86. Videodisc installation view by Will Brown, courtesy The Philadelphia Museum of Art.

324. Peter d'Agostino, *TransmissionS*, 1985–90. Video still. Courtesy Peter d'Agostino.

325. Peter d'Agostino, *DOUBLE YOU (and X,Y,Z)*, touch screen, 1981–85. Courtesy Peter d'Agostino.

326. Peter d'Agostino, *TransmissionS*, 1985–90. Video still. Courtesy Peter d'Agostino.

327. Peter d'Agostino, *TransmissionS: In the WELL*, 1990. Installation view. Courtesy Peter d'Agostino.

328. Courtesy Petrified Films, New York City, New York.

330. Woody Vasulka, *Art of Memory: The Legend*, 1987. Video still. Courtesy Marita Sturken.

344. Juan Downey, *Bachdisc*, 1988. Video still. Courtesy Juan Downey.

346. Juan Downey, *Bachdisc*, 1988. Video still. Courtesy Juan Downey.

348. PBS, Chicago, *The Best of Ernie Kovacs*, 1984. Video still. Courtesy Bruce Ferguson.

358. PBS, Chicago, *The Best of Ernie Kovacs*, 1984. Video still. Courtesy Bruce Ferguson.

359. PBS, Chicago, *The Best of Ernie Kovacs*, 1984. Video still. Courtesy Bruce Ferguson.

366. Joan Jonas, *Organic Honey's Visual Telepathy*, 1972. Performance view by Peter Moore, courtesy Joan Jonas.

368. Joan Jonas, *Mirage*, 1978. Performance view by Ben Blackwell. Courtesy Joan Jonas.

370. Joan Jonas, *He Saw Her Burning*, Genazzano, Italy, 1983. Performance view by Nanda Lanfranco, courtesy Joan Jonas.

371. Joan Jonas, *He Saw Her Burning*, 1983. Courtesy Joan Jonas.

373. Joan Jonas, *He Saw Her Burning*, Genazzano, Italy, 1983. Courtesy Joan Jonas.

376. Bruce and Norman Yonemoto, *Green Card: An American Romance*, 1982. Video still. Courtesy Bruce Yonemoto.

377. Bruce and Norman Yonemoto, *Green Card: An American Romance*, 1982. Video still. Courtesy Bruce Yonemoto.

381. Diagram from *Rough Edits*, page 101. Published by Nova Scotia Pamphlets4, 1987. Courtesy Norman M. Klein.

393. Max Almy, *Leaving the 20th Century*, 1982. Video still. Courtesy Max Almy.

404. Helen DeMichiel, *Consider Anything, Only Don't Cry*, 1988. Photograph from The Minnesota State Historical Society, courtesy Laura Kipris.

408. Laura Kipnis, *A Man's Woman*, 1988. Three video stills. Courtesy Laura Kipris.

415. Helen DeMichiel, *Consider Anything, Only Don't Cry*, 1988. Photographs from The Minnesota State Historical Society, courtesy Laura Kipris.

418. Courtesy of Petrified Films, New York City, New York.

420. Gary Hill, *In Situ*, 1986. Performance view. Courtesy Gary Hill.

423. Thierry Kuntzel, *Nostos II Sequence 2*, 1984. Video still. © MNAM Centre Georges Pompidou, Paris, courtesy Raymond Bellour.

429. Bill Viola, *Room for St. John of the Cross*, 1983. Installation view. Courtesy The San Francisco Museum of Modern Art.

432. Muntadas, *The Board Room*, 1987. Installation view by Charles Meyer, courtesy Antonio Muntadas.

434. Muntadas, *The Board Room*, detail, 1987. Installation view by Charles Meyer, courtesy Antonio Muntadas.

434. Muntadas, *The Board Room*, detail, 1987. Installation view by Charles Meyer, courtesy Antonio Muntadas.

436. Shito Terayama and Shuntaro Tanikawa, *Video Letter*, 1982–83. Video Still.

444. Tony Labat, original line drawings by Rigo, 1990. Courtesy Tony Labat.

450. Rita Myers, *Rift Rise*, 1986. Installation view by David Allison, courtesy Rita Myers.

453. Rita Myers, *The Allure of the Concentric*, 1985. Video still. Courtesy Rita Myers.

456. Mary Lucier, *Wilderness*, 1986. Installation view by Gordon Chibrowski, courtesy Mary Lucier.

458. Mary Lucier, *Dawn Burn*, 1975. Video still. Courtesy Mary Lucier.

459. Mary Lucier, *Fire Writing*, The Kitchen, New York, 1975. Performance view by David Arky, courtesy Mary Lucier.

461. Mary Lucier, *Ohio at Giverny*, 1983. Two video stills. Courtesy Mary Lucier.

462. Mary Lucier, *Wilderness*, 1986. Video still by Rob Shelley, courtesy Mary Lucier.

464. Woody Vasulka, Hybrid Hand from the series, *Didactic Video*, 1983. Video still. Courtesy Woody Vasulka.

467. Woody Vasulka, Hybrid Studies from the series, *Didactic Video*, 1986. Video still. Courtesy Woody Vasulka.

468. Woody Vasulka, Hybrid Studies from the series, *Didactic Video*, 1986. Video still. Courtesy Woody Vasulka.

469. Woody Vasulka, Hybrid Studies from the series, *Didactic Video*, 1986. Video still. Courtesy Woody Vasulka.

473. Steina Vasulka, *Summer Salt*, 1982. Video still. Courtesy Steina Vasulka.

474. Steina Vasulka, *Voice Windows*, 1986. Video still. Courtesy Steina Vasulka.

475. Steina Vasulka, *Lilith*, 1987. Video still. Courtesy Steina Vasulka.

476. Bill Viola, *Information*, 1973. Video still by Kira Perov, courtesy Bill Viola.

487. Tony Oursler, *Video Dream*, from *Spheres of Influence*, 1989. Retouched production still. Courtesy Tony Oursler.

494. Bay Area Video Coalition's interformat suite. Photograph by Ron Compesi, courtesy BAVC.

Index

This publication is made possible by the generous support of the following:
The National Endowment for the Arts Media, Arts National Services
The National Endowment for the Arts Visual Artists Forums
The Rockefeller Foundation
The Zellerbach Family Fund

Library of Congress Catalog Number 90-081584
Hardcover ISBN: 0-89381-389-3
Paperback ISBN: 0-89381-390-7

The staff at Aperture for *Illuminating Video* is Michael E. Hoffman, Executive Director; Steve Dietz, Editor; Jane D. Marsching, Assistant Editor; Shelby Burt, Thomas Seelig, Editorial Work Scholars; Stevan Baron, Production Director; Linda Tarack, Production Associate; Karsten Moll, Design Work-Scholar.

Book design concept by Bethany Johns.

Aperture Foundation, Inc. publishes a periodical, books, and portolios of fine photography to communicate with serious photographers and creative people everywhere. A complete catalog is available upon request. Address: 20 East 23 Street, New York, New York 10010.

The Bay Area Video Coalition, a non-profit media arts center, was formed in 1976 as a support center for independent film and video producers and artists. Since its inception BAVC has provided: low cost access to sophisticated video production and post-production facilities; a bi–monthly journal, *Video Networks;* professional workshops and seminars; consulting services in all aspects of video production; a print and videotape resource library of media books and major media periodicals; grants management; awards sponsorship; and programming for viewing by national audiences.

N
6494
V53
I49
1991

Illuminating video.

$45.00

DATE			
1/31/08			